ZOOLOGY

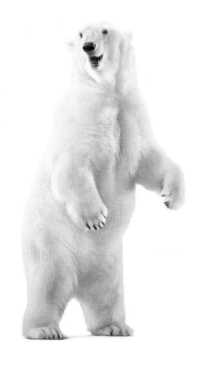

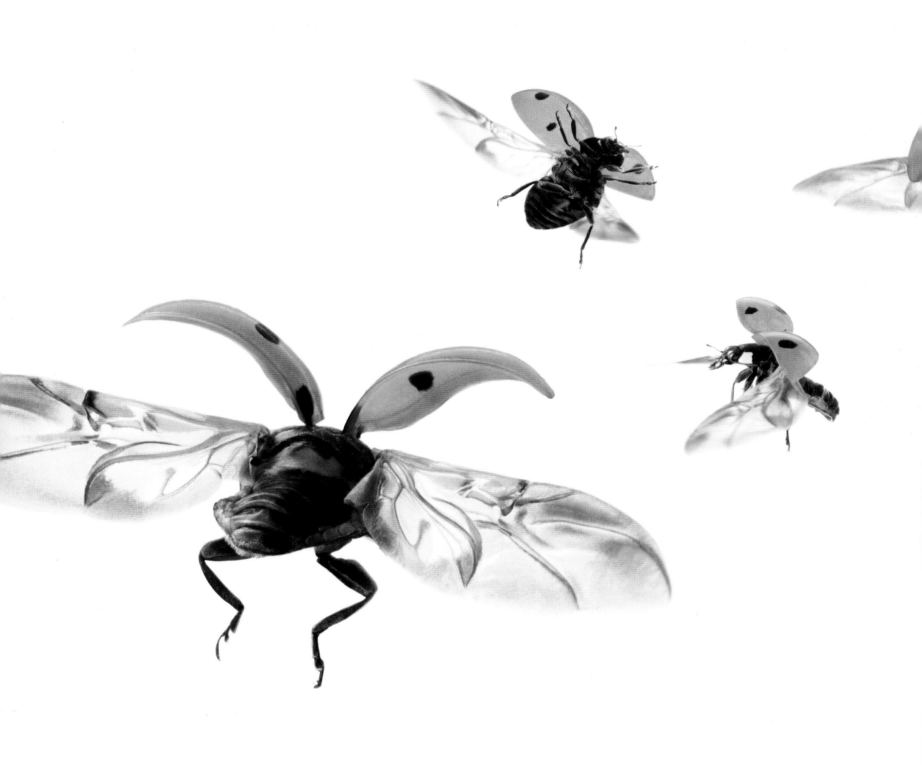

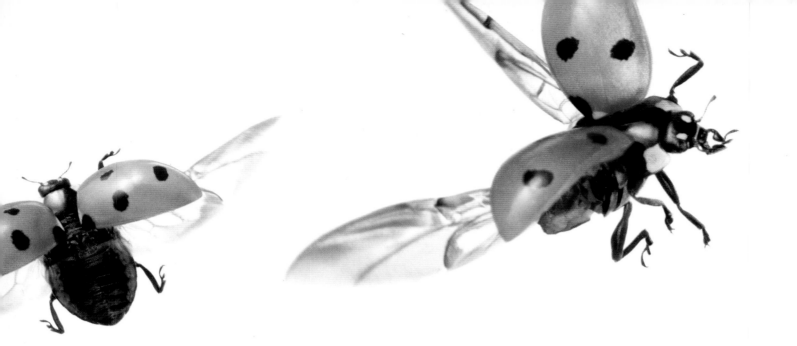

SMITHSONIAN

ZOOLOGY

THE SECRET WORLD OF ANIMALS

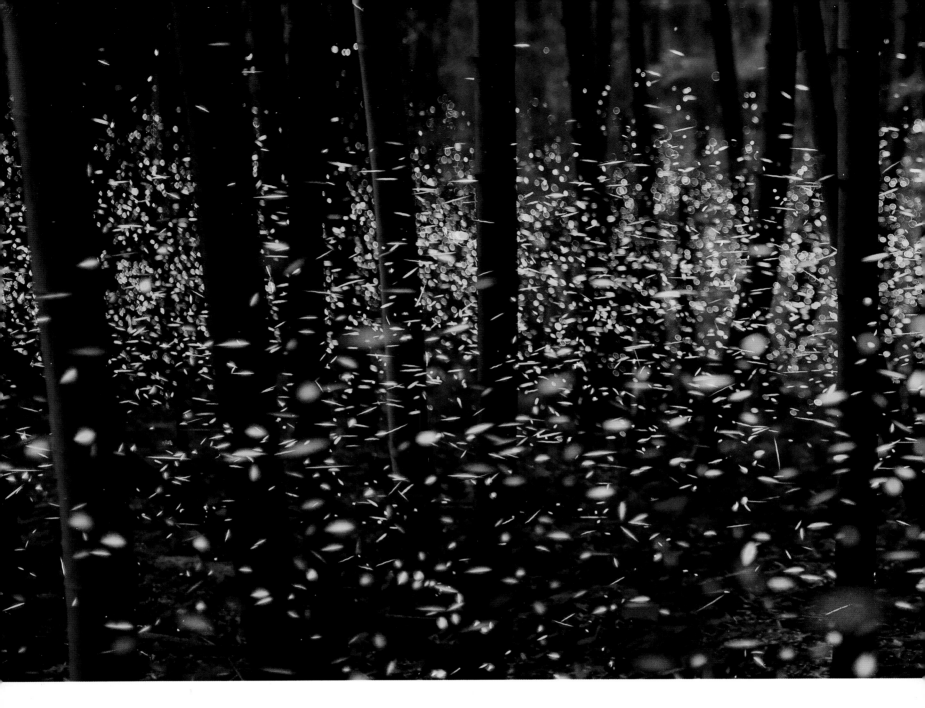

DK LONDON

Senior Editor Rob Houston
Editors Jemima Dunne, Steve Setford,
Kate Taylor, Ruth O'Rourke-Jones
US editor Jill Hamilton
Photographer Gary Ombler
Producer, Pre-Production Rob Dunn
Senior Producer Meskerem Berhane
Managing Editor Angeles Gavira Guerrero
Associate Publishing Director Liz Wheeler
Publishing Director Jonathan Metcalf

Senior Art Editor Ina Stradins
Project Art Editors Simon Murrell,
Steve Woosnam-Savage
Design Assistants Briony Corbett,
Bianca Zambrea
Jacket Design Development Manager Sophia MTT
Jacket Designer Akiko Kato
Managing Art Editor Michael Duffy
Art Director Karen Self
Design Director Phil Ormerod

DK INDIA

Senior Art Editor Chhaya Sajwan
Art Editors Anukriti Arora, Jomin Johny, Shipra Jain
Senior Managing Art Editor Arunesh Talapatra
Senior Picture Researcher Surya Sarangi
Project Picture Researcher Aditya Katyal

Senior DTP Designer Jagtar Singh
DTP Designer Jaypal Singh Chauhan
Production Manager Pankaj Sharma
Pre-Production Manager Balwant Singh

First American Edition, 2019
Published in the United States by DK Publishing
1450 Broadway, Suite 801, New York, NY 10018

Copyright © 2019 Dorling Kindersley Limited
DK, a Division of Penguin Random House LLC
19 20 21 22 23 10 9 8 7 6 5 4 3 2 1
001–310754–Oct/2019

A catalog record for this book is available from the Library of Congress.
ISBN 978-1-4654-8251-8

Printed and bound in China

A WORLD OF IDEAS:
SEE ALL THERE IS TO KNOW
www.dk.com

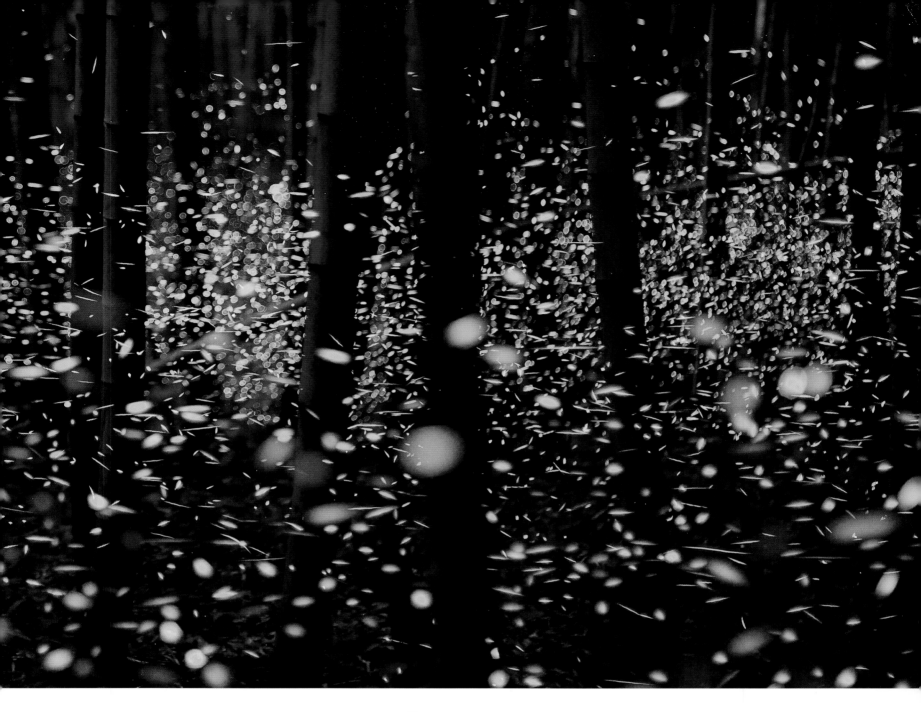

Contributors

Jamie Ambrose is an author, editor, and Fulbright scholar with a special interest in natural history. Her books include DK's *Wildlife of the World*.

Derek Harvey is a naturalist with a particular interest in evolutionary biology, who studied Zoology at the University of Liverpool. He has taught a generation of biologists, and has led student expeditions to Costa Rica, Madagascar, and Australasia. His books include DK's *Science: The Definitive Visual Guide* and *The Natural History Book*.

Esther Ripley is a former managing editor who writes on a range of cultural subjects, including art and literature.

Classification section contributors
Richard Beatty, Rob Hume, Tom Jackson

Half-title page Polar bear (*Ursus maritimus*)
Title page Seven-spot ladybird (*Coccinella septempunctata*)
Above Fireflies in a forest on the island of Shikoku, Japan
Contents page Blue iguana (*Cyclura lewisi*)

 S M I T H S O N I A N

Established in 1846, the Smithsonian Institution—the world's largest museum and research complex—includes 19 museums and galleries and the National Zoological Park. The total number of artifacts, works of art, and specimens in the Smithsonian's collections is estimated at 137 million, the bulk of which is contained in the National Museum of Natural History, which holds more than 126 million specimens and objects. The Smithsonian is a renowned research center, dedicated to public education, national service, and scholarship in the arts, sciences, and history.

Smithsonian consultants
Bryan Amaral, Senior Curator
Steve Sarro, Curator, Small Mammal House
Kenton Kerns, Assistant Curator, Small Mammal House
Meredith Bastian, Curator, Primates
Becky Malinsky, Assistant Curator, Primates
Rachel Metz, Curator, American Trail and Amazonia
Rebecca Sturniolo, Assistant Curator, American Trail
Ed Smith, Assistant Curator, Amazonia
Donna Stockton, **Thomas Wippenbeck**, Animal Keepers, Amazonia
Alan M. Peters, Curator, Reptile Discovery Center
Matthew Neff, Animal Keeper, Reptile Discovery Center
Sara Hallager, Curator, Bird House

Craig Saffoe, Curator, Great Cats, Kids' Farm, and Andean Bears
Leigh Pitsko, Assistant Curator, Great Cats, Kids' Farm, and Andean Bears
Laurie Thompson, Assistant Curator, Giant Pandas
Deborah Flinkman, Animal Keeper, Elephant Trails
Gil Myers, Assistant Curator, Cheetah Conservation Station
Dolores Reed, Animal Keeper, Smithsonian Conservation Biology Institute
Adrienne Crosier, **Brian Gratwicke**, Biologists, Smithsonian Conservation Biology Institute
Pamela Baker-Masson, Associate Director, Communications, Exhibit, and Planning
Jen Zoon, Communications Specialist

contents

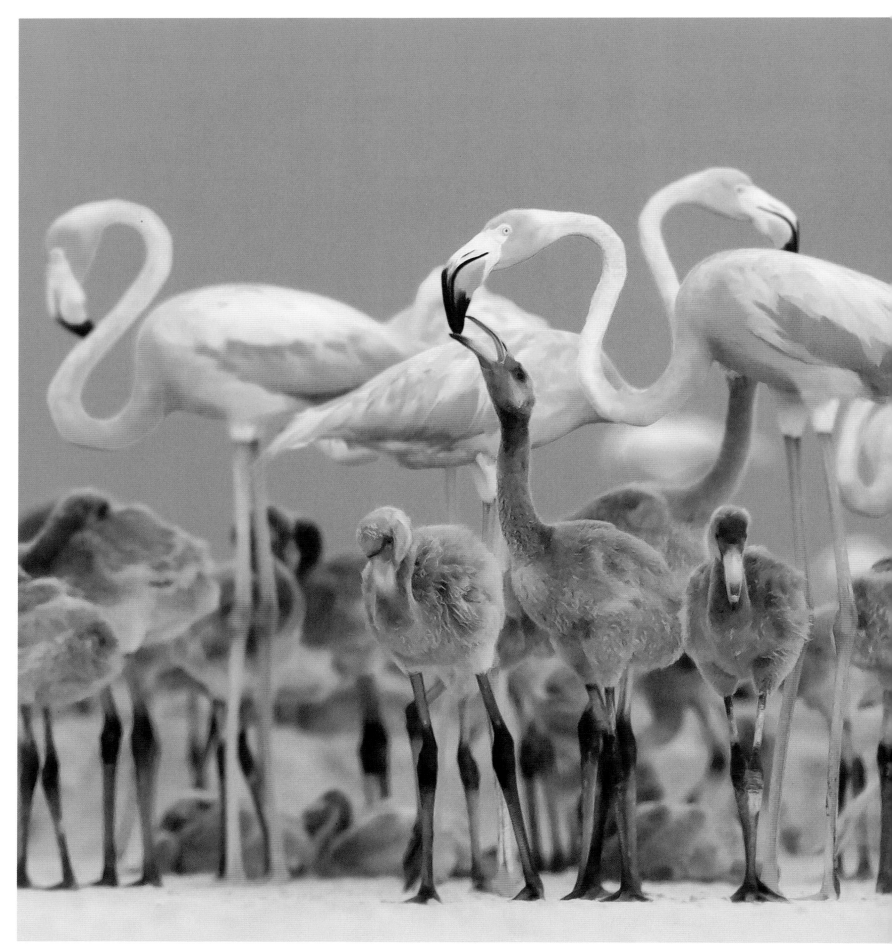

AMERICAN FLAMINGO *Phoenicopterus ruber*

foreword

Beauty is alluring, truth is essential, and art is surely humanity's purest reaction to these ideals. But what of that other irrepressible human trait—curiosity? Well, for me curiosity is the fuel for science, which in turn is the art of understanding truth and beauty. And this beautiful book presents a perfect fusion of these paragons, celebrating art, revealing remarkable truths, and igniting a curiosity for natural science.

In life all form must have a function, it can be in transition, but it's never redundant. This means that from childhood onward, we can study and question the shapes and structures of natural forms and try to determine what they are for and how they work. I remember examining a feather, weighing it, preening it, bending it, twisting it to watch its iridescence flash from green to purple, all the while working through a process of understanding why it was an asset to bird flight and behavior. Such investigation is perhaps the most fundamental skill of a naturalist and the essential technique of a scientist. And then I tried to paint it, its simple beauty the inspiration for art.

Natural forms also allow us to identify relatedness between species, throwing light on their evolution, which in turn opens our eyes to how we group them together. Of course there are tricksters—mammals with beaks that lay eggs! It's certainly fun to discover how our predecessors were fooled by these strange anomalies, but it's even more satisfying to uncover the truth as to why animals evolved such apparently bizarre forms.

This book reveals that nature is not short of such fascinations and revels in the joy that we can never completely satisfy our curiosities because there is always more to learn and know about life.

CHRIS PACKHAM
NATURALIST, BROADCASTER,
AUTHOR, AND PHOTOGRAPHER

the animal kingdom

animal. a living organism that is made of many cells that usually collaborate to form tissues and organs, and that ingests organic matter—such as plants or other animals—for nutrition and energy.

Single-celled relatives
Many complex single-celled organisms, such as this ciliate, *Paramecium bursaria*, were once called "protozoa" and classified as animals. But DNA evidence shows they are only distant relatives of the animal kingdom.

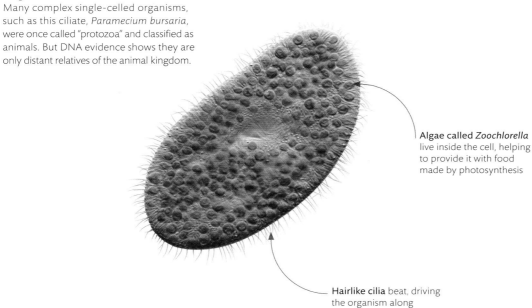

Algae called *Zoochlorella* live inside the cell, helping to provide it with food made by photosynthesis

Hairlike cilia beat, driving the organism along

what is an animal?

Animals differ from the two other major kingdoms of multicellular organisms—fungi and plants—in the fabric of their bodies. Animals have collagen protein holding their cells together into tissues, and and all but the simplest use nerves and muscles to move. Whether rooted to one spot like sponges, or as active as ants, animals gather food. Unlike fungi that absorb dead matter, or photosynthesizing plants, animals feed on other organisms.

THE SIMPLEST ANIMALS

Sponges are the simplest animals alive today. Unlike more complex animals, whose cells become fixed for purpose in the adult body, sponge cells are totipotent—each capable of regenerating the entire body. Some sponge cells develop beating hairlike flagella that create a current for filter-feeding. The hairs are almost identical to those of single-celled organisms called choanoflagellates, suggesting that the first animals evolved from similar organisms.

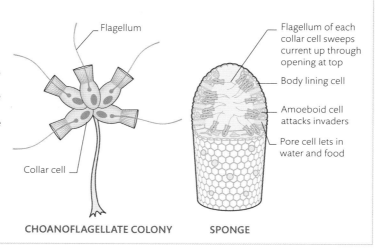

Flagellum

Collar cell

CHOANOFLAGELLATE COLONY

Flagellum of each collar cell sweeps current up through opening at top

Body lining cell

Amoeboid cell attacks invaders

Pore cell lets in water and food

SPONGE

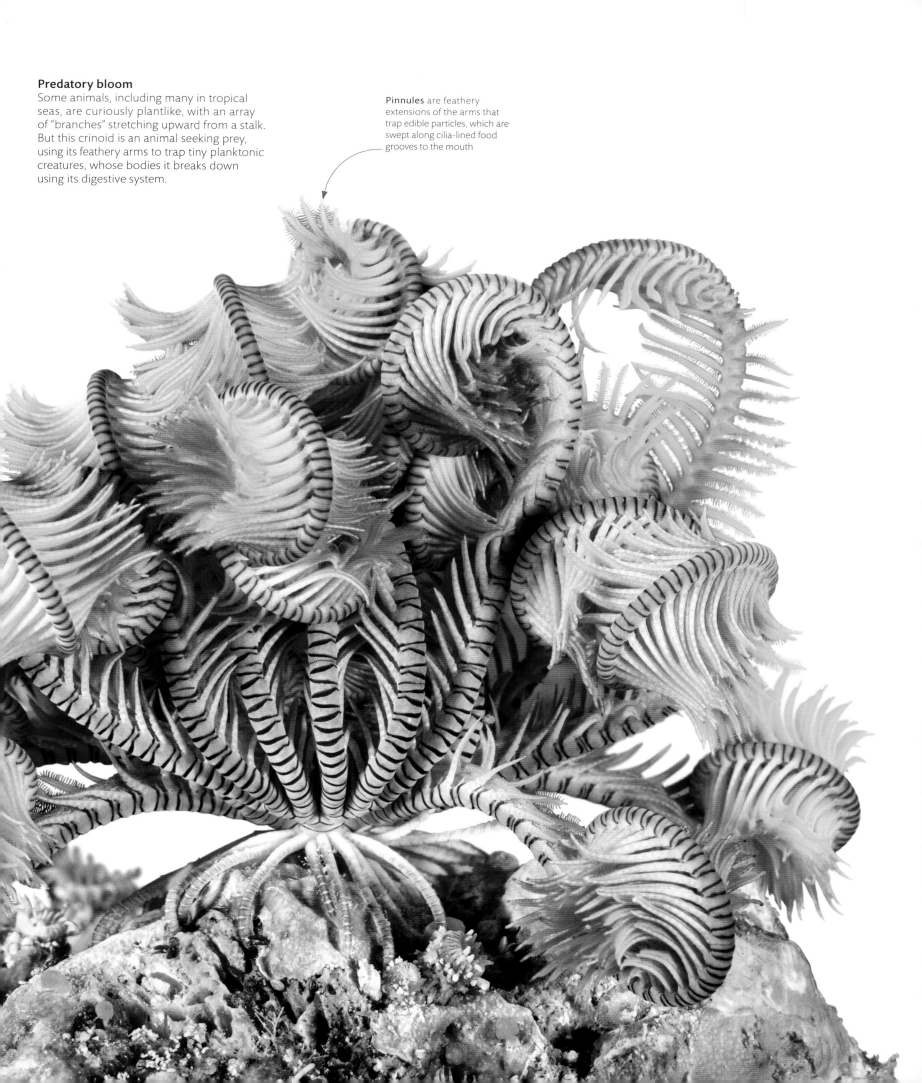

Predatory bloom

Some animals, including many in tropical seas, are curiously plantlike, with an array of "branches" stretching upward from a stalk. But this crinoid is an animal seeking prey, using its feathery arms to trap tiny planktonic creatures, whose bodies it breaks down using its digestive system.

Pinnules are feathery extensions of the arms that trap edible particles, which are swept along cilia-lined food grooves to the mouth

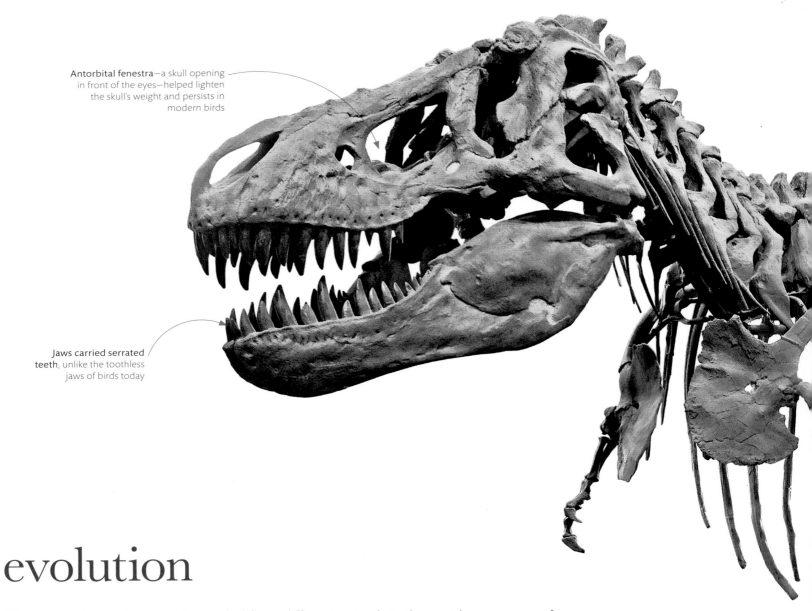

Antorbital fenestra—a skull opening
in front of the eyes—helped lighten
the skull's weight and persists in
modern birds

Jaws carried serrated
teeth, unlike the toothless
jaws of birds today

evolution

All animals alive today have descended from different animals in the past by a process of evolution. No single individual evolves, rather entire populations accumulate differences over many generations. Mutation—random replication errors in the genetic material—is the source of inherited variation, while other evolutionary processes, notably natural selection—the driving source of adaptation—determine which variants survive and reproduce. Over millions of years small changes add up to bigger ones, helping explain the appearance of new species.

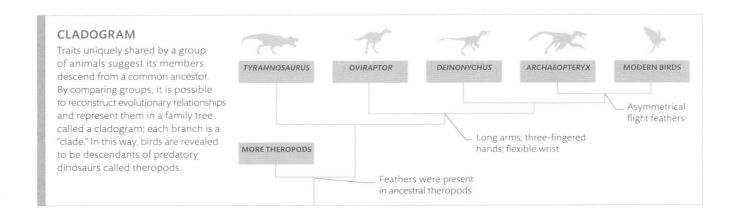

CLADOGRAM

Traits uniquely shared by a group of animals suggest its members descend from a common ancestor. By comparing groups, it is possible to reconstruct evolutionary relationships and represent them in a family tree called a cladogram; each branch is a "clade." In this way, birds are revealed to be descendants of predatory dinosaurs called theropods.

TYRANNOSAURUS OVIRAPTOR DEINONYCHUS ARCHAEOPTERYX MODERN BIRDS

MORE THEROPODS

Asymmetrical
flight feathers

Long arms; three-fingered
hands; flexible wrist

Feathers were present
in ancestral theropods

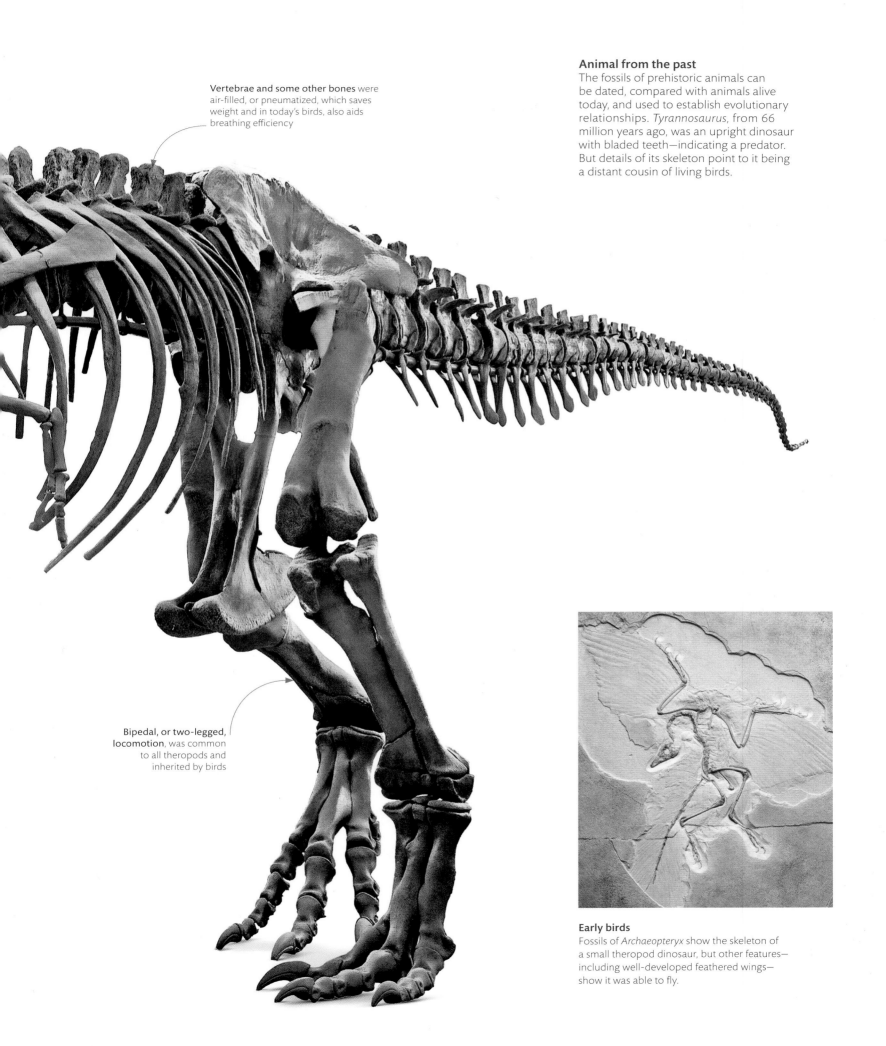

Vertebrae and some other bones were air-filled, or pneumatized, which saves weight and in today's birds, also aids breathing efficiency

Bipedal, or two-legged, locomotion, was common to all theropods and inherited by birds

Animal from the past
The fossils of prehistoric animals can be dated, compared with animals alive today, and used to establish evolutionary relationships. *Tyrannosaurus*, from 66 million years ago, was an upright dinosaur with bladed teeth—indicating a predator. But details of its skeleton point to it being a distant cousin of living birds.

Early birds
Fossils of *Archaeopteryx* show the skeleton of a small theropod dinosaur, but other features—including well-developed feathered wings—show it was able to fly.

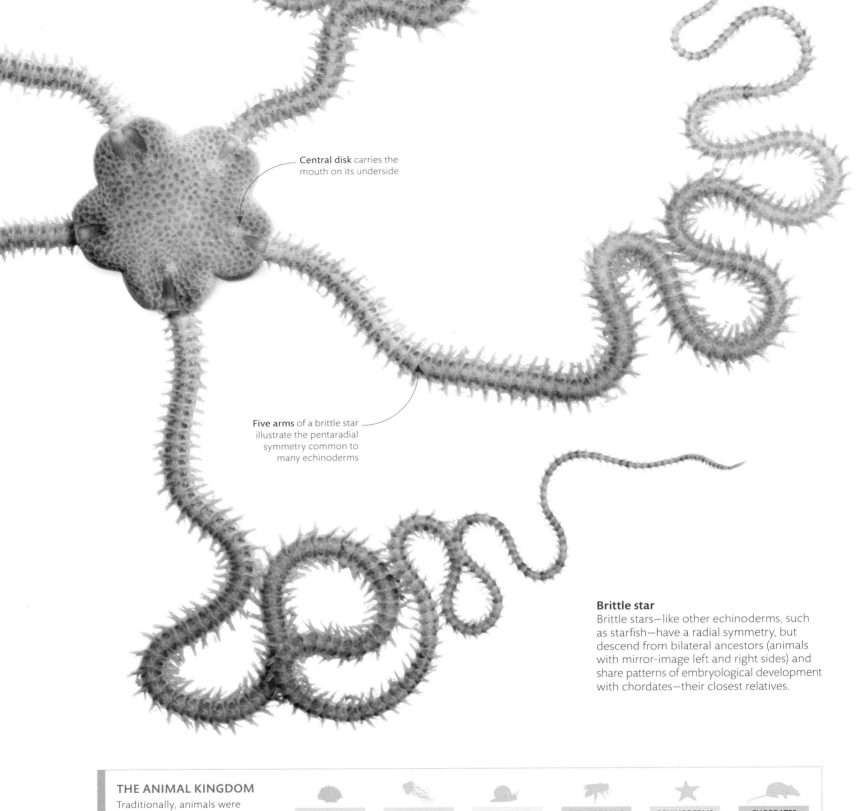

Central disk carries the mouth on its underside

Five arms of a brittle star illustrate the pentaradial symmetry common to many echinoderms

Brittle star
Brittle stars—like other echinoderms, such as starfish—have a radial symmetry, but descend from bilateral ancestors (animals with mirror-image left and right sides) and share patterns of embryological development with chordates—their closest relatives.

THE ANIMAL KINGDOM

Traditionally, animals were divided into invertebrates (without backbones) and vertebrates (with backbones), but this neglects the true pattern of their evolutionary relationships. Most animals lack backbones, and a cladogram (family tree) shows that all vertebrates make up just a subgroup of the chordates—only one of the multiple branches of the family tree. The deepest, oldest splits in the tree occurred with shifts in body symmetry.

SPONGES

CNIDARIANS include jellyfish

SPIRALIANS include molluscs and many worms

ECDYSOZOANS include insects and other arthropods

ECHINODERMS include starfish

CHORDATES include mammals and other vertebrates

Return to radial symmetry

Radial symmetry

Bilateral symmetry

Each pipe is part of a weakly organized colony that can survive being broken into pieces

Pipe sponge

Lacking permanent organization of body tissues, sponges diverged early from the base of the animal kingdom family tree and are regarded as the "sister group" of all other groups of animals with more complex tissues.

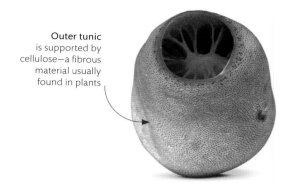

Outer tunic is supported by cellulose—a fibrous material usually found in plants

Sea squirt

Vertebrates belong to the same group as sea squirts—the chordates. While most adult sea squirts are fixed to the seabed, they have tadpolelike swimming larvae with bodies supported by a rodlike notochord—a precursor of a vertebrate backbone.

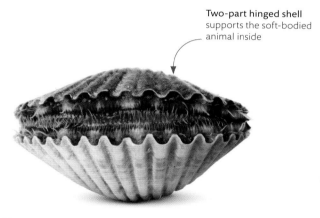

Two-part hinged shell supports the soft-bodied animal inside

Clam

Mollusks, such as this clam, are united with earthworms and allies in a group called spiralians, according to DNA evidence. Many share a particular form of early development that involves spiral arrangement of cells in the developing embryo.

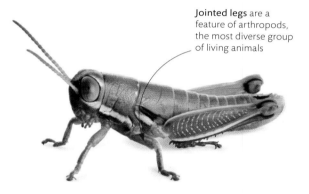

Jointed legs are a feature of arthropods, the most diverse group of living animals

Grasshopper

The most species-rich group of animals—the ecdysozoans—include jointed-legged arthropods, such as insects and crustaceans, as well as nematode worms. Their growth involves "ecdysis"—the molting of a tough cuticle or exoskeleton.

types of animal

Scientists have described some 1.5 million species of animals. They organize this diversity into groups of animals whose shared characteristics suggest common ancestry. Some, such as echinoderms, have a starlike radial symmetry; others have bodies arranged like our own—with head and tail ends. Most are popularly called invertebrates, because they lack a backbone. But invertebrates as different as a sponge and an insect otherwise have nothing uniquely in common and no direct evolutionary relationship, so scientists do not recognize them as a natural group.

Family groups

There are around 200 beetle families; the four largest are represented here. The biggest, the rove beetles, has 56,000 described species—nearly as many as all backboned animals combined. The other three groups have 30,000 to 50,000 each. It is likely that 90 percent of beetle species are still yet to be discovered.

Carnivorous beetle with a powerful jaw

Short wing case

Metallic-colored wing case common in leaf beetles

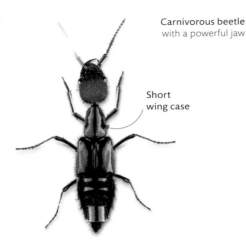

ROVE BEETLES (STAPHYLINIDAE)
Metallic blue rove beetle
Plochionocerus simplicicollis

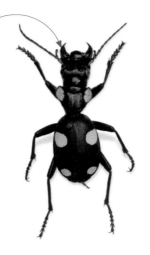

GROUND BEETLES (CARABIDAE)
Six-spot ground beetle
Anthia sexguttata

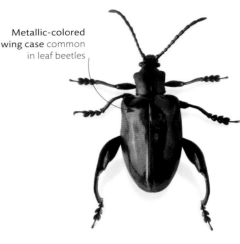

LEAF BEETLES (CHRYSOMELIDAE)
Violet frog-legged beetle
Sagra buqueti

Diversity by habitat

Almost every land or freshwater habitat capable of supporting life—with the exception of the coldest polar regions—has its own species of beetles. The rich rain forest habitats could contain hundreds of thousands of undiscovered species. Only oceans, largely unconquered by insects, lack beetles, but some do survive by the shore.

Fog condenses dew on body, which beetle drinks, hence its name

Large eyes used for hunting in daylight

Exoskeleton reflects light, making beetle appear gold

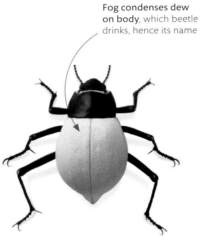

DESERT HABITAT
Black-and-white fog beetle
Onymacris bicolor

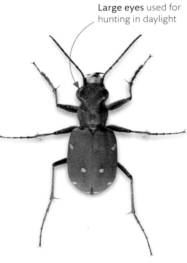

MOORLAND HABITAT
Green tiger beetle
Cicindela campetris

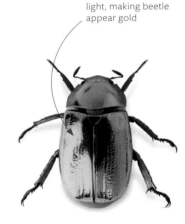

RAIN FOREST HABITAT
Golden jewel scarab
Chrysina resplendens

Beetle behavior

Like any successful group of animals, the triumph of the beetles comes down to their ability to make a living in different ways. In each case, their versatile mouthparts have the potential to chew through anything. Some species eat leaves and plant matter, others hunt prey, and there are beetles that thrive on foods such as beeswax, fungi, and animal waste.

Shield and horn protects beetle when competing for dung

Fanlike antenna supports sensors that detect food

Head case is irridescent; color changes according to angle viewed

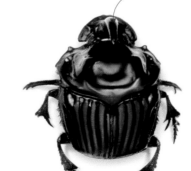

DUNG-ROLLER
Green devil dung beetle
Oxysternon conspicillatum

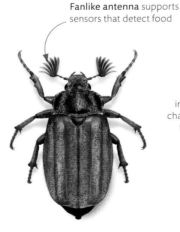

LEAF AND ROOT-EATER
Cockchafer
Melolontha melolontha

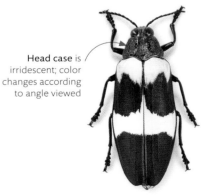

WOOD BORER
Banded jewel beetle
Chrysochroa rugicollis

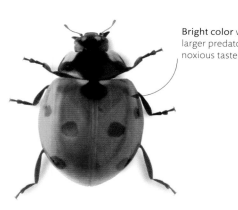

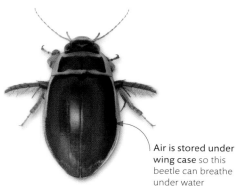

beetle diversity

Despite the extraordinary range of animal life in the sea and on land, one-quarter of all described species belong to a single group of insects—beetles. Like any taxonomic group, they are built on a common theme. They all have hardened wing cases, called elytra, and chewing mouthparts. But in 300 million years of evolution, they have diversified into a multitude of forms.

Angled **antennae** and long nose beak typical in weevils

WEEVILS (CURCULIONIDAE)
Schönherr's blue weevil
Eupholus schoenherri

Collector's pieces
Inspired by their diversity, many naturalists are passionate collectors of beetles. Austrian specialist Karl Heller named this longhorn *Rosenbergia weiskei* in honor of the German explorer Emil Weiske, who discovered it in the New Guinea jungle in 1898.

Mouthparts drink sap of fig trees

Extremely long, hornlike **antennae**, used for sensing food plants

Air is stored under wing case so this beetle can breathe under water

FRESHWATER POND
Great diving beetle
Dytiscus marginalis

Bright color warns larger predators of noxious taste

Head and body can be 2 in (5 cm) long

PREDATOR
Seven-spotted ladybug
Coccinella septempunctata

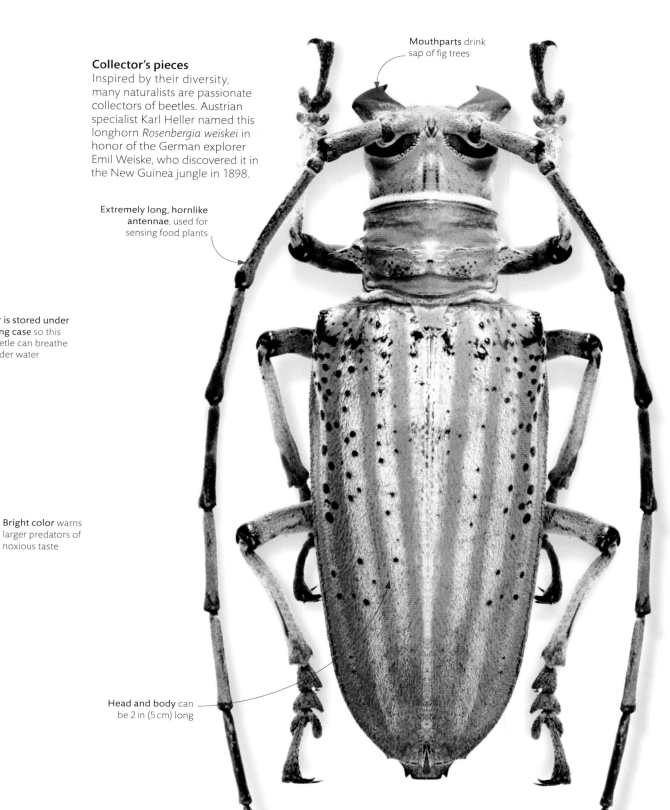

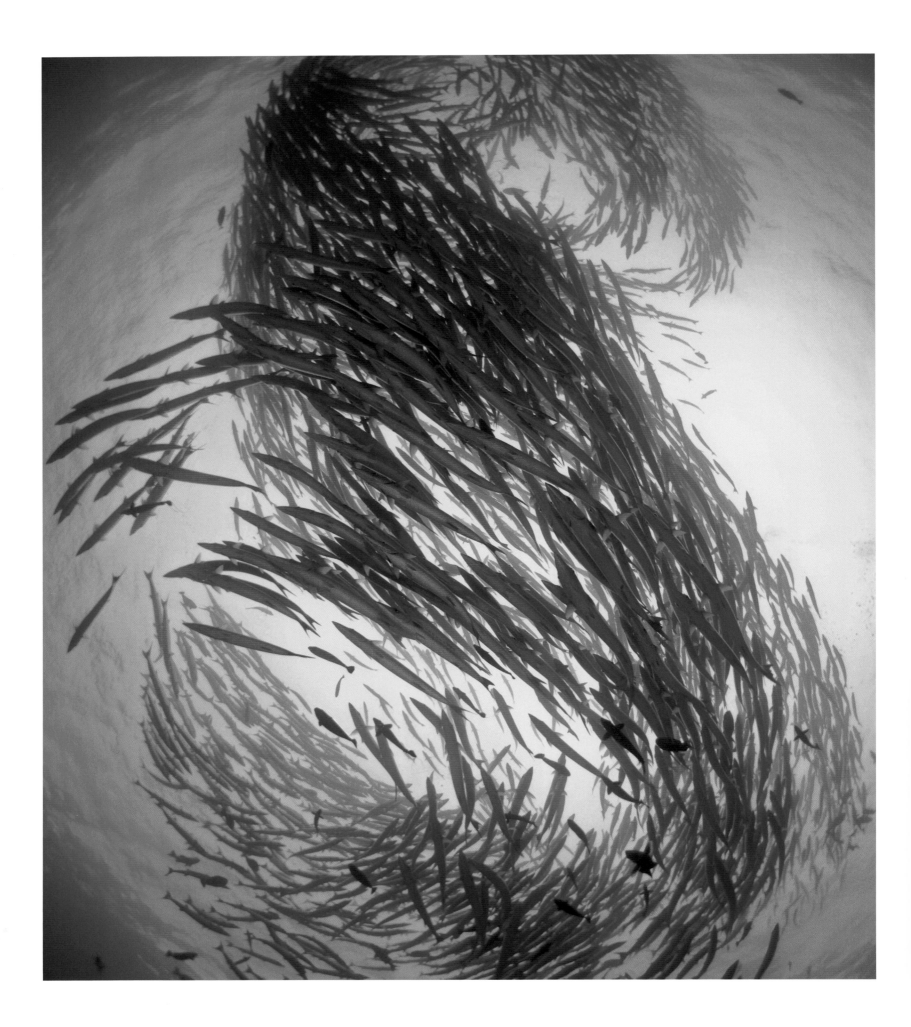

fish and amphibians

The first backboned animals were fish, and around half of today's 69,000 or so vertebrate species have retained the fish body form. The archetypal fish has a hydrodynamic shape that aids movement in water, scaly skin, fins that stabilize and control movement, and gills that absorb oxygen—but many forms have deviated from this plan. Amphibians are descendants of a group of fleshy-finned fish, and were the first vertebrates to walk on land.

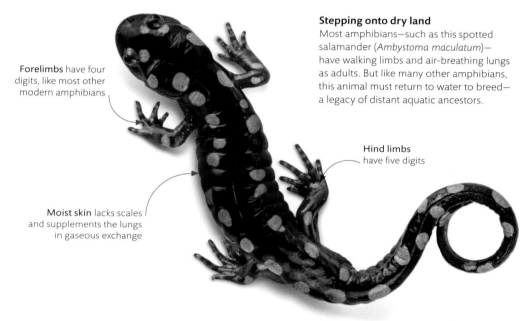

Forelimbs have four digits, like most other modern amphibians

Moist skin lacks scales and supplements the lungs in gaseous exchange

Hind limbs have five digits

Stepping onto dry land
Most amphibians—such as this spotted salamander (*Ambystoma maculatum*)—have walking limbs and air-breathing lungs as adults. But like many other amphibians, this animal must return to water to breed—a legacy of distant aquatic ancestors.

Ocean origins
The first fish swam in the oceans half a billion years ago. The saw-toothed barracuda (*Sphryraena putnamae*) and other modern fish are very different from those early jawless pioneers. Faster muscles, a swim bladder controlling buoyancy, and jaws make barracudas and other predatory schooling fish masters of their underwater world.

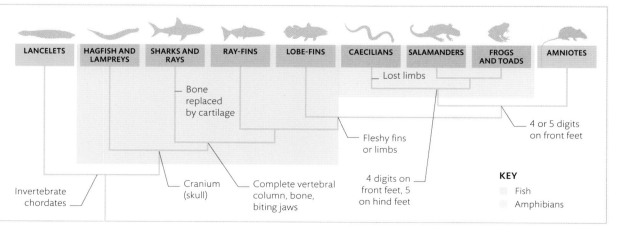

FROM WATER TO LAND
Fish do not form a natural group, or "clade." Clades contain all descendants of a common ancestor, but fish descendants include land-living vertebrates. Fish are an evolutionary "grade"— a stage in an evolutionary trend, in this case a vertebrate body with fins and gills. Amphibians are the sister group of lobe-fins— a clade of fleshy-finned fish that today include only the lungfish and coelacanths.

LANCELETS | HAGFISH AND LAMPREYS | SHARKS AND RAYS | RAY-FINS | LOBE-FINS | CAECILIANS | SALAMANDERS | FROGS AND TOADS | AMNIOTES

Lost limbs

Bone replaced by cartilage

4 or 5 digits on front feet

Fleshy fins or limbs

Invertebrate chordates

Cranium (skull)

Complete vertebral column, bone, biting jaws

4 digits on front feet, 5 on hind feet

KEY
Fish
Amphibians

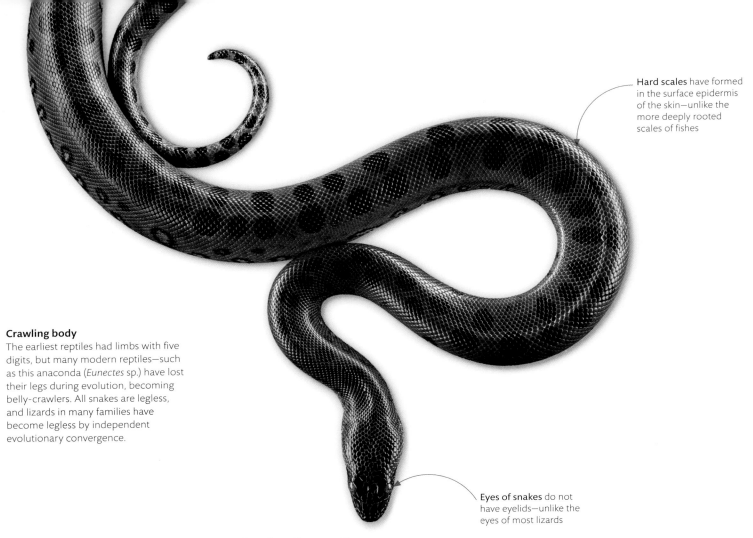

Hard scales have formed in the surface epidermis of the skin—unlike the more deeply rooted scales of fishes

Crawling body
The earliest reptiles had limbs with five digits, but many modern reptiles—such as this anaconda (*Eunectes* sp.) have lost their legs during evolution, becoming belly-crawlers. All snakes are legless, and lizards in many families have become legless by independent evolutionary convergence.

Eyes of snakes do not have eyelids—unlike the eyes of most lizards

reptiles and birds

Reptiles represent a major shift in body plan as vertebrates became better adapted for life out of water. Compared with their amphibian ancestors, reptiles acquired a harder, scaly skin that resists drying out, and hard-shelled eggs that can develop on land. Giant reptiles, in the form of dinosaurs, dominated the world for 150 million years, and the descendants of dinosaurs—the birds—today match living reptiles in number of species.

Features of flight
With its coat of feathers, a grey crowned crane (*Balearica regulorum*) is unmistakably a bird. Its aerial lifestyle is made possible by forelimbs modified as wings and lightweight, hollow bones.

REPTILES AND DESCENDANTS
Like fish, reptiles represent a grade of animal life (see p.25), not a clade—because both birds and mammals are among their descendants. Some of the earliest reptiles split into two main branches, one of which gave rise to the mammals. The other branch produced all living reptiles, as well as prehistoric forms, such as aquatic plesiosaurs, flying pterosaurs, and dinosaurs. Birds descend from a group of upright, predatory dinosaurs called theropods (pp.14–15).

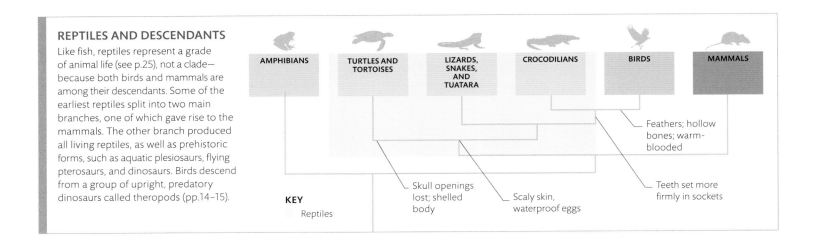

| AMPHIBIANS | TURTLES AND TORTOISES | LIZARDS, SNAKES, AND TUATARA | CROCODILIANS | BIRDS | MAMMALS |

Feathers; hollow bones; warm-blooded

Teeth set more firmly in sockets

Skull openings lost; shelled body

Scaly skin, waterproof eggs

KEY
◻ Reptiles

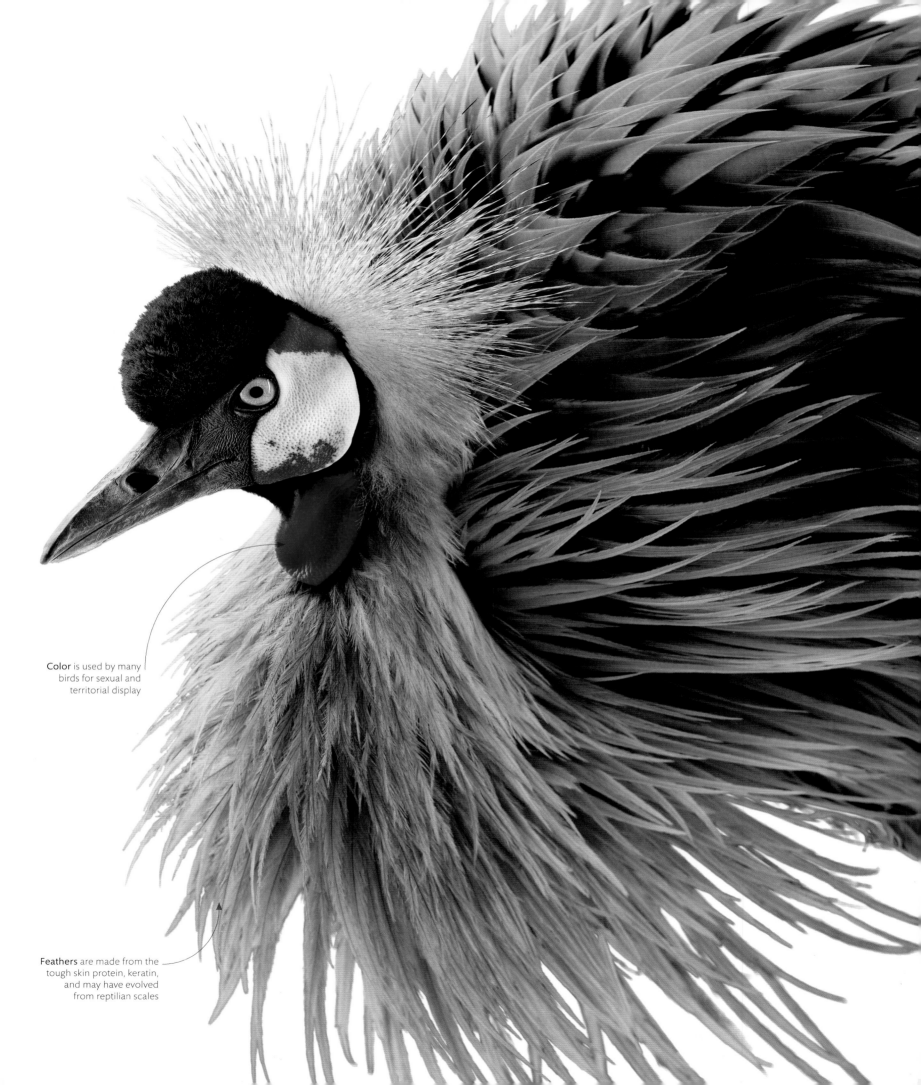

Color is used by many birds for sexual and territorial display

Feathers are made from the tough skin protein, keratin, and may have evolved from reptilian scales

MAMMAL RELATIONSHIPS

Like birds and living amphibians—but unlike reptiles and fish—mammals constitute a clade: a natural group containing all the descendants of a common ancestor. The most ancient division among living mammals is between egg-laying monotremes (platypus and echidnas) and mammals with live-birth—marsupials and placentals. Today, placentals make up 95 percent of mammal species.

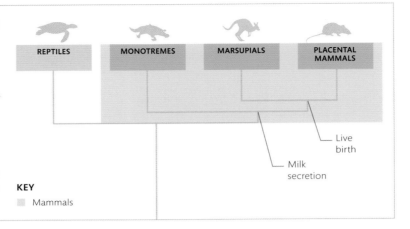

| REPTILES | MONOTREMES | MARSUPIALS | PLACENTAL MAMMALS |

Live birth

Milk secretion

KEY
Mammals

Brain power

Warm-bloodedness provides consistently optimal conditions for the functions of the body's tissues—something that undoubtedly helped increase mammal brain size. A mandrill (*Mandrillus sphinx*) has better problem-solving skills than a lizard and is capable of being a more accomplished parent.

mammals

Mammals descended from a group of reptiles that flourished before the time of the dinosaurs. The first true, furry mammals lived alongside dinosaurs, but during this time remained small and shrewlike. They diversified only after the dinosaurs went extinct. Like birds, mammals became warm-blooded, and regulation of a constant body temperature helped them stay active even in the cold. But, unlike birds, most mammals abandoned egg-laying to give birth to live young, nourished by milk produced from their eponymous mammary glands.

Herds

To a certain degree, mammals filled many of the ecological niches vacated by the dinosaurs. Mammals became the largest land animals, and herds of herbivores, such as this plains zebra (*Equus quagga*), became some of the biggest gatherings of animal biomass on the planet.

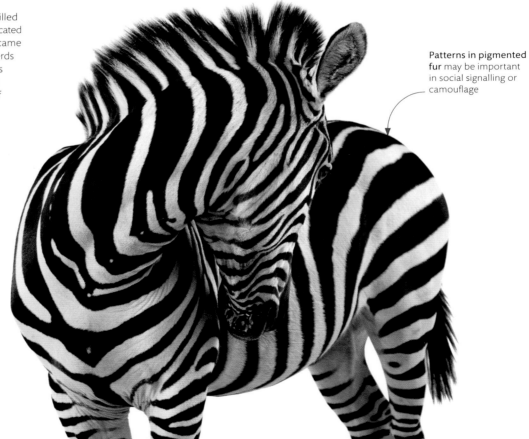

Patterns in pigmented fur may be important in social signalling or camouflage

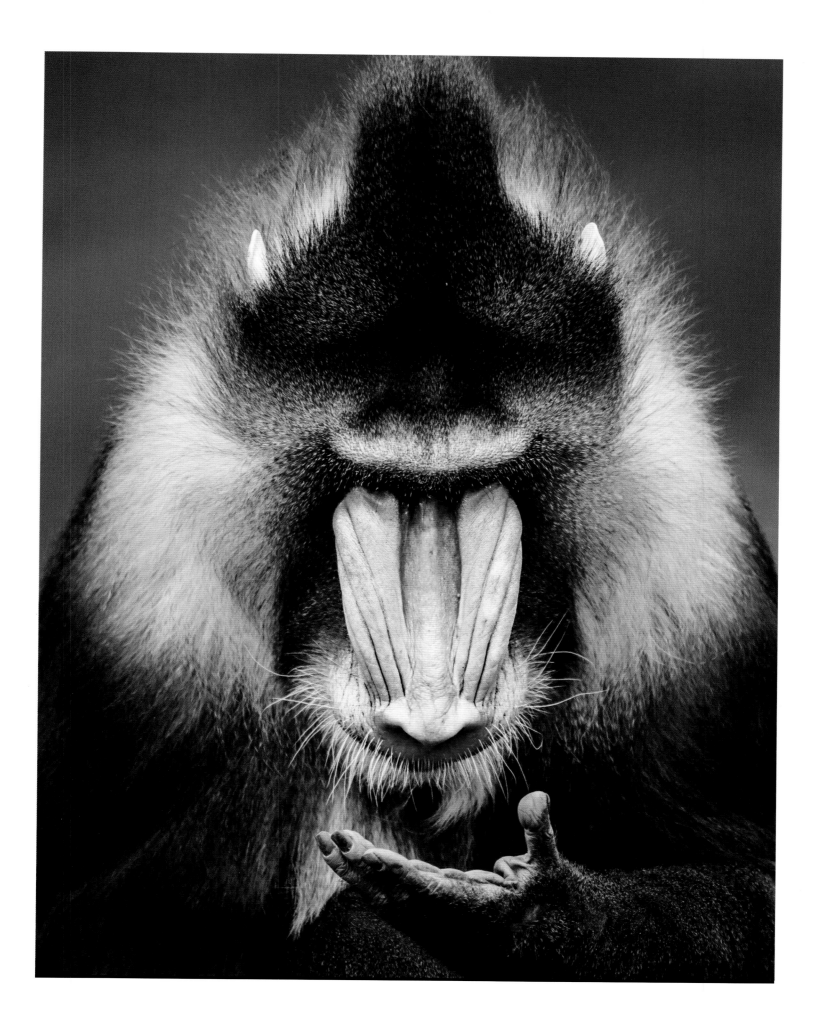

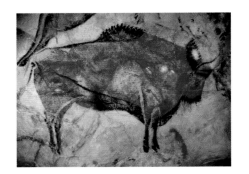

Female bison (c.16,000–14,000 BCE)
Sophisticated techniques in Spain's Altamira cave include linework on the bison's horns and hooves and scraped paint to produce shading.

Horses and bull (c.15,000–13,000 BCE)
In Lascaux's great hall of the bulls, a red and black horse is flanked by the figure of a bull and a frieze of small horses. The world's largest cave art animal, a bull 17 ft (5.2 m) long, is in this hall.

animals in art

prehistoric paintings

Discoveries over the past 200 years reveal a sophistication in prehistoric painting that dissolves the difference between Paleolithic and present-day art. The pictures of animals and people that adorn hundreds of caves in western Europe and around the world go far beyond simple representation. They suggest that for more than 30,000 years cave painting has been a human imperative driven by mystic purposes.

It took more than 20 years for experts to confirm that the vibrant visions of animal life cycles on the walls and ceilings of the caves in Altamira were prehistoric works. After their discovery in Cantabria, Spain, in the 1870s, one critic maintained that the paintings were so recent he could wipe the paint away with a finger.

Some 70 years later, four teenagers squeezed through a foxhole into the caves of Lascaux, near Montignac, southern France. They became the

first humans in 17,000 years to walk through its 770 ft (235 m) of galleries depicting nearly 2,000 animals, human figures, and abstract signs. At the two sites, sacred works of animal art were created by lamplight using pigments made from ochers and manganese oxide in the soil on surfaces that were almost inaccessible, suggesting a private devotional intent. Unsurprisingly, both caves have earned the epithet "the Sistine Chapel of Prehistoric Art."

66 With the cave of Altamira, painting reached a peak of perfection which cannot be bettered. 99

LUIS PERICOT-GARCIA, *PREHISTORIC AND PRIMITIVE ART,* 1967

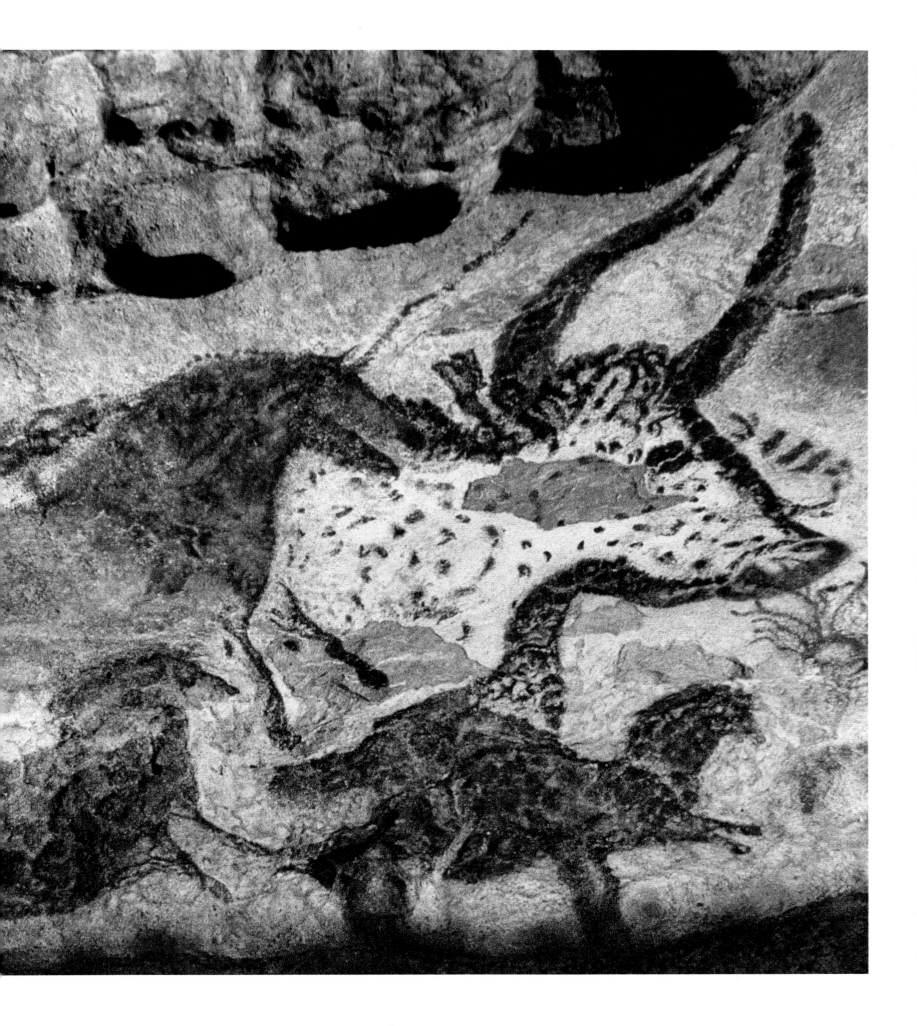

shape.and size

shape. the external physical form
or outline of an animal.

size. the spatial dimensions, proportions,
or extent of an animal.

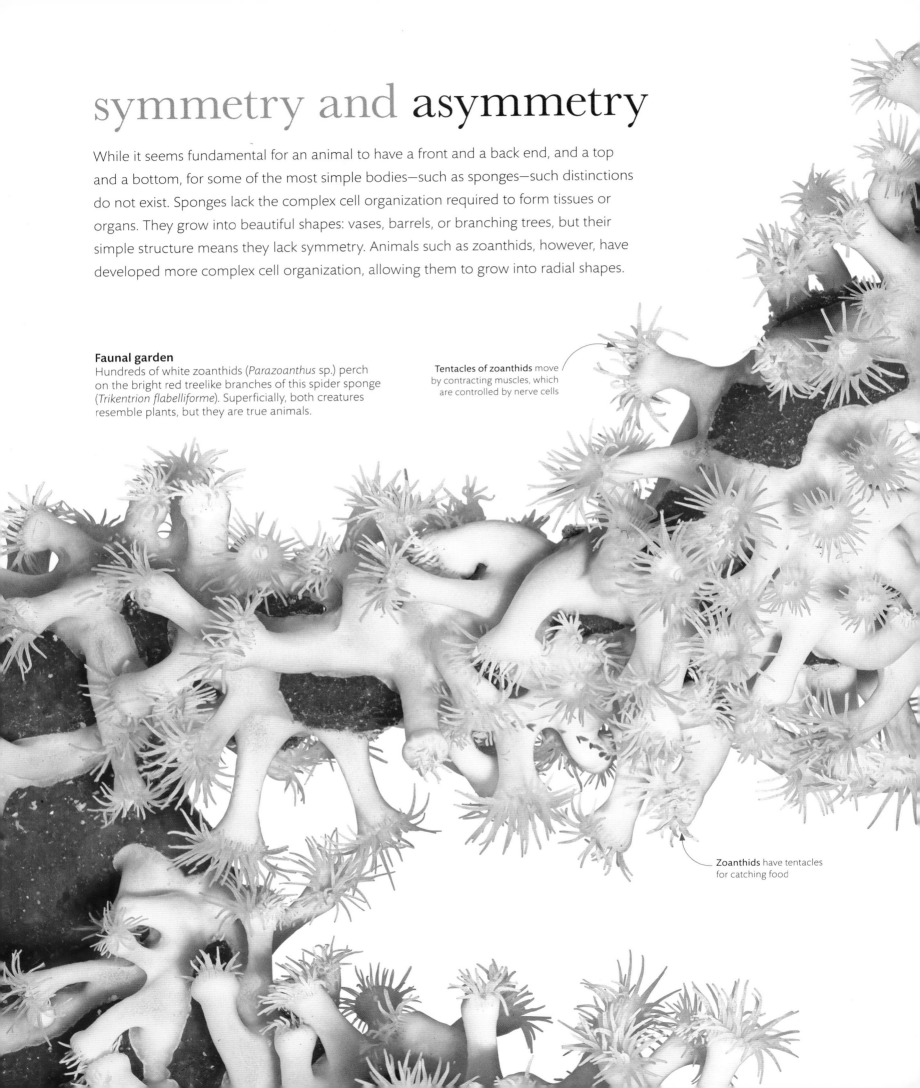

symmetry and asymmetry

While it seems fundamental for an animal to have a front and a back end, and a top and a bottom, for some of the most simple bodies—such as sponges—such distinctions do not exist. Sponges lack the complex cell organization required to form tissues or organs. They grow into beautiful shapes: vases, barrels, or branching trees, but their simple structure means they lack symmetry. Animals such as zoanthids, however, have developed more complex cell organization, allowing them to grow into radial shapes.

Faunal garden
Hundreds of white zoanthids (*Parazoanthus* sp.) perch on the bright red treelike branches of this spider sponge (*Trikentrion flabelliforme*). Superficially, both creatures resemble plants, but they are true animals.

Tentacles of zoanthids move by contracting muscles, which are controlled by nerve cells

Zoanthids have tentacles for catching food

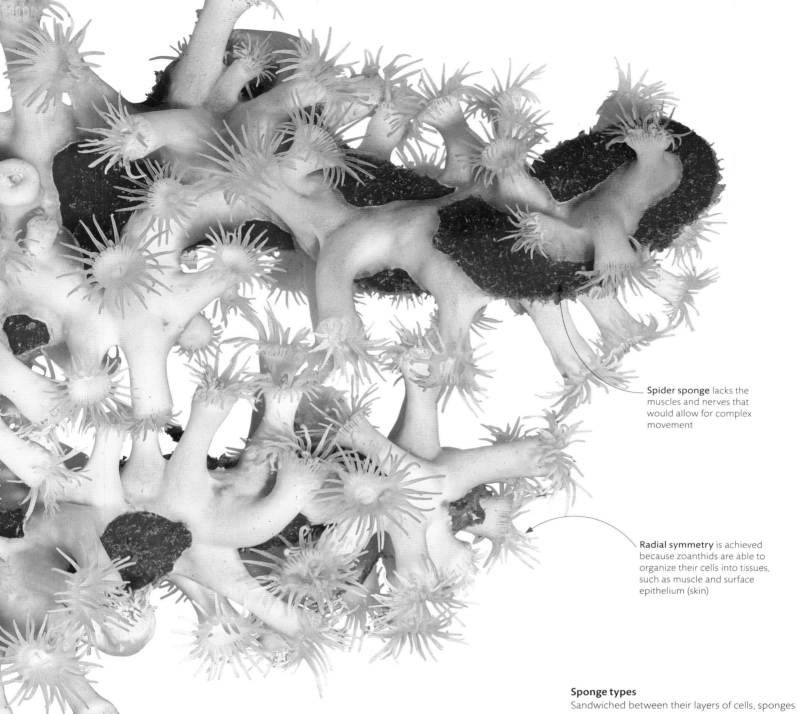

Spider sponge lacks the
muscles and nerves that
would allow for complex
movement

Radial symmetry is achieved
because zoanthids are able to
organize their cells into tissues,
such as muscle and surface
epithelium (skin)

Sponge types

Sandwiched between their layers of cells, sponges
have a skeleton that holds them upright. In most,
this is calcium-based but others have a glassy
skeleton made from silica or—in demosponges—
a softer one made from protein.

Spicules around
osculum (opening)
deter predators

Lacy lattice of
silica spicules

Fan-shaped lobes form
asymmetrical shape

CALCAREOUS SPONGE

GLASS SPONGE

DEMOSPONGE

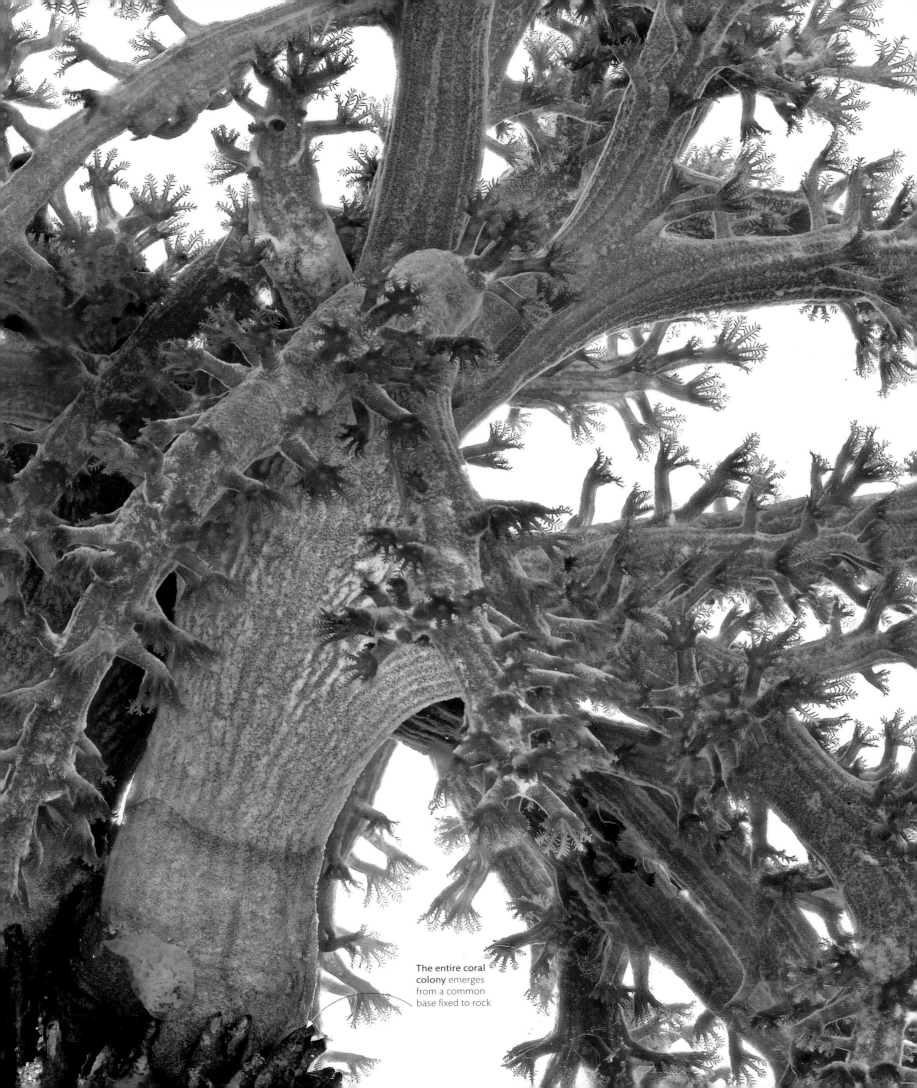

The **entire coral colony** emerges from a common base fixed to rock

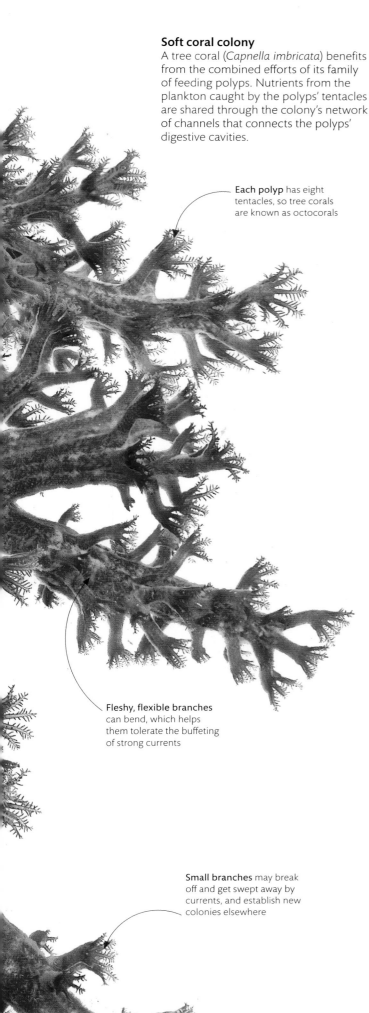

Soft coral colony
A tree coral (*Capnella imbricata*) benefits from the combined efforts of its family of feeding polyps. Nutrients from the plankton caught by the polyps' tentacles are shared through the colony's network of channels that connects the polyps' digestive cavities.

Each polyp has eight tentacles, so tree corals are known as octocorals

Fleshy, flexible branches can bend, which helps them tolerate the buffeting of strong currents

Small branches may break off and get swept away by currents, and establish new colonies elsewhere

COLONY DEVELOPMENT
A colony can be any group of animals that live close together, but for corals the connections are especially intimate. Each colony germinates from a single fertilized egg, so all its branches and polyps end up as the genetically identical parts of a massively branching individual.

Coenenchyme (shared colonial tissue) covered with surface epidermis (skin)

Single polyp

Rocky substrate

LATERAL COLONY GROWTH

Hydrocaulus— the branching stem of the colony

Axial (leading) polyp

Lateral (side) polyp

VERTICAL COLONY GROWTH

forming colonies

An animal that relies on its tentacles to gather food gets more nourishment by sweeping more of the water around it. Many anemone-like creatures sprout branches to do just that, forming a colony of animals called polyps. Some branch upward like trees, others spread sideways into mats, while stony corals lay down rocky foundations (see pp.64–65) that are the basis of coral reefs.

Specialized polyps
Some colonial animals, such as the microscopic hydrozoan *Obelia*, produce polyps that are specialized for different tasks. Some of the animal's polyps are dedicated to feeding, while others produce eggs and sperm for reproduction.

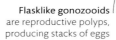

Flasklike gonozooids are reproductive polyps, producing stacks of eggs

Retractable gastrozooids are feeding polyps, with tentacles that catch plankton

SIMPLEST NERVOUS SYSTEM

Lacking any sign of a head or tail, the nervous system of a cnidarian is not centralized into a brain as in other animals. Instead, nerve cell fibers are spread throughout the body as a simple net between the animal's gut and outer body wall. As in other animals, sensors communicate signals to muscle cells using electrical nerve impulses in order to coordinate behavior.

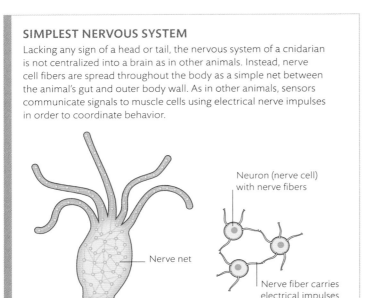

Neuron (nerve cell) with nerve fibers

Nerve net

Nerve fiber carries electrical impulses

NERVOUS SYSTEM CLOSE-UP OF NEURONS

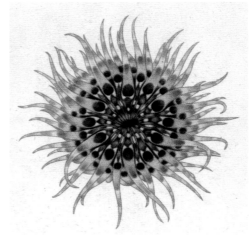

View down the axis

The body parts of a sea anemone are arranged around a central axis. The axis is marked by its gut, which has a single upward-facing opening in the middle of the tentacles. This opening both receives prey and expels waste.

Changing body form

An adult magnificent sea anemone (*Heteractis magnifica*) is arranged around a central point. However, like many other animals with radial symmetry, it begins life as a larva with bilateral symmetry.

Tentacles, moved by muscular contractions, transfer prey to the mouth or retract when danger threatens

Tentacle tips contain specialized stinging cells called nematocysts, which paralyze small prey

radial symmetry

Bodies encircled by tentacles were common among early animals found in prehistoric seas half a billion years ago, and they are still present in many animals living today. Cnidarians—a group of animals that includes anemones, corals, and jellyfish—have no front and back, but have radial bodies that sense the world from all directions at once. All of them are aquatic, and rely on tentacles that wave in water to trap passing prey.

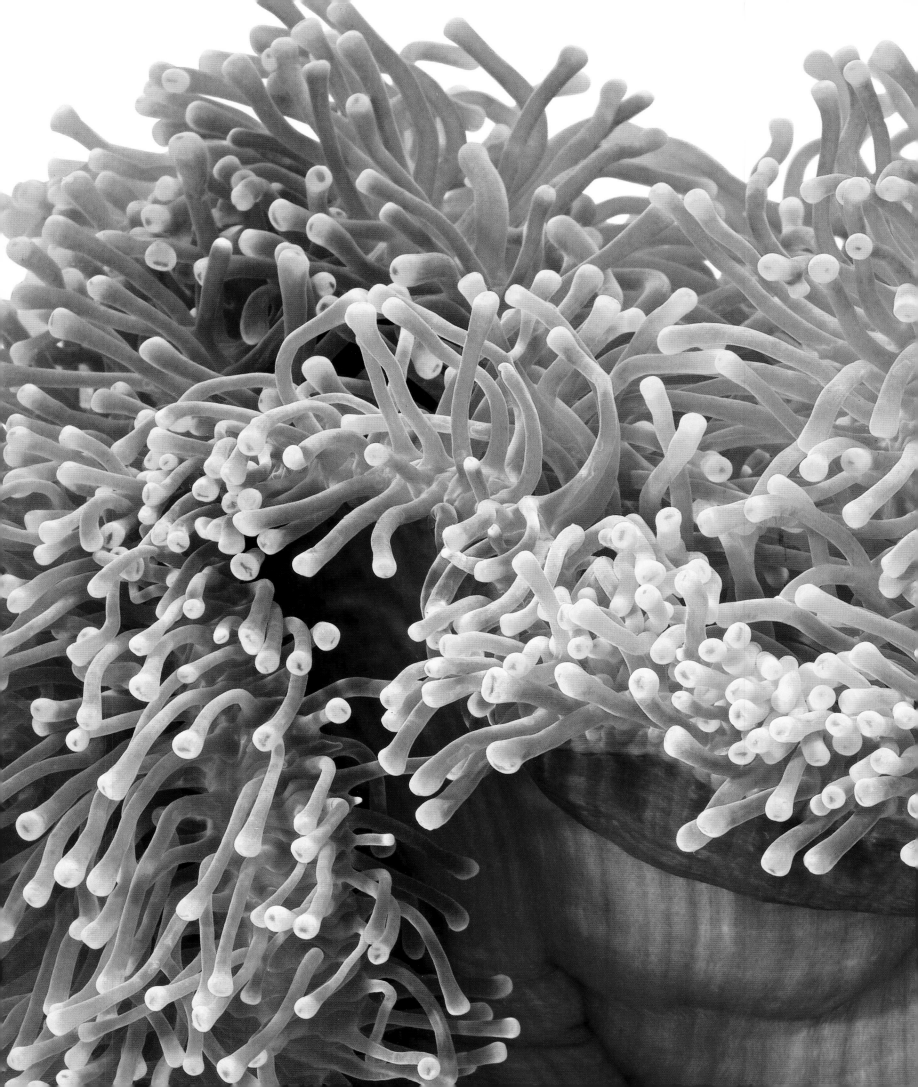

symmetry in motion

An animal that can break free of the ocean floor and live in open water is surrounded by opportunities—but it faces new challenges, too. Jellyfish are free-swimming relatives of anemones; most have rings of tentacles that hang down from a soft floating bell. Lacking firm anchorage, jellyfish risk being swept away, but they can use muscles in their jelly to move against the currents to feast on the planktonic food coming from every direction.

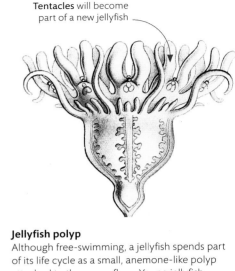

Tentacles will become part of a new jellyfish

Jellyfish polyp
Although free-swimming, a jellyfish spends part of its life cycle as a small, anemone-like polyp attached to the ocean floor. Young jellyfish bud off from the polyp and swim away.

Free-swimming predator
The pulsating bell of a Pacific sea nettle (*Chrysaora fuscescens*) pushes the jellyfish up through the water column, trailing its stinging tentacles. The jellyfish lacks the sensory equipment to pursue prey actively, so it relies on the long reach of its tentacles to ensnare tiny fish and shrimp.

Pulsation of the bell helps the jellyfish travel up to 0.6 mile (1 km) each day

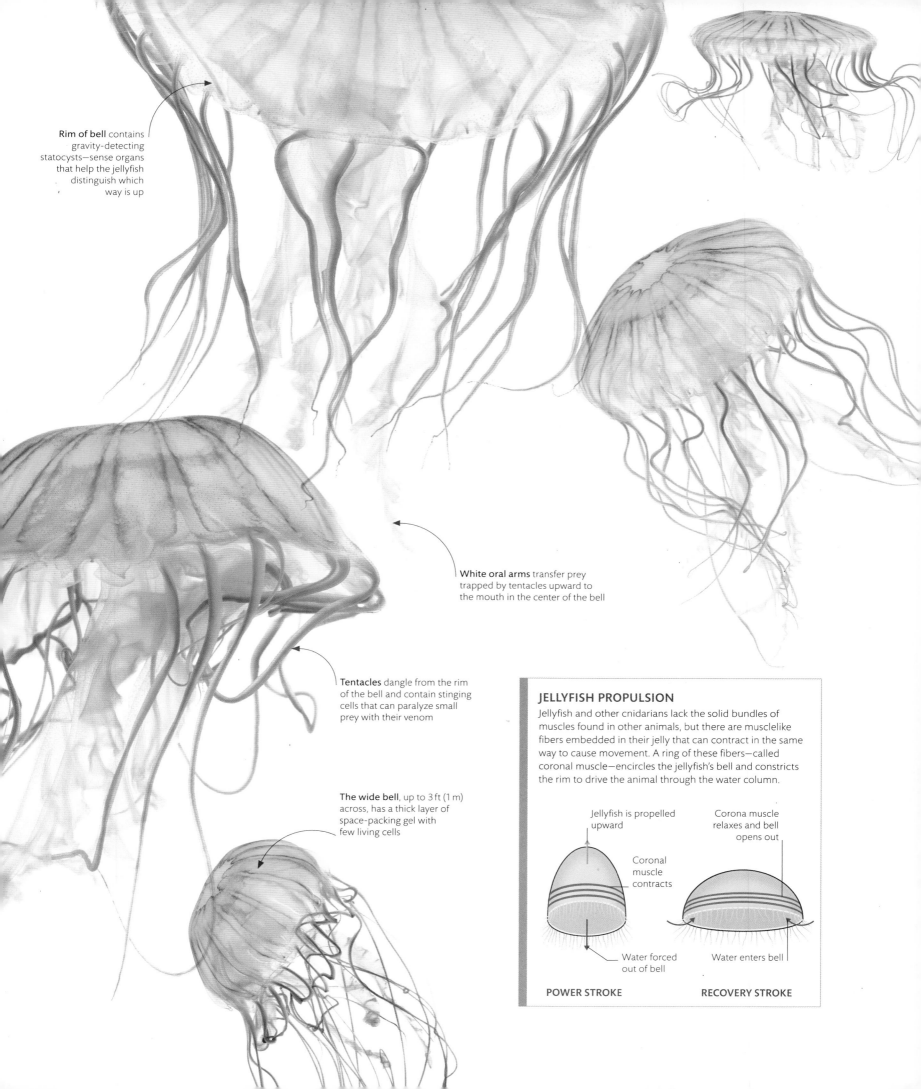

Rim of bell contains gravity-detecting statocysts—sense organs that help the jellyfish distinguish which way is up

White oral arms transfer prey trapped by tentacles upward to the mouth in the center of the bell

Tentacles dangle from the rim of the bell and contain stinging cells that can paralyze small prey with their venom

The wide bell, up to 3 ft (1 m) across, has a thick layer of space-packing gel with few living cells

JELLYFISH PROPULSION

Jellyfish and other cnidarians lack the solid bundles of muscles found in other animals, but there are musclelike fibers embedded in their jelly that can contract in the same way to cause movement. A ring of these fibers—called coronal muscle—encircles the jellyfish's bell and constricts the rim to drive the animal through the water column.

Jellyfish is propelled upward

Coronal muscle contracts

Water forced out of bell

POWER STROKE

Corona muscle relaxes and bell opens out

Water enters bell

RECOVERY STROKE

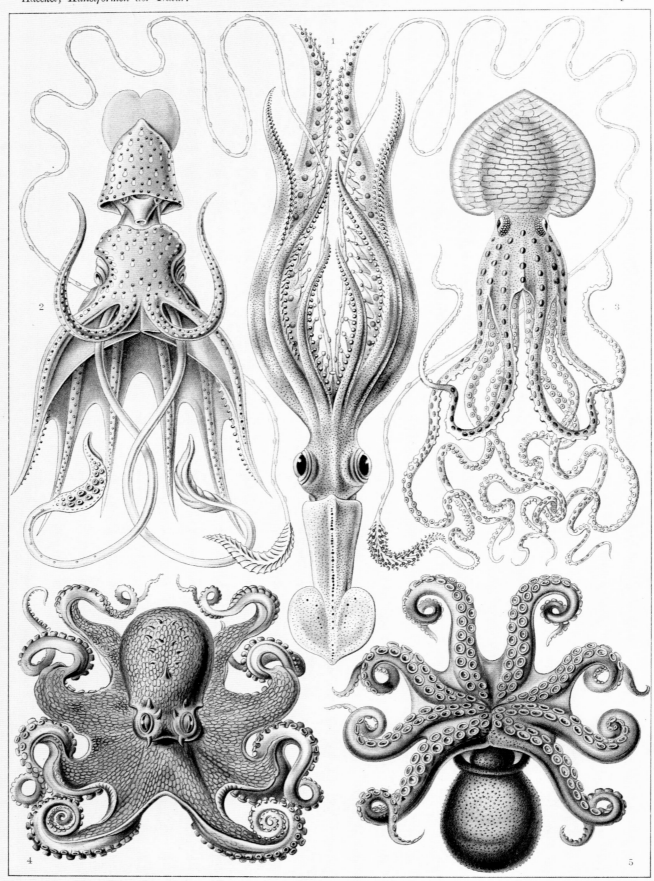

Gamochonia. — Trichterkraken.

Cephalopods

Combining science with artistry, the illustrations of biologist Ernst Heinrich Haeckel (1834–1919), such as these exquisitely arranged gamochonia (cephalopods), included thousands of new species. The evolutionary theorist's major 1904 work, *Kunstformen der Natur* (*Art Forms of Nature*), explored symmetry and levels of organization in body forms.

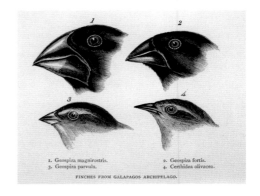

Darwin's finches (1845)

John Gould's observation that Darwin's diverse bird specimens—collected from different Galápagos islands—all belonged to the same family of finches, became a mainspring of Darwin's theory of natural selection.

animals in art

the darwinists

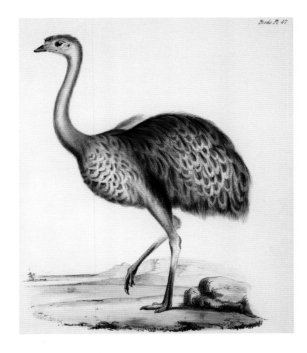

Small rhea (1841)

English ornithologist and artist John Gould identified and illustrated many of the birds Darwin encountered on the voyage of H.M.S. *Beagle*, including a small species of rhea that he named *Rhea darwinii*.

For wealthy young gentlemen of independent means in the 19th century, the study of natural history was a route to self-improvement and a rationale for global travel. Their interest was fueled by Charles Darwin's accounts of zoological exploration aboard the H.M.S. *Beagle* and, ultimately, by his groundbreaking theories on the origins of humankind.

Although most natural history societies and organizations were run by amateurs, scientific methodology had gained traction in the 100 years since Linnaeus introduced a global classification system for plants (1753) and animals (1758). Under his influence, the British Royal Navy included naturalists on voyages to collect and record flora and fauna, and Charles Darwin was asked to join H.M.S. *Beagle*.

Intellectual rigor called for a new approach to art: zoological drawing had to be accurate and formulaic to enable comparison of anatomy between species. Over the course of the 19th century, the London Zoological Society commissioned hundreds of drawings and paintings.

Its artists included John Reeves, a tea merchant with the East India company who traveled to China in 1812 and spent 19 years in Macao working with Chinese artists on plant and animal pictures.

Ornithologist and taxidermist John Gould was a major illustrator of specimens for Darwin's *The Voyage of the Beagle* (1839), and offered insights through his drawing. Another contributor to Darwin's work was Reverend Leonard Jenyns, part of a group of Cambridge-educated naturalists engaged in a golden age of zoology, botany, and geology. Jenyns used local illustrators for his own *Notebook of the Fauna of Cambridgeshire* and noted that, such was the appetite for rare specimens, persons in the "lower classes" were supplementing their living collecting and selling insects from the fens.

In the footsteps of Darwin came Ernst Haeckel, a German polymath who mapped a genealogical tree, coined biological terms such as "ecology" and "phylogeny," and produced eye-opening works on invertebrates. The remarkable artistry of his biological illustrations was an inspiration to art nouveau artists.

> 66 The affinities of all the beings of the same class have sometimes been represented by a great tree. I believe this simile largely speaks the truth. 99
>
> CHARLES DARWIN, *ON THE ORIGIN OF THE SPECIES*, 1859

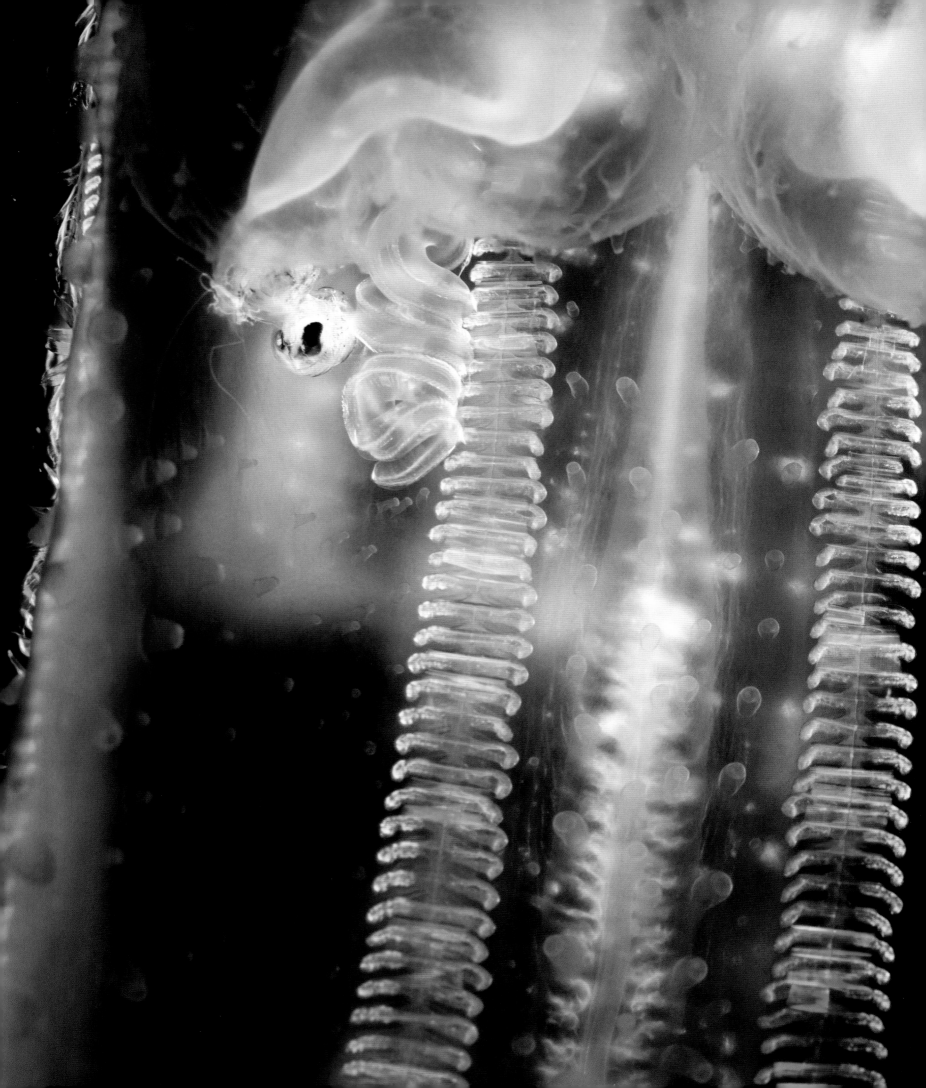

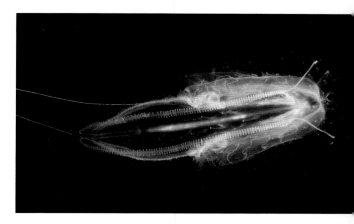

Tiny voyager
Just 4–7 in (10–18 cm) long, the warty comb jelly is usually found in the upper layers of open seas from the Atlantic Ocean and the Mediterranean Sea to subtropical waters.

spotlight species

comb jellies

Drifting through the oceans in sizes that range from the microscopic to 6 ft (2 m), comb jellies, or ctenophores, are often mistaken for jellyfish (see pp.36–37). While both gelatinous invertebrates have existed for at least 500 million years and share many features, the two are very different.

The word ctenophore means "comb-bearing" and describes the hairlike cilia that these animals use for propulsion—the largest known creatures to do so. These cilia are arranged in comblike groups called ctenes, which are fused at the base and arranged in eight rows along each side of the animal.

Like jellyfish, comb jellies' bodies are 95 percent water, covered in a thin cell layer—the ectoderm. An internal layer, or endoderm, lines the animals' gut cavity. The middle, transparent jellylike layer is called the mesoglea, which in comb jellies contains three cell types: contractile or muscular, nerve, and mesenchymal. Mesenchyme develops into a range of tissues in complex organisms, but in comb jellies, it is simply connective tissue.

Comb jellies are found in all oceans, from equatorial to polar waters. There are only 187 known species and they come in myriad shapes, from lobed to long and belt-shaped. Some have retractable fringed tentacles covered in cells that exude a gluelike substance to catch prey. They are hermaphroditic, reproducing by releasing both sperm and eggs, and rely on currents to bring them into contact with others. Comb jellies are rapacious carnivores, with a mouth at one end and two anal pores that release waste at the other. Individuals of some species can eat 500 copepods (tiny crustaceans) an hour, and have been known to wipe out fish populations because they leave nothing for any surviving fish larvae or fry to eat.

Light show
Adult warty comb jellies (*Leucothea multicornis*) develop two transparent lobes, as well as the combs (or ctenes) that generate rainbowlike colors as they refract and reflect light.

bodies with simple heads

The ability to move forward with a brain that leads from the front was a strategic improvement over the way radial animals seemed to flounder in open water. Flatworms were among the first animals to be able to move from place to place in this way. They have distinct front and back ends, with a body symmetry that means their left and right sides are mirror images. Despite the limitations of shape, they have evolved into large, flamboyant forms.

Body is so thin oxygen can reach all cells just by seeping in through surface of animal

Delicate beauty
Facing forward with their wide heads, flatworms like this Hyman's polyclad (*Pseudobiceros hymanae*) glide over rocky reefs. The name "polyclad," meaning "many branches," refers to how its branched gut disperses food through its paper-thin body without the need for circulating blood.

Flatworm is tapered at the rear

LEADING FROM THE FRONT
Forward-moving animals have more sense organs at the front, or head, where they are most needed. A flatworm has the simplest centralized nervous system of any animal. A collection of nerve cells, or neurons, in its head process incoming information, then communicate with the rest of its body via nerve cords and nerves that contain lines of neurons.

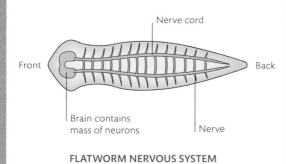

Nerve cord

Front

Back

Brain contains mass of neurons

Nerve

FLATWORM NERVOUS SYSTEM

Slippery mucus released by glandular cells on the underside help flatworm glide smoothly across the seabed

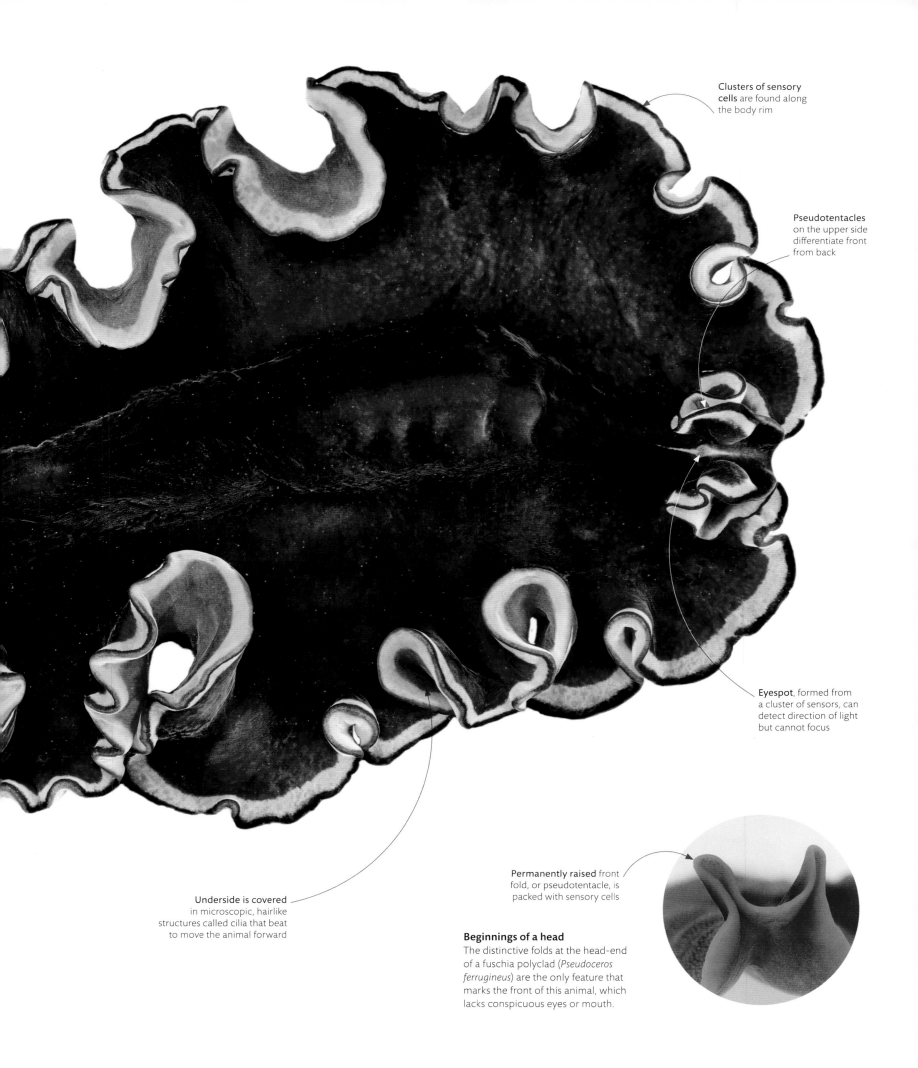

Clusters of sensory cells are found along the body rim

Pseudotentacles on the upper side differentiate front from back

Eyespot, formed from a cluster of sensors, can detect direction of light but cannot focus

Permanently raised front fold, or pseudotentacle, is packed with sensory cells

Underside is covered in microscopic, hairlike structures called cilia that beat to move the animal forward

Beginnings of a head

The distinctive folds at the head-end of a fuschia polyclad (*Pseudoceros ferrugineus*) are the only feature that marks the front of this animal, which lacks conspicuous eyes or mouth.

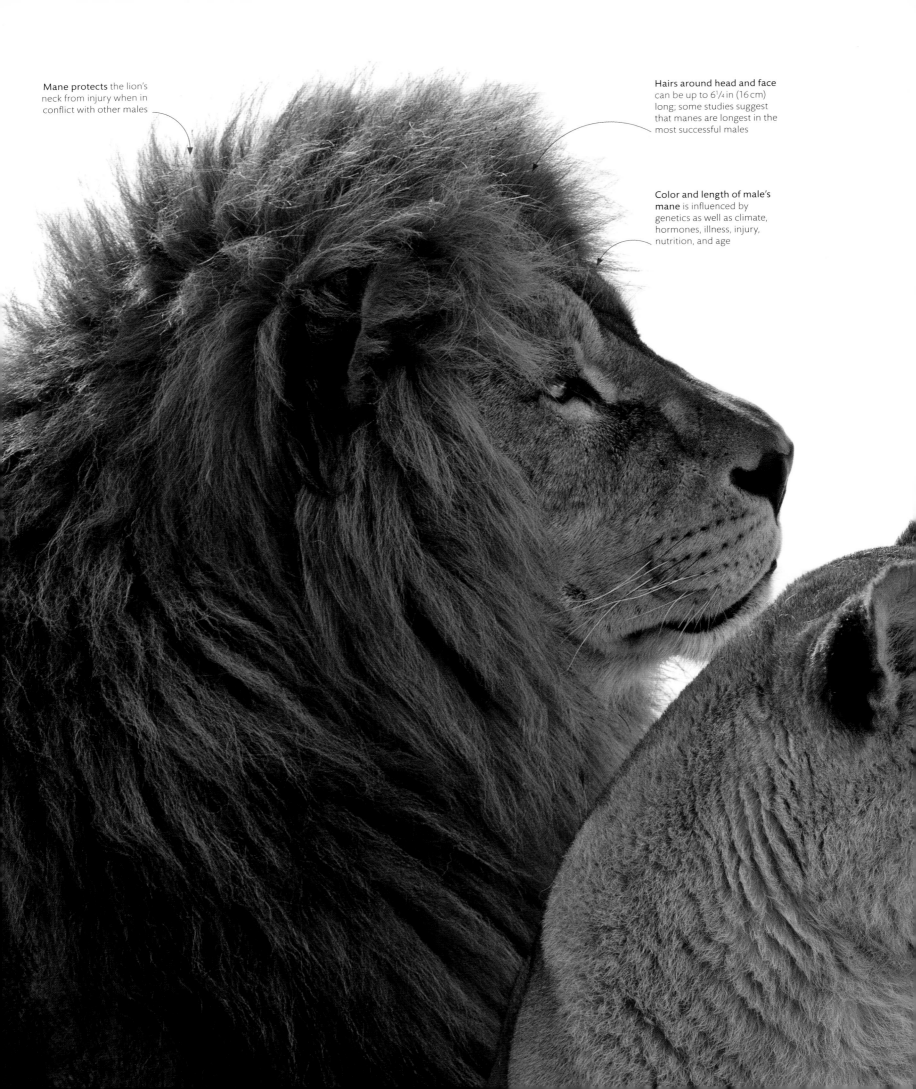

Mane protects the lion's neck from injury when in conflict with other males

Hairs around head and face can be up to 6¼ in (16 cm) long; some studies suggest that manes are longest in the most successful males

Color and length of male's mane is influenced by genetics as well as climate, hormones, illness, injury, nutrition, and age

sexual differences

Most animals develop into one of two sexes, determined by genes or the environment. The differences in sexually mature individuals advertise that they are ready to produce offspring of their own. In some animals this sexual dimorphism is reflected in body size. In many mammals the males are bigger than females. In addition, the larger the male, the more likely he is to succeed with choosy females. In other species, such as some fish, a larger female may produce more eggs or bigger offspring, increasing their chances of survival.

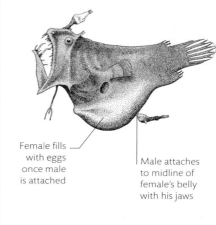

Male and female
The mane of a male lion (*Panthera leo*) is a clear indicator of his fitness to sire a lioness's cubs because its thickness correlates with his testosterone level. A fuller mane means higher fertility and a more assertive temperament, which can be passed on to the lioness's cubs.

Adults in waiting
All lion cubs look similar; and a male only starts to develop a mane at 12 months, but sexual development is determined by genetics before birth. Like all mammals, male cubs have XY chromosomes, while the females have XX. The Y chromosome masculinizes the body, while its absence feminizes it.

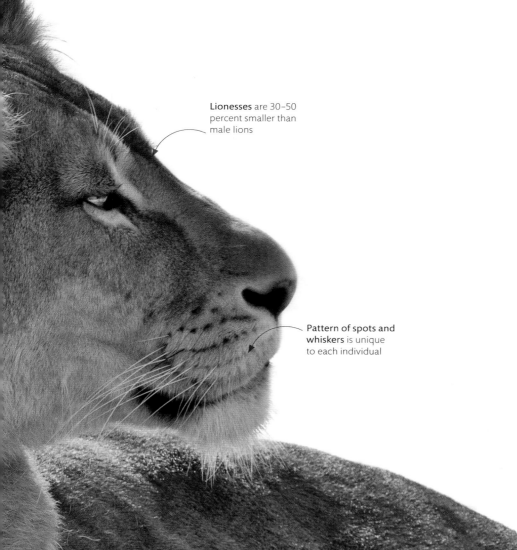

Lionesses are 30–50 percent smaller than male lions

Pattern of spots and whiskers is unique to each individual

GENDER EXTREMES
Sexual dimorphism is driven to extremes in some deep-sea anglerfish species, where the male is 10 times smaller than the female. Tiny males attach parasitically to females, an act that brings both sexes—perhaps uniquely among animals—to sexual maturity. It is only after the large-bodied female has been fertilized that she can produce her eggs.

Female fills with eggs once male is attached

Male attaches to midline of female's belly with his jaws

DEEP-SEA ANGLERFISH PAIR
Linophryne argyresca

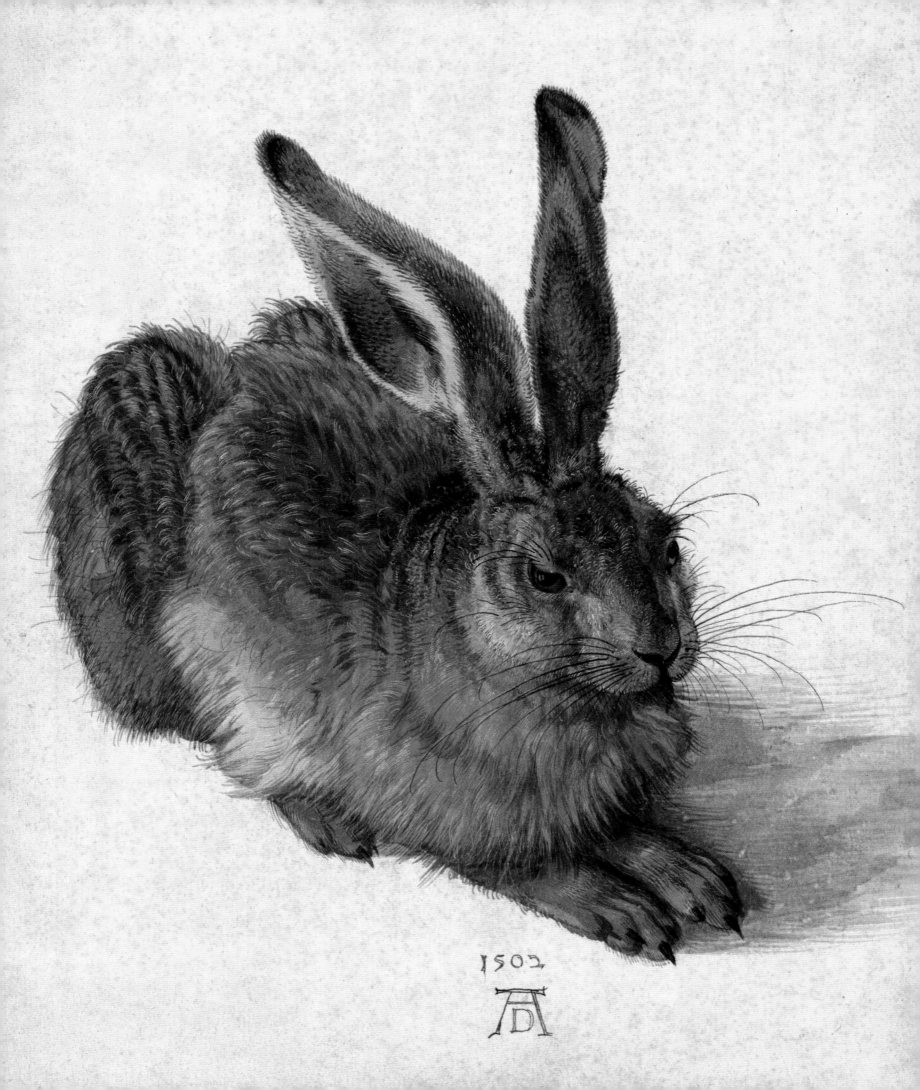

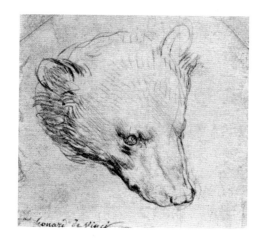

Head of a Bear (c.1480)
Leonardo da Vinci's sketchbooks reveal his fascination with bears, many of which lived wild in the mountains of Tuscany and Lombardy. This small-scale observation in metalpoint on prepared paper was probably of an animal in captivity.

the renaissance eye

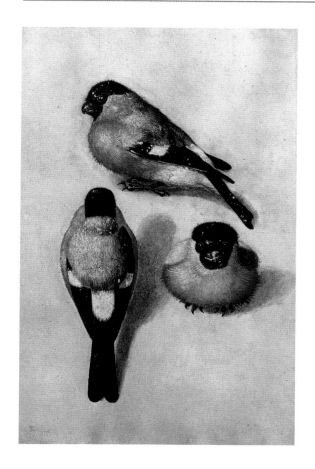

In the quiet spaces between their great works, artists of the Renaissance produced watercolors and sketches of animals that revealed a profound sensitivity to the natural world. Nature was the new religion of the Renaissance, fueled by retranslations of ancient Greek texts that advocated an ethical and scientific approach to the study of animals.

The genius of the Renaissance, Leonardo da Vinci, prepared for his major works with anatomical studies of animals and sketches that tap into animal behavior. Following in his footsteps in the north, Albrecht Dürer's preparatory watercolors of flora and fauna were destined to enhance the grand visions of sacred stories in his paintings, woodcuts, and engravings. They reveal a deep engagement with nature.

A new sensitivity to animals had emerged from humanist rediscovery of the works of Greek philosophers such as Aristotle. His reverence for animal life sat in sharp contrast to medieval notions of unfeeling beasts with satanic qualities. The result was an explosion in the study of natural history. Swiss naturalist Conrad Gessner mirrored Aristotle's work with his five-volume *Historia Animalium* (1551–58), which set out to catalog every known animal and mythical creature. His vast collection of illustrations included Dürer's woodcut of a rhinoceros as a metallic, armor-plated beast. At the time, no rhino had been seen in Europe: the only specimen, a gift from the King of Portugal to Pope Leo X, drowned in a shipwreck in 1616.

Three Studies of a Bullfinch (1543)
Sophisticated perspective and precise anatomical observation are encapsulated in Albrecht Dürer's watercolors, which were usually preparatory studies for major works.

The Young Hare (1502)
The almost tangible softness of the fur and the spark of life in the eyes of this young hare has made Albrecht Dürer's study one of his most revered works. He painted his hare in gouache and watercolor in his workshop in Nuremburg, most likely combining observation of hares in the field with observation of a taxidermist's specimen in his studio.

" Every kind of animal will reveal to us something natural and something beautiful. "

ARISTOTLE, *ON THE PARTS OF ANIMALS BOOK 1*, 350 BCE

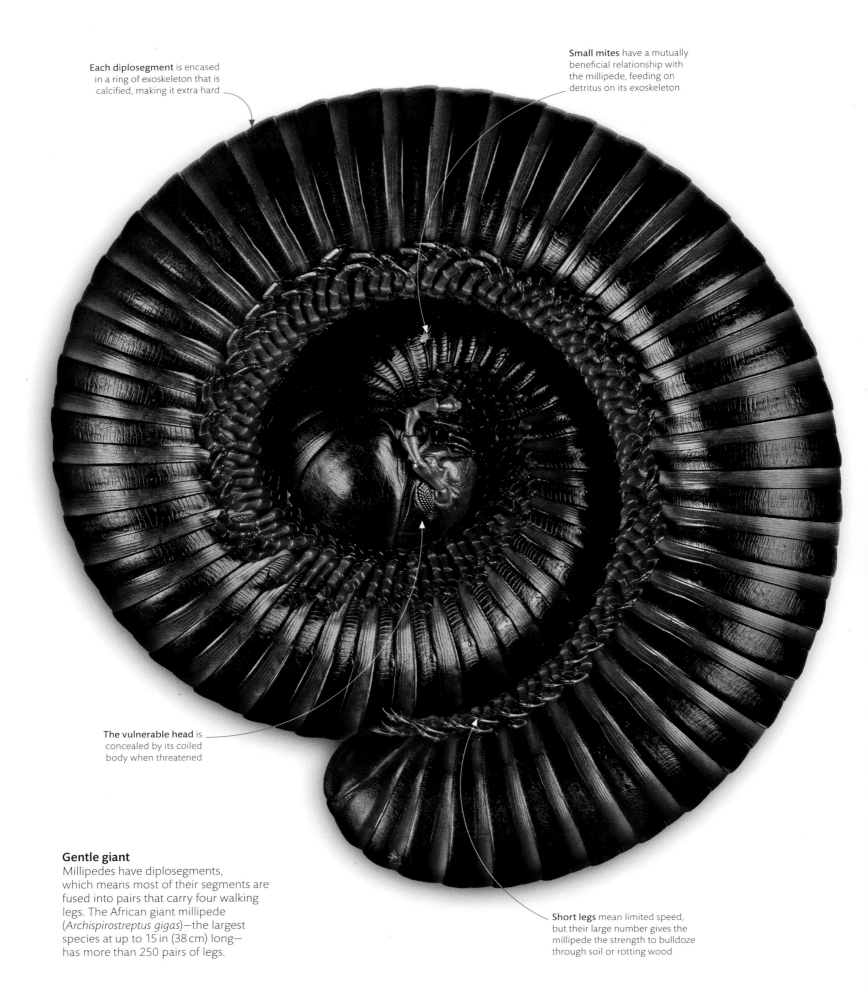

Each diplosegment is encased in a ring of exoskeleton that is calcified, making it extra hard

Small mites have a mutually beneficial relationship with the millipede, feeding on detritus on its exoskeleton

The vulnerable head is concealed by its coiled body when threatened

Gentle giant

Millipedes have diplosegments, which means most of their segments are fused into pairs that carry four walking legs. The African giant millipede (*Archispirostreptus gigas*)—the largest species at up to 15 in (38 cm) long—has more than 250 pairs of legs.

Short legs mean limited speed, but their large number gives the millipede the strength to bulldoze through soil or rotting wood

segmented bodies

Some animals get bigger during their development by repeatedly duplicating segments of their body. In the evolution of worms, this kind of segmentation allowed body sections to be moved independently (see pp.66–67). Hard-bodied arthropods, including millipedes and centipedes, inherited this segmented body plan from wormlike ancestors, but the addition of jointed legs has made their locomotion even more effective.

Fast-moving predator
Unlike related millipedes, centipedes such as the Asian giant centipede (*Scolopendra subspinipes*) have just one pair of legs per segment. All centipedes are predatory and have venomous claws.

Long legs extending from the sides of the body increase stride, meaning the centipede can run with considerable speed

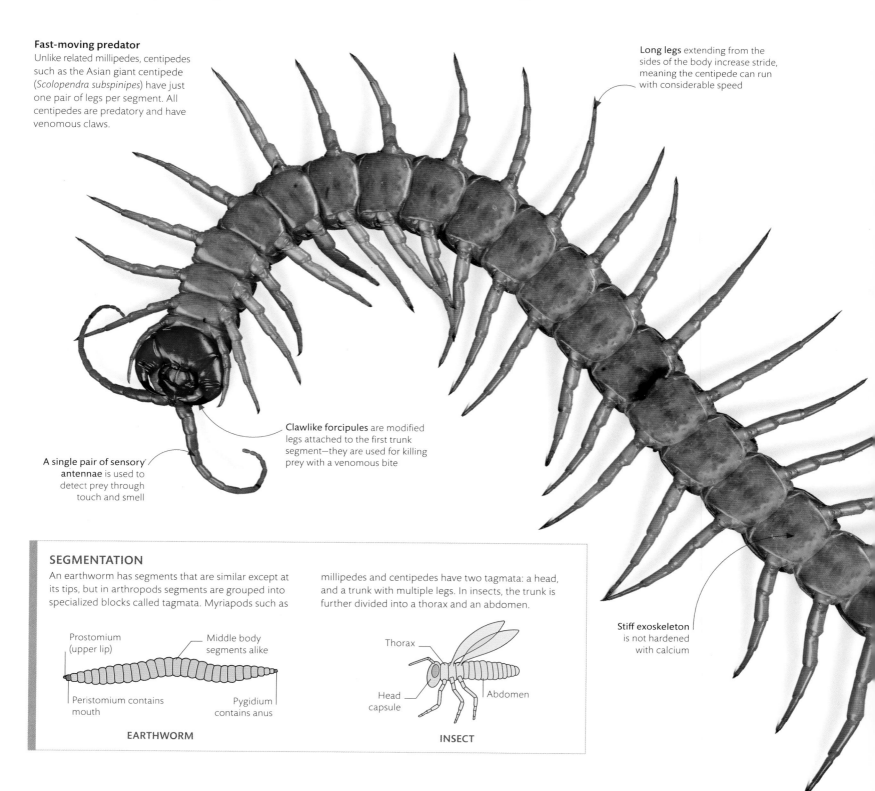

Clawlike forcipules are modified legs attached to the first trunk segment—they are used for killing prey with a venomous bite

A single pair of sensory antennae is used to detect prey through touch and smell

Stiff exoskeleton is not hardened with calcium

SEGMENTATION

An earthworm has segments that are similar except at its tips, but in arthropods segments are grouped into specialized blocks called tagmata. Myriapods such as millipedes and centipedes have two tagmata: a head, and a trunk with multiple legs. In insects, the trunk is further divided into a thorax and an abdomen.

Prostomium (upper lip)

Middle body segments alike

Peristomium contains mouth

Pygidium contains anus

EARTHWORM

Thorax

Head capsule

Abdomen

INSECT

vertebrate bodies

A spine, or vertebral column, provides a solid support
for the body but is flexible so the body can bend. This
is possible because the column is built from smaller
articulating blocks, or vertebrae, made of cartilage or bone.
The power for bending comes from muscle blocks called
myotomes that flank the column. The spines of the first
vertebrates—fish—swung sinuously from side to side; this
movement made them a success in water and later helped
their four-legged descendants crawl on land.

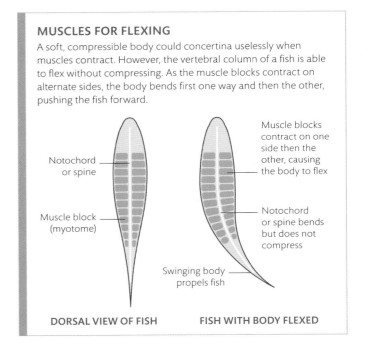

MUSCLES FOR FLEXING
A soft, compressible body could concertina uselessly when
muscles contract. However, the vertebral column of a fish is able
to flex without compressing. As the muscle blocks contract on
alternate sides, the body bends first one way and then the other,
pushing the fish forward.

Notochord
or spine

Muscle block
(myotome)

Muscle blocks
contract on one
side then the
other, causing
the body to flex

Notochord
or spine bends
but does not
compress

Swinging body
propels fish

DORSAL VIEW OF FISH FISH WITH BODY FLEXED

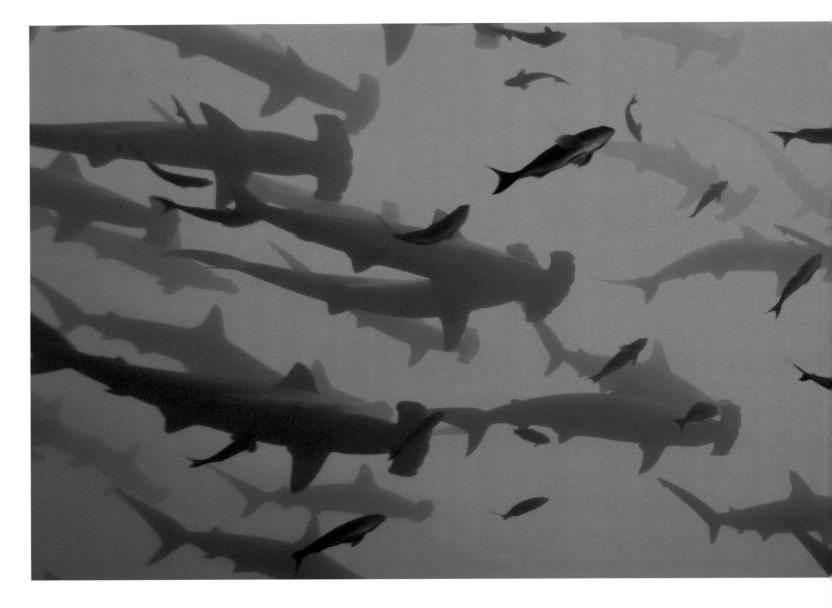

Lancelet

The fishlike lancelet (*Branchiostoma lanceolatumhas*) a rubbery notochord supporting its back: the evolutionary precursor of a bony or cartilaginous spine. A notochord is present in vertebrate embryos; it is replaced by a vertebral column during development.

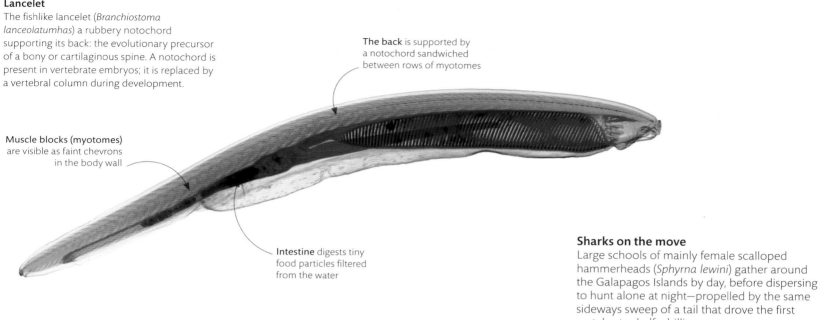

The back is supported by a notochord sandwiched between rows of myotomes

Muscle blocks (myotomes) are visible as faint chevrons in the body wall

Intestine digests tiny food particles filtered from the water

Sharks on the move

Large schools of mainly female scalloped hammerheads (*Sphyrna lewini*) gather around the Galapagos Islands by day, before dispersing to hunt alone at night—propelled by the same sideways sweep of a tail that drove the first vertebrates half a billion years ago.

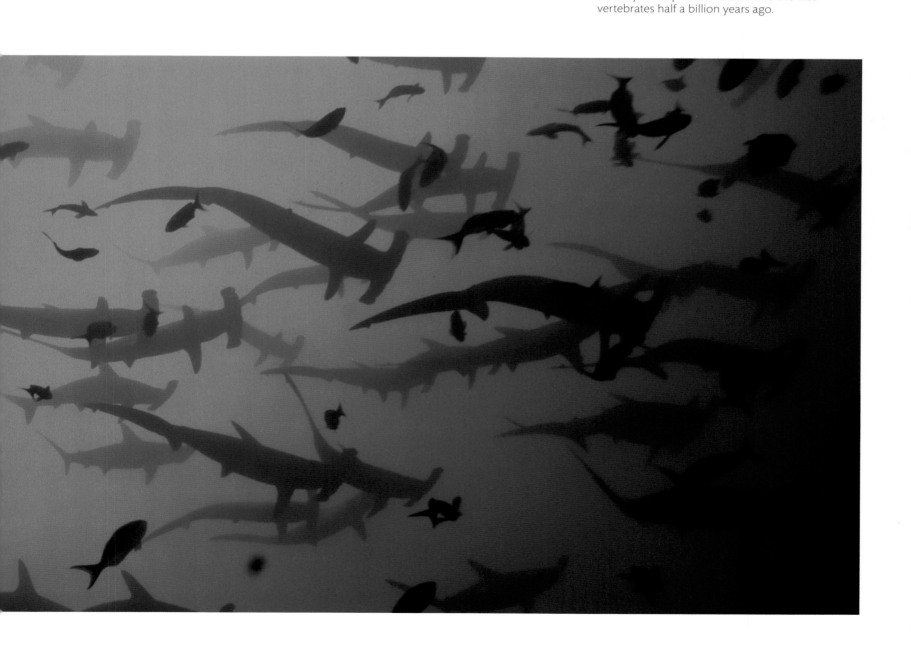

Frog evolution

Frogs' body form evolved partly by reducing the number of vertebrae in their spine to nine or eight. The few living frogs with nine vertebrae today belong to the "ancient frogs," or Archaeobatrachia, two of which also appear to retain a tail, although this is actually a boneless mating organ. Mesobatrachians, an intermediate evolutionary stage, and the diverse Neobatrachians ("new frogs") acquired more typical frog traits—new frogs have a tongue and a voice.

Tail is part of the male cloaca, used for internal fertilization

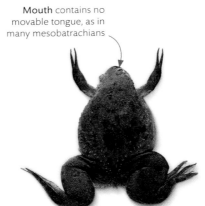

ARCHAEOBATRACHIA
Tailed frog
Ascaphus truei

Mouth contains no movable tongue, as in many mesobatrachians

MESOBATRACHIA
African clawed frog
Xenopus laevis

Eardrum present, as in most neobatrachians

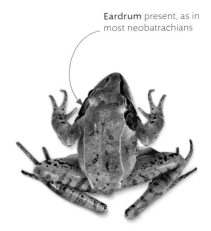

NEOBATRACHIA
European common frog
Rana temporaria

Lifestyles

Despite their reliance on keeping their skin moist, frogs and toads have met the demands of a range of habitats. Most require a water source to reproduce (see pp.316–17), but can be found even in deserts, where burrowing species sit out dry periods underground, often sealed in cocoons to retain moisture. Many ambush prey on forest floors, while others are active tree-climbing hunters.

Sticky disk on each finger (and toe) aids climbing

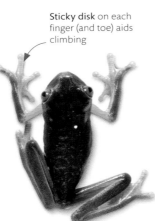

FLY-CATCHER
Red-eyed tree frog
Agalychnis callidryas

Markings mimic leaf litter where frog hides during the day

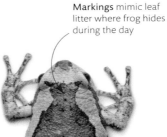

WORM-EATER
Banded bullfrog
Kaloula pulchra

Wide mouth suits a sit-and-wait predator with no teeth, which must swallow large prey whole

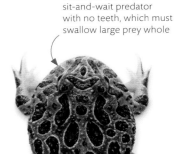

MOUSE-CATCHER
Argentinian horned frog
Ceratophrys ornata

Size variations

Frog and toad sizes are as diverse as their numbers, and the discovery of new miniature species constantly moves the lower boundary of the size range. The smallest known living frog is *Paedophryne amauensis* of Papua New Guinea, which measures just ¼ in (7.7 mm) long; the largest, at 13 ½ in (30 cm) long and weighing up to 7 lb 3 oz (3.3 kg), is the West African goliath frog (*Conraua goliath*).

Body color changes to white with yellow, black-rimmed spots in the sun

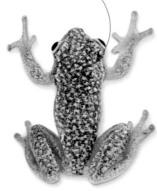

1 ⅓ IN (3–3.3 CM)
Madagascan reed frog
Heterixalus alboguttatus

Long "neck" section allows frog to move head from side to side

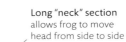
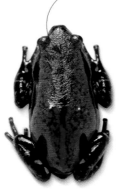

1 ¾–2 ⅓ IN (4.1–6.2 CM)
West African rubber frog
Phrynomantis microps

Skin controls evaporation so frog can adjust to seasonally wet or dry habitats

2 ¾–4 ½ IN (7–11.5 CM)
White's tree frog
Ranoidea caerulea

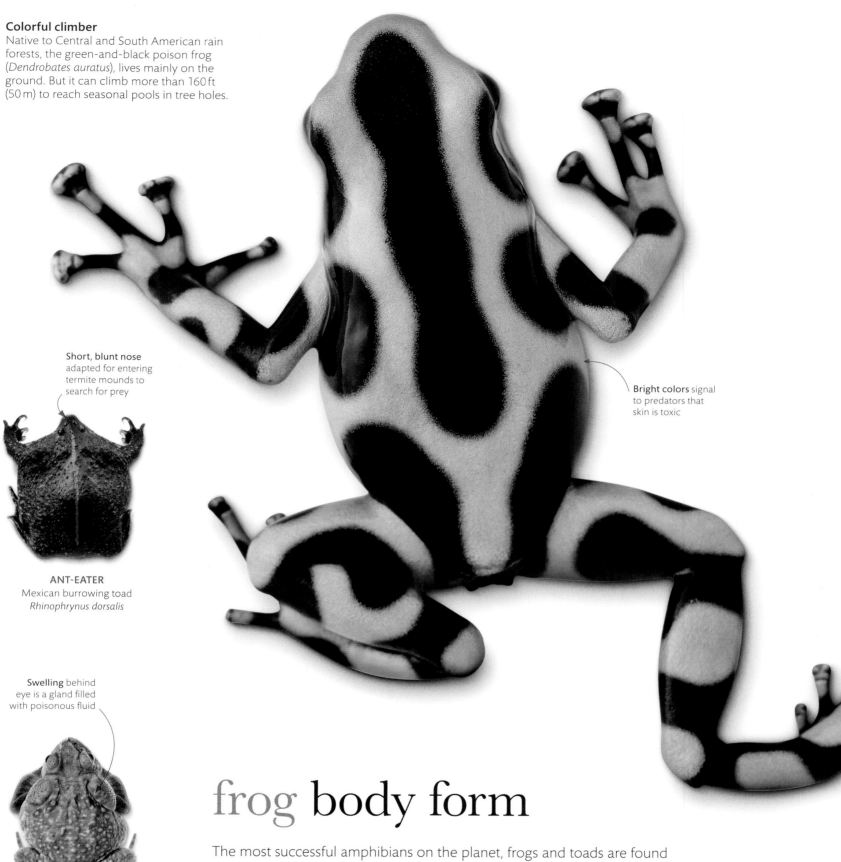

Colorful climber
Native to Central and South American rain forests, the green-and-black poison frog (*Dendrobates auratus*), lives mainly on the ground. But it can climb more than 160 ft (50 m) to reach seasonal pools in tree holes.

Short, blunt nose adapted for entering termite mounds to search for prey

ANT-EATER
Mexican burrowing toad
Rhinophrynus dorsalis

Bright colors signal to predators that skin is toxic

Swelling behind eye is a gland filled with poisonous fluid

UP TO 8⅔ IN (22 CM)
American cane toad
Rhinella marina

frog body form

The most successful amphibians on the planet, frogs and toads are found on every continent except Antarctica. Their body shape has remained largely unchanged for 250 million years. Their heads are attached by a single neck vertebra to truncated bodies, they have elongated hindlimbs, and, in adults, the tail is replaced by fused vertebrae known as a urostyle.

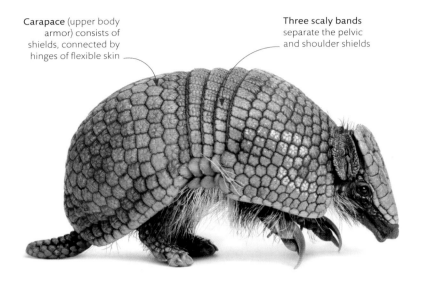

Carapace (upper body armor) consists of shields, connected by hinges of flexible skin

Three scaly bands separate the pelvic and shoulder shields

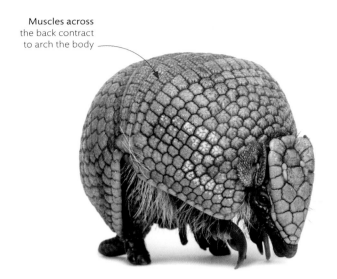

Muscles across the back contract to arch the body

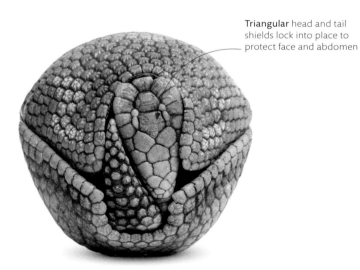

Triangular head and tail shields lock into place to protect face and abdomen

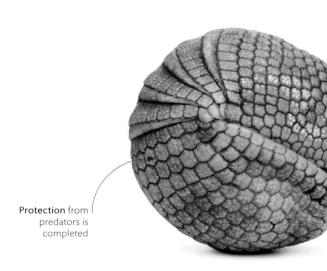

Protection from predators is completed

defensive roll

Strong muscles and a degree of flexibility are all it takes for any animal to change shape as it moves, but some animals manage especially dramatic transformations when confronted with danger. All armadillos are already protected by bony plates that cover the upper part of their bodies and, when hazards threaten, most lie flat on the ground with their limbs withdrawn. However, two species of three-banded armadillos have the flexibility to roll up into a ball in self-defense.

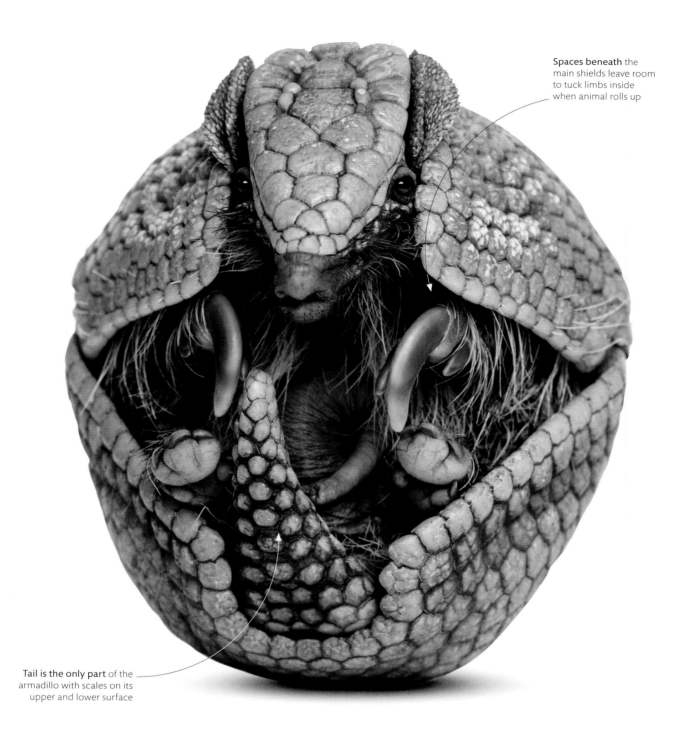

Spaces beneath the main shields leave room to tuck limbs inside when animal rolls up

Tail is the only part of the armadillo with scales on its upper and lower surface

Armor-plated protection
The carapace of the southern three-banded armadillo (*Tolypeutes matacus*) is made up of plates of bone, or osteoderms, overlaid with a horny epidermis. The plates are only partially attached to the body, which leaves space inside for it to withdraw its limbs completely and so roll into a ball.

LIFE ON THE EDGE

An elephant's sheer size buffers it in an unpredictable environment. It moves slowly and has large reserves that allow it to survive on very little nutrition for weeks. But the tiniest warm-blooded animals, such as shrews, which can weigh as little as ¾ oz (2 g), have no energy reserves and lose a far greater proportion of their energy as radiated body heat, so need to eat almost continually just to prevent starvation.

SHREW (SORICIDAE FAMILY)

Ears of the savanna elephant can be 6½ ft (2 m) from top to bottom

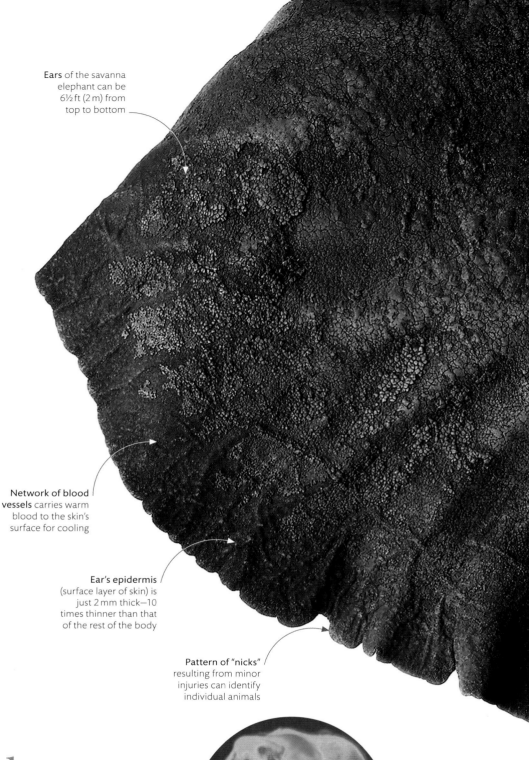

Network of blood vessels carries warm blood to the skin's surface for cooling

Ear's epidermis (surface layer of skin) is just 2 mm thick—10 times thinner than that of the rest of the body

Pattern of "nicks" resulting from minor injuries can identify individual animals

Adapted for life in the tropics

The skin of an African savanna elephant (*Loxodonta africana*)—the world's largest land animal—is sparsely haired to help compensate for its massive heat-generating bulk. While it lacks the oil-producing glands of other mammals, mud baths condition its skin, and wrinkles help lock in moisture.

giant animals

The largest animals alive today—elephants and whales—are vast compared with the tiniest invertebrates that can perch on a pinhead. Their size brings benefits—bigger animals can repel predators and intimidate competitors—but they require more food and oxygen. The pull of gravity also subjects their bodies to formidable stresses and strains, so they need very strong skeletons and powerful muscles to be able to move.

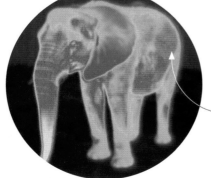

Thermal image shows that the bulk of the elephant's body is warm (red) but the tips of its ears are cool (blue)

Staying cool

Mammals generate body heat to maintain vital functions. Overheating could be a problem for this warm-blooded giant but elephants can lose heat by flapping their ears to cool the blood pumped through them.

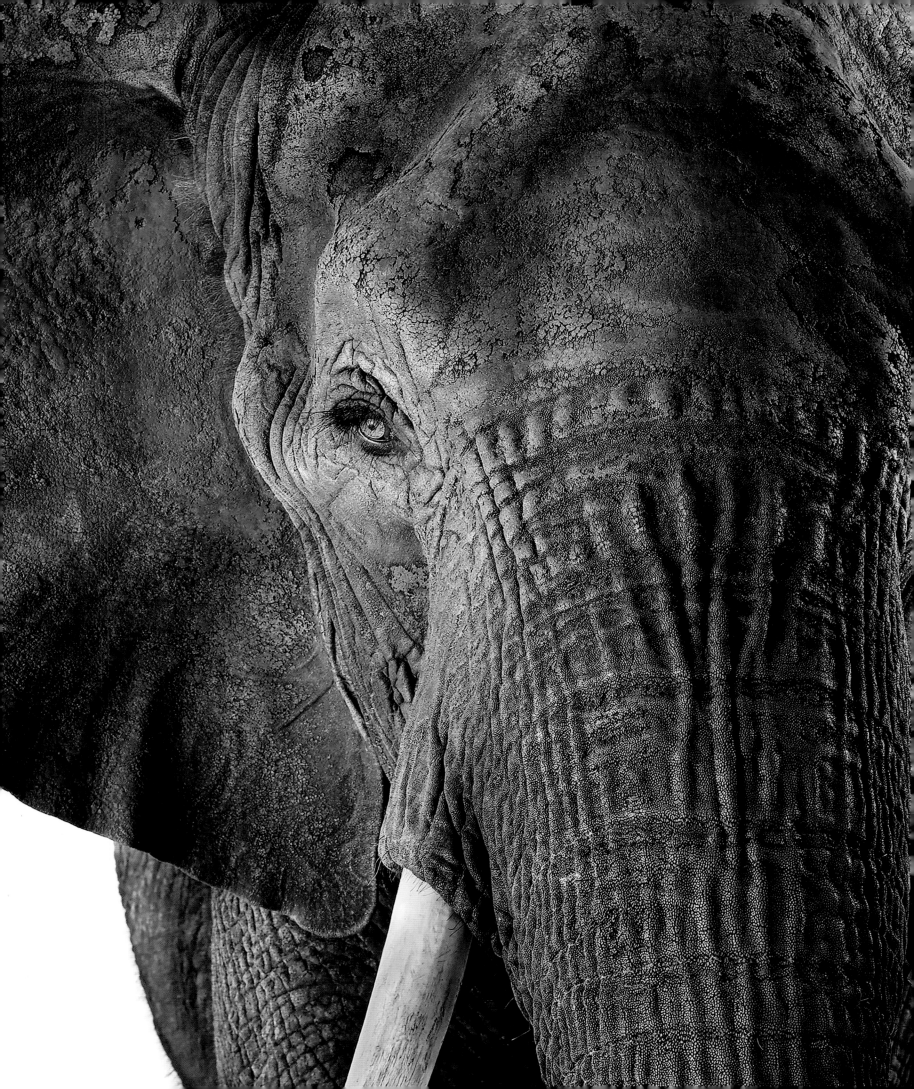

Malabar unicorn
Italian explorer Marco Polo claimed an encounter with a unicorn occurred during his 24-year journey across Asia, but his description of an ugly animal wallowing in the mud suggests it was probably a rhino. For the 15th-century edition of Polo's *Livre des Merveilles du Monde* (*Book of Wonders of the World*), the illustrator opted for a more traditional unicorn surrounded by indigenous animals of Malabar, India.

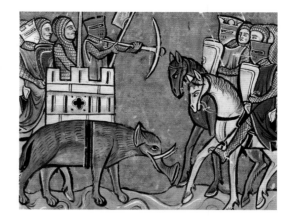

Recreating elephants
Elephants in the 13th-century *Rochester Bestiary* were given a variety of colors, trumpet-shaped trunks, and boarlike features. This war elephant is shown bearing a turreted howdah of soldiers.

animals in art

fantasy beasts

Bestiaries were medieval catalogs of creatures based on the belief that the beasts, birds, fish, and even rocks of the Earth had God-given qualities and characteristics. Stories about the good and evil inherent in the world's wildlife were easy-to-grasp tutorials for the medieval mind. Many bestiaries were lavish, illuminated works with animal pictures that would linger in the imagination of illiterate audiences.

Many of the European bestiaries, written mainly in Latin or in vernacular French in France, originate from the *Physiologus*—an ancient Alexandrian text, featuring 50 animals, which was probably written between the 2nd and 4th century CE. Here, nature's innocent beasts were given behaviors and traits that linked them to Christ or the devil. The pelican, for example, was believed to revive its dead young with its own blood, making it a powerful symbol of the Resurrection.

In 13th-century bestiaries, the whale is shown as a huge multifinned fish that mimics an island to lure ships onto its back. When the unwitting sailors build a fire on its sandy skin, the hot, angry whale drags them into the deep: a reminder of the devil's temptations and sinners' descent into hell. Hedgehogs are depicted rolling on grapes to spear them and carry them to their young. A roaring panther is shown with sweet-smelling breath that draws all animals to him.

Most of the illustrations were the work of artistically untrained monks forced to base their attempts at exotic animals on verbal accounts and carvings. A crocodile with a doglike head seems to be drawn as much from the imagination as a unicorn.

Even the first-hand observations of the 13th-century explorer Marco Polo added little to medieval understanding of wildlife in distant lands. The Venetian explorer dictated his recollections of his 24-year journey to Rustichello da Pisa, an inmate incarcerated with him in a Genoese prison. What became a bestseller in Europe was illustrated with fanciful miniatures of animals and birds, but Polo's descriptions of "everything different… and excelling in both size and beauty" were treated with scepticism.

> " To tame the unicorn so it can be captured, a virgin girl is placed in its path. "

ROCHESTER BESTIARY, 13TH CENTURY

tall animals

A high head gives an animal a better view of danger and enables it to reach food inaccessible to competitors. In this respect, no other living animal can match the giraffe. Its stature comes from an elongated neck and its especially long lower leg bones. But this height also demands a stronger heart to pump blood so far against gravity, and double the typical mammalian blood pressure to keep it moving.

Heads above the rest
Giraffes (*Giraffa camelopardalis*) are the tallest living animals—males can be 20 ft (6 m) from ground to crown. Several factors have favored their evolution: the height enables better vigilance and higher browsing, and their shape provides a greater surface area from which to radiate heat, enabling them to remain cool.

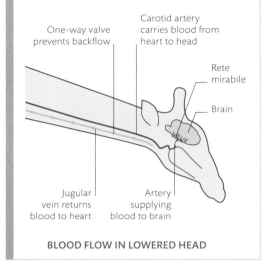

NECK CIRCULATION
When a giraffe lowers its head, a network of elastic-walled blood vessels at the base of the brain – the rete mirabile—expands to help absorb the rush of blood that might otherwise damage it. A series of one-way valves along the jugular vein close to prevent blood flowing backwards under pressure of gravity.

One-way valve prevents backflow

Carotid artery carries blood from heart to head

Rete mirabile

Brain

Jugular vein returns blood to heart

Artery supplying blood to brain

BLOOD FLOW IN LOWERED HEAD

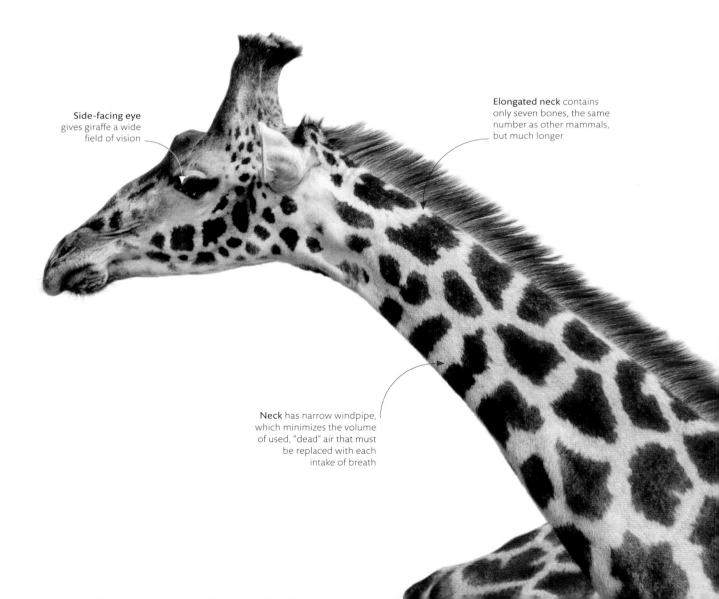

Side-facing eye gives giraffe a wide field of vision

Elongated neck contains only seven bones, the same number as other mammals, but much longer

Neck has narrow windpipe, which minimizes the volume of used, "dead" air that must be replaced with each intake of breath

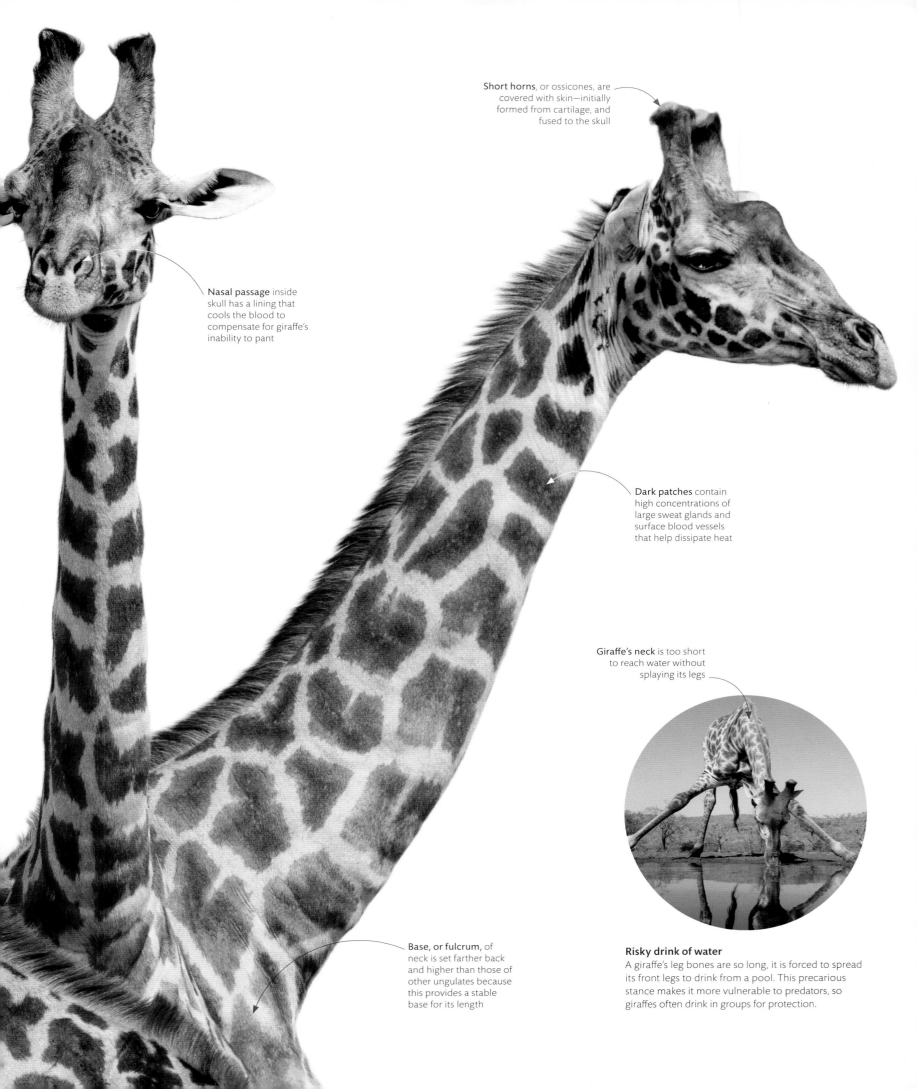

Short horns, or ossicones, are covered with skin—initially formed from cartilage, and fused to the skull

Nasal passage inside skull has a lining that cools the blood to compensate for giraffe's inability to pant

Dark patches contain high concentrations of large sweat glands and surface blood vessels that help dissipate heat

Giraffe's neck is too short to reach water without splaying its legs

Base, or fulcrum, of neck is set farther back and higher than those of other ungulates because this provides a stable base for its length

Risky drink of water
A giraffe's leg bones are so long, it is forced to spread its front legs to drink from a pool. This precarious stance makes it more vulnerable to predators, so giraffes often drink in groups for protection.

skeletons

skeleton. an internal or external framework—often of a stiff material, such as bone or cartilage—that supports the shape and movement of an animal.

Sea fans

The silver tree gorgonian (*Muricea* sp.) is reinforced with hollow pipes of a horny material called gorgonin. It is strong enough to resist the buffeting of ocean currents. The fanlike shape of this yellow sea fan (*Annella mollis*) also helps it withstand the current.

Communal skeleton of the gorgonian helps the colony grow erect branches, exposing the polyps to more plankton

Gorgonians with dense, featherlike colonies are more easily uprooted by strong currents, so grow in calmer, deeper waters

Polyps

The skeleton of a coral or gorgonian is a lifeless substructure but supports living polyps on the surface. Each polyp sits within its own hard cup, called a corallite, which protects its soft body.

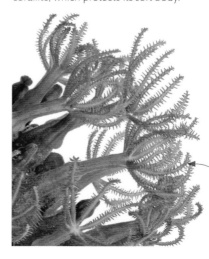

Each tentacle is covered with stinging cells that enable it to stun its prey

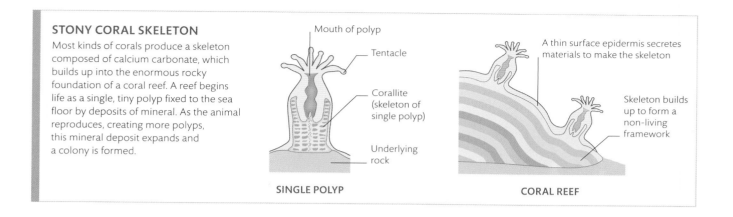

STONY CORAL SKELETON

Most kinds of corals produce a skeleton composed of calcium carbonate, which builds up into the enormous rocky foundation of a coral reef. A reef begins life as a single, tiny polyp fixed to the sea floor by deposits of mineral. As the animal reproduces, creating more polyps, this mineral deposit expands and a colony is formed.

Mouth of polyp

Tentacle

Corallite (skeleton of single polyp)

Underlying rock

SINGLE POLYP

A thin surface epidermis secretes materials to make the skeleton

Skeleton builds up to form a non-living framework

CORAL REEF

communal skeletons

A skeleton can support a sprawling colony just as effectively as a woody trunk and branches support a tree's foliage. Corals and their relatives excel at making massive skeletons to carry thousands of tiny polyps (see pp.32–33). Built from hornlike protein, rocky mineral, or chitin (the same material found in the shells of crabs), these skeletons can grow thick beneath the thin layer of skin that connects all the polyps living on their surface.

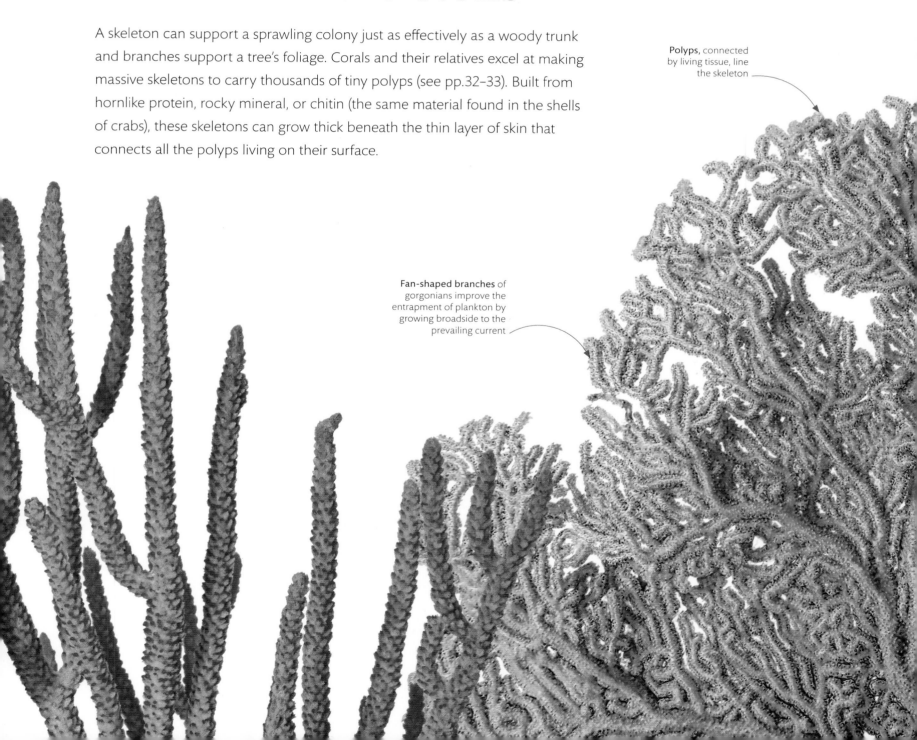

Polyps, connected by living tissue, line the skeleton

Fan-shaped branches of gorgonians improve the entrapment of plankton by growing broadside to the prevailing current

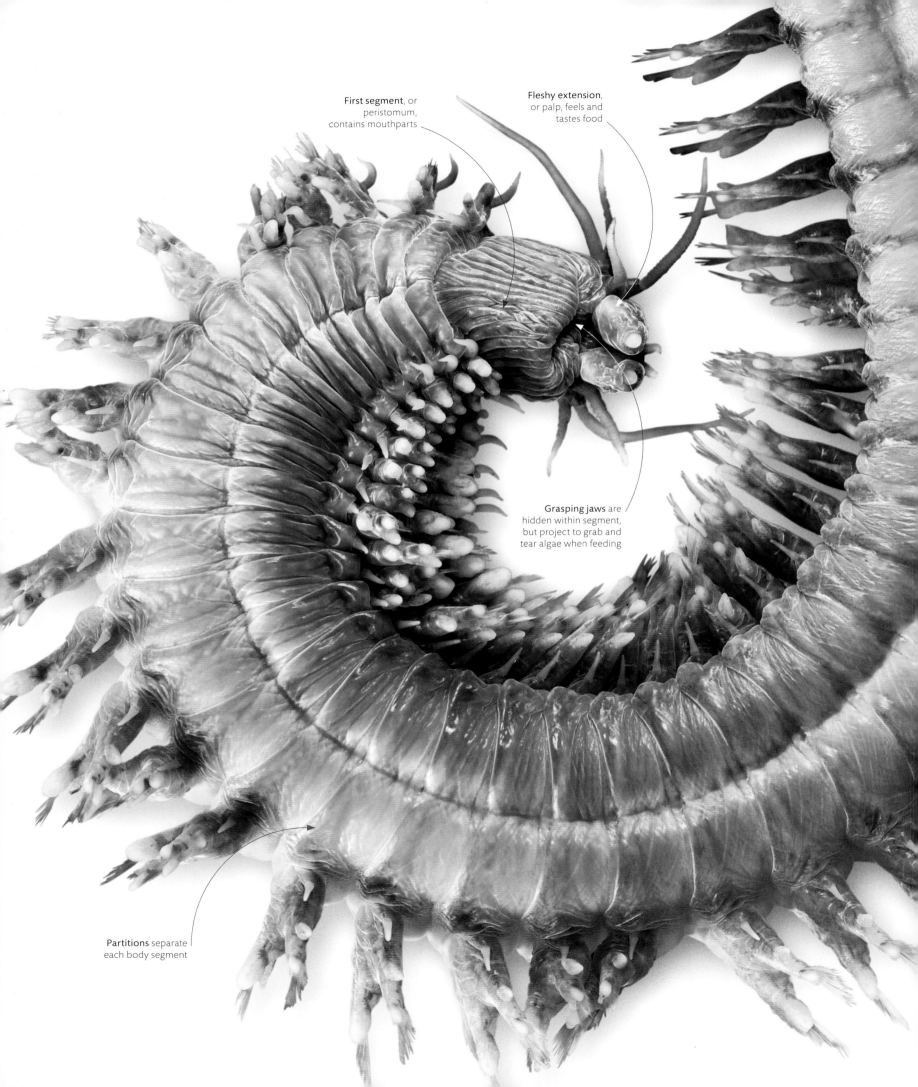

First segment, or peristomum, contains mouthparts

Fleshy extension, or palp, feels and tastes food

Grasping jaws are hidden within segment, but project to grab and tear algae when feeding

Partitions separate each body segment

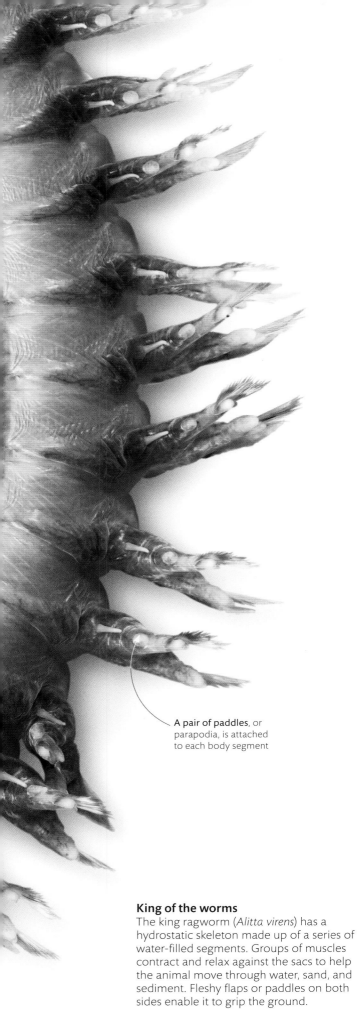

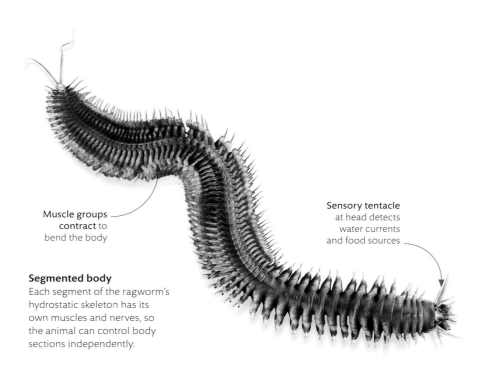

Muscle groups contract to bend the body

Sensory tentacle at head detects water currents and food sources

Segmented body
Each segment of the ragworm's hydrostatic skeleton has its own muscles and nerves, so the animal can control body sections independently.

A pair of paddles, or parapodia, is attached to each body segment

water skeletons

Annelids—the group of animals that includes earthworms— have bodies that are not supported by hard bones or solid armor. Instead they have flexible, water-filled (or hydrostatic) skeletons. Water can be the perfect skeletal substance because it cannot be compressed and it flows to fill any shape. As a result, by coordinating their efforts, the animal's muscles can squeeze against the water-filled parts of the body to move it forward.

King of the worms
The king ragworm (*Alitta virens*) has a hydrostatic skeleton made up of a series of water-filled segments. Groups of muscles contract and relax against the sacs to help the animal move through water, sand, and sediment. Fleshy flaps or paddles on both sides enable it to grip the ground.

MOVING IN WAVES
By contracting alternate groups of muscles along either side of the body, while those on the opposite side relax and lengthen, a ragworm creates S-shaped transverse waves that pass along its body, helping it move along the sand or swim through water.

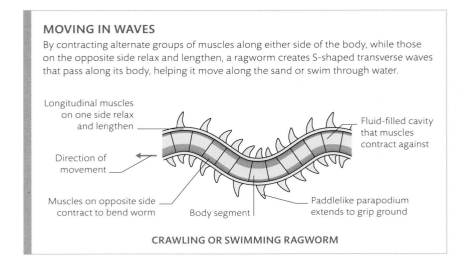

Longitudinal muscles on one side relax and lengthen

Direction of movement

Muscles on opposite side contract to bend worm

Body segment

Fluid-filled cavity that muscles contract against

Paddlelike parapodium extends to grip ground

CRAWLING OR SWIMMING RAGWORM

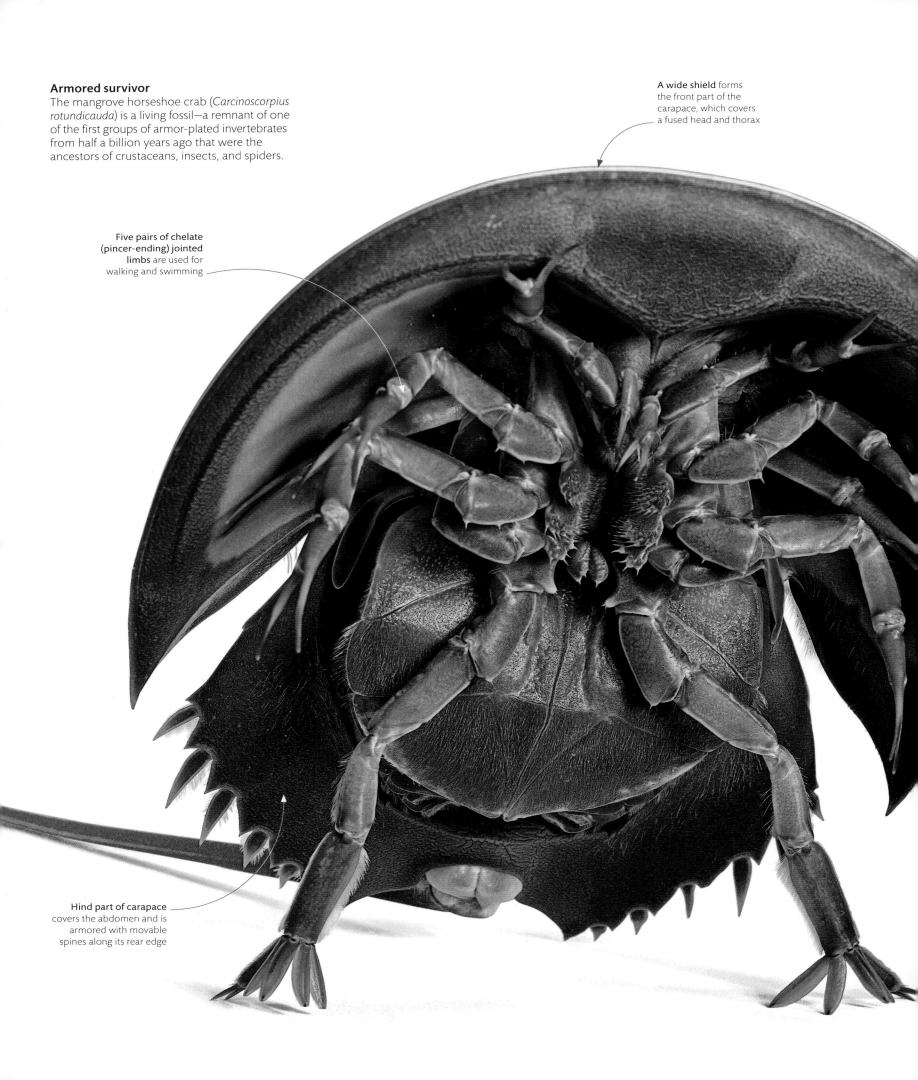

Armored survivor
The mangrove horseshoe crab (*Carcinoscorpius rotundicauda*) is a living fossil—a remnant of one of the first groups of armor-plated invertebrates from half a billion years ago that were the ancestors of crustaceans, insects, and spiders.

A wide shield forms the front part of the carapace, which covers a fused head and thorax

Five pairs of chelate (pincer-ending) jointed limbs are used for walking and swimming

Hind part of carapace covers the abdomen and is armored with movable spines along its rear edge

False crab
Despite their name, horseshoe crabs are more closely related to arachnids than to true crabs. Like them, they lack antennae and the body is divided into two parts: the prosoma (fused head and thorax) and the opisthosoma (or abdomen).

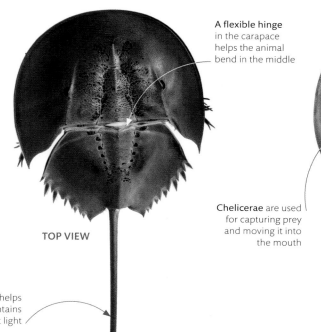

A flexible hinge in the carapace helps the animal bend in the middle

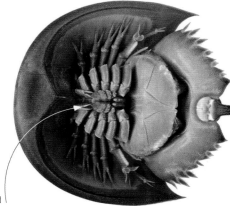

Chelicerae are used for capturing prey and moving it into the mouth

TOP VIEW

UNDERSIDE VIEW

The stiff, tail-like telson helps the animal steer and contains sensors that detect light

The horseshoe crab's exoskeleton, unlike those of many other aquatic arthropods, does not contain calcium carbonate

external skeletons

Many aquatic animals with soft, flabby bodies are supported by water, both externally and internally. But a hard skeleton provides a more rigid framework that keeps the animal's shape. Animals supported by an external casing—known as an exoskeleton—have better control over their movements, can move faster, and can also grow bigger. Exoskeletons develop around the body like a suit of armor, so they must be molted periodically to make room underneath for the animal to grow.

Reinforced exoskeletons
Arthropods have a rigid exoskeleton made of a substance called chitin. The exoskeletons of many arthropods that live in water—especially crustaceans—are also reinforced with minerals such as calcium carbonate, which make the exoskeleton stronger, but also heavier. However, the water surrounding aquatic arthropods supports the weight of its heavy skeleton.

exoskeletons on land

The animals that colonized land for the first time half a billion years ago had a hard external skeleton, or exoskeleton, that articulated around flexible joints. This armor protected them from physical harm and even—by evolving a waxy layer—helped prevent dehydration. But there was a big drawback for these land animals, because without the buoyancy of water, armor is heavy. Today the largest armored invertebrates are still found in the sea (see pp. 68–69). Those that have invaded land, such as woodlice, are limited to small size. But the spiders and, above all, the insects (with their better waterproofing and breathing pores—see box) make up for this in numbers and diversity.

INSECT EXOSKELETONS

Skeletal modifications helped insects become the dominant arthropods on land. Not only are they better waterproofed, but their outer "shells" are punctured by a system of breathing pores (spiracles) that deliver oxygen directly to muscles through microscopic air-filled tubes.

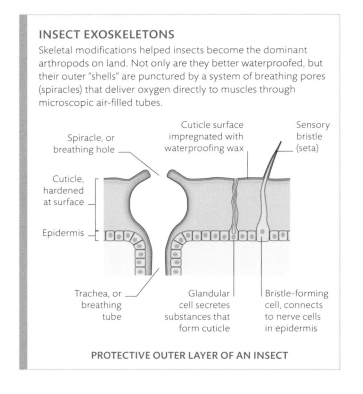

Spiracle, or breathing hole

Cuticle surface impregnated with waterproofing wax

Sensory bristle (seta)

Cuticle, hardened at surface

Epidermis

Trachea, or breathing tube

Glandular cell secretes substances that form cuticle

Bristle-forming cell, connects to nerve cells in epidermis

PROTECTIVE OUTER LAYER OF AN INSECT

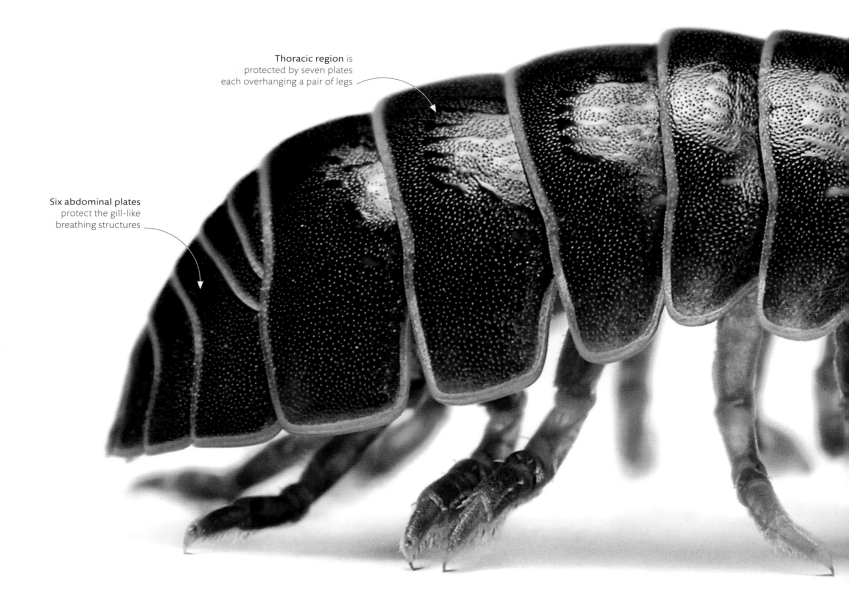

Thoracic region is protected by seven plates each overhanging a pair of legs

Six abdominal plates protect the gill-like breathing structures

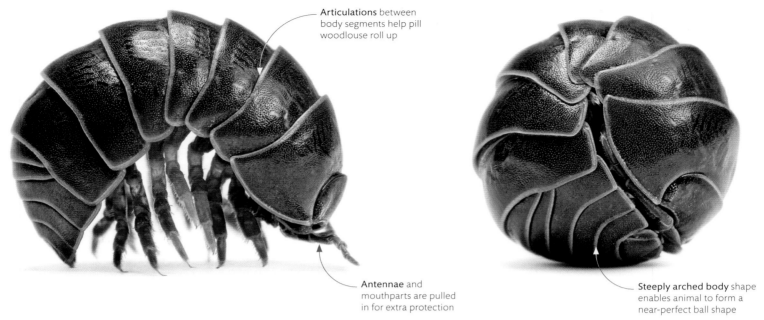

Articulations between body segments help pill woodlouse roll up

Antennae and mouthparts are pulled in for extra protection

Steeply arched body shape enables animal to form a near-perfect ball shape

Defense mechanism

Unlike other species of woodlice, pill woodlice have the extra defensive strategy of being able to roll into a ball—something that helps protect them from predators.

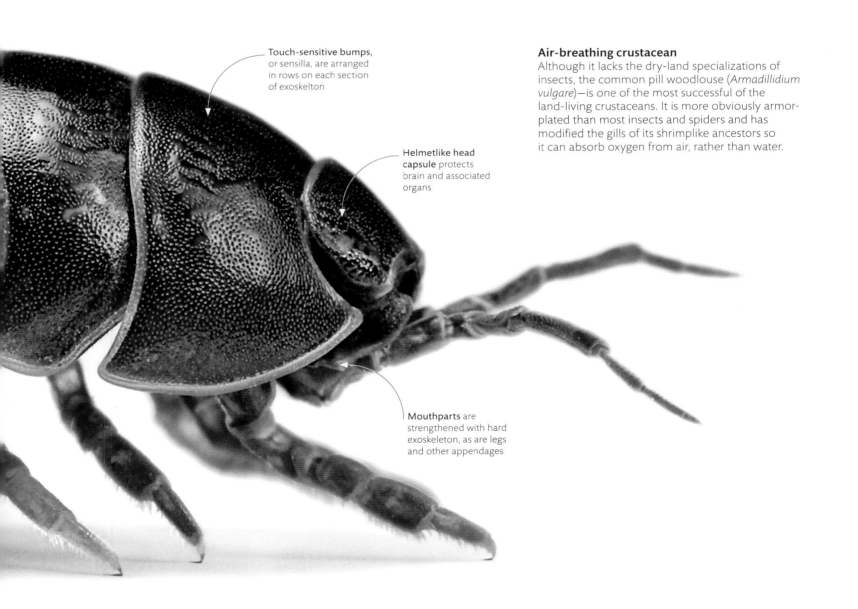

Touch-sensitive bumps, or sensilla, are arranged in rows on each section of exoskelton

Helmetlike head capsule protects brain and associated organs

Mouthparts are strengthened with hard exoskeleton, as are legs and other appendages

Air-breathing crustacean

Although it lacks the dry-land specializations of insects, the common pill woodlouse (*Armadillidium vulgare*)—is one of the most successful of the land-living crustaceans. It is more obviously armor-plated than most insects and spiders and has modified the gills of its shrimplike ancestors so it can absorb oxygen from air, rather than water.

Waving spines

Having a skeleton that is made up of plates joined into a test (shell) reduces mobility. But in urchins such as the white-dotted long-spined urchin (*Diadema setosum*), muscles can move the spines to repel intruders, while beneath its body, suckerlike tube feet (see pp.214–15) pull the animal over the seabed.

The base of each spine has a flexible connection with the rest of the skeleton, which allows the spine to move from side to side

SIDE VIEW

chalky skeletons

Starfish and urchins belong to a group of animals called echinoderms—a word meaning "spiny skin." The name refers to their unique chalky skeleton, which is made from crystals of calcium carbonate that are packed loosely into the animal's rough skin (as in starfish), or joined together into a shell, or "test" (as in sea urchins). Despite their starlike radial symmetry, these animals are among the closest living relatives of backboned animals.

Long sucker-tipped tubes called tube feet reach beyond the spines and are used for attaching to the seabed and crawling along

Hard-tipped defensive spines are hollow and brittle, releasing a mild venom when broken

PENTARADIAL BODY PLAN

Most echinoderms have pentaradial symmetry, meaning that their body is arranged in five parts around a central point. The symmetry is seen most clearly in the five arms of a typical starfish, but it occurs in the shell-like plates visible on a dead urchin that has lost its spines, as well as in related animals, such as brittle stars (see pp.212–13) and sea cucumbers.

SEA URCHINS AND TESTS

JAW APPARATUS

Five teeth protrude from the jaw, helping the sea urchin rasp algae from rocks

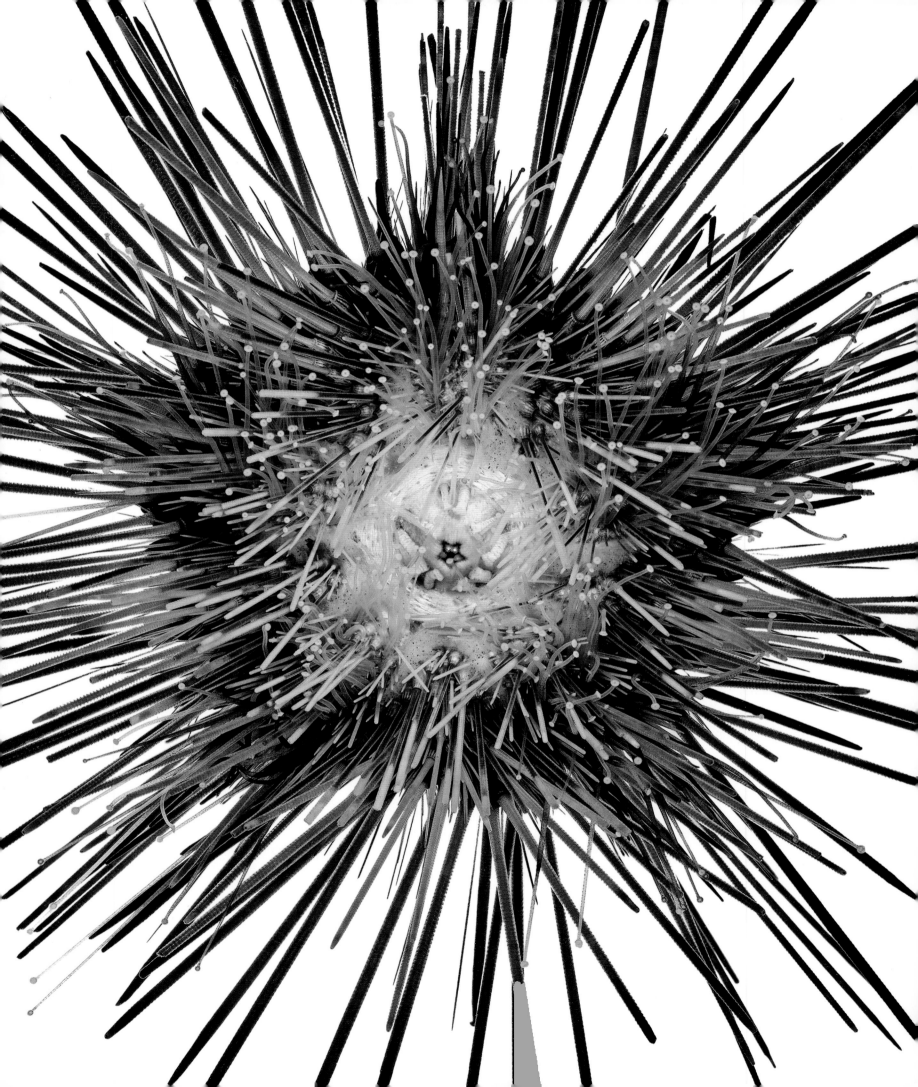

internal skeletons

Backboned animals—vertebrates—have a solid, jointed frame inside their body, surrounded by muscle. Unlike an invertebrate exoskeleton, this endoskeleton is built from within. It grows with the body, so it never needs to be molted. This is possible because of the evolution of hard bone and flexible cartilage: living tissues that shape and reshape during development.

The vertebral column, a repeating sequence of bony elements called vertebrae, provides a flexible supporting axis for the body's muscles

Dyed components
Like most vertebrates, the skeleton of an adult clingfish (*Gobiesox* sp.)—a coastal fish named for its suckerlike pelvic fins—is mainly bone (stained violet in this specimen). But it also retains parts made from softer cartilage (blue) that exclusively supported the embryo.

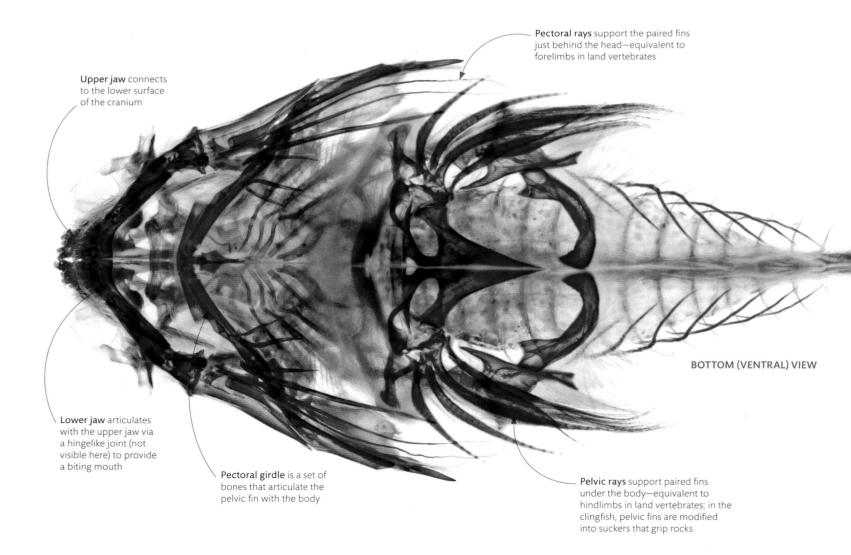

Pectoral rays support the paired fins just behind the head—equivalent to forelimbs in land vertebrates

Upper jaw connects to the lower surface of the cranium

BOTTOM (VENTRAL) VIEW

Lower jaw articulates with the upper jaw via a hingelike joint (not visible here) to provide a biting mouth

Pectoral girdle is a set of bones that articulate the pelvic fin with the body

Pelvic rays support paired fins under the body—equivalent to hindlimbs in land vertebrates; in the clingfish, pelvic fins are modified into suckers that grip rocks

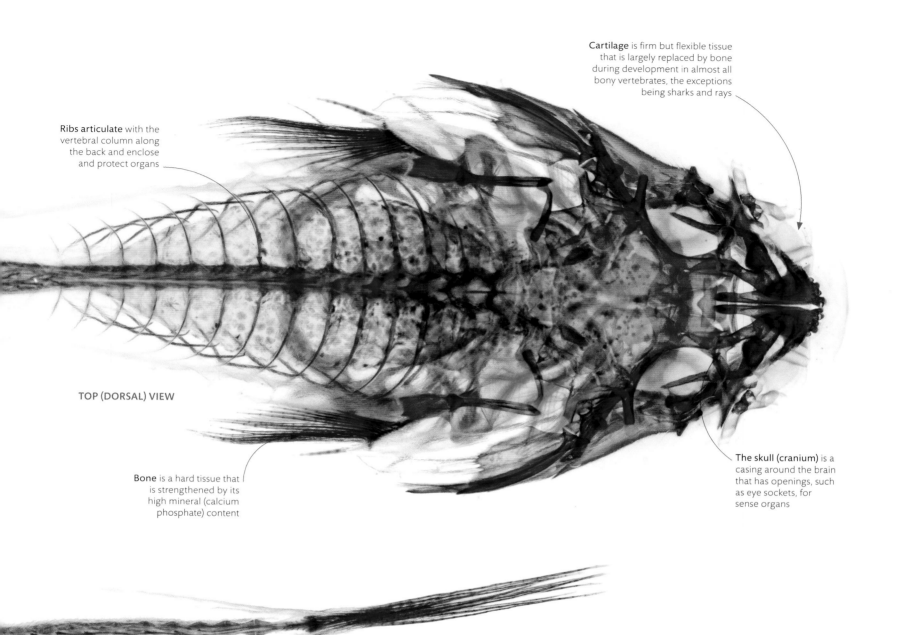

Cartilage is firm but flexible tissue that is largely replaced by bone during development in almost all bony vertebrates, the exceptions being sharks and rays

Ribs articulate with the vertebral column along the back and enclose and protect organs

TOP (DORSAL) VIEW

Bone is a hard tissue that is strengthened by its high mineral (calcium phosphate) content

The skull (cranium) is a casing around the brain that has openings, such as eye sockets, for sense organs

VERTEBRATE SKELETON

The vertebral column, also called the backbone or spine, supports the length of a vertebrate's body and encloses the spinal cord, while the skull protects the brain. Together, these make up the axial skeleton. Articulating with the axial skeleton are parts that aid locomotion: the so-called appendicular skeleton. The earliest vertebrates—which were all fish—had fins, but they later evolved walking limbs.

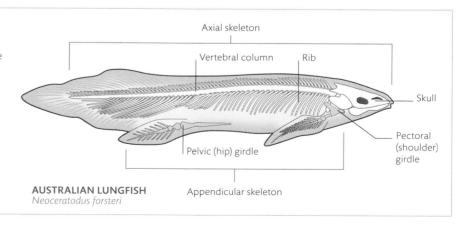

AUSTRALIAN LUNGFISH
Neoceratodus forsteri

Axial skeleton

Vertebral column

Rib

Skull

Pelvic (hip) girdle

Pectoral (shoulder) girdle

Appendicular skeleton

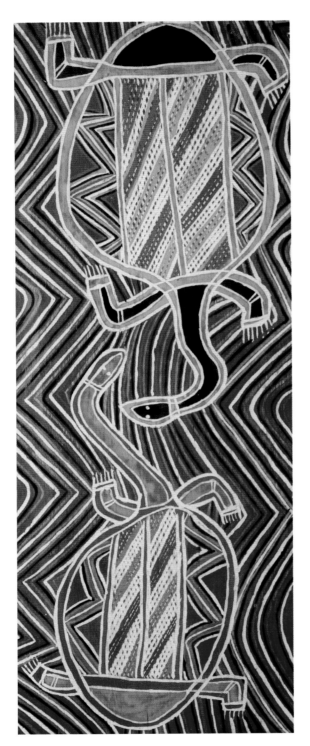

aboriginal insights

The painted walls of the rocky outcrops that sheltered Australian aboriginal clans for millennia tell the story of the native fish and animals these groups relied on for food. Many of these prehistoric artists used X-ray effects that reveal the inner working and structures of the animals they hunted and their complete understanding of every part of them.

The first human migrants are thought to have arrived on Australian soil more than 50,000 years ago, marking the beginning of the oldest continuous culture in history. The earliest records of their civilization include charcoal drawings (c.20,000 BCE) of now extinct animals such as the Tasmanian tiger, but it is in the more recent galleries of rock art in the Ubirr caves of Arnhem Land, Northern Australia, that the continuum of aboriginal life and belief is on full view.

Across the walls of the caves' interiors, the rich variety of animals and fish from the nearby East Alligator River and Nadab flood plain is painted in an X-ray style that dates back 8,000 years. Most were painted in the "freshwater period", spanning the past 2,000 years, and depict an abundance of fish, mussels, waterfowl, wallabies, goannas, and echidnas.

Long-necked turtles
A bark painting of two long-necked turtles uses a variety of aboriginal techniques including traditional cross-hatching, known as "rarrk," which is believed to endow the turtles with spiritual power.

The artists' colors were derived from charcoal and ocher, a local hard clay found in red (the most enduring color), pink, white, yellow, and, occasionally, blue. It was ground to a powder and mixed with egg, water, pollen, or animal fat or blood to make paint. The bones and organs, as familiar to the hunter as the living animal, were mapped out inside the lifelike outlines of each creature. Over the centuries, aboriginal art diversified across different regions of Australia with symbolic dot paintings prevalent in central and western desert regions; X-ray art in the Northern Territory; and a style of fine cross-hatching particular to "rarrk" paintings in Arnhem Land. These are often rendered on the inside of a piece of bark. Artists use hairlike bristles from reeds or human hair for painstaking line-filling within the outlines of their animal portraits. They believe that the technique bestows spirituality on the subject.

The symbolic associations of Australia's animals sit at the heart of Dreamtime. This creation myth is based on the belief that the rivers, streams, land, hills, rocks, plants, animals, and people were created by spirits, who gave tools, land, totems, and dreaming to every clan.

Sacred rules for clan conduct, moral laws, and beliefs were passed down through storytelling, dance, painting, and song. In many cave galleries, ancestral art has been painted over across the centuries but the core messages remain the same.

> ❝ Cave... he never move. No one can shift that cave, because it dream. It story, it law. ❞

BIG BILL NEIDJIE, BUNIDJ CLAN

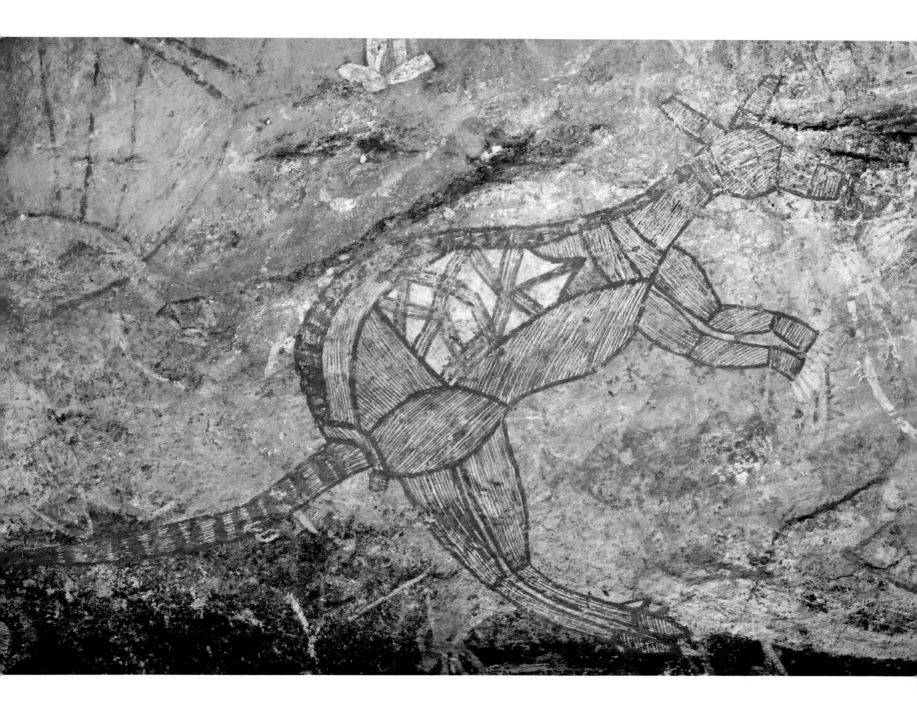

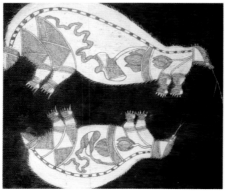

Rock art wallaby
A wallaby with its tailbones and spine visible decorates the cave walls at Ubirr, Kakadu, Northern Territory, one of the oldest continuously inhabited shelters. Animal food sources were painted here for thousands of years.

Inside-out anteaters
Two anteaters, painted on the inside of a strip of bark, offer a lesson in anatomy. Heart, stomach, and intestines are rendered in detail in a 20th-century X-ray style, cross-hatched painting from Western Arnhem Land, Australia.

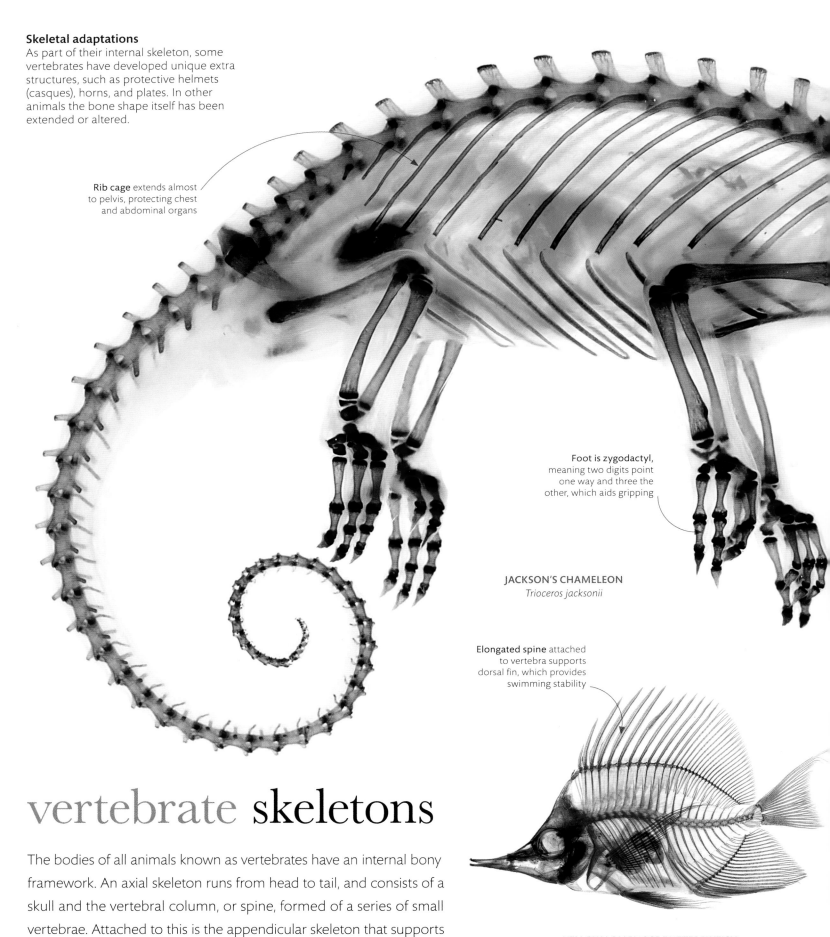

Skeletal adaptations
As part of their internal skeleton, some vertebrates have developed unique extra structures, such as protective helmets (casques), horns, and plates. In other animals the bone shape itself has been extended or altered.

Rib cage extends almost to pelvis, protecting chest and abdominal organs

Foot is zygodactyl, meaning two digits point one way and three the other, which aids gripping

JACKSON'S CHAMELEON
Trioceros jacksonii

Elongated spine attached to vertebra supports dorsal fin, which provides swimming stability

vertebrate skeletons

The bodies of all animals known as vertebrates have an internal bony framework. An axial skeleton runs from head to tail, and consists of a skull and the vertebral column, or spine, formed of a series of small vertebrae. Attached to this is the appendicular skeleton that supports limbs in four-legged animals, fins in fish, and legs and wings in birds.

YELLOW LONGNOSE BUTTERFLYFISH
Forcipiger flavissimus

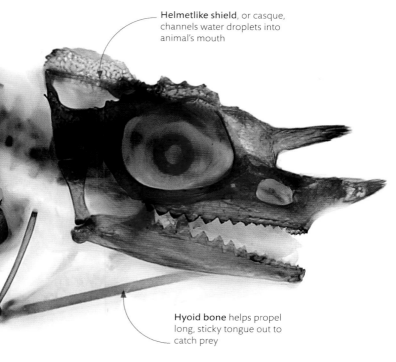

Helmetlike shield, or casque, channels water droplets into animal's mouth

Hyoid bone helps propel long, sticky tongue out to catch prey

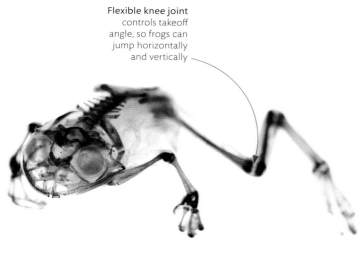

Flexible knee joint controls takeoff angle, so frogs can jump horizontally and vertically

JAPANESE TREE FROG
Hyla japonica

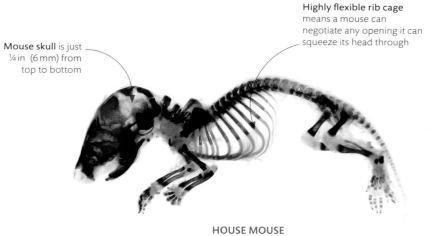

Highly flexible rib cage means a mouse can negotiate any opening it can squeeze its head through

Mouse skull is just ¼ in (6 mm) from top to bottom

HOUSE MOUSE
Mus musculus

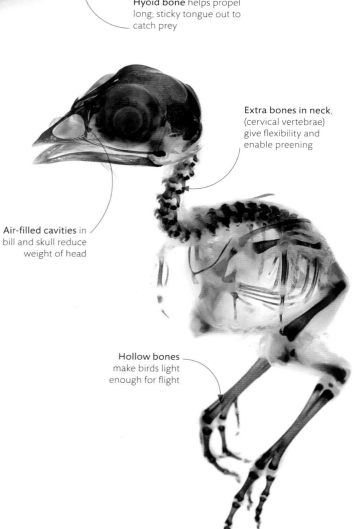

Extra bones in neck, (cervical vertebrae) give flexibility and enable preening

Air-filled cavities in bill and skull reduce weight of head

Hollow bones make birds light enough for flight

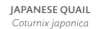

JAPANESE QUAIL
Coturnix japonica

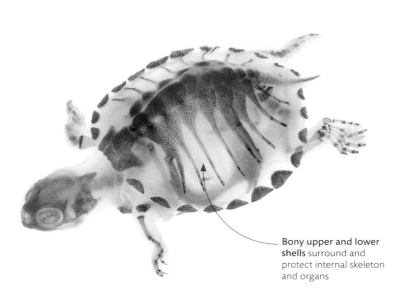

Bony upper and lower shells surround and protect internal skeleton and organs

JAPANESE POND TURTLE
Mauremys japonica

Shell from bone
Like other chelonians, the upper
shell (carapace) and lower shell
(plastron) of an Indian star
tortoise (*Geochelone elegans*)
are made up of interlocking
plates that correspond with
the dermal bones that grow
within the skin. Above this is
a hornlike layer of keratin,
impregnated with pigments.

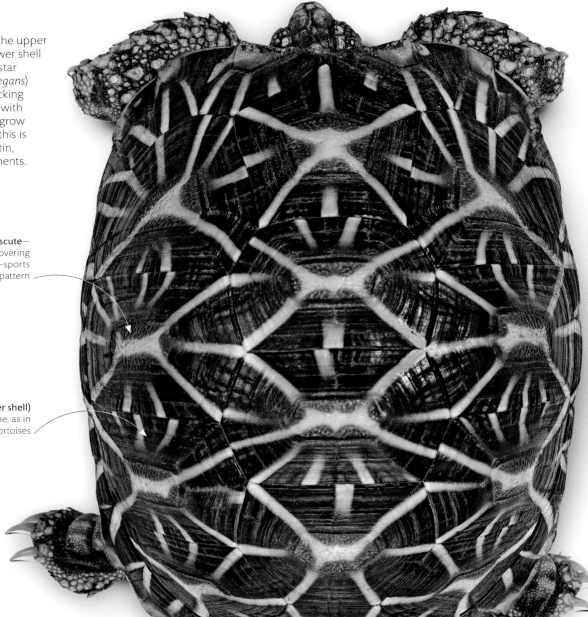

Each scute—
a hornlike layer covering
a plate of bone—sports
a starlike pattern

Carapace (upper shell)
has a high dome, as in
other terrestrial tortoises

Thick, elephantine
limbs carry claws that
help grip the ground

vertebrate shells

The shells of chelonians (turtles and tortoises) provide a unique form of
protection among backboned animals: much of their body is enveloped in
bone. This provides impressive protection against predators but compromises
mobility because of its weight and rigidity. The necks of chelonians have to
be longer and more flexible than in other reptiles to reach out for food,
while extra-strong limb muscles provide propulsion on land or in water.

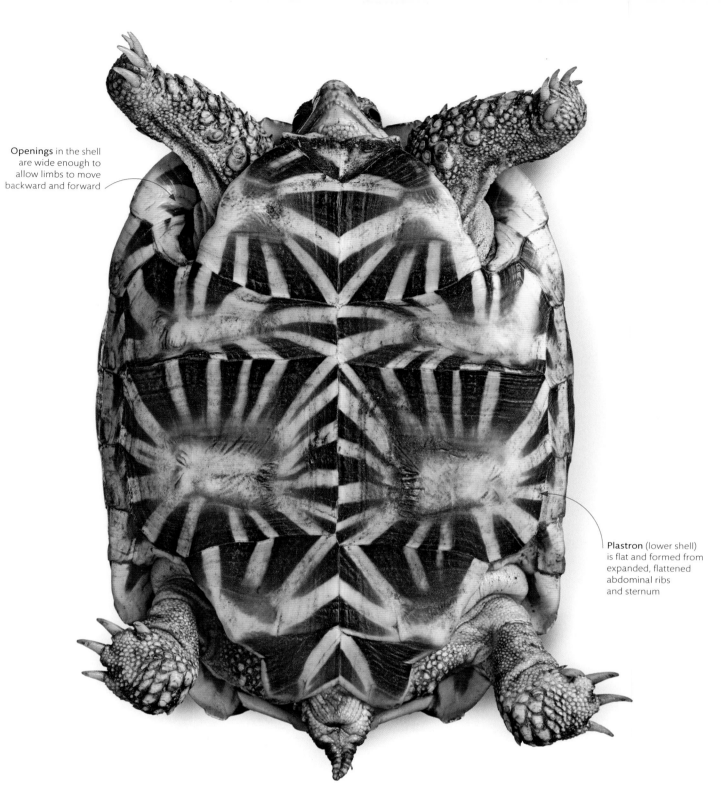

Openings in the shell
are wide enough to
allow limbs to move
backward and forward

Plastron (lower shell)
is flat and formed from
expanded, flattened
abdominal ribs
and sternum

BODY ARMOR

With spine and ribs fused to the shell—
and shoulder and pelvic bones uniquely
within the ribcage—chelonians enjoy
almost total body protection; many
can even retract their limbs and head
inside their shell. However, conventional
breathing by moving the ribcage is
impossible. Instead, the shoulder girdle
swings back and forth to ventilate the lungs.

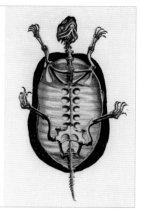

**TORTOISE SKELETON
(PLASTRON REMOVED)**

Neck bends sideways so
that the head rests under
the edge of the shell

Retracting the neck

Some chelonians pull their head back
into the shell by curving the neck into
a S-shape; others, such as this gibba
turtle (*Mesoclemmys gibba*), fold their
head and neck to the side.

bird skeletons

Despite the wealth of species—more than 10,000—the body plan of most birds is remarkably similar, largely due to the physical constraints of flight. They have two legs used for walking and perching, their forelimbs are fashioned as wings, and some bones of the spine, collar, and pelvis are fused to take the stresses of jumping and landing. Most of the bones are pneumatic, or air-filled, which minimizes weight (see box), so less energy is spent on becoming airborne and parents can sit on their eggs without breaking them.

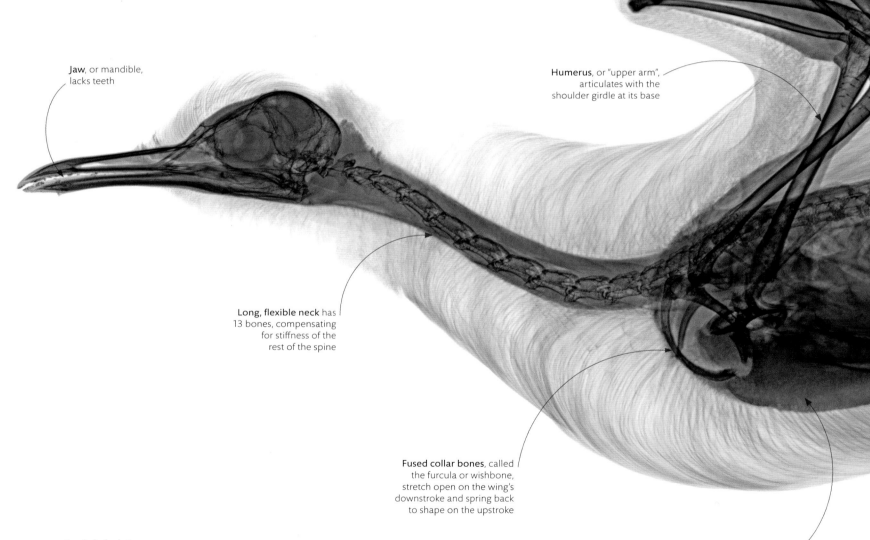

Jaw, or mandible, lacks teeth

Humerus, or "upper arm", articulates with the shoulder girdle at its base

Long, flexible neck has 13 bones, compensating for stiffness of the rest of the spine

Fused collar bones, called the furcula or wishbone, stretch open on the wing's downstroke and spring back to shape on the upstroke

Large keel bone, or carina, of the breastbone serves as an attachment point for flight muscles

Aerial skeleton
This taxidermied specimen of a Mediterranean gull (*Larus melanocephalus*) shows how wings pivot around the bones of the pectoral (shoulder) girdle. Compared with that of their reptilian ancestors, the body skeleton of a bird is shorter and more compact, with the center of gravity shifted over the hind limbs.

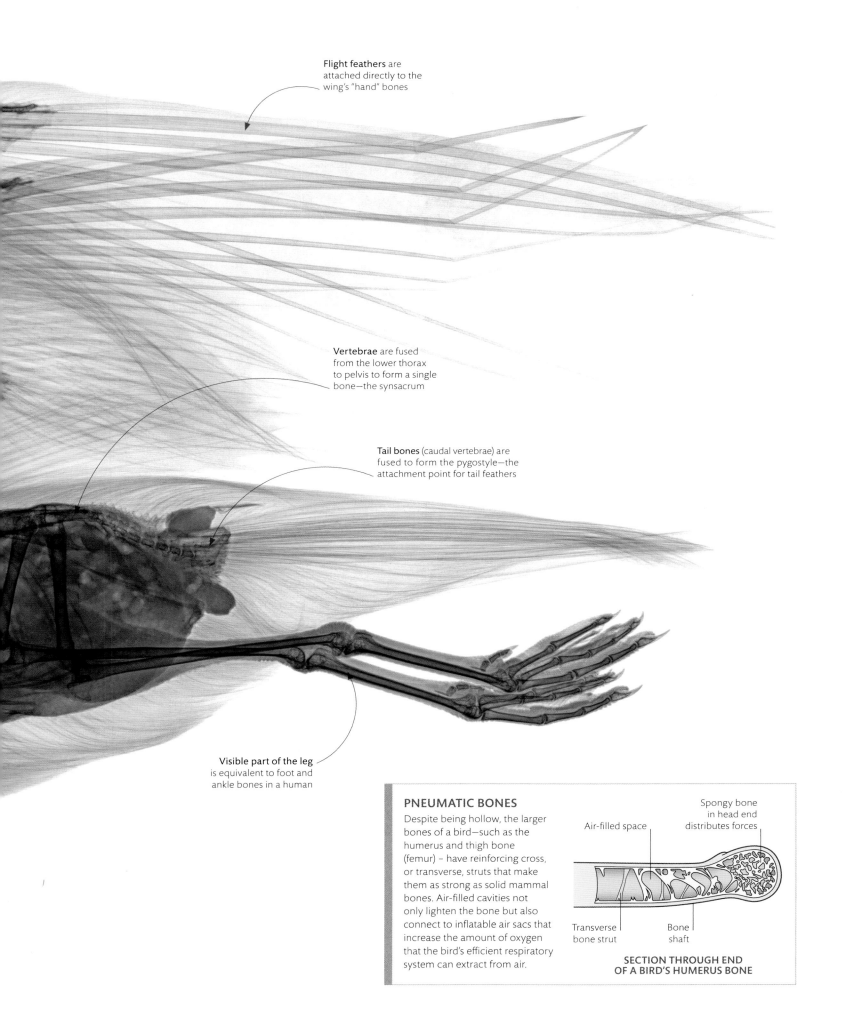

Flight feathers are attached directly to the wing's "hand" bones

Vertebrae are fused from the lower thorax to pelvis to form a single bone—the synsacrum

Tail bones (caudal vertebrae) are fused to form the pygostyle—the attachment point for tail feathers

Visible part of the leg is equivalent to foot and ankle bones in a human

PNEUMATIC BONES

Despite being hollow, the larger bones of a bird—such as the humerus and thigh bone (femur) – have reinforcing cross, or transverse, struts that make them as strong as solid mammal bones. Air-filled cavities not only lighten the bone but also connect to inflatable air sacs that increase the amount of oxygen that the bird's efficient respiratory system can extract from air.

Air-filled space

Spongy bone in head end distributes forces

Transverse bone strut

Bone shaft

SECTION THROUGH END OF A BIRD'S HUMERUS BONE

cheetah

Many carnivores rely on ambush or the cooperaton of the pack, but the cheetah (*Acinonyx jubatus*) uses sudden bursts of speed to catch its prey. With huge, bounding strides facilitated by its flexible spine, the cheetah can reach 63 mph (102 kph), making this big cat the fastest animal on four legs.

Native to Africa and a few locations in Iran, cheetahs inhabit a wide range of habitats, from dry forest and scrubland to grasslands and even desert. They typically hunt small antelopes, such as Thomson's gazelle (*Eudorcas thomsonii*): animals that, having coevolved with hunters, are also fast—and vigilant, too. A herd is quick to spot a predator and will keep it in view to deny the element of surprise, so a cheetah must strike at the right moment or waste precious energy on a fruitless pursuit.

Relying on stealth and camouflage, the cheetah approaches slowly, crouching low and freezing midstride if seen. When it gets near enough to its prey—ideally less than 165 ft (50 m) away—it explodes into a sprint. Within seconds, the cheetah has reached 37 mph (60 kph) and more than doubled its breathing rate as it homes in on the bolting gazelle. As the cheetah draws level, it swipes its paw and hooks the quarry off balance with its dew claw.

Explosive speed is no guarantee of a meal. Sprinting for prey is an energy-sapping hunting strategy, and the cheetah tires sooner than the gazelle. Should the target not be felled within 985 ft (300 m), the cheetah will give up the chase.

If the hunt is a success, the cheetah suffocates the victim by clamping its jaws over the animal's throat, panting through enlarged nostrils as it recovers. Even then, a meal is not certain: many cheetahs lose their kills to leopards, lions, or hyenas (the same predators that take a high toll of cheetah cubs). Dragging the carcass to cover is a priority, as is eating the meat as rapidly as possible: a cheetah can devour up to 30 lb (14 kg) of flesh in one sitting.

Closing in for the kill

Typically, half of all sprints result in a kill, but by targeting fawns, such as this Thomson's gazelle, the success rate can reach 100 percent.

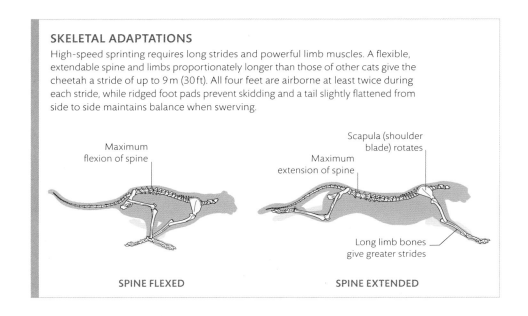

SKELETAL ADAPTATIONS

High-speed sprinting requires long strides and powerful limb muscles. A flexible, extendable spine and limbs proportionately longer than those of other cats give the cheetah a stride of up to 9 m (30 ft). All four feet are airborne at least twice during each stride, while ridged foot pads prevent skidding and a tail slightly flattened from side to side maintains balance when swerving.

Maximum
flexion of spine

Scapula (shoulder
blade) rotates

Maximum
extension of spine

Long limb bones
give greater strides

SPINE FLEXED

SPINE EXTENDED

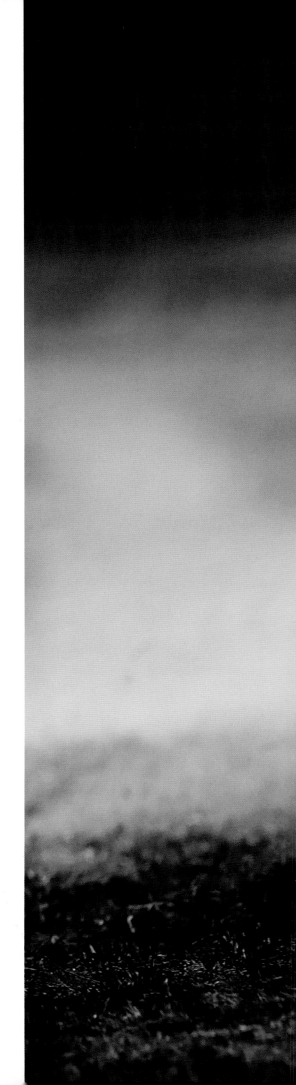

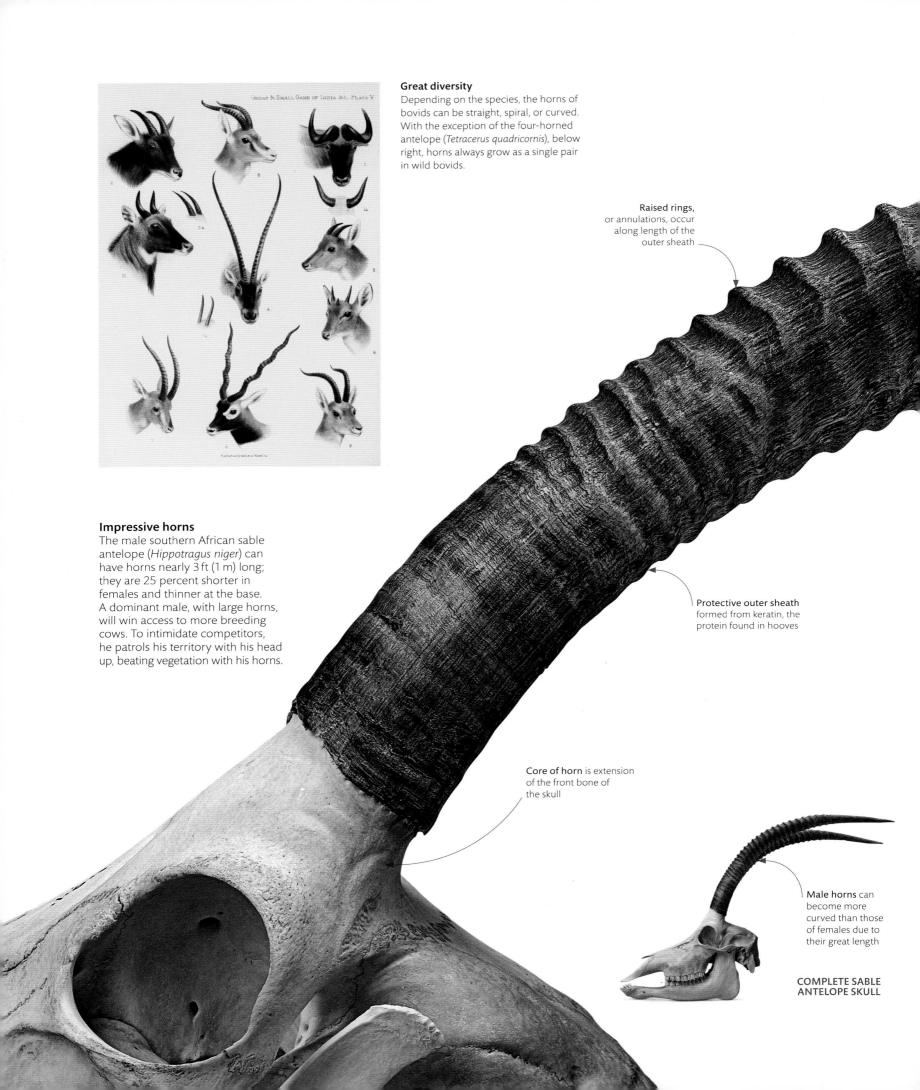

Great diversity
Depending on the species, the horns of bovids can be straight, spiral, or curved. With the exception of the four-horned antelope (*Tetracerus quadricornis*), below right, horns always grow as a single pair in wild bovids.

Raised rings, or annulations, occur along length of the outer sheath

Impressive horns
The male southern African sable antelope (*Hippotragus niger*) can have horns nearly 3 ft (1 m) long; they are 25 percent shorter in females and thinner at the base. A dominant male, with large horns, will win access to more breeding cows. To intimidate competitors, he patrols his territory with his head up, beating vegetation with his horns.

Protective outer sheath formed from keratin, the protein found in hooves

Core of horn is extension of the front bone of the skull

Male horns can become more curved than those of females due to their great length

COMPLETE SABLE ANTELOPE SKULL

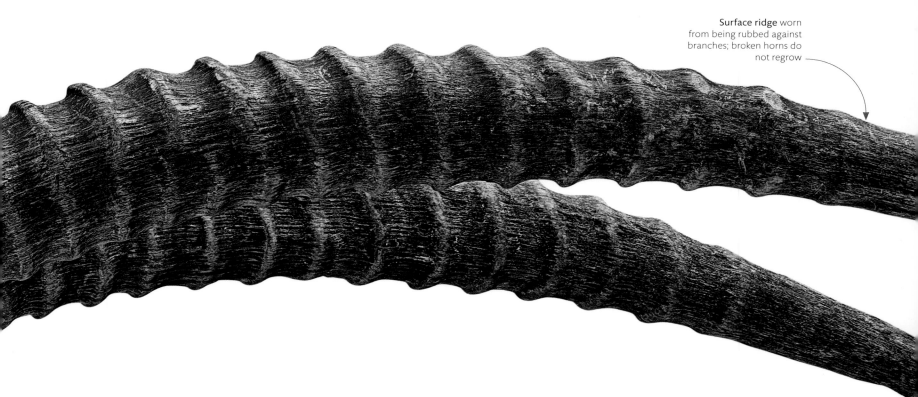

mammal horns

Many animals have projections on their body—from the Amazonian purple scarab beetle (see p.115) to the hornlike scales of some lizards—but only hoofed mammals, such as antelope, have true horns that are bony extensions of their skulls. Typically bigger in males, and often lacking in females, horns—unlike the branching antlers of male deer (see pp.88–89)—are permanent, unbranched fixtures, used in battles to establish male dominance or as defense against predators.

HORNS AND ANTLERS

True horns are produced by bovids, or Bovidae (which includes cattle, antelope, and goats). Only deer of the Cervidae family have antlers. New antlers are grown each year, nourished by a layer of skin called velvet, and shed at the end of the breeding season. In contrast, horns grow continuously throughout an animal's life and the outer layer has a dried sheath of horny keratin.

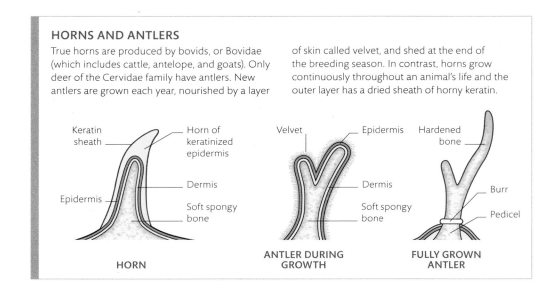

Keratin sheath

Epidermis

Horn of keratinized epidermis

Dermis

Soft spongy bone

HORN

Velvet

Epidermis

Dermis

Soft spongy bone

ANTLER DURING GROWTH

Hardened bone

Burr

Pedicel

FULLY GROWN ANTLER

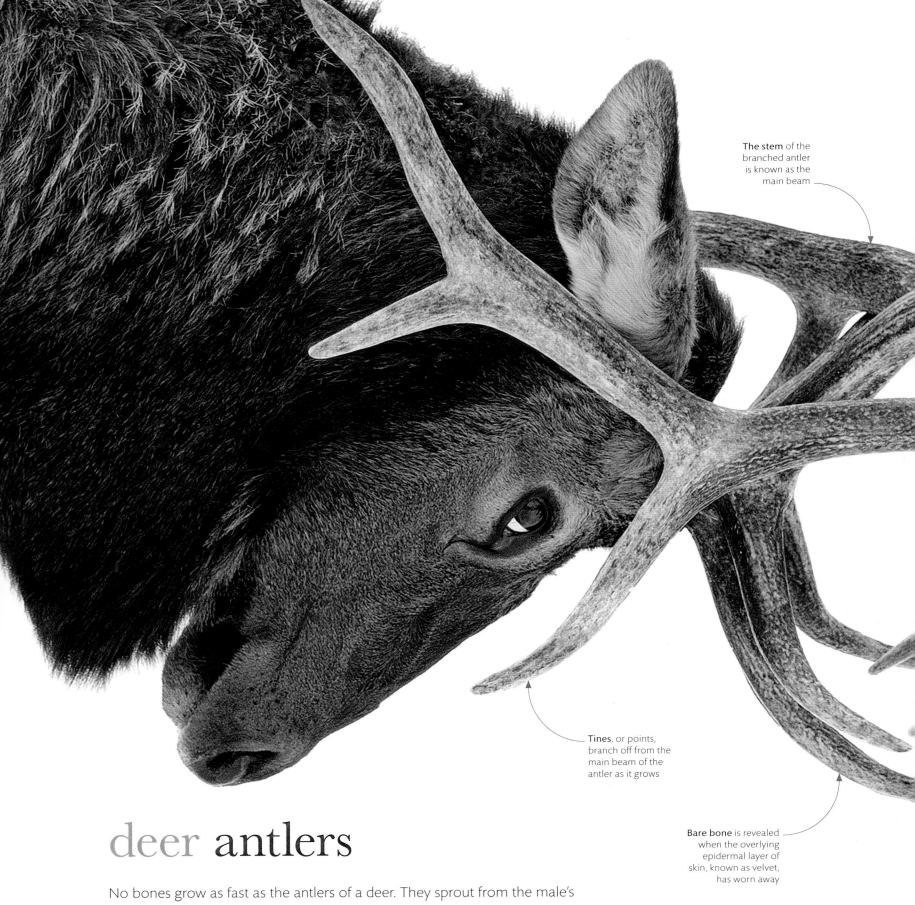

The stem of the branched antler is known as the main beam

Tines, or points, branch off from the main beam of the antler as it grows

Bare bone is revealed when the overlying epidermal layer of skin, known as velvet, has worn away

deer antlers

No bones grow as fast as the antlers of a deer. They sprout from the male's skull, and over several months they branch into a heavy display used in combat over females. Antlers are fed by a rich blood supply within a layer of skin that later shrivels away, exposing the bone. When breeding is over, the antlers fall off—so new ones must grow the next year.

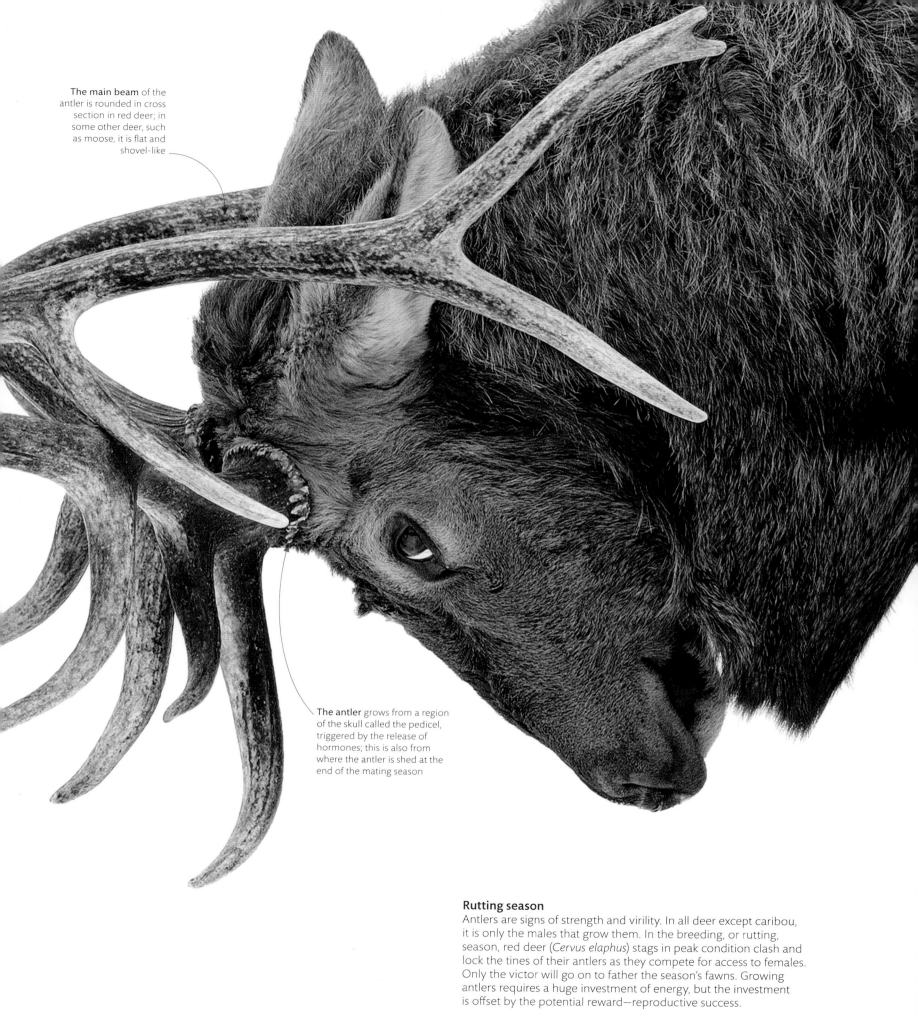

The main beam of the antler is rounded in cross section in red deer; in some other deer, such as moose, it is flat and shovel-like

The antler grows from a region of the skull called the pedicel, triggered by the release of hormones; this is also from where the antler is shed at the end of the mating season

Rutting season

Antlers are signs of strength and virility. In all deer except caribou, it is only the males that grow them. In the breeding, or rutting, season, red deer (*Cervus elaphus*) stags in peak condition clash and lock the tines of their antlers as they compete for access to females. Only the victor will go on to father the season's fawns. Growing antlers requires a huge investment of energy, but the investment is offset by the potential reward—reproductive success.

skin, coats, and armor

skin. a thin layer of tissue forming the outer covering of the body, often consisting of two layers: the dermis and epidermis.

coat. the natural covering of an animal, such as fur, feathers, scales, or a test.

armor. a strong, defensive covering that protects the body from injury.

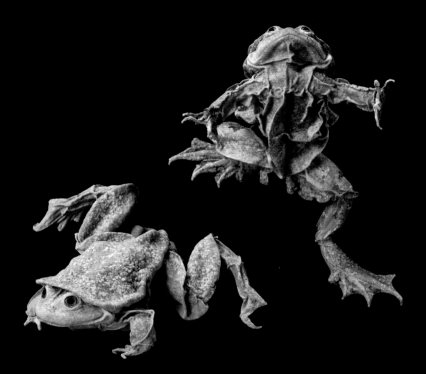

Transparent skin
The two ways in which amphibians gather oxygen are strikingly evident in the body of a reticulated glass frog (*Hyalinobatrachium valerioi*). The frog's transparent, permeable skin accounts for much of its oxygen intake, while the rest of the oxygen it needs is drawn into the blood via the frog's lungs.

Underwater frog
At lower temperatures, water carries more oxygen. High in the Andes Mountains of South America, the loose-folded skin of the Titicaca water frog (*Telmatobius culeus*) helps it stay in the lake's cool depths by maximizing oxygen uptake without recourse to lungs.

permeable skin

Skin is a protective barrier that separates the delicate living tissues inside the body from the harsh, changeable environment outside. It seals the body from infection and can self-repair when injured. But a completely airtight seal is not wholly beneficial. At least a small quantity of oxygen usually seeps into the surface directly from water or air outside, but for many animals this so-called cutaneous gaseous exchange is critical. Amphibians may get more than 50 percent of their oxygen this way—necessitating a skin that is sufficiently permeable to let oxygen through unimpeded.

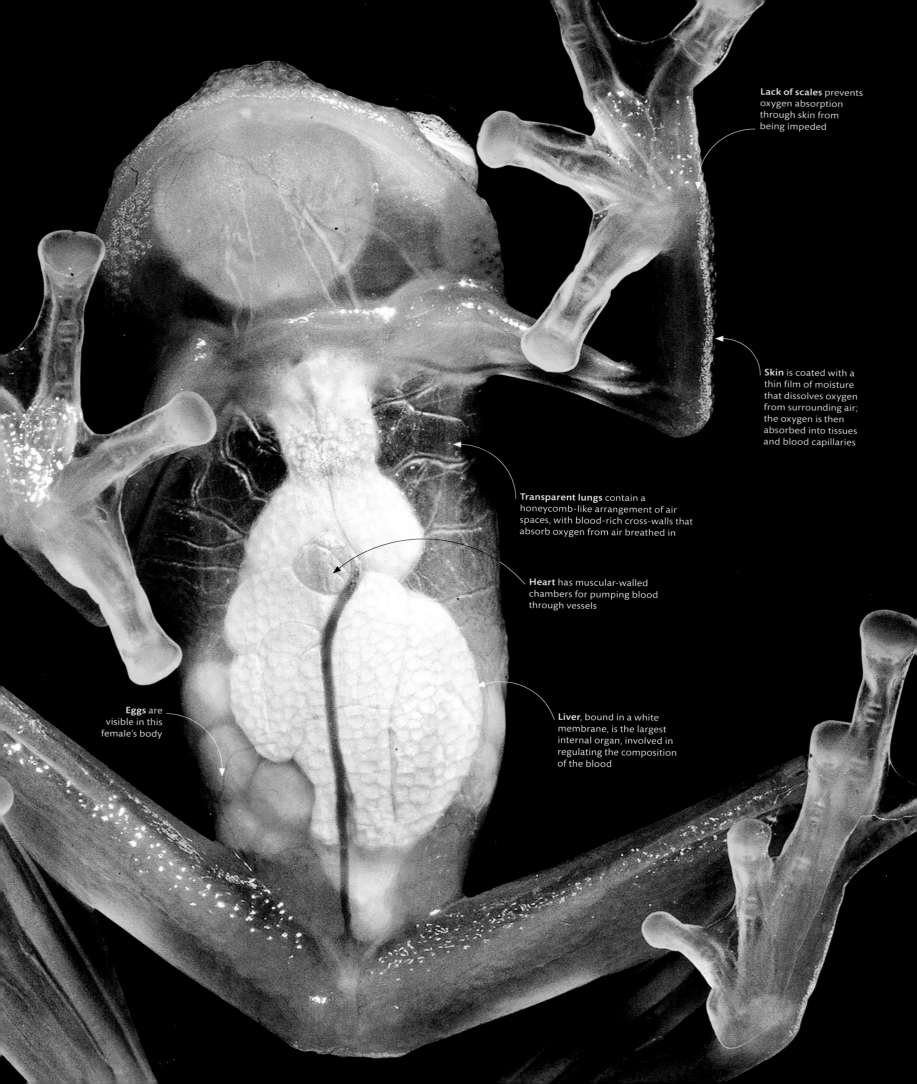

Lack of scales prevents oxygen absorption through skin from being impeded

Skin is coated with a thin film of moisture that dissolves oxygen from surrounding air; the oxygen is then absorbed into tissues and blood capillaries

Transparent lungs contain a honeycomb-like arrangement of air spaces, with blood-rich cross-walls that absorb oxygen from air breathed in

Heart has muscular-walled chambers for pumping blood through vessels

Eggs are visible in this female's body

Liver, bound in a white membrane, is the largest internal organ, involved in regulating the composition of the blood

getting oxygen

The chemical processes of respiration release energy from nutrients, and almost all animals use oxygen to help this happen. Oxygen is taken into the body from the surroundings, and waste carbon dioxide escapes out. This happens most effectively across a large surface area with a thin wall. The simplest route is through the skin, but that alone usually only satisfies the smallest animals. Special respiratory organs—gills and lungs—make gas exchange more efficient for larger bodies.

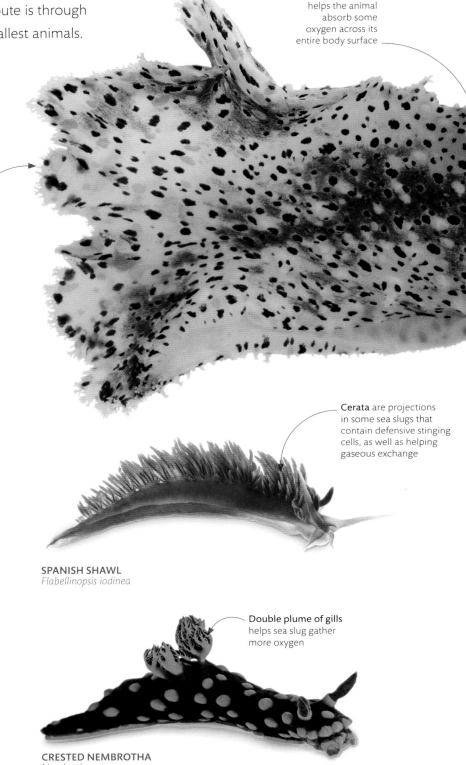

Permeable skin helps the animal absorb some oxygen across its entire body surface

Spots of pigment help camouflage the slug on the seabed

Cerata are projections in some sea slugs that contain defensive stinging cells, as well as helping gaseous exchange

SPANISH SHAWL
Flabellinopsis iodinea

Double plume of gills helps sea slug gather more oxygen

CRESTED NEMBROTHA
Nembrotha cristata

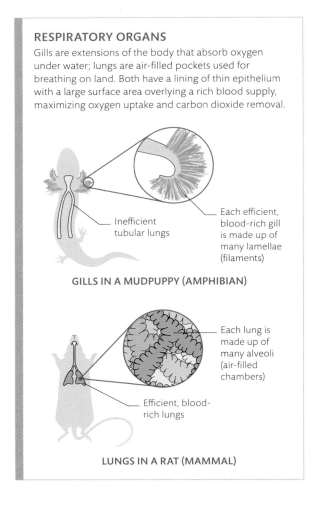

RESPIRATORY ORGANS

Gills are extensions of the body that absorb oxygen under water; lungs are air-filled pockets used for breathing on land. Both have a lining of thin epithelium with a large surface area overlying a rich blood supply, maximizing oxygen uptake and carbon dioxide removal.

Inefficient tubular lungs

Each efficient, blood-rich gill is made up of many lamellae (filaments)

GILLS IN A MUDPUPPY (AMPHIBIAN)

Each lung is made up of many alveoli (air-filled chambers)

Efficient, blood-rich lungs

LUNGS IN A RAT (MAMMAL)

Plume of gills
Tilesius's luminous sea slug (*Plocamopherus tilesii*) grows to a length of 4¾ in (12 cm). Such a body size is too large for permeable skin to satisfy the animal's entire oxygen needs. But the sea slug also has a plume of gills on its back to absorb extra oxygen from the water and make up the oxygen deficit.

Feathery extensions of the gills increase the surface area for absorbing oxygen from the water

Rhinophores are soft, hornlike projections of the head, used for sensing chemicals in the water

Wide muscular "foot" secretes slime that makes crawling forward easier; this slow locomotion minimizes energy consumption, so less oxygen is needed than in faster-moving animals

Legs in this variable species can be blue, red, brown, or black

Poison from diet

Like other South American poisonous species, left, this strawberry poison frog (*Oophaga pumilio*) acquires its toxins by eating toxic arthropods, such as ants.

Warts result from thickening of the epidermis; some are glandular

toxic skin

Amphibian skin is thin and lacks scales, so it can absorb oxygen across its surface. The skin relies on the poisons it produces, some of which can be devastatingly effective, for protection. Glands in the skin—sometimes swollen into wartlike growths—release toxic fluid, which at the very least deters predators through its bitter taste, but in some species it is fast-acting and lethal.

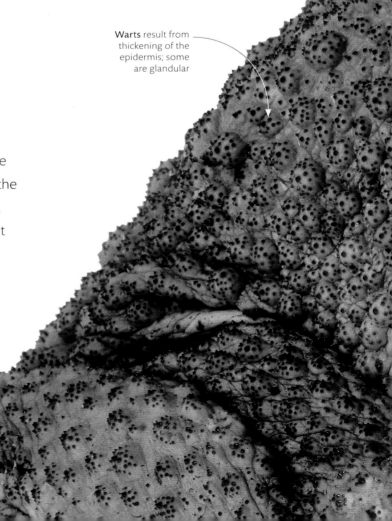

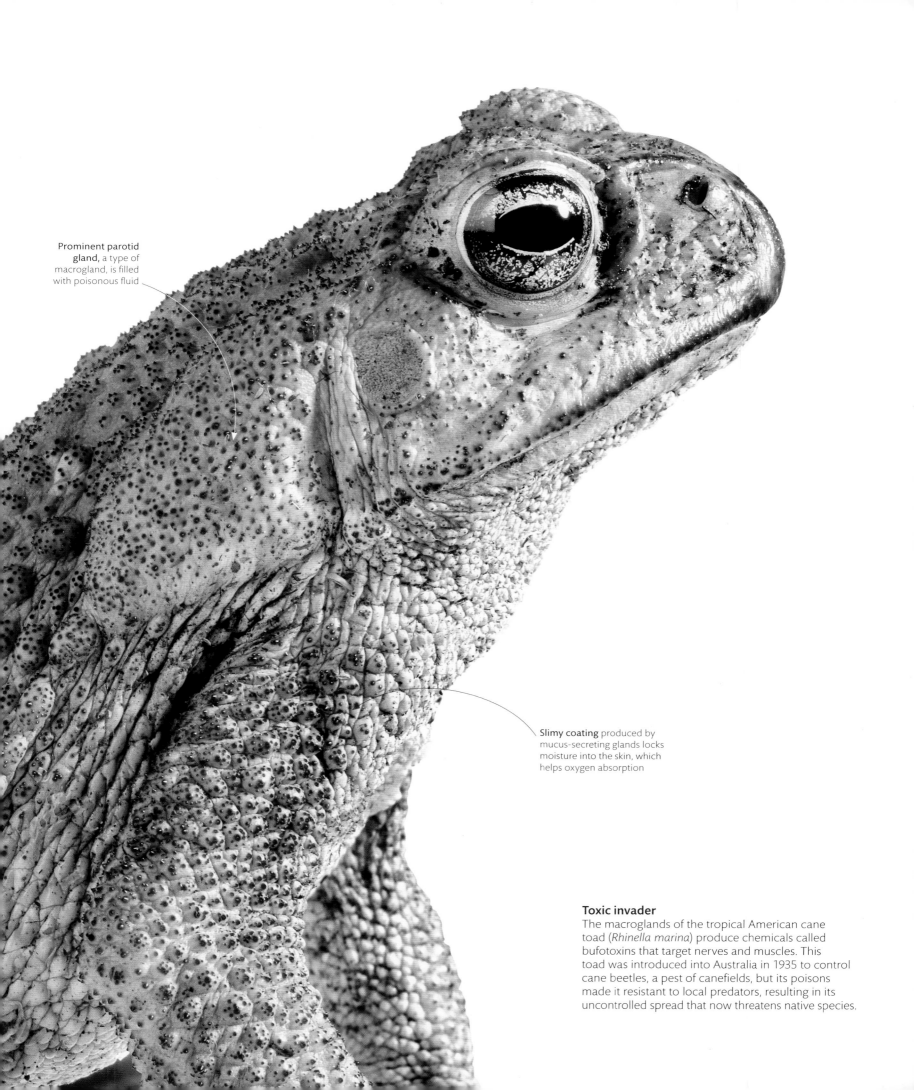

Prominent parotid gland, a type of macrogland, is filled with poisonous fluid

Slimy coating produced by mucus-secreting glands locks moisture into the skin, which helps oxygen absorption

Toxic invader

The macroglands of the tropical American cane toad (*Rhinella marina*) produce chemicals called bufotoxins that target nerves and muscles. This toad was introduced into Australia in 1935 to control cane beetles, a pest of canefields, but its poisons made it resistant to local predators, resulting in its uncontrolled spread that now threatens native species.

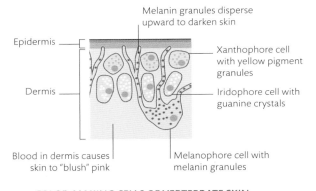

Melanin granules disperse upward to darken skin

Epidermis

Dermis

Xanthophore cell with yellow pigment granules

Iridophore cell with guanine crystals

Blood in dermis causes skin to "blush" pink

Melanophore cell with melanin granules

COLOR-MAKING CELLS OF VERTEBRATE SKIN

Juvenile skin pattern changes to black dots on white in adult fish

HARLEQUIN FISH
Plectorhynchus chaetodonoides

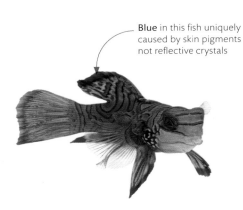

Blue in this fish uniquely caused by skin pigments not reflective crystals

MANDARINFISH
Synchiropus splendidus

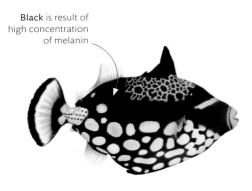

Black is result of high concentration of melanin

YOUNG CLOWN TRIGGERFISH
Balistoides conspicillum

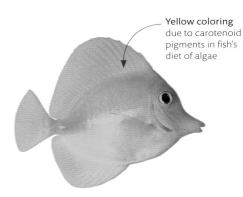

Yellow coloring due to carotenoid pigments in fish's diet of algae

YELLOW TANG
Zebrasoma flavescens

skin color

Many of the outstanding colors that adorn the bodies of animals come from pigments generated by chemical processes inside skin cells—the biological equivalents of paints and dyes. Brown and black are due to pigments called melanins; yellow, orange, and red come from carotenoids—the same pigments that color carrots, daffodils, and egg yolks. But greens, blues, and violets usually arise because of the way skin, scales, or feathers bend and reflect light at the body surface.

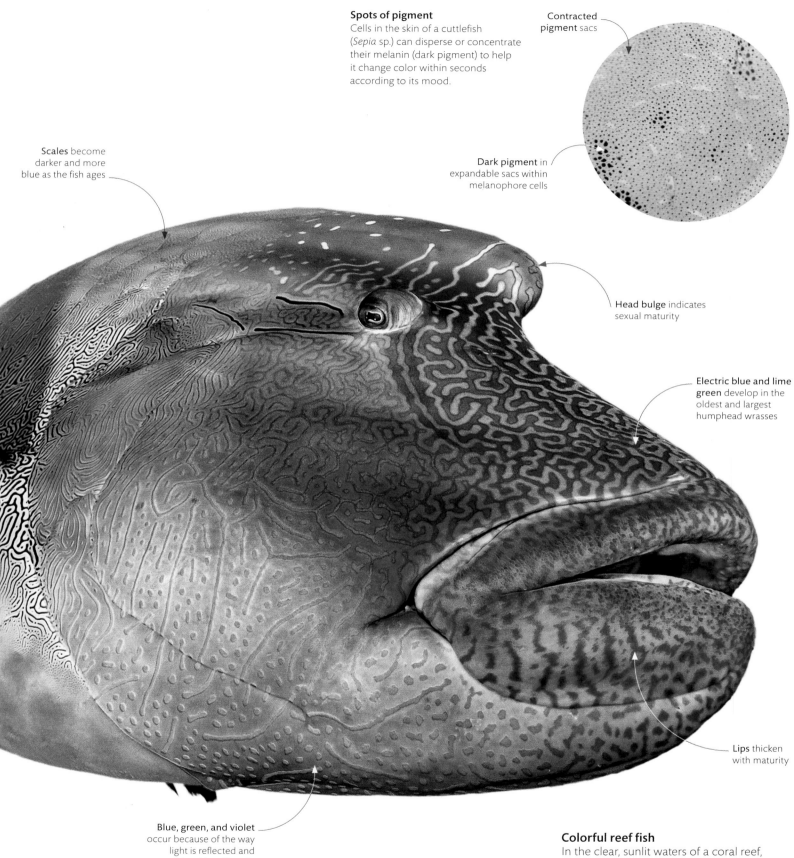

Spots of pigment
Cells in the skin of a cuttlefish (*Sepia* sp.) can disperse or concentrate their melanin (dark pigment) to help it change color within seconds according to its mood.

Contracted **pigment** sacs

Scales become darker and more blue as the fish ages

Dark pigment in expandable sacs within melanophore cells

Head bulge indicates sexual maturity

Electric blue and lime green develop in the oldest and largest humphead wrasses

Lips thicken with maturity

Blue, green, and violet occur because of the way light is reflected and scattered by skin cells

Colorful reef fish
In the clear, sunlit waters of a coral reef, colors send signals about species identities, as well as whether individuals are old enough to reproduce. Blue predominates in many species, including this humphead wrasse (*Chelinus undulatus*), because blue light travels farther in water.

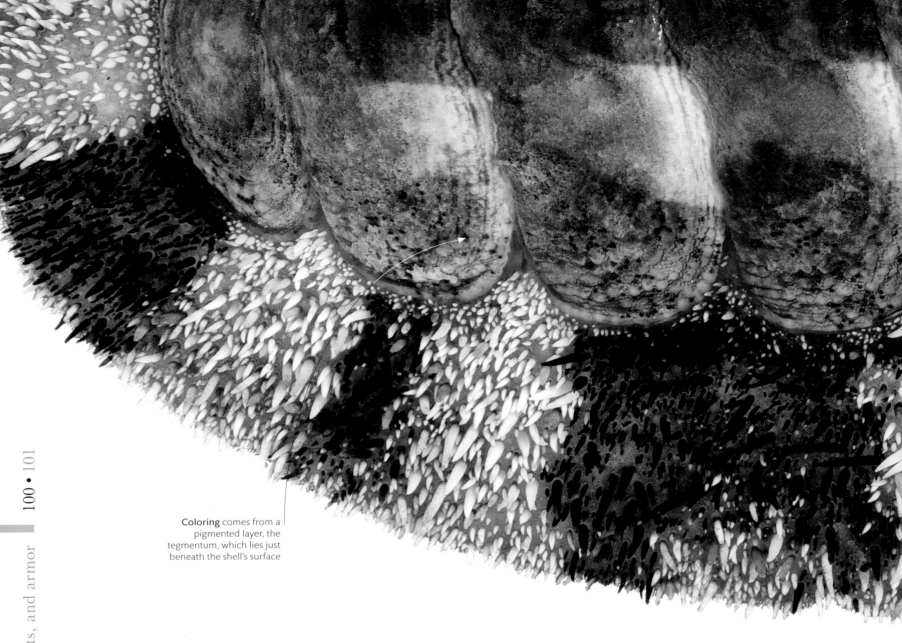

Coloring comes from a pigmented layer, the tegmentum, which lies just beneath the shell's surface

forming a shell

A shell is a characteristic feature of snails and other mollusks. While some mollusks, such as slugs and octopuses, get by without it, for many, a shell is vital protection for the soft body lying underneath. The shell is formed on a sheet of skin and muscle called the mantle, which stretches over the animal's back. The mantle encloses a cavity that contains gills and openings for excretory and reproductive systems. On its upper surface, the mantle releases substances that harden into a shell, which can be as simple as a limpet's cone or as complex as a twisted conch.

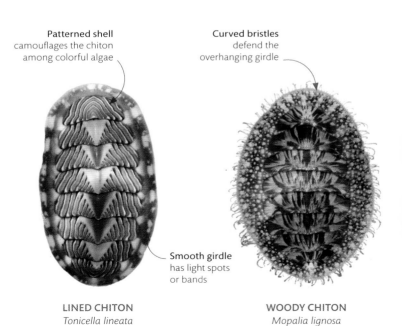

Patterned shell camouflages the chiton among colorful algae

Curved bristles defend the overhanging girdle

Smooth girdle has light spots or bands

LINED CHITON
Tonicella lineata

WOODY CHITON
Mopalia lignosa

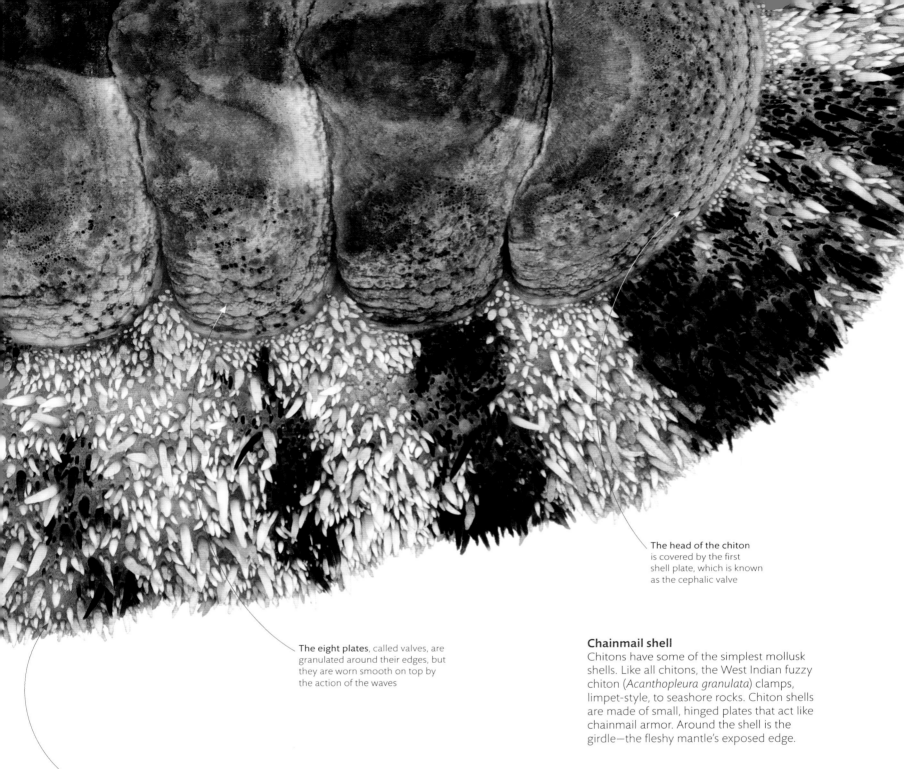

The head of the chiton is covered by the first shell plate, which is known as the cephalic valve

The eight plates, called valves, are granulated around their edges, but they are worn smooth on top by the action of the waves

Chainmail shell

Chitons have some of the simplest mollusk shells. Like all chitons, the West Indian fuzzy chiton (*Acanthopleura granulata*) clamps, limpet-style, to seashore rocks. Chiton shells are made of small, hinged plates that act like chainmail armor. Around the shell is the girdle—the fleshy mantle's exposed edge.

The girdle—the overhanging edge of the mantle—shields the gills beneath; in this species, the mantle is protected on top by sharp calcareous spines

HOW SHELLS ARE MADE

The mantle of a mollusk, such as a chiton, is not only highly muscular, helping the animal move, it also has shell-building glands in its epidermis. These secrete a firm protein called conchin, which is impregnated with chalky minerals like those in the skeletons of stony corals and sea urchins.

Mantle

Shell plate (valve)

Girdle of mantle

CHITON CROSS SECTION

Periostracum: shell's thin organic surface layer of conchin

Calcareous layer of shell: conchin with calcium for hardness

Shell

Epithelium of mantle secretes substances for making the shell

Mantle

Mantle muscles

SHELL-FORMING MANTLE

mollusk shells

Most mollusks belong to one of two major classes—gastropods (snails and slugs) or bivalves (which includes oysters and clams). Gastropods have a single shell, often twisted into a spiral, whereas bivalves are formed of two parts (called valves) hinged together. Each class can be further divided into groups based on the shape of the shell.

gastropod shells

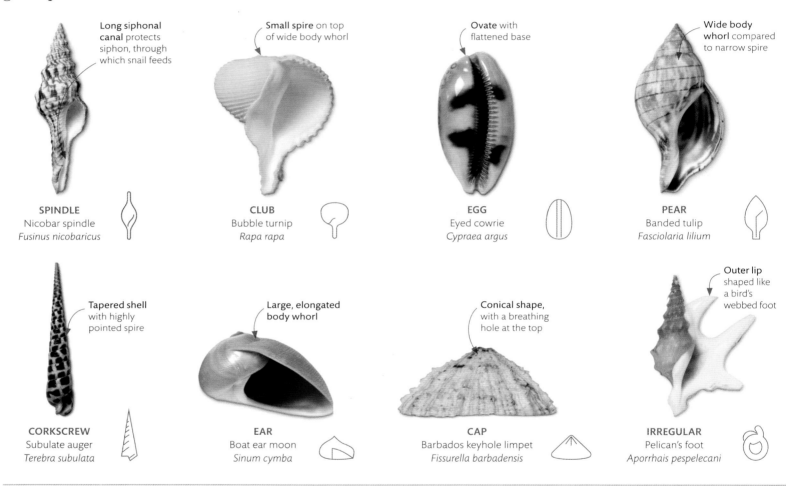

Long siphonal canal protects siphon, through which snail feeds

SPINDLE
Nicobar spindle
Fusinus nicobaricus

Small spire on top of wide body whorl

CLUB
Bubble turnip
Rapa rapa

Ovate with flattened base

EGG
Eyed cowrie
Cypraea argus

Wide body whorl compared to narrow spire

PEAR
Banded tulip
Fasciolaria lilium

Tapered shell with highly pointed spire

CORKSCREW
Subulate auger
Terebra subulata

Large, elongated body whorl

EAR
Boat ear moon
Sinum cymba

Conical shape, with a breathing hole at the top

CAP
Barbados keyhole limpet
Fissurella barbadensis

Outer lip shaped like a bird's webbed foot

IRREGULAR
Pelican's foot
Aporrhais pespelecani

bivalve shells

Hinge where the two valves connect

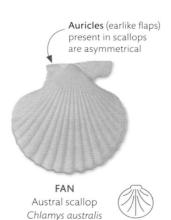

DISCUS
Ringed dosinia
Dosinia anus

Auricles (earlike flaps) present in scallops are asymmetrical

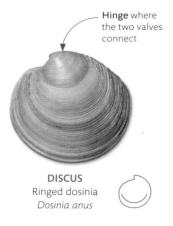

FAN
Austral scallop
Chlamys australis

Wide base forms triangular outline

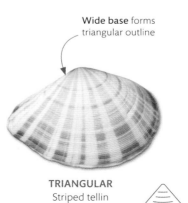

TRIANGULAR
Striped tellin
Tellina virgata

Thin, oblong-shaped valve

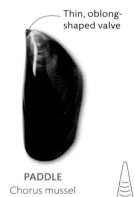

PADDLE
Chorus mussel
Choromytilus chorus

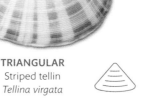

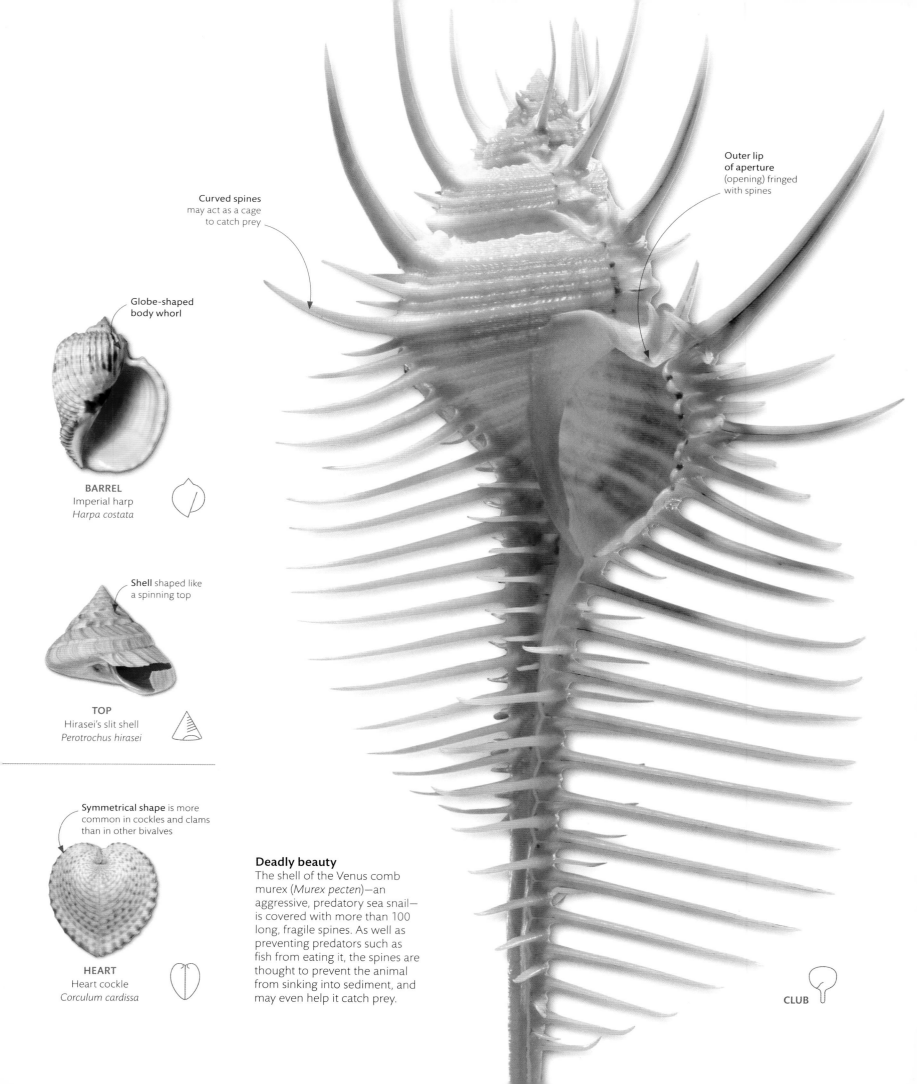

Curved spines
may act as a cage
to catch prey

Outer lip
of aperture
(opening) fringed
with spines

Globe-shaped
body whorl

BARREL
Imperial harp
Harpa costata

Shell shaped like
a spinning top

TOP
Hirasei's slit shell
Perotrochus hirasei

Symmetrical shape is more
common in cockles and clams
than in other bivalves

HEART
Heart cockle
Corculum cardissa

Deadly beauty
The shell of the Venus comb
murex (*Murex pecten*)—an
aggressive, predatory sea snail—
is covered with more than 100
long, fragile spines. As well as
preventing predators such as
fish from eating it, the spines are
thought to prevent the animal
from sinking into sediment, and
may even help it catch prey.

CLUB

vertebrate scales

Formed from folds of skin, a coating of scales provides flexible armor.
Fish scales have a bony core that grows from the deeper dermis of the skin.
Reptile scales are restricted to the surface epidermis and usually bone-free.
They contain hard keratin, plus oils that stop the skin below from drying out.

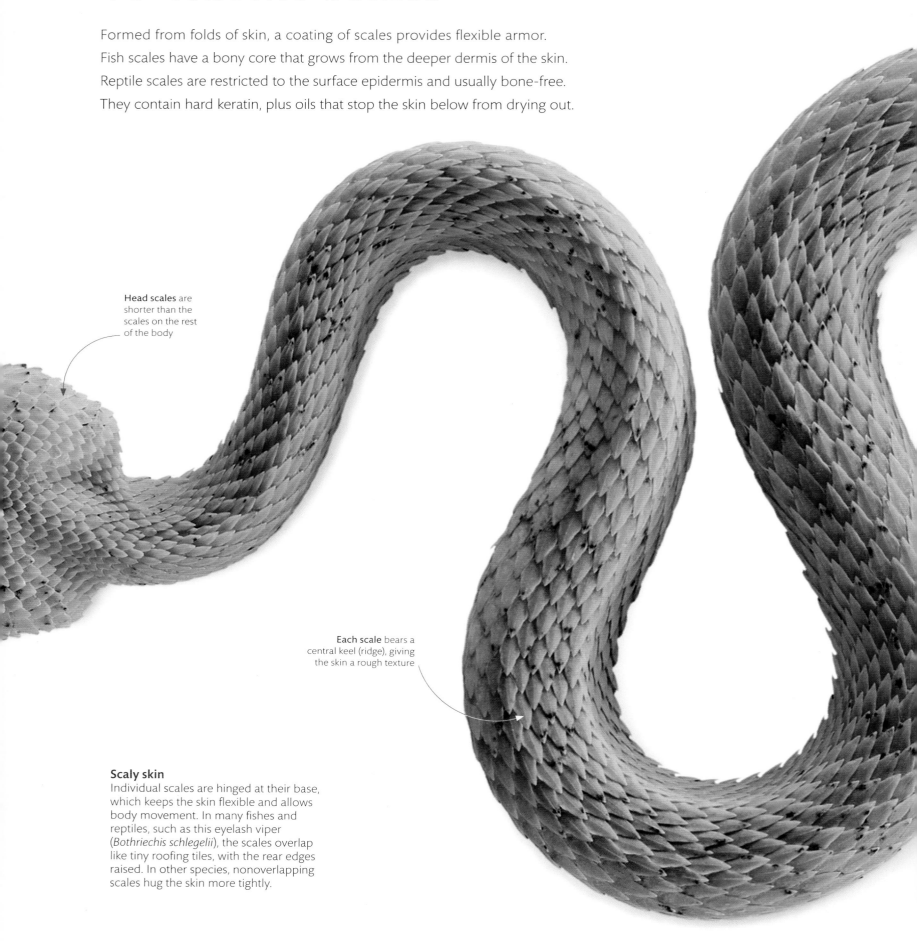

Head scales are shorter than the scales on the rest of the body

Each scale bears a central keel (ridge), giving the skin a rough texture

Scaly skin
Individual scales are hinged at their base, which keeps the skin flexible and allows body movement. In many fishes and reptiles, such as this eyelash viper (*Bothriechis schlegelii*), the scales overlap like tiny roofing tiles, with the rear edges raised. In other species, nonoverlapping scales hug the skin more tightly.

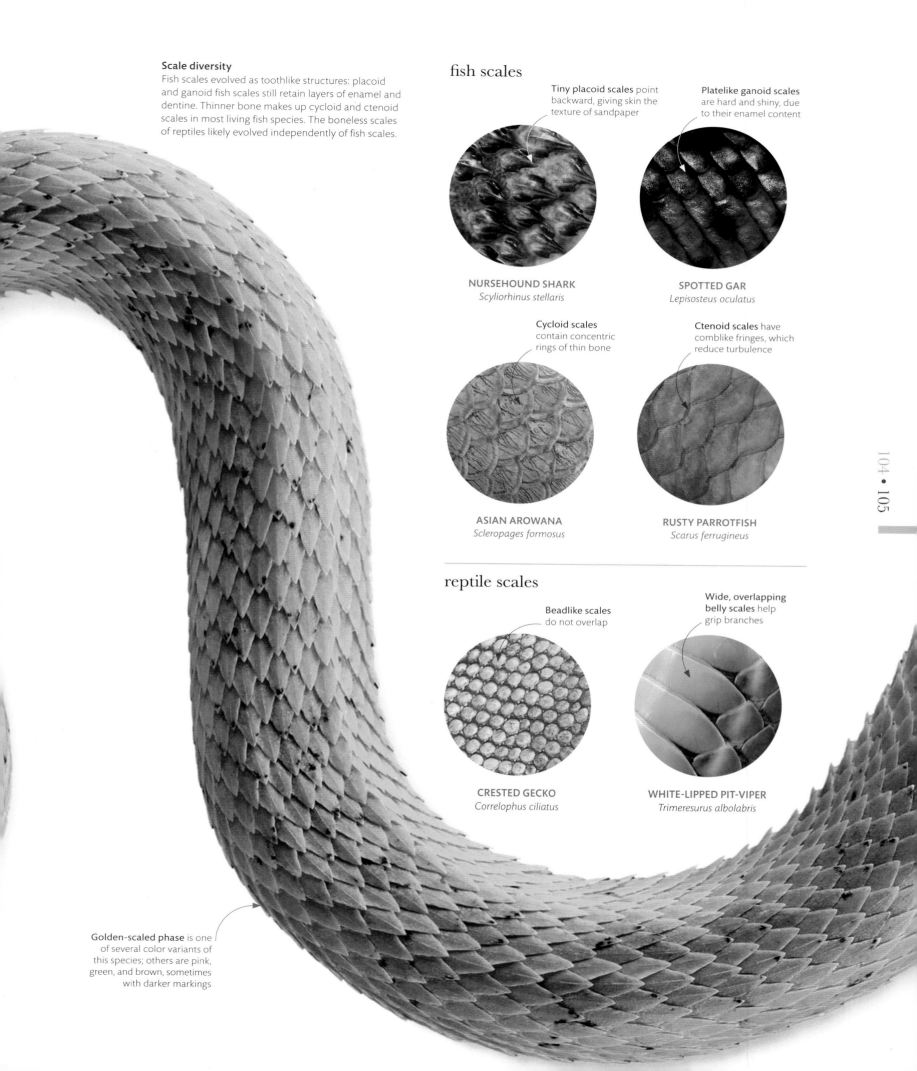

Scale diversity

Fish scales evolved as toothlike structures: placoid and ganoid fish scales still retain layers of enamel and dentine. Thinner bone makes up cycloid and ctenoid scales in most living fish species. The boneless scales of reptiles likely evolved independently of fish scales.

Golden-scaled phase is one of several color variants of this species; others are pink, green, and brown, sometimes with darker markings

fish scales

Tiny placoid scales point backward, giving skin the texture of sandpaper

Platelike ganoid scales are hard and shiny, due to their enamel content

NURSEHOUND SHARK
Scyliorhinus stellaris

SPOTTED GAR
Lepisosteus oculatus

Cycloid scales contain concentric rings of thin bone

Ctenoid scales have comblike fringes, which reduce turbulence

ASIAN AROWANA
Scleropages formosus

RUSTY PARROTFISH
Scarus ferrugineus

reptile scales

Beadlike scales do not overlap

Wide, overlapping belly scales help grip branches

CRESTED GECKO
Correlophus ciliatus

WHITE-LIPPED PIT-VIPER
Trimeresurus albolabris

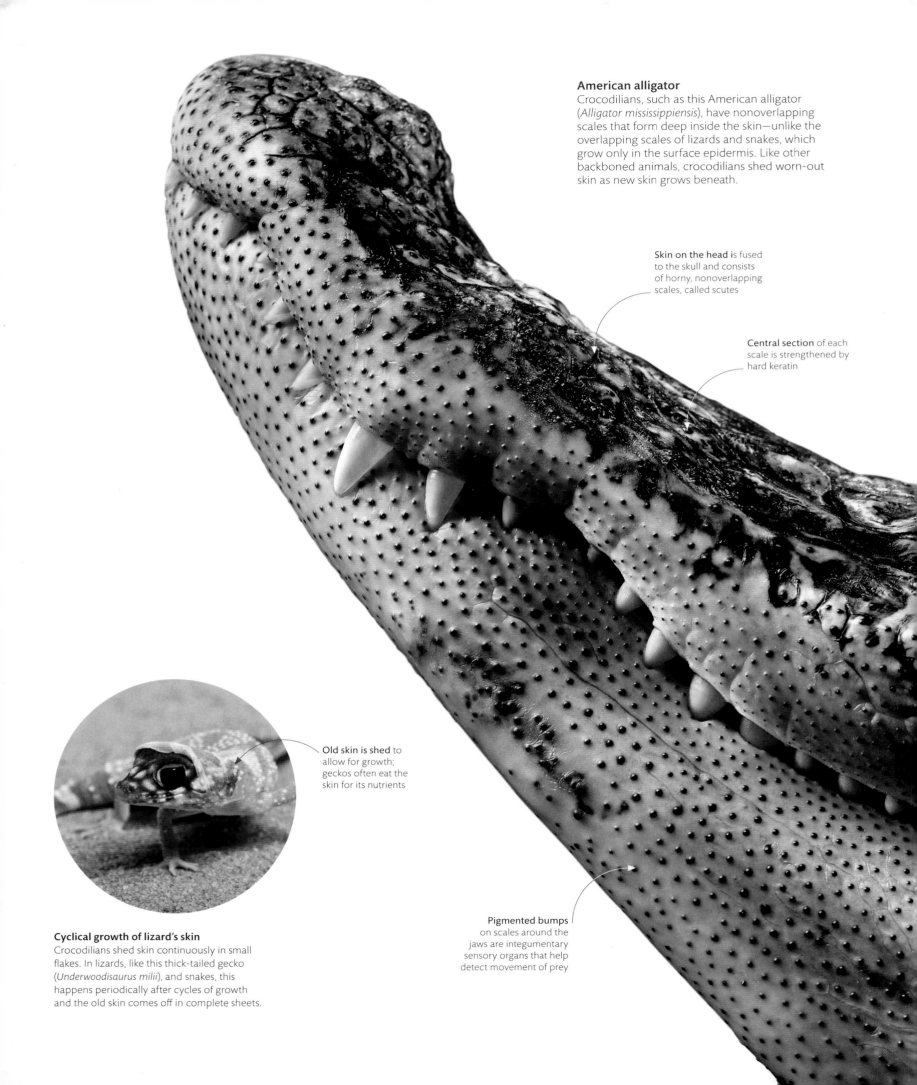

American alligator
Crocodilians, such as this American alligator (*Alligator mississippiensis*), have nonoverlapping scales that form deep inside the skin—unlike the overlapping scales of lizards and snakes, which grow only in the surface epidermis. Like other backboned animals, crocodilians shed worn-out skin as new skin grows beneath.

Skin on the head is fused to the skull and consists of horny, nonoverlapping scales, called scutes

Central section of each scale is strengthened by hard keratin

Old skin is shed to allow for growth; geckos often eat the skin for its nutrients

Cyclical growth of lizard's skin
Crocodilians shed skin continuously in small flakes. In lizards, like this thick-tailed gecko (*Underwoodisaurus milii*), and snakes, this happens periodically after cycles of growth and the old skin comes off in complete sheets.

Pigmented bumps on scales around the jaws are integumentary sensory organs that help detect movement of prey

reptile skin

The scaly skin of reptiles has a tough, dry, surface that keeps moisture locked in so they are better adapted for life on land than their scaleless amphibian ancestors. Reptile skin contains two types of the horny material keratin: one is hard and brittle, the other soft and pliable. The combination provides a flexible barrier that shields the body from abrasion and keeps the skin from drying out.

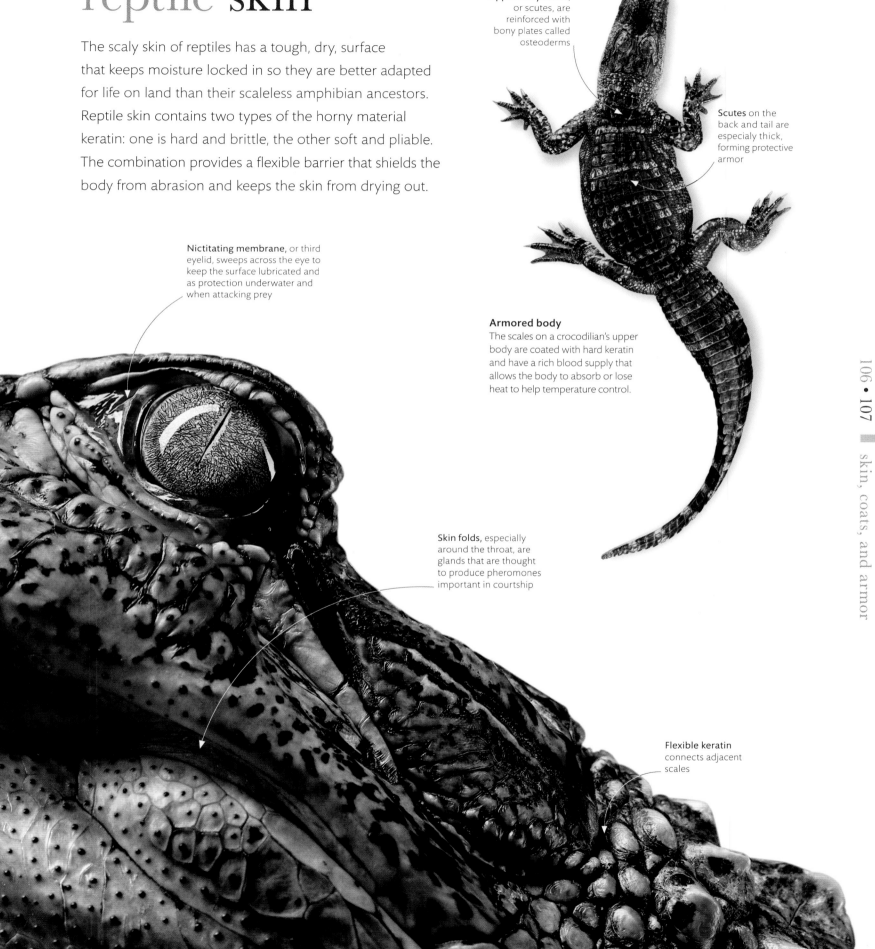

Upper body scales, or scutes, are reinforced with bony plates called osteoderms

Scutes on the back and tail are especialy thick, forming protective armor

Nictitating membrane, or third eyelid, sweeps across the eye to keep the surface lubricated and as protection underwater and when attacking prey

Armored body
The scales on a crocodilian's upper body are coated with hard keratin and have a rich blood supply that allows the body to absorb or lose heat to help temperature control.

Skin folds, especially around the throat, are glands that are thought to produce pheromones important in courtship

Flexible keratin connects adjacent scales

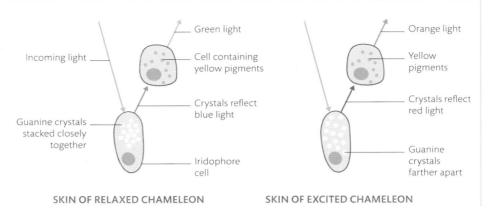

CHANGING COLOR

Many animals change color by expanding sacs of dark pigment in their skin (see p. 99), but others, such as chameleons, do it with crystals. Like many reptiles and amphibians, they have skin cells called iridophores, containing color-reflecting crystals (see p. 98), but chameleons can move these crystals using neural control—changing their color-reflecting properties within seconds.

Incoming light

Green light

Cell containing yellow pigments

Crystals reflect blue light

Guanine crystals stacked closely together

Iridophore cell

SKIN OF RELAXED CHAMELEON

Orange light

Yellow pigments

Crystals reflect red light

Guanine crystals farther apart

SKIN OF EXCITED CHAMELEON

GREEN SKIN

ORANGE SKIN

Showing off
In most panther chameleons, color change involves a shift in background color from green (when the animal is relaxed) to orange or red (when it is excited). In its rested state, the lizard is better camouflaged among the leaves of its treetop habitat.

advertisement colors

Color sends a powerful signal in animals with the vision to detect it, and as they grow, many acquire strong colors that indicate sexual maturity or warn off rivals. Other animals can change color at will by neural or hormonal control. Flashes of color can send social signals—such as a change in disposition, a show of aggression in the face of competitors, or a willingness to mate—all without the danger of permanently attracting predators.

Beneath the scales
is the dermis of the skin, which contains color-making cells

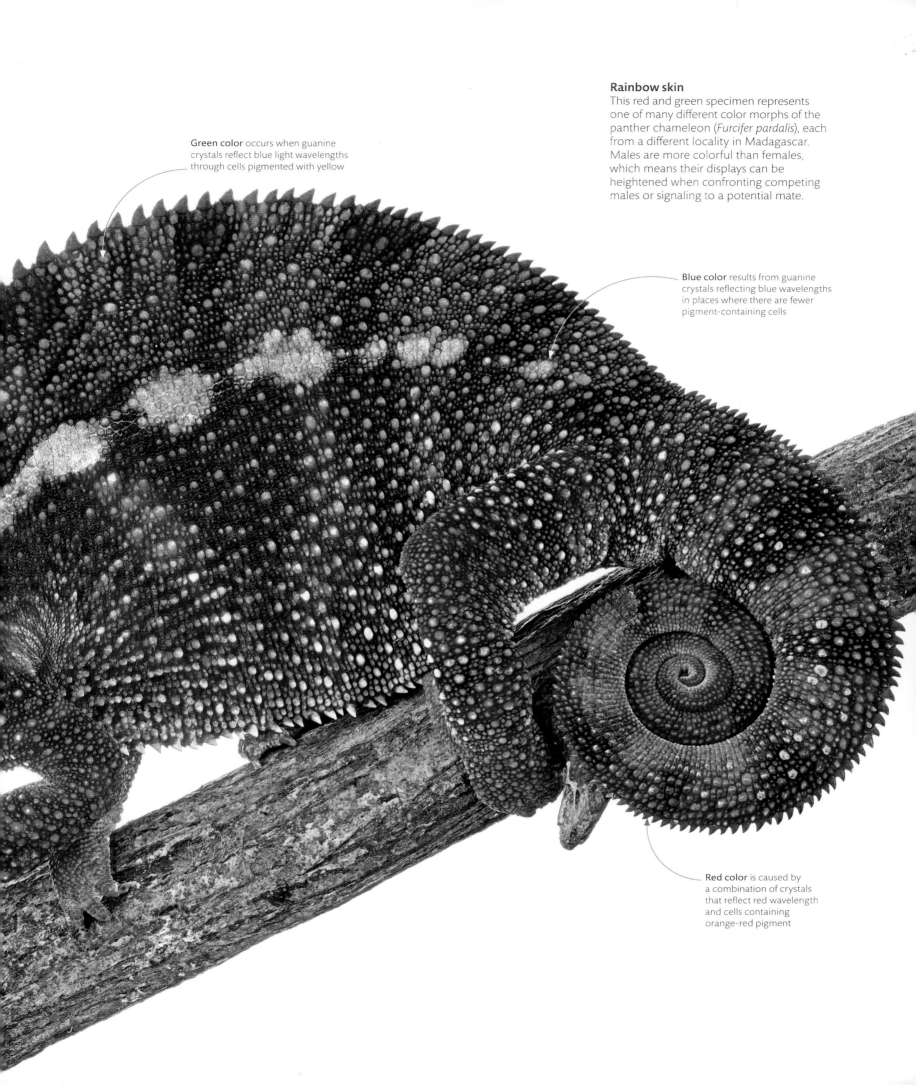

Green color occurs when guanine crystals reflect blue light wavelengths through cells pigmented with yellow

Rainbow skin
This red and green specimen represents one of many different color morphs of the panther chameleon (*Furcifer pardalis*), each from a different locality in Madagascar. Males are more colorful than females, which means their displays can be heightened when confronting competing males or signaling to a potential mate.

Blue color results from guanine crystals reflecting blue wavelengths in places where there are fewer pigment-containing cells

Red color is caused by a combination of crystals that reflect red wavelength and cells containing orange-red pigment

Chameleon (c.1612)
Larger than life on a branch amid hovering insects, Ustad Mansur's chameleon is a study of the creature's physiology and habitat.

Squirrels in a plane tree (c.1610)
A miniature of playful squirrels is attributed to Mughal court favorite Abu al-Hasan. They appear to be European red squirrels absent from Emperor Jahangir's realm—so these were most likely observed in his private zoo. This meticulous representation of animals and birds suggests contribututions from fellow artist Ustad Mansur.

animals in art

in the mughal courts

The wealth and power of the Mughals, who ruled India and much of south Asia from the 16th to the 18th century, was matched by their love of esthetics. Jewel-like miniatures of legends, battles, portraits, and hunting scenes were prized in the royal courts. The fourth emperor, Jahangir, also indulged a passion for natural history by commissioning accurate paintings of flora and fauna that are now regarded as exquisite works of art.

During the successive reigns of Humayun, Akbar, and Jahangir, leading artists from Persia (present-day Iran), central Asia, and Afghanistan were lured by the wealth and prestige of the Mughal courts. Miniatures were often a collaboration between calligraphers, designers, and artists: the drawings first covered with a wash of white before color was applied in thin layers with fine hair brushes. The paintings were then burnished to an enamel finish with an agate stone.

Jahangir's favorites, Abu al-Hasan and Ustad Mansur, traveled with him across the empire and were given the title "wonder of the age" for their work. Jahangir's love of animals is revealed in memoirs that record the specimens that were brought to him: a rare falcon from the Shah of Persia; a zebra from Abyssinia; a turkey cock and Himalayan cheer pheasant from an agent in Goa, India. Two dodos in Jahangir's menagerie in Surat were probably gifts from traders.

The Dodo in color (c.1627)
Ustad Mansur, a leading artist in the 17th-century court of the Emperor Jahangir, worked under the direct orders of his patron to record rare specimens of birds, animals, and plants. Mansur is thought to have painted this rare picture of a dodo in color.

66 He had brought several strange and unusual animals… I ordered the artists to draw their likenesses. 99

THE JAHANGIRNAMA: MEMOIRS OF JAHANGIR, EMPEROR OF INDIA, 1627

frills and dewlaps

Some of the best kinds of ornaments used for display are those that can be flaunted only when needed. Displays that are permanently on show risk attracting the attention of predators, and those that can be flashed in a moment can be even more eye-catching. Some lizards use a movable bony apparatus located in the bottom of their throat to spreads flaps of skin. This can act as a social signal to others of the same species, or can make the lizard appear more threatening to predators.

Open frill
The frilled lizard (*Chlamydosaurus kingii*) gapes its mouth and spreads its neck frill in territorial disputes, or as a scare tactic when facing an enemy. The bony hyoid apparatus in its throat carries long, backward-pointing spines called ceratobranchial bones. These are erected by muscles to stretch the skin into a fan.

Orange skin of the frill creates a bigger visual impact on the observer

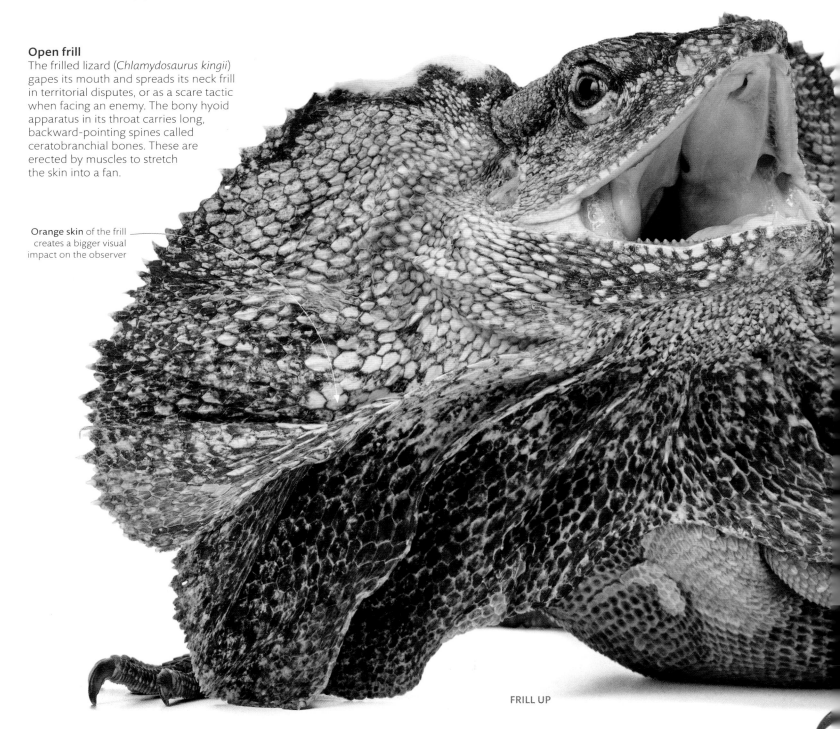

FRILL UP

HEAD SIGNALS

In iguanas and anoles, muscles that pull on the hyoid apparatus work to extend a dewlap under the throat. In some species, the dewlap is brightly colored. In this way, dewlap flashes, coupled with head-bobs, are used in communication, especially in attracting mates.

GREEN IGUANA *Iguana iguana*

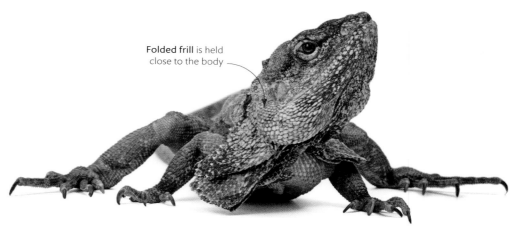

Folded frill is held close to the body

FRILL DOWN

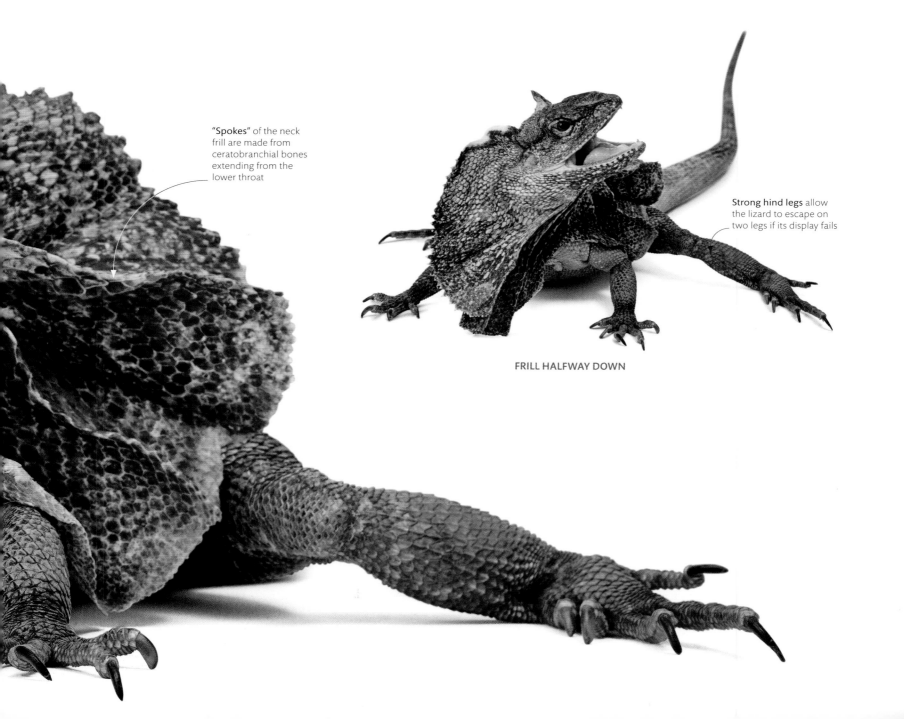

"Spokes" of the neck frill are made from ceratobranchial bones extending from the lower throat

Strong hind legs allow the lizard to escape on two legs if its display fails

FRILL HALFWAY DOWN

weapons and fighting

Physical conflict can be dangerous, so most animals avoid it even if equipped with weaponry—but sometimes the prize is worth the risk. The jaws of male stag beetles grow so large that they cannot even close them to bite. But they can wield them in jaw-to-jaw pushing matches over sources of food or a potential mate, and like their mammalian namesakes (see pp.88–89), it is brute strength that determines the victor.

Fighting male stag beetles
These bronze elkhorn stag beetles (*Lamprima adolphinae*) are using their antlerlike jaws, or mandibles, in combat. Those with bigger jaws have an advantage, and can lift their opponent and throw him to the ground.

Serrated edge can hook onto opponent's exoskeleton

Enlarged jaw curves upwards and is useless for feeding

Mouthparts lap sweet liquid food such as tree sap or juice, but cannot bite

Forked-tip jaw can lift adversary off the ground

Antenna projects outwards to prevent damage during conflict

GROWING BODIES

Body parts that are used for display or as weapons grow more rapidly than the rest of the body, so they end up disproportionately larger. The example here shows the growth rate of the male fiddler crab claw relative to its body size. These crabs use their single enlarged claws in combat when competing with males, and they wave them to attract females.

COMPARING BODY AND WEAPON GROWTH

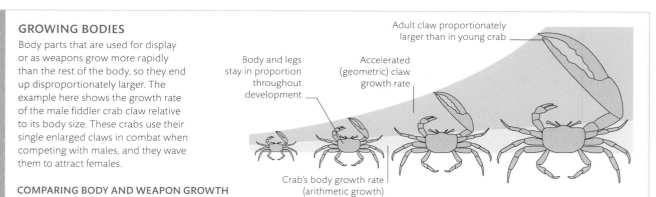

Adult claw proportionately larger than in young crab

Body and legs stay in proportion throughout development

Accelerated (geometric) claw growth rate

Crab's body growth rate (arithmetic growth)

Weapons for both sexes

Both the male and female Amazonian purple scarab (*Coprophanaeus lancifer*) are equipped with hornlike weapons. Males employ theirs in combat over a mate, while females use them to defend carcasses from other females, so they can bury the carcass as food for their larvae.

Rhinoceros-like horn

Wide shield used to burrow through soil

Shovel-like foot is used to bury food for larvae

Hardened wing case, or elytron, forms part of protective exoskeleton

Camouflaged flatfish
The peacock flounder (*Bothus lunatus*) starts life swimming upright but changes shape dramatically as it grows. The eye on the right side of the fish moves over to the left side. The right side of the flounder becomes its underside, while the left side—now with both eyes—acquires the mottled pigmentation that conceals it so successfully on the stony sea bed.

Long, continuous dorsal fin extends along the length of the flounder's body

Fin can be used to disturb sediment so that it partially buries the fish's body

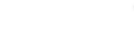

blending in

A successful disguise can benefit animals in different ways. Vulnerable animals that otherwise lack defensive weapons can avoid the attention of hunters, while predators themselves can use camouflage to ambush prey. For most animals, blending in is a matter of using their inherited shape and color to hide in an appropriate habitat. However, other animals are more versatile, and—under the influence of their nervous system—are able to change color or pattern to match their background.

FLOUNDER BLENDING IN TO FINE SEDIMENT

FLOUNDER BLENDING IN TO COARSE SEDIMENT

Matching patterns
Peacock flounders have the ability to match the color and pattern of their background due to specialized color-changing skin cells (see p.98). These cells contain microscopic granules of pigment that can bunch together or disperse to lighten or darken the skin. According to what environment the peacock flounder detects with its vision, hormones are released to change the distribution of pigment in the skin within seconds.

Eyes, raised on turrets, move independently to give all-round vision from the sea floor

Left eye remains on the left—like most other flatfish species— lending this species the name "left-handed flounder"

Blue spots may help conceal the fish in the sunlight-dappled coastal shallows

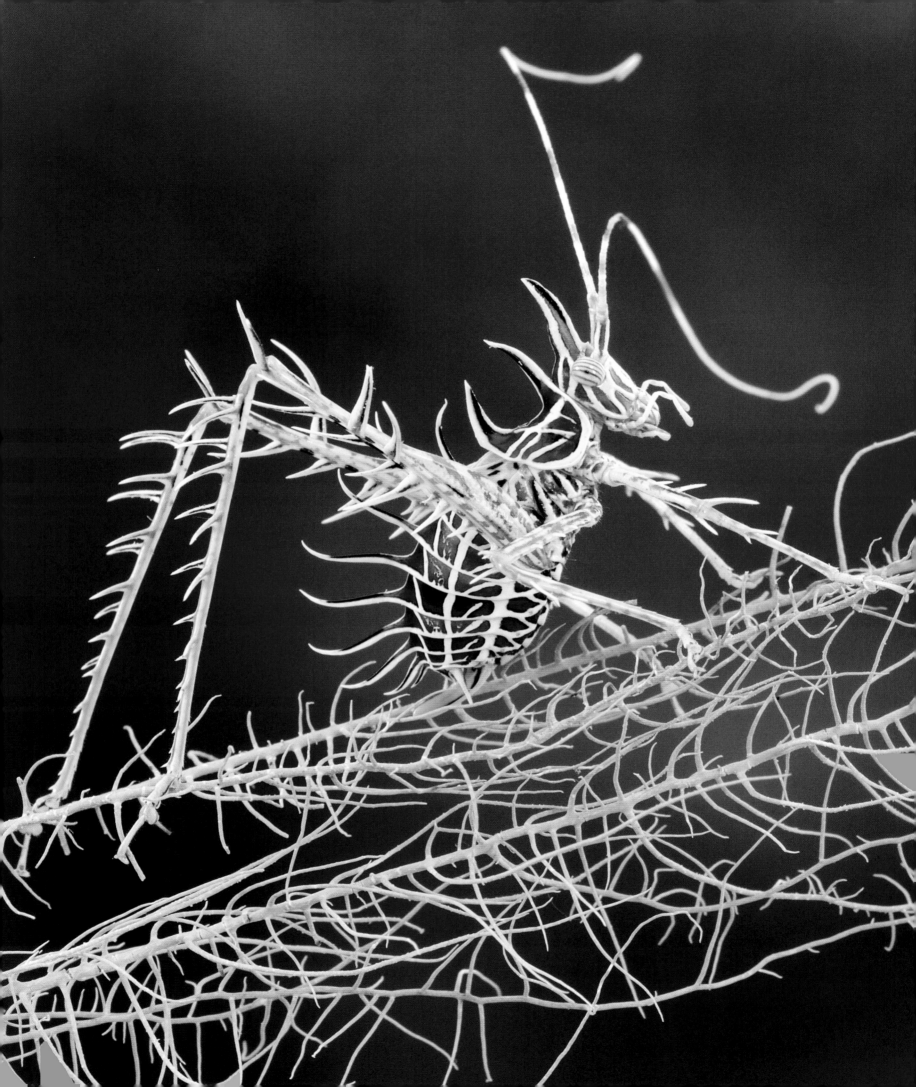

lichen katydid

As a prey item for birds, reptiles, bats, ground- and tree-dwelling mammals, other insects, and spiders, the lichen katydid (*Markia hystrix*) needs to conceal itself in its rain forest habitat. What it lacks in chemical and physical defenses, it makes up for with exceptional camouflage and mimicry.

Native to Central and South America, the lichen katydid is a nocturnal and tree-dwelling insect; these traits help it avoid predators that hunt in daylight or mainly on the ground. Its chances of survival are enhanced by adaptations to its color, body shape, and movements that make it virtually indistinguishable from the beard lichen (*Usnea* sp.) on which it feeds.

As well as blending in with the lichen's green-and-white coloring, the katydid's body and legs have spines that mimic the

latticelike form of the beard lichen. This combination makes the katydid especially difficult for predators to spot, particularly since the wings of the adults are also marked with lichenlike patterns. To further evade detection, the katydid typically moves with very slow, deliberate steps—unless it feels threatened, in which case it takes flight to escape danger.

The variety of mimicry in katydids is astonishing: there are also species that resemble leaves, moss, bark, and even rock. Leaf mimicry includes color-matching, leaf-shaped bodies with veinlike patterns, and sometimes patches resembling decay or holes. As a result, individuals in the same species can look very different, making the predator's task of telling leaf from insect even harder.

Perfect disguise
This juvenile lichen katydid has not yet grown its wings, but it still perfectly matches the color of the lichen—even down to the darker patches that mimic the spaces between the thin branches.

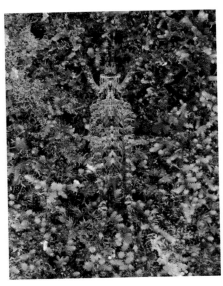

Moss mimic
The plantlike ornamentations of the moss katydid (*Championica montana*) of Costa Rica and Panama are actually protective spines.

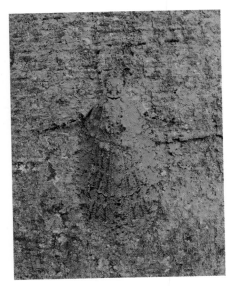

Fake scar tissue
Like unrelated scale insects, some katydids' appearance resembles the ridges produced when bark has been torn or pierced.

An array of colors
Bird's feathers come in many colors. The black and browns result from melanin pigment granules made in skin cells; yellows and reds are intensified by diet. Blues, violets, and greens occur because of the way feather structure bends or scatters light. (See Cells for color, p.98.)

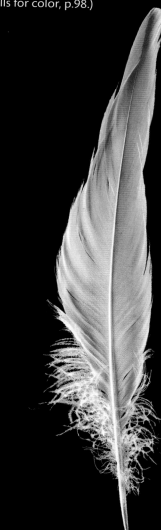

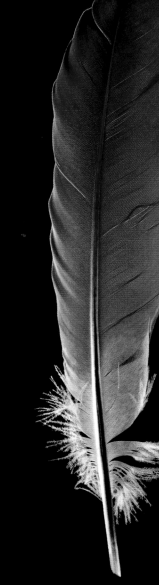

LILAC BREASTED ROLLER
Coracias caudatus

VULTURINE GUINEAFOWL
Acryllium vulturinum

AMERICAN FLAMINGO
Phoenicopterus ruber

CROWNED CRANE
Balearica regulorum

MALE ECLECTUS PARROT
Eclectus roratus

GREAT ARGUS PHEASANT
Argusianus argus

feathers

Birds are the only living animals that are feathered. Feathers probably evolved from modified scales in their dinosaur ancestors, but whether these "protofeathers" initially helped with trapping body heat or were aerodynamic aids for gliding or flight is uncertain. In modern birds, feathers serve both purposes—an undercoat of downy feathers provides thermal insulation, while stiff-bladed feathers make the body streamlined and help provide the necessary lift for carrying the bird through the air.

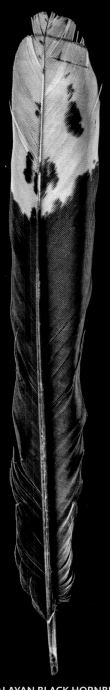

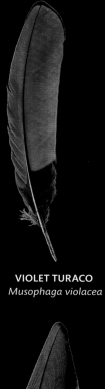

VIOLET TURACO
Musophaga violacea

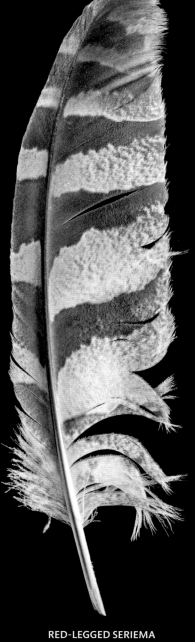

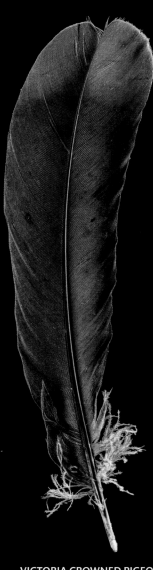

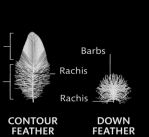

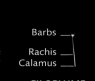

MALAYAN BLACK HORNBILL
Anthracoceros malayanus

RED-FRONTED MACAW
Ara rubrogenys

RED-LEGGED SERIEMA
Cariama cristata

VICTORIA CROWNED PIGEON
Goura victoria

TYPES OF FEATHER

Feathers grow from follicles, each forming a shaft and wide vane. The vane begins as a sheet of keratin-making cells, then a complex pattern of slits opens to separate the barbs. Flight and contour feathers have self-sealing vanes held together by microscopic hooks (see p.123). Fluffy down feathers insulate from the cold, while filoplumes are sensory.

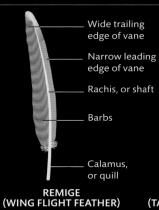

- Wide trailing edge of vane
- Narrow leading edge of vane
- Rachis, or shaft
- Barbs
- Calamus, or quill

REMIGE
(WING FLIGHT FEATHER)

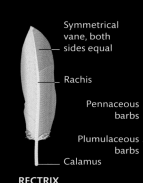

- Symmetrical vane, both sides equal
- Rachis
- Calamus

RECTRIX
(TAIL FLIGHT FEATHER)

- Pennaceous barbs
- Plumulaceous barbs

- Barbs
- Rachis
- Rachis

CONTOUR FEATHER

- Barbs
- Rachis

DOWN FEATHER

- Barbs
- Rachis
- Calamus

FILOPLUME

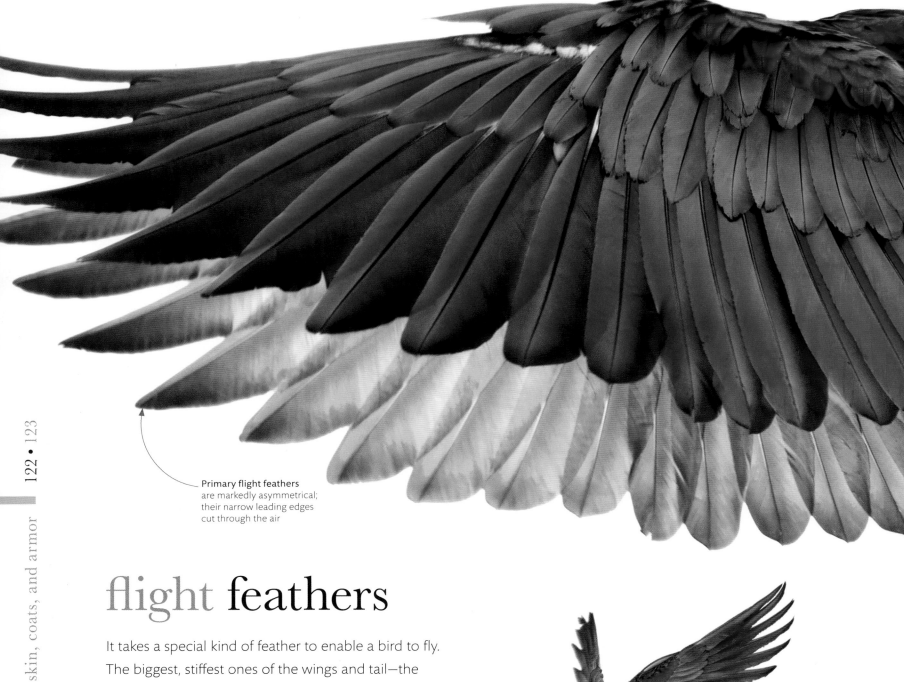

Primary flight feathers
are markedly asymmetrical;
their narrow leading edges
cut through the air

flight feathers

It takes a special kind of feather to enable a bird to fly.
The biggest, stiffest ones of the wings and tail—the
flight feathers—are attached directly to the skeleton
and account for most of the surface of the wings and
the tail. These feathers have self-sealing vanes that
depend on a complex system of microscopic hooks
(see box opposite) to maintain the bladelike shape so
important for lifting a bird into the air.

Feathery brake
The flight feathers in both the wings and the tail are
also used as brakes for landing. In this green-winged
macaw, more than half of the wing is made up of
flight feathers and its distinctive tail feathers are as
long as the head and body combined.

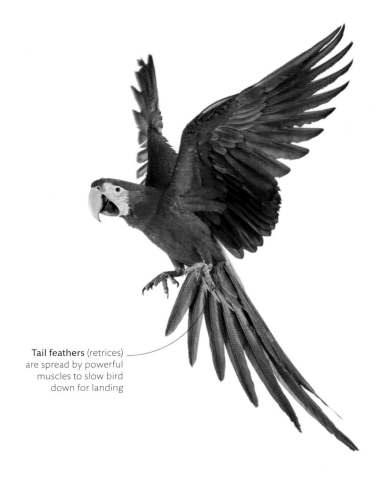

Tail feathers (retrices)
are spread by powerful
muscles to slow bird
down for landing

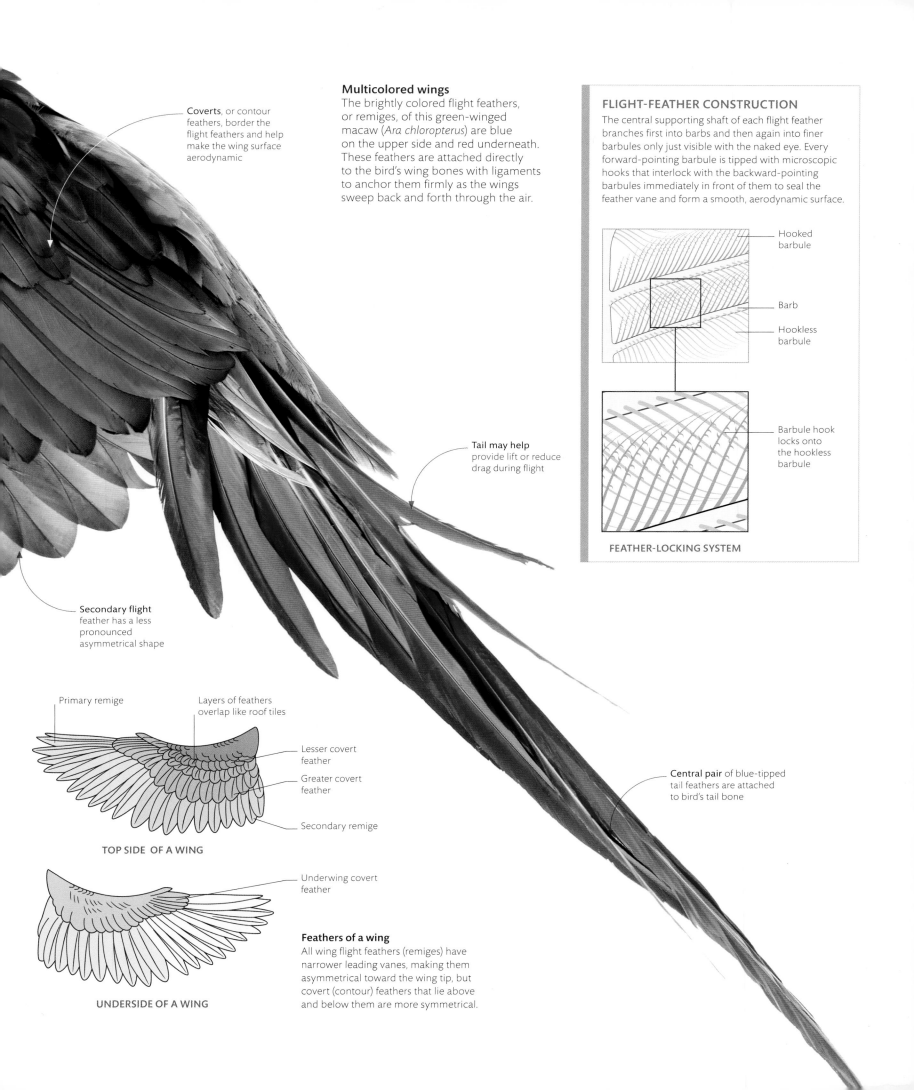

Coverts, or contour feathers, border the flight feathers and help make the wing surface aerodynamic

Multicolored wings
The brightly colored flight feathers, or remiges, of this green-winged macaw (*Ara chloropterus*) are blue on the upper side and red underneath. These feathers are attached directly to the bird's wing bones with ligaments to anchor them firmly as the wings sweep back and forth through the air.

FLIGHT-FEATHER CONSTRUCTION
The central supporting shaft of each flight feather branches first into barbs and then again into finer barbules only just visible with the naked eye. Every forward-pointing barbule is tipped with microscopic hooks that interlock with the backward-pointing barbules immediately in front of them to seal the feather vane and form a smooth, aerodynamic surface.

Hooked barbule

Barb

Hookless barbule

Barbule hook locks onto the hookless barbule

FEATHER-LOCKING SYSTEM

Tail may help provide lift or reduce drag during flight

Secondary flight feather has a less pronounced asymmetrical shape

Primary remige

Layers of feathers overlap like roof tiles

Lesser covert feather

Greater covert feather

Secondary remige

TOP SIDE OF A WING

Underwing covert feather

UNDERSIDE OF A WING

Central pair of blue-tipped tail feathers are attached to bird's tail bone

Feathers of a wing
All wing flight feathers (remiges) have narrower leading vanes, making them asymmetrical toward the wing tip, but covert (contour) feathers that lie above and below them are more symmetrical.

Clandestine show-off

Some of the most extravagant plumages belong to birds that hide deep in thick forests, such as the southern crowned pigeon (*Goura scheepmakeri*) of New Guinea. This bird is seen only by those that really matter—potential mates that are attracted to its visual cues. Males and females are the same color and both sport identical crests.

Competing for attention

Males of many bird species, such as these standardwing birds of paradise (*Semioptera wallacii*), display in groups called leks, and the females gather to choose a mate. The male's elaborate plumage reflects his primary need to attract a mate. Conversely, the female is plain so she is well camouflaged as she raises her brood alone.

Lacy crest feathers
have hookless barbs
and lack solid shafts

display plumage

Feathers are strikingly versatile instruments of visual display. Structurally, their vanes can be long and stiff such as those in a pheasant's tail, or wispy like ostrich plumes, and colors can be bold and brash for showing off or cryptic for hiding. Birds flaunt extravagant ornamentation more than many mammals, perhaps because they can fly away from danger, but also because their better color vision makes this kind of social signaling a highly effective way both to attract mates and to intimidate competitors.

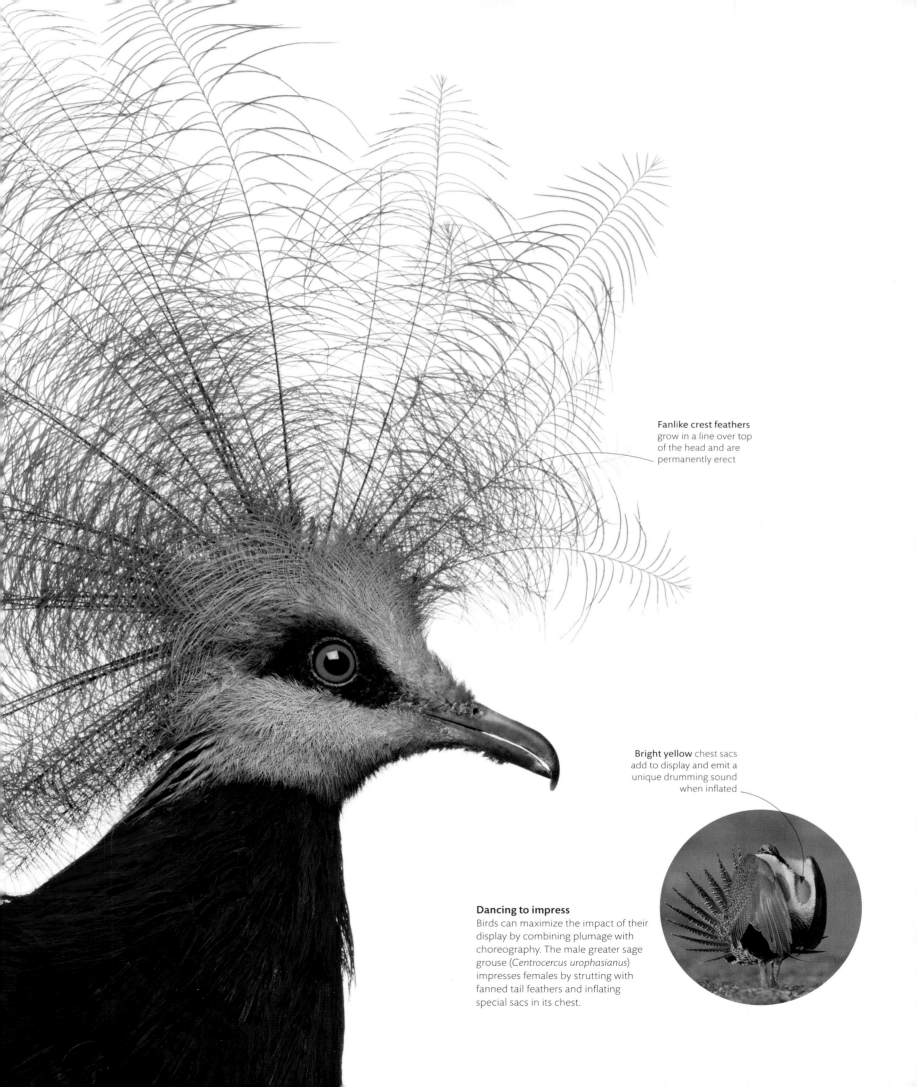

Fanlike crest feathers grow in a line over top of the head and are permanently erect

Bright yellow chest sacs add to display and emit a unique drumming sound when inflated

Dancing to impress
Birds can maximize the impact of their display by combining plumage with choreography. The male greater sage grouse (*Centrocercus urophasianus*) impresses females by strutting with fanned tail feathers and inflating special sacs in its chest.

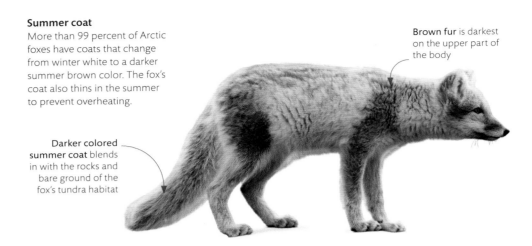

Summer coat
More than 99 percent of Arctic foxes have coats that change from winter white to a darker summer brown color. The fox's coat also thins in the summer to prevent overheating.

Brown fur is darkest on the upper part of the body

Darker colored summer coat blends in with the rocks and bare ground of the fox's tundra habitat

seasonal protection

A furry skin is a quintessential part of being a mammal. Hair is made from keratin— the same tough protein that hardens the surface skin of all vertebrates that live on land. The ability to grow especially dense layers of hair in the coldest places and the harshest conditions means that mammals can trap enough vital body heat near the skin to survive and stay active, even when temperatures drop to freezing point and below.

DOUBLE FUR LAYERS

All hairs grow from specialized pockets of the skin's surface epidermis known as follicles, and there are two types: guard hairs and smaller secondary, or accessory, hairs that make up the underfur. The latter are effective at trapping air close to the skin surface, reducing heat loss. In addition, minute muscles attached to larger guard hairs can pull them straight, erecting the fur for extra insulation in very cold conditions.

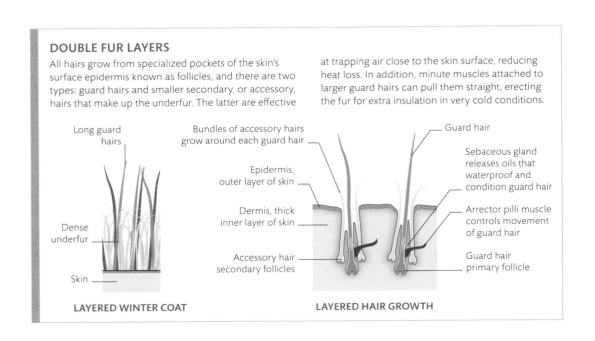

Long guard hairs

Dense underfur

Skin

LAYERED WINTER COAT

Bundles of accessory hairs grow around each guard hair

Epidermis, outer layer of skin

Dermis, thick inner layer of skin

Accessory hair secondary follicles

Guard hair

Sebaceous gland releases oils that waterproof and condition guard hair

Arrector pilli muscle controls movement of guard hair

Guard hair primary follicle

LAYERED HAIR GROWTH

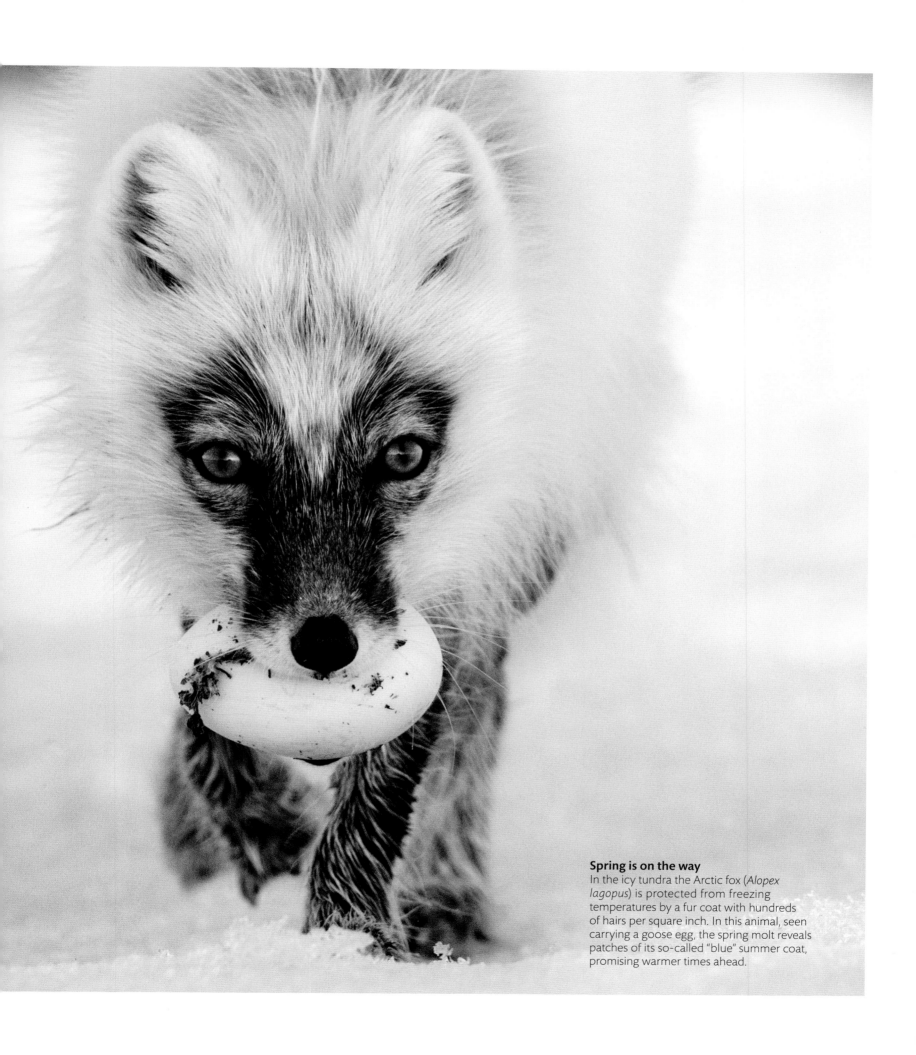

Spring is on the way
In the icy tundra the Arctic fox (*Alopex lagopus*) is protected from freezing temperatures by a fur coat with hundreds of hairs per square inch. In this animal, seen carrying a goose egg, the spring molt reveals patches of its so-called "blue" summer coat, promising warmer times ahead.

Color

Fur colors and the patterns they form, including countershading (having a light belly to contrast a darker back) and dappling, often hide animals in their habitats. As well as acting as camouflage, some patterns, such as a giraffe's spots and a zebra's stripes, are thought to help control body temperature and, in the zebra's case, deter flies. Black-and-white coloration is sometimes a warning that the animal can exude a toxic substance or retaliate fiercely if threatened.

Form

Fur can be thin or thick, smooth or coarse. Animals in temperate and hot climates are typically covered in shorter, uniform hair, but those facing extreme cold have ultra-thick or double coats, consisting of soft, insulating underfur topped with coarse, water-resistant guard hair. Moles usually have velvety fur that can lie in any direction, minimizing friction with the soil. Even the spines, quills, and scales seen on some mammals are modified hairs.

WARNING
Striped skunk
Mephitis mephitis

COUNTERSHADING
Blackbuck
Antilope cervicapra

SINGLE LENGTH, SHORT COAT
Lion
Panthera leo

DOUBLE COAT
Musk ox
Ovibos moschatus

WOOL
Dall sheep
Ovis dalli

SPINES
Lesser hedgehog tenrec
Echinops telfairi

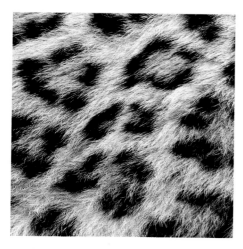

DAPPLED
North Chinese leopard
Panthera pardus japonensis

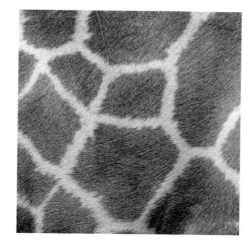

SPOTTED
Reticulated giraffe
Giraffa camelopardalis reticulata

STRIPED
Plains zebra
Equus quagga

WATERPROOF
Common seal
Phoca vitulina

LOW FRICTION
European mole
Talpa europaea

COARSE
Brown-throated three-toed sloth
Bradypus variegatus

mammal fur

Whether called fur, hair, or whiskers, all mammalian skin coverings
are made of the same material: a protein called keratin. While
providing insulation and protection, fur also camouflages predators
and prey, reduces friction, and signals sexual maturity, and certain
colors and patterns may have additional functions.

Waterproof guard hair
covers dense underfur
and traps insulating
layer of air in coat

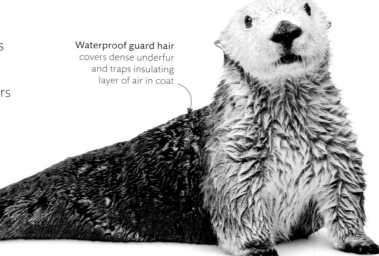

Densest fur on Earth
With up to 1 million per sq in (155,000 hairs per sq cm)
the southern sea otter (*Enhydra lutris*) maintains a
comfortable body temperature in water as cold as
34°F (1°C), despite a lack of thick, insulating blubber.

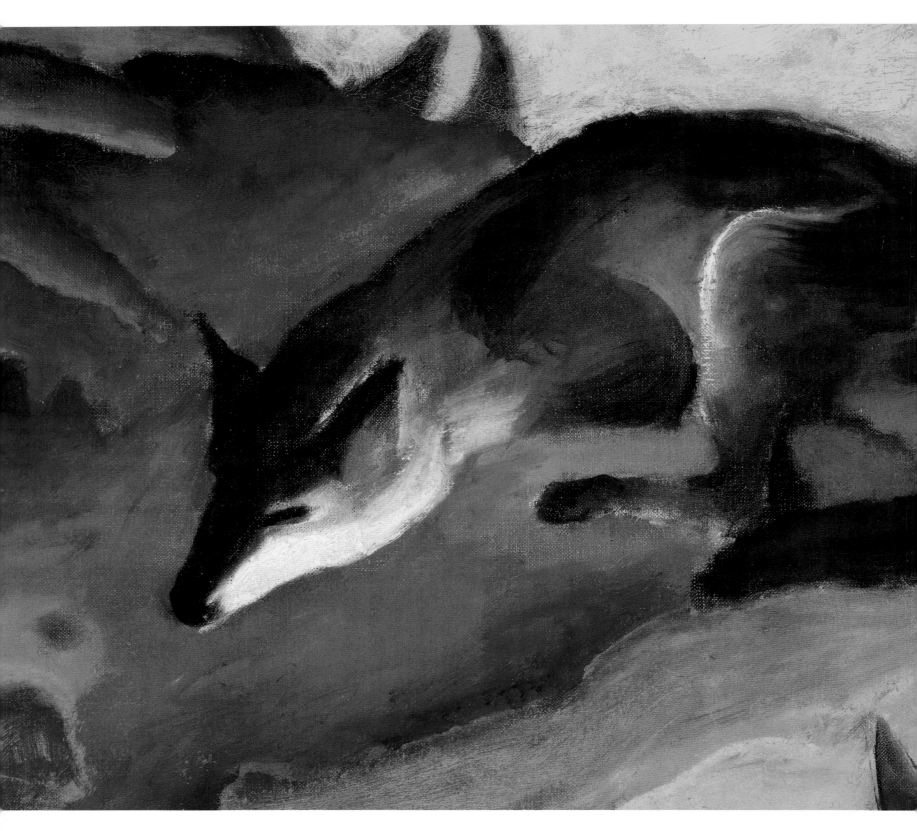

Blue Fox (1911)
Animals were the leitmotif of Franz Marc's
work, to which he returned continually
throughout his brief life. The German painter
and printmaker used simplified contours
and shapes, and he invested his colors with
spiritual associations to "penetrate
into the soul" of his subjects.

Two Crabs (1889)
Vincent van Gogh's still life painting of vibrant red crabs on a sea-green background pairs complementary colors to dazzling effect. The Dutch post-impressionist may have been prompted by a woodcut of crabs by the Japanese master Hokusai.

animals in art

expressionist nature

At the turn of the 20th century artists sought revolutionary ways to reflect the pace and complexity of modern life. In a startling new approach, Expressionist painters elevated line, shape, and, most importantly, color above fidelity to the natural world. Reviewers labeled French painters such as Henri Matisse and Georges Rouault, "Fauves" (wild beasts) because of the raw emotion on display in their vivid pigments and the visceral response of their audience.

While the late 19th-century Impressionists had been preoccupied with capturing fleeting changes in light in their landscapes, flowers, and portraits, post-Impressionists took a new direction. The obsession with color and form in the works of Vincent van Gogh, for example, were a step on the way to abstract painting, and an inspiration to the Expressionist German artist Franz Marc. Like the Fauves, Marc was concerned with man's empathy with the natural world. Animals were key: in Munich he studied animal anatomy; in Berlin he spent countless hours sketching the shapes of animals and birds and observing their behavior at Berlin Zoo. "How does a horse see the world, or an eagle, a deer, or a dog? How poor and how soulless is our convention of placing animals in a landscape which belongs to our eyes, instead of penetrating into the soul of the animal in order to imagine his perception?" he wrote in a treatise in 1920.

In 1911 Marc co-founded *Der Blaue Reiter* (*Blue Rider*) magazine and art movement with Vassily Kandinsky who shared the belief that their abstract art was a counterbalance to a toxic world. In any painting, color was a separate entity with transcendent associations: blue was male, stern and spiritual; yellow, female, gentle and happy; red, brutal and heavy—the juxtaposition and mixing of colors added insight and balance to works.

Marc's paintings of the *Blue Fox* and *The Little Blue Horses* suggest innocence, while his *The Yellow Cow* has a boundless joy. In an apocalyptic painting of wildlife, *Fate of the Animals* (1913), his colored beasts, trapped in a forest of burning red, foreshadow the approaching World War in which he lost his life.

66 The natural feeling for life possessed by animals set in vibration everything good in me. 99

FRANZ MARC, *LETTER FROM THE WESTERN FRONT,* APRIL 1915

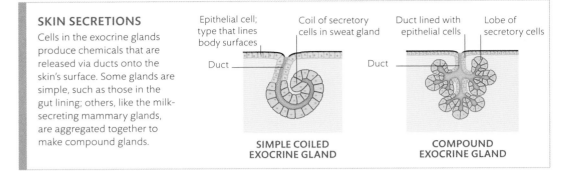

SKIN SECRETIONS

Cells in the exocrine glands produce chemicals that are released via ducts onto the skin's surface. Some glands are simple, such as those in the gut lining; others, like the milk-secreting mammary glands, are aggregated together to make compound glands.

Epithelial cell; type that lines body surfaces

Coil of secretory cells in sweat gland

Duct lined with epithelial cells

Lobe of secretory cells

Duct

Duct

SIMPLE COILED EXOCRINE GLAND

COMPOUND EXOCRINE GLAND

skin glands

Glands are organs that secrete useful substances. Endocrine glands release body chemicals called hormones into the bloodstream, while exocrine glands discharge their contents through ducts onto a surface epithelium, for example, digestive juices into the gut from its walls, or as secretions over the skin. Mammals have many skin glands; some produce watery sweat that cools it or oil for waterproofing, while others generate chemical scents to mark territory, identify individuals, or stimulate courtship.

Facial scent glands

Many hoofed mammals have scent glands on the face. The preorbital glands of the Kirk's dik-dik exude a dark tarlike secretion that it smears on twigs and branches near dung heaps and regular pathways through its territory.

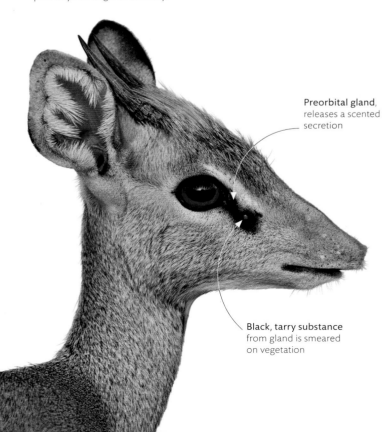

Preorbital gland, releases a scented secretion

Black, tarry substance from gland is smeared on vegetation

Social signaling

Group organization for this African antelope, the Kirk's dik-dik (*Madoqua kirkii*), depends on scent. Horned males (center) accompany their female and recent offspring and both adults (males more than the females) deter enemies by marking their territory with facial secretions.

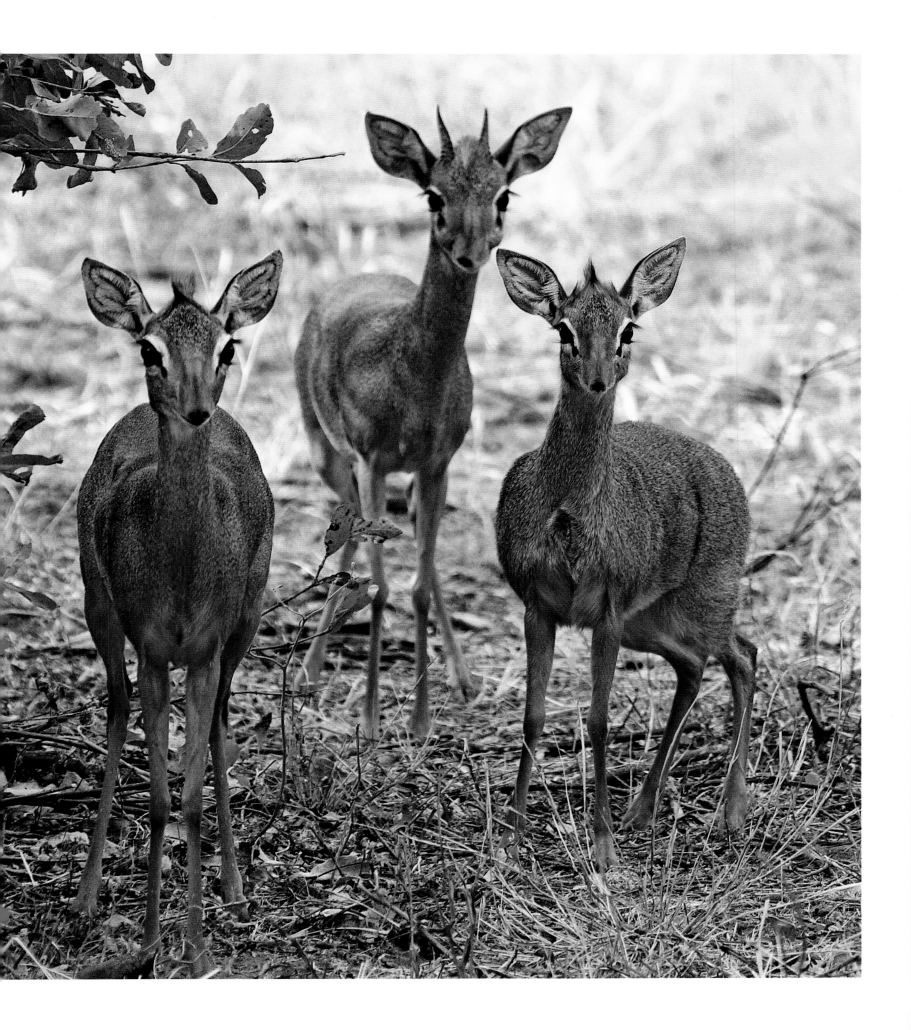

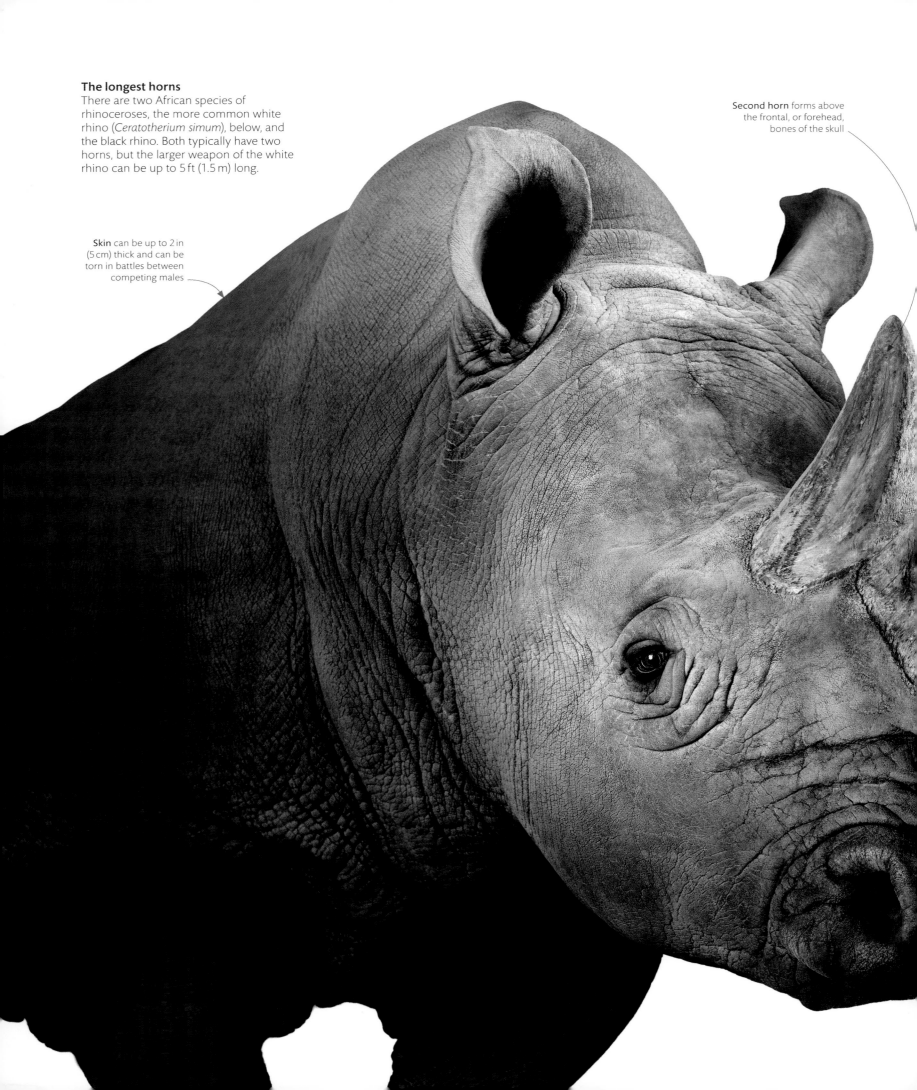

The longest horns
There are two African species of rhinoceroses, the more common white rhino (*Ceratotherium simum*), below, and the black rhino. Both typically have two horns, but the larger weapon of the white rhino can be up to 5 ft (1.5 m) long.

Second horn forms above the frontal, or forehead, bones of the skull

Skin can be up to 2 in (5 cm) thick and can be torn in battles between competing males

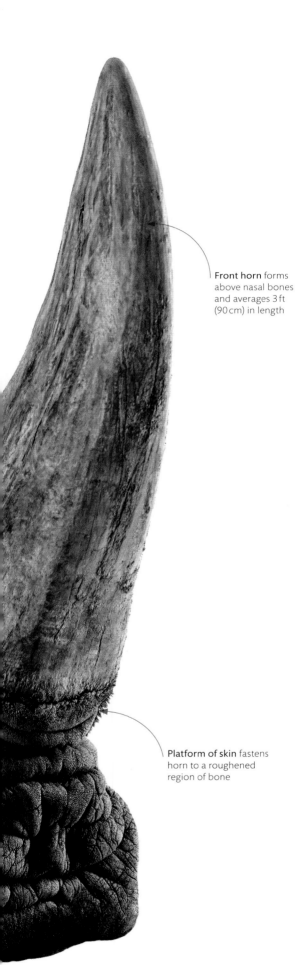

Front horn forms above nasal bones and averages 3 ft (90 cm) in length

Platform of skin fastens horn to a roughened region of bone

One-horned rhinoceros
There are three rhinoceros species in Asia. The Indian rhinoceros (*Rhinoceros unicornis*), right, has a single horn, while females of the one-horned Javan rhinoceros (*R. sondaicus*) are hornless.

Distinctive skin folds give the Indian rhinoceros a more armored look than its African counterpart

horns from skin

No other animal has horns like those of a rhinoceros, whose name comes from the Greek for "nose-horn." The horns are unique not only in that they sit on the skull, but also in how they are formed. Other animal's horns are bone covered with a sheath of hardened skin (see p.87), while those of a rhinoceros are made from the protein keratin, which also makes claws and hair, compacted to form a defensive weapon that can be wielded just as effectively.

STRUCTURE OF A RHINOCEROS HORN

Scans of rhinoceros horns reveal that, although lacking a bony core, the centre is reinforced with calcium and a pigment called melanin, which protects it from the sun's rays. The outer layers are softer and can become worn. But there is no scientific evidence for the purported therapeutic value that is driving rhinos to extinction.

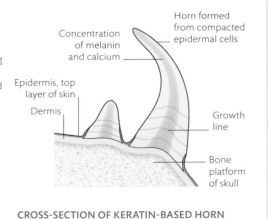

Horn formed from compacted epidermal cells

Concentration of melanin and calcium

Epidermis, top layer of skin

Dermis

Growth line

Bone platform of skull

CROSS-SECTION OF KERATIN-BASED HORN

armored skin

Keratin is a horny protein that strengthens skin. It is found in its purest form in hairs, claws, and feathers, and in some animals it is used as armor. Pangolins are protected by hard, keratinized, nail-like scales that are highly sensitive to touch—only the underside of the body is unprotected. To make and maintain the scales, pangolins need a high-protein diet—something they satisfy by eating countless ants and termites.

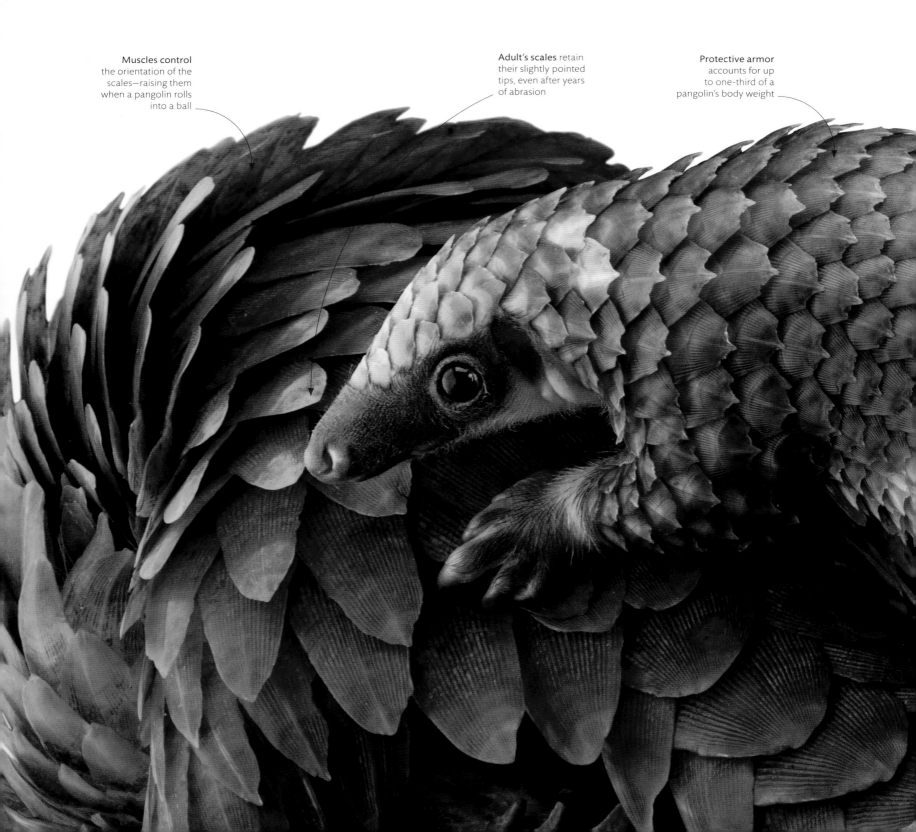

Muscles control
the orientation of the scales—raising them when a pangolin rolls into a ball

Adult's scales retain their slightly pointed tips, even after years of abrasion

Protective armor accounts for up to one-third of a pangolin's body weight

Armadillo protection
Like pangolins, armadillos have hard scales, but they are fused together to form a continuous shield supported on bony plates. The pink fairy armadillo (*Chlamyphorus truncatus*), the smallest species, uses its rump plate to compact sand in its burrows, or possibly to plug the entrance in self-defense.

PANGOLIN SCALES
The scales of pangolins are produced by cells in the skin that become filled with hard keratin (or keratinized) as they form this nonliving, hornlike material—a process known as cornification. The scales most resemble the nails of primates. As their exposed edges are worn down, they are "repaired" with new keratin made at the base of the scale from cornifying cells in the epidermis.

Worn outer surface replenished with newly keratinized cells

New keratinized cells form in middle layer of scale

Corrugated surface of mature scale

Cornified outer layer of epidermis, known as the stratum corneum

Lower layer of epidermis (where cells divide)

Dermis

Raised dermal papilla from which keratinized cells grow to form scales

SKIN CROSS-SECTION SHOWING SCALE FORMATION

Scales of an infant
have a characteristic three-pointed shape, which becomes smoother with age

Overlapping scales
protect against bites from larger predators but provide little defense against stinging insects

Protected from birth
A newborn common African pangolin (*Manis tricuspis*) comes into the world covered with soft scales, which rapidly harden. Shortly after birth the infant learns to cling for safety on its mother's back and—like her—rolls into a ball if it is in danger.

senses

sense. a faculty—such as sight, hearing, smell, taste, or touch—by which an animal receives information about the external world.

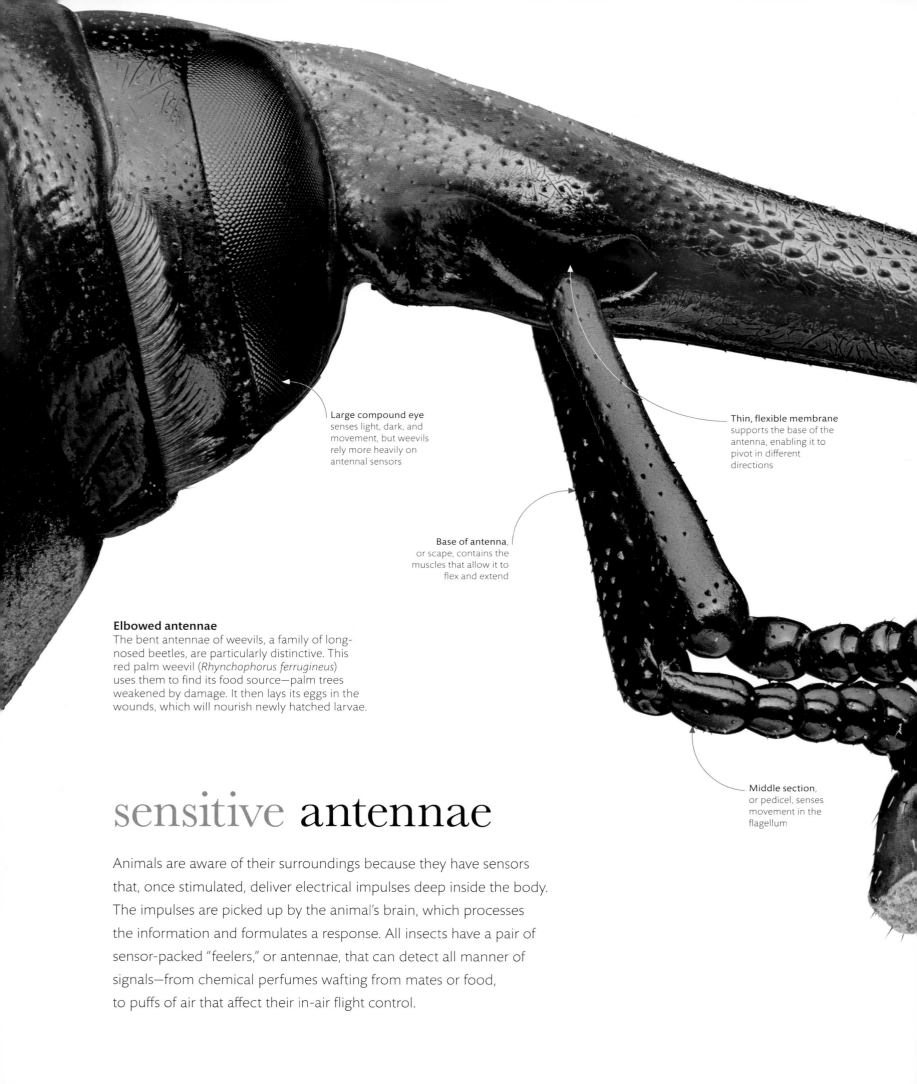

Large compound eye
senses light, dark, and
movement, but weevils
rely more heavily on
antennal sensors

Thin, flexible membrane
supports the base of the
antenna, enabling it to
pivot in different
directions

Base of antenna,
or scape, contains the
muscles that allow it to
flex and extend

Elbowed antennae
The bent antennae of weevils, a family of long-
nosed beetles, are particularly distinctive. This
red palm weevil (*Rhynchophorus ferrugineus*)
uses them to find its food source—palm trees
weakened by damage. It then lays its eggs in the
wounds, which will nourish newly hatched larvae.

Middle section,
or pedicel, senses
movement in the
flagellum

sensitive antennae

Animals are aware of their surroundings because they have sensors
that, once stimulated, deliver electrical impulses deep inside the body.
The impulses are picked up by the animal's brain, which processes
the information and formulates a response. All insects have a pair of
sensor-packed "feelers," or antennae, that can detect all manner of
signals—from chemical perfumes wafting from mates or food,
to puffs of air that affect their in-air flight control.

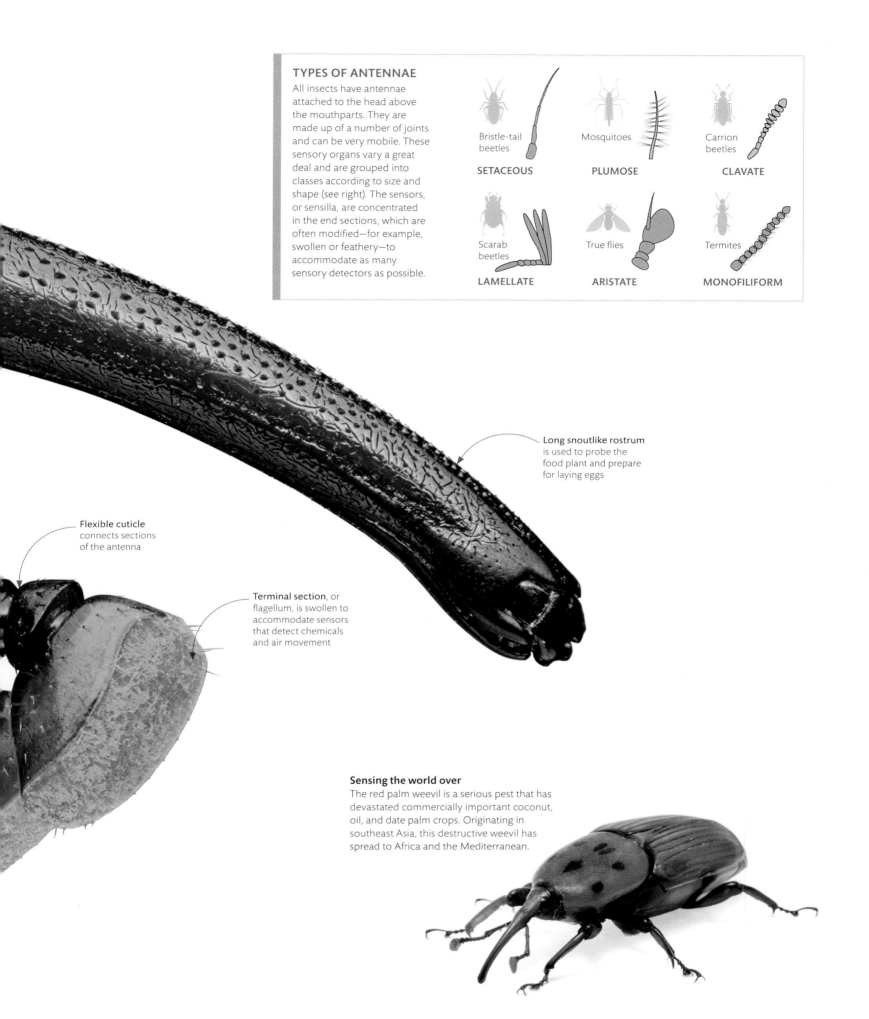

TYPES OF ANTENNAE

All insects have antennae attached to the head above the mouthparts. They are made up of a number of joints and can be very mobile. These sensory organs vary a great deal and are grouped into classes according to size and shape (see right). The sensors, or sensilla, are concentrated in the end sections, which are often modified—for example, swollen or feathery—to accommodate as many sensory detectors as possible.

Bristle-tail beetles
SETACEOUS

Mosquitoes
PLUMOSE

Carrion beetles
CLAVATE

Scarab beetles
LAMELLATE

True flies
ARISTATE

Termites
MONOFILIFORM

Long snoutlike rostrum is used to probe the food plant and prepare for laying eggs

Flexible cuticle connects sections of the antenna

Terminal section, or flagellum, is swollen to accommodate sensors that detect chemicals and air movement

Sensing the world over
The red palm weevil is a serious pest that has devastated commercially important coconut, oil, and date palm crops. Originating in southeast Asia, this destructive weevil has spread to Africa and the Mediterranean.

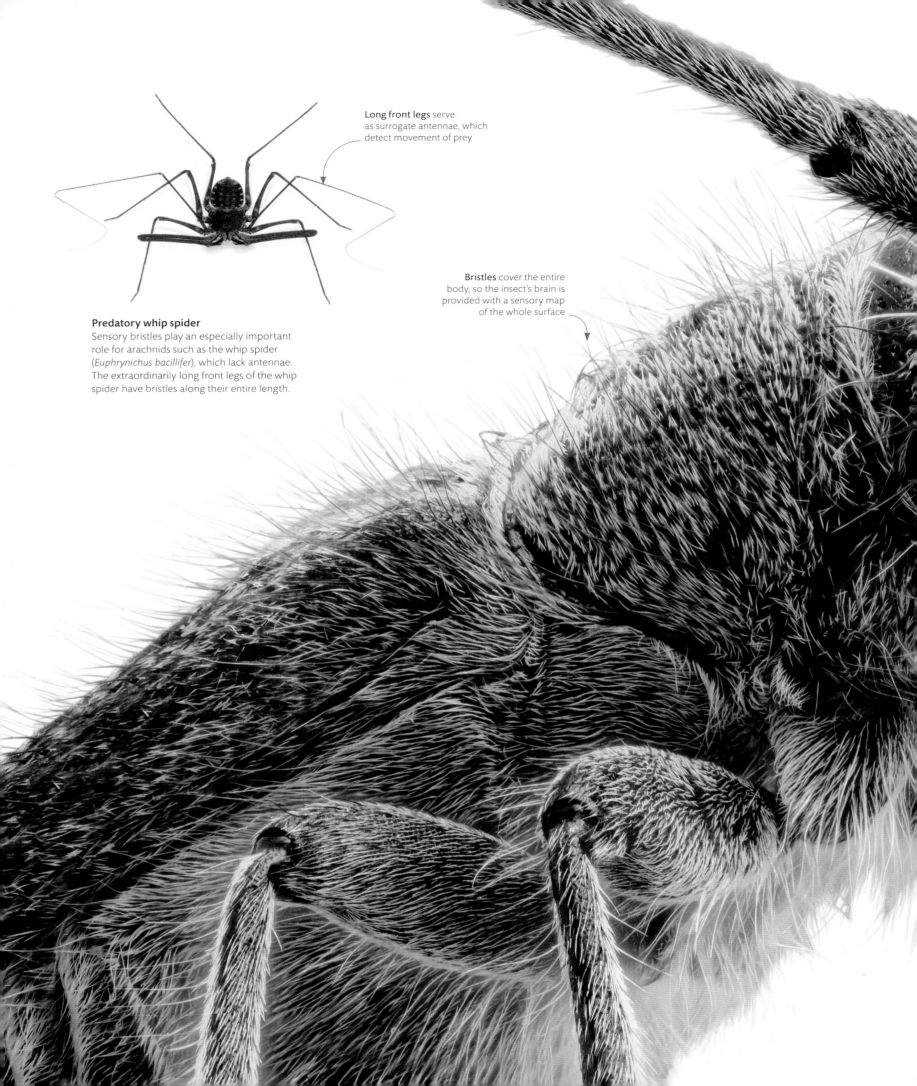

Long front legs serve as surrogate antennae, which detect movement of prey

Bristles cover the entire body, so the insect's brain is provided with a sensory map of the whole surface

Predatory whip spider
Sensory bristles play an especially important role for arachnids such as the whip spider (*Euphrynichus bacillifer*), which lack antennae. The extraordinarily long front legs of the whip spider have bristles along their entire length.

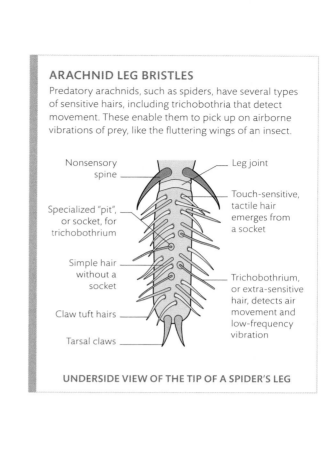

ARACHNID LEG BRISTLES
Predatory arachnids, such as spiders, have several types of sensitive hairs, including trichobothria that detect movement. These enable them to pick up on airborne vibrations of prey, like the fluttering wings of an insect.

Nonsensory spine

Leg joint

Specialized "pit", or socket, for trichobothrium

Touch-sensitive, tactile hair emerges from a socket

Simple hair without a socket

Trichobothrium, or extra-sensitive hair, detects air movement and low-frequency vibration

Claw tuft hairs

Tarsal claws

UNDERSIDE VIEW OF THE TIP OF A SPIDER'S LEG

Densely coated beetle
When viewed under high magnification, the extraordinary coat of sensory bristles (or setae) on this bluish longhorn beetle (*Opsilia coerulescens*) shows just how much insects rely on tactile stimulation. Each hair—when deflected—tells the insect where it is, as well as what is happening around it.

Every touch-sensitive hair (seta) emerges from a socket connected to sensory nerve endings

Concentrations of hairs at the joints—hair plates – sense movement of body parts and provide information about their relative positions

sensory bristles

The skin of any animal is at the frontline of its surroundings, so is filled with sensory nerve endings that pick up signals from the environment and carry them to the brain. For animals such as insects and arachnids with a hard exoskeleton outside their skin, cells in the epidermis produce an array of specialized tactile bristles that poke through the tough outer layer to improve the body's sensitivity to touch and movement.

> " By the help of microscopes, there is nothing so small, as to escape our inquiry... "

ROBERT HOOKE, *MICROGRAPHIA*, 1665

The flea (1665)
In his book *Micrographia*, natural philosopher Robert Hooke reveals the unexplored complexity of a flea made visible by his revolutionary adjustable microscope.

small world

After 200 years of exploration had brought the world's wildlife to European shores, the 17th century saw a new age of discovery, which revealed the mysteries of a smaller world. The new science of entomology was fueled by advances in microscopes, by the artistic skills of scientists, and by artists who used precise methods to portray insect life in acclaimed works of art.

Insects and forget-me-nots (1653)
Jan van Kessel II used scientific texts as sources for delicate watercolors on parchment of beetles, moths, butterflies, and grasshoppers. He sometimes created pictures of his name spelled out with caterpillars.

Illustration skills became an imperative for the new entomologists of the 17th century. English inventor and scientist Robert Hooke was a consummate artist. Using a new compound microscope with illumination, he revealed the unimagined anatomy of insects, and identified plant cells. When he published his astounding drawings in his 1665 work *Micrographia*, the insects were so alien, some refused to believe they were real.

In the Netherlands, textile merchant Antonie van Leeuwenhoek created tiny microscopes using 1-mm lenses. Their manufacture was a closely guarded secret, but they were probably forged from the glass pearls that were used to examine cloth. Their unparalleled magnification revealed the structure of single-celled organisms, bacteria, and spermatozoa.

In the same period, notable artists immersed themselves in acute observation of natural subjects. Jan van Kessel II, from the illustrious Brueghel family, worked with live insect specimens and pored over illustrated scientific texts to bring complete accuracy to art.

In her teenage years, Frankfurt-born Maria Sibylla Merian (1647–1717) was fascinated by the metamorphosis of caterpillars into moths and butterflies. She went on to become one of the first artists to draw insects and butterflies on their host plants. After moving to Amsterdam, Merian was given, at age 52, a rare government sponsorship to record insect life in the Dutch colony of Surinam. Carl Linnaeus later used the magnificent drawings from her book *Metamorphosis of the Insects of Surinam* to classify new species.

Caterpillars, butterflies, and flowers (1705)
Two saturniid moths (*Arsenura armida*), widespread in Mexico and South America, frame the flowering branch of a towering tropical tree in a watercolor from Maria Sibylla Merian's remarkable book on the insects of Surinam. The larvae shown are not the early stage of this moth, as Merian supposed, but from an unknown species.

SENSITIVE HAIRS

Each whisker—technically called a vibrissa—is linked to a few sensory nerve endings near the skin's surface, which mainly wrap around the whisker. However, 80 percent of the nerve endings associated with the whisker are deeper down and lie parallel with the root of the whisker. When the whisker bends away from its follicle base, the nerve endings are stimulated to fire electrical impulses to the brain.

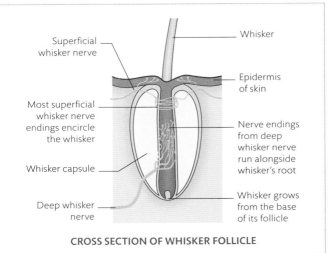

Superficial whisker nerve

Most superficial whisker nerve endings encircle the whisker

Whisker capsule

Deep whisker nerve

Whisker

Epidermis of skin

Nerve endings from deep whisker nerve run alongside whisker's root

Whisker grows from the base of its follicle

CROSS SECTION OF WHISKER FOLLICLE

Feeling for fishes

Whiskers enable animals to "feel" their surroundings by sensing minute vibrations in the water or air. The whiskers of a California sea lion (*Zalophus californianus*) can detect the tiny wake caused by its fish prey against the background movement of the currents, and even determine a target's size, shape, and texture by touch. They allow the sea lion to find food in the limited visibility of turbid coastal waters.

sensory whiskers

The hairs of a mammal are rooted to nerves and muscles, enabling the animal to detect their movement. Hairs on the face—notably in carnivores and rodents—have evolved to become especially sensitive, being attached to complex bundles of nerve fibers that fire impulses in response to the slightest touch. It is possible that, millions of years ago, the very first "protohairs" in the reptilian ancestors of mammals evolved with this tactile function, as nocturnal or burrowing pioneers struggled to find their way in darkness.

Whiskered bird

Some birds have stiff, modified feathers, called rictal bristles, that project from the base of the bill and may work like whiskers. Rictal bristles are conspicuous in nightjars and flycatchers, which perhaps use them to detect contact with insects when hunting on the wing. They are most developed in nocturnal species: kiwi use their rictal bristles to feel for invertebrates on the ground, aided by a sense of smell that is unusually strong for a bird.

Each rictal bristle is a modified feather with a stiffened shaft that lacks barbs

Coat consists of guard hairs overlying shorter fine underhairs; oil secreted by glands under the skin keeps the coat waterproofed

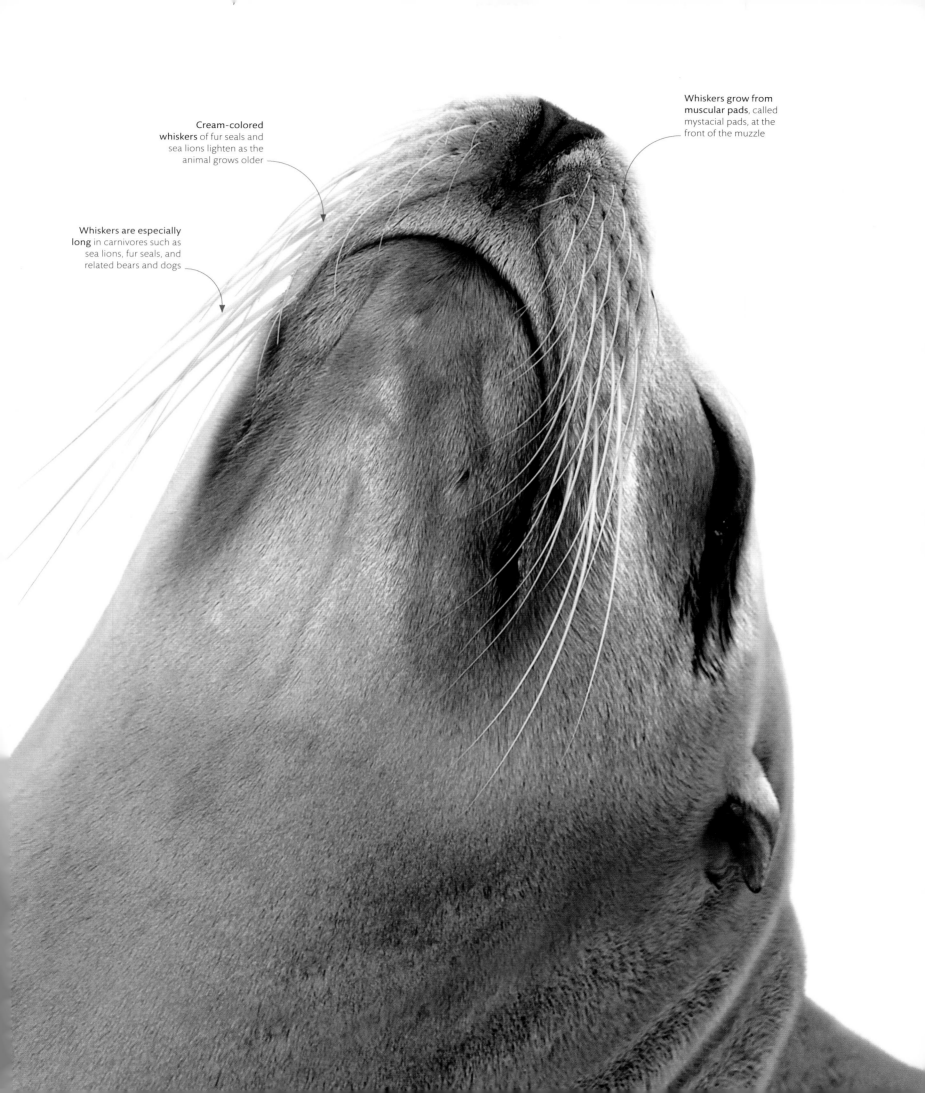

Cream-colored whiskers of fur seals and sea lions lighten as the animal grows older

Whiskers grow from muscular pads, called mystacial pads, at the front of the muzzle

Whiskers are especially long in carnivores such as sea lions, fur seals, and related bears and dogs

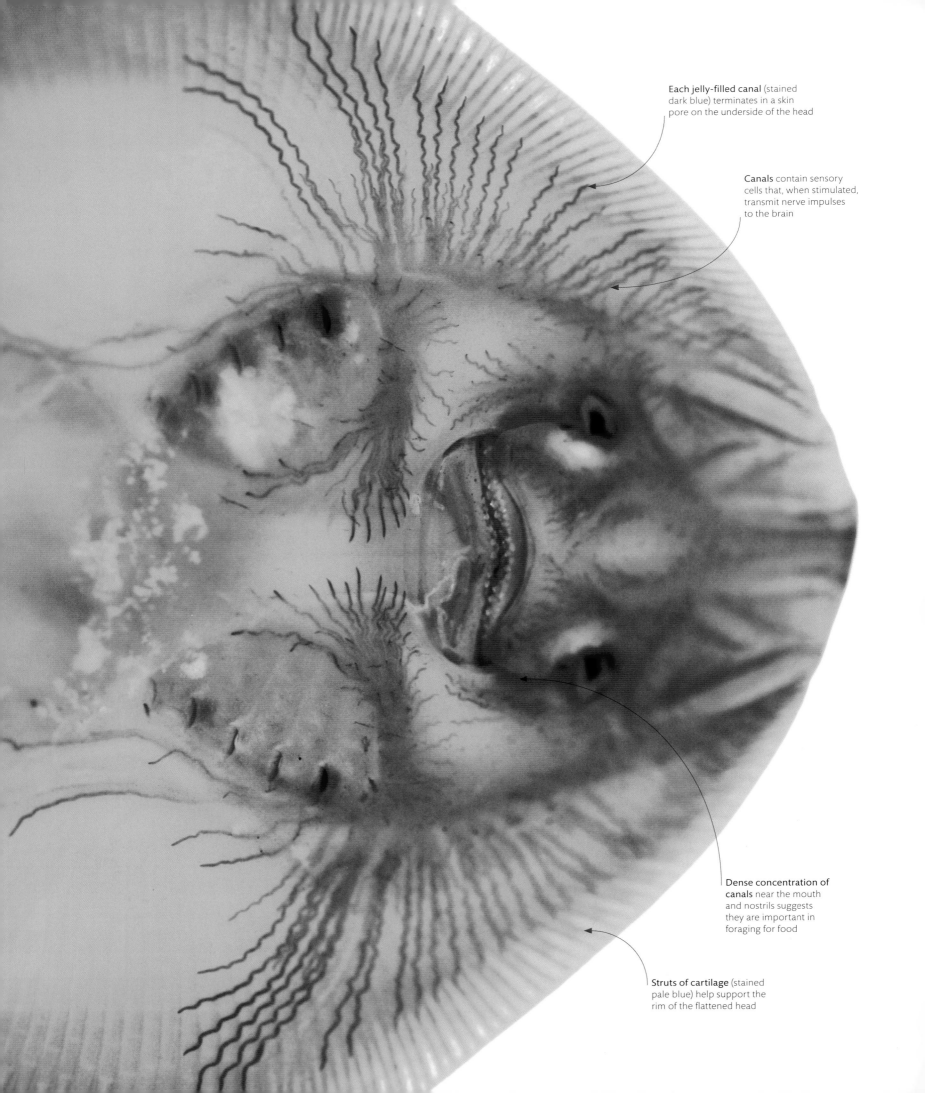

Each jelly-filled canal (stained dark blue) terminates in a skin pore on the underside of the head

Canals contain sensory cells that, when stimulated, transmit nerve impulses to the brain

Dense concentration of canals near the mouth and nostrils suggests they are important in foraging for food

Struts of cartilage (stained pale blue) help support the rim of the flattened head

Sensory canals

This underside view of the flattened head of a little skate (*Leucoraja erinacea*)—here stained blue—reveals dark, radiating, jelly-filled canals called ampullary organs. The canals contain sensory cells that detect electrical fields produced by the muscles of prey animals. Once triggered, the cells fire off nerve impulses to the skate's brain, guiding the fish's underslung mouth towards invertebrates buried, and unseen, in sea-floor sediment.

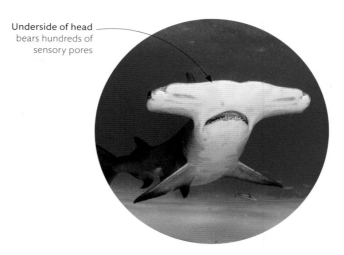

Underside of head bears hundreds of sensory pores

Targeting prey

An arrangement of sensors along the wide front of its modified head helps a great hammerhead shark (*Sphyrna mokarran*) triangulate chemical and electrical signals to pinpoint prey.

sensing underwater

Underwater animals live in a medium that is denser than air—a place where sound travels better, but light is diminished by turbidity or depth, and odors disperse more slowly. Aquatic animals have evolved sensory systems adapted to these conditions: tactile receptors that detect the slightest ripples and remarkable sensors that pick up chemical traces or even faint electric signals from prey.

DETECTING MOVEMENT

Fishes sense water movement via their lateral line system: a series of canals that run along the body, under the skin. The canals channel water from the surroundings to bend neuromasts—jelly-topped bundles of sensory cells—that send nerve impulses to the brain as they move back and forth.

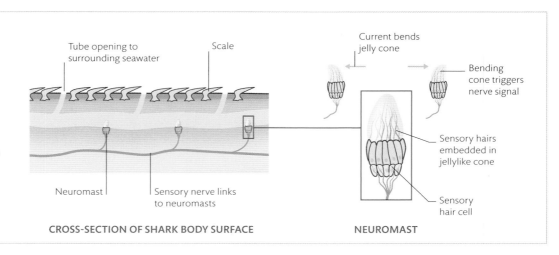

Tube opening to surrounding seawater

Scale

Current bends jelly cone

Bending cone triggers nerve signal

Sensory hairs embedded in jellylike cone

Neuromast

Sensory nerve links to neuromasts

Sensory hair cell

CROSS-SECTION OF SHARK BODY SURFACE

NEUROMAST

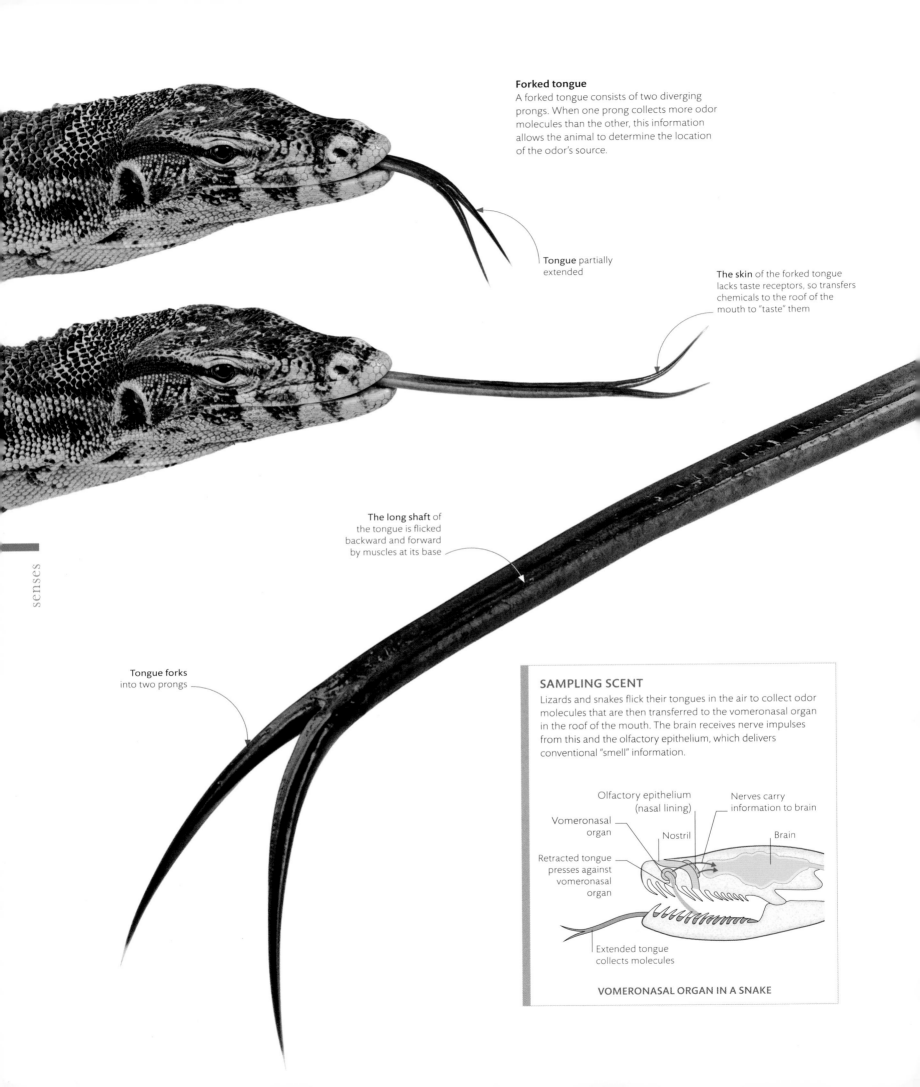

Forked tongue
A forked tongue consists of two diverging prongs. When one prong collects more odor molecules than the other, this information allows the animal to determine the location of the odor's source.

Tongue partially extended

The skin of the forked tongue lacks taste receptors, so transfers chemicals to the roof of the mouth to "taste" them

The long shaft of the tongue is flicked backward and forward by muscles at its base

Tongue forks into two prongs

SAMPLING SCENT

Lizards and snakes flick their tongues in the air to collect odor molecules that are then transferred to the vomeronasal organ in the roof of the mouth. The brain receives nerve impulses from this and the olfactory epithelium, which delivers conventional "smell" information.

Olfactory epithelium (nasal lining)

Nerves carry information to brain

Vomeronasal organ

Nostril

Brain

Retracted tongue presses against vomeronasal organ

Extended tongue collects molecules

VOMERONASAL ORGAN IN A SNAKE

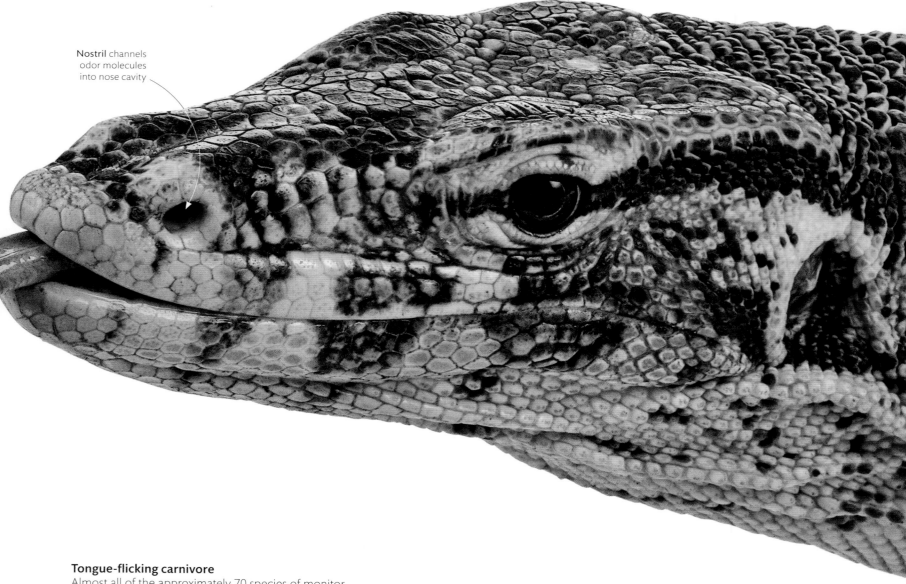

Nostril channels
odor molecules
into nose cavity

Tongue-flicking carnivore
Almost all of the approximately 70 species of monitor
lizard have a taste for meat and can sense live prey or
carrion by flicking their tongue. The Asian water monitor
(*Varanus salvator*) is one of the largest when full-grown,
attacking animals up to the size of young crocodiles.

tasting the air

Chemoreception, or sensing chemicals, can take the form of smelling odors
(olfaction) or tasting flavors in the mouth—but sometimes the distinction is blurred.
The vomeronasal (or Jacobson's) organ is a sense organ that supplements the main
olfactory system in many amphibians, reptiles, and mammals. In lizards and snakes,
it senses odor molecules collected from the air by a forked tongue, helping the
animal "taste" the air for prey, predators, or even potential mates.

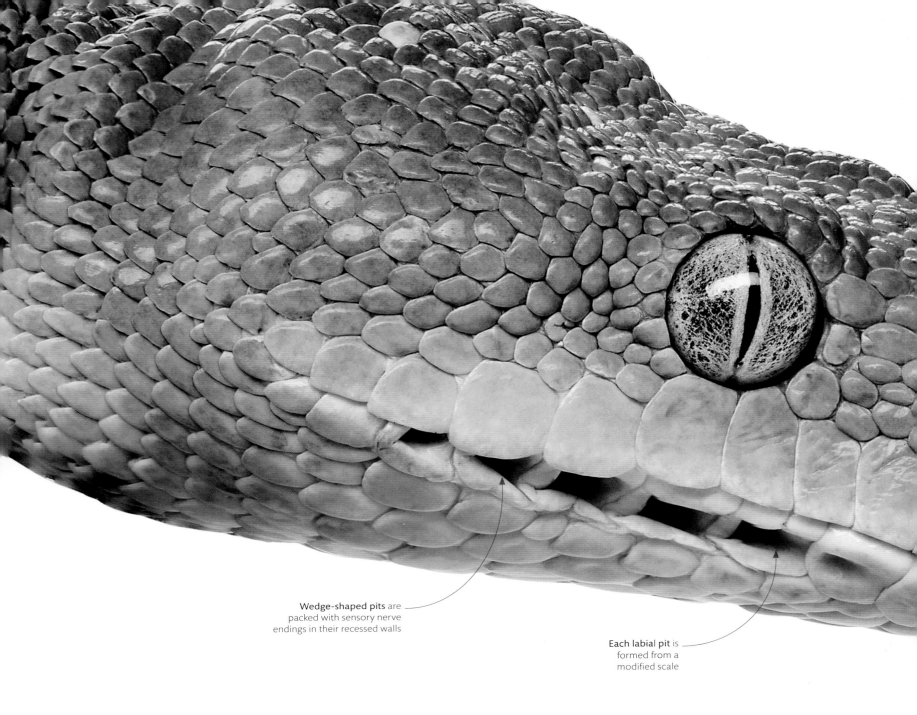

Wedge-shaped pits are packed with sensory nerve endings in their recessed walls

Each labial pit is formed from a modified scale

sensing heat

Many animals sense a source of heat not by using temperature sensors, but with cells that detect infrared radiation. Infrared is a form of electromagnetic radiation—with a wavelength slightly longer than that of visible red light— emitted by warm objects. Animals with infrared sensors can pick up these radiation signals at great distances, helping predators, such as certain kinds of snakes, track down warm-blooded prey.

Heat sensors

The infrared sensors of pythons, such as this green tree python (*Morelia viridis*), are carried in pits along the upper and lower lip and on the snout. These pits help the snake detect its prey at night. The python reaches out at lightning-fast speed to grab prey with its jaws, which it then kills by constriction.

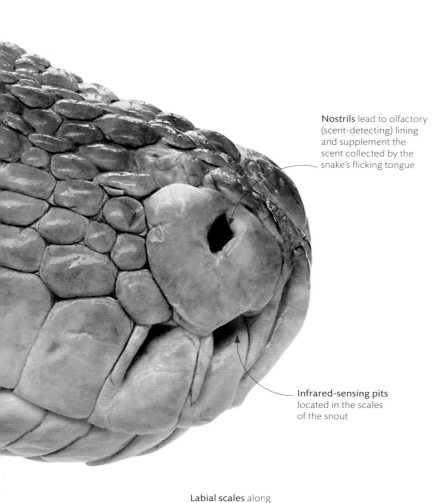

Nostrils lead to olfactory (scent-detecting) lining and supplement the scent collected by the snake's flicking tongue

Infrared-sensing pits located in the scales of the snout

INFRARED RECEPTORS

Sensory nerve endings act as infrared receptors and are triggered when surrounding tissue is warmed by infrared. In boas, nerve endings are embedded in surface scales, and in pythons at the base of pits. In both, some heat dissipates into the skin. Pit-vipers have nerve endings that are suspended in membranes, which warm more quickly, making them more sensitive.

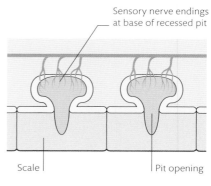

Sensory nerve endings at base of recessed pit

Scale

Pit opening

PIT LOCATION IN PYTHON

Parallel lives

Despite evolving in a different part of the world, the emerald tree boa (*Corallus caninus*) from South America, shares a number of characteristics with the green tree python from New Guinea. Both are nocturnal hunters that live in the low branches of the rain forest, and both use infrared detectors to hunt for warm-blooded prey in the dark.

Labial scales along the upper and lower lips of boas support sensory nerve endings

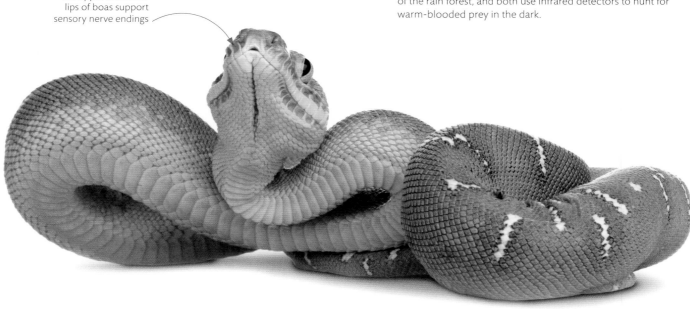

electrical sense

Swimming in murky water can make moving around safely and finding food difficult. Some animals take advantage of the fact that minerals in water cause it to conduct electricity, which can be detected with special sensors. Most fish and a group of egg-laying mammals—the monotremes—use these sensors to pick up electrical signals that indicate the presence of prey or predators.

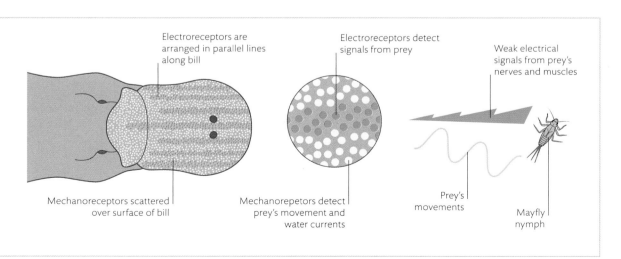

Eyes and ears remain closed when in water, so animal is dependent on sensory bill

Frontal shield, made of sensor-packed skin, extends the area for detecting electrical signals

Flared nostrils close during diving

Rubbery skin carrying sensors covers beak-shaped facial bones

Horny pads instead of teeth grind the exoskeletons of invertebrate prey

ELECTROSENSING PREY

There are two kinds of egg-laying mammals. Spiny echidnas have some electrical sensors in their pointed noses, enabling them to probe soil for worms. But the aquatic platypus's duck bill is packed with them. Its prey gives off electrical signals that are picked up almost instantaneously by the bill. Other sensors detect movement in the water slightly later. The animal's brain uses this time difference to determine the position of the prey in the water.

Electroreceptors are arranged in parallel lines along bill

Mechanoreceptors scattered over surface of bill

Electroreceptors detect signals from prey

Mechanorepetors detect prey's movement and water currents

Weak electrical signals from prey's nerves and muscles

Prey's movements

Mayfly nymph

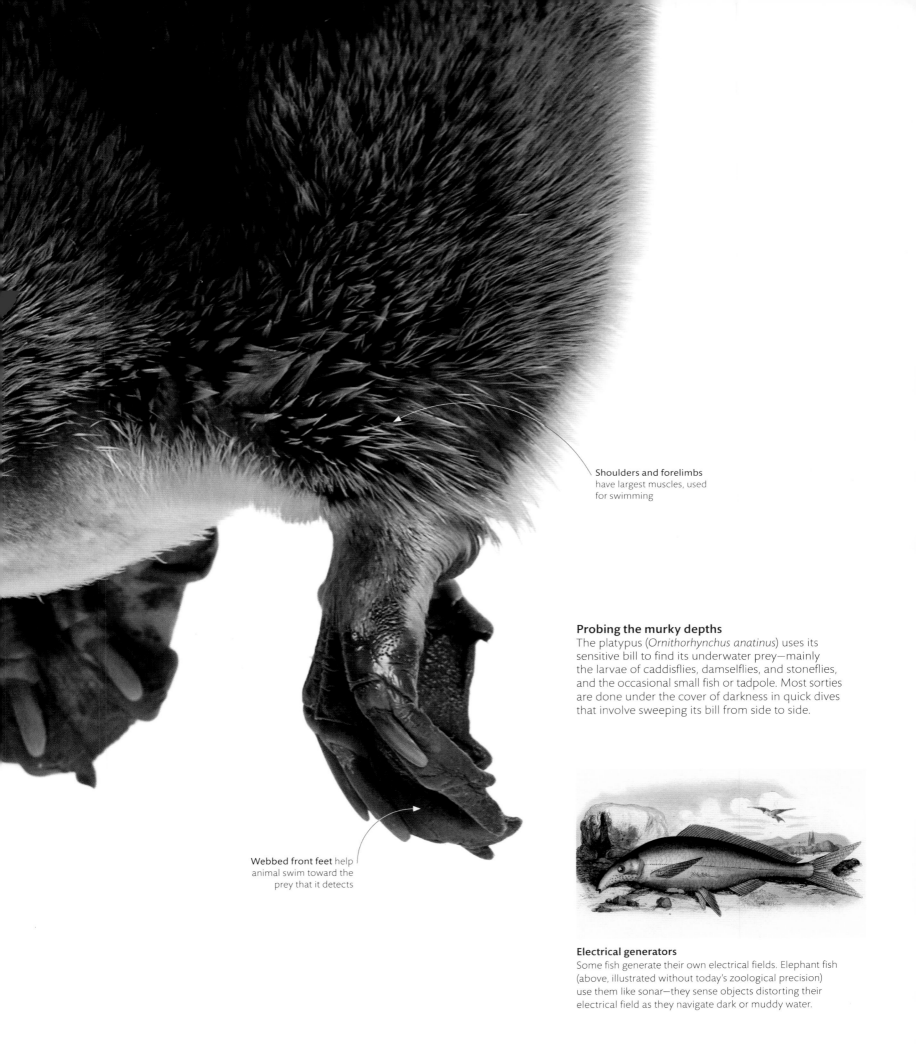

Shoulders and forelimbs have largest muscles, used for swimming

Webbed front feet help animal swim toward the prey that it detects

Probing the murky depths

The platypus (*Ornithorhynchus anatinus*) uses its sensitive bill to find its underwater prey—mainly the larvae of caddisflies, damselflies, and stoneflies, and the occasional small fish or tadpole. Most sorties are done under the cover of darkness in quick dives that involve sweeping its bill from side to side.

Electrical generators

Some fish generate their own electrical fields. Elephant fish (above, illustrated without today's zoological precision) use them like sonar—they sense objects distorting their electrical field as they navigate dark or muddy water.

Eyespots
This planarian flatworm (*Dugesia* sp.) has a dark spot on the inner surface of each eye. The spots screen out light so that each eye senses light coming from a different direction.

Each eye is a "cup" of nerve fibers that detects light on only one side of the dark eye-spot

detecting light

Sensing light requires a pigment that is chemically altered when illuminated. Even bacteria and plants have this, but only animals generate information from light in a way that provides genuine vision. Light stimulates pigment-containing cells in their eyes to send impulses to the brain for processing. The simplest animal eyes—flatworm eyes—sense light and its direction, but complex eyes, like spider eyes, use lenses to focus and create images.

Eyes of a hunter
Most types of spider have eight eyes, each with a lens. Web-building spiders rely more on tactile cues than vision, but pursuit-hunters, such as this jumping spider, use their large, forward-facing eyes to judge both detail and depth when ambushing prey.

FLATWORM AND SPIDER EYES

The eyes of flatworms are little more than clusters of nerve fibers with packages of visual pigment at their swollen ends. Spider eyes are more complex, with a lens that focuses light onto a layer of pigment-containing cells called a retina.

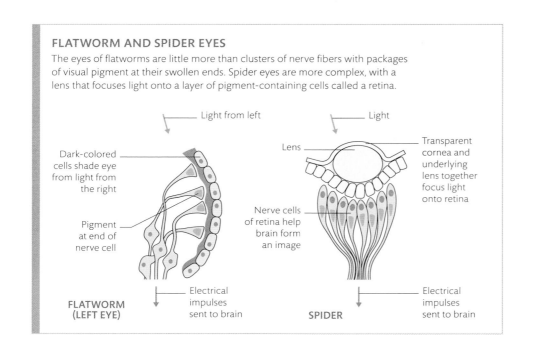

Light from left

Light

Dark-colored cells shade eye from light from the right

Pigment at end of nerve cell

Lens

Transparent cornea and underlying lens together focus light onto retina

Nerve cells of retina help brain form an image

Electrical impulses sent to brain

Electrical impulses sent to brain

FLATWORM (LEFT EYE)

SPIDER

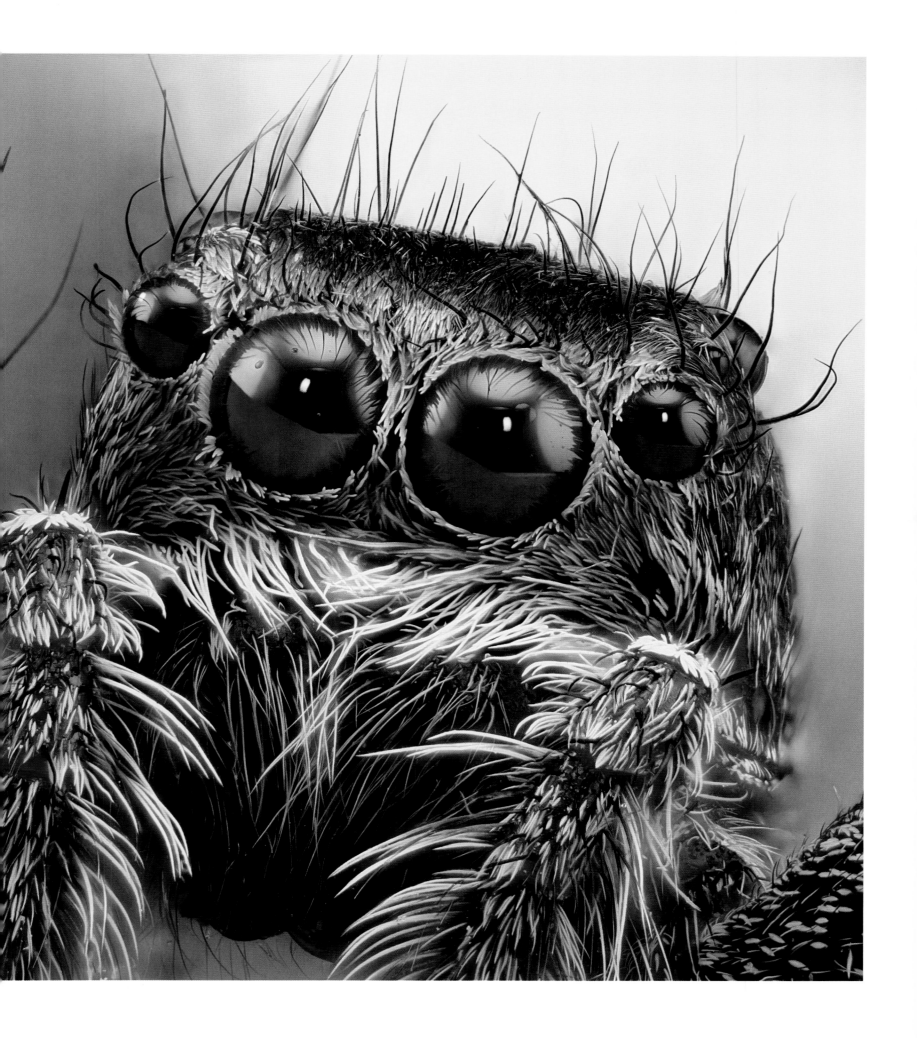

Horizontal pupils

Apart from exceptions such as the predatory mongoose, most mammals with horizontal pupils are grazing herbivores, such as deer and gazelles. Grazing animals spend much of their time with their heads lowered. Horizontal pupils allow them not only to keep the ground in sharp focus, they also help provide a panoramic-type view—vital for predator detection. The eyes constantly rotate to align the horizontal pupil with the ground's focal plane.

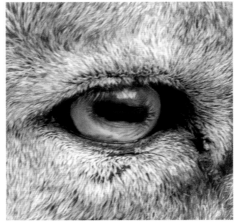

ALPINE IBEX
Capra ibex

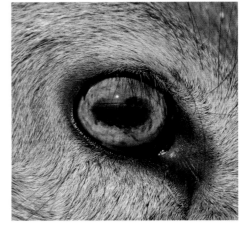

RED DEER
Cervus elaphus

Round pupils

Generally, the greater the distance from the ground, the rounder the pupil—as in taller mammals such as great apes or elephants. Active hunters that rely on strength or speed to catch their prey—such as big cats or wolves—also have circular pupils, as do birds of prey such as owls and eagles, which need to pinpoint prey positions from great heights.

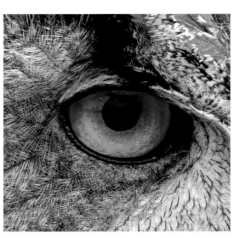

EAGLE OWL
Bubo bubo

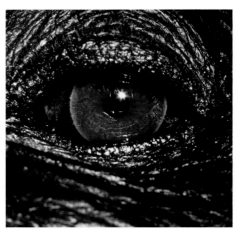

WESTERN GORILLA
Gorilla gorilla

Vertical pupils

Small ambush predators, including smaller cats such as bobcats, that use hide-and-strike techniques to catch their prey often have vertical pupils. This shape is optimal for judging distance without moving their heads—which could alert prey to their presence. Vertical pupils tend to be found in animals that hunt in changing light conditions, as the pupil shape reacts quickly; enlarging in dim light and rapidly constricting in bright conditions.

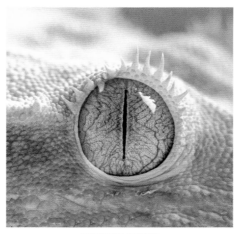

CRESTED GECKO
Correlophus ciliatus

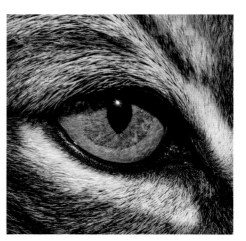

BOBCAT
Lynx rufus

pupil shapes

Pupil shape can be a strong indicator not only of where an animal fits into the food chain, but what types of hunting techniques it uses if it is a predator, or, if it is a prey species, how, what, and where it eats. While some animals have pupils shapes that cannot easily be categorized, most pupils fall into three basic types: horizontal, circular, or vertical.

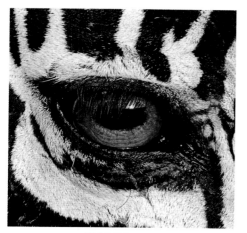

PLAINS ZEBRA
Equus quagga

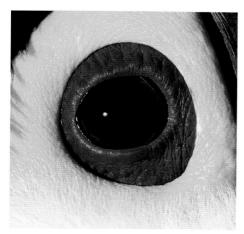

TOCO TOUCAN
Ramphastos toco

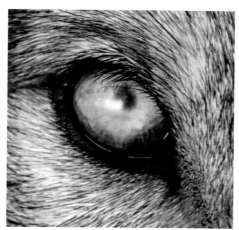

GRAY WOLF
Canis lupus

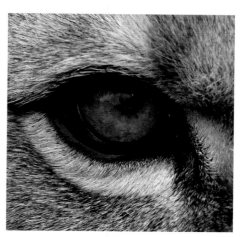

LION
Panthera leo

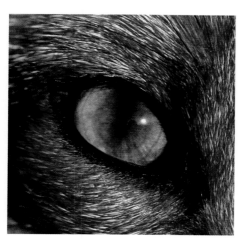

RED FOX
Vulpes vulpes

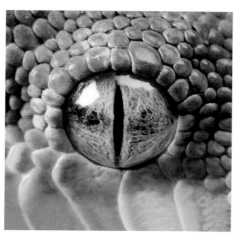

GREEN TREE PYTHON
Morelia viridis

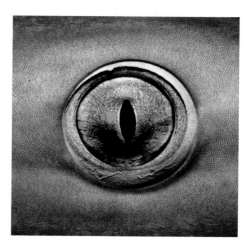

WHITETIP REEF SHARK
Triaenodon obesus

compound eyes

Insects and related animals see the world with the tiniest of lenses, clustered together in hundreds or thousands to form compound eyes. Each lens is part of a visual unit called an ommatidium, or facet, complete with light detectors and nerves that lead to the brain. Individual ommatidia cannot make a sharp image, but collectively they can detect the slightest movement—an object, such as a predatory bird, passing across the eye stimulates one ommatidium after another.

Sensitive eyes
Males of the tapered dronefly (*Eristalis pertinax*) have compound eyes with bigger facets than those of females, enabling them to collect more light for chasing mates. Bigger facets usually results in poorer resolution, but the intricate neural wiring in the eyes of droneflies and other fast-moving true flies produces a visual system that is both ultra-sensitive and high in resolution.

Eyes meet in the middle across the head in male droneflies; females have smaller eyes that do not join

Setae (sensitive bristles) detect tactile stimulation, including movement of air

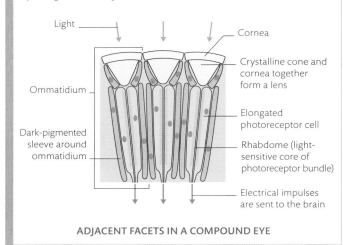

LIGHT-COLLECTING FACETS
Each facet (ommatidium) has a cone-shaped lens that focuses light through a rhabdome—the light-sensitive core of a bundle of long photoreceptor cells. A dark-pigmented sleeve prevents light from passing between adjacent facets.

Light

Cornea

Ommatidium

Crystalline cone and cornea together form a lens

Elongated photoreceptor cell

Dark-pigmented sleeve around ommatidium

Rhabdome (light-sensitive core of photoreceptor bundle)

Electrical impulses are sent to the brain

ADJACENT FACETS IN A COMPOUND EYE

Each tiny lens in a compound eye collects less light than do the larger, single-lens eyes of vertebrates

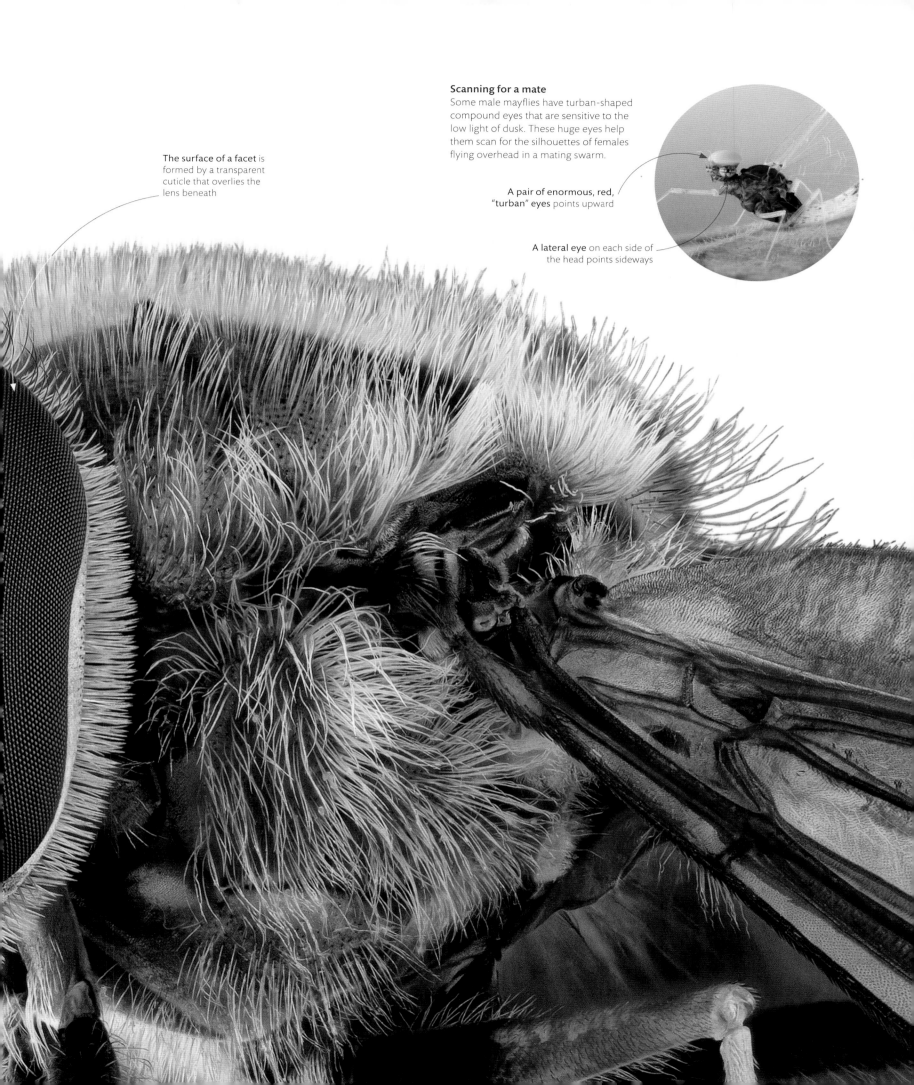

The surface of a facet is formed by a transparent cuticle that overlies the lens beneath

Scanning for a mate
Some male mayflies have turban-shaped compound eyes that are sensitive to the low light of dusk. These huge eyes help them scan for the silhouettes of females flying overhead in a mating swarm.

A pair of enormous, red, "turban" eyes points upward

A lateral eye on each side of the head points sideways

Colorful crustacean
On brightly colored coral reefs, mantis shrimp use their color vision to detect food, mates, and competitors.

Colorful, paddlelike antennal scales are used for signaling over territory and during courtship

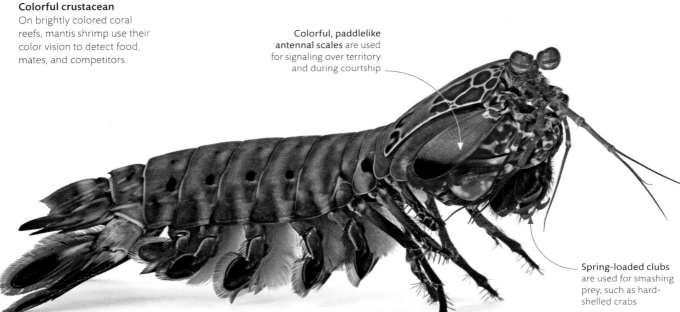

Spring-loaded clubs are used for smashing prey, such as hard-shelled crabs

color vision

The eyes of many animals go further than just detecting light—they can discriminate wavelengths of light, too. This means that they sense color, from short-wave blue to long-wave red, and the spectrum in-between. They are able to do so because their eyes contain different kinds of visual pigments that absorb the different wavelengths. Living in a colorful world means animals can pick up on many more visual signals, such as enticements to mate during courtship, or warnings to stay away from danger.

Broadening the spectrum
Humans have three kinds of color-sensitive visual pigments; the compound eyes of a peacock mantis shrimp (*Odontodactylus scyllarus*) contain 12. It can see wavelengths that are invisible to humans, such as ultraviolet and infrared.

Complex, multicolored pattern is important in social signaling

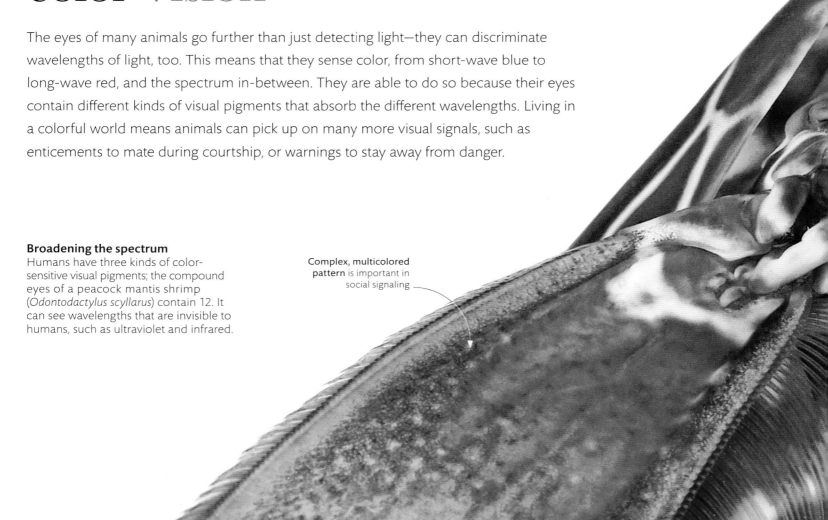

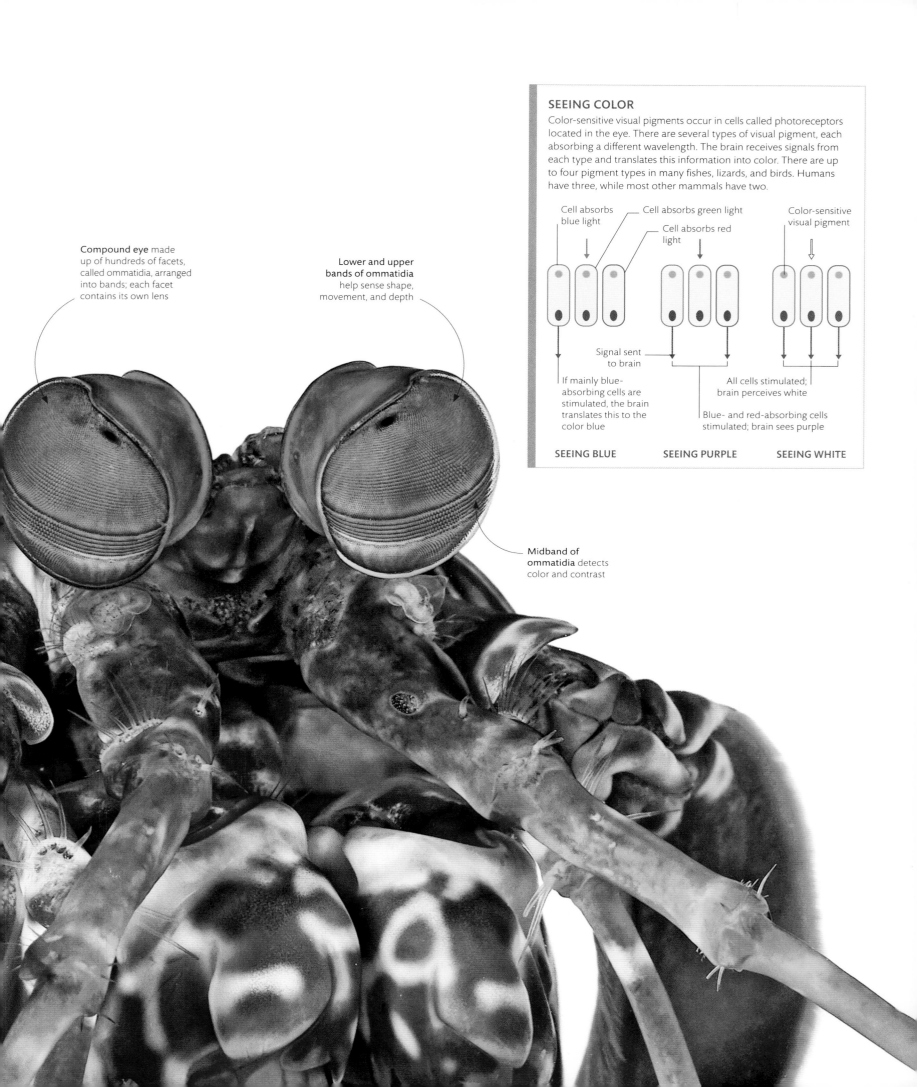

Compound eye made up of hundreds of facets, called ommatidia, arranged into bands; each facet contains its own lens

Lower and upper bands of ommatidia help sense shape, movement, and depth

Midband of ommatidia detects color and contrast

SEEING COLOR

Color-sensitive visual pigments occur in cells called photoreceptors located in the eye. There are several types of visual pigment, each absorbing a different wavelength. The brain receives signals from each type and translates this information into color. There are up to four pigment types in many fishes, lizards, and birds. Humans have three, while most other mammals have two.

Cell absorbs blue light

Cell absorbs green light

Cell absorbs red light

Color-sensitive visual pigment

Signal sent to brain

If mainly blue-absorbing cells are stimulated, the brain translates this to the color blue

All cells stimulated; brain perceives white

Blue- and red-absorbing cells stimulated; brain sees purple

SEEING BLUE **SEEING PURPLE** **SEEING WHITE**

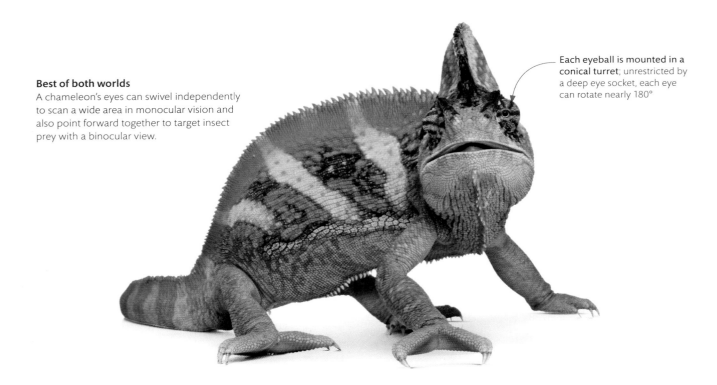

Best of both worlds
A chameleon's eyes can swivel independently to scan a wide area in monocular vision and also point forward together to target insect prey with a binocular view.

Each eyeball is mounted in a conical turret; unrestricted by a deep eye socket, each eye can rotate nearly 180°

seeing depth

Unlike the simpler eyes of many invertebrates, the paired eyes of vertebrates have lenses that adjust their position or shape to focus at different distances. Their light-detecting cells, or photoreceptors, form a layer called the retina at the back of the eye. The cells' extraordinary sensitivity provides the brain with sufficient data for the animal to see a detailed, even three-dimensional, picture of the world around them.

JUDGING DISTANCE

Animals with their eyes on the sides of the head scan a wide area in separate monocular ("one-eye") fields of view. Those with forward-facing eyes have overlapping fields combined into a binocular ("two-eye") view. Although this narrows the total field of view, the brain combines the slightly different views coming from left and right within the region of overlap to create a sense of depth, allowing more accurate judging of distances.

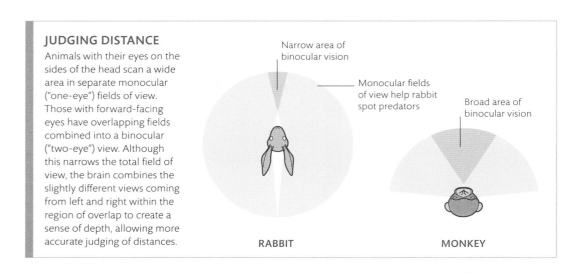

Narrow area of binocular vision

Monocular fields of view help rabbit spot predators

Broad area of binocular vision

RABBIT

MONKEY

Nocturnal tree-dweller
The lifestyle of the spectral tarsier (*Tarsius tarsier*) places great demands on its binocular vision. Not only must the tarsier judge distances accurately with its huge, forward-facing eyes when leaping through trees, it must also do so in the dark of a rain forest night.

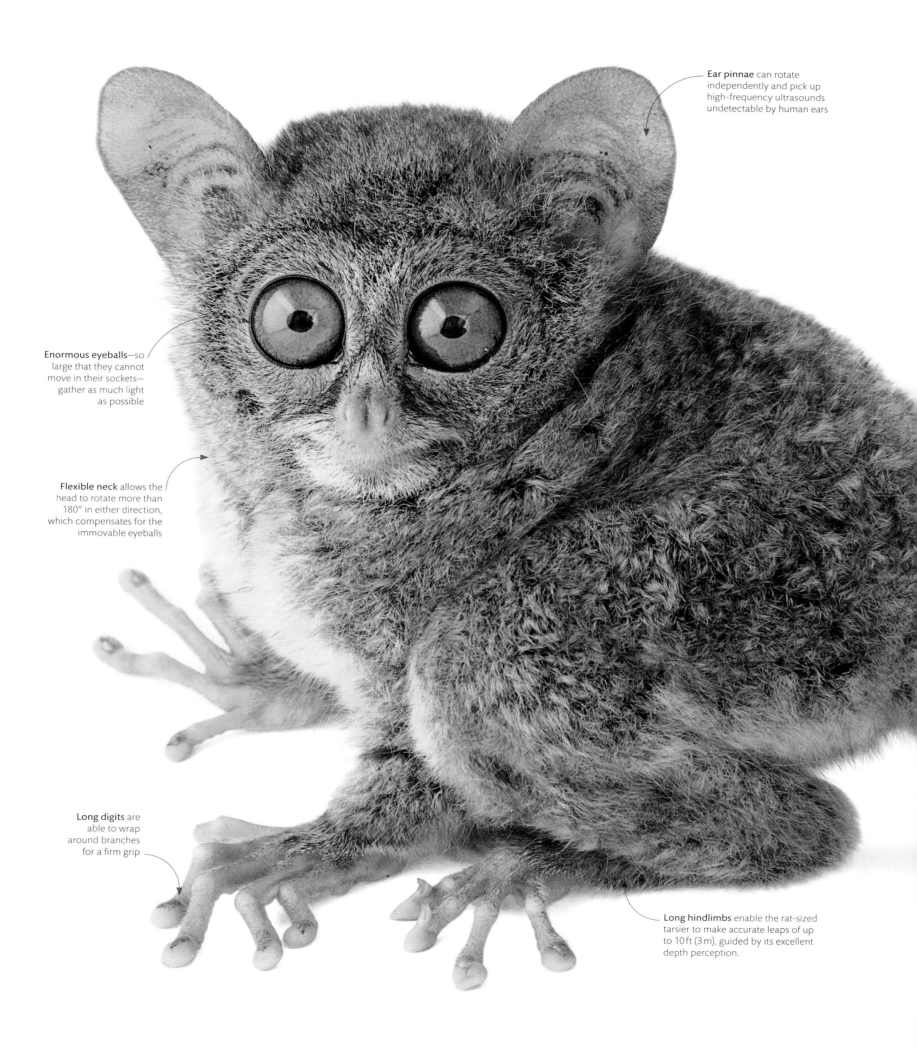

Ear pinnae can rotate independently and pick up high-frequency ultrasounds undetectable by human ears

Enormous eyeballs—so large that they cannot move in their sockets—gather as much light as possible

Flexible neck allows the head to rotate more than 180° in either direction, which compensates for the immovable eyeballs

Long digits are able to wrap around branches for a firm grip

Long hindlimbs enable the rat-sized tarsier to make accurate leaps of up to 10 ft (3 m), guided by its excellent depth perception.

common kingfisher

The distinctive common kingfisher (*Alcedo atthis*) certainly lives up to its name. This bird cannot pursue prey underwater like some seabirds: for example, penguins have denser bones and tight-fitting plumage that works like a swimsuit, so they can plunge the depths for food. Instead, the kingfisher must first target fish accurately from its perch above the water.

There are more than 100 species of kingfishers, but most—such as the Australasian kookaburras—hunt on land. It is likely that kingfishers evolved in tropical forests, where they are still at their most diverse, and used their daggerlike bills to snatch small animals from the ground. Only about 25 percent of them—including the common kingfisher of Eurasia—specialize in diving for fish.

Diving kingfishers must be accurate and fast, and their hunting instinct is so strong that in winter they will smash thin ice to get a meal. Their hollow bones and waterproof plumage make them very buoyant and they cannot stay submerged, so kingfishers target their prey before they hit the water. From a favorite riverside spot, a bird selects a fish in the water beneath it. It adjusts its angle of attack to take account of the way light from its target bends at the water surface (see below). Then the dive begins. The bird plunges in toward its prey, pulling back its wings to form a streamlined shape that can cut through the water. An opaque eyelid—the nictitating membrane found in many vertebrates—pulls over its eyes to protect them. The bird grabs the fish with its bill, then buoyancy and a few wing flaps bring it back to the surface. Back on its perch, the bird holds the fish by its tail, smashes its head against the branch, then flips it and swallows it head-first, so the backward-pointing scales go down more easily. From start to finish, the entire episode lasts only a few seconds.

Flash of blue

The common kingfisher's diet is 60 percent fish—the rest being aquatic invertebrates. This bird typically dives steeply from about 3–6 ft (1–2 m) above the water, plunging to a depth of 3 ft (1 m).

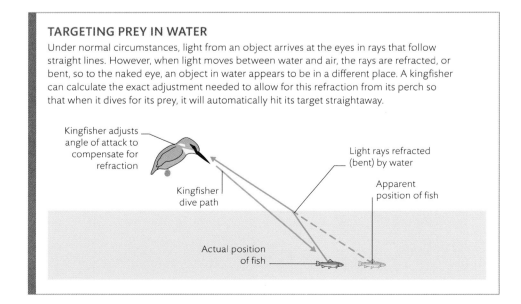

TARGETING PREY IN WATER

Under normal circumstances, light from an object arrives at the eyes in rays that follow straight lines. However, when light moves between water and air, the rays are refracted, or bent, so to the naked eye, an object in water appears to be in a different place. A kingfisher can calculate the exact adjustment needed to allow for this refraction from its perch so that when it dives for its prey, it will automatically hit its target straightaway.

Kingfisher adjusts angle of attack to compensate for refraction

Light rays refracted (bent) by water

Kingfisher dive path

Apparent position of fish

Actual position of fish

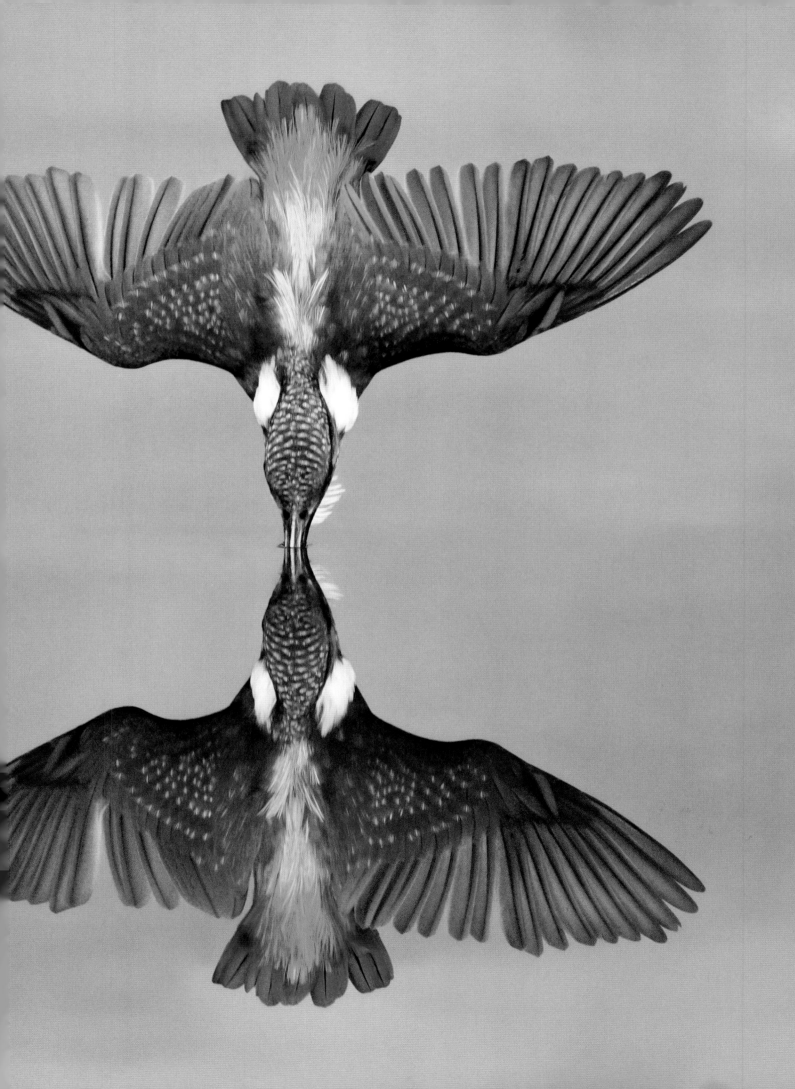

Scare tactics
The wing pattern of both the male (below) and female polyphemus moth serves to startle predators, such as frogs and birds, by flashing spots that resemble the eyes of a hunting owl.

Longest part of the antennae, the flagellum, is highly modified for accommodating sensory receptors

scent detection

Smell or taste is often associated with food, but can also signal remarkably precise information about other animals nearby. Prey species, for instance, might sense a predator by detecting a substance that is unique to them. And many social signals, such advertisements to mate, take the form of chemical perfumes called pheromones that attract animals with the sensitivity to detect them—sometimes from a considerable distance.

Base of antenna is flexible and contains sensors that are triggered when flagellum is moved by air currents

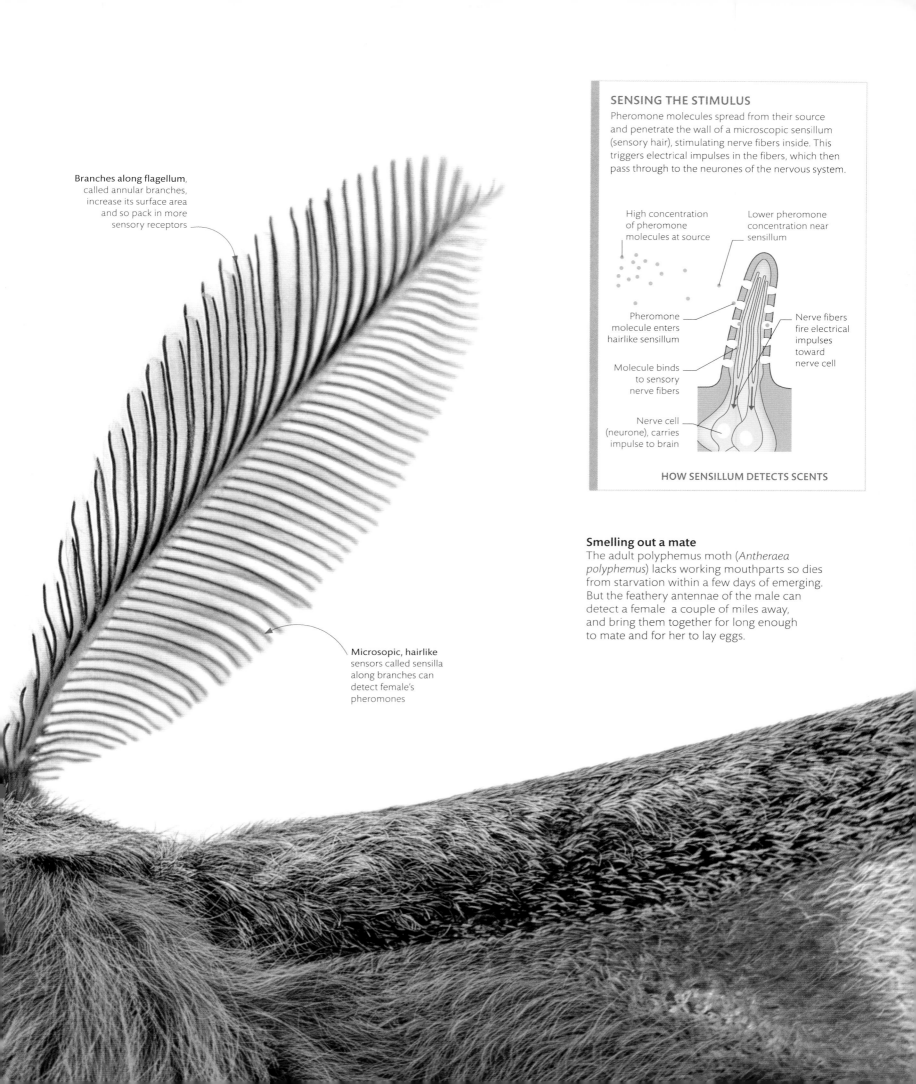

Branches along flagellum, called annular branches, increase its surface area and so pack in more sensory receptors

Microsopic, hairlike sensors called sensilla along branches can detect female's pheromones

SENSING THE STIMULUS
Pheromone molecules spread from their source and penetrate the wall of a microscopic sensillum (sensory hair), stimulating nerve fibers inside. This triggers electrical impulses in the fibers, which then pass through to the neurones of the nervous system.

High concentration of pheromone molecules at source

Lower pheromone concentration near sensillum

Pheromone molecule enters hairlike sensillum

Nerve fibers fire electrical impulses toward nerve cell

Molecule binds to sensory nerve fibers

Nerve cell (neurone), carries impulse to brain

HOW SENSILLUM DETECTS SCENTS

Smelling out a mate
The adult polyphemus moth (*Antheraea polyphemus*) lacks working mouthparts so dies from starvation within a few days of emerging. But the feathery antennae of the male can detect a female a couple of miles away, and bring them together for long enough to mate and for her to lay eggs.

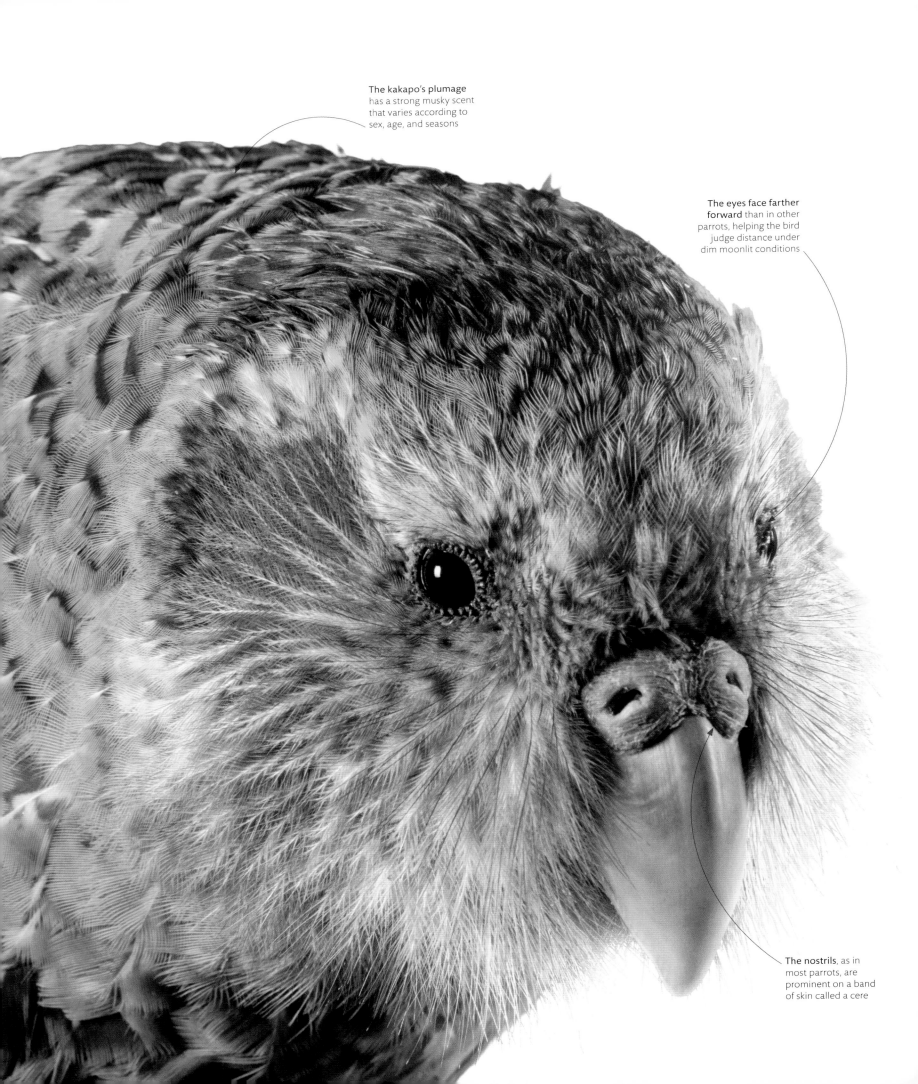

The kakapo's plumage has a strong musky scent that varies according to sex, age, and seasons

The eyes face farther forward than in other parrots, helping the bird judge distance under dim moonlit conditions

The nostrils, as in most parrots, are prominent on a band of skin called a cere

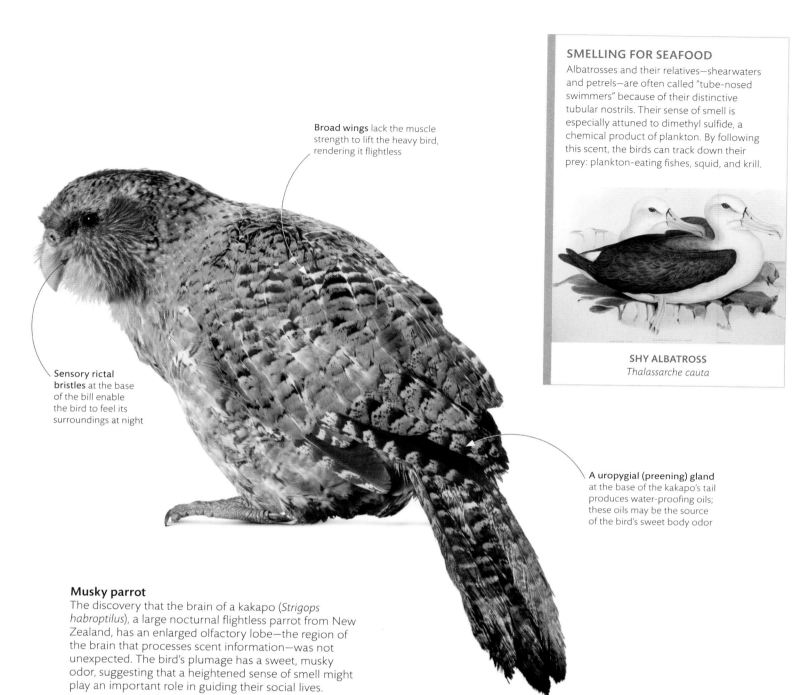

Broad wings lack the muscle strength to lift the heavy bird, rendering it flightless

SMELLING FOR SEAFOOD
Albatrosses and their relatives—shearwaters and petrels—are often called "tube-nosed swimmers" because of their distinctive tubular nostrils. Their sense of smell is especially attuned to dimethyl sulfide, a chemical product of plankton. By following this scent, the birds can track down their prey: plankton-eating fishes, squid, and krill.

SHY ALBATROSS
Thalassarche cauta

Sensory rictal bristles at the base of the bill enable the bird to feel its surroundings at night

A uropygial (preening) gland at the base of the kakapo's tail produces water-proofing oils; these oils may be the source of the bird's sweet body odor

Musky parrot
The discovery that the brain of a kakapo (*Strigops habroptilus*), a large nocturnal flightless parrot from New Zealand, has an enlarged olfactory lobe—the region of the brain that processes scent information—was not unexpected. The bird's plumage has a sweet, musky odor, suggesting that a heightened sense of smell might play an important role in guiding their social lives.

smell in birds

Most types of birds seem to use vision or hearing more than their sense of smell, but smell still has a role to play in their lives, and many species rely on it. Albatrosses, for example, fly crosswind over the ocean to pick up the scent of prey in the water below, while turkey vultures can smell carrion on the ground from far away. It is now thought that most birds even produce their own unique odor profiles, helping individuals recognize one another or locate their nests.

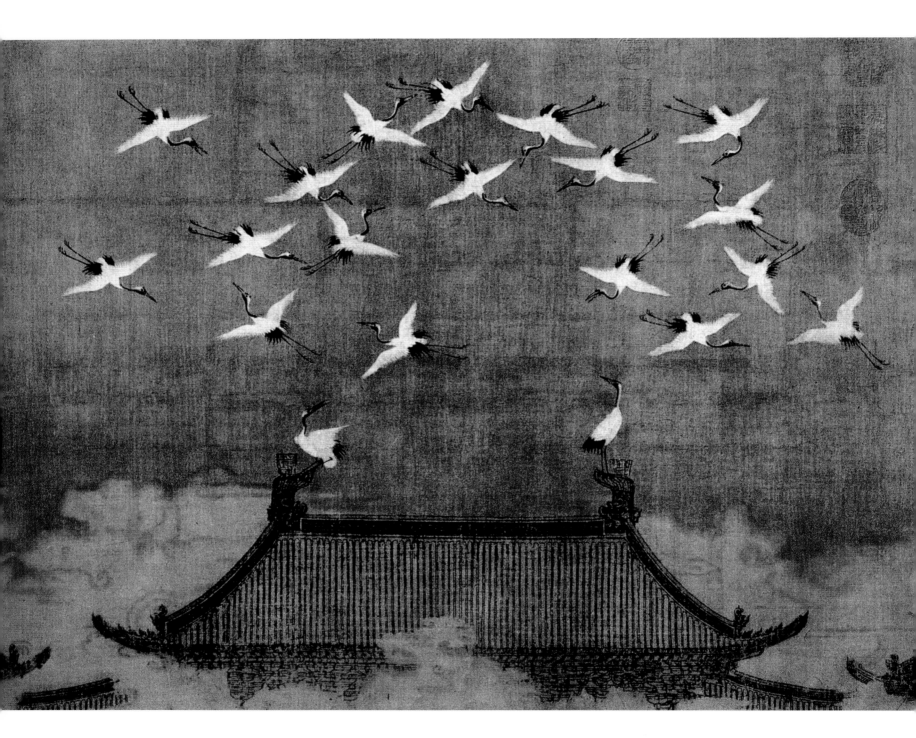

Auspicious Cranes (1112)
A silk handscroll of 20 cranes whirling against
an azure sky commemorates the auspicious
gathering of a cloud of cranes above the roof
of the royal palace. Emperor Huizong (1082–1135),
an artist and poet in his own right, created this
magical piece of work under his own name—
Zhao Ji—in recognition of the event.

Song birds

During a period of extraordinary creativity that became known as the "Chinese Renaissance," artists of the Northern Song Dynasty produced paintings and poetry with a sensitivity and lyricism that would not be equalled elsewhere in the world for the next 400 years. The landscapes, animals, and, in particular, bird paintings produced during the 12th century are regarded by experts as the finest in the history of Chinese art.

At the heart of the enterprise was Zhao Ji, an unprepared heir to the throne who had spent his childhood indulging his passions for the arts with little regard for state affairs. He was crowned Emperor Huizong but finished his disastrous 26-year reign in penury as a common prisoner after the collapse of the Northern Song Dynasty and defeat by Jurchen forces. During his years as ruler, Huizong was a patron who brought the finest artists to his court and who was himself gifted in painting, calligraphy, poetry, music, and architecture.

The intertwined arts of poetry, calligraphy, and painting were used mainly on silk hand scrolls that were designed to be unfurled and read in sections from right to left. Some vertical scrolls were displayed briefly on walls, but most were personal to the viewer rather than public exhibits. The traditional subjects were landscapes and intimate naturalistic animal and bird portraits. Birds as subjects were steeped in the tradition of augury: Mandarin ducks represented happiness and loyalty because they mate for life and were said to pine to death at the loss of a mate; doves denoted love and fidelity; owls were an ill omen; cranes symbolized longevity and wisdom. A flock of 20 cranes descending through sunlit clouds over the royal palace in 1112 was seen as an auspicious sign; Zhao Ji depicted the event with a painting and poem of breathtaking beauty.

The legacy of the Song Dynasty is visible in the work of late 19th- and early 20th-century artists who began to experiment with a synthesis between traditional landscape, flower, fish, and bird painting and Western styles. Brothers Gao Jianfu and Gao Qifeng studied "Nihonga" fusion painting in Japan before establishing, with Chen Shuren, the Lingnan School in the Guangdong region of China. By the 1920s, the Lingnan style had become distinctive. Characterized by blank space and bright coloring, today it remains a popular fusion of old and new.

Woodpecker (1927)
Traditional Chinese flower and bird painting is combined with Western styles and Japanese white highlights in Gao Qifeng's woodpecker. The dry brushstrokes on the scroll are typical of the school that he established, which was based on Japanese Nihonga art.

> ❝ Immortal birds, proclaiming good news, suddenly appear with their measured dance. ❞
>
> ZHAO JI, IN HIS POEM , *AUSPICIOUS CRANES*, 1112

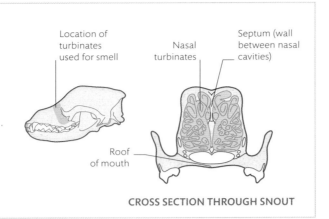

TURBINATES
The rear part of the snout
of most mammals is packed with
a labyrinth of paper-thin, scroll-
like bony walls called turbinates.
Turbinates increase the surface
area for olfactory epithelium: a
lining of sensory cells connected
to nerve endings. These detect a
huge variety of scent molecules,
even at low concentration. Most
mammals—except for whales,
dolphins, and most primates—
have a good sense of smell.

Location of
turbinates
used for smell

Nasal
turbinates

Septum (wall
between nasal
cavities)

Roof
of mouth

CROSS SECTION THROUGH SNOUT

smell in mammals

The noses of land vertebrates evolved from the simple nasal pits of their fish
ancestors into more complex scent-detecting channels. These connect to the
back of the mouth, so breathing is possible even with the mouth closed. In
mammals, large nasal chambers warm and moisten the incoming air before
it reaches the olfactory epithelium (see box). Sensory cells in the lining detect
smells from food sources, as well as signaling chemicals, called pheromones,
that play an important role in the social lives of mammals.

Rhinarium (a tough nose
disk supported by cartilage)
is used to push into hard soil
and excavate buried food

Fleshy tentacles
encircle each nostril

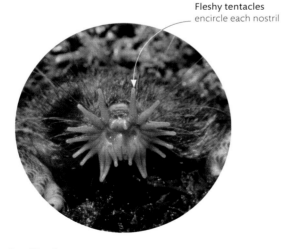

Nostrils can be closed
to prevent soil and
debris from entering
the nasal passages

Tip of the snout is moved
by small muscles, so the
pig can probe for food
without moving its head

Smelling in water
The star-nosed mole (*Condylura cristata*) forages
for invertebrates in waterlogged ground by
blowing out bubbles and breathing them back
in to detect the scent of food. It also feels for prey
with 25,000 touch receptors on its nasal tentacles.

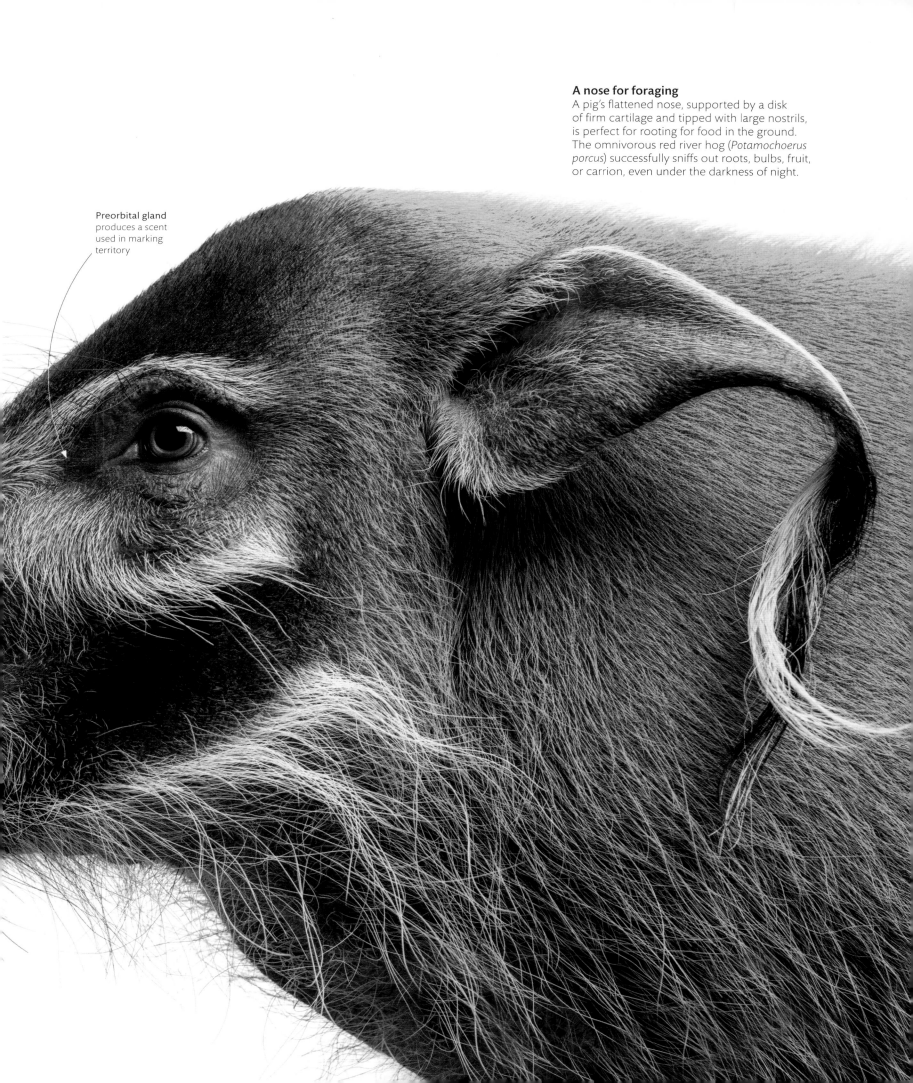

A nose for foraging
A pig's flattened nose, supported by a disk of firm cartilage and tipped with large nostrils, is perfect for rooting for food in the ground. The omnivorous red river hog (*Potamochoerus porcus*) successfully sniffs out roots, bulbs, fruit, or carrion, even under the darkness of night.

Preorbital gland produces a scent used in marking territory

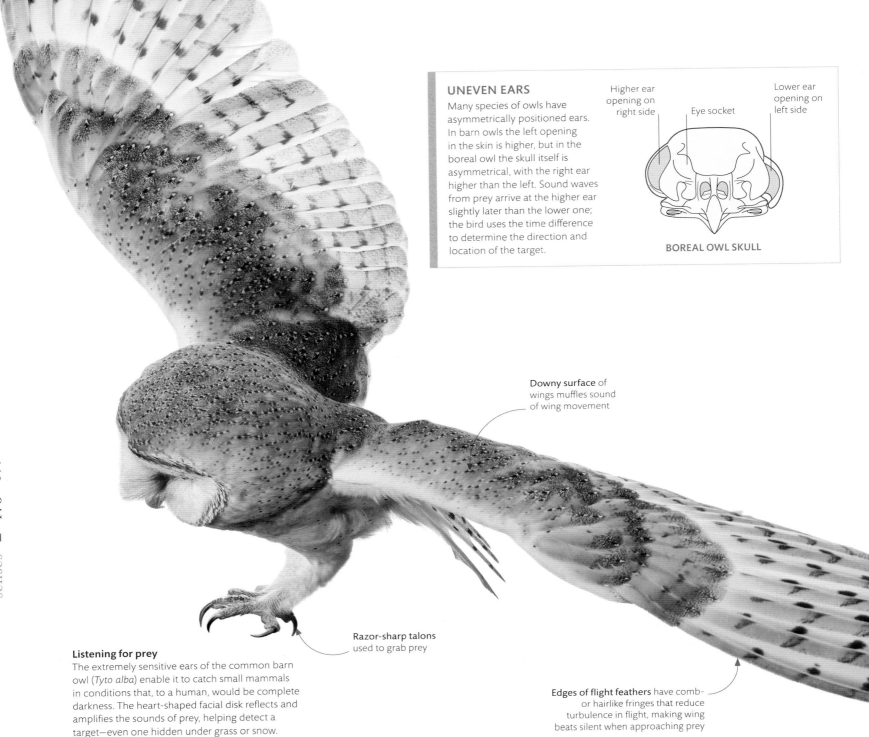

UNEVEN EARS

Many species of owls have asymmetrically positioned ears. In barn owls the left opening in the skin is higher, but in the boreal owl the skull itself is asymmetrical, with the right ear higher than the left. Sound waves from prey arrive at the higher ear slightly later than the lower one; the bird uses the time difference to determine the direction and location of the target.

Higher ear opening on right side

Eye socket

Lower ear opening on left side

BOREAL OWL SKULL

Downy surface of wings muffles sound of wing movement

Listening for prey
The extremely sensitive ears of the common barn owl (*Tyto alba*) enable it to catch small mammals in conditions that, to a human, would be complete darkness. The heart-shaped facial disk reflects and amplifies the sounds of prey, helping detect a target—even one hidden under grass or snow.

Razor-sharp talons used to grab prey

Edges of flight feathers have comb- or hairlike fringes that reduce turbulence in flight, making wing beats silent when approaching prey

how animals hear

Animals hear by detecting vibrations, or sound waves. Inside their ears, vertebrates have sound-sensitive cells with cilia (microscopic hairs) that deflect when sound waves pass over them, triggering nerve signals that the brain interprets as sound. Land vertebrates, such as birds, have an eardrum (see p.178) that transmits and amplifies sound waves from the air into the inner ear, where the animal discriminates loudness and pitch.

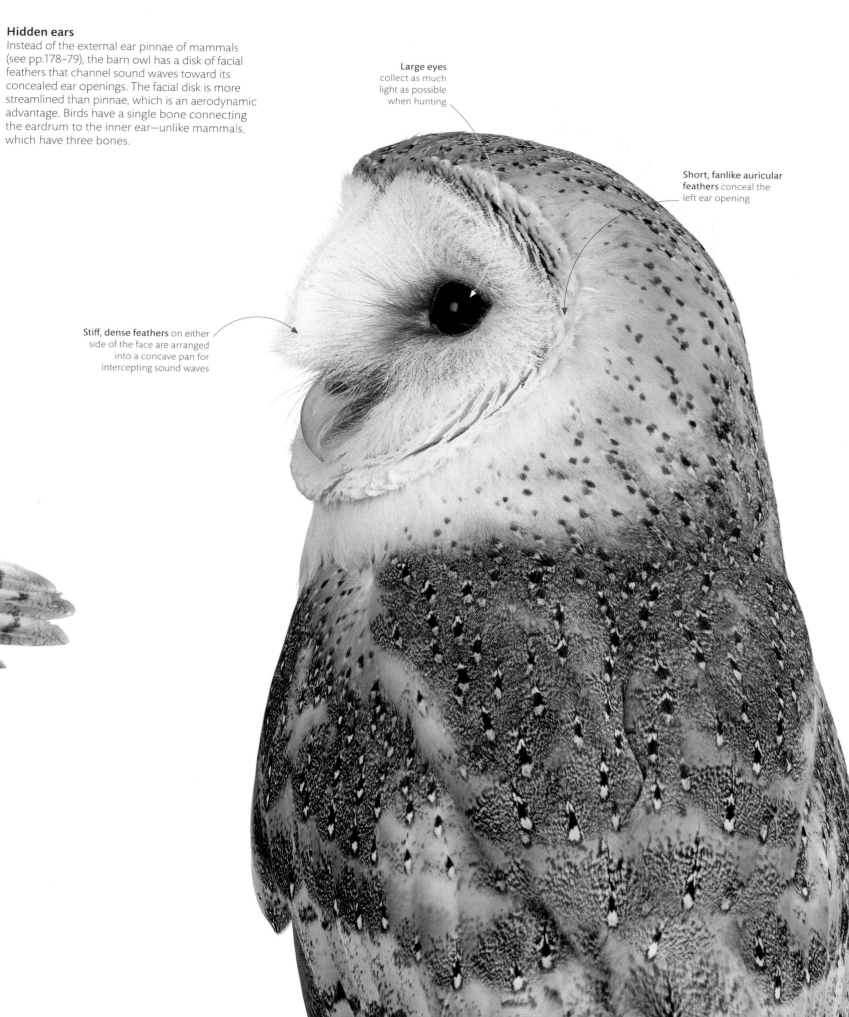

Hidden ears

Instead of the external ear pinnae of mammals (see pp.178–79), the barn owl has a disk of facial feathers that channel sound waves toward its concealed ear openings. The facial disk is more streamlined than pinnae, which is an aerodynamic advantage. Birds have a single bone connecting the eardrum to the inner ear—unlike mammals, which have three bones.

Large eyes collect as much light as possible when hunting

Short, fanlike auricular feathers conceal the left ear opening

Stiff, dense feathers on either side of the face are arranged into a concave pan for intercepting sound waves

Large-eared omnivore
Native to the South American pampas, the maned wolf (*Chrysocyon brachyurus*) uses its large ears to listen for prey among the tall grasses. However, only 20 percent of its hunting attempts end with a meal, so up to half of its diet is made up of fruit.

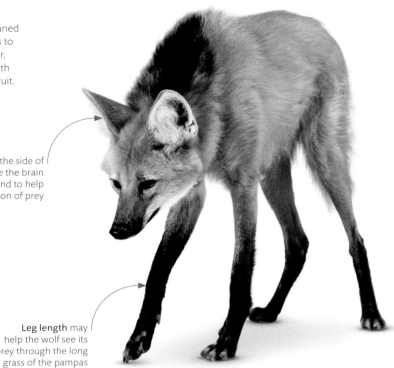

Ear openings on the side of the head provide the brain with stereo sound to help judge the position of prey

Leg length may help the wolf see its prey through the long grass of the pampas

mammal ears

Mammals rely on their hearing more than many other animals, both to listen for danger—especially at night—and to hunt for prey. Several features have evolved in mammals that improve their sense of hearing. Inside a mammal's head, the ears have evolved three bones, or ossicles, that amplify sound vibrations. On the outside, they have two fleshy pinnae, or natural trumpets, that direct sounds into the ear toward the amplifying system.

Acute sense of smell combined with superb hearing and vision enables this animal to hunt effectively at night

MAMMALIAN HEARING

The working parts of a mammal's ear lie deep inside its head. Sound waves (see p.180) are channeled into the ear canal, where they vibrate a membranous drum. The vibrations are then transmitted through a chain of tiny bones, or ossicles, toward the inner ear. Here, cells in a fluid-filled coiled tube, the cochlea, detect the vibration and send nerve impulses toward the brain.

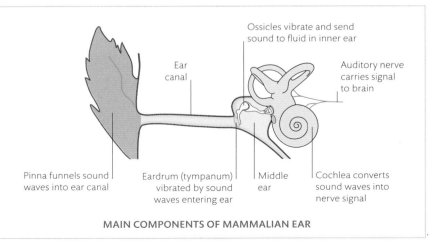

Ossicles vibrate and send sound to fluid in inner ear

Ear canal

Auditory nerve carries signal to brain

Pinna funnels sound waves into ear canal

Eardrum (tympanum) vibrated by sound waves entering ear

Middle ear

Cochlea converts sound waves into nerve signal

MAIN COMPONENTS OF MAMMALIAN EAR

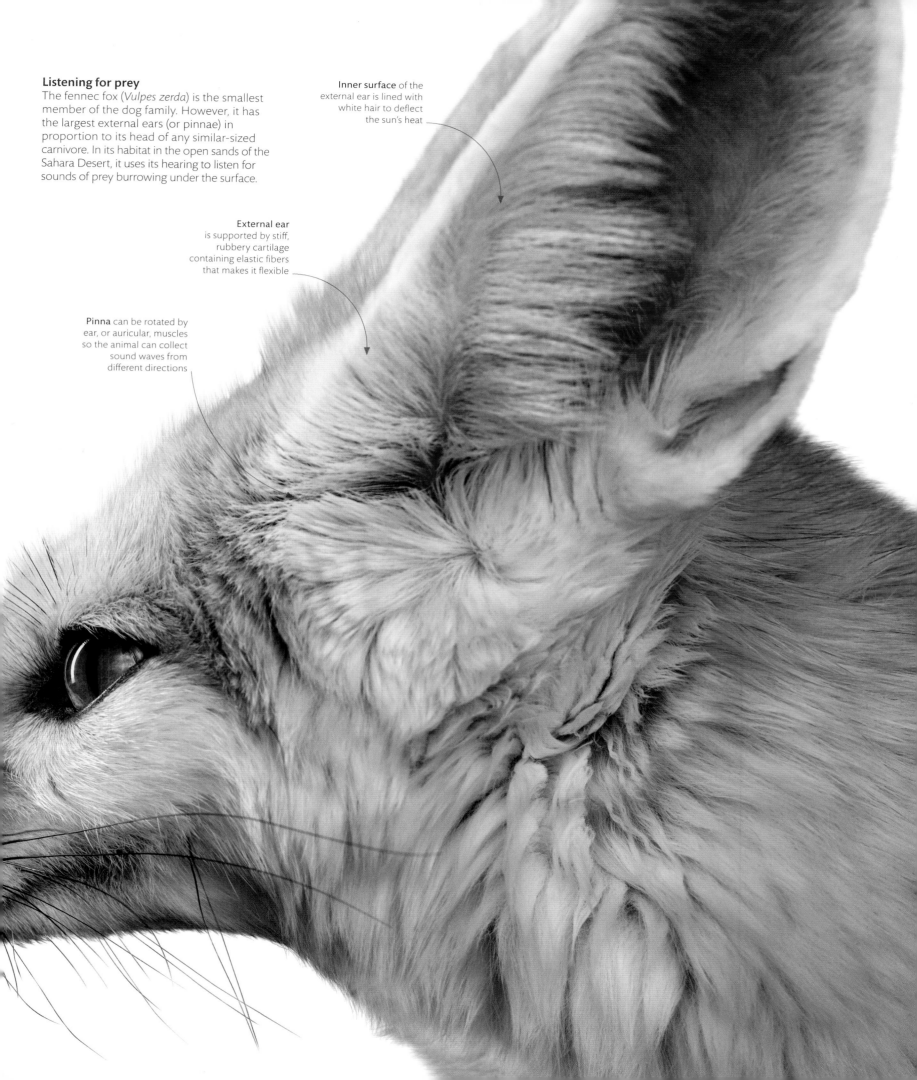

Listening for prey
The fennec fox (*Vulpes zerda*) is the smallest member of the dog family. However, it has the largest external ears (or pinnae) in proportion to its head of any similar-sized carnivore. In its habitat in the open sands of the Sahara Desert, it uses its hearing to listen for sounds of prey burrowing under the surface.

Inner surface of the external ear is lined with white hair to deflect the sun's heat

External ear is supported by stiff, rubbery cartilage containing elastic fibers that makes it flexible

Pinna can be rotated by ear, or auricular, muscles so the animal can collect sound waves from different directions

NATURAL SONAR

With each pulse of sound it emits—using the larynx in microbats, but with the tongue in some large fruit bats—the bat disarticulates its inner ear bones to avoid self-deafening, restoring them a fraction of a second later to receive the echo. The pulses have a moth-sized wavelength—any longer, and the sound would fail to reflect strongly. Using high-frequency (short wavelength) sound ensures good reflection from small objects, as well as fine discrimination and resolution.

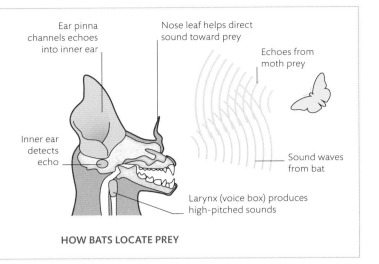

Ear pinna channels echoes into inner ear

Nose leaf helps direct sound toward prey

Echoes from moth prey

Inner ear detects echo

Sound waves from bat

Larynx (voice box) produces high-pitched sounds

HOW BATS LOCATE PREY

Echolocators

Among bats, the microbats possess the most impressive echolocation abilities. A diversity of facial equipment—nose leaves that focus sound pulses and large ears that receive the echoes—has evolved in more than 1,000 microbat species. Nose leaves are often highly developed in species that emit calls through the nostrils. However, most microbats actually emit their calls through the mouth, so they lack the elaborate nose leaf or facial ornament.

listening for echoes

When vision is compromized at night or in murky water, some animals rely on a natural form of sonar called echolocation. By listening for the echoes of sounds that the animal emits, it can build up a picture of its surroundings. Bats use echolocation to negotiate obstacles and pinpoint flying insects. The echoes from their high-frequency calls tell the bats the size, shape, position, and distance of objects, and even the texture.

Sound directors, sound detectors

Nose leaves that focus echolocation pulses are found in microbats such as horseshoe bats, false vampire bats, and leaf-nosed bats. Some bats can instantly change the shape of their large ear pinnae to pinpoint the source of echoes from prey.

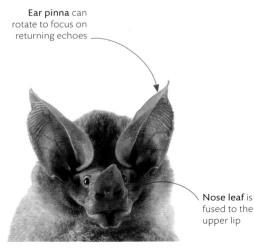

Ear pinna can rotate to focus on returning echoes

Nose leaf is fused to the upper lip

WHITE-THROATED ROUND-EARED BAT
Lophostoma silvicolum

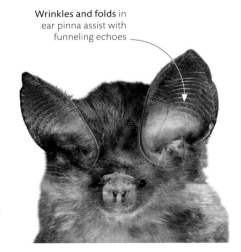

Wrinkles and folds in ear pinna assist with funneling echoes

POMONA LEAF-NOSED BAT
Hipposideros pomona

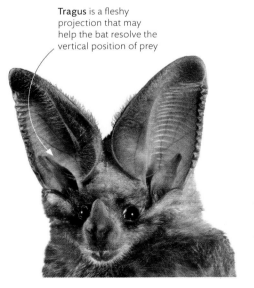

Tragus is a fleshy projection that may help the bat resolve the vertical position of prey

CALIFORNIA LEAF-NOSED BAT
Macrotus californicus

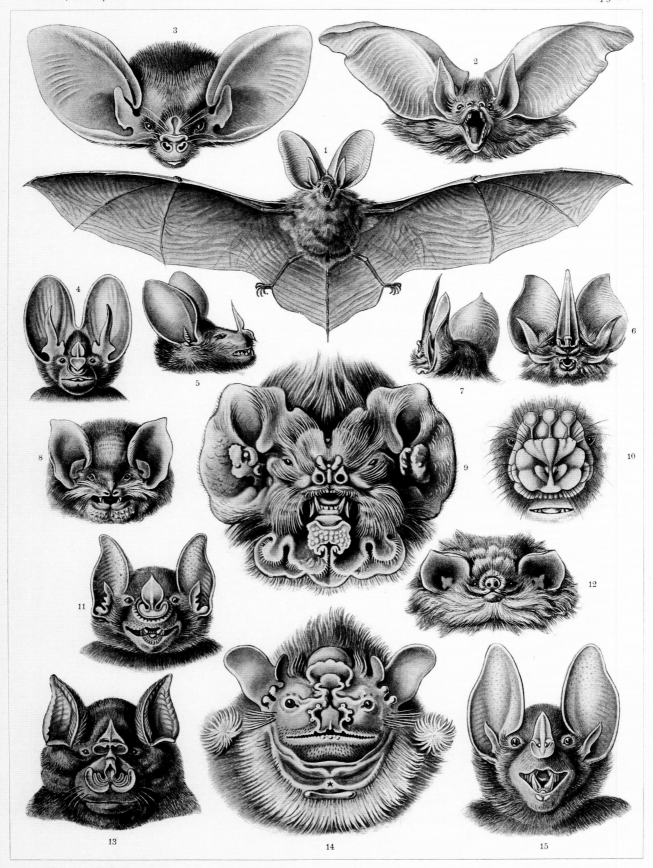

Chiroptera. — Flebertiere.

common dolphin

The intelligence of dolphins is well known and shown by their complex behavior. As a proportion of body size, their brains are second only to humans. Not only are common dolphins (*Delphinus* spp.) highly skilled at targeting prey, but they even work together to maximize their catch.

Common dolphins swim in warm ocean waters around the world, generally no deeper than about 600 ft (180 m). Like other cetaceans, dolphins are about as well adapted to life in water as it is possible for an air-breathing mammal to be. The entire body is hydrodynamic—it is propelled by a tail fluke (see pp.274–75), steered with front flippers, and its nostrils are fashioned as a blowhole in the top of the head.

A dolphin's brain is a powerful information processor. Sound travels better in water than in air, and dolphins locate prey by echolocation. They beam clicks produced below the blowhole through an oil-filled "melon" in their forehead, and direct the returning echo toward the inner ear through oily channels in the lower jaw. The region of the brain concerned with auditory information is greatly expanded to deal with the data received; only parts of the brain involved in olfaction are reduced compared with other mammals that rely more on a sense of smell.

But a dolphin uses its brain for more than just decoding sensory input. The mammalian neocortex, a folded surface layer of brain tissue—and seat of the highest cognitive skills—is especially well developed, which explains why they are so good at storing memories, making reasoned decisions, and inventing new behaviors. A pod of common dolphins can communicate so well that they cooperate when hunting fishes, herding them into tighter schools for easier pickings.

Cooperative brains
Long-nosed common dolphins (*Delphinus capensis*) swim in waters over the continental shelves—a pod is seen here forcing sardines into a bait-ball. A second, short-nosed species (*D. delphis*) lives farther offshore.

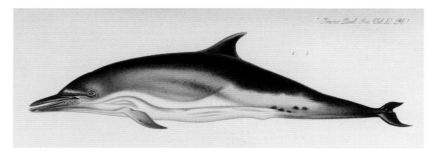

Colorful disguise
A 19th-century illustration depicts the color patches on common dolphins—among the brightest of all cetaceans—which may serve to break up their outline, helping them avoid detection by bigger predators.

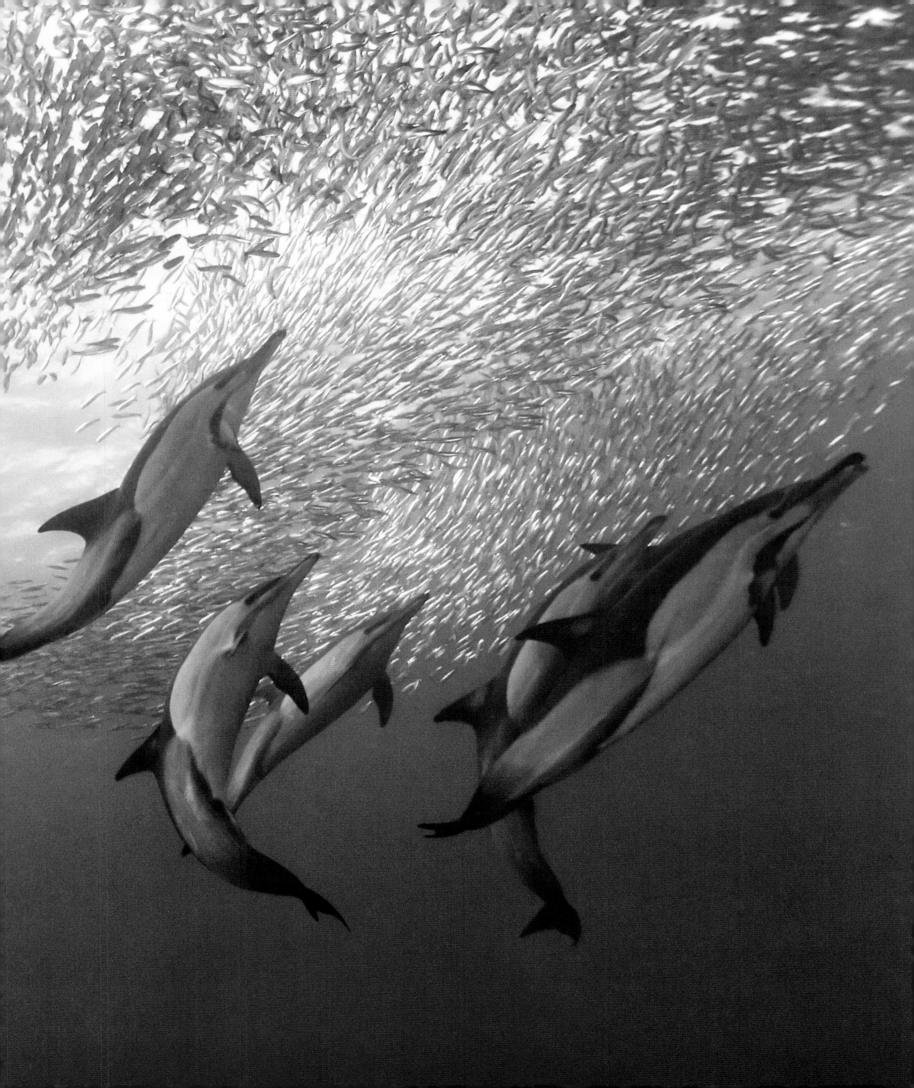

mouths and jaws

mouth. an opening through which many animals take in food and emit sounds.

jaw. a hinged structure that forms the frame of the mouth in animals that bite and chew, and that is used for manipulating food.

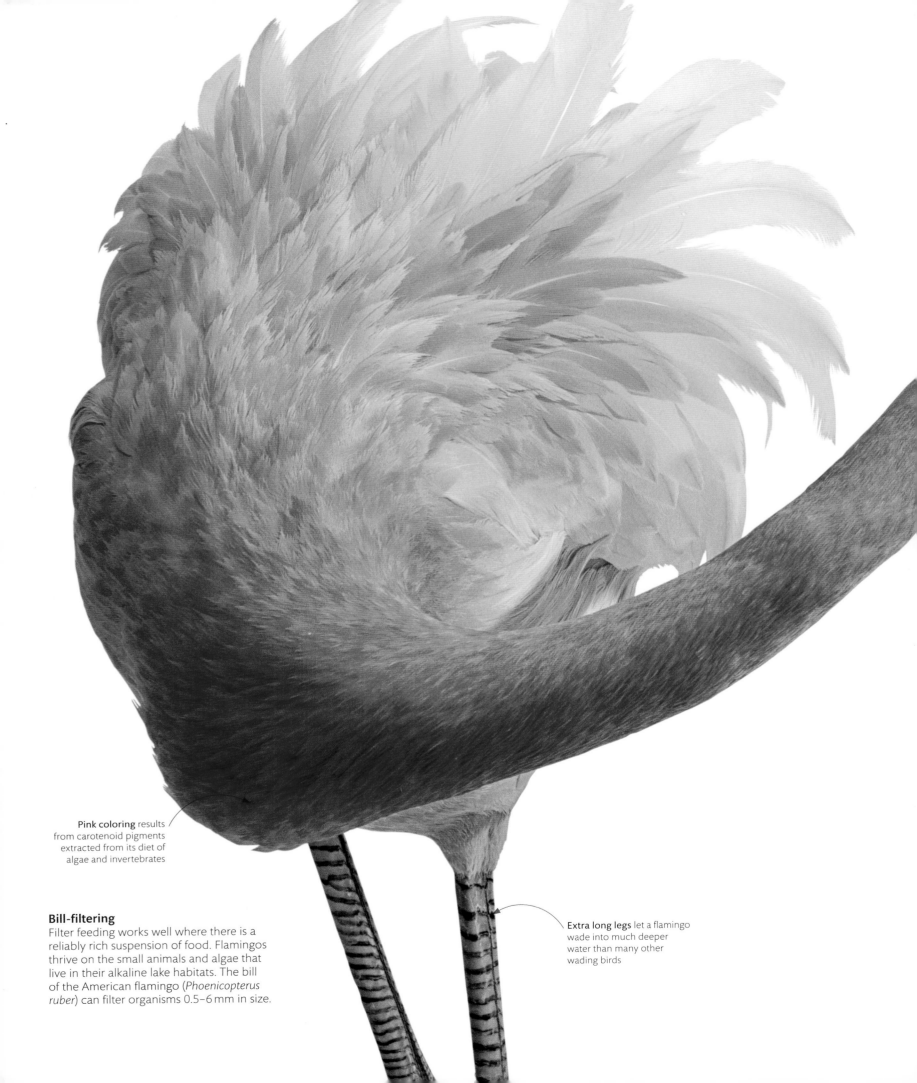

Pink coloring results from carotenoid pigments extracted from its diet of algae and invertebrates

Bill-filtering

Filter feeding works well where there is a reliably rich suspension of food. Flamingos thrive on the small animals and algae that live in their alkaline lake habitats. The bill of the American flamingo (*Phoenicopterus ruber*) can filter organisms 0.5–6 mm in size.

Extra long legs let a flamingo wade into much deeper water than many other wading birds

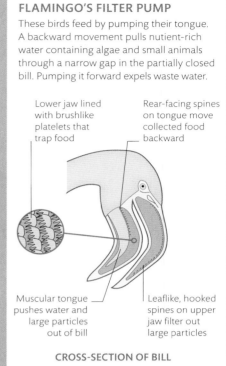

FLAMINGO'S FILTER PUMP

These birds feed by pumping their tongue. A backward movement pulls nutient-rich water containing algae and small animals through a narrow gap in the partially closed bill. Pumping it forward expels waste water.

Lower jaw lined with brushlike platelets that trap food

Rear-facing spines on tongue move collected food backward

Muscular tongue pushes water and large particles out of bill

Leaflike, hooked spines on upper jaw filter out large particles

CROSS-SECTION OF BILL

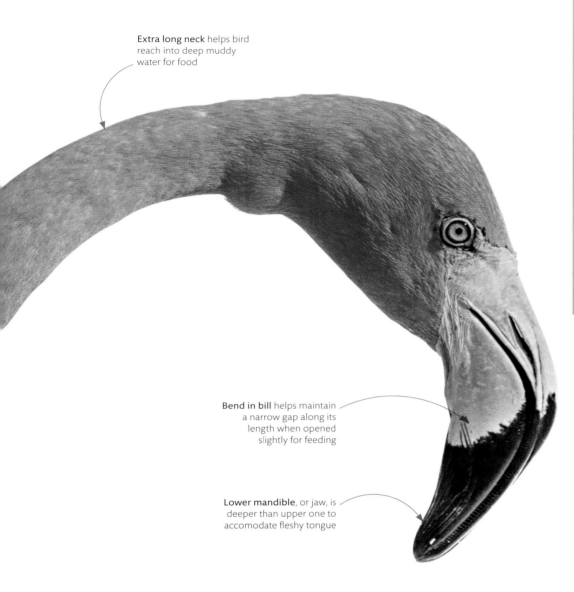

Extra long neck helps bird reach into deep muddy water for food

Bend in bill helps maintain a narrow gap along its length when opened slightly for feeding

Lower mandible, or jaw, is deeper than upper one to accomodate fleshy tongue

filter feeding

Many animals acquire their nourishment from the tiniest of food particles, often suspended in water, and have evolved efficient methods for collecting them. The smallest invertebrates trap the small particles with mucus, but in bigger, stronger animals, food-rich water is driven through a fine-mesh filter that traps the foodstuff. Known as filter feeding, this is not only exploited by the largest animals of all, the blue whale and whale shark, but also smaller ones like mackerel, as well as water-wading flamingos.

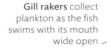

Gill rakers collect plankton as the fish swims with its mouth wide open

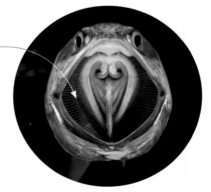

Ocean filter

Many open ocean fish such as this Indian mackerel (*Rastrelliger kanagurta*) have bony extensions in their gill cage, or gill rakers, that filter plankton from the water as the fish swims.

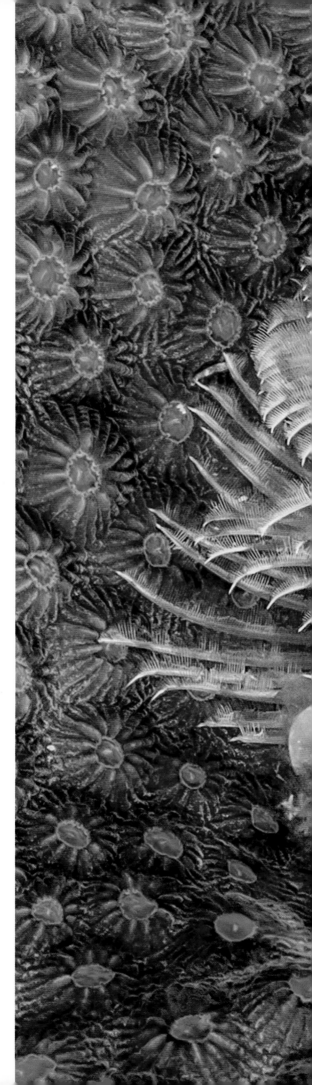

christmas tree worms

Miniature "forests" of these treelike animals not only live on coral reefs, but also help protect them. Christmas tree worms (*Spirobranchus giganteus*) may look more like plants than animals, but their feathery spirals are in fact modified gill-tentacles through which they feed and breathe.

These remarkable creatures begin life as embryos created by broadcast spawning. Male and female worms simultaneously release sperm and eggs into the water that together produce free-floating larvae. After hours or weeks, a larva settles on a hard coral and metamorphoses into a creature inhabiting a mucus tube—the beginnings of the carbonate tube in which this worm will live for as long as 30 years.

The juvenile worm ingests calcium-rich particles and processes them, via a special gland, into calcium carbonate, which it excretes to form a 8-in (20-cm) tube that extends deep into the coral's hard outer framework. The only visible part of a Christmas tree worm is its prostomium, which takes the form of two spiral "trees"—the rest of the animal remains in its tube. If the worm senses danger, it retracts the trees into the tube, too (see box below).

Each Christmas tree worm spiral consists of 5 to 12 whorls that bristle with tiny tentacles, or radioles, which in turn are covered with filamentous pinnules, which themselves bear microscopic hairlike cilia. The cilia beat, creating a current that pulls in the plankton on which the worm feeds.

At the base of each tree, these animals have two compound eyes, each with up to 1,000 facets. Scientists are not sure what they can see, but experiments show that they retract if predatory fish approach, even when the fish does not cast a shadow.

Gift for the coral reef
The worm feeds by wafting food along a groove running down each tentacle—and eventually to the mouth at the base of the "tree." As it feeds, the currents it creates also bring in nutrients for the coral and help disperse damaging waste.

HEADS UP
Life as a tube-building, sedentary filter feeder is possible through some extraordinary modifications to the average annelid head. The highly specialized tentacles around the mouth of serpulid worms form a protective lid, while others have developed into feathery structures that serve as both food-gathering organs and gills for respiration. A Christmas tree worm's head end, or prostomium, stands ⅓–¾in (1–2cm) high and can be 1 ½in (3.8cm) wide and its 1 ⅕in (3cm) body is safely protected by its tube. If danger is detected the prostomium can retract its inside this tube too.

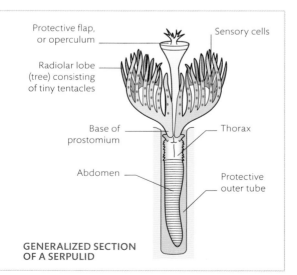

Protective flap, or operculum

Sensory cells

Radiolar lobe (tree) consisting of tiny tentacles

Base of prostomium

Thorax

Abdomen

Protective outer tube

GENERALIZED SECTION OF A SERPULID

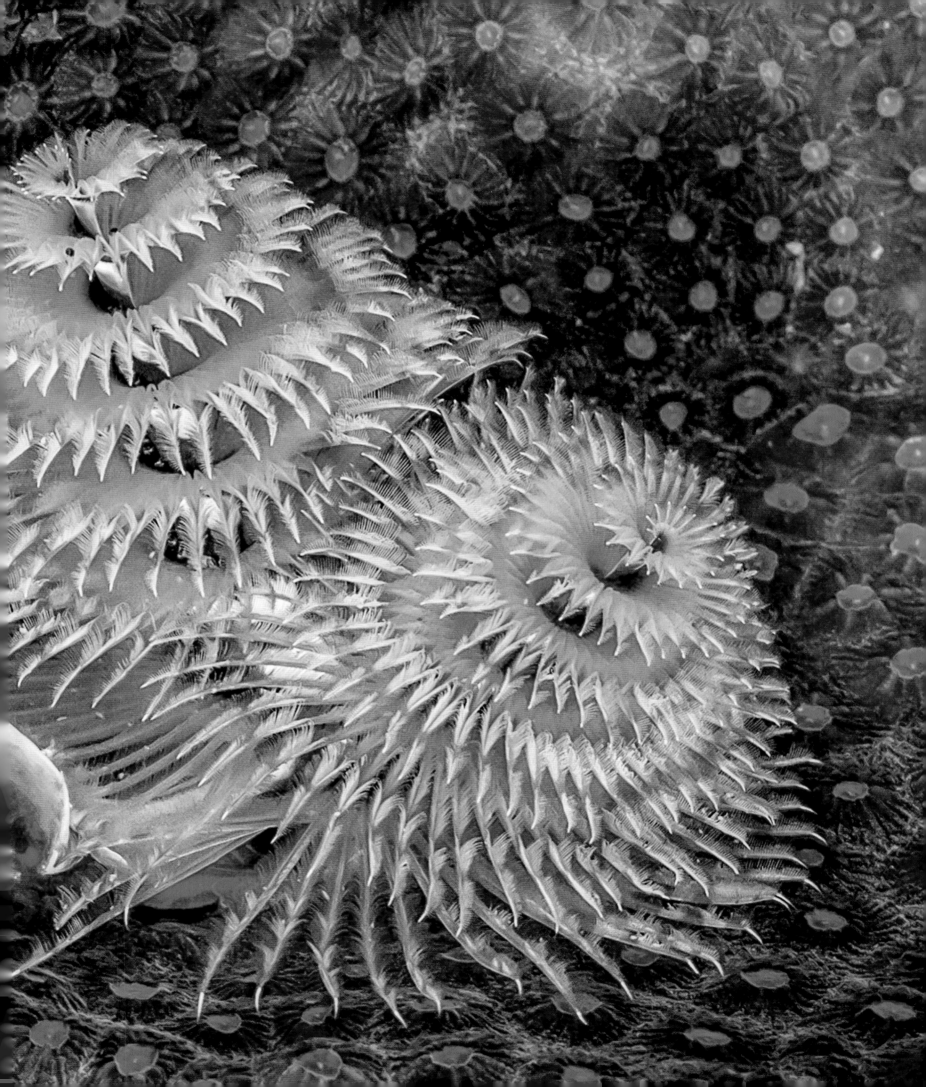

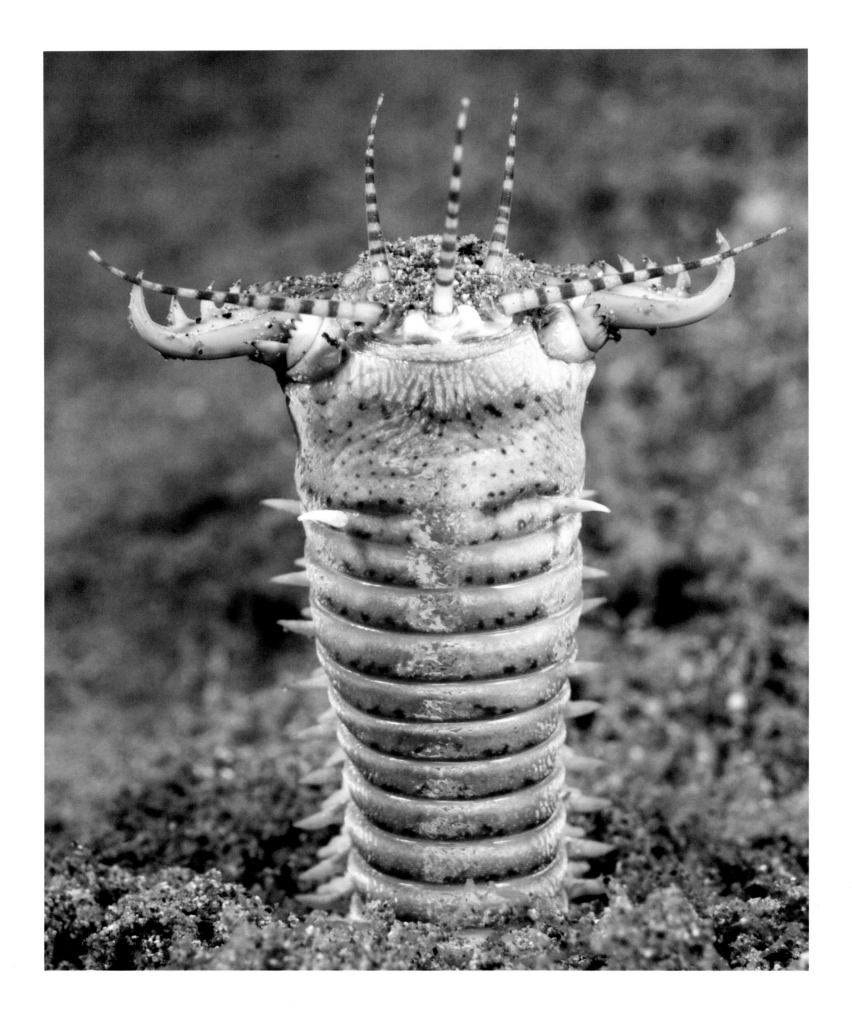

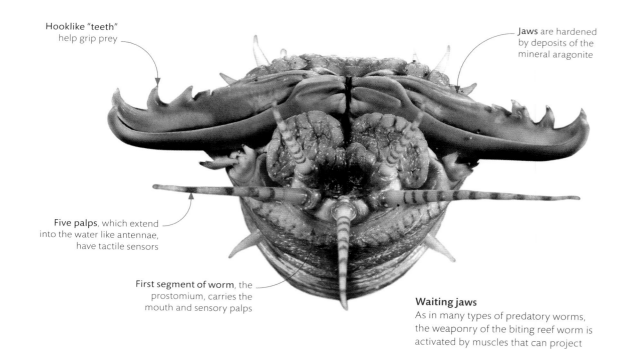

Hooklike "teeth"
help grip prey

Jaws are hardened
by deposits of the
mineral aragonite

Five palps, which extend
into the water like antennae,
have tactile sensors

First segment of worm, the
prostomium, carries the
mouth and sensory palps

Waiting jaws
As in many types of predatory worms,
the weaponry of the biting reef worm is
activated by muscles that can project
the pharynx (throat) through the mouth.

invertebrate jaws

Prior to the evolution of jaws, animals fed on whatever material they could
fit into their mouths and swallow whole, as jellyfish and anemones still do.
Muscle-powered jaws that could slice, grind, or rasp gave early wormlike
animals access to new food sources, enabling animals to break large solid
items of food—such as leaves or flesh—into manageable fragments that could
be swallowed and digested easily. Sharp jaws became equally effective as
defensive weapons or tools for capturing and dispatching prey. Today, jaws
of varying size, form, and complexity are wielded by a wide diversity of
invertebrates, from ants to giant squid and predatory worms.

Hydraulic jaws
Pressure of fluids inside the body pushes the throat of a
biting reef worm (*Eunice aphroditois*) outward, making
the serrated jaws and sensory palps gape around the
mouth. Any fish that swims close enough stimulates the
palps and releases the pressure, so the jaws snap shut
around the fish's body as the throat retracts back inside.

BLOODSUCKER JAWS

Many jaws work like scissors, pivoting blades
together as they close, but those of a leech are
more like scalpels. After clamping an oral sucker
to the skin of a victim, the leech's three jaws slice
through, leaving a Y-shaped wound. Salivary
glands release their secretions over the sharp
blades. Anticoagulant in the saliva ensures that
the blood keeps flowing freely from the wound,
while powerful muscles in the leech's pharynx
(throat) suck up the liquid meal.

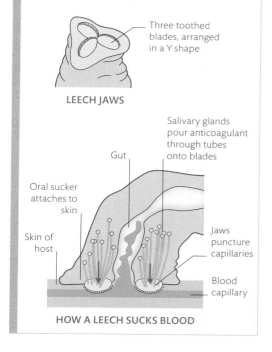

Three toothed
blades, arranged
in a Y shape

LEECH JAWS

Salivary glands
pour anticoagulant
through tubes
onto blades

Gut

Oral sucker
attaches to
skin

Skin of
host

Jaws
puncture
capillaries

Blood
capillary

HOW A LEECH SUCKS BLOOD

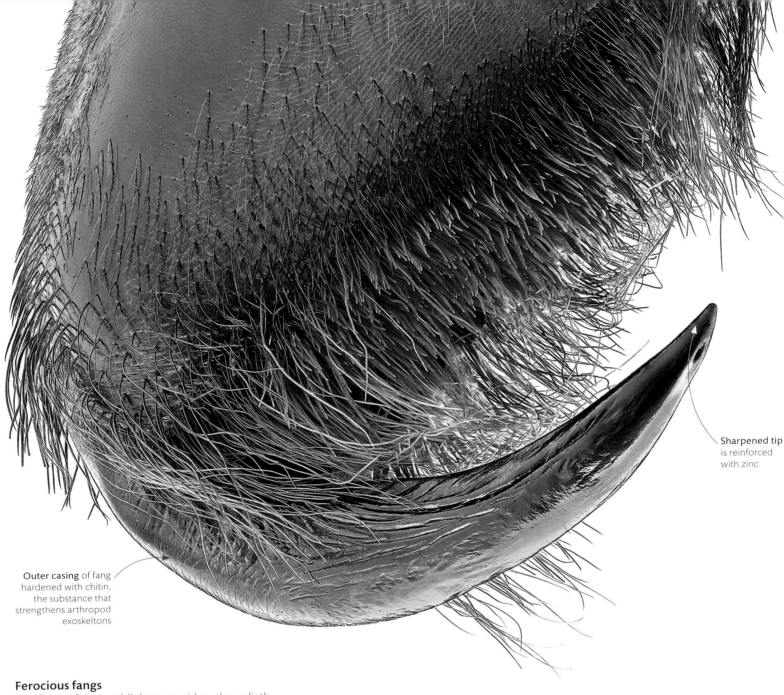

Sharpened tip is reinforced with zinc

Outer casing of fang hardened with chitin, the substance that strengthens arthropod exoskeltons

Ferocious fangs
The fangs of the world's largest spider—the goliath birdeater (*Theraphosa blondi*)—retain their menacing gleam even in their discarded molted skin, as seen here. These fangs, turned inward, reveal the tiny apertures that deliver the venom. Despite its size this spider is not life-threatening to humans.

injecting venom

Spiders are the dominant invertebrate predators almost everywhere on land. For billions of insects, and a few lizards or birds, spiders are killers. Except for a few hundred nonvenomous types, most of the 50,000 or so spider species kill with venom that they inject into their victim with fangs. Spiders cannot ingest solid food, so while the venom paralyzes prey to stop it from struggling, they spew digestive enzymes into the body to liquidize it. Only a few—black widows, the Brazilian wolf spider, and the Australian funnel-web—have venom that is dangerous to humans.

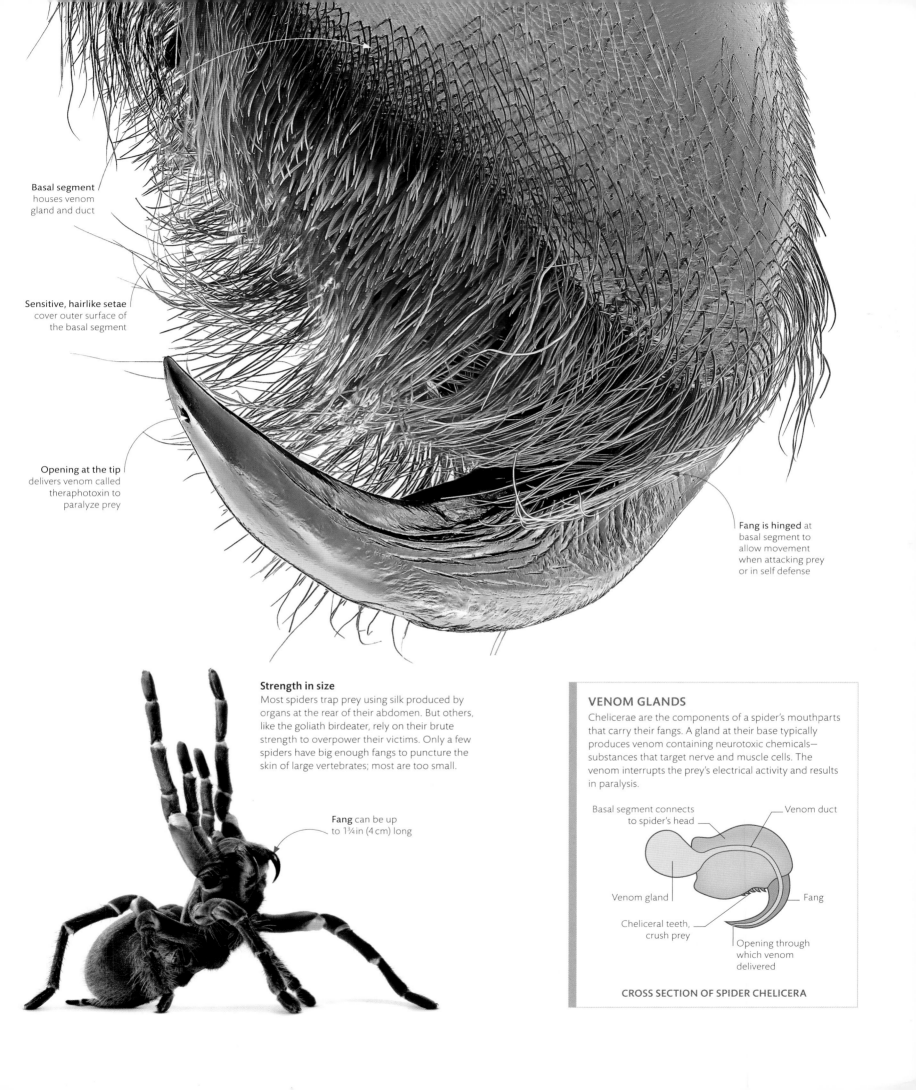

Basal segment
houses venom
gland and duct

Sensitive, hairlike setae
cover outer surface of
the basal segment

Opening at the tip
delivers venom called
theraphotoxin to
paralyze prey

Fang is hinged at
basal segment to
allow movement
when attacking prey
or in self defense

Strength in size
Most spiders trap prey using silk produced by
organs at the rear of their abdomen. But others,
like the goliath birdeater, rely on their brute
strength to overpower their victims. Only a few
spiders have big enough fangs to puncture the
skin of large vertebrates; most are too small.

Fang can be up
to 1¾ in (4 cm) long

VENOM GLANDS
Chelicerae are the components of a spider's mouthparts
that carry their fangs. A gland at their base typically
produces venom containing neurotoxic chemicals—
substances that target nerve and muscle cells. The
venom interrupts the prey's electrical activity and results
in paralysis.

Basal segment connects
to spider's head

Venom duct

Venom gland

Fang

Cheliceral teeth,
crush prey

Opening through
which venom
delivered

CROSS SECTION OF SPIDER CHELICERA

Hornlike teeth
encircle the
mouth opening

Life without jaws
Lampreys and hagfish are the only living vertebrates that lack biting jaws. The European brook lamprey (*Lampetra planeri*) uses its suckerlike mouth to cling to rocks; only its larvae, which lack the suction disk, feed. Many other lamprey species are parasitic as adults, attaching to a fish by the mouth and feeding on the host's blood and tissues.

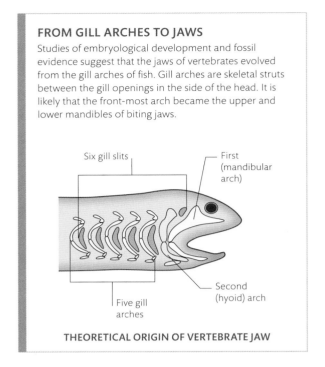

FROM GILL ARCHES TO JAWS
Studies of embryological development and fossil evidence suggest that the jaws of vertebrates evolved from the gill arches of fish. Gill arches are skeletal struts between the gill openings in the side of the head. It is likely that the front-most arch became the upper and lower mandibles of biting jaws.

Six gill slits

First
(mandibular
arch)

Five gill
arches

Second
(hyoid) arch

THEORETICAL ORIGIN OF VERTEBRATE JAW

vertebrate jaws

The first fish that swam in prehistoric oceans half a billion years ago had jawless mouths that probably rasped food from seafloor sediment—until the evolution of jaws enabled vertebrates to diversify. Opening and closing jaws can pump oxygen-rich water across the gills, and this may have been their first role in the earliest jawed fish. Since jaws can also bite, their evolution inevitably revolutionized the way that vertebrates could feed. Biting jaws opened the way for herbivorous vertebrates to chew on plants and for carnivores to kill prey.

Jaw bones
As in all mammals, the lower jaw of the pygmy hippopotamus is formed from a single bone called a dentary. The reptilian ancestors of mammals hinged their jaws with different bones, but during evolution, those bones have been repurposed as the tiny middle-ear ossicles that improve mammal hearing.

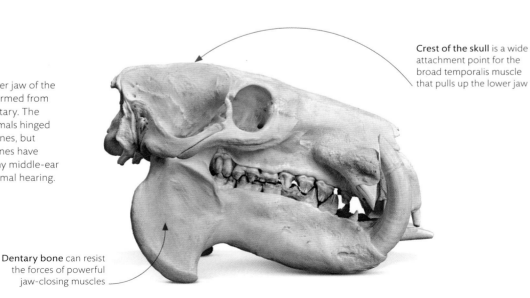

Crest of the skull is a wide attachment point for the broad temporalis muscle that pulls up the lower jaw

Dentary bone can resist the forces of powerful jaw-closing muscles

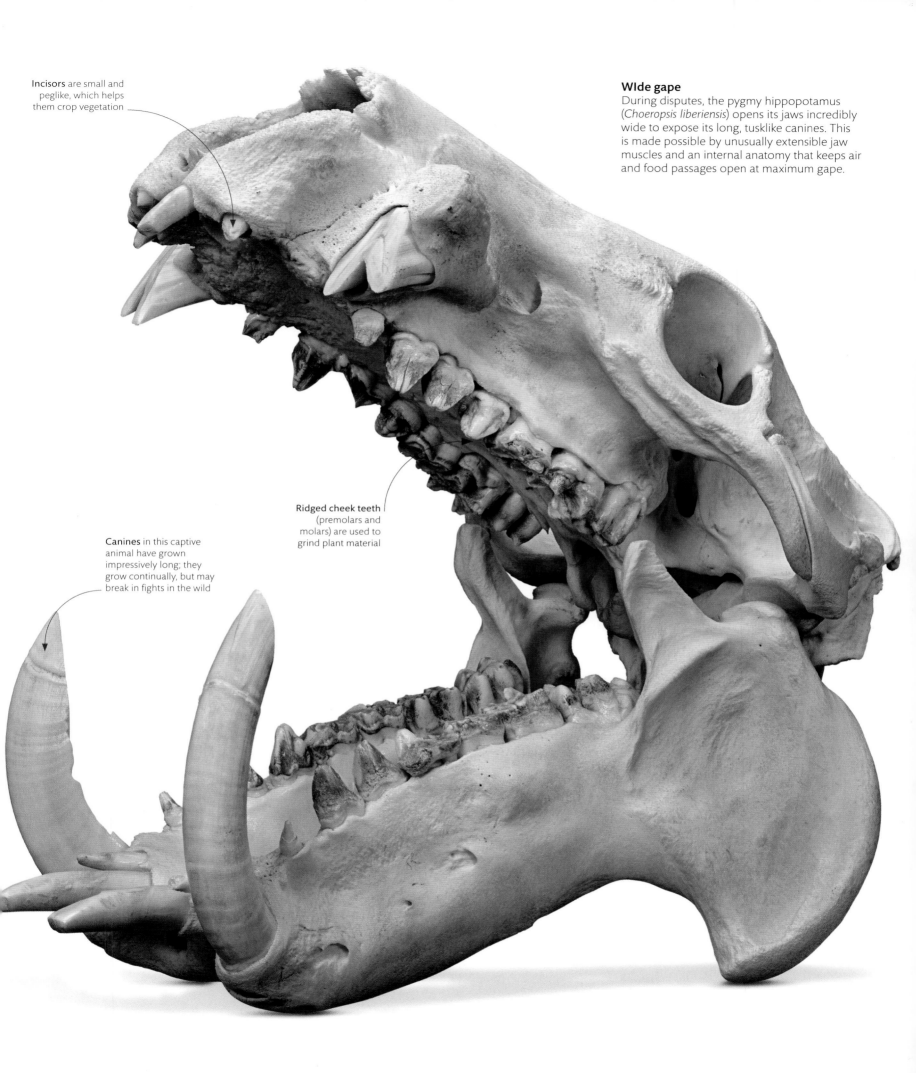

Incisors are small and peglike, which helps them crop vegetation

Wide gape
During disputes, the pygmy hippopotamus (*Choeropsis liberiensis*) opens its jaws incredibly wide to expose its long, tusklike canines. This is made possible by unusually extensible jaw muscles and an internal anatomy that keeps air and food passages open at maximum gape.

Ridged cheek teeth (premolars and molars) are used to grind plant material

Canines in this captive animal have grown impressively long; they grow continually, but may break in fights in the wild

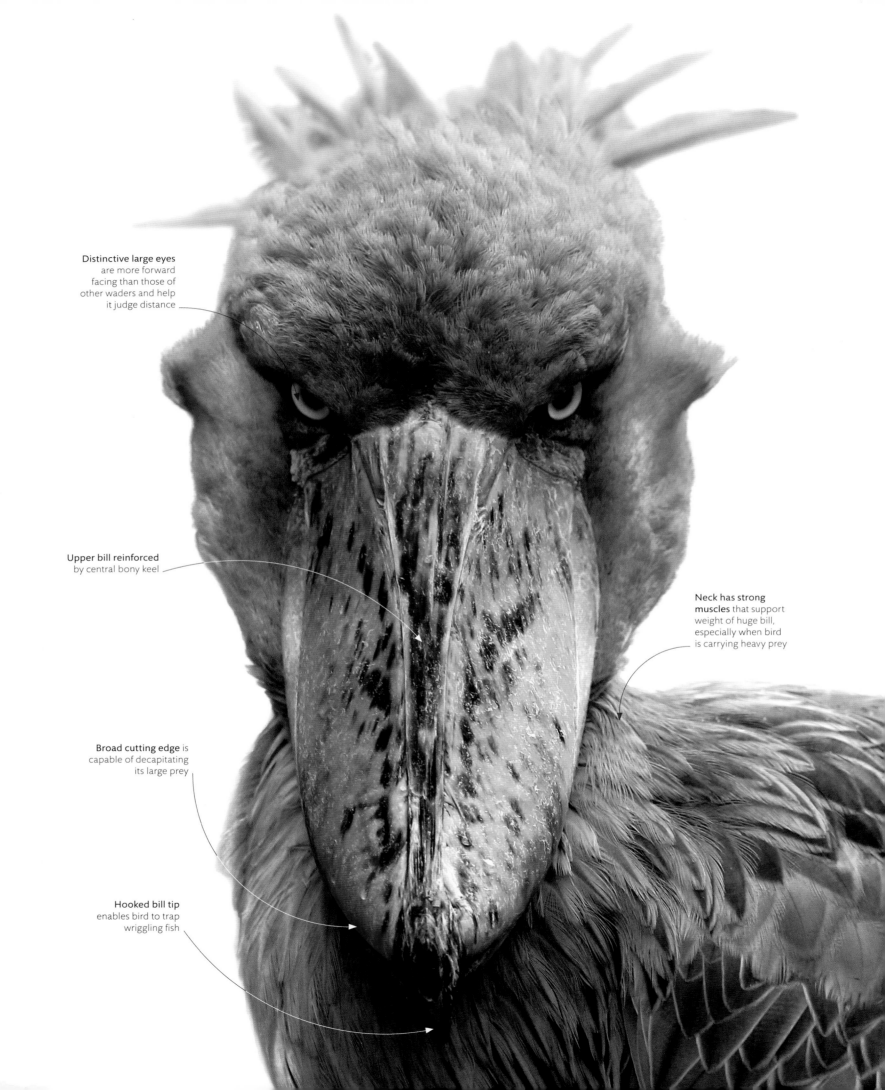

Distinctive large eyes are more forward facing than those of other waders and help it judge distance

Upper bill reinforced by central bony keel

Neck has strong muscles that support weight of huge bill, especially when bird is carrying heavy prey

Broad cutting edge is capable of decapitating its large prey

Hooked bill tip enables bird to trap wriggling fish

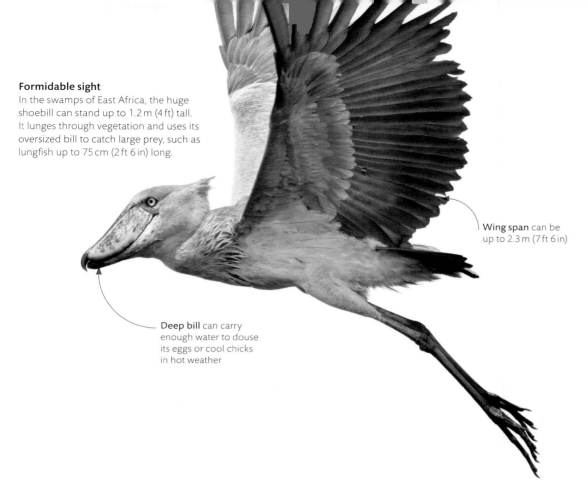

Formidable sight
In the swamps of East Africa, the huge shoebill can stand up to 1.2 m (4 ft) tall. It lunges through vegetation and uses its oversized bill to catch large prey, such as lungfish up to 75 cm (2 ft 6 in) long.

Wing span can be up to 2.3 m (7 ft 6 in)

Deep bill can carry enough water to douse its eggs or cool chicks in hot weather

bird bills

During evolution, birds lost the feature that gave their reptilian ancestors such a formidable bite—teeth. Instead, they gained a versatile horny beak that varies from a cutting-edged weapon to a delicate tool that can crush seeds or probe for nectar (see pp.198–99). Thanks to the flexibility of their jaws, birds can open their mouth to manipulate food not just by dropping the lower mandible, but also by hinging the top mandible upward.

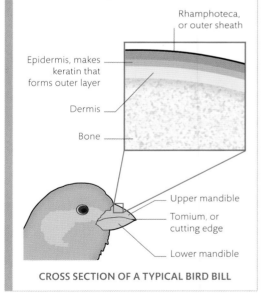

STRUCTURE OF A BIRD'S BILL
The bony core of a bird's bill has a tough, often hard and horny, outer coating, or rhamphotheca, made of the same tissue as claws and nails—keratin. This layer is supplied with blood vessels and nerves, making the bill sensitive to touch.

Rhamphoteca, or outer sheath

Epidermis, makes keratin that forms outer layer

Dermis

Bone

Upper mandible

Tomium, or cutting edge

Lower mandible

CROSS SECTION OF A TYPICAL BIRD BILL

Fearsome wader
Once called the whale-headed stork, the shoebill (*Balaeniceps rex*) is a wading bird, but it is more closely related to the pelican according to its DNA. Although lacking a pouch, its upper bill is hooked and reinforced with a keel, like that of a pelican.

bird bill shapes

Birds' bills have evolved in response to the food available in their habitats, resulting in a wide variety of beak shapes that reflect what and how they eat. While many birds are omnivores, consuming both live prey and vegetation depending on the season, most specialize in a particular food source, such as seeds, nectar, or invertebrates.

fruit, seed, and nut eating

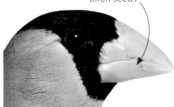

Cone-shape helps bird peck out and crush cedar, pine, and birch seeds

JAPANESE GROSBEAK
Eophona personata

Strong beak can break nutshells, crush seeds, and peel fruit

BLUE-AND-YELLOW MACAW
Ara ararauna

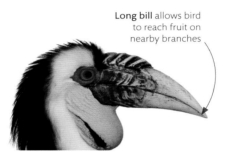

Long bill allows bird to reach fruit on nearby branches

WREATHED HORNBILL
Rhyticeros undulatus

nectar drinking

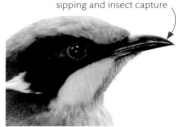

Longish bill permits both nectar sipping and insect capture

YELLOW-TUFTED HONEYEATER
Lichenostomus melanops

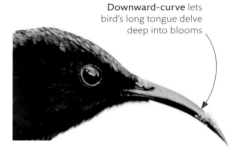

Downward-curve lets bird's long tongue delve deep into blooms

BLACK-THROATED SUNBIRD
Aethopyga saturata

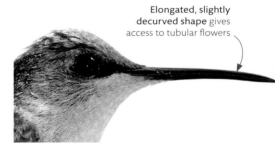

Elongated, slightly decurved shape gives access to tubular flowers

VIOLET-CROWNED WOODNYMPH
Thalurania colombica colombica

mud and soil probing

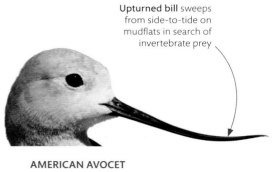

Upturned bill sweeps from side-to-tide on mudflats in search of invertebrate prey

AMERICAN AVOCET
Recurvirostra americana

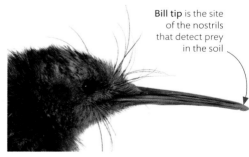

Bill tip is the site of the nostrils that detect prey in the soil

BROWN KIWI
Apteryx mantelli

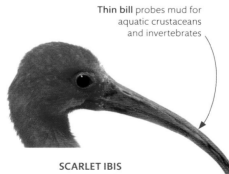

Thin bill probes mud for aquatic crustaceans and invertebrates

SCARLET IBIS
Eudocimus ruber

Matching bill to food

The form and size of a bird's bill is a good clue as to what makes up the bulk of its diet. For example, a short, thick, conical bill—such as that of a finch—indicates a seed-eater, while carnivorous birds, such as eagles and other raptors, typically have a curved, razor-sharp beak tip that rips flesh into manageable chunks.

flesh ripping and gobbling

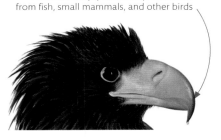

Hooked, deeply curved tip tears flesh from fish, small mammals, and other birds

STELLER'S SEA EAGLE
Haliaeetus pelagicus

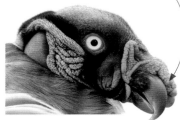

Sharp bill rips skin and hard tissue from carcasses

KING VULTURE
Sarcoramphus papa

Wedge-shaped beak probes corpses for meat and snaps up small prey

MARABOU STORK
Leptoptilos crumenifer

insect catching

Short beak set on wide mouth that scoops up insects

EUROPEAN NIGHTJAR
Caprimulgus europaeus

Slender, tweezerlike form snatches worms and insects from the ground

EUROPEAN ROBIN
Erithacus rubecula

Strong, downcurved beak plucks bees from the air

GREEN BEE-EATER
Merops orientalis

fishing

Keel-like knob on upper bill supports weight of caught fish

GREAT WHITE PELICAN
Pelecanus onocrotalus

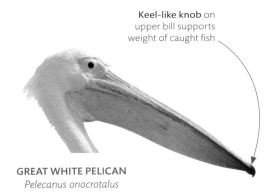

Colorful beak holds several small fish at once

ATLANTIC PUFFIN
Fratercula arctica

Streamlined shape gives smooth entry into water

GIANT KINGFISHER
Megaceryle maxima

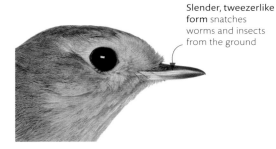

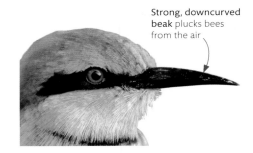

PLATE LXVI.

Ivory-billed Woodpecker. PICUS PRINCIPALIS. Linn. *Male. Female. 2.3.*

Drawn from Nature and Published by John J. Audubon F.R.S.F.L.S.

Engraved, Printed & Coloured by R. Havell.

Darwin's flycatcher
John Gould worked extensively with the preserved specimens brought back from Charles Darwin's voyages. His illustration of a yellow and grey female Darwin's flycatcher (*Pyrocephalus nanus*) from the Galápagos Islands is from *The Zoology of the Voyage of HMS Beagle* (1838).

animals in art

art of the ornithologist

The number, brilliance, and variety of form, song, and flight of the world's birds was one of the most tantalizing challenges to 19th-century naturalists. This was the age of recording, sketching, and classifying birds, and new printing techniques that produced iconic works of ornithological art.

Enthusiasts traveling the globe brought home accounts of their natural history discoveries and also bird specimens, many of which ended up in the hands of taxidermist and ornithologist John Gould (1804–1881). The first curator and preserver at the London Zoological Society, Gould went on to publish some of the world's finest bird volumes. A new method of printing, lithography, which involved drawing images on limestone blocks, enabled the production of vibrant hand-colored prints. Gould traveled in Europe to catalog and sketch birds for his major work, *The Birds of Europe* (1832–33) before embarking on a two-year expedition to Tasmania and Australia. Working with his wife, Elizabeth,

a painter, he produced a seven-volume work on Australian birds that included 328 species new to science.

Lifelike as the birds appear in these vibrant bird books, the majority were killed, dissected, and stuffed before they were painted. In the US, naturalist and hunter John James Audubon wire-rigged the fresh corpses of birds against a backdrop of their habitats to produce dazzlingly realistic images. Shunned by US scientists, he sought subscriptions from noble houses and university libraries in Britain to sponsor monumental aquatint plates of every bird in the Americas. The 200 printed copies of *The Birds of America* took nearly 12 years and $115,000 to complete.

Budgerigars
English ornithologist John Gould produced 600 lithographs in superb detail and color for his iconic *The Birds of Australia* (1840–48). After he brought the first two budgerigars to England in 1840, they became popular as pets.

Ivory-billed woodpecker
John James Audubon's desire to produce life-sized portraits of every bird in America called for "double elephant paper", 100 cm x 67 cm (39 in x 26 in). The ivory-billed woodpecker, now thought to be extinct, is one of the 435 monumental plates in *The Birds of America* (1827–38).

66 I never for a day gave up listening to the songs of our birds, or watching their peculiar habits, or delineating them in the best way I could. 99

JOHN JAMES AUDUBON, *AUDUBON AND HIS JOURNALS*, 1899

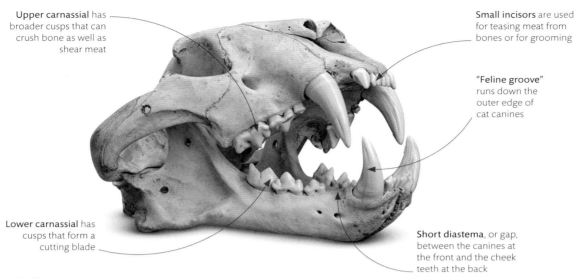

Upper carnassial has broader cusps that can crush bone as well as shear meat

Small incisors are used for teasing meat from bones or for grooming

"Feline groove" runs down the outer edge of cat canines

Lower carnassial has cusps that form a cutting blade

Short diastema, or gap, between the canines at the front and the cheek teeth at the back

Tiger skull
Like those of other carnivorans, the formidably strong jaws of the tiger (*Panthera tigris*) carry deeply-rooted cheek teeth, called carnassials, that slice together like scissors to cut through meat. Long canines that puncture skin are used to grip struggling prey.

carnivore teeth

Any animal that consumes flesh—such as a jellyfish, a tiger beetle, or a crocodile—is described as carnivorous, but some of the most impressive adaptations to a meat-eating lifestyle occur in the mammalian order Carnivora. These so-called carnivorans—including cats, dogs, weasels, and bears—rely on powerful biting jaws equipped with teeth that can stab, kill, and dismember. And like most other mammals, their modified teeth ensure that the mouth can multitask while processing food.

DIFFERENTIATED TEETH

In most fish, amphibians, and reptiles, the teeth are similar in shape. An alligator's teeth are uniformly conical. This uniformity is known as homodont dentition. But mammals, in contrast, have differentiated, or heterodont, dentition, which enables them to process food in different ways. Typically, there are chisel-shaped incisors at the front that nibble or crop, conical stabbing canines behind the incisors, and ridged cheek teeth (premolars and molars) at the back that crush and grind food.

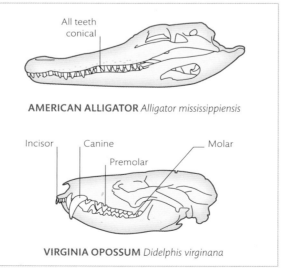

All teeth conical

AMERICAN ALLIGATOR *Alligator mississippiensis*

Incisor Canine Molar
Premolar

VIRGINIA OPOSSUM *Didelphis virginana*

A killer's teeth

Although still fearsome, the canine teeth of a cheetah (*Acinonyx jubatus*) are proportionately smaller than those of other cats; smaller canine roots leave more space in the nasal cavity to "pant" through the nostrils while gripping prey after a high-speed chase. The daggerlike canines, used for clamping a victim's throat to suffocate, are unmistakably those of a carnivore.

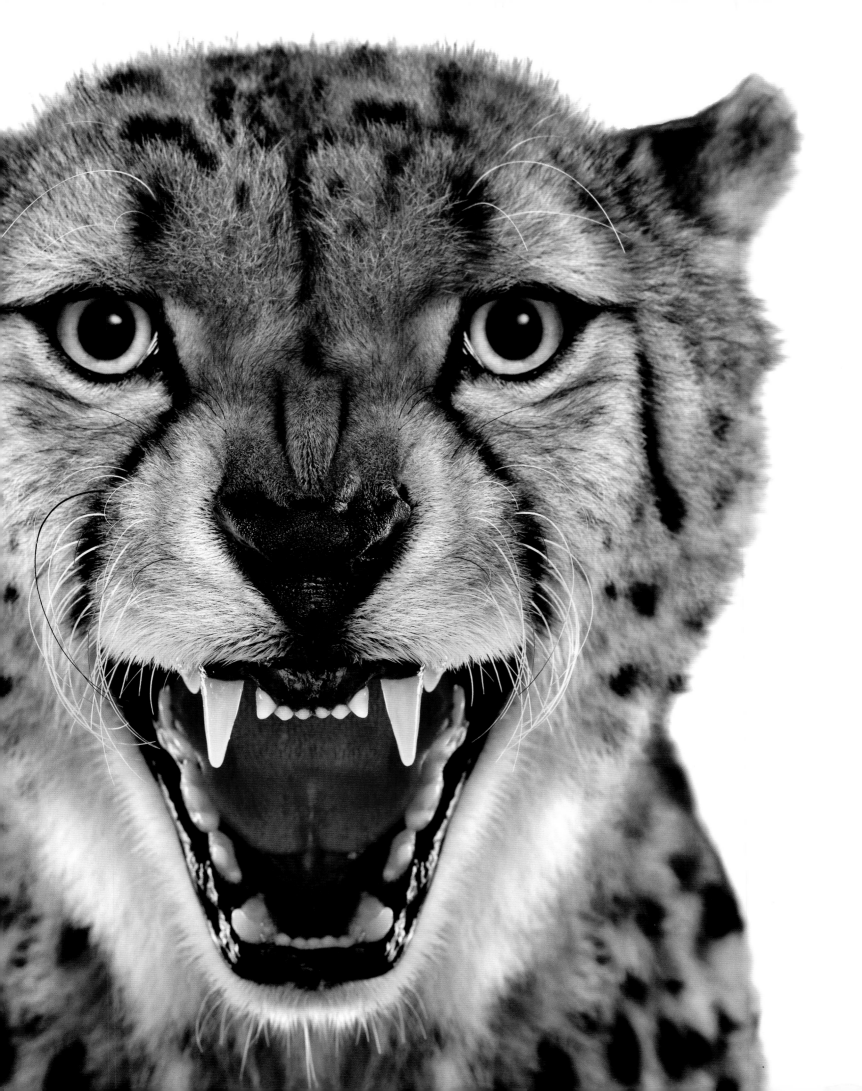

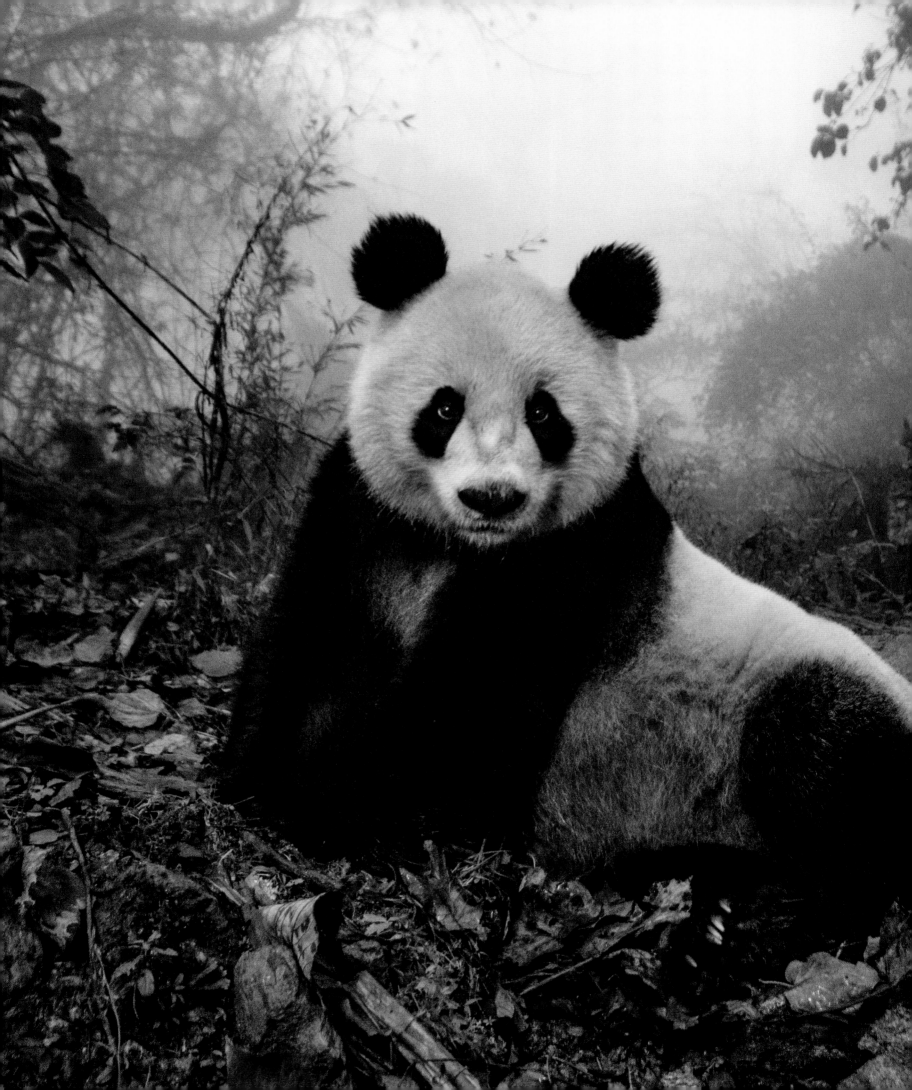

Mistaken identity
Giant pandas were unknown outside Asia until the 1860s, when a black-and-white skin reached the West. Even then at least one scientist believed it belonged to a giant relative of the raccoon.

spotlight species

giant panda

With its rounded face, mainly vegetarian diet, and black-and-white coat, the giant panda (*Ailuropoda melanoleuca*) at first seems more like a large raccoon than a bear. While DNA testing places this mammal firmly in the bear family, its anatomy and dietary habits continue to intrigue scientists.

The giant panda is one of the world's most vulnerable mammals and it is estimated that only 1,500–2,000 remain in the wild. Adults can be 4–6 ft (1.2–1.8 m) long and can weigh up to 300 lb (136 kg). Although slow-moving, they can swim and wade through water, and are agile climbers, and use an enlarged wrist-bone, called a pseudo-thumb, to manipulate bamboo. Mature by the age of 5 or 6, the normally solitary males and females spend a few days or weeks together during the mating season, usually between March and May. Cubs are born 3–6 months later, and stay with their mothers for up to two years.

This animal's diet is an enigma. A panda spends up to 16 hours a day eating 20–40 lb (9–18 kg) of food, then rests for hours. Its heritage as well as its canine teeth and short digestive tract suggest that it is a carnivore. But 99 percent of its food intake is nutritionally poor bamboo, and it has ultra-strong jaw muscles and broad, flat molars that can grind this tough plant material. Most carnivores lack the gut bacteria needed to digest grasses, but giant pandas have enough to break down some of the cellulose they eat; they only receive 17–20 percent of a meal's energy – just enough to survive. Their diet means they cannot build up the fat reserves that allow a deep sleep (torpor) through winter.

Mountain dweller
Once also found in lowland areas, human encroachment has restricted the animal to higher ground. Giant pandas now inhabit only a few dense mountain forests of central China.

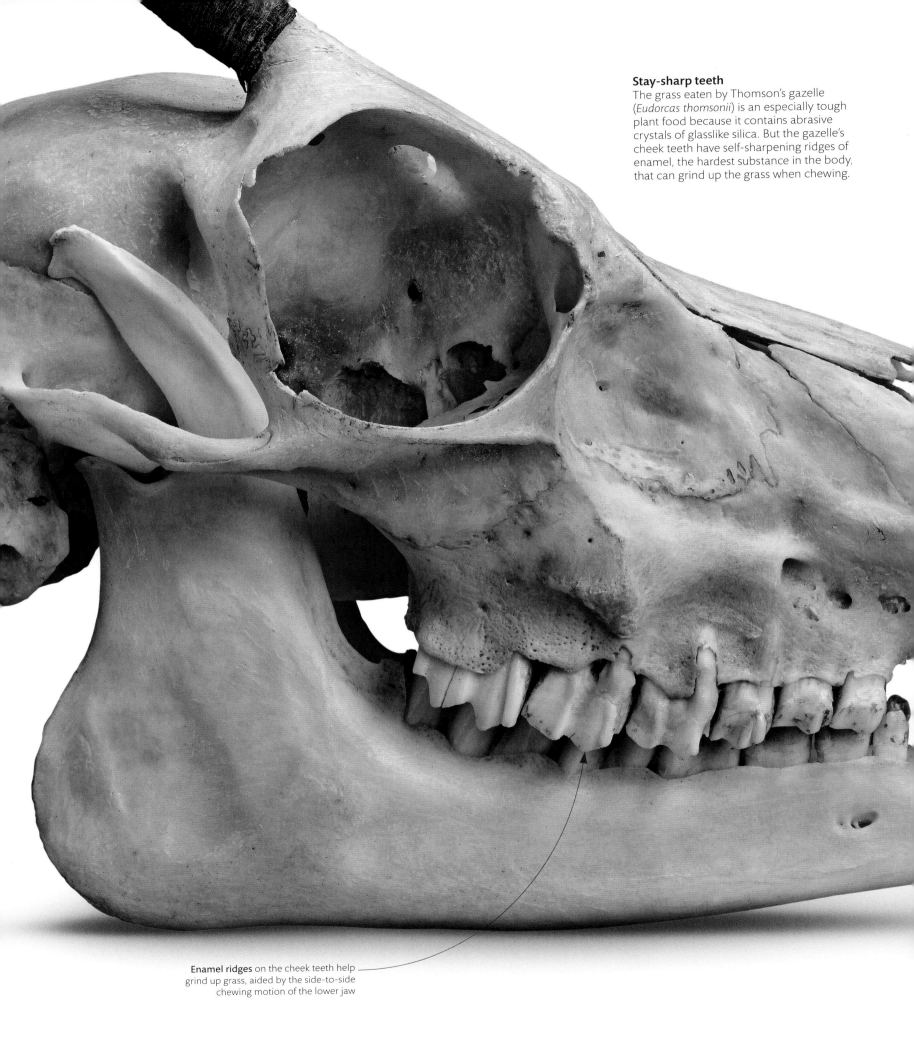

Stay-sharp teeth
The grass eaten by Thomson's gazelle (*Eudorcas thomsonii*) is an especially tough plant food because it contains abrasive crystals of glasslike silica. But the gazelle's cheek teeth have self-sharpening ridges of enamel, the hardest substance in the body, that can grind up the grass when chewing.

Enamel ridges on the cheek teeth help grind up grass, aided by the side-to-side chewing motion of the lower jaw

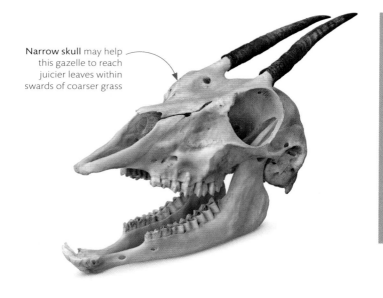

Narrow skull may help this gazelle to reach juicier leaves within swards of coarser grass

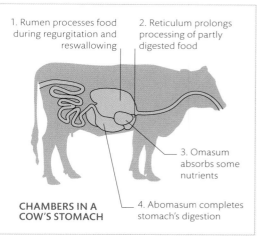

USING MICROBES

The microbes inside the gut of herbivores produce the enzyme cellulase, which digests plant fiber into sugar and fatty acids. In many plant-eating mammals, such as horses, rhinoceroses, and rabbits, the microbes inhabit enlarged parts of the intestine, but ruminants (including cows and antelopes) house the microbes in a multichambered stomach.

CHAMBERS IN A COW'S STOMACH

1. Rumen processes food during regurgitation and reswallowing

2. Reticulum prolongs processing of partly digested food

3. Omasum absorbs some nutrients

4. Abomasum completes stomach's digestion

A skull for grazing
Like other grazers that eat abrasive grass, Thomson's gazelle has a long row of grinding cheek teeth. Browsers—herbivores that feed on the soft leaves of low shrubs—often have a shorter row of cheek teeth.

eating plants

An animal that relies on plants for its nutrition faces a problem: plant material is packed with fibrous cellulose—the constituent of plant cell walls—that is difficult to digest. Herbivores need the means not only to cut and chew tough leaves, but also to extract nutrients from the resulting pulp. As well as having a specialized dentition, herbivores harbor cultures of living microbes in their digestive system. The microbes provide the enzymes necessary to digest plant fiber into sugars that can be assimilated by the body.

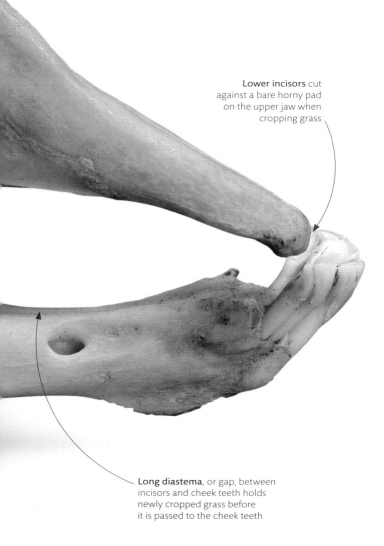

Lower incisors cut against a bare horny pad on the upper jaw when cropping grass

Long diastema, or gap, between incisors and cheek teeth holds newly cropped grass before it is passed to the cheek teeth

Poppy seed head is a hard, tough capsule; a small rodent, such as a harvest mouse, can gain entry with its specialized gnawing incisors

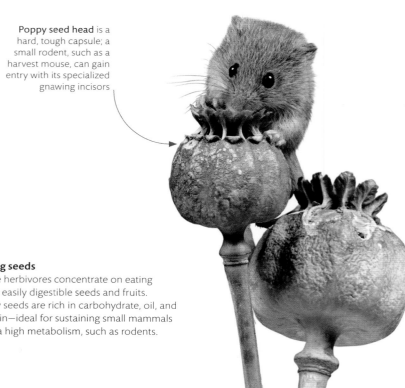

Eating seeds
Some herbivores concentrate on eating more easily digestible seeds and fruits. Many seeds are rich in carbohydrate, oil, and protein—ideal for sustaining small mammals with a high metabolism, such as rodents.

flexible faces

Eating is the primary purpose of the mouth and jaws of any animal. But in mammals—especially higher primates—the extraordinary flexibility of the face, which is controlled by hundreds of tiny muscles, can also be commandeered to communicate signals that are important in organizing social groups. For animals that depend heavily on vision and visual displays, the face has become a way of advertising mood and intent.

EXPRESSIVE FACES

Chimpanzees live in complex social groups, and they use facial expressions to advertise their feelings and emotions. Expressions like a play-face indicating happiness, a tooth-bearing grin showing fear, or a pout meaning they are craving reassurance, effect responses in other members of the group. They might even trigger feelings of empathy that help reinforce social bonding.

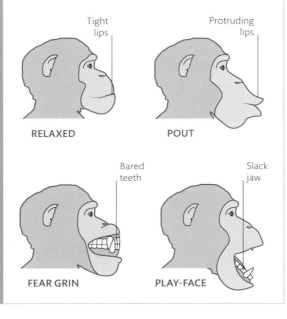

Tight lips

RELAXED

Protruding lips

POUT

Bared teeth

FEAR GRIN

Slack jaw

PLAY-FACE

Look at me

The Bornean orangutan (*Pongo pygmaeus*) collects fruit from trees and uses its flexible lips to help it separate the flesh from skin and seeds. Although orangutans are generally more solitary than African apes, they are social animals and share the capacity for facial expression.

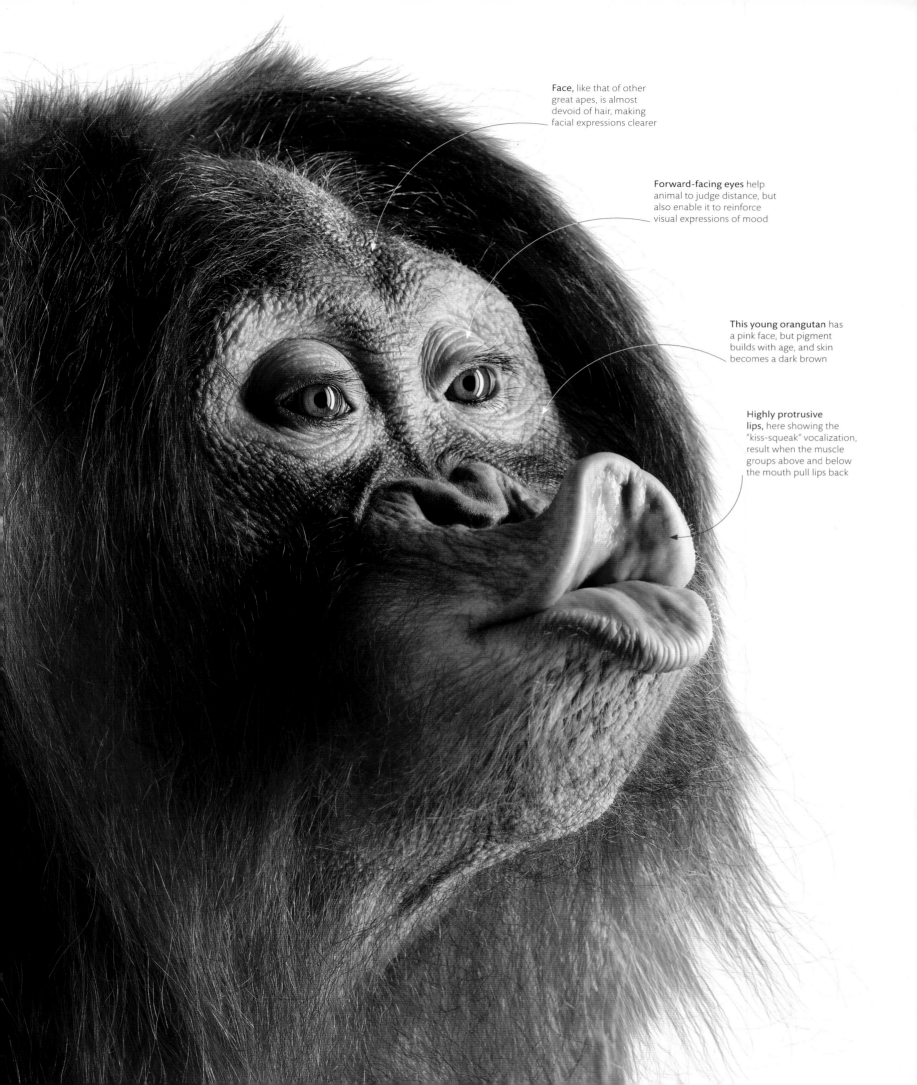

Face, like that of other great apes, is almost devoid of hair, making facial expressions clearer

Forward-facing eyes help animal to judge distance, but also enable it to reinforce visual expressions of mood

This young orangutan has a pink face, but pigment builds with age, and skin becomes a dark brown

Highly protrusive lips, here showing the "kiss-squeak" vocalization, result when the muscle groups above and below the mouth pull lips back

legs, arms, tentacles, and tails

leg. a weight-bearing limb used for locomotion and support.

arm. a vertebrate forelimb typically used for grasping, or the appendage of an octopus.

tentacle. a flexible appendage used for locomotion, grasping, feeling, or feeding.

tail. an elongated, flexible appendage at the hindmost part of an animal.

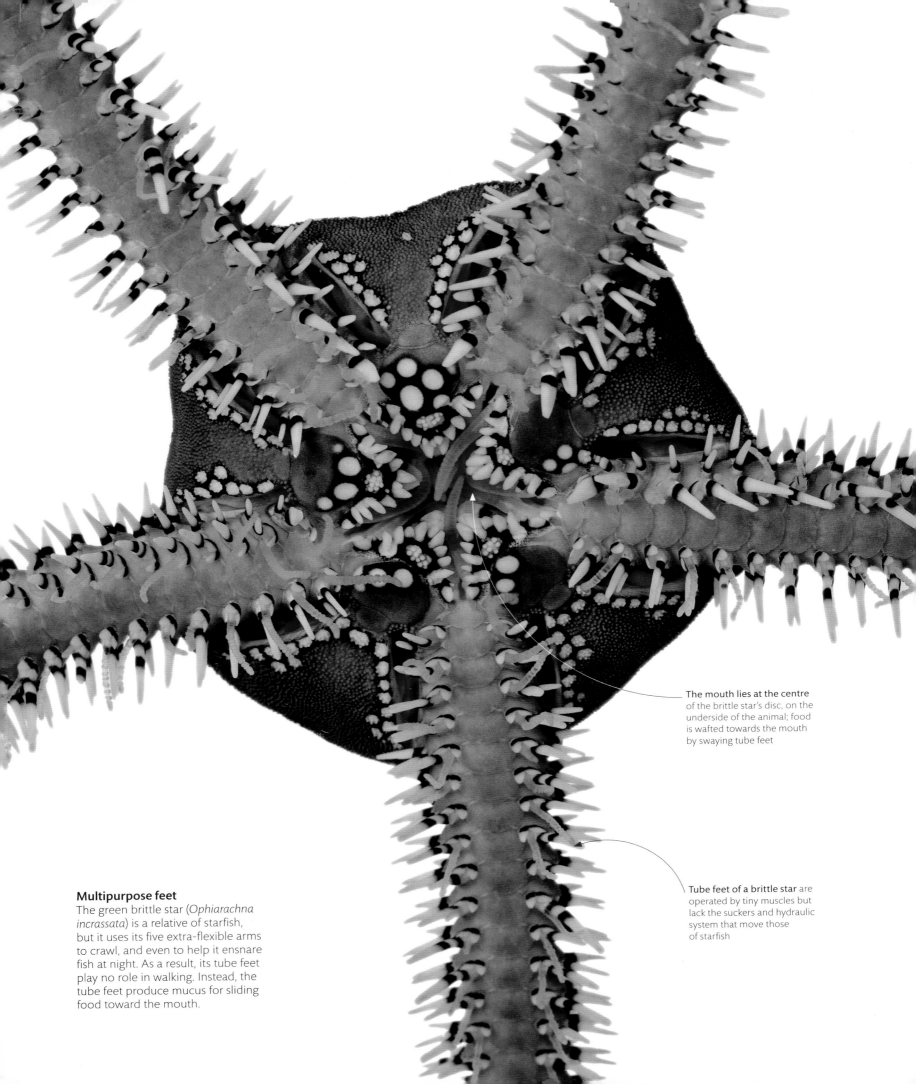

The mouth lies at the centre of the brittle star's disc, on the underside of the animal; food is wafted towards the mouth by swaying tube feet

Tube feet of a brittle star are operated by tiny muscles but lack the suckers and hydraulic system that move those of starfish

Multipurpose feet

The green brittle star (*Ophiarachna incrassata*) is a relative of starfish, but it uses its five extra-flexible arms to crawl, and even to help it ensnare fish at night. As a result, its tube feet play no role in walking. Instead, the tube feet produce mucus for sliding food toward the mouth.

tube feet

Starfish and brittle stars have a similar kind of radial symmetry as anemones, but while anemones are fixed to the seabed and rely on food drifting by, the other two animals can move to hunt or graze. Through the coordinated efforts of hundreds of fleshy projections—called tube feet—on their underside, starfish seem to glide along the ocean floor. Meanwhile, brittle stars can wriggle and even grip potential prey with their long flexible arms, leaving their tube feet for probing and sensing.

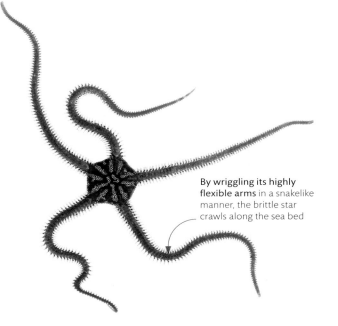

By wriggling its highly flexible arms in a snakelike manner, the brittle star crawls along the sea bed

GREEN BRITTLE STAR
Ophiarachna incrassata

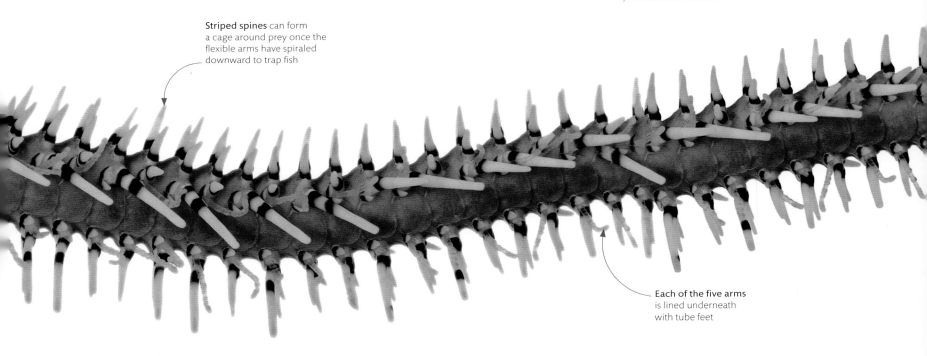

Striped spines can form a cage around prey once the flexible arms have spiraled downward to trap fish

Each of the five arms is lined underneath with tube feet

STARFISH HYDRAULICS

In starfish, a sac of seawater—called an ampulla—which is located above each tube foot, is filled by a system of water channels unique to these kinds of animals. When muscles in the ampulla contract, they squeeze the seawater down into the tube foot. The tube foot extends and sticks to the seabed by its sucker, before muscles in the foot contract to pull the animal forward.

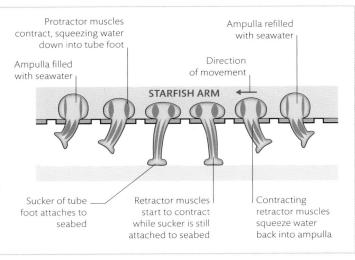

Protractor muscles contract, squeezing water down into tube foot

Ampulla filled with seawater

Ampulla refilled with seawater

Direction of movement

STARFISH ARM

Sucker of tube foot attaches to seabed

Retractor muscles start to contract while sucker is still attached to seabed

Contracting retractor muscles squeeze water back into ampulla

Suckered feet
Starfish tube feet are tipped with suckers that help them walk. These suckers can be strong enough to pull open mussel shells.

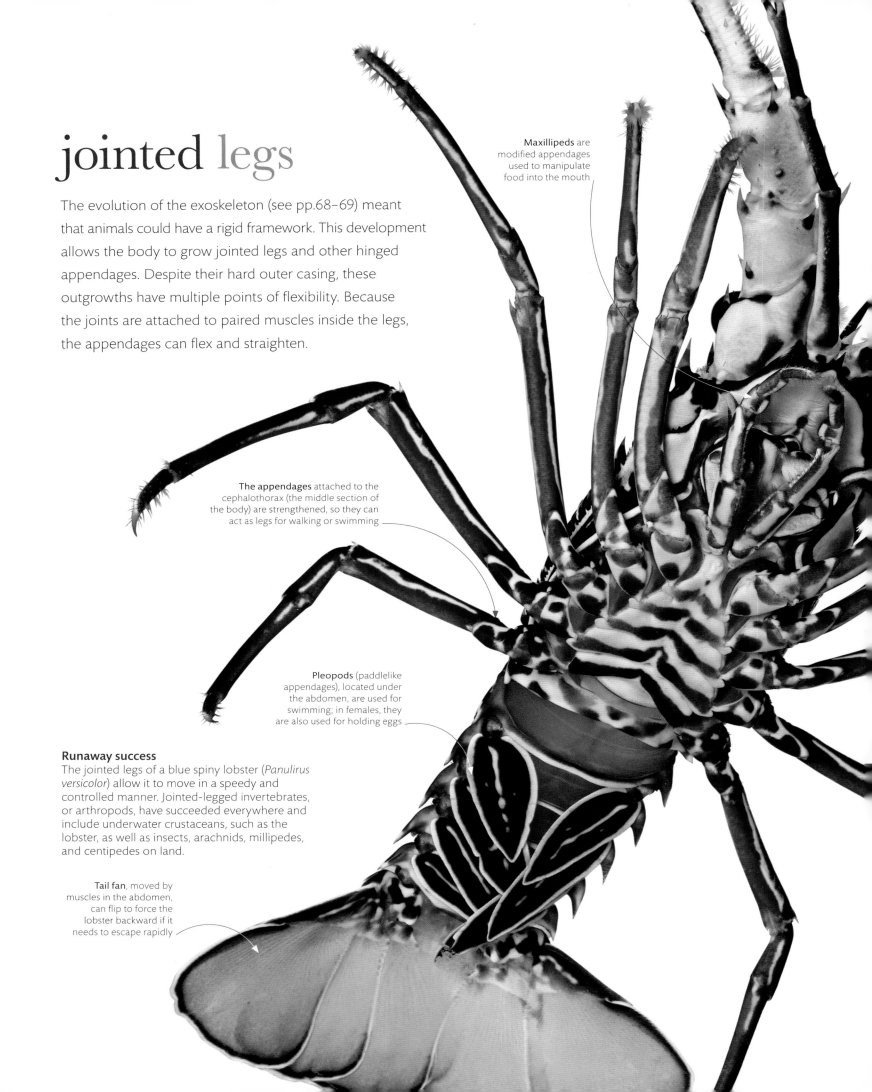

jointed legs

The evolution of the exoskeleton (see pp.68–69) meant
that animals could have a rigid framework. This development
allows the body to grow jointed legs and other hinged
appendages. Despite their hard outer casing, these
outgrowths have multiple points of flexibility. Because
the joints are attached to paired muscles inside the legs,
the appendages can flex and straighten.

Maxillipeds are
modified appendages
used to manipulate
food into the mouth

The appendages attached to the
cephalothorax (the middle section of
the body) are strengthened, so they can
act as legs for walking or swimming

Pleopods (paddlelike
appendages), located under
the abdomen, are used for
swimming; in females, they
are also used for holding eggs

Runaway success
The jointed legs of a blue spiny lobster (*Panulirus
versicolor*) allow it to move in a speedy and
controlled manner. Jointed-legged invertebrates,
or arthropods, have succeeded everywhere and
include underwater crustaceans, such as the
lobster, as well as insects, arachnids, millipedes,
and centipedes on land.

Tail fan, moved by
muscles in the abdomen,
can flip to force the
lobster backward if it
needs to escape rapidly

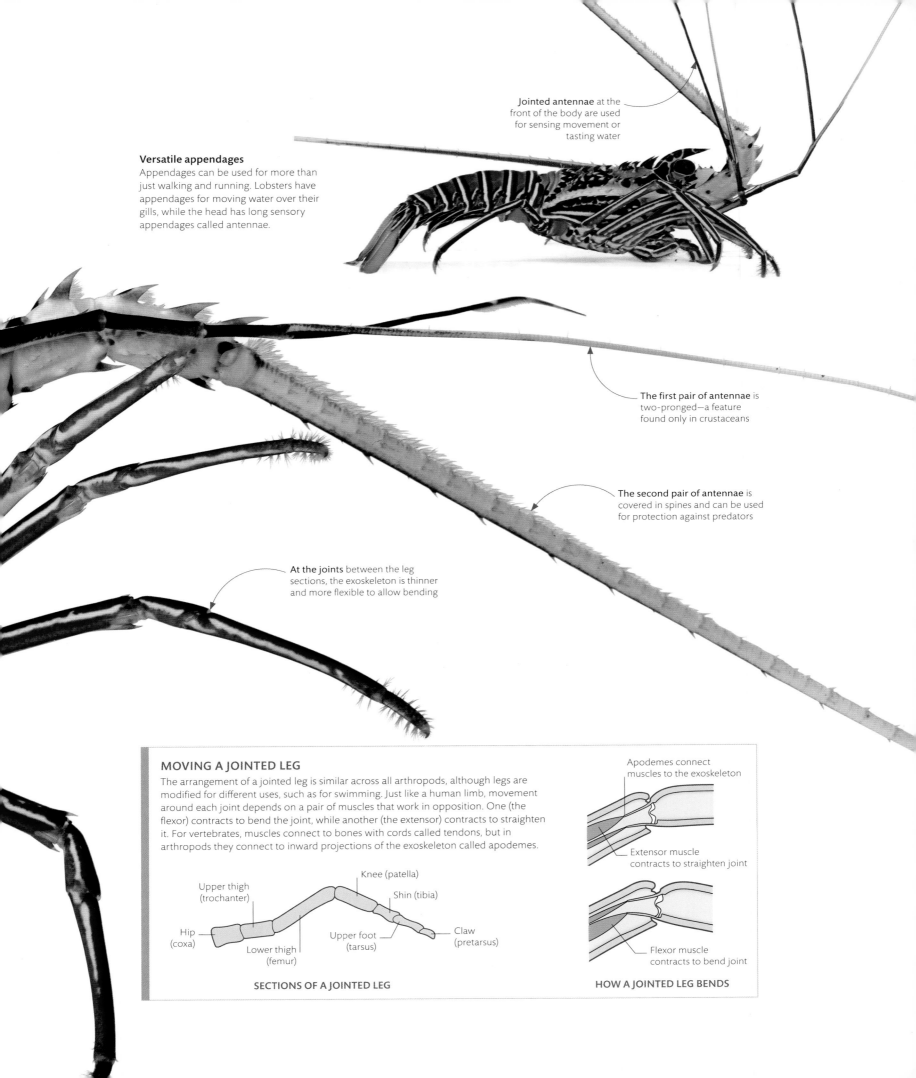

Versatile appendages
Appendages can be used for more than just walking and running. Lobsters have appendages for moving water over their gills, while the head has long sensory appendages called antennae.

Jointed antennae at the front of the body are used for sensing movement or tasting water

The first pair of antennae is two-pronged—a feature found only in crustaceans

The second pair of antennae is covered in spines and can be used for protection against predators

At the joints between the leg sections, the exoskeleton is thinner and more flexible to allow bending

MOVING A JOINTED LEG

The arrangement of a jointed leg is similar across all arthropods, although legs are modified for different uses, such as for swimming. Just like a human limb, movement around each joint depends on a pair of muscles that work in opposition. One (the flexor) contracts to bend the joint, while another (the extensor) contracts to straighten it. For vertebrates, muscles connect to bones with cords called tendons, but in arthropods they connect to inward projections of the exoskeleton called apodemes.

Upper thigh (trochanter)

Knee (patella)

Shin (tibia)

Hip (coxa)

Lower thigh (femur)

Upper foot (tarsus)

Claw (pretarsus)

SECTIONS OF A JOINTED LEG

Apodemes connect muscles to the exoskeleton

Extensor muscle contracts to straighten joint

Flexor muscle contracts to bend joint

HOW A JOINTED LEG BENDS

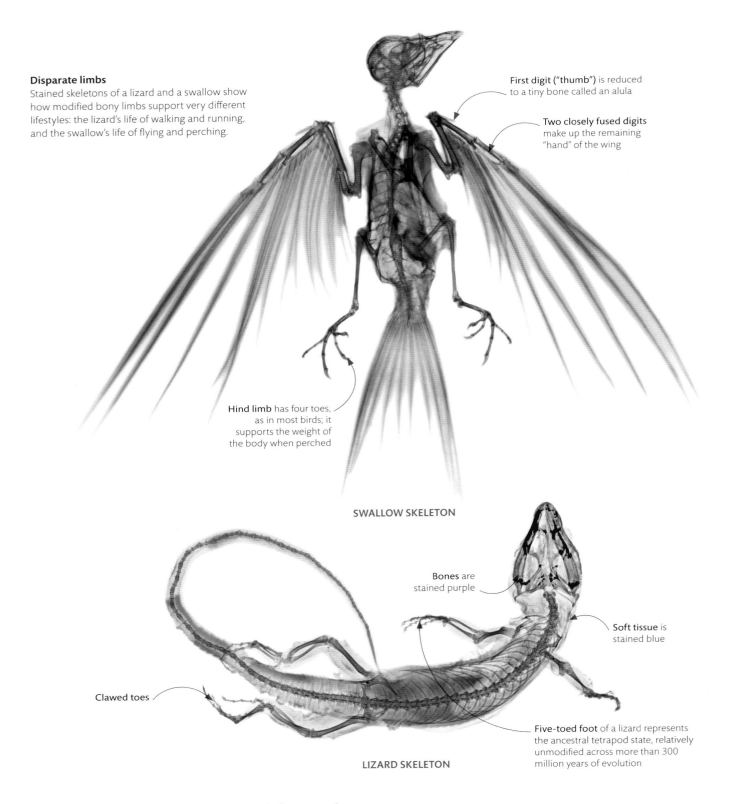

Disparate limbs
Stained skeletons of a lizard and a swallow show how modified bony limbs support very different lifestyles: the lizard's life of walking and running, and the swallow's life of flying and perching.

First digit ("thumb") is reduced to a tiny bone called an alula

Two closely fused digits make up the remaining "hand" of the wing

Hind limb has four toes, as in most birds; it supports the weight of the body when perched

SWALLOW SKELETON

Bones are stained purple

Soft tissue is stained blue

Clawed toes

Five-toed foot of a lizard represents the ancestral tetrapod state, relatively unmodified across more than 300 million years of evolution

LIZARD SKELETON

vertebrate limbs

Four-limbed vertebrates, or tetrapods, evolved from fish with fleshy fins that became modified for walking on land. The tetrapods inherited bony limbs consisting of a single upper limb bone hinged to two parallel lower limb bones, in turn articulated with a foot carrying no more than five digits. From this common "pentadactyl" (five-toed) arrangement, tetrapods evolved wings and flippers; some, like snakes, lost their limbs altogether.

Aerial frog
This X-ray image of Wallace's flying frog (*Rhacophorus nigropalmatus*) reveals the five-toed feet and four-toed hands typical of most living limbed amphibians. Elongated digits on the frog's hands and feet support wide webbings that are used to parachute down from high tree branches and even glide short distances.

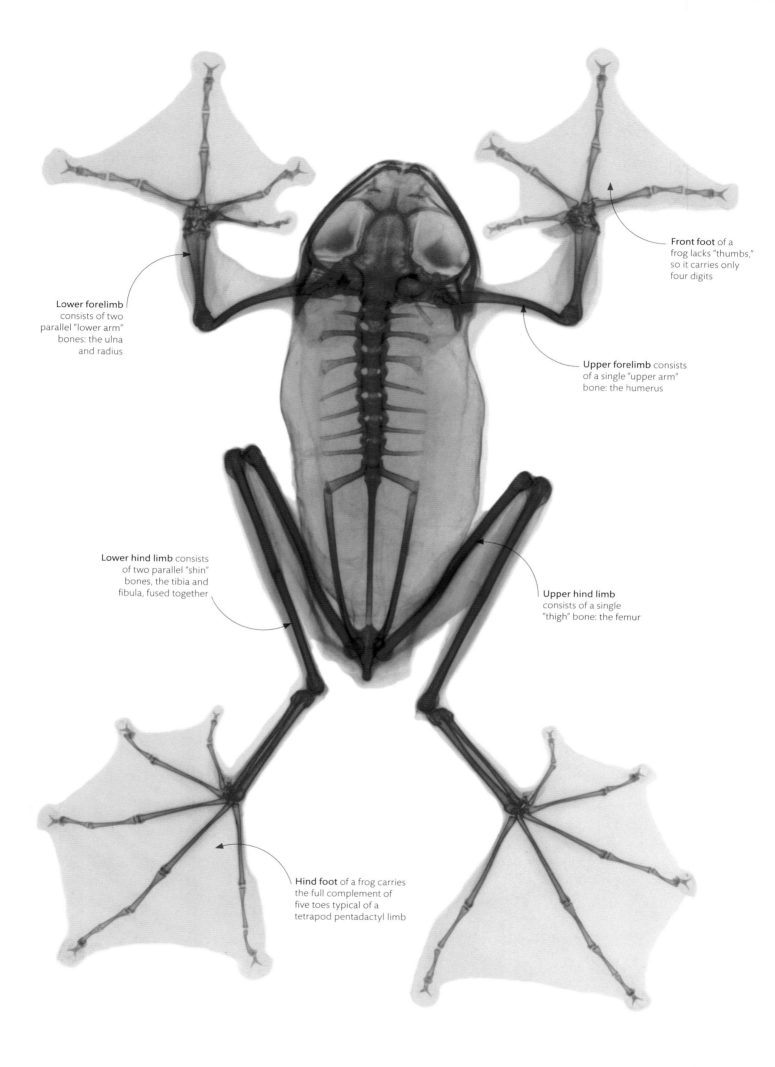

Lower forelimb consists of two parallel "lower arm" bones: the ulna and radius

Front foot of a frog lacks "thumbs," so it carries only four digits

Upper forelimb consists of a single "upper arm" bone: the humerus

Lower hind limb consists of two parallel "shin" bones, the tibia and fibula, fused together

Upper hind limb consists of a single "thigh" bone: the femur

Hind foot of a frog carries the full complement of five toes typical of a tetrapod pentadactyl limb

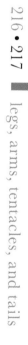

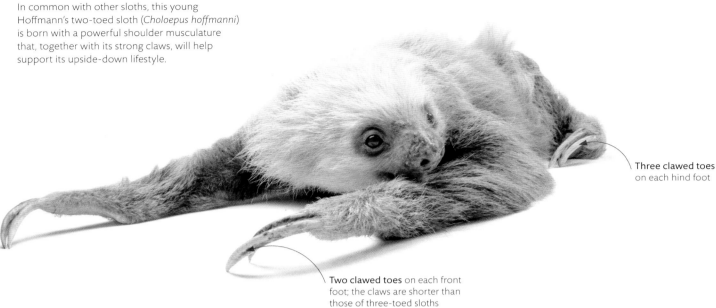

Two-toed sloth
In common with other sloths, this young Hoffmann's two-toed sloth (*Choloepus hoffmanni*) is born with a powerful shoulder musculature that, together with its strong claws, will help support its upside-down lifestyle.

Three clawed toes on each hind foot

Two clawed toes on each front foot; the claws are shorter than those of three-toed sloths

mammal claws

The curved claws at the end of land vertebrates' digits are used for a variety of tasks, from grooming and improving traction, to use as weapons. They occur in all birds, most reptiles and mammals, and even some amphibians. Claws are composed of keratin—the same hard protein found in horns—produced by special cells at their base. They grow continuously, nourished by a central blood vessel; only wear prevents them from growing too long.

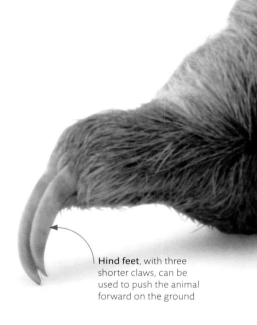

Hind feet, with three shorter claws, can be used to push the animal forward on the ground

PROTRACTABLE CLAWS
Among mammals, only cats and related civets keep their claws retracted to protect their sharp tips. They are protracted (extended) for use as weapons when the muscles of the toes contract to spread the paw wide.

Retractor ligament keeps claw pulled back

Slack dorsal tendon

Claw sheath encloses claw

Slack ventral tendon

CLAWS RETRACTED

Elastic retractor ligament stretches

Dorsal tendon pulled taut by dorsal toe muscle

Claw extends from sheath

Ventral tendon pulled taut by ventral toe muscle

CLAWS PROTRACTED

Claws as hooks
Like the other sloths of Central and South America, a brown-throated three-toed sloth (*Bradypus variegatus*) cannot grasp branches to climb because its digits are partially fused. Instead, it uses its enlarged claws as hooks to haul itself up and hang from trees. On the ground, where the claws are a hindrance, the sloth is forced to crawl on its forearms.

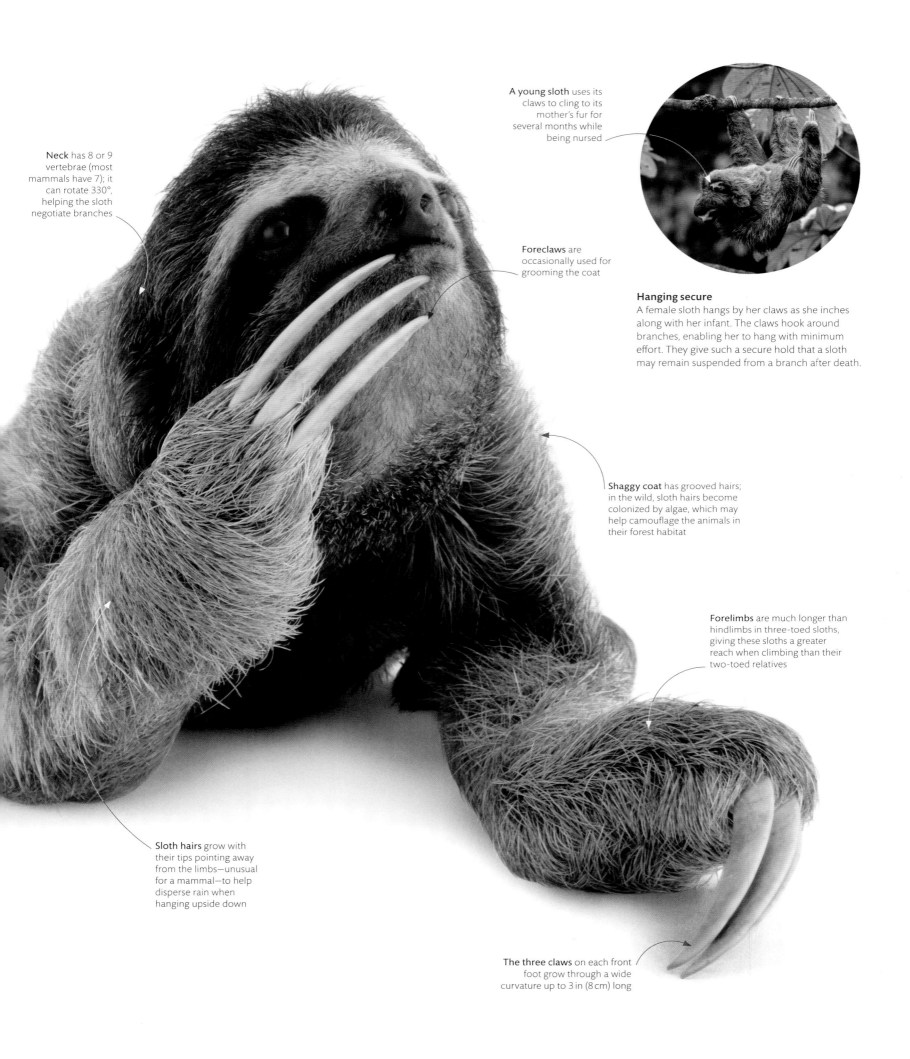

Neck has 8 or 9 vertebrae (most mammals have 7); it can rotate 330°, helping the sloth negotiate branches

A young sloth uses its claws to cling to its mother's fur for several months while being nursed

Foreclaws are occasionally used for grooming the coat

Hanging secure

A female sloth hangs by her claws as she inches along with her infant. The claws hook around branches, enabling her to hang with minimum effort. They give such a secure hold that a sloth may remain suspended from a branch after death.

Shaggy coat has grooved hairs; in the wild, sloth hairs become colonized by algae, which may help camouflage the animals in their forest habitat

Forelimbs are much longer than hindlimbs in three-toed sloths, giving these sloths a greater reach when climbing than their two-toed relatives

Sloth hairs grow with their tips pointing away from the limbs—unusual for a mammal—to help disperse rain when hanging upside down

The three claws on each front foot grow through a wide curvature up to 3 in (8 cm) long

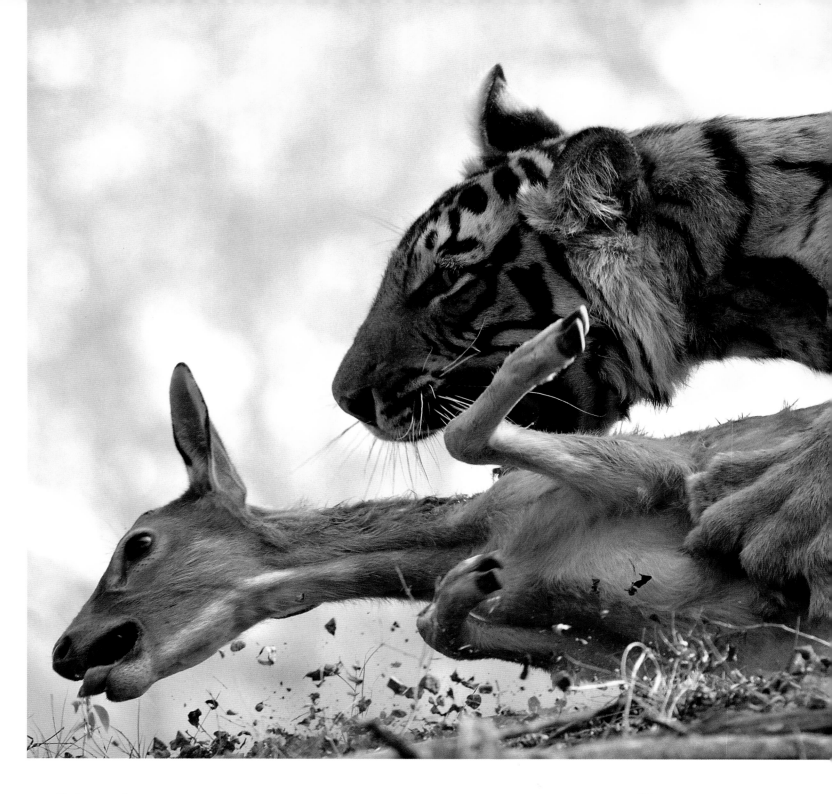

spotlight species

tiger

The tiger (*Panthera tigris*) is the largest of the cat family and a consummate predator, with almost every aspect of its anatomy geared toward the capture, killing, and devouring of prey. Solitary, mostly nocturnal hunters, tigers rely on finely tuned senses, speed, and raw power to ambush or stalk animals ranging in size from pigs and small deer to Asian water buffalo.

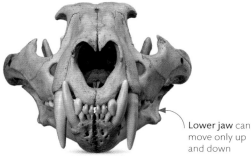

Lower jaw can move only up and down

Mighty bite
The tiger skull is short, broad, and robust and the lower jaw sacrifices chewing ability for pure bite power.

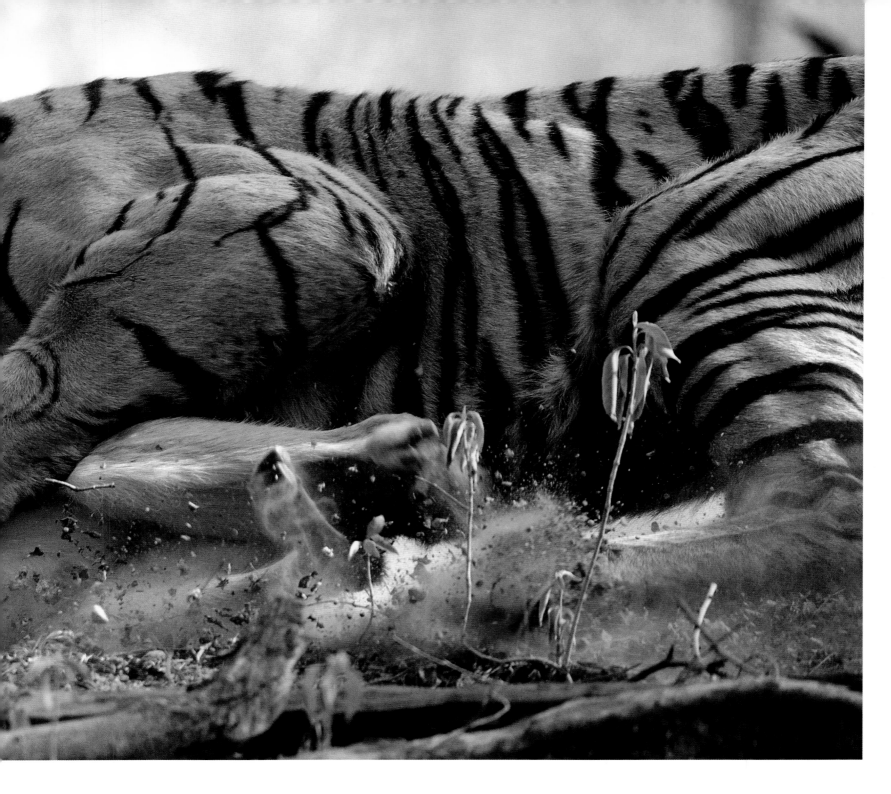

Not all tigers are giants. Amur (formerly Siberian) tigers are up to three times heavier than those found in the tropical forests of Indonesia, where large body size would encumber movement and increase the chances of overheating. But all exhibit immense athleticism, thanks to a flexible spine and long, muscular limbs. A large adult can leap 32 ft (10 m) horizontally from a standing start, and its large, forward-facing eyes aid stereoscopic vision enabling it to judge distance accurately. Tiger forelimbs and shoulders are immense and the claws are fully retractable, so they do not become blunt through abrasion. Claws are deployed in climbing, for marking territory with scratch marks, and in fighting, as well as to snag, grip, and bring down their prey. The jaws and teeth come into play once the prey is downed—clamping vicelike onto the windpipe of large prey, or dispatching smaller animals with a bone-splitting bite to the neck.

For such large animals, tigers can be remarkably inconspicuous. The boldly patterned coat provides startlingly effective camouflage in strong or dappled light, in forests, on grassland, or even rocky ground. In rare variants, the orange may be replaced by white. The stripes remain, but the camouflage is compromised.

The huge distribution and the variety of habitats in which tigers once thrived hint at the adaptability of a species that belies its shrunken range and endangered status. This results largely from manmade activites, and three of the nine described subspecies are extinct.

Raw power
Tigers typically attack from behind and, using bodyweight, can overwhelm prey in seconds. A deer this size can be eaten in one meal, while larger prey may be cached and consumed over several days.

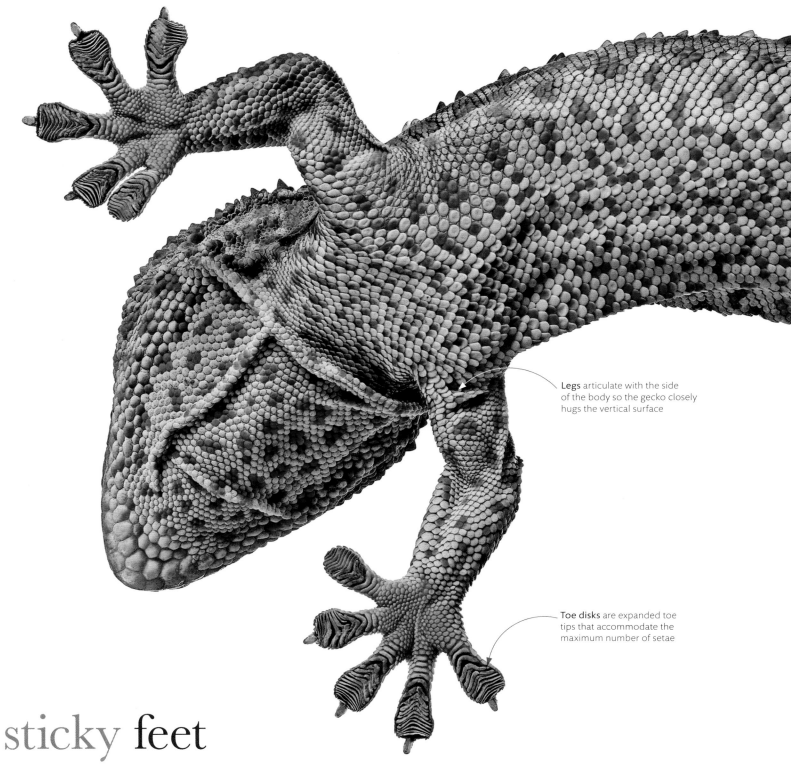

Legs articulate with the side of the body so the gecko closely hugs the vertical surface

Toe disks are expanded toe tips that accommodate the maximum number of setae

sticky feet

While clawed toes and grasping feet are invaluable for climbing, for small animals, the tiny forces of attraction at play between atoms and molecules add up to give sufficient grip on even the smoothest of surfaces. The toe pads of geckos are covered in millions of microscopic hairs called setae. They all stick to a surface, and can collectively contribute enough force to hold the weight of an 11 oz (300 g) lizard, even upside down.

Wall climber

Many species of geckos use their climbing ability to grip smooth leaves or rock faces, but for some, the walls and ceilings of buildings serve just as well for hunting for insects and other invertebrates. The tokay gecko (*Gecko gecko*) originally lived in rainforests, but has adapted to life alongside humans and is seen inside homes in the tropics.

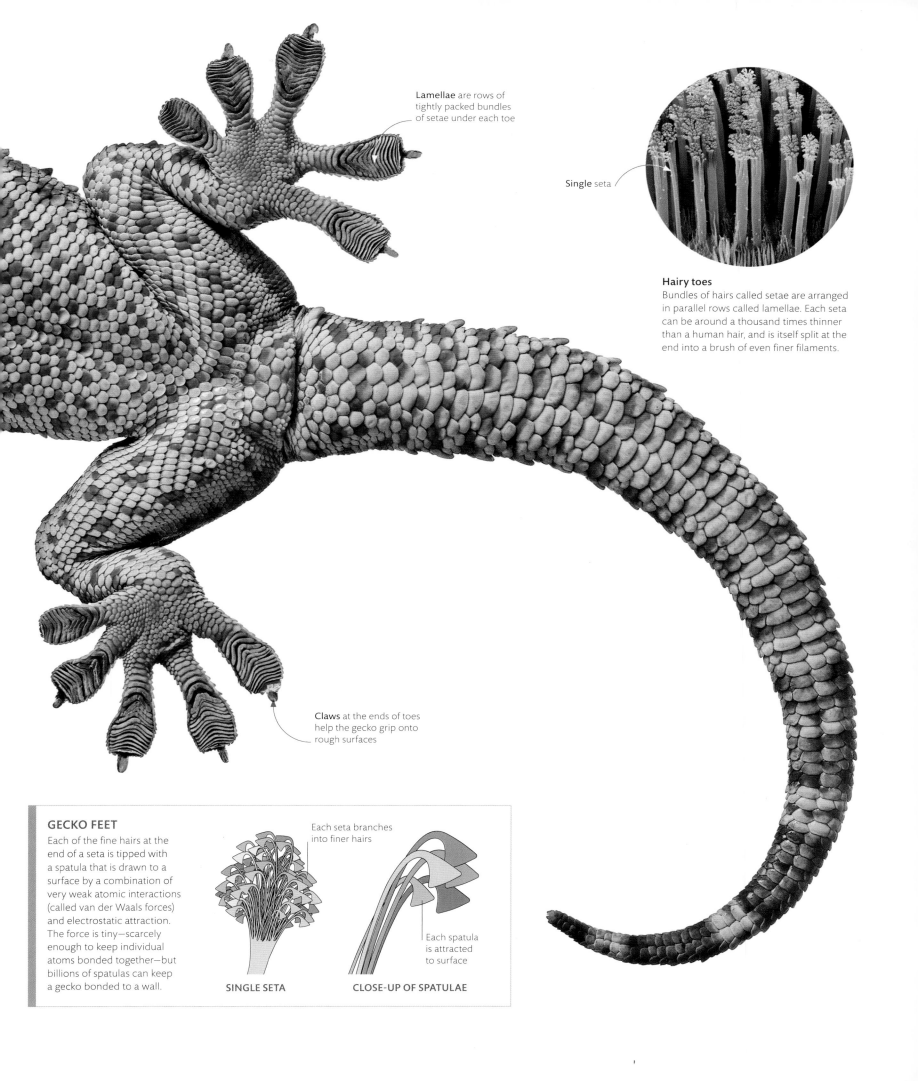

Lamellae are rows of tightly packed bundles of setae under each toe

Single seta

Hairy toes
Bundles of hairs called setae are arranged in parallel rows called lamellae. Each seta can be around a thousand times thinner than a human hair, and is itself split at the end into a brush of even finer filaments.

Claws at the ends of toes help the gecko grip onto rough surfaces

GECKO FEET

Each of the fine hairs at the end of a seta is tipped with a spatula that is drawn to a surface by a combination of very weak atomic interactions (called van der Waals forces) and electrostatic attraction. The force is tiny—scarcely enough to keep individual atoms bonded together—but billions of spatulas can keep a gecko bonded to a wall.

Each seta branches into finer hairs

Each spatula is attracted to surface

SINGLE SETA

CLOSE-UP OF SPATULAE

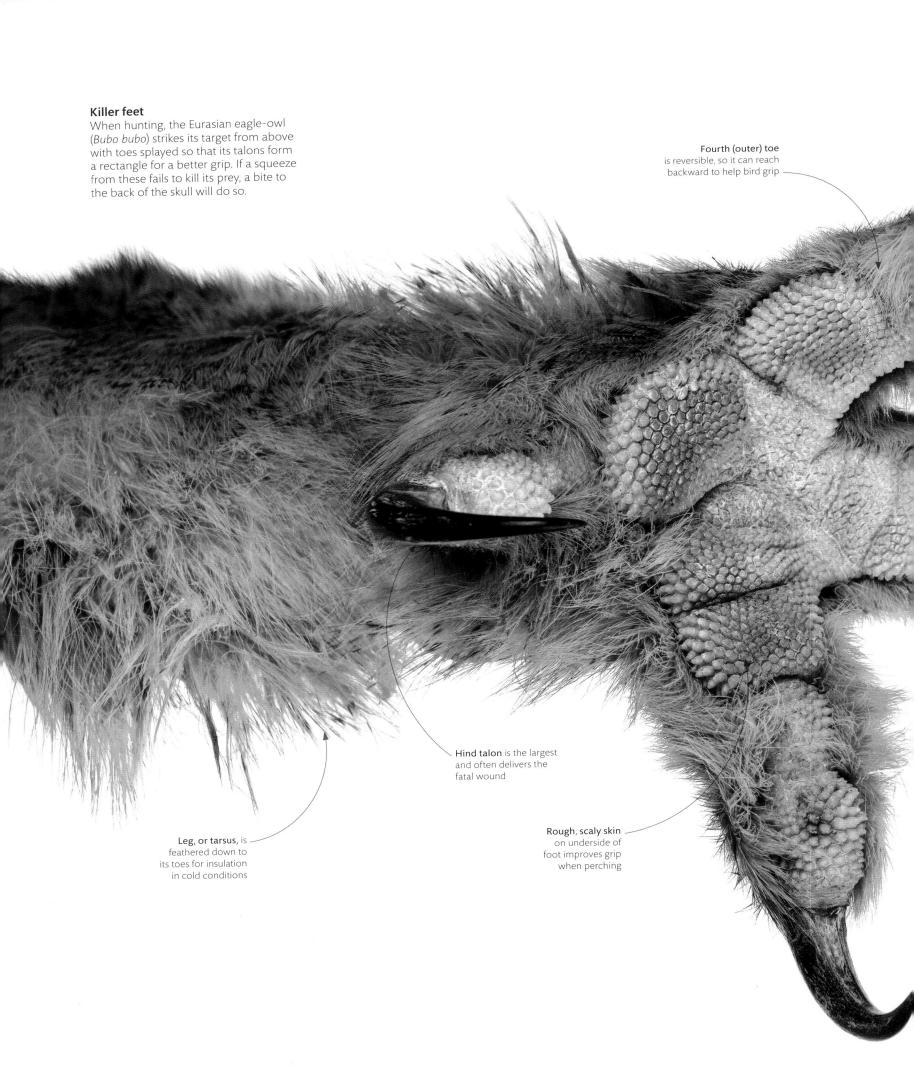

Killer feet

When hunting, the Eurasian eagle-owl (*Bubo bubo*) strikes its target from above with toes splayed so that its talons form a rectangle for a better grip. If a squeeze from these fails to kill its prey, a bite to the back of the skull will do so.

Fourth (outer) toe is reversible, so it can reach backward to help bird grip

Hind talon is the largest and often delivers the fatal wound

Leg, or tarsus, is feathered down to its toes for insulation in cold conditions

Rough, scaly skin on underside of foot improves grip when perching

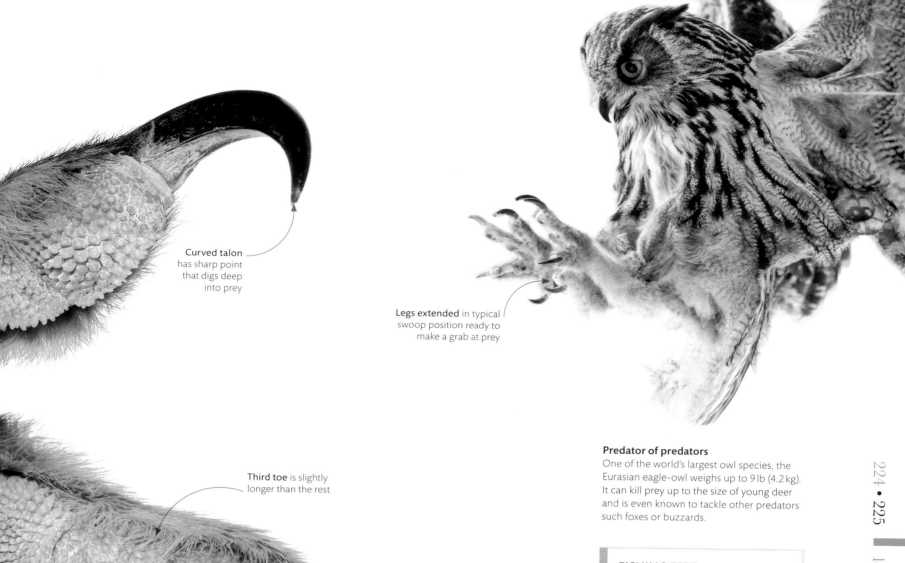

Curved talon
has sharp point
that digs deep
into prey

Legs extended in typical
swoop position ready to
make a grab at prey

Third toe is slightly
longer than the rest

Predator of predators
One of the world's largest owl species, the
Eurasian eagle-owl weighs up to 9 lb (4.2 kg).
It can kill prey up to the size of young deer
and is even known to tackle other predators
such foxes or buzzards.

FISHING FEET
Like owls, fishing ospreys lift their
heavy prey with feet that have two
toes pointing forward and two back.
In addition, they are equipped with
long, curved talons and spiky skin on
the underside of their toes to ensure
that they can grip their slippery catch
securely as they lift it from the water.

OSPREY *Pandion Haliaetus*

raptor feet

Predatory birds, or raptors, are armed with formidable weaponry—a bill
and talons. Both function like daggers to puncture flesh, and are brandished
with impressive muscle power, but it is the clawed feet that usually deliver the
killing blow. Raptors squeeze prey in a vicelike grip and the talons puncture
vital organs, to ensure the body is lifeless when the bird is ready to feed.

Hanging lock

Bats such as this Indian fruit bat (*Pteropus giganteus*) also rely on specially roughened tendons that can lock into position when their claws grip a perch, letting them hang with little muscular effort. Unlike birds, bats do not have opposable digits on their feet.

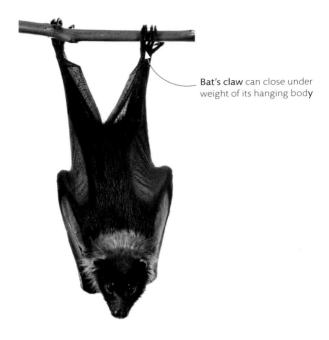

Bat's claw can close under weight of its hanging body

climbing and perching

When four-legged, backboned animals evolved flight, their forelimbs were commandeered as wings, leaving the hindlimbs to support their bodies when they landed. Today, bats still have claws on their wings, which can help with gripping, but birds rely entirely on their two legs to both run and climb. But both of these expert aeronauts have feet that can support their entire weight while they hold tightly onto perches without becoming fatigued—even when they are sleeping. As a result, both bats and birds are perfectly at home far from the ground.

LOCKED TENDONS

When a bird perches, its thigh muscles contract to bend the legs, pulling on the flexor tendons that extend to the tips of the toes. The increase in tension in the tendons causes the bird's toes to grasp the perch. The tendons run through sheaths and both sheaths and tendons have corresponding corrugated surfaces that lock together under the weight of the bird.

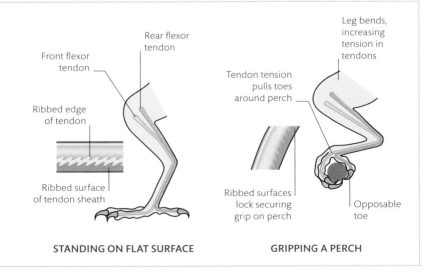

Rear flexor tendon

Front flexor tendon

Ribbed edge of tendon

Ribbed surface of tendon sheath

Leg bends, increasing tension in tendons

Tendon tension pulls toes around perch

Ribbed surfaces lock securing grip on perch

Opposable toe

STANDING ON FLAT SURFACE

GRIPPING A PERCH

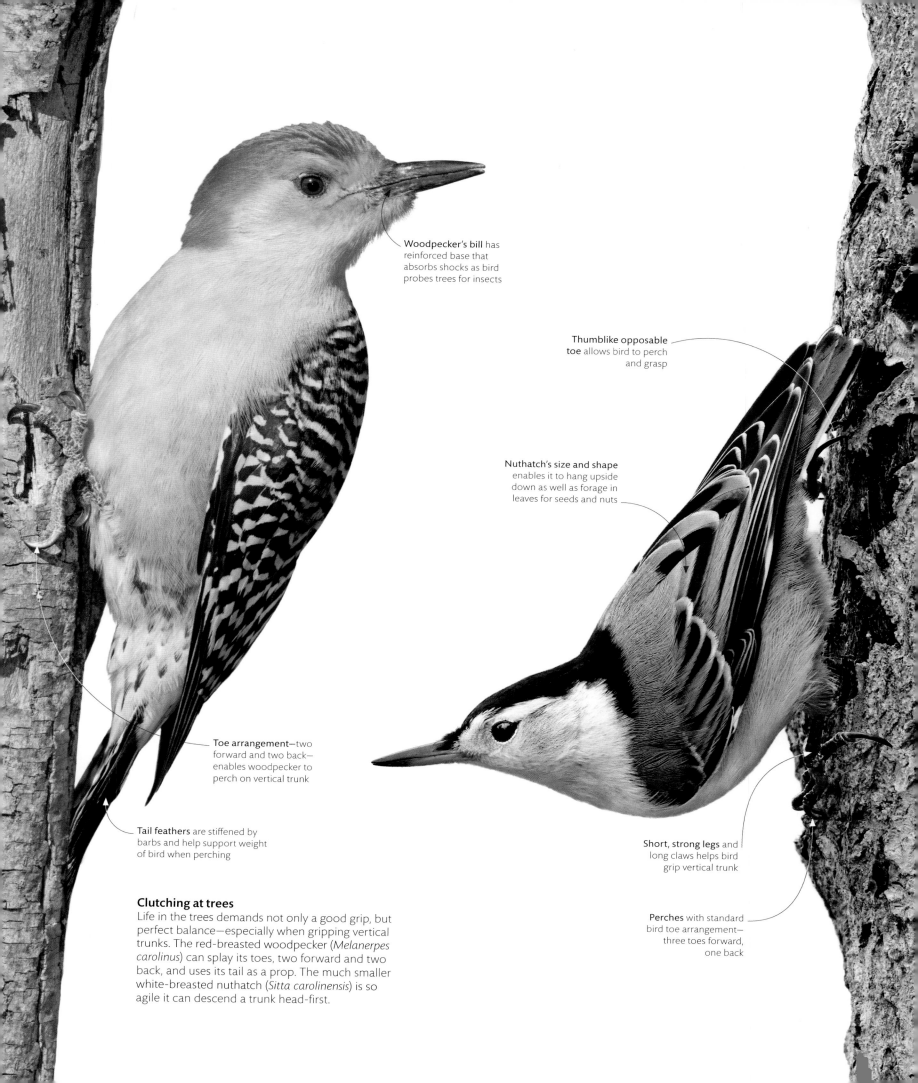

Woodpecker's bill has reinforced base that absorbs shocks as bird probes trees for insects

Thumblike opposable toe allows bird to perch and grasp

Nuthatch's size and shape enables it to hang upside down as well as forage in leaves for seeds and nuts

Toe arrangement—two forward and two back—enables woodpecker to perch on vertical trunk

Tail feathers are stiffened by barbs and help support weight of bird when perching

Short, strong legs and long claws helps bird grip vertical trunk

Perches with standard bird toe arrangement—three toes forward, one back

Clutching at trees

Life in the trees demands not only a good grip, but perfect balance—especially when gripping vertical trunks. The red-breasted woodpecker (*Melanerpes carolinus*) can splay its toes, two forward and two back, and uses its tail as a prop. The much smaller white-breasted nuthatch (*Sitta carolinensis*) is so agile it can descend a trunk head-first.

Even-toed hoofed mammals
Chevrotains are among the smallest hoofed mammals, some little bigger than a rabbit. Like other even-toed hoofed mammals, each limb is supported by the third and fourth hoofed toes.

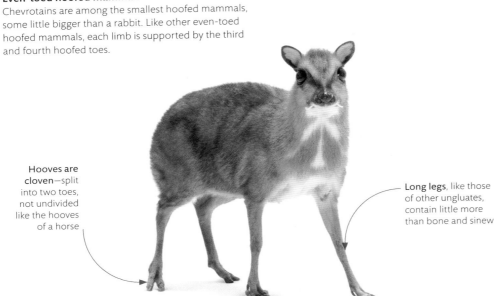

Hooves are cloven—split into two toes, not undivided like the hooves of a horse

Long legs, like those of other ungluates, contain little more than bone and sinew

mammal hooves

Many mammals adapted for running fast stand on the tips of toes that end in flat-bottomed hooves, instead of the curved claws of their ancestors. The number of digits is also reduced, with the body weight concentrated across a pair of toes in deer, antelope, and other cloven-hoofed mammals, or just a single hoofed toe in horses and zebras. Hoof-tipped feet at the end of long, slender, lightweight limb—with stocky muscles packed high up near the body's center of mass—enable the legs to swing through a bigger stride, maximizing speed when evading predators.

FOOT POSTURES

Plantigrade mammals, such as humans and bears, support their body weight on the flats of their feet; in faster runners, the foot bones are raised, increasing leg length. With digitigrade mammals, such as dogs, the end bones of the digits are flat on the ground, but in unguligrade (hoofed) mammals, the entire digits are raised to the toe-tip position, which maximizes stride length.

KEY
- Femur (thigh)
- Tibula-fibula (lower leg)
- Tarsus (upper foot)
- Metatarsus (lower foot)
- Phalanges (toes)

PLANTIGRADE (BEAR)

DIGITIGRADE (DOG)

UNGULIGRADE (HORSE)

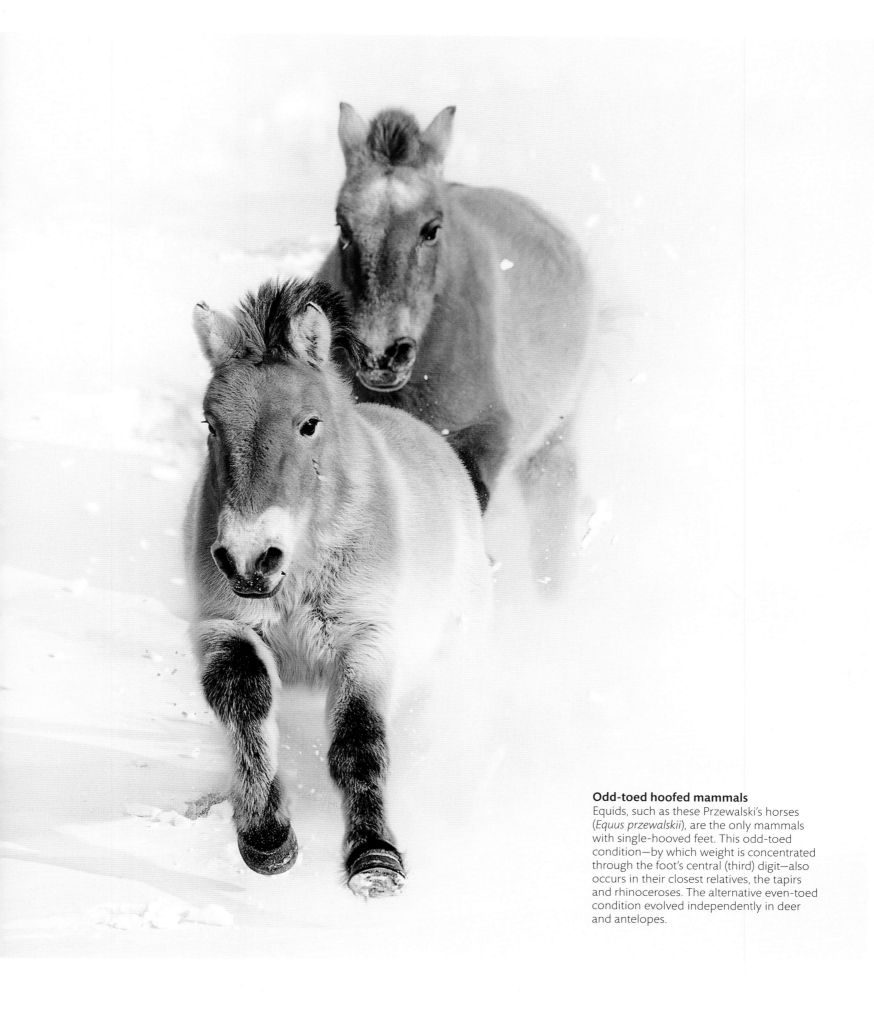

Odd-toed hoofed mammals
Equids, such as these Przewalski's horses (*Equus przewalskii*), are the only mammals with single-hooved feet. This odd-toed condition—by which weight is concentrated through the foot's central (third) digit—also occurs in their closest relatives, the tapirs and rhinoceroses. The alternative even-toed condition evolved independently in deer and antelopes.

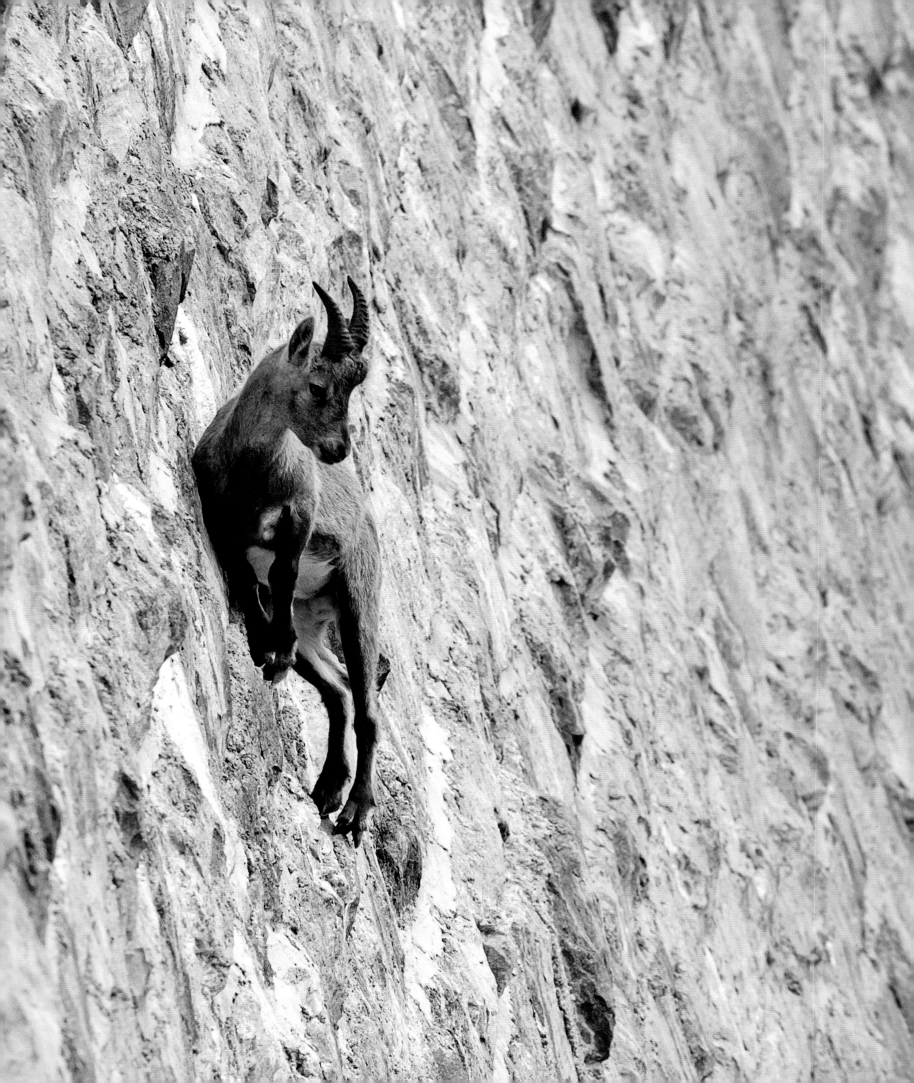

alpine ibex

It takes nerves of steel to balance on a precipitous rock face, but for goats, sheep, and ibex it is a way of life. It is clearly worth the risk because it ensures that they are well out of reach of predators—a considerable benefit for animals that are otherwise exposed in open habitat.

About 11 million years ago—somewhere in Asia—a tribe of sure-footed, hoofed animals evolved into specialized rock-climbers. They developed short, sturdy shin bones and today species of takins, chamois, goats, sheep, and ibex account for more than a third of all horned cloven-hoofed mammals in the mountains across Eurasia and parts of North America.

The Alpine ibex of central Europe became better rock-climbers than most and live at altitudes of up to 10,500 ft (3,200 m), far above the tree line. They are also seen perching on the walls of dams with gradients of 60 degrees. These

Nimble youth
A young male Alpine ibex is climbing the slope of a manmade dam in northern Italy, attracted to the salt that exudes from the stonework. The ibex follows a zigzag route as it climbs the wall and takes a more linear one on the way down.

animals have padded hooves for traction (see below) and develop calluses in the backs of their knees to protect them among sharp rocks. Their habitat is free from large predators and in winter the steep rocky slopes and the sides of ravines offer some respite from deep snow. Ewes give birth up there, and their kids quickly learn to keep their footing on the slopes; the mothers wait until spring to lead their young to meadows, where the grazing is better. It takes lighter bodies and shorter legs to negotiate the steep rock faces so, in their 11th year, males move to flatter ground, and never return to the slopes.

Mountain life is difficult and many ibex die in avalanches. They are also at risk of an infectious eye disease that causes blindness, which accounts for nearly 1 in 3 falling to their deaths. But populations are buoyant and when food is abundant, up to 95 percent of young ibex kids survive into adulthood.

HOOVES THAT GRIP

Being cloven-hoofed is key to the Alpine ibex being able to climb a steep rock face. Its toes can splay apart to grip the ground. Beneath each toe, a rubbery sole acts like a suction pad to provide traction between the ibex's feet and the ground that is greater than that between rubber and concrete.

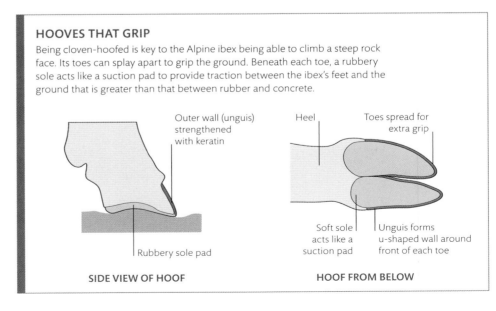

Outer wall (unguis) strengthened with keratin

Rubbery sole pad

SIDE VIEW OF HOOF

Heel

Toes spread for extra grip

Soft sole acts like a suction pad

Unguis forms u-shaped wall around front of each toe

HOOF FROM BELOW

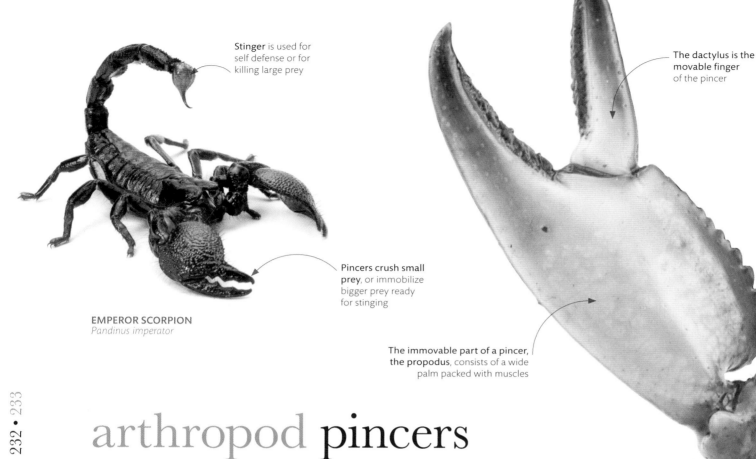

Stinger is used for self defense or for killing large prey

EMPEROR SCORPION
Pandinus imperator

Pincers crush small prey, or immobilize bigger prey ready for stinging

The **dactylus** is the movable finger of the pincer

The **immovable part of a pincer, the propodus**, consists of a wide palm packed with muscles

arthropod pincers

Some arthropod mouthparts function like pincers to bite or grasp, but other forms of pincers develop at the ends of the limbs of animals such as crabs, crayfishes, and scorpions. These pincers, called chelae, rely on the same kinds of muscles that move walking limbs, except that pincer muscles clamp together clawlike fingers. The smallest pincers deftly manipulate food, while the biggest can be wielded as fearsome defensive weapons.

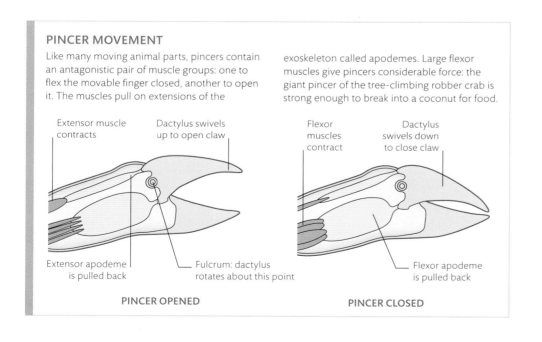

PINCER MOVEMENT

Like many moving animal parts, pincers contain an antagonistic pair of muscle groups: one to flex the movable finger closed, another to open it. The muscles pull on extensions of the exoskeleton called apodemes. Large flexor muscles give pincers considerable force: the giant pincer of the tree-climbing robber crab is strong enough to break into a coconut for food.

Extensor muscle contracts

Dactylus swivels up to open claw

Extensor apodeme is pulled back

Fulcrum: dactylus rotates about this point

PINCER OPENED

Flexor muscles contract

Dactylus swivels down to close claw

Flexor apodeme is pulled back

PINCER CLOSED

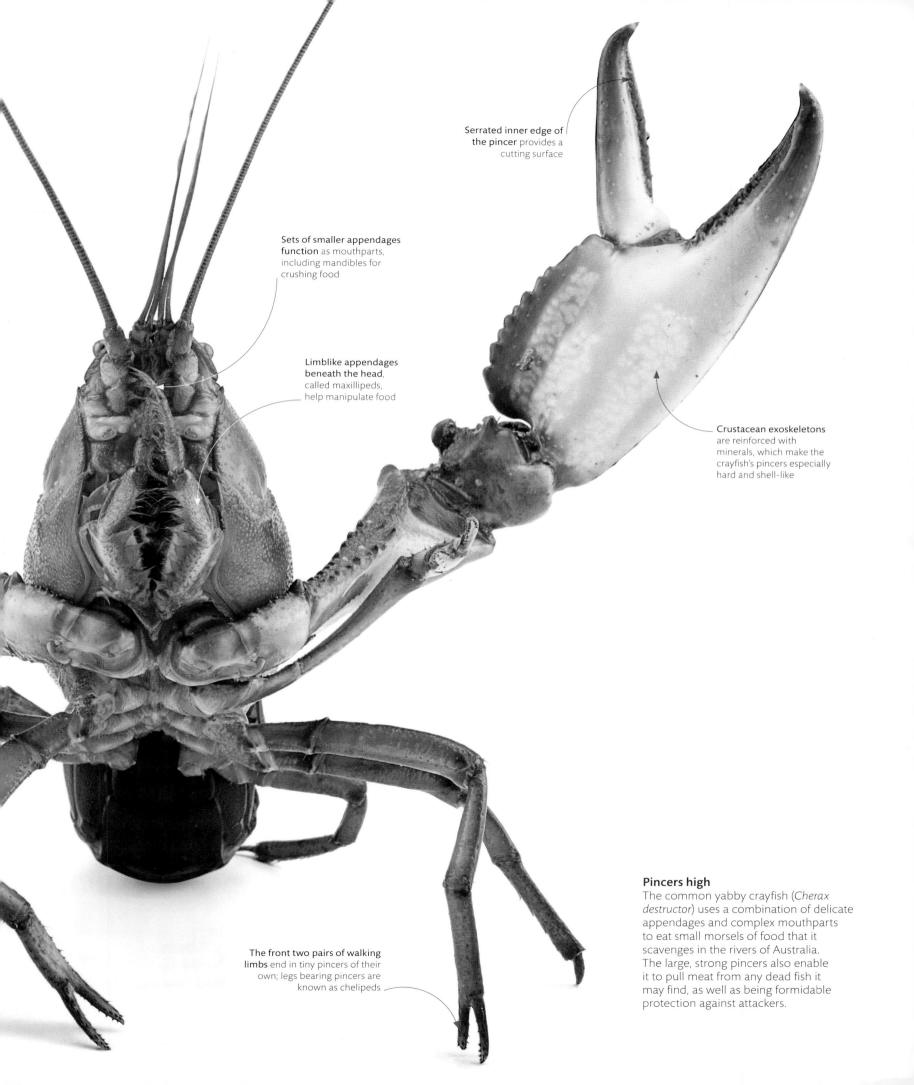

Serrated inner edge of the pincer provides a cutting surface

Sets of smaller appendages function as mouthparts, including mandibles for crushing food

Limblike appendages beneath the head, called maxillipeds, help manipulate food

Crustacean exoskeletons are reinforced with minerals, which make the crayfish's pincers especially hard and shell-like

The front two pairs of walking limbs end in tiny pincers of their own; legs bearing pincers are known as chelipeds

Pincers high

The common yabby crayfish (*Cherax destructor*) uses a combination of delicate appendages and complex mouthparts to eat small morsels of food that it scavenges in the rivers of Australia. The large, strong pincers also enable it to pull meat from any dead fish it may find, as well as being formidable protection against attackers.

Crayfish and two shrimps (c.1840)
During his country-wide travels in his forties, Utagawa Hiroshige (Ando) was entranced by the splendor of the countryside, producing woodcuts of landscapes and nature portraits that inspired Western artists. The clattering legs and wayward feelers of this crayfish come alive on the page, printed at a time when the technique, color, and texture of Japanese woodcuts were at a peak.

Two carp (1831)
Every scale and fin ray is delineated in Katsushika Hokusai's woodcut of two carp against a backdrop of emerald pondweed. A symbol of the Samurai, the fish represents courage, dignity, and endurance.

animals in art

artists of the floating world

Woodcut prints of the floating world, called *ukiyo-e*, were not, as one might suppose, nature studies of sea and river life. The "floating world" in Japan referred to the theaters and brothels that were the haunts of wealthy traders in the late 17th century, when prints of city life, erotica, folk tales, and landscapes became immensely popular. Toward the end of the 19th century, domestic tourism opened the country up to its people, and leading artists responded with sublime pictures of scenery and subtle portraits of bird, fish, and other animal life.

At their peak of production, prints were produced in the thousands at fixed prices that made them affordable to all. The publisher had overall control of the editions, working with a designer or artist, a woodblock cutter, and a printer. A copy of the artist's picture was laid face down on a block of fine-grained cherry wood, then the cutter carved through the paper to transfer the design onto this key block. From the mid-18th century, monochrome and simple two-color prints were replaced with glorious full-color "brocade" prints that used separate blocks for each color. Copies were printed by hand, which caused little wear to the blocks and allowed thousands of prints to be produced.

Since ancient times, the bedrock of the Shinto religion endowed every mountain, stream, and tree with spirits known as Kami. In folk tradition, animals were symbolic: for example, rabbits bestowed prosperity, while cranes symbolized a long life. When 19th-century artist Utagawa Hiroshige (Ando) abandoned the *ukiyo-e* subjects of courtesans, kabuki actors, and city life in favor of idealized views of the natural world, it chimed with a national imperative to return to traditional values. Hiroshige's serene landscapes and subtle renderings of birds, animals, and fish also found a wide audience in the West, inspiring Impressionist artists such as Vincent van Gogh, Claude Monet, Paul Cezanne, and James Whistler.

The 70-year-long oeuvre of contemporary artist and printmaker Katsushika Hokusai was similarly celebrated in Japan and in the West. Looking back on his vast production of brush paintings, sea, and landscapes, views of Mount Fuji, and flower, bird, and animal studies he wrote: "At 73, I began to grasp the structures of birds and beasts, insects and fish… If I go on trying, I will surely understand them still better by the time I am 86, so that by 90 I will have penetrated to their essential nature."

> ❝ (Hiroshige) had the knack of vividly bringing home to the mind of an onlooker the beauties of Nature. ❞

SOTARO NAKAI, IN *THE COLOR-PRINTS OF HIROSHIGE*, EDWARD F. STRANGE, 1925

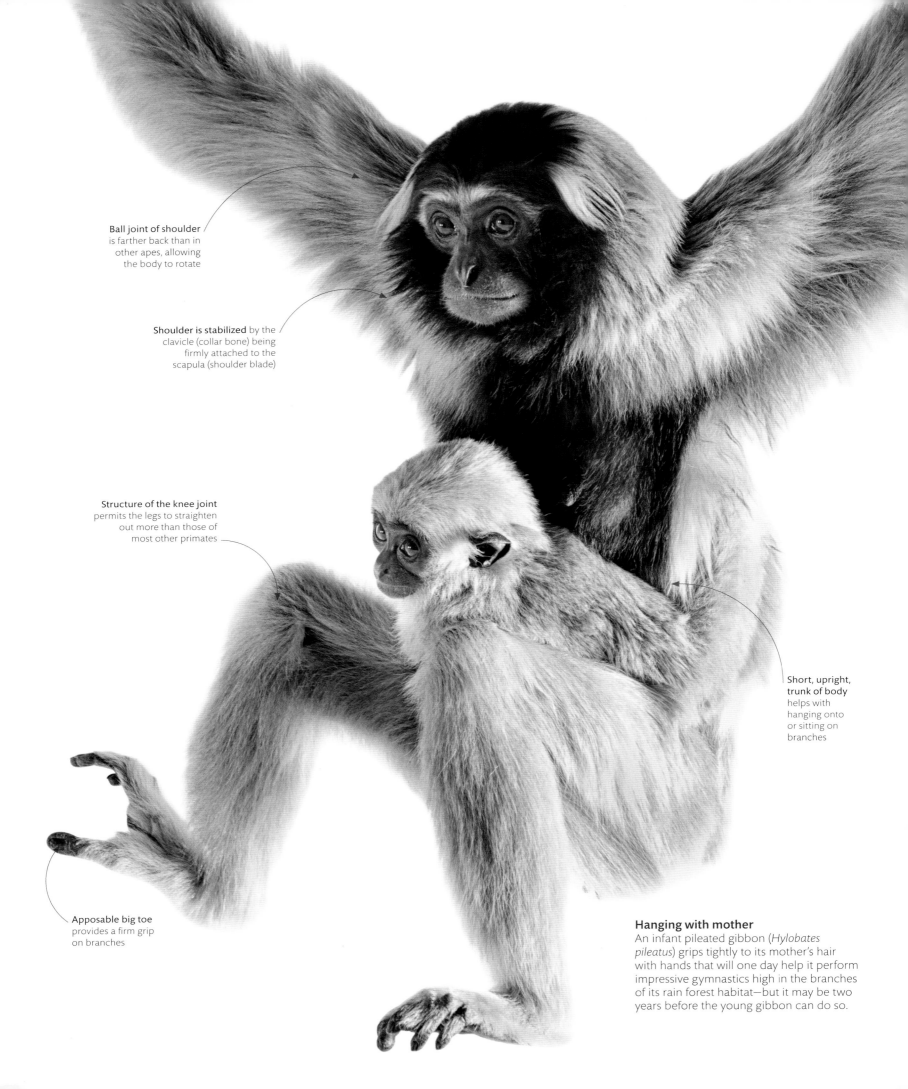

Ball joint of shoulder
is farther back than in
other apes, allowing
the body to rotate

Shoulder is stabilized by the
clavicle (collar bone) being
firmly attached to the
scapula (shoulder blade)

Structure of the knee joint
permits the legs to straighten
out more than those of
most other primates

**Short, upright,
trunk of body**
helps with
hanging onto
or sitting on
branches

Apposable big toe
provides a firm grip
on branches

Hanging with mother
An infant pileated gibbon (*Hylobates
pileatus*) grips tightly to its mother's hair
with hands that will one day help it perform
impressive gymnastics high in the branches
of its rain forest habitat—but it may be two
years before the young gibbon can do so.

Walking upright
Adaptations to an arboreal lifestlye, such as modified knees, also give gibbons a more rapid stride than other non-human primates when walking on the ground.

Exceptionally long arms increase the gibbon's reach, maximizing the speed at which it can swing through the trees

Thumb is proportionately shorter and less opposable than in other apes, so the gibbon finds it harder to grasp and hold objects

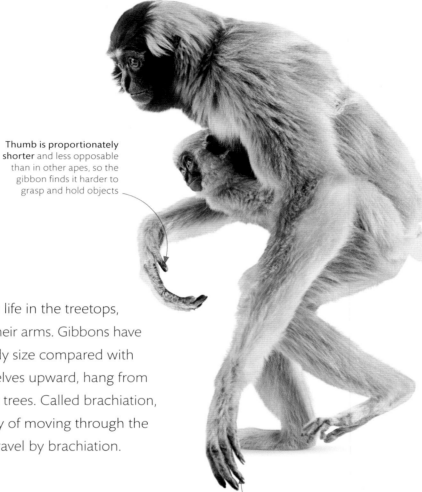

swinging through trees

As climbing primates, such as gibbons, adapted to life in the treetops, most of their strong muscular control shifted into their arms. Gibbons have exceptionally long arms in proportion to their body size compared with other primates. They use their arms to pull themselves upward, hang from branches, and swing hand-over-hand through the trees. Called brachiation, this arm-swinging propulsion is a fast, efficient way of moving through the canopy. Gibbons and spider monkeys habitually travel by brachiation.

Very long fingers form a reliable hook when hanging from branches

BRACHIATION

The gibbon's flexible wrist joints permit the rotation necessary for arm-swinging. At more leisurely speeds, a gibbon always has at least one hand on a branch, but by swinging completely free it can increase the distance between handholds to move faster through the trees.

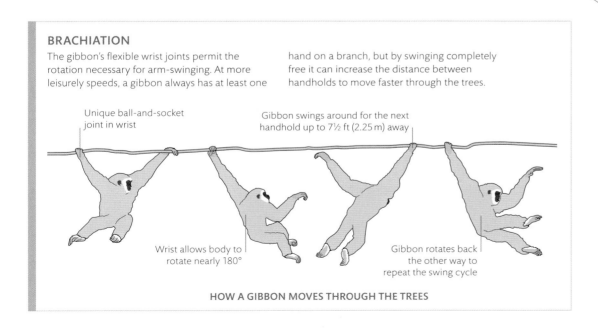

Unique ball-and-socket joint in wrist

Gibbon swings around for the next handhold up to 7½ ft (2.25 m) away

Wrist allows body to rotate nearly 180°

Gibbon rotates back the other way to repeat the swing cycle

HOW A GIBBON MOVES THROUGH THE TREES

MANUAL DEXTERITY

An opposable thumb—where the thumb is opposite the fingers—helps primates grip. Apes use a power grip for climbing. They can manipulate objects with a precision grip, but their short thumbs have to clamp against the side of their index finger. Humans—with longer thumbs—can more comfortably pinch fingertip and thumb tip together.

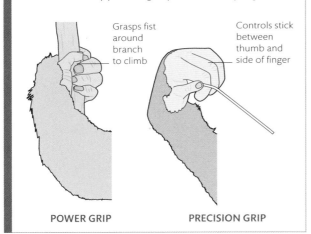

Grasps fist around branch to climb

Controls stick between thumb and side of finger

POWER GRIP

PRECISION GRIP

Versatile tool

The hand of a great ape—such as this bonobo (*Pan paniscus*)—combines strength with extraordinary sensitivity. Like related chimpanzees and humans, most bonobos are right-handed, but they can also use both hands simultaneously.

Long, narrow fingers can move independently of each other

Fingertip pads have more sensory receptor cells than any other part of the body

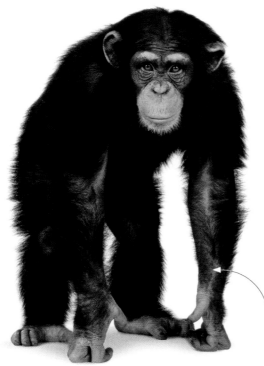

Partially flexed posture allows body weight to press down through the knuckles

"Knuckle" walkers

Grasping hands with sensitive fingertips are useful in trees—but less so when walking on all fours. This common chimpanzee (*Pan troglodytes*), like all African apes, spends much of its time on the ground, and can support its weight on its knuckles. This not only protects the sensitive skin of the palms, but means they can carry objects while moving from place to place.

Flat fingernails, rather than claws, are found in most primates, although some have both claws and nails

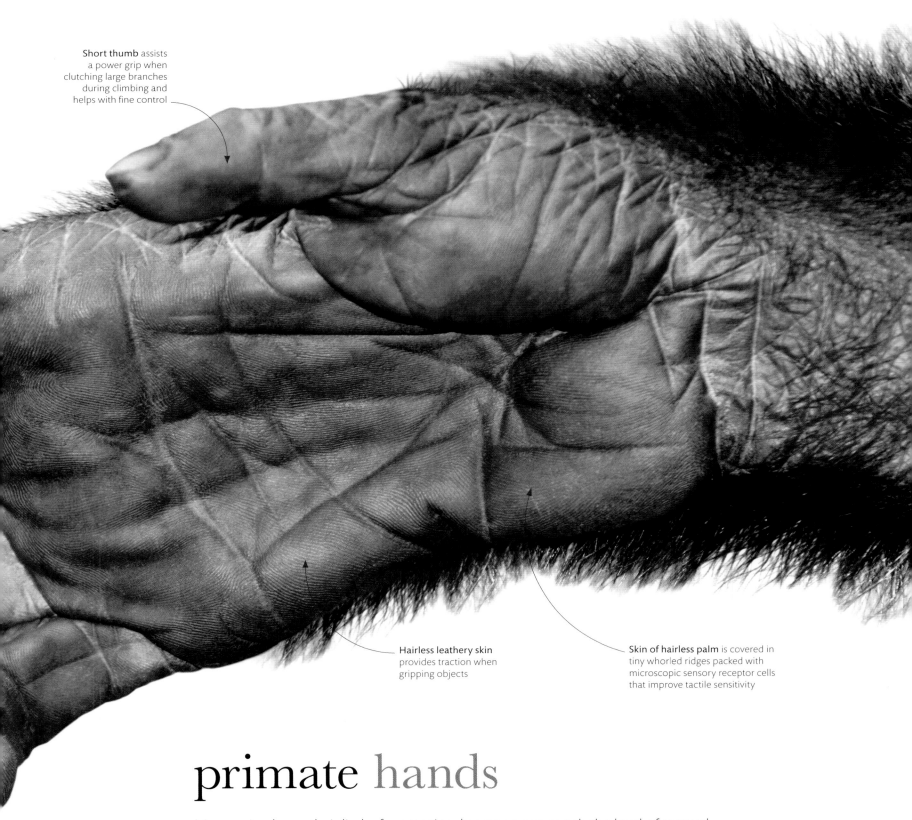

Short thumb assists a power grip when clutching large branches during climbing and helps with fine control

Hairless leathery skin provides traction when gripping objects

Skin of hairless palm is covered in tiny whorled ridges packed with microscopic sensory receptor cells that improve tactile sensitivity

primate hands

Many animals use their limbs for grasping, but none can match the level of manual dexterity found in higher primates. The hands of apes and monkeys have evolved maximum mobility of the digits—and their fingertips are equipped with highly sensitive pads capable of distinguishing countless pinpoints of contact. This, combined with their superior brain power, makes primates expert in manipulating objects around them.

orangutan

The sole surviving members of the *Pongo* genus, orangutans dwell in Asia's dwindling rain forests, and evolutionary adaptations have given them a body ideally suited to climbing through the canopy. These highly intelligent creatures use tools, make rain shelters, and self-medicate with herbs.

Asia's great ape is the largest and heaviest arboreal (or tree-dwelling) mammal on Earth, and one of the most critically endangered. The word orangutan means "person of the forest," and there are three distinct species: Bornean (*Pongo pygmaeus*), Sumatran (*P. abelii*), and the rarer Tapanuli (*P. tapanuliensis*), found exclusively in northern Sumatra's Batang Toru forest. All three look similar, with shaggy hair that varies from orange to reddish depending on the species, relatively short but large torsos, and very long powerful arms.

Adult males weigh more than 200 lb (90 kg) and females range from 66 to 110 lb (30–50 kg). Their bodies are adapted to be able to navigate their way across highly flexible branches of the forest's trees. Unlike lighter primates, they rely on a combination of movements and physical skills such as walking, climbing, and swinging to cross wider gaps. Orangutans spend most of their lives feeding, foraging, resting, and moving through the rain forest canopy—especially Sumatran orangutans, which rarely come to ground level because of predators such as tigers. They live on a diet of fruit, supplemented by leaves, nonleafy vegetation, and insects, with the occasional egg or small mammal. Mature animals are mainly solitary, but females, who breed once every 4 or 5 years, can be seen with dependent offspring—usually a single youngster—which can remain with their mother for up to 11 years.

Seeking new heights

With grasping hands and feet, and arm muscles seven times more powerful than a human's, orangutans are master climbers. This Bornean *P. pygmaeus* is scaling a 100-ft (30-m) strangler-fig vine in search of food.

Made for life in the forest canopy
In addition to highly developed muscles, the skeleton of an orangutan reveals some unique adaptations that make it well suited to its life in the trees.

Large skull protects a highly developed brain that can control complex movements in three dimensions

Flexible hip joints rotate as much as the shoulder joints

Dense upper arm bone (humerus) provides anchorage point for arm muscles for extra strength

Feet have opposable toes for gripping branches

Arms are one and half times longer than legs; a mature animal's arm span can be more than 6 ft (2 m)

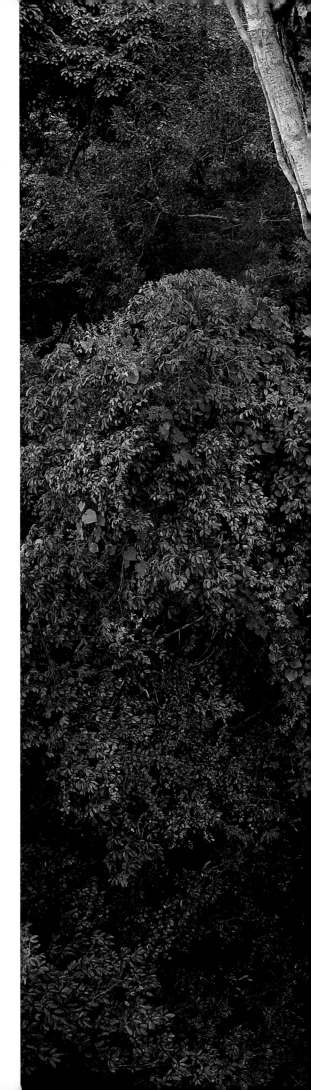

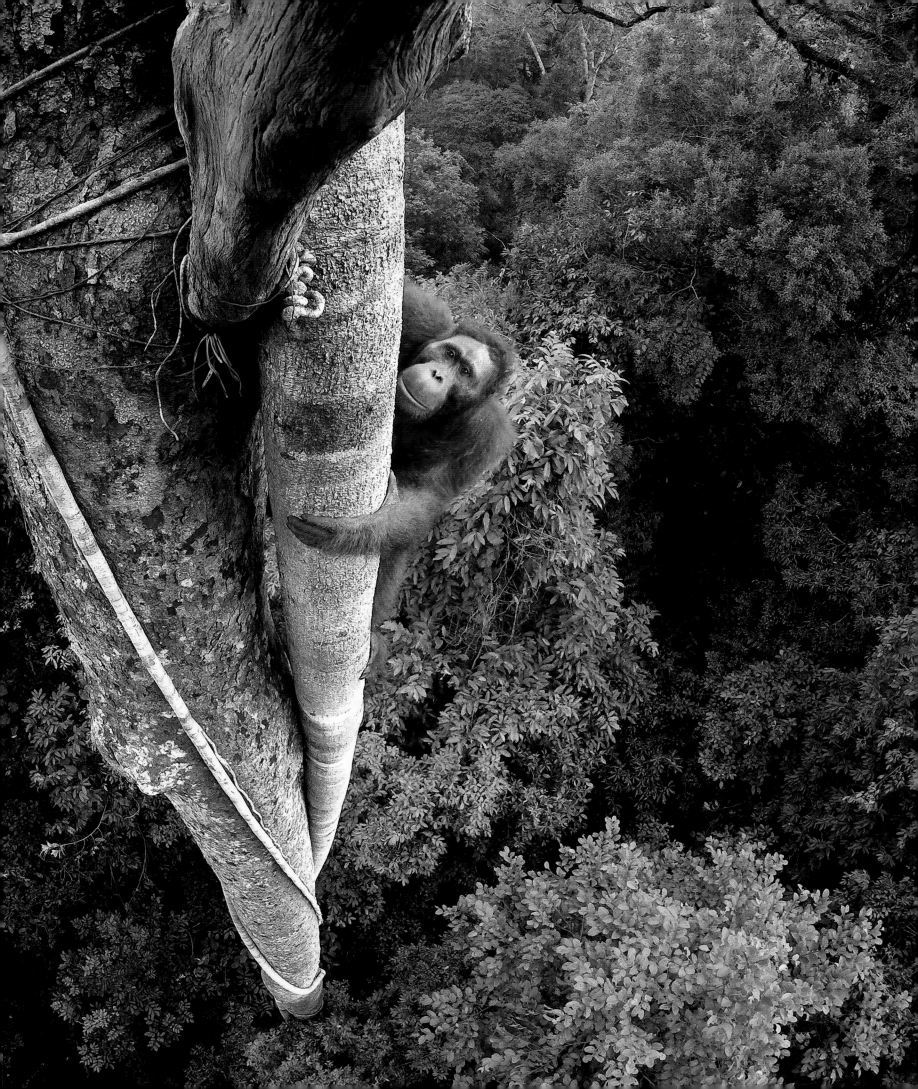

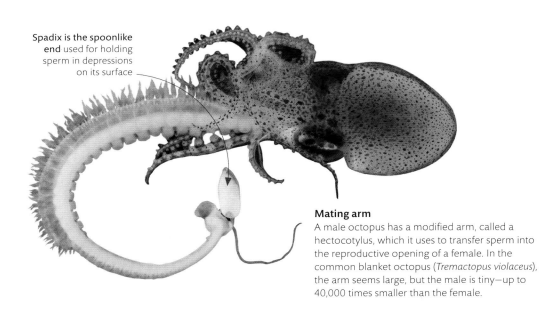

Spadix is the spoonlike end used for holding sperm in depressions on its surface

Mating arm
A male octopus has a modified arm, called a hectocotylus, which it uses to transfer sperm into the reproductive opening of a female. In the common blanket octopus (*Tremactopus violaceus*), the arm seems large, but the male is tiny—up to 40,000 times smaller than the female.

octopus arms

Some mollusks—including octopuses and squids—have abandoned the slow crawling life of their relatives, the slugs and snails, to become agile hunters. They have a large head with big eyes, and around their mouth is a circle of muscular arms. Octopuses have eight suckered arms joined by a web of skin, making a highly effective mechanism for grabbing prey.

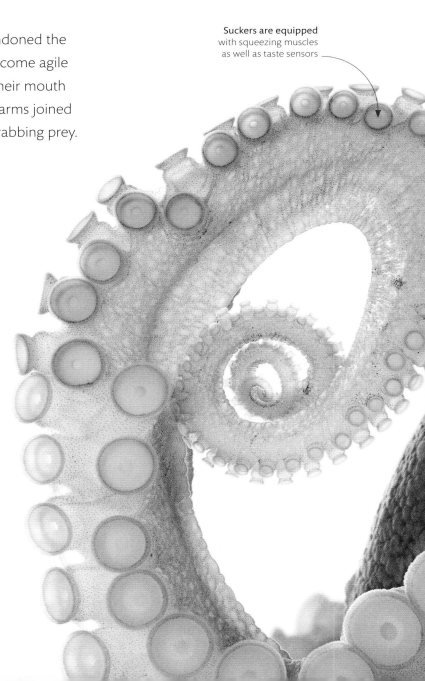

Suckers are equipped with squeezing muscles as well as taste sensors

MUSCLE-PACKED ARM
Composed almost entirely of muscle, an octopus arm works as a muscular hydrostat: the muscles squeeze against each other, rather than against a skeleton. Longitudinal, horizontal, and vertical muscles move the arm in different directions, as in other fleshy hydrostats, such as tongues or elephant trunks.

Epidermis

Dermis

Horizontal muscle

Suction cup muscle

Vein

Vertical muscle

Longitudinal muscle

Artery

Nerve cord

Sucker cup

CROSS SECTION OF OCTOPUS ARM AND SUCKER

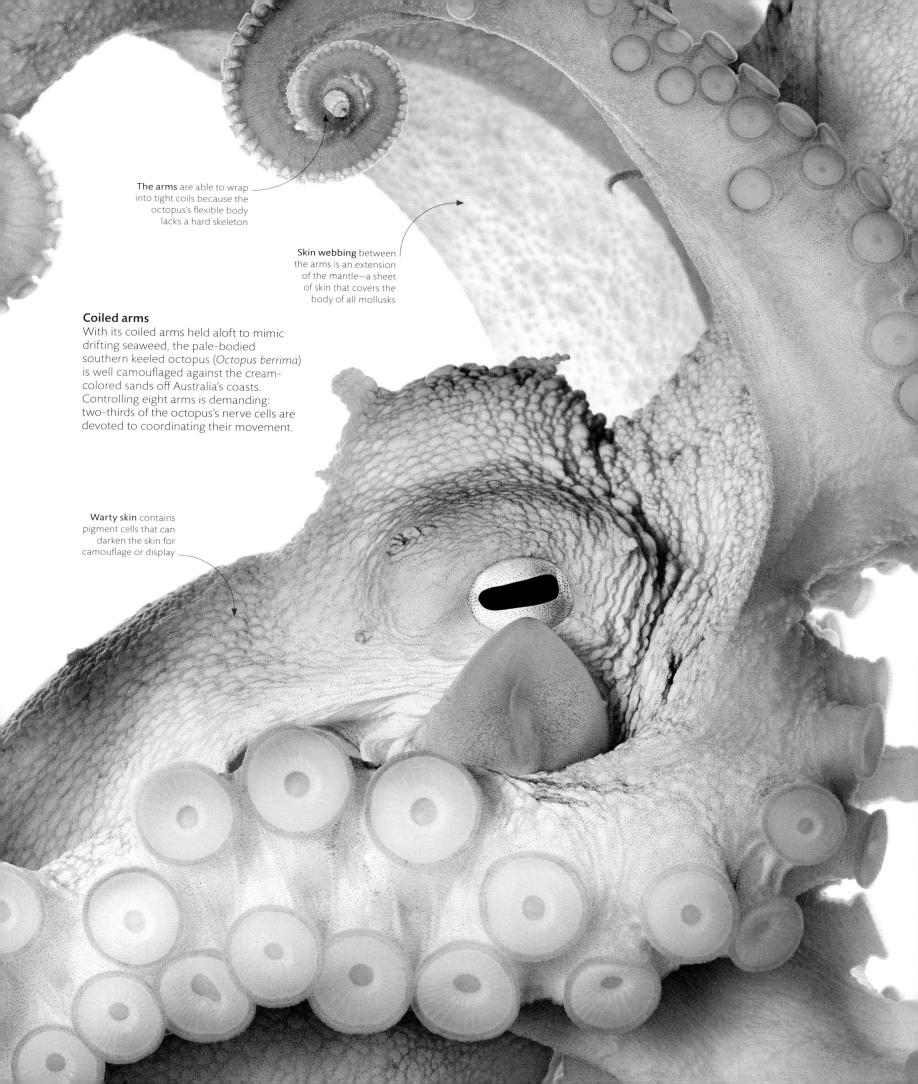

The arms are able to wrap into tight coils because the octopus's flexible body lacks a hard skeleton

Skin webbing between the arms is an extension of the mantle—a sheet of skin that covers the body of all mollusks

Coiled arms

With its coiled arms held aloft to mimic drifting seaweed, the pale-bodied southern keeled octopus (*Octopus berrima*) is well camouflaged against the cream-colored sands off Australia's coasts. Controlling eight arms is demanding: two-thirds of the octopus's nerve cells are devoted to coordinating their movement.

Warty skin contains pigment cells that can darken the skin for camouflage or display

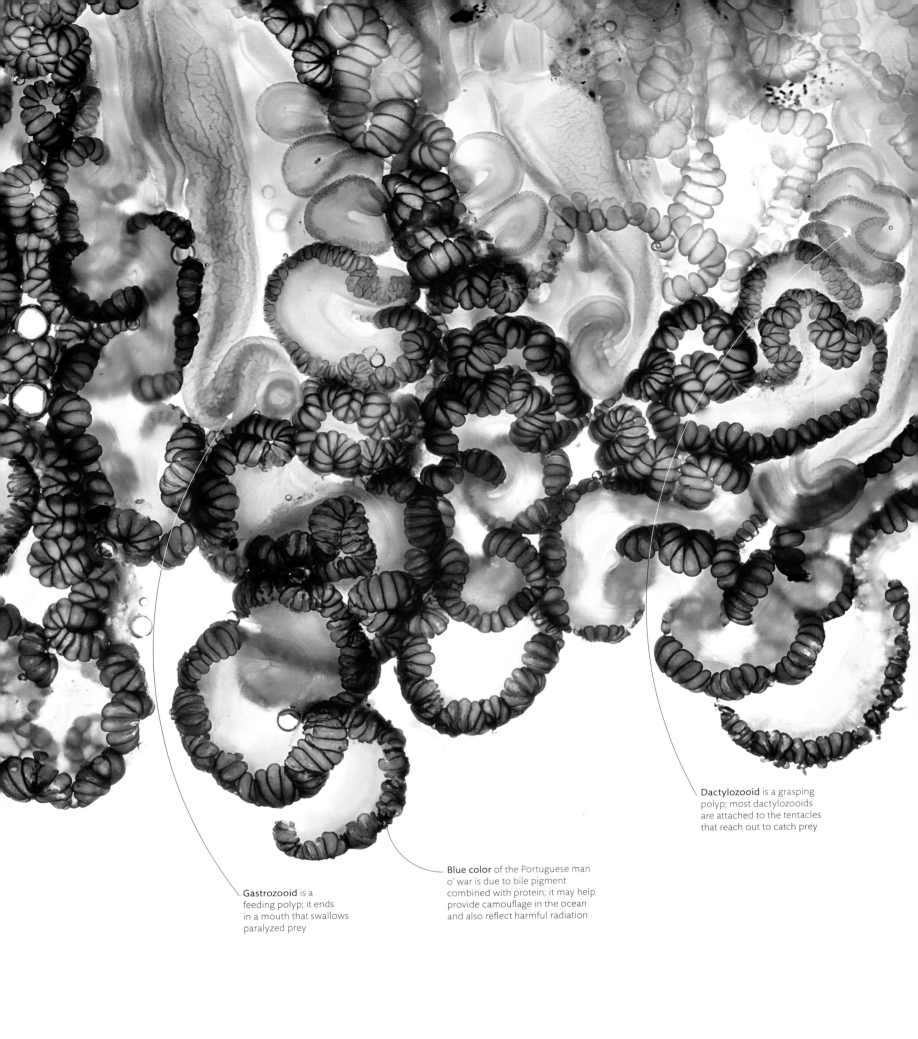

Dactylozooid is a grasping polyp; most dactylozooids are attached to the tentacles that reach out to catch prey

Blue color of the Portuguese man o' war is due to bile pigment combined with protein; it may help provide camouflage in the ocean and also reflect harmful radiation

Gastrozooid is a feeding polyp; it ends in a mouth that swallows paralyzed prey

Deadly reach
The Portuguese man o' war (*Physalia physalis*) is a siphonophore. Siphonophores are not single animals, but floating colonies made up of interconnected individuals called polyps (see pp.32–33). The polyps of the Portuguese man o' war are specialized and perform various tasks, such as feeding or reproduction; some carry stinging tentacles that trail 100 ft (30 m) or more, trapping any small animals they come into contact with.

Coils of the tentacles contain concentrated batteries of nematocysts that paralyze small fishes and other marine animals

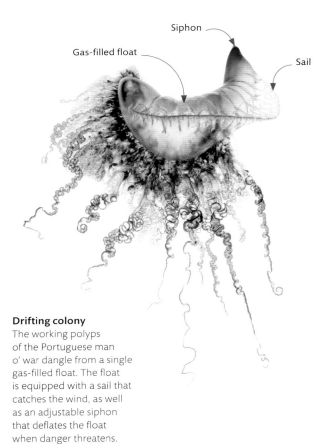

Siphon

Gas-filled float

Sail

Drifting colony
The working polyps of the Portuguese man o' war dangle from a single gas-filled float. The float is equipped with a sail that catches the wind, as well as an adjustable siphon that deflates the float when danger threatens.

stinging tentacles

Jellyfishes and their relatives, such as the Portuguese man o' war, are predators, but they do not overcome prey by swift pursuit or muscular power. Instead, they rely on paralyzing venom to subdue their victims. The skin of their tentacles is peppered with specialized cells called nematocysts, each harboring an elaborate apparatus that fires a microscopic, venom-laced harpoon into the prey's flesh.

DISCHARGING VENOM

Nematocysts contain a coiled inverted tube— like the finger of a rubber glove turned inside out— steeped in venom. Once triggered by contact with prey, the lid of the nematocyst snaps open and the tube springs out. Spines break the prey's skin and allow venom to flow into the wound.

Triggering bristle

Closed lid

Inverted tube with thin, coiled end

RESTING NEMATOCYST

Tube carries venom into wound

Bristle deflected by touch

Spine

Barb

Open lid

Cell nucleus

DISCHARGED NEMATOCYST

prehensile tails

A "prehensile" part of the body is used for grasping. Jaws, hands, and feet are typically prehensile, but many animals can use their tail, too. A fully prehensile tail has the strength and flexibility to support the entire weight of the body. Spider monkeys use their tail as a fifth limb to suspend from branches, while seahorses use their tail to cling to waterweed so they are not swept away by currents (see pp.262–63). Many animals have tails that are prehensile to a lesser degree, but can still assist in climbing or in support.

Sensitive tail
The tail of a brown-headed spider monkey (*Ateles fusciceps*) has a naked patch of skin near its tip, with ridges that resemble the sensitive pads on primate fingers (see p.238). It uses its tail to grip branches for swinging, feeding, or drinking.

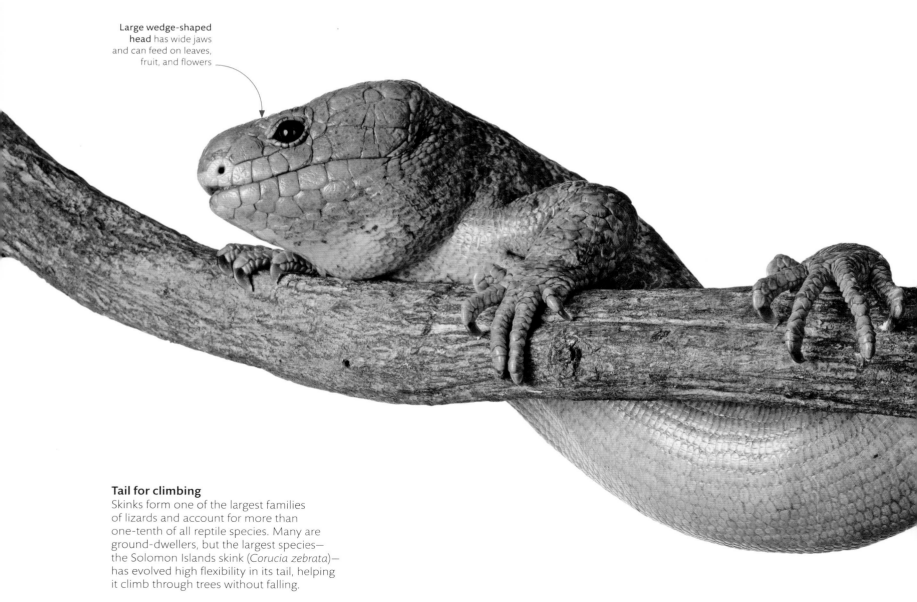

Large wedge-shaped head has wide jaws and can feed on leaves, fruit, and flowers

Tail for climbing
Skinks form one of the largest families of lizards and account for more than one-tenth of all reptile species. Many are ground-dwellers, but the largest species— the Solomon Islands skink (*Corucia zebrata*)— has evolved high flexibility in its tail, helping it climb through trees without falling.

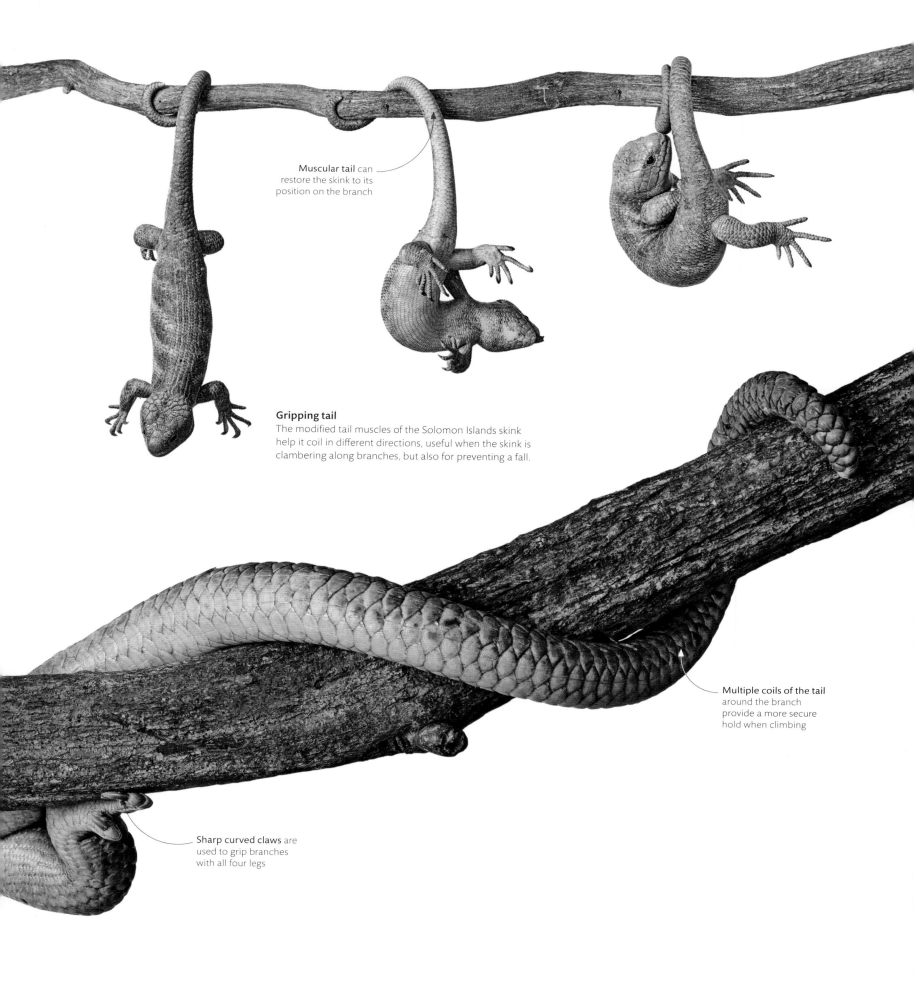

Muscular tail can restore the skink to its position on the branch

Gripping tail
The modified tail muscles of the Solomon Islands skink help it coil in different directions, useful when the skink is clambering along branches, but also for preventing a fall.

Multiple coils of the tail around the branch provide a more secure hold when climbing

Sharp curved claws are used to grip branches with all four legs

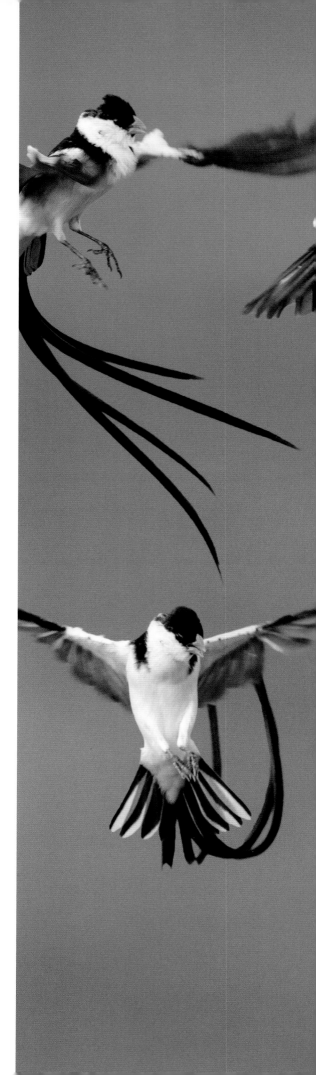

pintailed whydah

The remarkable finchlike pintailed whydah (*Vidua macroura*) is ecologically fascinating. The noisy song, spectacular display flights, and show-stopping, ribbonlike tail plumes are all male characteristics, yet their development is driven by the critical eye of the drab, inconspicuous female.

The pintailed whydah is widely distributed across sub-Saharan Africa, and nonnative populations are also found in Portugal, Puerto Rico, California, and Singapore. Males and females are small—their bodies are about 4¾–5 in (12–13 cm) long. While the female is unremarkable to look at, she has a significant influence on the males of her species. A quirk of evolution resulted in female whydahs developing a preference for males with striking black-and-white plumage, a scarlet bill, and long tail feathers. A process called runaway sexual selection is probably responsible for then driving the last feature to preposterous proportions—at around 8 in (20 cm), the tail is almost twice as long as the body.

The bold colors and conspicuous tail were probably considered more desirable since they are a reliable indication of vitality, good nutritional status, and low parasite load. Over time, sexiness became

what mattered most and the choices of generations of females has driven male tail length to the point where it is a survival disadvantage. The plumes take energy to grow and maintain, they make flight harder, and they must increase the chances of being caught by a predator. But biologically, longer tails carry the irresistible benefit of an opportunity to breed. In principle, shorter-tailed males may live longer, but on average father fewer offspring. However, tails cannot grow infinitely long, and natural selection picks off males with the longest tails, no matter how attractive they are.

Courtship display
This multiple-exposure photograph captures a single male bird using rhythmic wingbeats to emphasize his tail streamers, while he bobs up and down attempting to stay in one place in front of the female's perch.

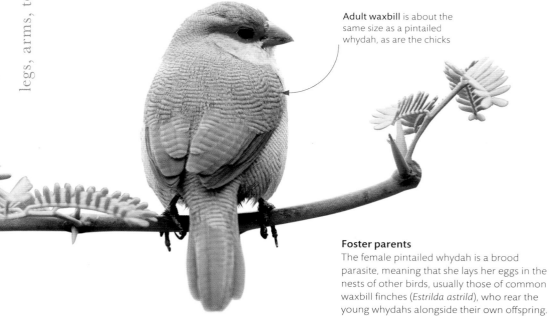

Adult waxbill is about the same size as a pintailed whydah, as are the chicks

Foster parents
The female pintailed whydah is a brood parasite, meaning that she lays her eggs in the nests of other birds, usually those of common waxbill finches (*Estrilda astrild*), who rear the young whydahs alongside their own offspring.

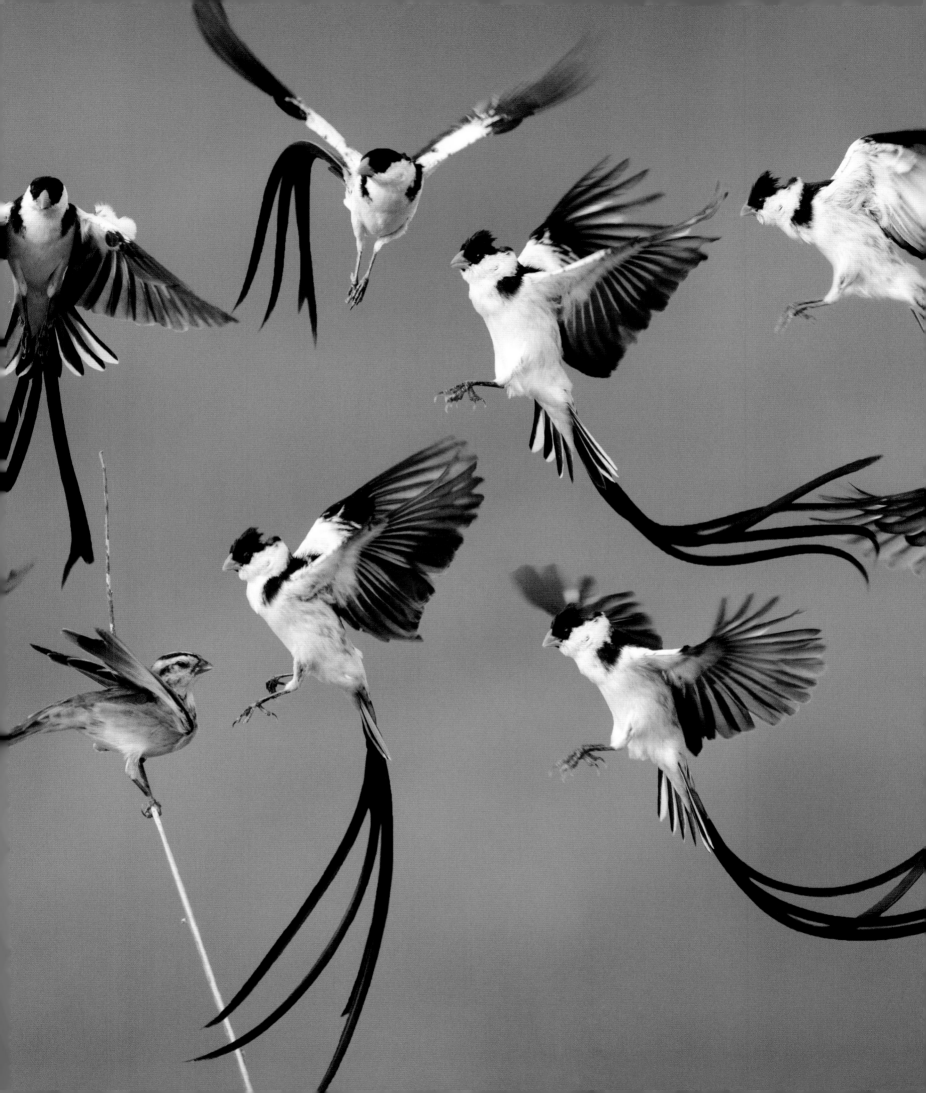

fins, flippers and paddles

fin. a thin, membranous appendage used for propulsion, steering, and balance.

flipper. a broad, flat limb, such as those found on seals, whales, and penguins, especially suited to swimming.

paddle. a fin or flipper of an aquatic animal.

Strong swimmers
Animals with the size and strength to swim against currents, such as this courting pair of Caribbean reef squid (*Sepioteuthis sepiodea*), make up the ocean's nekton population.

Undulating fins and a siphon jet, along either side of the body, propel this animal through water

Planktonic slug
Sea angels, sea butterflies, and other sea slugs of the open ocean use fleshy, winglike flaps, or parapodia, to propel themselves. The largest sea angel, the naked sea butterfly (*Clione limacina*), is no more than 1¹/₅ in (3 cm) long. For all its flapping, it is at the mercy of ocean currents and classed as plankton.

nekton and plankton

Many aquatic animals—so-called nektonic fauna—are strong swimmers and can battle against currents. But others, plankton, drift with currents. The tiniest animals are likely to be planktonic: water's viscosity makes progress for them equivalent to a human moving through syrup so currents, rather than muscle power, carry them from place to place. Some, such as fish and crabs, are larvae of animals while others stay as drifting animals their entire lives.

PLANKTONIC LIFE

Copepods (right)—crustaceans mostly less than 1 mm long—are components of zooplankton found in aquatic habitats from oceans to ponds. Many of these animals rely on long, spindly, antennae-like appendages that twitch backward so they appear to jump through the water. These darting movements enable them to overcome water's viscosity without fatiguing, making them among the fastest and strongest of all animals for their size.

Copepoda.

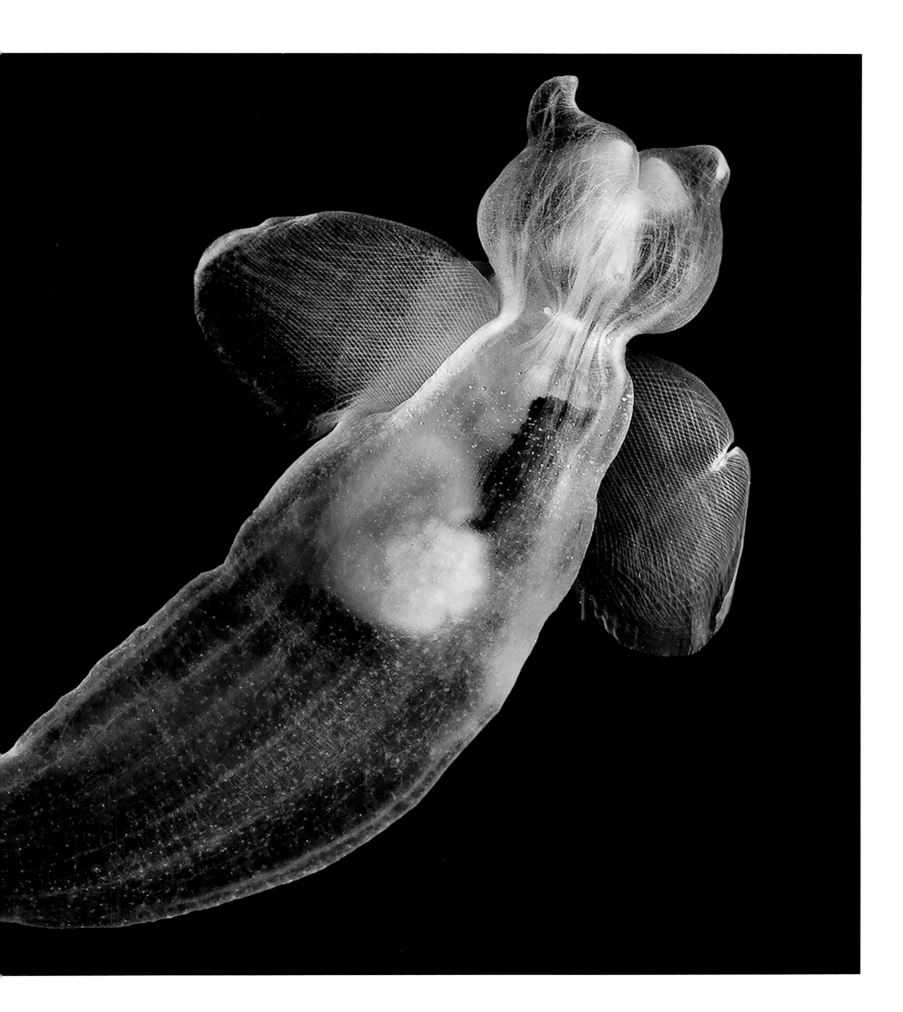

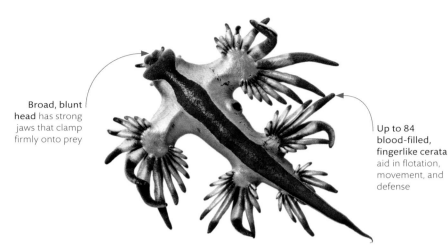

Broad, blunt head has strong jaws that clamp firmly onto prey

Up to 84 blood-filled, fingerlike cerata aid in flotation, movement, and defense

Drifting predator
The blue dragon's ability to float on its back, riding the surface tension, brings it into contact with the larger blue cnidarians on which it feeds. The dark blue at the tips of its cerata probably comes from the blue pigment of its prey.

spotlight species

blue dragon sea slug

A weak swimmer, the blue dragon sea slug (*Glaucus atlanticus*) spends most of its life floating upside down in the open ocean. This sea slug feeds mainly on the highly venomous Portuguese man o' war. The sting of this tiny predator, which reaches about 1 in (3 cm) long, can be more powerful than that of its much larger prey.

The blue dragon, also known as the blue angel or sea swallow, is a type of sea slug called a nudibranch. Like other sea slugs, blue dragons are shell-less marine snails, have soft bodies, and use a toothlike scraper called a radula to tear chunks off prey when feeding. However, unlike its benthic relatives that inhabit the ocean floor, the blue dragon is pelagic: it is found throughout the sea's upper levels and has been identified in temperate and tropical oceans worldwide.

The "wings" that give the animal its common name are fanlike projections called cerata, which protrude from the blue dragon's sides. Cerata usually grow on a sea slug's back, but in this species they sprout from body parts resembling stubby forearms and leg stumps. The blue dragon can move these appendages and their cerata, so they function rather like limbs and fingers, effectively enabling the

sea slug to swim—albeit weakly—toward prey. Floating, however, is its chief mode of locomotion, accomplished by means of an air-filled capsule in its stomach. This capsule, coupled with the cerata's large surface area, allows the blue dragon to float easily, drifting wherever wind and wave take it. Countershading offers the blue dragon some protection: when lying on its back, its dark, silver-blue belly blends in with the water's surface, hiding it from the eyes of airborne predators. Its paler back is camouflaged against the sky when viewed by predators from below.

Dragon with tentacles
A Portuguese man o' war's tentacles are the blue dragon's favorite food. The sea slug consumes the man o' war's stinging cells, or nematocysts, intact. It concentrates them in special sacs at the tips of its cerata to deploy as a defense.

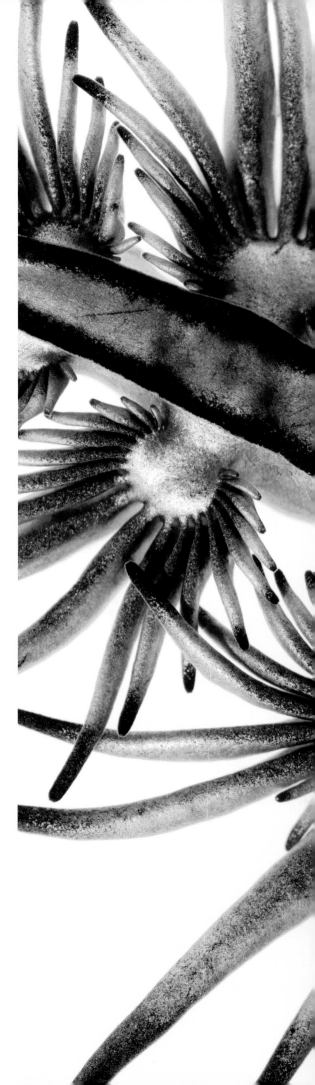

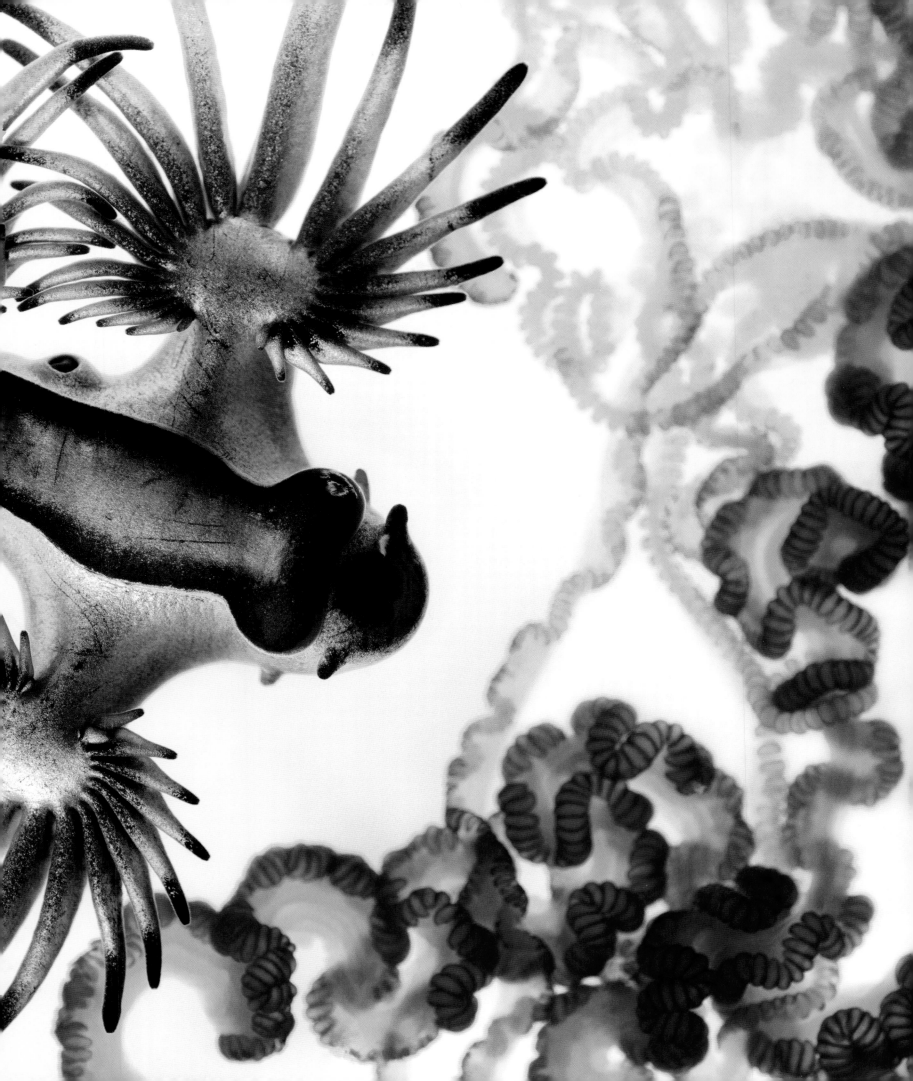

how fishes swim

Fishes swim forwards by undulating the body or oscillating appendages (see p.50 and p.259). But the challenge of moving in the three dimensions of open water involves more than propulsion: fishes must control the way they move vertically and horizontally, as well as stay upright. Their body must also be buoyant to prevent them from sinking. Sharks achieve buoyancy with oily tissues, while most bony fishes are kept buoyant by a gas-filled swim bladder.

Life on the bottom
Eel-shaped fishes, like the burbot (*Lota lota*), depicted here in a stylized 16th-century illustration, avoid the problems of mid-water swimming by living on the bottom. Multiple waves of undulation passing down the elongated body generate more drag than experienced by short-bodied fishes. But a slower swimming speed is well suited to a life spent in burrows and crevices.

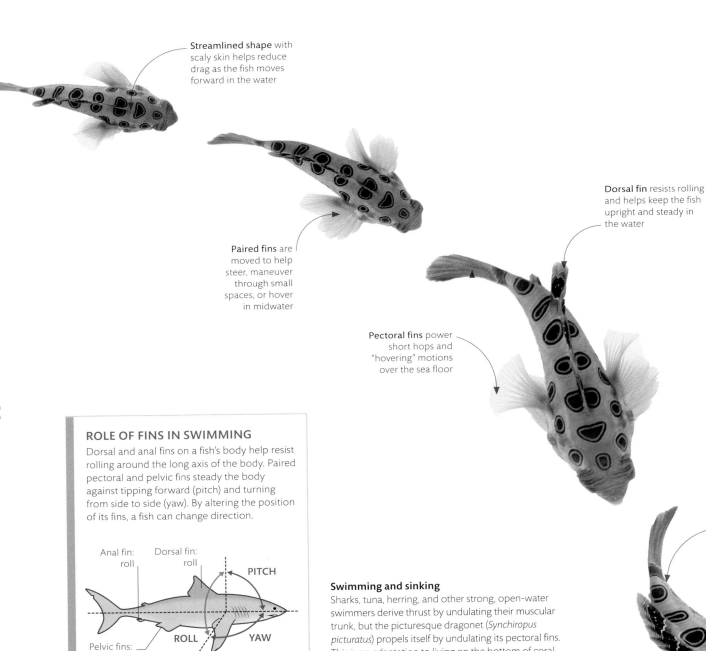

Streamlined shape with scaly skin helps reduce drag as the fish moves forward in the water

Paired fins are moved to help steer, maneuver through small spaces, or hover in midwater

Dorsal fin resists rolling and helps keep the fish upright and steady in the water

Pectoral fins power short hops and "hovering" motions over the sea floor

Tail, like the trunk, plays a much-reduced role in swimming in comparison to midwater species

ROLE OF FINS IN SWIMMING

Dorsal and anal fins on a fish's body help resist rolling around the long axis of the body. Paired pectoral and pelvic fins steady the body against tipping forward (pitch) and turning from side to side (yaw). By altering the position of its fins, a fish can change direction.

Anal fin: roll

Dorsal fin: roll

PITCH

Pelvic fins: yaw

ROLL **YAW**

Pectoral fins: pitch and yaw

HOW SHARK FINS CONTROL MOVEMENT

Swimming and sinking
Sharks, tuna, herring, and other strong, open-water swimmers derive thrust by undulating their muscular trunk, but the picturesque dragonet (*Synchiropus picturatus*) propels itself by undulating its pectoral fins. This is an adaptation to living on the bottom of coral reefs, where short, swimming "hops" are the best way of travelling. In dragonets, the swim bladder is small or absent, so they are negatively buoyant: they sink when forward propulsion stops. But by moving their pectoral fins, they can advance over the bottom.

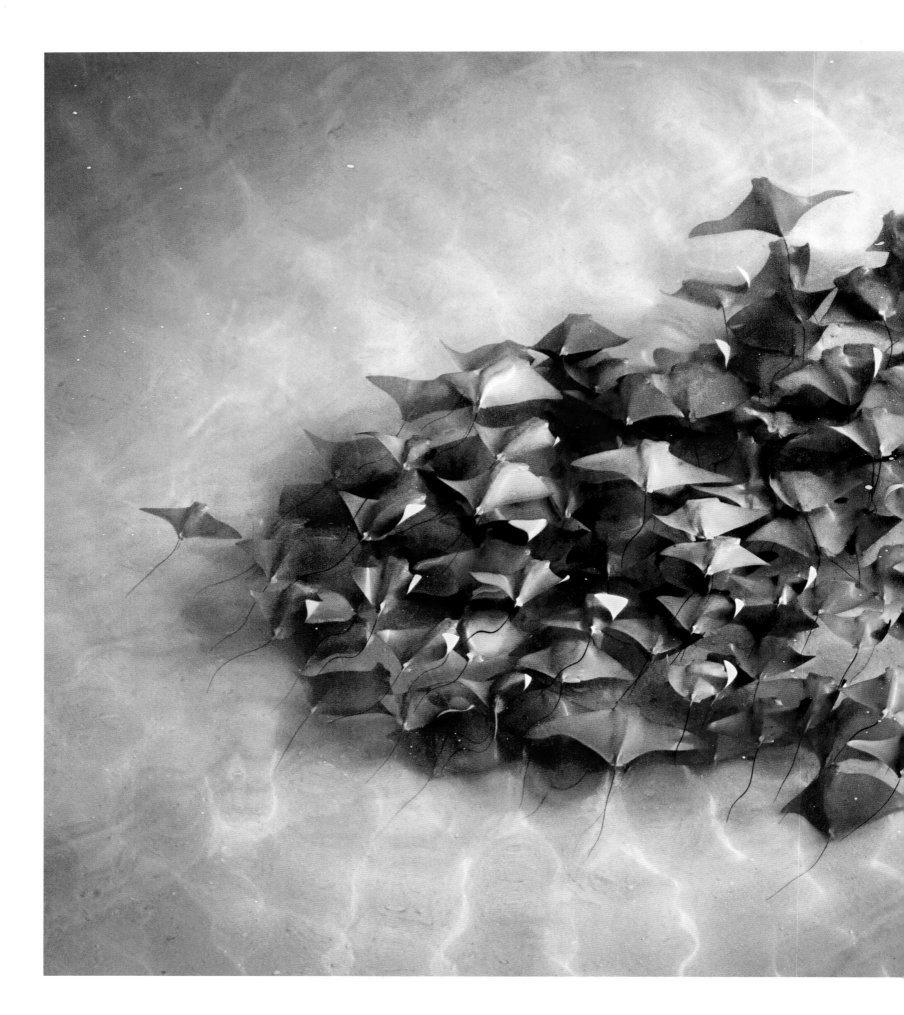

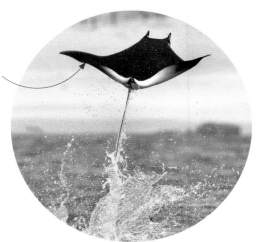

Pectoral fins
continue to flap up
and down when the
ray leaves the water

Giant ray
Cownose rays, with their rhomboid shape
and bulbous, protruding head, are among the
largest rays. They cruise in warm waters above
continental shelves or around estuaries and
bays. The short-tailed cownose ray (*Rhinoptera
jayakari*), reaching a "fin-span" of 35 in (90 cm),
has a shorter whiplike tail than most. It often
gathers into huge schools, as seen here.

Mobula ray leaping
A few large-finned rays, such as mobulas (*Mobula* sp.),
leap from the water in spectacular displays. Whether
this dislodges parasites or is a social signal is not clear.

underwater wings

All fishes need a source of propulsion. In rays, it comes from large, projecting
pectoral fins that connect to the flattened body along a wide base stretching
from head to tail. The smallest rays swim using delicate undulations that ripple
back along the margins of these fins—they can even hover in midwater—but
larger species flap them like wings to "fly" through the ocean.

FORWARD PROPULSION

Some fishes propel themselves by undulating body
parts (shown in orange). Jacks and trevallies, which use
a wavelike body motion, are faster swimmers than
those, like rays, with rippling fins. Other fishes use
oscillation, where a structure is moved back and forth
(shown in blue). Box fishes have a rigid, armored body,
so they flap their tails to generate force, while wrasses
row through water with their pectoral fins.

Undulating
pectoral fins

RETICULATED FRESHWATER STINGRAY
Potamotrygon orbignyi

Oscillating
tail fin

YELLOW BOXFISH
Ostracion cubicus

Undulating
rear of body
and tail fin

GIANT TREVALLY
Caranx ignobilis

Oscillating
pectoral fin

BANDED WRASSE
Notolabris fucicola

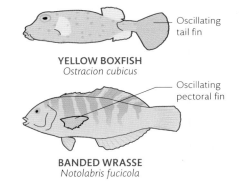

fish fins

Fins provide directional control as fish propel their bodies through the water (see p.259), and they contribute to the propulsion itself – the caudal, or tail, fin increases the force of an undulating fish body. Many fish, such as seahorses (see pp.262–63), rely entirely on fin movement for swimming. The most prominent types of fin are the caudal and dorsal fins, and the paired pectoral and pelvic fins.

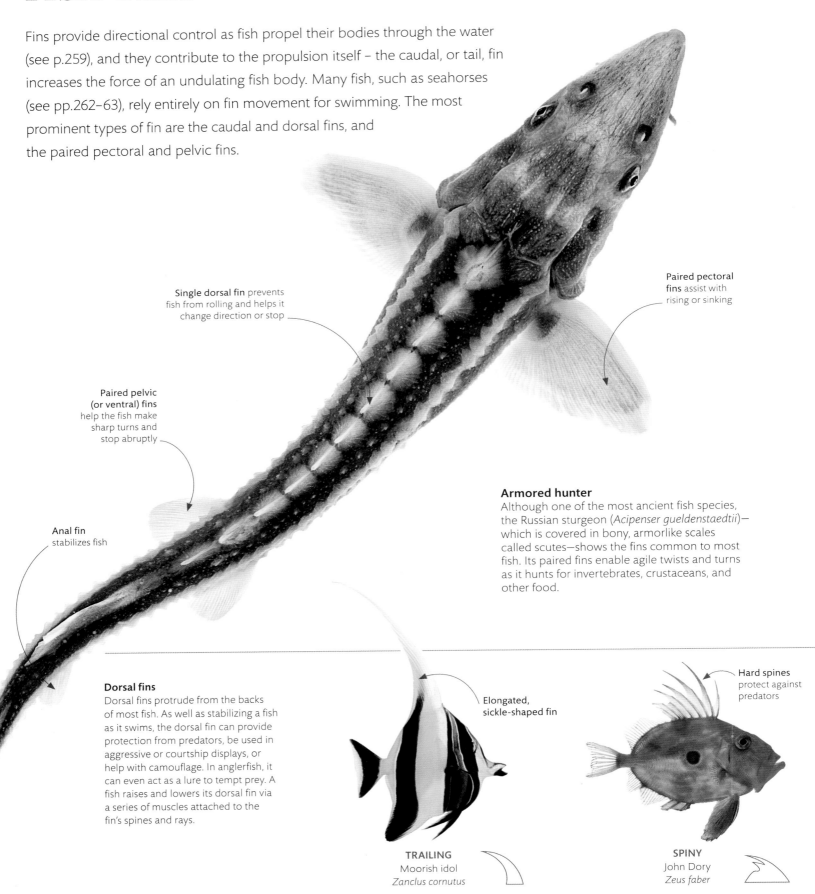

Single dorsal fin prevents fish from rolling and helps it change direction or stop

Paired pectoral fins assist with rising or sinking

Paired pelvic (or ventral) fins help the fish make sharp turns and stop abruptly

Anal fin stabilizes fish

Armored hunter
Although one of the most ancient fish species, the Russian sturgeon (*Acipenser gueldenstaedtii*)—which is covered in bony, armorlike scales called scutes—shows the fins common to most fish. Its paired fins enable agile twists and turns as it hunts for invertebrates, crustaceans, and other food.

Dorsal fins
Dorsal fins protrude from the backs of most fish. As well as stabilizing a fish as it swims, the dorsal fin can provide protection from predators, be used in aggressive or courtship displays, or help with camouflage. In anglerfish, it can even act as a lure to tempt prey. A fish raises and lowers its dorsal fin via a series of muscles attached to the fin's spines and rays.

Elongated, sickle-shaped fin

Hard spines protect against predators

TRAILING
Moorish idol
Zanclus cornutus

SPINY
John Dory
Zeus faber

Caudal fins

Most fish propel themselves using their body and caudal, or tail, fin. The shape of a fish's tail provides clues as to how and where it lives. Unlobed, rounded, or straight caudal fins are found mainly on slower-moving, shallow-water dwellers, while lunate and forked caudal fins are typical of fast-moving or long-distance swimmers found in open or deeper waters.

Broad tail is good for agile manoeuvres, but creates high drag

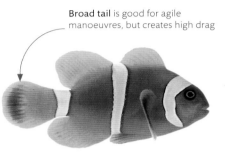

ROUNDED
Maroon clownfish
Premnas biaculeatus

Thin, rigid tail enables high-speed swimming

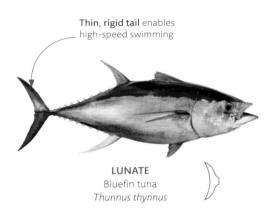

LUNATE
Bluefin tuna
Thunnus thynnus

Narrow tail base reduces drag

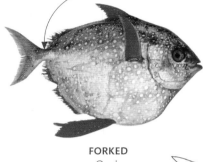

FORKED
Opah
Lampris guttatus

Flattened shape provides good acceleration and maneuverability

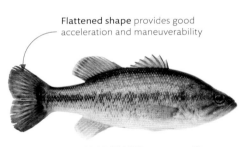

EMARGINATE
Largemouth bass
Micropterus salmoides

Tail point formed by fused anal and caudal fins

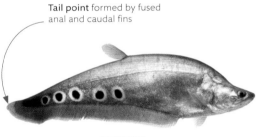

POINTED
Clown knifefish
Chitala ornata

Large surface area helps maneuverability

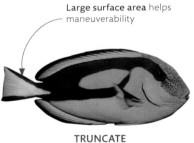

TRUNCATE
Regal blue tang
Paracanthurus hepatus

Spine can be used to lock the fish into crevices at night for protection

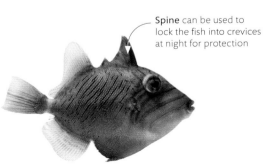

LOCKING DORSAL
Queen triggerfish
Balistes vetula

Long dorsal fin stops fish from rolling

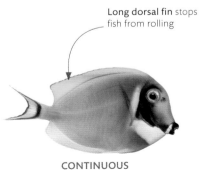

CONTINUOUS
Powder blue tang
Acanthurus leucosternon

Second dorsal fin made of soft rays

First dorsal fin has hard spines

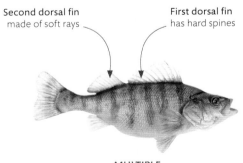

MULTIPLE
Yellow perch
Perca flavescens

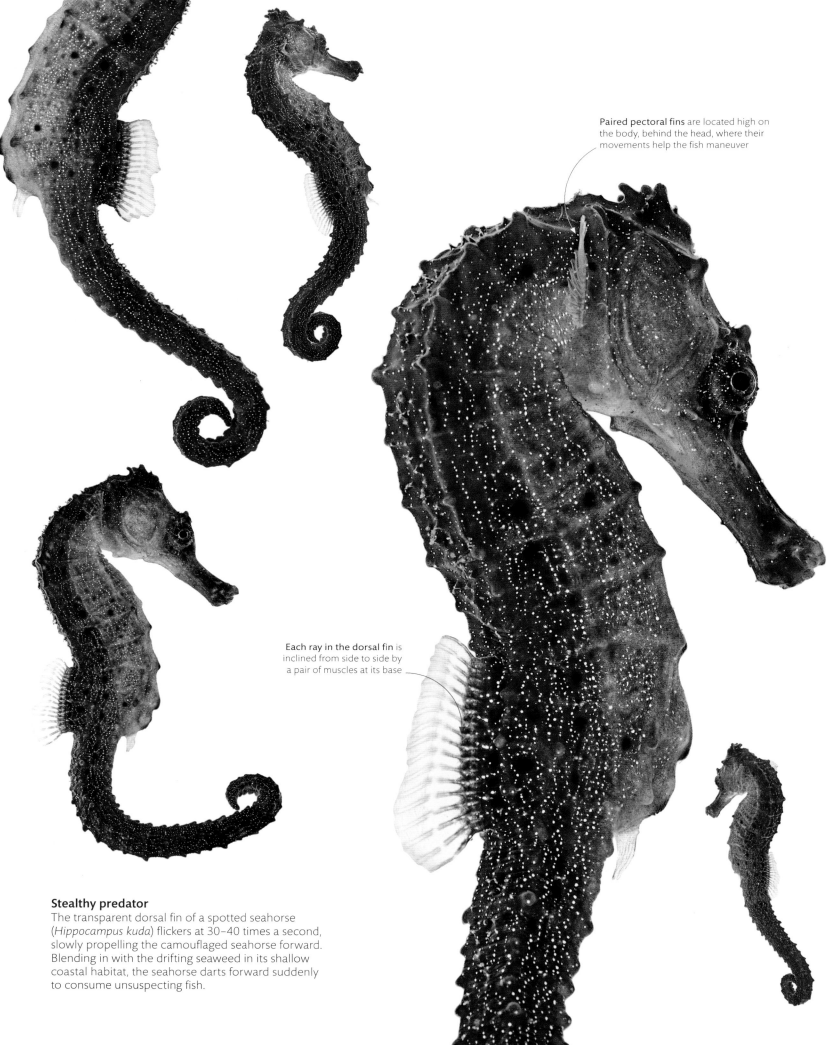

Paired pectoral fins are located high on the body, behind the head, where their movements help the fish maneuver

Each ray in the dorsal fin is inclined from side to side by a pair of muscles at its base

Stealthy predator

The transparent dorsal fin of a spotted seahorse (*Hippocampus kuda*) flickers at 30–40 times a second, slowly propelling the camouflaged seahorse forward. Blending in with the drifting seaweed in its shallow coastal habitat, the seahorse darts forward suddenly to consume unsuspecting fish.

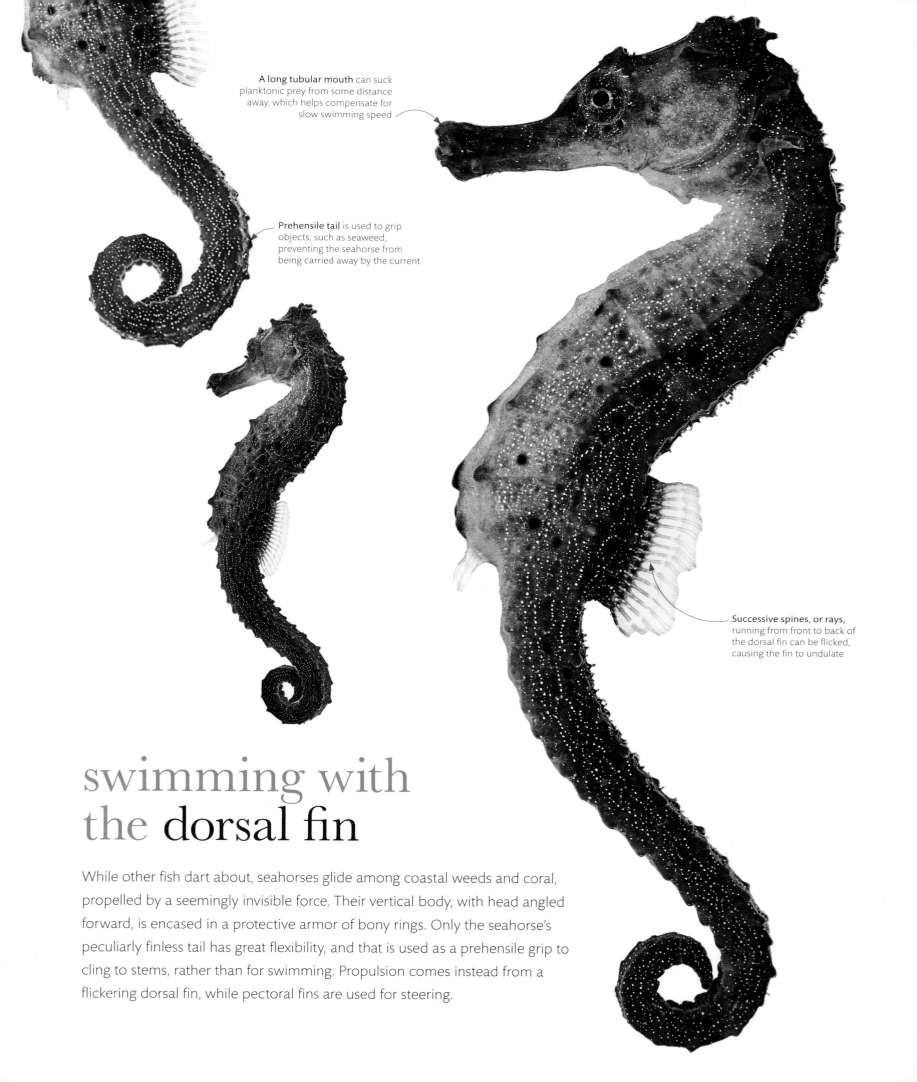

A long tubular mouth can suck planktonic prey from some distance away, which helps compensate for slow swimming speed

Prehensile tail is used to grip objects, such as seaweed, preventing the seahorse from being carried away by the current

Successive spines, or rays, running from front to back of the dorsal fin can be flicked, causing the fin to undulate

swimming with the dorsal fin

While other fish dart about, seahorses glide among coastal weeds and coral, propelled by a seemingly invisible force. Their vertical body, with head angled forward, is encased in a protective armor of bony rings. Only the seahorse's peculiarly finless tail has great flexibility, and that is used as a prehensile grip to cling to stems, rather than for swimming. Propulsion comes instead from a flickering dorsal fin, while pectoral fins are used for steering.

four-winged flying fish

When it comes to escaping marine predators, the four-winged flying fish (*Hirundichthys affinis*) has a distinct advantage. It can propel itself out of the water to reach an airborne speed of up to 44 mph (72 kph), gliding 1,312 ft (400 m) at a single stretch, and also turn and alter its altitude in midglide.

An estimated 65 species of flying fish inhabit tropical and temperate oceans, divided into two categories based on their "wing" numbers. All have two greatly enlarged pectoral fins that allow them to glide over water, a streamlined body, and an unevenly forked tail with a much larger lower lobe. Four-winged species such as *Hirundichthys affinis*, which is found in the eastern and northwestern Atlantic, the Gulf of Mexico, and the Caribbean, also have enlarged pelvic fins; this second set of wings gives them an aerodynamic edge over their two-winged cousins.

Unlike birds and bats, flying fish do not actively flap but glide, relying on the surface area of their extended pectoral fins to stay airborne. The pelvic fins of *H. affinis* and other four-wingers likely evolved as a stabilizing aid that controls pitch, functioning in a similar way to an aeroplane's horizontal tail fins. Pelvic wings may also be a response to size:

flying fish range in length from around 6 to 20 in (15 to 50 cm), and four-winged species like *H. affinis* tend to be longer than two-wingers. Only four-wingers are able to change direction in midair.

To get airborne, the four-winged flying fish swims toward the surface at up to 22 mph (36 kph). As the tail, beating at 50 times per second, launches the fish clear of the water, the pectoral fins unfurl and the fish begins to glide. Flying fish are found in waters warmer than 68–73°F (20–23°C); experts believe that their muscles could not contract rapidly enough to achieve takeoff in cooler temperatures.

Extended air time
Flying fish reenter the water tail-first, but by rapidly beating their tails whenever the larger lobe touches the water—behavior called taxiing—they can prolong flights several times. In the air, tails are held high for stability.

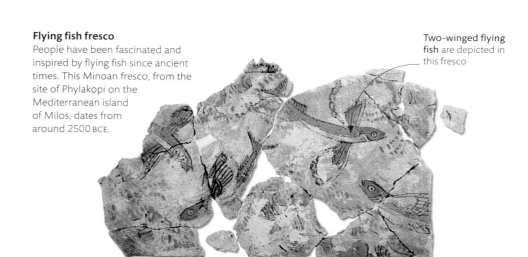

Flying fish fresco
People have been fascinated and inspired by flying fish since ancient times. This Minoan fresco, from the site of Phylakopi on the Mediterranean island of Milos, dates from around 2500 BCE.

Two-winged flying fish are depicted in this fresco

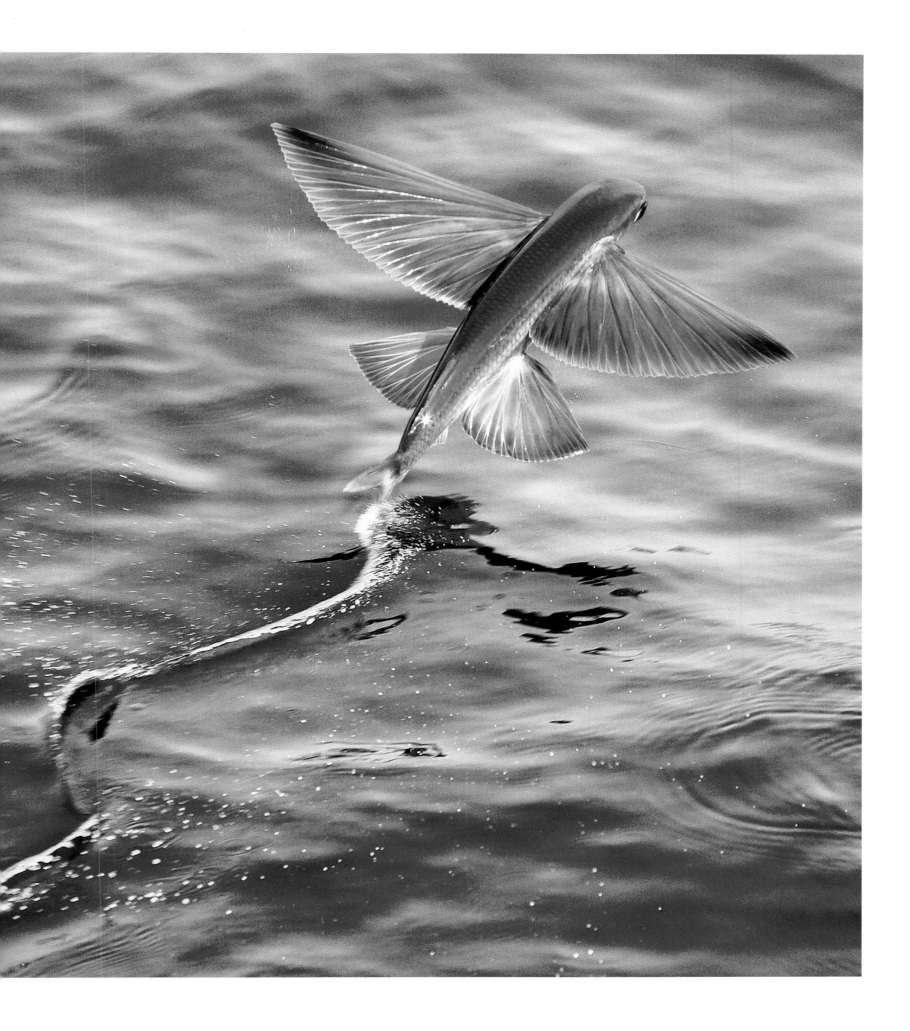

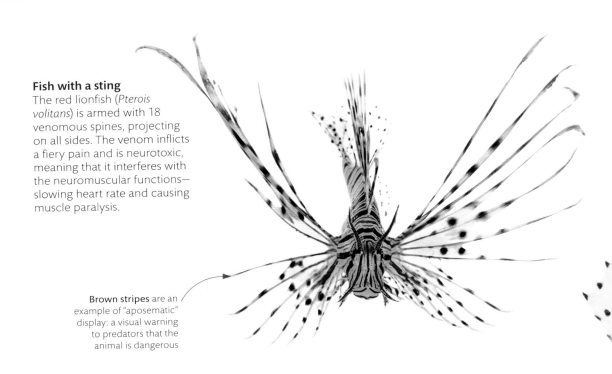

Fish with a sting
The red lionfish (*Pterois volitans*) is armed with 18 venomous spines, projecting on all sides. The venom inflicts a fiery pain and is neurotoxic, meaning that it interferes with the neuromuscular functions—slowing heart rate and causing muscle paralysis.

Brown stripes are an example of "aposematic" display: a visual warning to predators that the animal is dangerous

venomous spines

Nearly all fish alive today have fins that are supported by stiff, flexible rays that grow within the surface of the skin, then embed deeper and fan out to provide structural support in the adult fish. In some fish, however, the fronts of the fins have reinforcement in the form of harder, bony spines. Spines alone offer some physical protection from predators, but other fish, such as those in the scorpionfish family, go further and use their spines as weapons for injecting venom. These stingers produce some of the most lethal cocktails of toxins found in the animal kingdom.

The anal fin has three venomous spines on the leading edge

DELIVERING VENOM

A cross section through a venomous spine of a lionfish reveals a length of solid bone—deeply grooved on either side to carry a pair of long glands—beneath a spongy coat. As the spine punctures the flesh, the skin rolls back and the pressure of the impact squeezes the glands to release venom into the wound.

Venom gland

Bony core

Skin seals in venom

SPINE BEFORE PENETRATING VICTIM

Surface epithelium rubbed away

Venom released

SPINE AFTER PENETRATING VICTIM

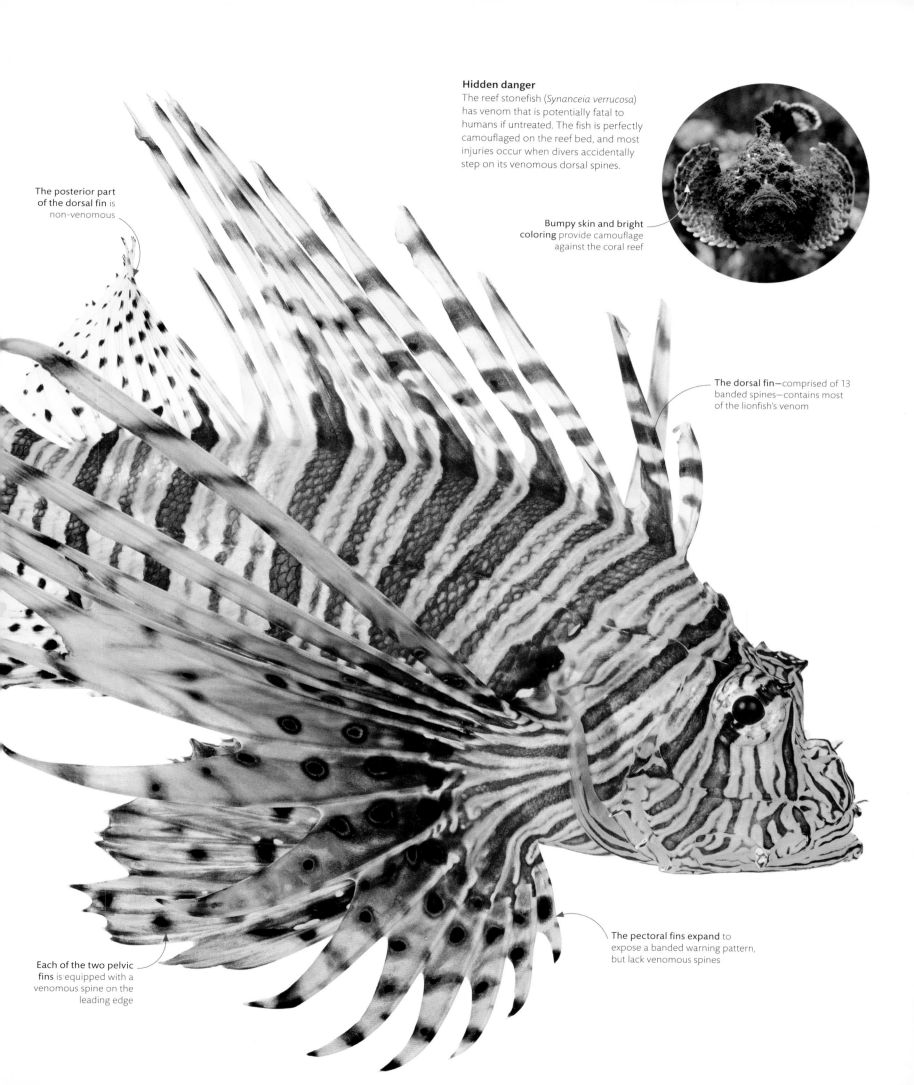

Hidden danger
The reef stonefish (*Synanceia verrucosa*) has venom that is potentially fatal to humans if untreated. The fish is perfectly camouflaged on the reef bed, and most injuries occur when divers accidentally step on its venomous dorsal spines.

Bumpy skin and bright coloring provide camouflage against the coral reef

The posterior part of the dorsal fin is non-venomous

The dorsal fin—comprised of 13 banded spines—contains most of the lionfish's venom

The pectoral fins expand to expose a banded warning pattern, but lack venomous spines

Each of the two pelvic fins is equipped with a venomous spine on the leading edge

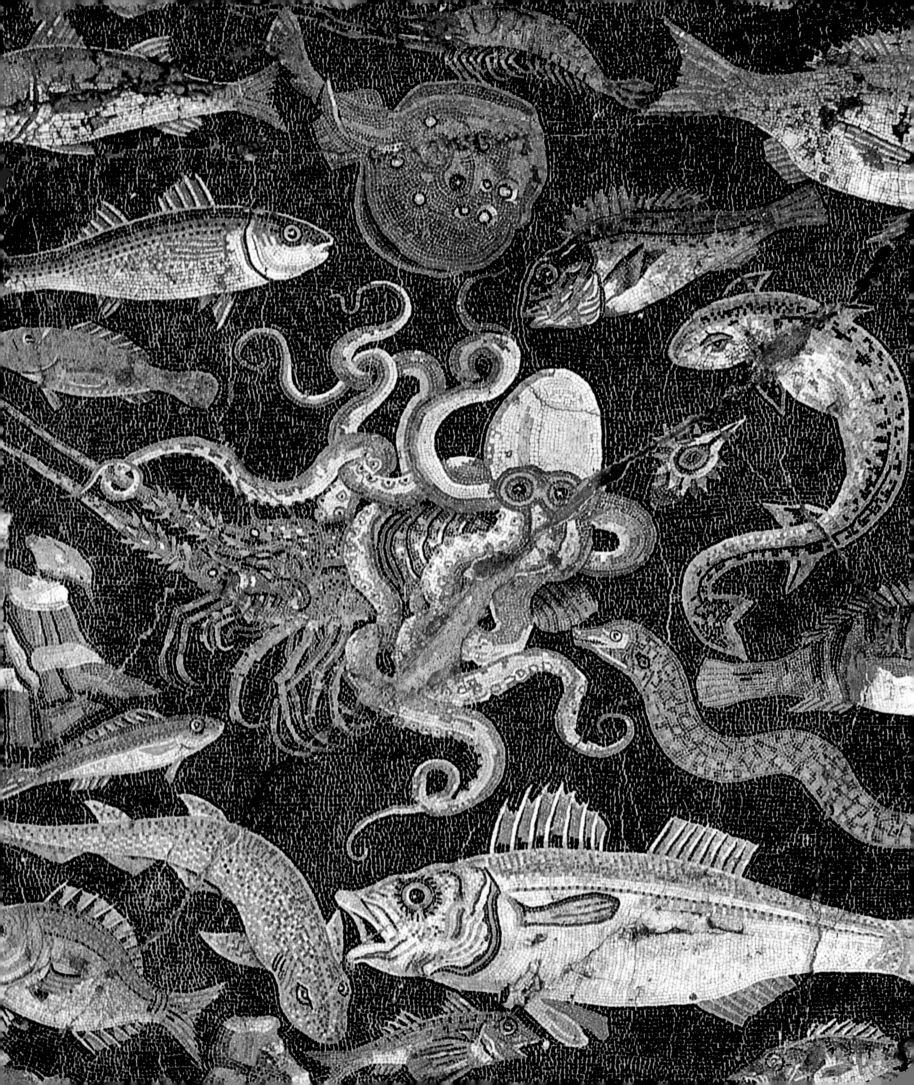

Elephant mosaic
Romans prized elephants as workhorses, for combat, and for their status as exotic animals. This elephant, part of a trio with a horse and bear, is from a 2nd- or 3rd-century floor mosaic from the "House of the Laberii" in Oudhna, Tunisia.

animals in art

empire of abundance

The vibrant frescoes and mosaics that survive in every corner of the old Roman Empire reveal an easy acceptance of nature's bounty. Images of fish and animals for the table, exotic pets, sacred creatures, and hunting and circus scenes celebrate the abundance of the natural world. Yet in reality, many Roman pursuits showed a total disregard for animal well-being.

The interior designers of the Roman world were unnamed craftsmen and painters commissioned to adorn walls and floors with frescoes and mosaics that revealed the wealth and status of noble households. Large sealife mosaics were the preferred decoration for public baths and private houses, where fresh and saltwater oyster and fish ponds provided a ready source of food. In the finest works, artisans created identifiable species, from dogfish and rays to sea bream and bass. Some villas had gullies bringing seawater from the bay of Naples to their ponds.

The majority of elephants in Roman art are thought to be a small subspecies of North African elephant that is now extinct. Larger Indian elephants are shown carrying soldiers into battle. Mosaics in Sicily show how elephants were captured in the hundreds in India and Africa along with leopards, lions, tigers, rhinoceroses, and bears, among many others. Transported on ships, they were kept for public exhibition and *venatios*—staged hunts in arenas.

Peacock fresco
Romans imported peacocks from India to be bred as creatures sacred to the Goddess Juno, exotic pets for the wealthy, and even as delicacies for banquets. This bright peacock on a fence is on a recovered fragment of a wall fresco (63BCE–79CE), probably from Pompeii, Italy.

Marine life
The rich harvest of the sea around Naples is depicted with a gourmet's eye in this 1st-century CE mosaic recovered from the ruins of Pompeii, Italy. The tableau of plump fish, shellfish, and eels, with a life and death struggle between a lobster and an octopus as its center, reads like a menu-board for the "House of the Faun" where it was found.

66 What pleasure can a cultivated man find in seeing a noble beast run through with a hunting spear. 99

CICERO, *AD FAMILIARES (LETTERS TO FRIENDS)*, 62–43 BCE

walking on the seabed

Some ocean fish have given up swimming in open water, instead settling for life on the seabed. For many, their fins have evolved accordingly, and rather than helping control the body in midwater, they are used for walking on the ocean floor. The paired pectoral and pelvic fins are more robust and help support the fish's weight. They have become broader at the end so that they work more like feet than fins. In frogfish and related cousins of deep-sea anglerfish, the pectoral fins are angled like elbows to give extra flexibility.

Handlike fin
The fingerlike bony rays of the frogfish's pectoral fin project beyond the webbing and help improve traction on the seabed.

Clown among the rocks
Perfectly camouflaged among the sponges at the base of a rocky coral reef, a clown frogfish (*Antennarius maculatus*) lacks the speed and agility of many open-water fish, but has the ability to clamber over the underwater terrain. It uses a flaglike lure to draw smaller fish toward its waiting jaws.

Warty, colorful skin of the slow-moving frogfish helps conceal it among corals, sponges, and seaweeds

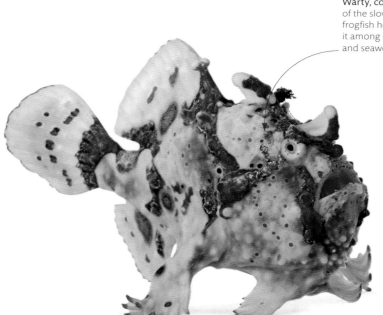

The flexible "elbow" joint of the pectoral fin means the footlike fin can bend for better control over walking

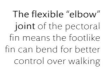

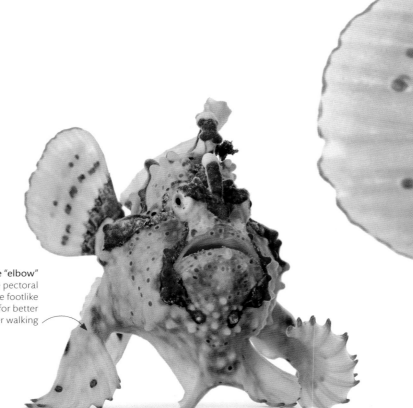

FINS AS LEGS

The fins of several groups of fish have evolved in a number of ways to help them walk. The pelvic fins are located closer to the front of the body to stabilize the fish, while the pectoral fins have become elongated to become more leglike. The mudskipper, which spends much of its time out of the water, relies mainly on pectoral fins for thrust, and uses its suckerlike pelvic fins for stability. In frogfish, both pairs of fins are leglike, and it can use them together to maximize thrust when walking, more like a four-legged land animal.

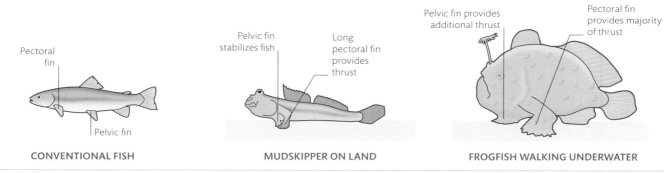

Pectoral fin

Pelvic fin

CONVENTIONAL FISH

Pelvic fin stabilizes fish

Long pectoral fin provides thrust

MUDSKIPPER ON LAND

Pelvic fin provides additional thrust

Pectoral fin provides majority of thrust

FROGFISH WALKING UNDERWATER

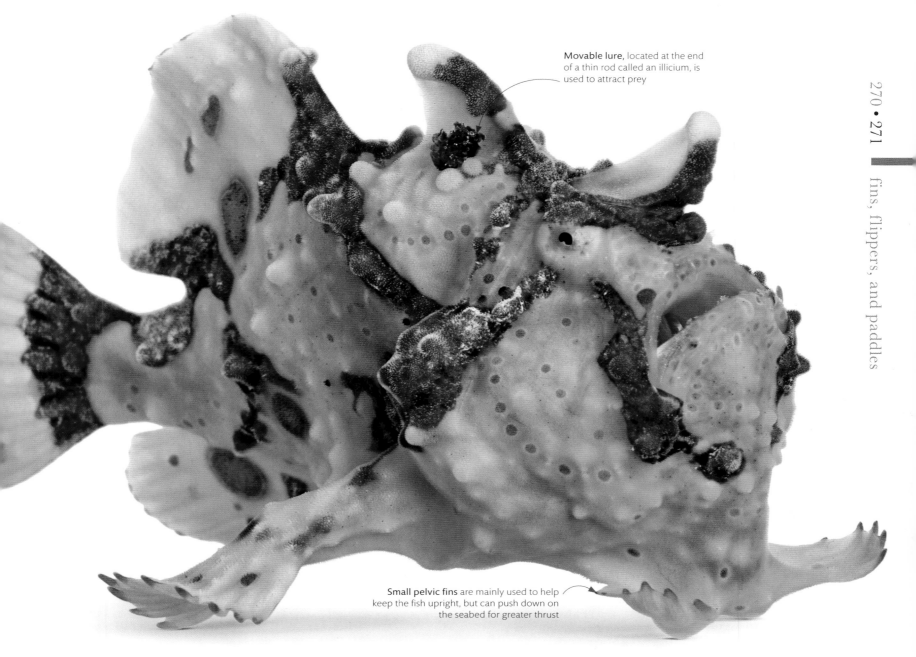

Movable lure, located at the end of a thin rod called an illicium, is used to attract prey

Small pelvic fins are mainly used to help keep the fish upright, but can push down on the seabed for greater thrust

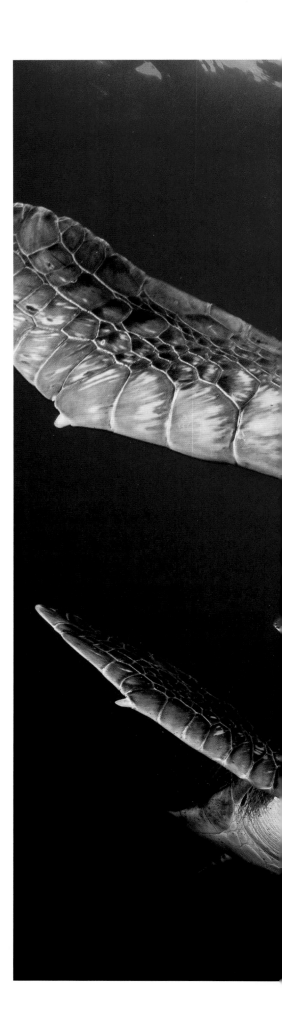

returning to water

Reptiles—with hard, water-resistant skin—evolved on land, but many of their kind have returned to the underwater habitat of their ancestors. For turtles that live in the oceans, the transition is virtually complete: together with one species of freshwater river turtle, they are now the only reptiles with feet perfectly modified into flippers. They only venture onto land to lay their eggs.

Cruising the ocean
Like all saltwater turtles, the green turtle (*Chelonia mydas*) swims by flapping its flippers, which push against the water to propel the body forward. Both upstroke and downstroke give propulsion, leaving the webbed hindfeet to work like a rudder for steering.

Leatherbacks, the largest of all turtles, are named for their shell, which is covered with leathery skin

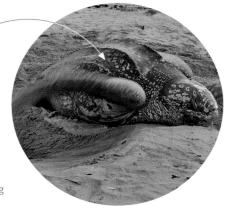

Feet for nesting
Weighing more than half a ton, a leatherback turtle (*Dermochelys coriacea*) uses its flippers to heave itself ashore and its back feet to dig a nest for its air-breathing eggs.

CONVERGENT EVOLUTION

Even though they are only distantly related, different kinds of swimming vertebrates have evolved flippers that match the hydrodynamic shapes of the fins of sharks and other fishes. Turtles and dolphins evolved from walking ancestors, while penguin flippers are modified wings.

Humerus · Radius · Digits · Ulna
DOLPHIN

Humerus · Radius · Digits · Ulna
TURTLE

Humerus · Radius · Digits · Ulna
PENGUIN

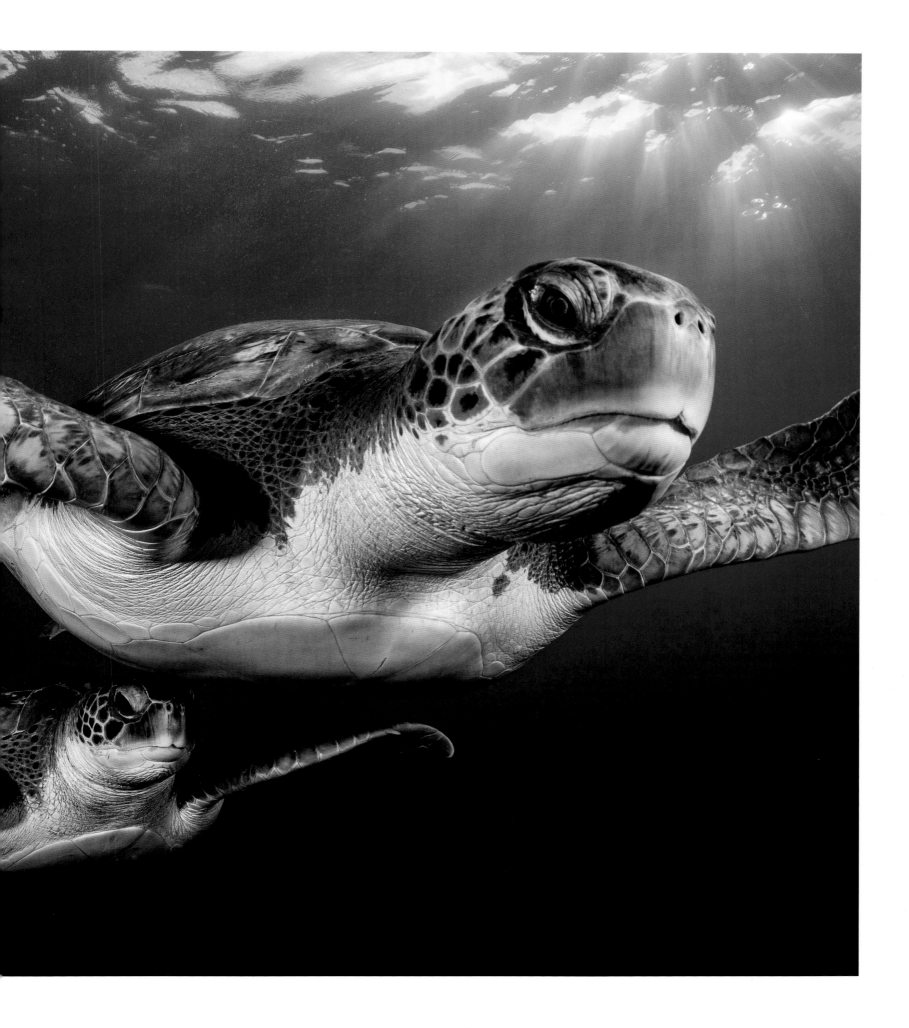

Extraordinary power
A cetacean's tail fluke contains no skeletal elements—the animal's vertebral column ends at its base. This massive boneless blade generates a powerful up-down sweep that pushes against the water to drive the whale's enormous body forward.

tail flukes

No mammals are better adapted for life in water than dolphins and whales, together known as cetaceans. Their torpedo-shaped bodies are streamlined, which minimizes drag, and their front limbs, modified as flippers, help with stability. But it is their huge tail blade, or fluke, that provides their forward thrust. This blade is made from a solid mass of connective tissue, strengthened by parallel bundles of the tough protein, collagen.

HORIZONTAL TAILS

The manatee and dugong, together known as sea cows, or sirenians, are aquatic mammals that have evolved similar adaptations to those of cetaceans. They use the same horizontal, up-down tail propulsion, which contrasts with the side-to-side tail movement of fishes. The dugong has a notched tail fluke similar to that of a cetacean, but the manatee has evolved a spatula-shaped tail paddle.

Flattened tail can propel the manatee at up to 15 mph (24 kph)

MANATEE *Trichechus* species

wings and parachutes

wing. any structure that generates lift
as an aerofoil, including either of the two
modified forelimbs in birds or bats, or one
of the extensions of the thoracic cuticle
in an insect, or one of the skin flaps of
a colugo or flying squirrel.

parachute. any structure—including
membranes and folds of skin between digits
and limbs—that maximizes air resistance
to slow an animal's fall.

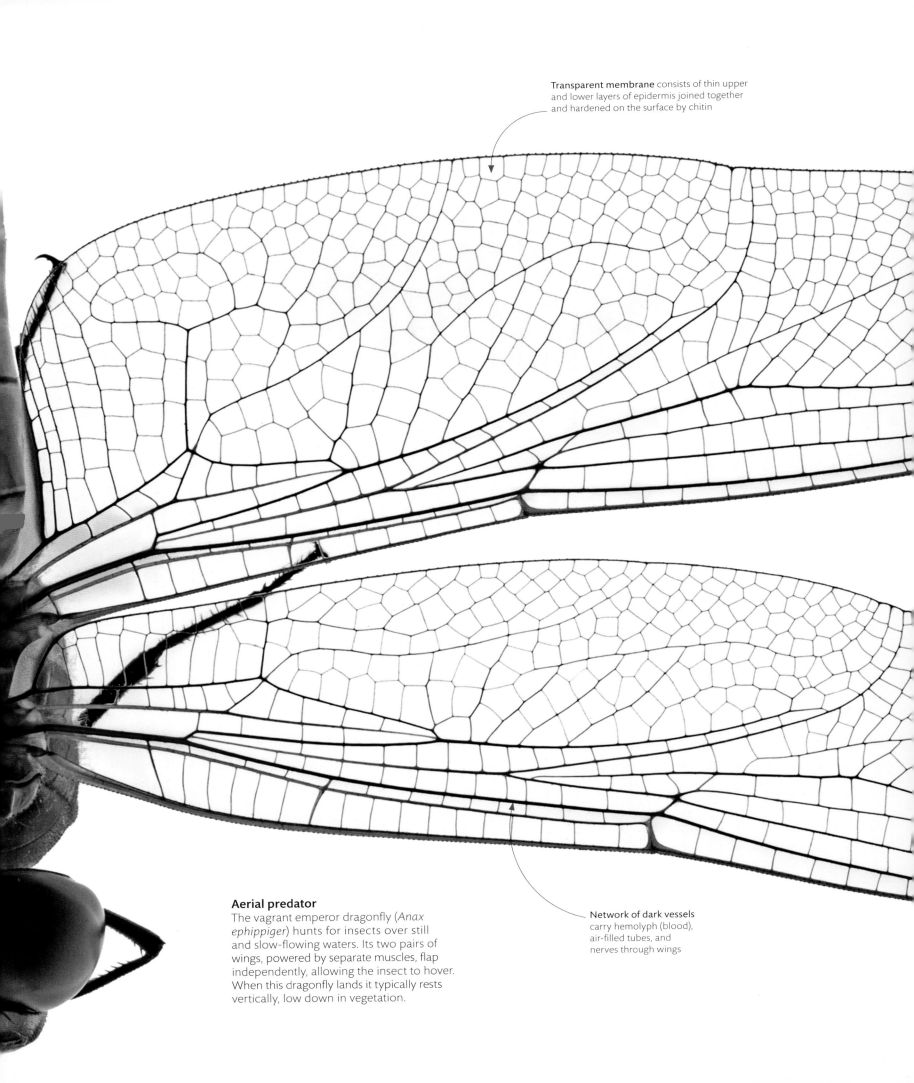

Transparent membrane consists of thin upper and lower layers of epidermis joined together and hardened on the surface by chitin

Aerial predator
The vagrant emperor dragonfly (*Anax ephippiger*) hunts for insects over still and slow-flowing waters. Its two pairs of wings, powered by separate muscles, flap independently, allowing the insect to hover. When this dragonfly lands it typically rests vertically, low down in vegetation.

Network of dark vessels carry hemolyph (blood), air-filled tubes, and nerves through wings

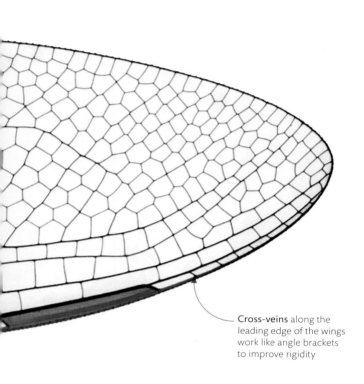

Cross-veins along the leading edge of the wings work like angle brackets to improve rigidity

Small creases on tip may help wing crumple without damage if it strikes an object

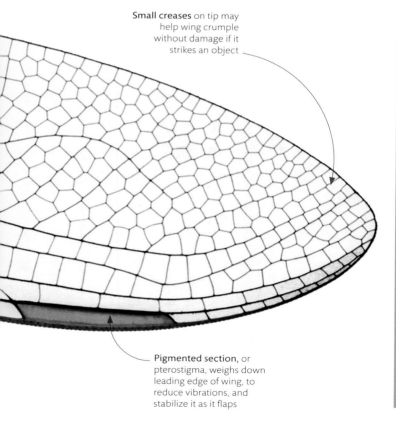

Pigmented section, or pterostigma, weighs down leading edge of wing, to reduce vibrations, and stabilize it as it flaps

Aerodynamics in miniature
When insect wings flap they create tiny vortices, or swirling eddies of air. These provide the lift that counteracts the gravitational pull of the animal's weight as seen in this sombre goldenring dragonfly (*Cordulegaster bidentata*).

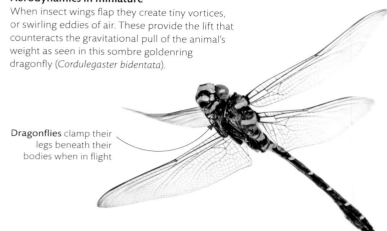

Dragonflies clamp their legs beneath their bodies when in flight

insect flight

Four hundred million years ago, insects became the first animals to take to the skies. Their flight was powered by flapping wings, and today they are still the only invertebrates capable of this. The challenges of becoming airborne and controlling midair maneuvers were met by the emergence of wings that evolved from flaps of hard exoskeleton. Their wings are strong and lightweight, and worked by combinations of powerful muscles.

MUSCLES IN THE THORAX

The first insects moved their wings with one set of muscles attached directly to the wings that pulled them down, and another set of indirect muscles that pulled on the roof of the thorax to "pivot" the wings back up. Dragonflies and mayflies still do this. Later insects rely more completely on indirect muscles that deform the shape of the thorax to move wings up and down, which increases the speed of the wingbeat to hundreds of times per second in true flies and bees.

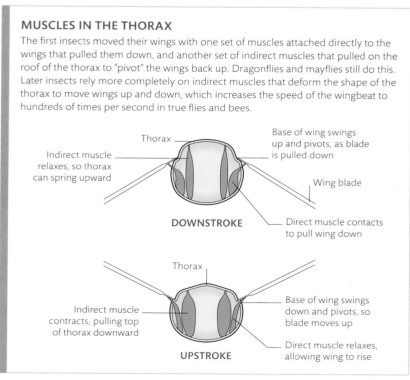

Indirect muscle relaxes, so thorax can spring upward

Thorax

Base of wing swings up and pivots, as blade is pulled down

Wing blade

DOWNSTROKE

Direct muscle contacts to pull wing down

Thorax

Indirect muscle contracts, pulling top of thorax downward

Base of wing swings down and pivots, so blade moves up

UPSTROKE

Direct muscle relaxes, allowing wing to rise

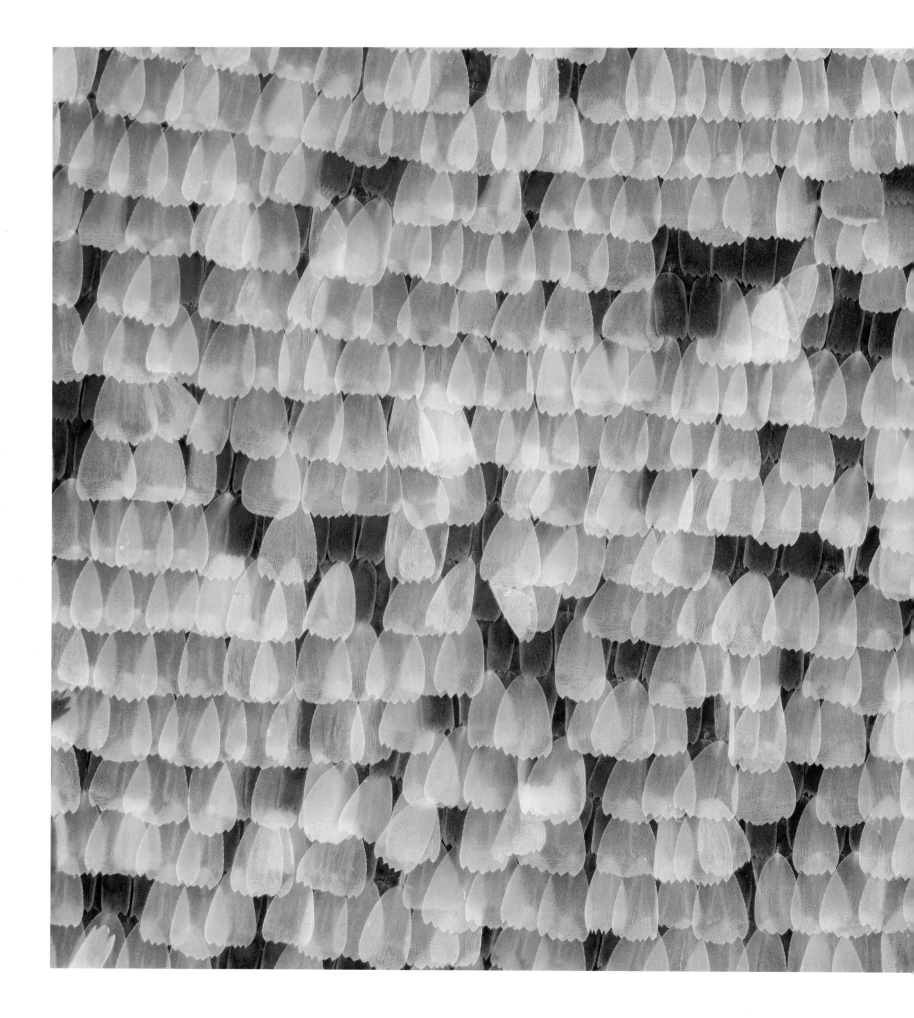

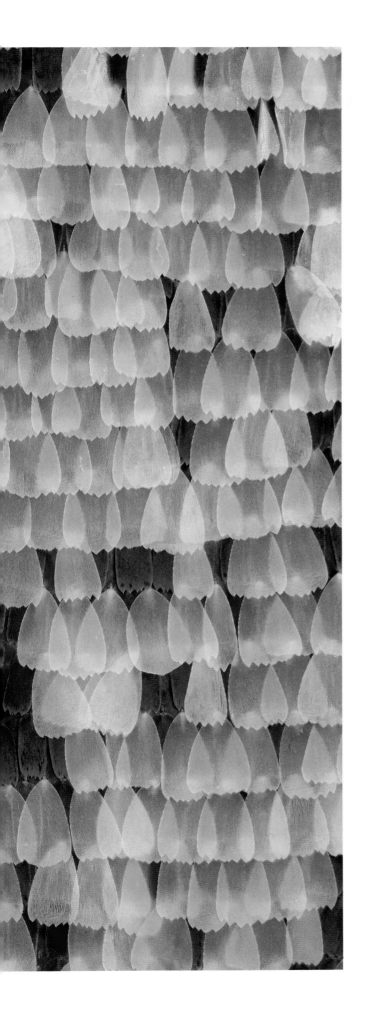

Trick of the light

The brilliant electric blue of the common blue morpho (*Morpho peleides*) butterfly is due to structure, not pigment. Tiny ridges on each scale—scarcely a thousandth of a millimeter apart—reflect light in such a way that interference between light rays cancels out all colors except blue, which is intensified.

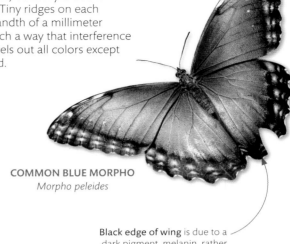

COMMON BLUE MORPHO
Morpho peleides

Black edge of wing is due to a dark pigment, melanin, rather than light interference

scaly wings

Insects of the order Lepidoptera—butterflies and moths—are unmistakable in that their wings and bodies are covered in tiny scales so delicately attached that they rub off like dust. Under the microscope, these overlapping scales resemble miniature roofing tiles. They may trap air to improve lift or even help the insects slip from the webs of predatory spiders. But they are also responsible for stunning color—whatever purpose this might serve.

MULTIPURPOSE COLOR

Butterflies, such as *Consul fabius* (top) and *Myscelia orsis* (center left), and even some day-flying moths, such as *Ceretes thais* (center right), are among the most colorful of lepidopterans and may flaunt their patterns in courtship or to repel predators. But colors can be also used in camouflage: the underwing of *C. fabius* (bottom) mimics a dead leaf, making the insect almost invisible when it closes its wings.

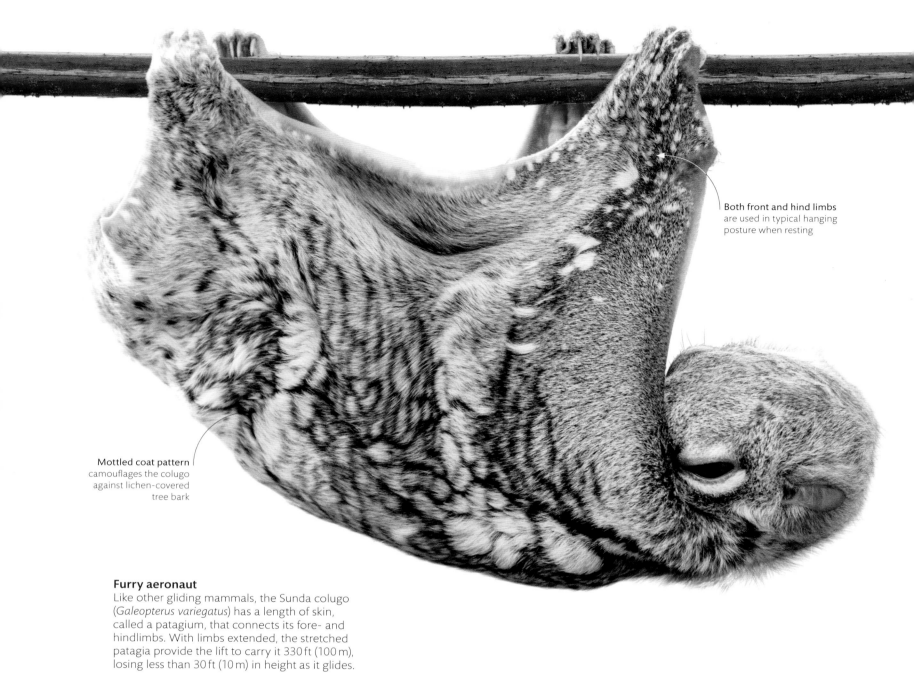

Both front and hind limbs are used in typical hanging posture when resting

Mottled coat pattern camouflages the colugo against lichen-covered tree bark

Furry aeronaut
Like other gliding mammals, the Sunda colugo (*Galeopterus variegatus*) has a length of skin, called a patagium, that connects its fore- and hindlimbs. With limbs extended, the stretched patagia provide the lift to carry it 330 ft (100 m), losing less than 30 ft (10 m) in height as it glides.

gliding and parachuting

Every major group of vertebrates—from fish to mammals—has some species that can glide through the air. This is unsurprising because it is a remarkably efficient way to move: as long as the animal can launch itself, it relies only on lift provided by its aerodynamic shape (rather than muscle-powered thrust) to cover a distance. Gliding minimizes drag during flight, but in contrast, parachuting maximizes drag. By turning a wing into a parachute, animals can reduce impact speed for a safe landing.

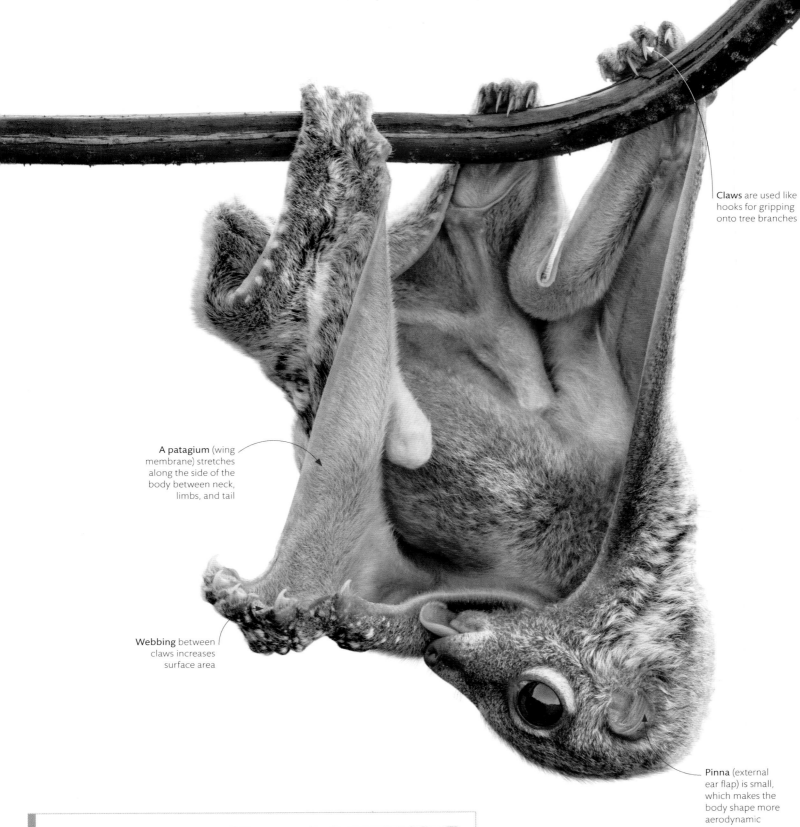

Claws are used like hooks for gripping onto tree branches

A **patagium** (wing membrane) stretches along the side of the body between neck, limbs, and tail

Webbing between claws increases surface area

Pinna (external ear flap) is small, which makes the body shape more aerodynamic

"FLYING" RODENTS

Gliding with patagia has evolved independently in several groups of mammals, including among marsupial possums and squirrels. The patagia of flying squirrels stretch from wrist to ankle. They can change direction midflight where necessary.

FLYING SQUIRRELS

how birds fly

For an animal to fly, it needs to overcome the pull of gravity and lift itself into the air, as well as propel itself forwards. No vertebrate group has as many flying species as birds. When birds evolved from upright, feathered dinosaurs, their muscle-powered forelimbs became modified into wings that gave both the lift and the propulsion necessary to conquer the skies. With fingers reduced, their arm bones provide the wings' frames, while stiff-bladed flight feathers—rooted firmly in the bones—form the aerodynamic surfaces.

Aerial predator
In normal flight, the common kestrel (*Falco tinnunculus*) has a cruising speed of about 20 mph (32 kph). Like other falcons, the kestrel has long, pointed wings that allow high-speed flight, occasional soaring, and also the ability to hover against the wind while scanning the ground below for small mammal prey.

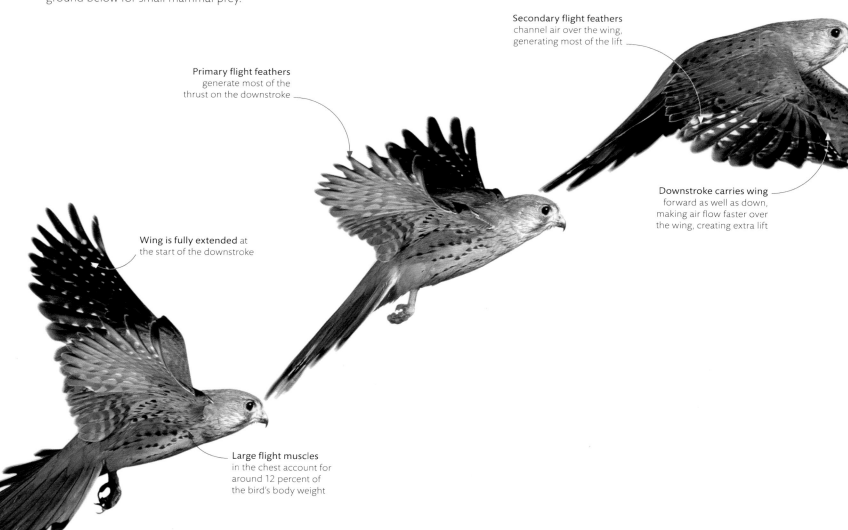

Secondary flight feathers channel air over the wing, generating most of the lift

Primary flight feathers generate most of the thrust on the downstroke

Downstroke carries wing forward as well as down, making air flow faster over the wing, creating extra lift

Wing is fully extended at the start of the downstroke

Large flight muscles in the chest account for around 12 percent of the bird's body weight

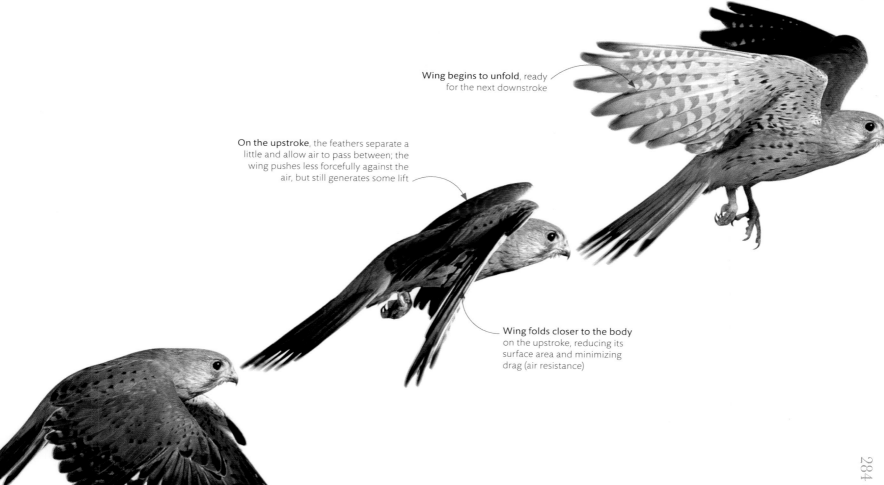

Wing begins to unfold, ready for the next downstroke

On the upstroke, the feathers separate a little and allow air to pass between; the wing pushes less forcefully against the air, but still generates some lift

Wing folds closer to the body on the upstroke, reducing its surface area and minimizing drag (air resistance)

Outer wing is stiff on the downstroke and pushes against the air, due to the way the feathers overlap, with the inner edge of each underneath the next feather

WINGS IN ACTION

Powerful chest muscles, connected to a strongly keeled sternum (breastbone), contract to flap the wings. This action gives the thrust needed to move forward. In most birds, the downstroke provides the propulsion. Lift is generated by the wings' shape—their convex upper surface causes air to flow faster and with lower pressure over the top of the wings than beneath, pulling the body upward.

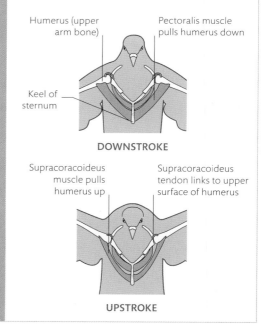

Humerus (upper arm bone)

Pectoralis muscle pulls humerus down

Keel of sternum

DOWNSTROKE

Supracoracoideus muscle pulls humerus up

Supracoracoideus tendon links to upper surface of humerus

UPSTROKE

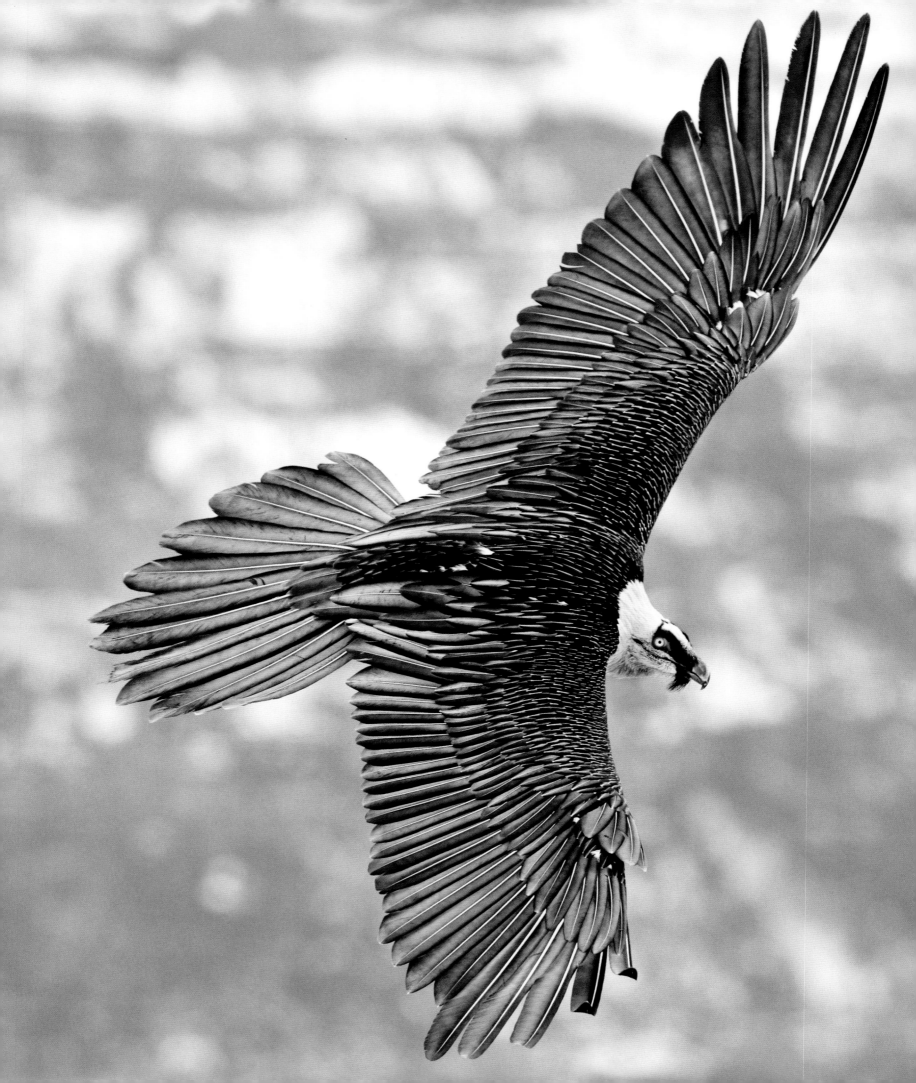

lammergeier

As long as a five-year-old child is tall, and weighing twice as much as many a domestic cat, the lammergeier (*Gypaetus barbatus*) is impressive when seen on the ground. In the air, this vulture is even more striking: a superb glider, it soars for hours over high, rugged terrain in search of bones to eat.

A mountain dweller of Europe, Asia, and Africa, the lammergeier, or bearded vulture, roosts on cliffs, usually above 3,300 ft (1,000 m) and possibly even higher than 16,400 ft (5,000 m) in Nepal.

Lammergeiers are the only vertebrates whose diet consists almost exclusively of bones (up to 85 percent). While facing little competition for this unusual dietary staple, they must range far and wide to find enough bones to sustain themselves; some birds have been known to travel as far as 435 miles (700 km) in a single day. For this reason, lammergeiers tend to be sparsely distributed and patrol vast territories that in some locations cover hundreds of square miles.

Their huge wingspan—up to 10 ft (3 m) in the slightly larger females—enables the birds to soar with barely a wingbeat, hitching rides on rising air currents. By scanning the terrain from on high or skimming over the ground, they can spot the carcasses of mountain goats or wild sheep on clifftops and in remote canyons.

While other vultures will gorge in a feast-or-famine strategy, lammergeiers are steady consumers, swallowing about 8 percent of their body weight—roughly 1 lb (465 g)—each day in bones. Small bones are swallowed whole; larger ones are carried aloft and dropped from 165 to 260 ft (50 to 80 m) onto rocks to shatter them into manageable pieces. Acidic gastric fluids dissolve these skeletal meals in 24 hours.

Life on the wing
Adult lammergeiers spend up to 80 percent of daylight hours in soaring flight, scouring the land below for food. Once airborne, they glide on mountain winds at speeds of 12–48 mph (20–77 kph).

Red-necked raptor
A lammergeier habitually stains its plumage a rusty red by bathing in soil or water rich in iron oxide. A greater degree of staining between individuals of a similar age may signifiy more dominant birds.

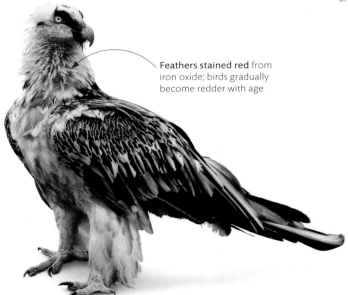

Feathers stained red from iron oxide; birds gradually become redder with age

Slotted high-lift wings

Deep notches between primary feathers on a broad wing shape provides greater lift, not only allowing birds to gain altitude with less effort but also to land in more confined spaces. Typical of raptors such as hawks and eagles, and soaring birds such as vultures, this shape is also found in swans and larger waders.

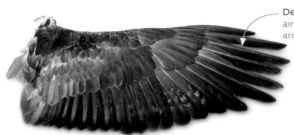

Deep slots reduce air turbulence around wingtips

GOLDEN EAGLE
Aquila chrysaetos

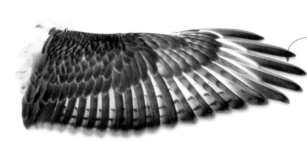

Long wing remains broad even at the tip

FERRUGINOUS HAWK
Buteo regalis

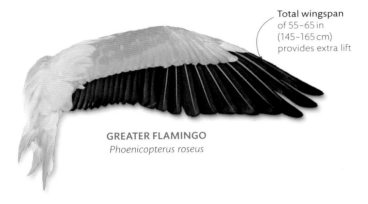

Total wingspan of 55–65 in (145–165 cm) provides extra lift

GREATER FLAMINGO
Phoenicopterus roseus

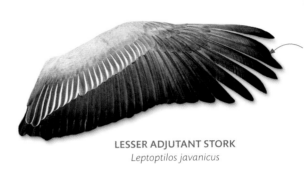

Feathers at tip become fingerlike extensions

LESSER ADJUTANT STORK
Leptoptilos javanicus

High-speed wings

Thin wings, tapering to a point produce the high-speed, ultra-maneuverable flights of aerial feeders such as swallows, swifts, and martins, and stealth hunters such as falcons. They are also seen in ducks and shorebird species, which, while not known for aerodynamic displays, use rapid wingbeats to move at high speed in level flight.

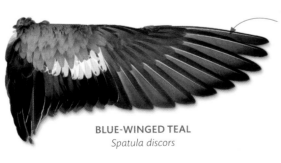

Wing shape suited to fast, direct flight

BLUE-WINGED TEAL
Spatula discors

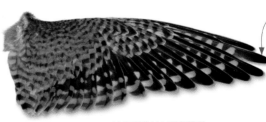

Pointed wingtip enables the high-speed "stoop," or dive, of this falcon

AMERICAN KESTREL
Falco sparverius

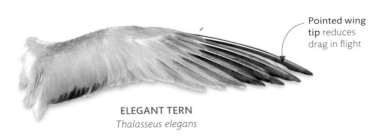

Pointed wing tip reduces drag in flight

ELEGANT TERN
Thalasseus elegans

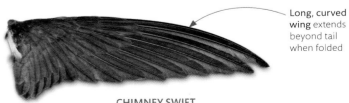

Long, curved wing extends beyond tail when folded

CHIMNEY SWIFT
(Chaetura pelagica)

Elliptical wings

Good for quick takeoffs and short bursts of speed, the elliptical wing shape of passerines (perching birds such as sparrows and thrushes) and game birds, provides excellent maneuverability in dense, brushy habitats, but at a high energy cost. Although many passerines still achieve long-distance migrations, game birds cannot sustain long flights.

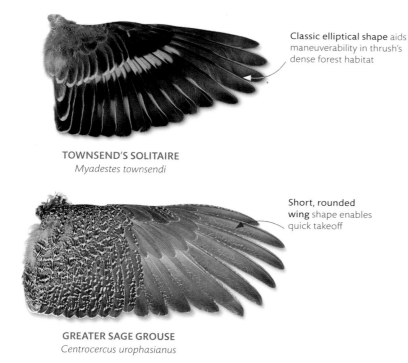

Classic elliptical shape aids maneuverability in thrush's dense forest habitat

TOWNSEND'S SOLITAIRE
Myadestes townsendi

Short, rounded wing shape enables quick takeoff

GREATER SAGE GROUSE
Centrocercus urophasianus

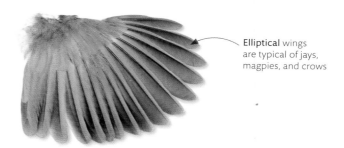

Elliptical wings are typical of jays, magpies, and crows

GREEN JAY
Cyanocorax luxuosus

Distinctive wing pattern makes bird conspicuous in flight

EURASIAN JAY
Garrulus glandarius

High-aspect ratio wings

Just like the pole used by a human tightrope walker, long, narrow wings give a bird more stability. This wing shape also produces less drag, which means birds can fly for longer using less energy. High-aspect ratio wings are responsible for the long, soaring flights of seabirds such as albatrosses, gulls, gannets, and petrels.

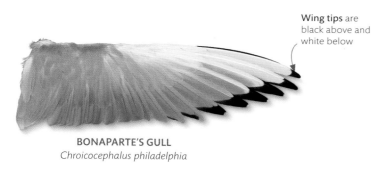

Wing tips are black above and white below

BONAPARTE'S GULL
Chroicocephalus philadelphia

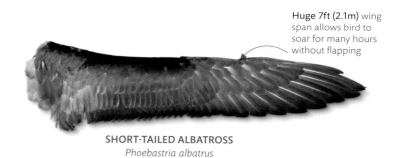

Huge 7ft (2.1m) wing span allows bird to soar for many hours without flapping

SHORT-TAILED ALBATROSS
Phoebastria albatrus

bird wings

Wing shape is an indicator of how a bird flies, and whether or not it is a predator or prey species. Apart from specialized wings, such as those of hummingbirds (see pp.292–93), whose shifting feathers provide the control needed to hover, most birds' wings can be grouped into four basic shapes, each related to a range of flight speeds, styles, and distances.

emperor penguin

At up to 101 lb (46 kg) in weight and 4½ ft (1.35 m) tall, Antarctica's emperor penguin (*Aptenodytes forsteri*) is the world's largest penguin. Although flightless like other penguins, a streamlined body and wings modified into flippers gives this species diving abilities that are unparalleled among birds.

In abandoning flight, emperor penguins have also lost buoyancy. Their bones are denser than those of flying birds, making their bodies slightly heavier than water. Their stiffened wings, originally used to stay airborne, now provide thrust in the denser medium of water. The only flexible wing joint connects the humerus (upper arm) to the shoulder. But the birds' wing muscles retain similar power to those of flying birds, so they can flap vigorously to dive deep in search of food. The feet, used for steering, are set so far back that on land the penguin must stand vertically.

With a heavier body, less energy is needed to stay submerged, allowing dives to be longer and deeper. As a result, each foraging expedition results in a bigger net energy gain. Emperor penguins catch shrimplike krill under the ice floes, but the bulk of their diet is fish and squid, often caught at depths of 660 ft (200 m) or more. A typical dives lasts 3 to 6 minutes,

but dive times of 20 to 30 minutes have been recorded, and emperors are capable of reaching as deep as 1,850 ft (565 m).

Body fat built up by the summer catch sustains the emperors through the harsh Antarctic winter, when the birds breed. Having laid a single egg, the female treks across the ice to feed out at sea. The male rests the egg on his feet and incubates it under a fold of warm abdominal skin, in temperatures as low as −80°F (−62°C); he does not eat at all during this time. When the chick hatches, he feeds it on nutritious "milk" secreted by his esophagus. After the female returns, the roles reverse: she cares for the chick, while he sets off for the ocean—and his first meal in four months.

Flying with flippers
Bubbles stream off the waterproof coats of these diving emperors. Once underwater, they flap their wings through such a wide arc that the tips nearly touch on the upstroke.

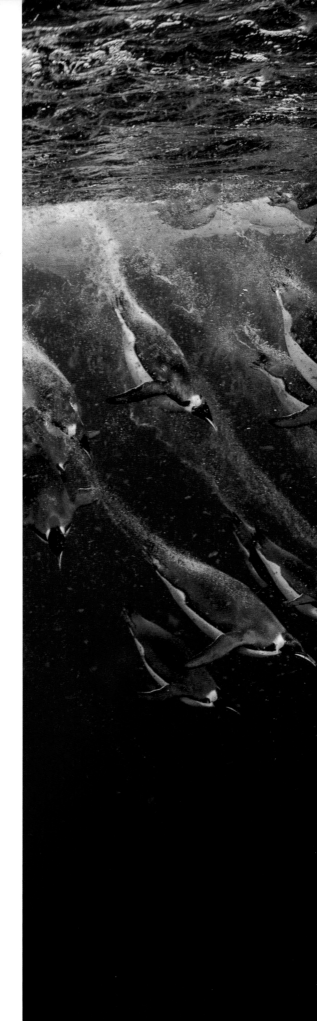

DIVING WINGS

Like penguins, auks (such as razorbills, puffins, and guillemots) use wing-propulsion to help them dive. Penguins' short, rigid wings only move at the base, but auks have larger, more flexible wings that limit their diving depth but permit them to get airborne.

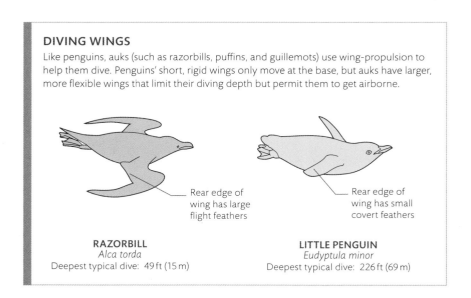

Rear edge of wing has large flight feathers

Rear edge of wing has small covert feathers

RAZORBILL
Alca torda
Deepest typical dive: 49 ft (15 m)

LITTLE PENGUIN
Eudyptula minor
Deepest typical dive: 226 ft (69 m)

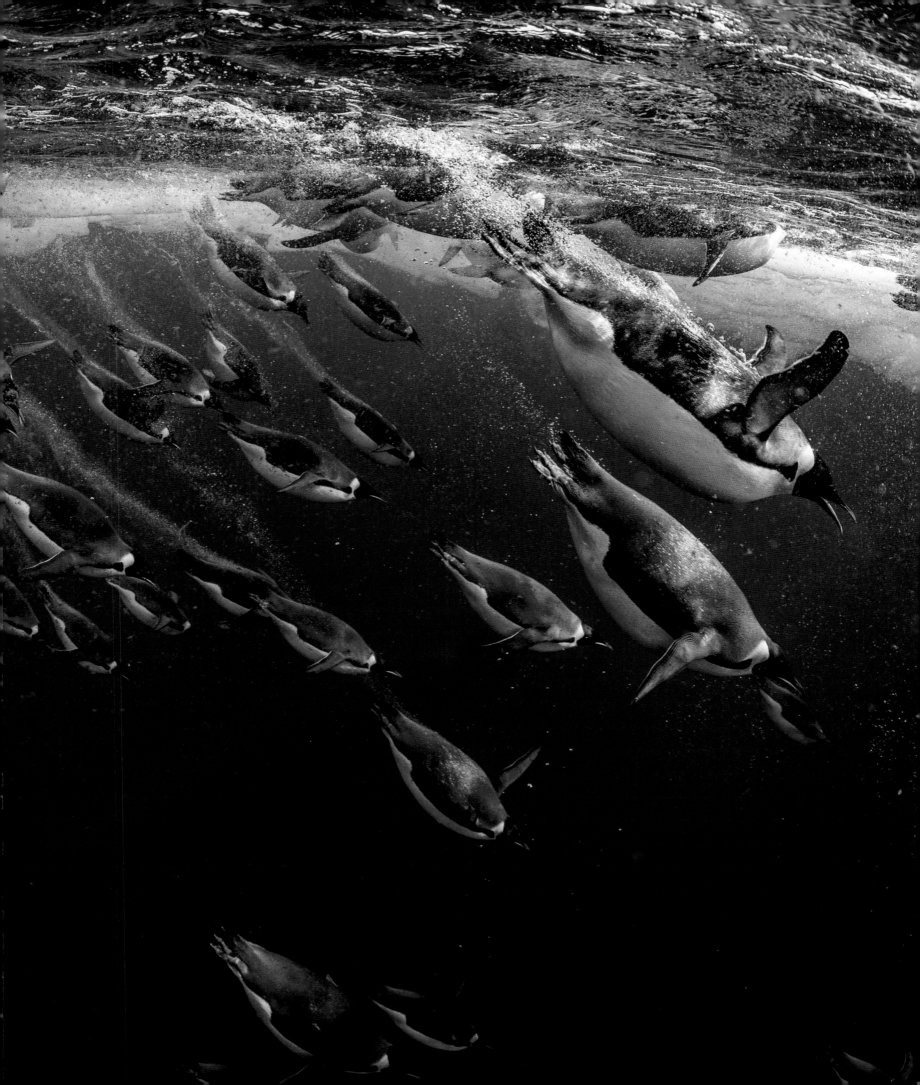

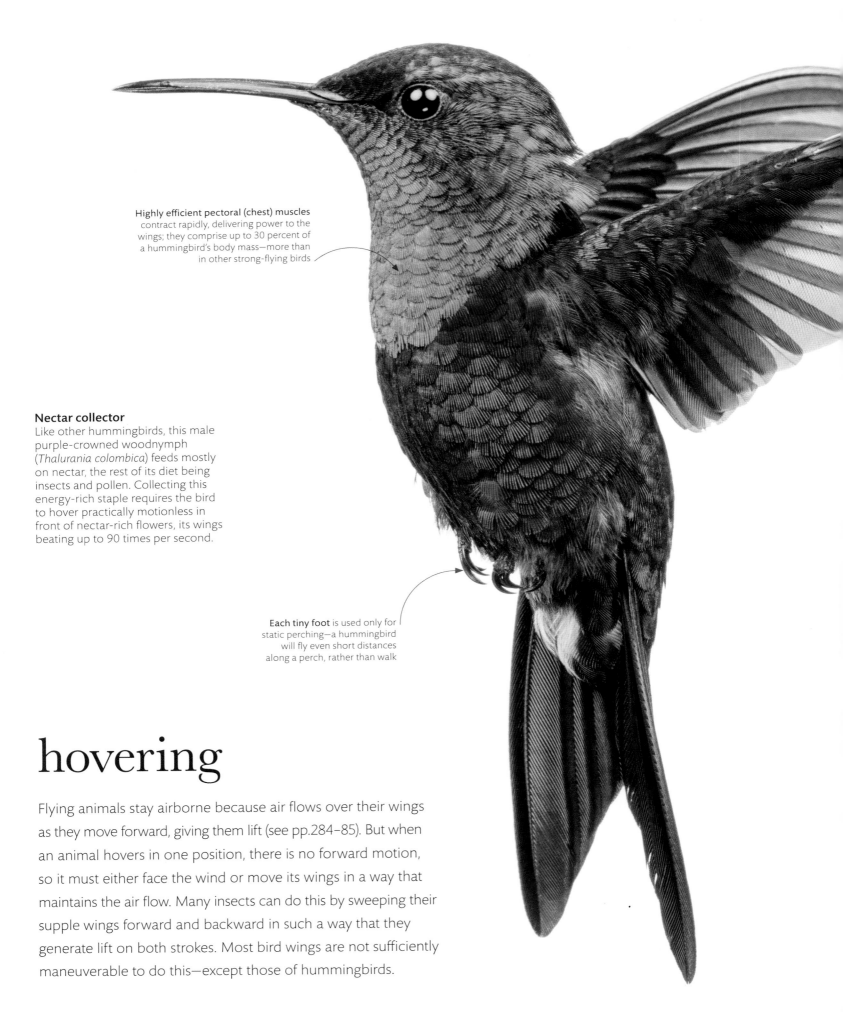

Highly efficient pectoral (chest) muscles contract rapidly, delivering power to the wings; they comprise up to 30 percent of a hummingbird's body mass—more than in other strong-flying birds

Nectar collector
Like other hummingbirds, this male purple-crowned woodnymph (*Thalurania colombica*) feeds mostly on nectar, the rest of its diet being insects and pollen. Collecting this energy-rich staple requires the bird to hover practically motionless in front of nectar-rich flowers, its wings beating up to 90 times per second.

Each tiny foot is used only for static perching—a hummingbird will fly even short distances along a perch, rather than walk

hovering

Flying animals stay airborne because air flows over their wings as they move forward, giving them lift (see pp.284–85). But when an animal hovers in one position, there is no forward motion, so it must either face the wind or move its wings in a way that maintains the air flow. Many insects can do this by sweeping their supple wings forward and backward in such a way that they generate lift on both strokes. Most bird wings are not sufficiently maneuverable to do this—except those of hummingbirds.

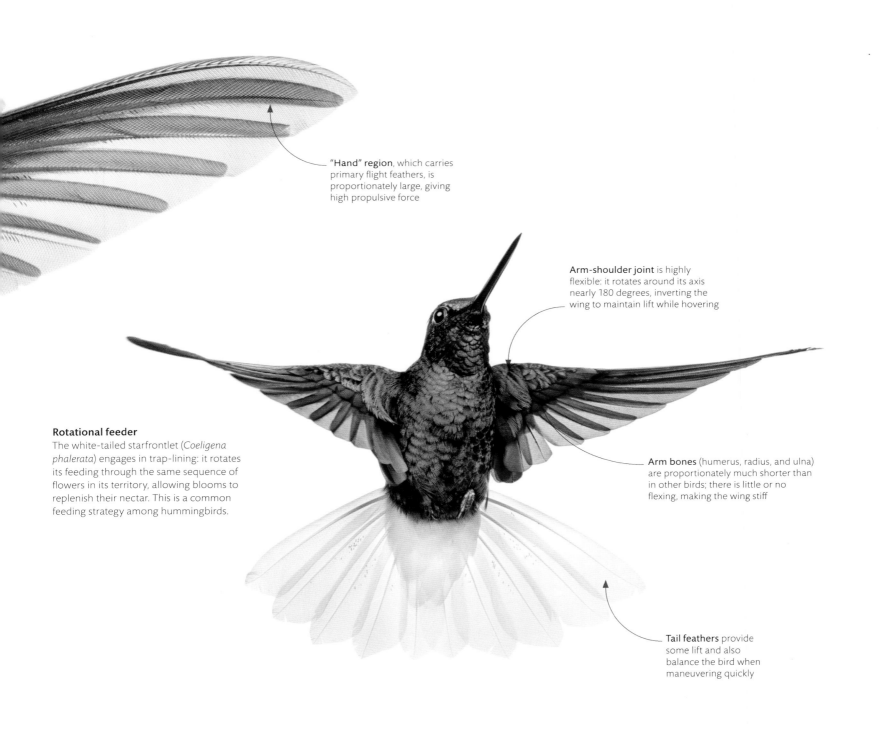

"Hand" region, which carries primary flight feathers, is proportionately large, giving high propulsive force

Arm-shoulder joint is highly flexible: it rotates around its axis nearly 180 degrees, inverting the wing to maintain lift while hovering

Rotational feeder
The white-tailed starfrontlet (*Coeligena phalerata*) engages in trap-lining: it rotates its feeding through the same sequence of flowers in its territory, allowing blooms to replenish their nectar. This is a common feeding strategy among hummingbirds.

Arm bones (humerus, radius, and ulna) are proportionately much shorter than in other birds; there is little or no flexing, making the wing stiff

Tail feathers provide some lift and also balance the bird when maneuvering quickly

HOW HOVERING WORKS

Hummingbird wings do not fold on the upstroke, like those of other birds, but stay open and flip upside-down. As a result, air flowing over the surface of the wings produces lift on both the forward "downstroke" and the backward "upstroke." Thrust is vertical, not horizontal, so it steadies the bird against gravity. The wings' figure-eight path helps overcome the momentum of the downstroke and swiftly reverses the wings' direction.

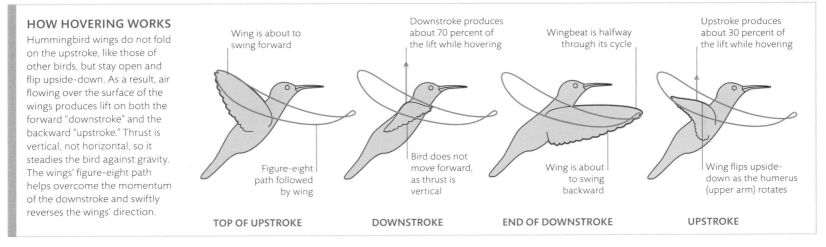

Wing is about to swing forward

Figure-eight path followed by wing

TOP OF UPSTROKE

Downstroke produces about 70 percent of the lift while hovering

Bird does not move forward, as thrust is vertical

DOWNSTROKE

Wingbeat is halfway through its cycle

Wing is about to swing backward

END OF DOWNSTROKE

Upstroke produces about 30 percent of the lift while hovering

Wing flips upside-down as the humerus (upper arm) rotates

UPSTROKE

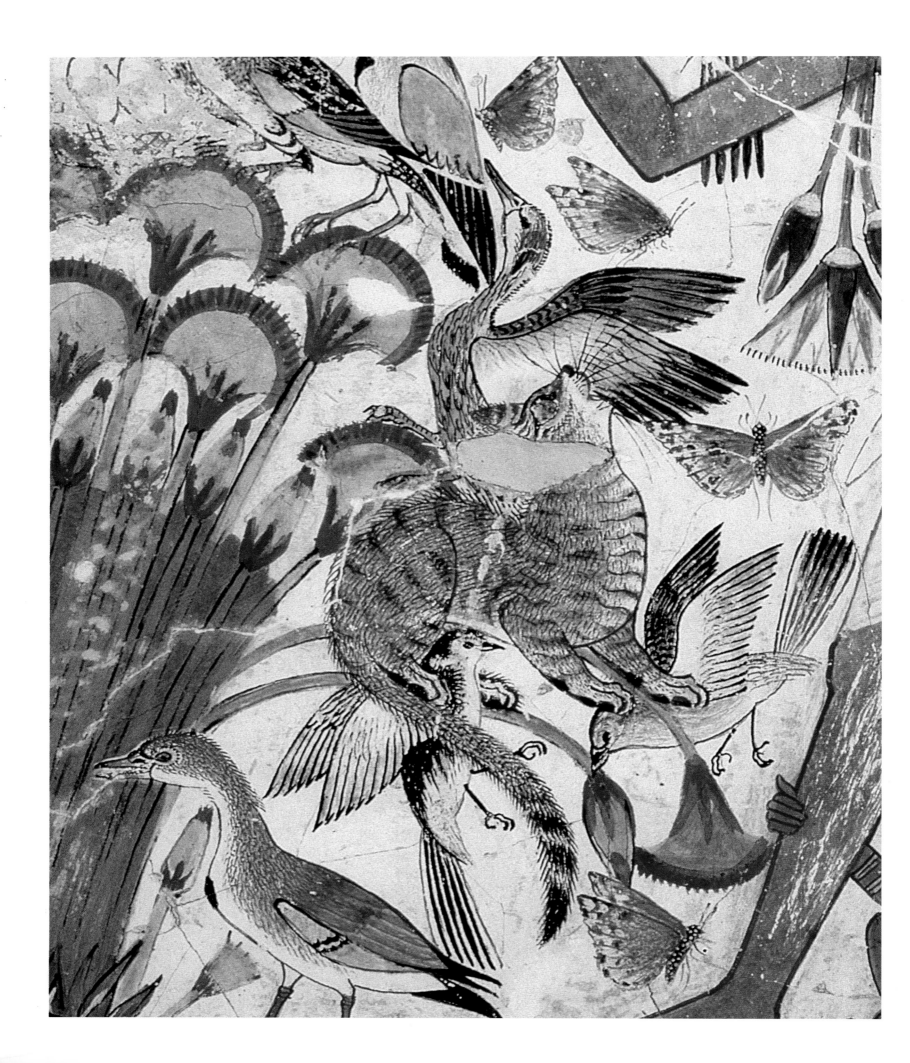

Meidum geese (4th Dynasty)
An Old Kingdom masterpiece in inscribed plaster and paint depicts three species: white-fronted, bean, and red-breasted geese. It was found in the tomb-chapel of Atet , wife of Prince Nefermaat, alongside Pharaoh Sneferu's pyramid at Meidum.

animals in art

egyptian bird life

In ancient Egypt, the banks of the Nile teemed with bird life. Homes were built close to the water, and residents were faithful observers, replicating bird shapes in religious icons and hieroglyphs and endowing their gods with avian powers and characteristics. The value of birds as a source of food and religious inspiration continued into the afterlife, where the deceased could choose to take on one of their many forms.

Egyptian art forms abound with reflections of the natural world, and birds enjoyed a particular reverence. The rich variety from sky-borne falcons, swallows, kites, and owls to waterside herons, cranes, and ibis is reflected in Egyptian script: up to 70 different species are incorporated in hieroglyphs.

Gods were apportioned with bird traits that enhanced their powers; Horus, ruler of the sky, is depicted with a falcon head because of the dizzying height of his flight. With one eye representing the sun and the other the moon, his journey across the sky mimicks the path of the sun from dawn to dusk. Thoth, the god of magic, wisdom, and the moon, bears an ibis head with a curved beak like a crescent moon.

Tomb paintings reveal the afterlife as a land of plenty. Using funerary spells, the deceased could transform into a chosen avian or take the form of the Ba, a human-headed bird that flees the tomb each night. In the 18th-dynasty tomb of Nebamum, the scribe is shown restored to human form to hunt game in fertile marshes and take stock of the domestic fowl provided for his eternity.

Animal deities (19th Dynasty 1306–1304 BCE)
In a tomb painting, falcon-headed Horus, son of Isis, god of the sky, welcomes Pharaoh Ramses I to the afterlife, assisted by the jackal-headed god of funerals and death, Anubis.

Nebamum's cat (18th dynasty c.1350 BCE)
An ecstatic tawny cat hunting birds is captured in a detail from the fresco *Nebamum Hunting in Marshes* found in the tomb of an Egyptian scribe. Cats were often symbols of Bastet, the goddess of fertility and pregnancy. The gilded eye on Nebamum's cat hints at religious significance.

> " As a falcon, I live in the light. My crown and my radiance have given me power. "

CHAPTER 78, *THE BOOK OF THE DEAD*

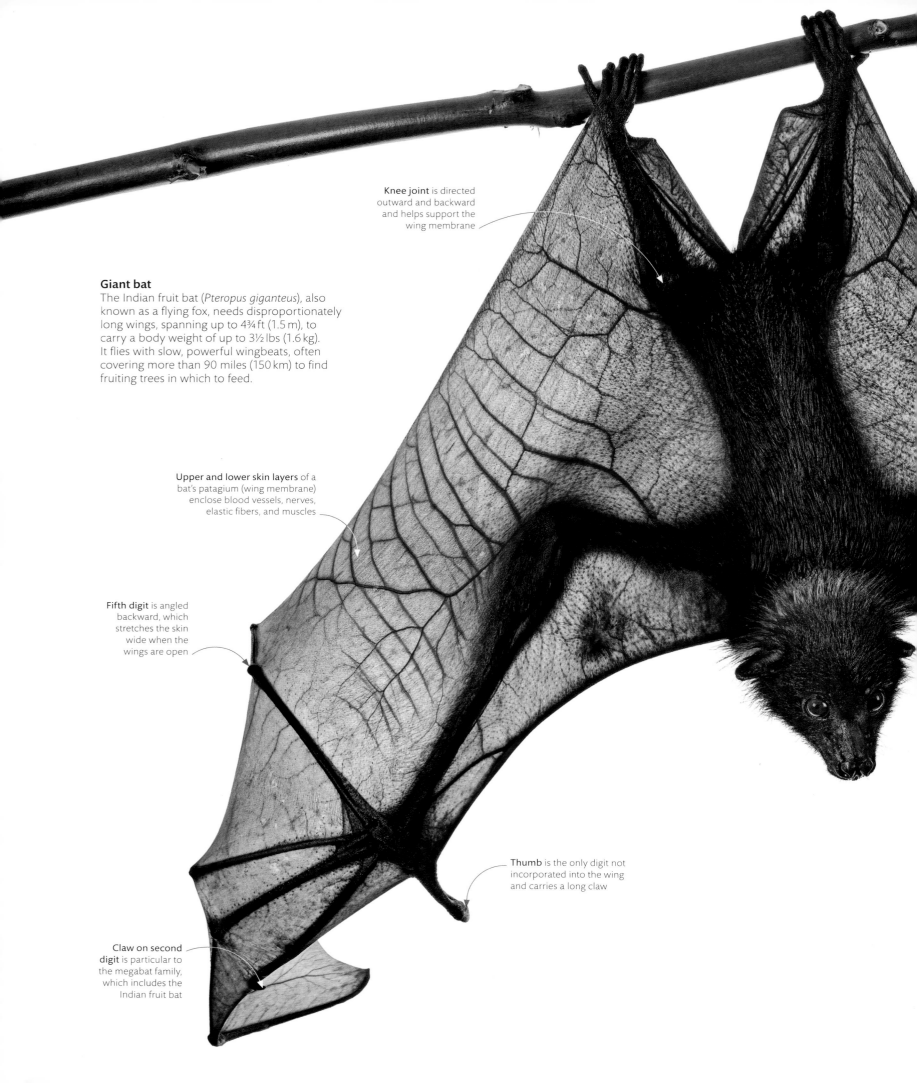

Knee joint is directed
outward and backward
and helps support the
wing membrane

Giant bat

The Indian fruit bat (*Pteropus giganteus*), also
known as a flying fox, needs disproportionately
long wings, spanning up to 4¾ ft (1.5 m), to
carry a body weight of up to 3½ lbs (1.6 kg).
It flies with slow, powerful wingbeats, often
covering more than 90 miles (150 km) to find
fruiting trees in which to feed.

Upper and lower skin layers of a
bat's patagium (wing membrane)
enclose blood vessels, nerves,
elastic fibers, and muscles

Fifth digit is angled
backward, which
stretches the skin
wide when the
wings are open

Thumb is the only digit not
incorporated into the wing
and carries a long claw

**Claw on second
digit** is particular to
the megabat family,
which includes the
Indian fruit bat

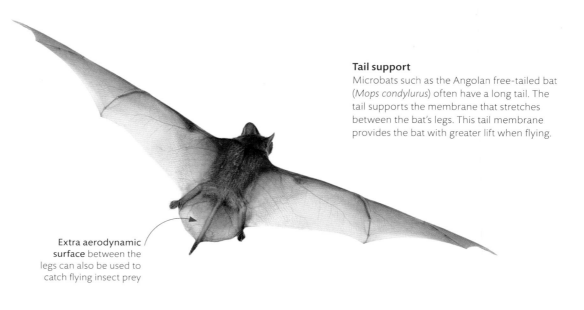

Tail support
Microbats such as the Angolan free-tailed bat (*Mops condylurus*) often have a long tail. The tail supports the membrane that stretches between the bat's legs. This tail membrane provides the bat with greater lift when flying.

Extra aerodynamic surface between the legs can also be used to catch flying insect prey

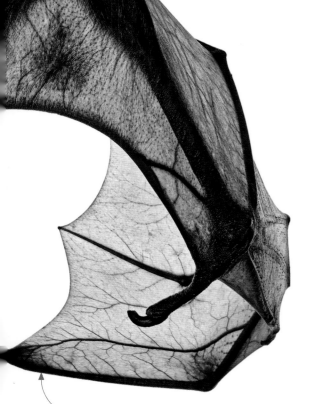

Third digit is usually the longest and reaches to the wingtip

wings of skin

Like birds, bats have powered flight; they beat their wings to generate the thrust necessary to move them through the air. However, instead of stiff flight feathers (see pp.124–25) providing the aerodynamic surface, bats have a skin membrane, stretched between elongated finger bones, which reaches back to their feet. Wings of living skin are more adjustable and sensitive to air around them, and allow bats to maneuver tightly while catching flying insects or foraging for fruit and nectar.

WING SHAPES

The shape of a wing is described by its aspect ratio: the proportion of its length to its width. Short, wide wings (low aspect ratio) occur in bats whose manoeuvrability and precision are important—such as in dense forest—whereas long, narrow wings (high aspect ratio) provide faster sustained flight high above the ground.

Egyptian slit-faced bat
Nycteris thebaica

Heart-nosed bat
Cardioderma cor

LOW ASPECT RATIO

Pel's pouched bat
Saccolaimus peli

Midas' free-tailed bat
Mops midas

HIGH ASPECT RATIO

eggs and offspring

egg. (1) the sex cell of a female animal before it is fertilized to become an embryo; (2) a protective package laid by a female animal, containing an embryo, along with a food supply and environment that supports its development.

offspring. the young of an animal.

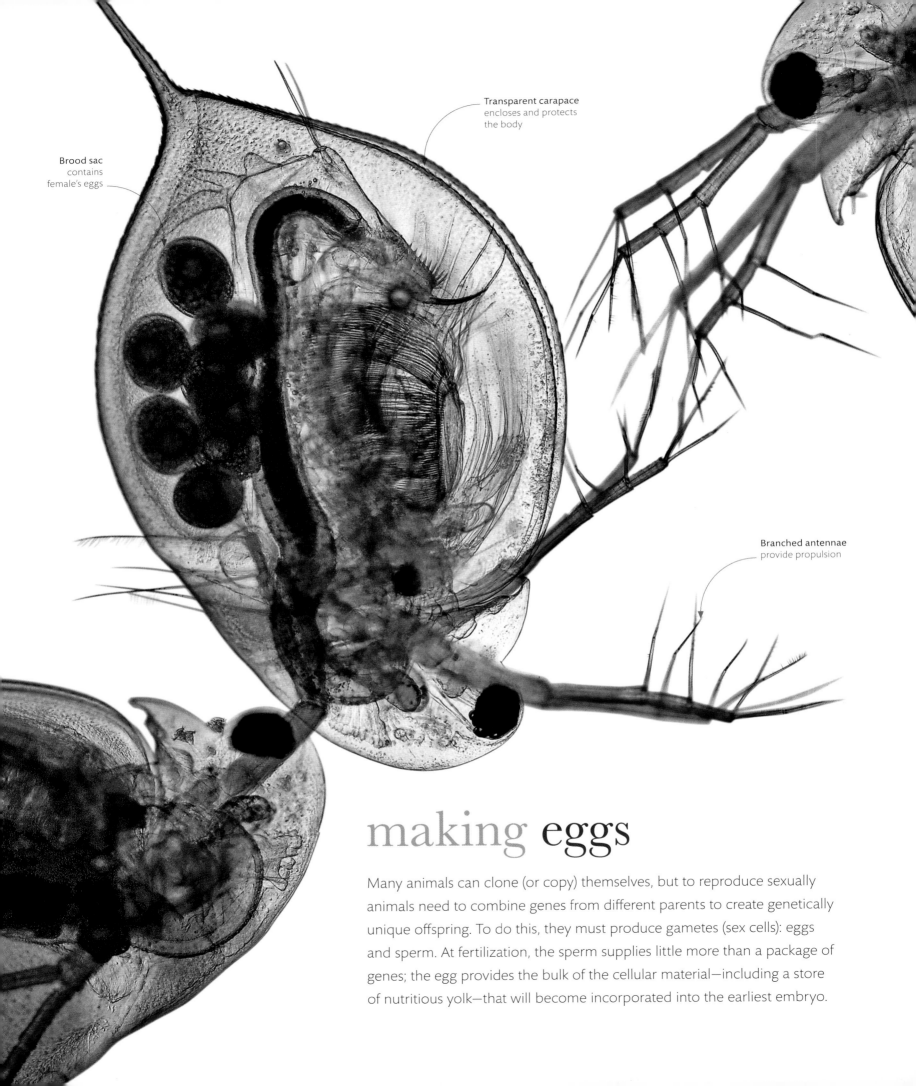

Brood sac
contains
female's eggs

Transparent carapace
encloses and protects
the body

Branched antennae
provide propulsion

making eggs

Many animals can clone (or copy) themselves, but to reproduce sexually animals need to combine genes from different parents to create genetically unique offspring. To do this, they must produce gametes (sex cells): eggs and sperm. At fertilization, the sperm supplies little more than a package of genes; the egg provides the bulk of the cellular material—including a store of nutritious yolk—that will become incorporated into the earliest embryo.

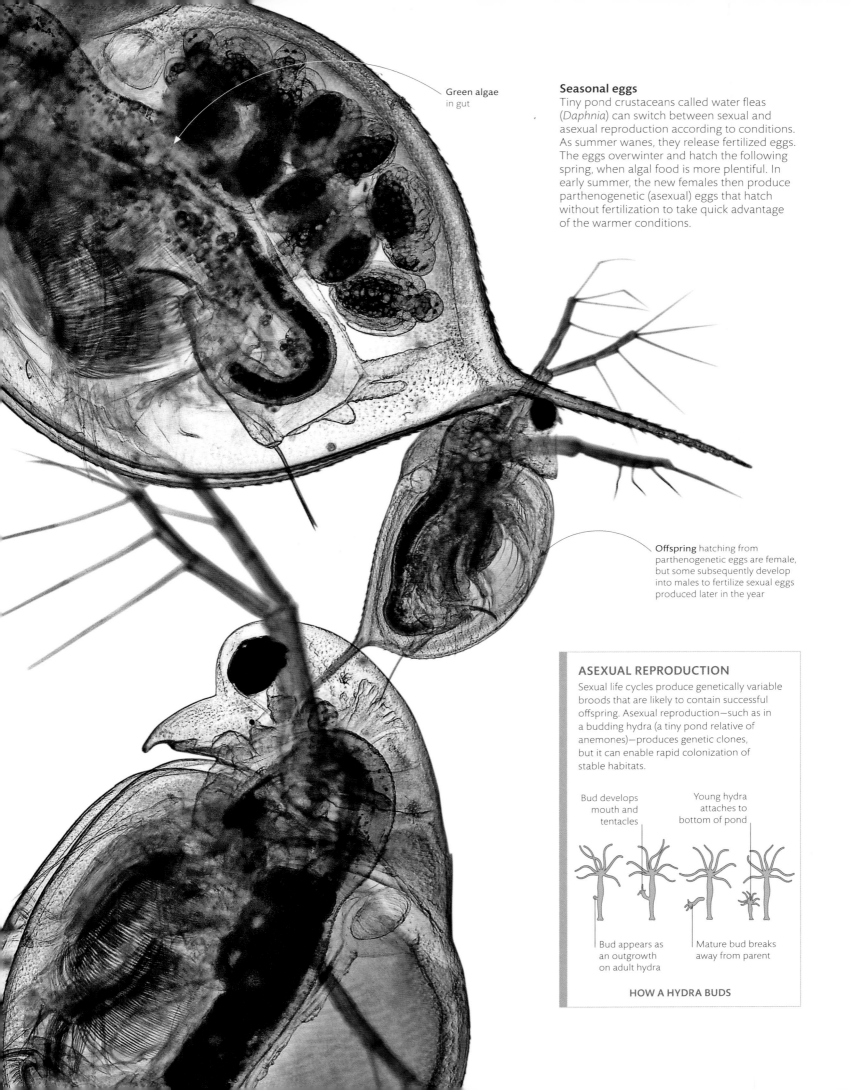

Green algae
in gut

Seasonal eggs
Tiny pond crustaceans called water fleas
(*Daphnia*) can switch between sexual and
asexual reproduction according to conditions.
As summer wanes, they release fertilized eggs.
The eggs overwinter and hatch the following
spring, when algal food is more plentiful. In
early summer, the new females then produce
parthenogenetic (asexual) eggs that hatch
without fertilization to take quick advantage
of the warmer conditions.

Offspring hatching from
parthenogenetic eggs are female,
but some subsequently develop
into males to fertilize sexual eggs
produced later in the year

ASEXUAL REPRODUCTION

Sexual life cycles produce genetically variable
broods that are likely to contain successful
offspring. Asexual reproduction—such as in
a budding hydra (a tiny pond relative of
anemones)—produces genetic clones,
but it can enable rapid colonization of
stable habitats.

Bud develops
mouth and
tentacles

Young hydra
attaches to
bottom of pond

Bud appears as
an outgrowth
on adult hydra

Mature bud breaks
away from parent

HOW A HYDRA BUDS

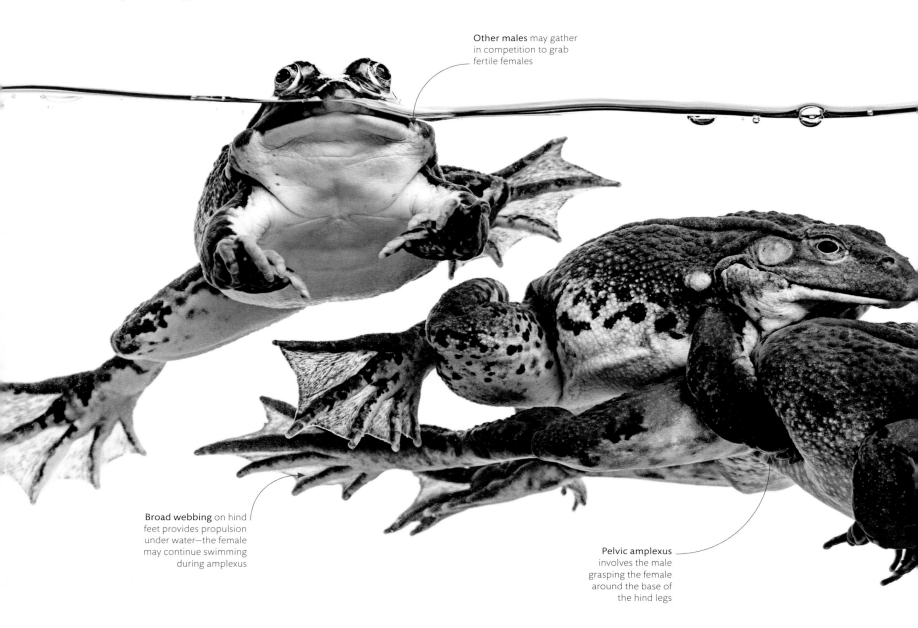

Spawning frogs
Almost all amphibians fertilize their eggs externally, and the majority of frogs maximize their chances of success by a behavior called amplexus. The male grasps the female, usually from behind, to bring their reproductive openings close together. Sperm and eggs are then released simultaneously.

Other males may gather in competition to grab fertile females

Broad webbing on hind feet provides propulsion under water—the female may continue swimming during amplexus

Pelvic amplexus involves the male grasping the female around the base of the hind legs

fertilization

In sexual reproduction, genetic variety is created when DNA from different individuals mixes as a sperm fertilizes an egg. Animals employ a variety of ways to ensure that this happens as effectively as possible: many that spawn (release eggs and sperm) in water simply produce as many sex cells as possible to increase the chance of sperm meeting egg; in other animals, females retain fewer eggs inside the body and the act of copulation achieves fertilization internally.

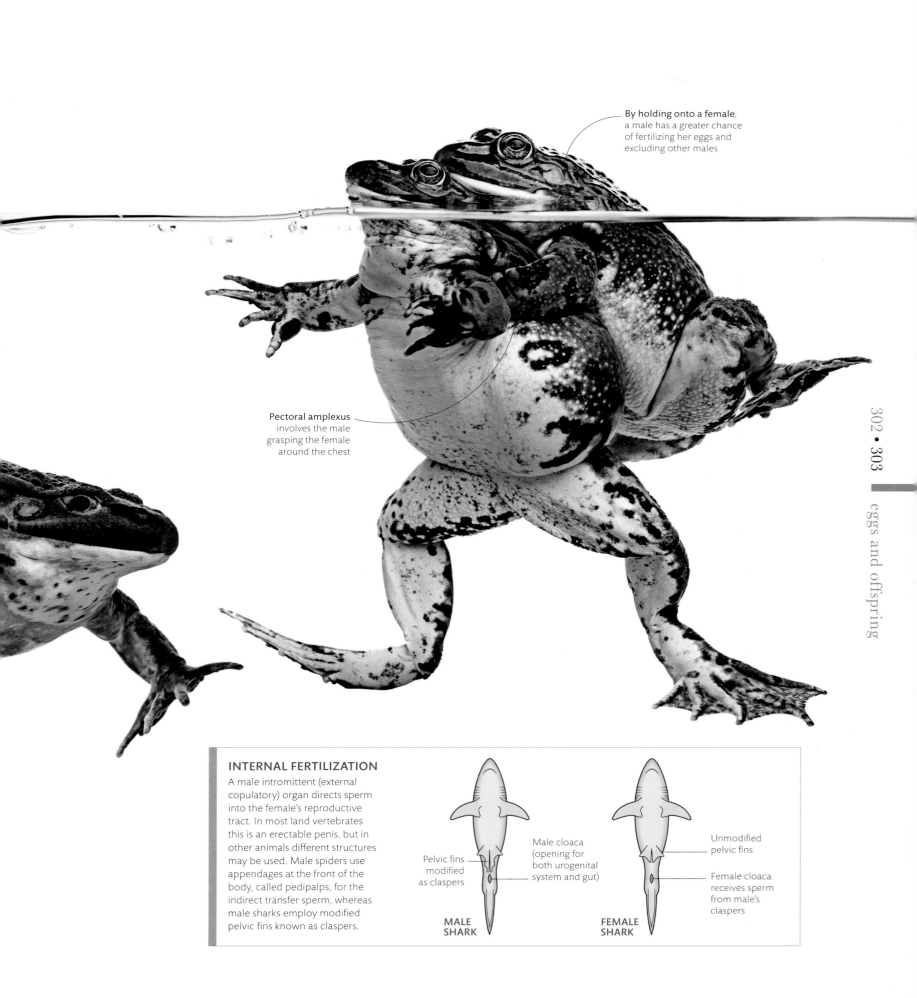

By holding onto a female, a male has a greater chance of fertilizing her eggs and excluding other males

Pectoral amplexus involves the male grasping the female around the chest

INTERNAL FERTILIZATION

A male intromittent (external copulatory) organ directs sperm into the female's reproductive tract. In most land vertebrates this is an erectable penis, but in other animals different structures may be used. Male spiders use appendages at the front of the body, called pedipalps, for the indirect transfer sperm, whereas male sharks employ modified pelvic fins known as claspers.

Pelvic fins modified as claspers

Male cloaca (opening for both urogenital system and gut)

MALE SHARK

Unmodified pelvic fins

Female cloaca receives sperm from male's claspers

FEMALE SHARK

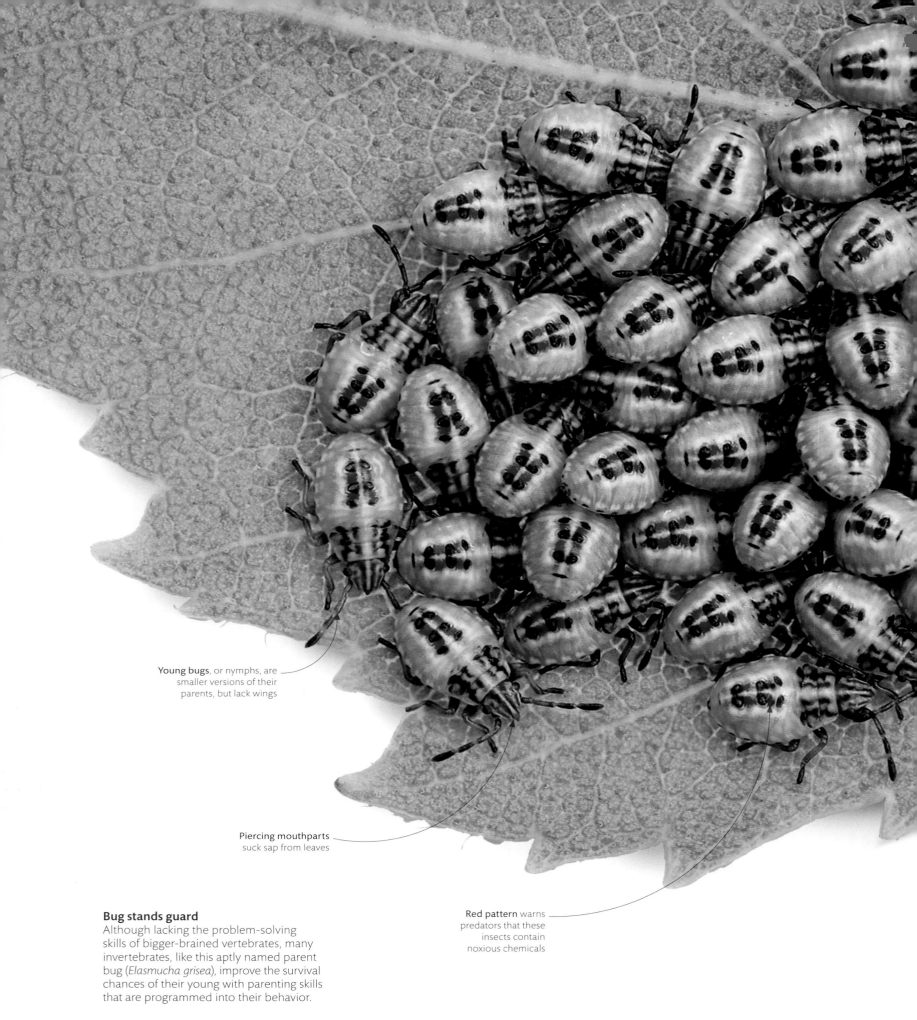

Young bugs, or nymphs, are smaller versions of their parents, but lack wings

Piercing mouthparts
suck sap from leaves

Bug stands guard
Although lacking the problem-solving skills of bigger-brained vertebrates, many invertebrates, like this aptly named parent bug (*Elasmucha grisea*), improve the survival chances of their young with parenting skills that are programmed into their behavior.

Red pattern warns predators that these insects contain noxious chemicals

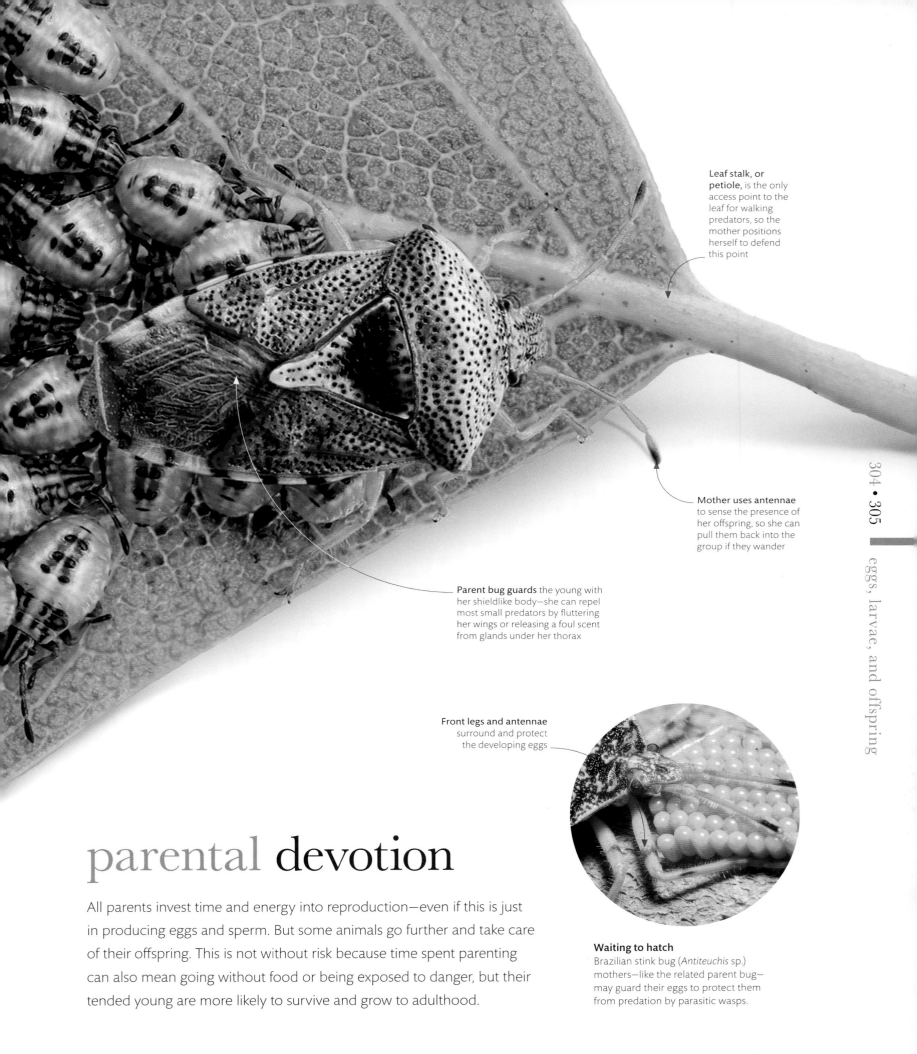

Leaf stalk, or petiole, is the only access point to the leaf for walking predators, so the mother positions herself to defend this point

Mother uses antennae to sense the presence of her offspring, so she can pull them back into the group if they wander

Parent bug guards the young with her shieldlike body—she can repel most small predators by fluttering her wings or releasing a foul scent from glands under her thorax

Front legs and antennae surround and protect the developing eggs

Waiting to hatch
Brazilian stink bug (*Antiteuchis* sp.) mothers—like the related parent bug—may guard their eggs to protect them from predation by parasitic wasps.

parental devotion

All parents invest time and energy into reproduction—even if this is just in producing eggs and sperm. But some animals go further and take care of their offspring. This is not without risk because time spent parenting can also mean going without food or being exposed to danger, but their tended young are more likely to survive and grow to adulthood.

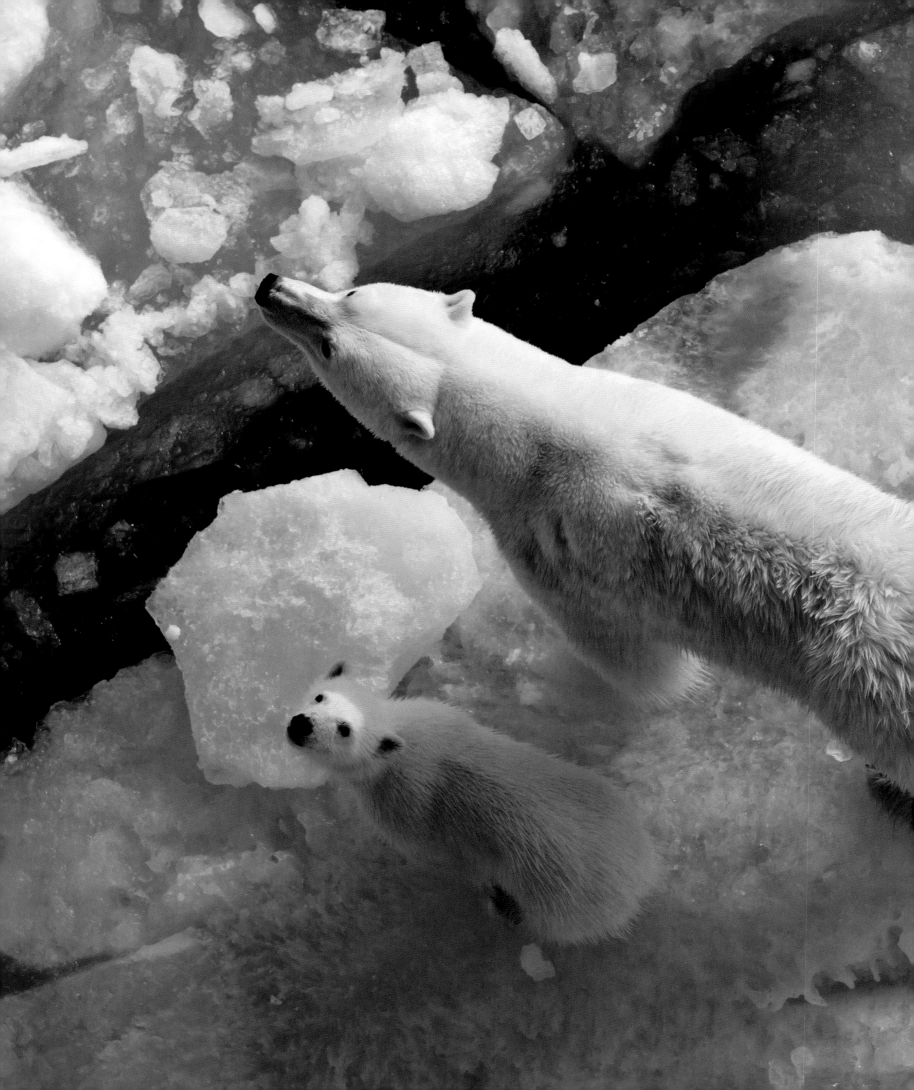

Twin cubs
Three-month-old cubs shelter in their maternity den. With sufficient food, the mother bear may successfully raise both of them, but it will be more than a year before they are independent.

spotlight species

polar bear

The polar bear (*Ursus maritimus*) is the top predator in the frozen Arctic, where temperatures can dip below -58°F (-50°C), but the species is highly vulnerable in a modern age of global warming. To survive the winter, the cubs rely on a devoted mother, a maternity den, and plenty of calorific milk.

Polar bears are the largest of the bear species. Genetic evidence suggests it took just 200,000 years for them to evolve from their brown bear ancestors into bigger, whiter, more carnivorous animals, better attuned to the Arctic seasons. Fattened by gorging on fat-rich seals all summer, polar bears can generate more body heat. Their thick coat of translucent hairs, left hollow by lost pigment, traps extra warm air near the skin. This exceptional insulation is critical as most polar bears stay active even in the coldest months—it is only the pregnant females that hibernate in winter.

Summer mating triggers ovulation, but as in other bears, the fertilized eggs do not implant in the womb until fall, by which time the polar bear has settled down for the winter in a snow cave or underground peat bank that will serve as a maternity den. The tiny cubs—typically two, each scarcely bigger than a guinea pig—are born between November and January and do not emerge from the den until the harshest months are over.

The mother suckles her cubs with milk enriched with seal fat from the previous summer, but while they feed, she fasts. When the family emerges in spring, she may not have eaten for 8 months, so must refuel on seal meat. As the ice retreats under the summer sun, polar bears hunt closer to shore or migrate north. But each year rising temperatures shrink the icy platforms they depend on, so these bears face an uncertain future.

Survival on the ice
Fractured floating sea ice is the best hunting ground for a polar bear and her cub as, beneath their feet, is a good supply of food in the form of seal meat. The mother can ambush seals as they surface for air in the gaps in the ice.

shelled eggs

The first backboned animals evolved on land more than 350 million years ago, but many remained tied to moist habitats because they laid soft eggs that dehydrated in air and that typically hatched into swimming larvae. Reptiles and birds escaped this restriction by producing hard-shelled eggs. Inside, the embryo is nurtured in a pool of fluid until it is ready to hatch into a miniature version of its air-breathing parents.

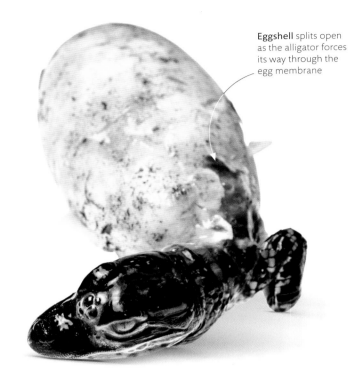

Eggshell splits open as the alligator forces its way through the egg membrane

Hatching out
After two months of incubation, warmed by the heat from a nest of decomposing vegetation, an American alligator (*Alligator mississippiensis*) is ready to hatch. Yelping while still inside the egg alerts the waiting mother, who will be ready to carry her newborn in her mouth from the nest to the water.

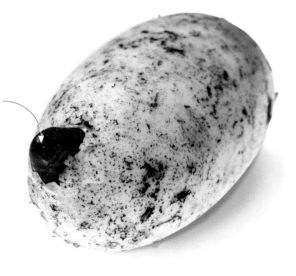

An egg-tooth (a horny patch of skin at the front of the upper jaw) is used to pierce the egg membrane under the shell

LIFE INSIDE THE EGG
A series of membrane-bound sacs provide the embryo's life-support system: an amnion that cushions its body, a yolk sac that supplies nourishment, and an allantois that absorbs oxygen seeping into the egg and stores waste.

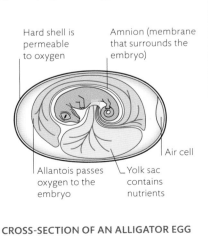

Hard shell is permeable to oxygen

Amnion (membrane that surrounds the embryo)

Air cell

Allantois passes oxygen to the embryo

Yolk sac contains nutrients

CROSS-SECTION OF AN ALLIGATOR EGG

Newly-hatched alligator can be up to 8 in (20 cm) long

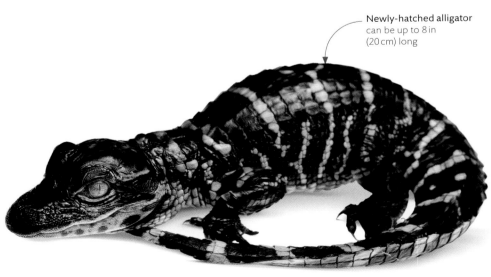

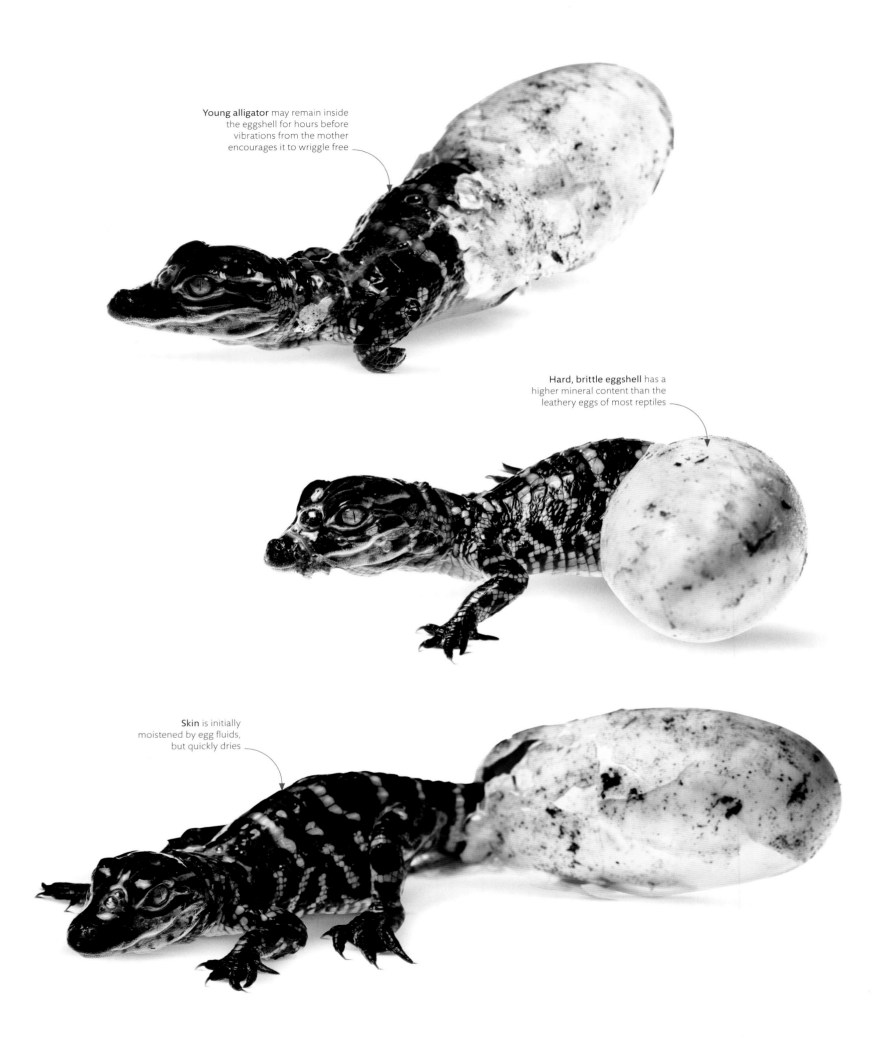

Young alligator may remain inside the eggshell for hours before vibrations from the mother encourages it to wriggle free

Hard, brittle eggshell has a higher mineral content than the leathery eggs of most reptiles

Skin is initially moistened by egg fluids, but quickly dries

bird eggs

Whatever their size or shape, birds' eggs consist of a membrane-covered embryo protected by an outer shell of calcium carbonate. The variety in eggshell colors, which may conceal the egg from predators, derives from just two pigments: protoporphyrin (reddish brown) and biliverdin (bluish green).

White eggs

Birds that lay eggs in nests hidden out of sight—in cavities such as tree holes or burrows, or in bowl-shaped nests—often lay white or pale eggs.

Tiny egg is plain because it is hidden in a cup-shaped nest

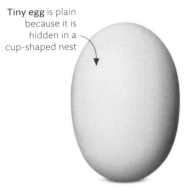

RUFOUS HUMMINGBIRD
Selasphorus rufus

Glossy white egg laid in nest burrow

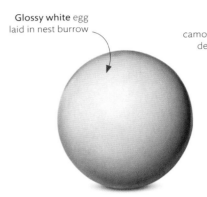

COMMON KINGFISHER
Alcedo atthis

Elliptical egg lacks camouflage since it is laid deep within tree trunk

BLACK WOODPECKER
Dryocopus martius

Blue and green eggs

Tree- or shrub-nesting birds tend to lay blue or green eggs. The color may act as a sunscreen, while the pattern often reflects the nest material, providing camouflage.

Plain blue and slightly glossy

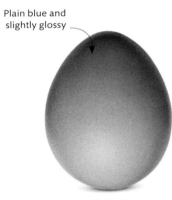

DUNNOCK
Prunella modularis

Blue with white speckles

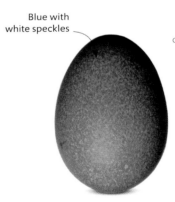

GREEN WOOD-HOOPOE
Phoeniculus purpureus

White layer flakes off during incubation, creating marbled pattern

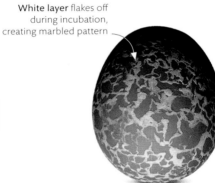

GUIRA CUCKOO
Guira guira

Earth-colored eggs

Birds that nest on the ground rely on camouflage protecting their eggs. Plain brown or speckled eggs are hard to see in sandy, scrubby, or rocky habitats.

Light brown and glossy

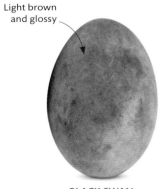

BLACK SWAN
Cygnus atratus

Reddish brown with darker blotches

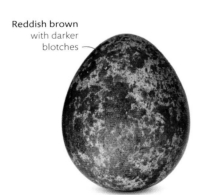

PEREGRINE FALCON
Falco peregrinus

Brown speckles blend into ground-nesting sites

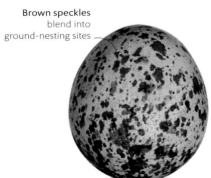

WOOD WARBLER
Phylloscopus sibilatrix

Dull white and oval-shaped

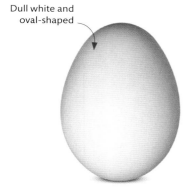

BARN OWL
Tyto alba

Sparsely dappled and round

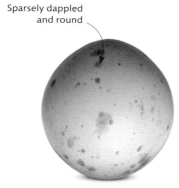

MASKED FINFOOT
Heliopais personatus

Reddish-brown speckles may mimic nesting site colors

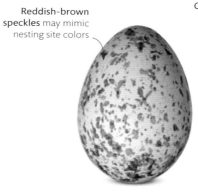

GREAT TIT
Parus major

Conical shape might help prevent egg from rolling off the cliff-ledge nesting site

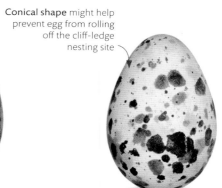

BLACK GUILLEMOT
Cepphus grylle

Blue color caused by biliverdin deposited during laying

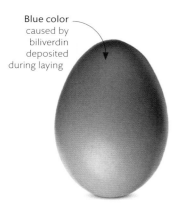

AMERICAN ROBIN
Turdus migratorius

Blotched pattern

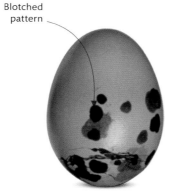

PLAIN PRINIA
Prinia inornata

Glossy, speckled, and oval-shaped

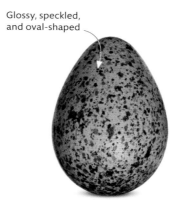

LARGE-BILLED CROW
Corvus macrorhynchos

Markings and color blend in with nest-site materials

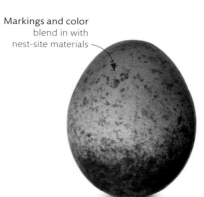

ANDEAN SPARROW
Zonotrichia capensis

Brown color mimics rock-ledge nesting sites

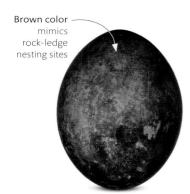

EGYPTIAN VULTURE
Neophron percnopterus

Color and shape blend in with beach pebbles

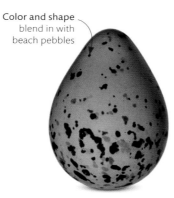

RINGED PLOVER
Charadrius hiaticula

Pebble shape disguises egg in coastal habitat

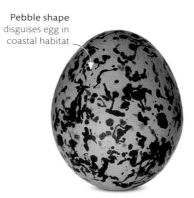

OYSTERCATCHER
Haematopus ostralegus

Almost black color—fresh eggs are green

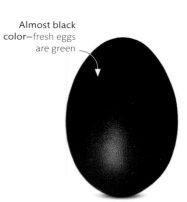

EMU
Dromaius novaehollandiae

NOURISHED IN THE WOMB

A placenta is an organ that develops in the mother's womb lining and passes nutrients and oxygen from her bloodstream into her embryo, enabling it to grow.

This explains why the newborn of a placental mammal, such as a monkey, is much larger and more developed than that of a marsupial.

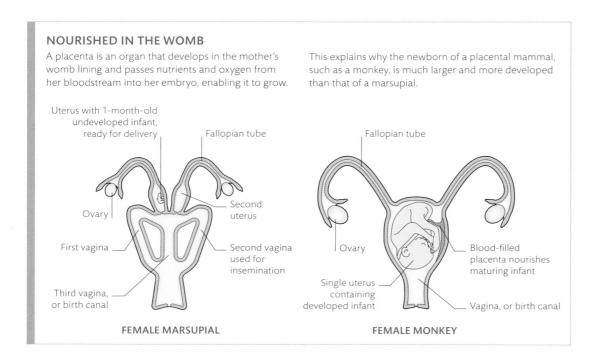

Uterus with 1-month-old undeveloped infant, ready for delivery

Fallopian tube

Ovary

Second uterus

First vagina

Second vagina used for insemination

Third vagina, or birth canal

FEMALE MARSUPIAL

Fallopian tube

Ovary

Blood-filled placenta nourishes maturing infant

Single uterus containing developed infant

Vagina, or birth canal

FEMALE MONKEY

marsupial pouches

In most mammals, the unborn infant is nourished inside the mother's womb by a blood-filled organ called a placenta over a prolonged pregnancy. But in marsupials, the reproductive strategy is different; the pregnancy is short and the newborn completes most of its development outside the mother's body. Her pouch provides a warm shelter, and as with other mammals, the mother's milk is the baby's lifeline.

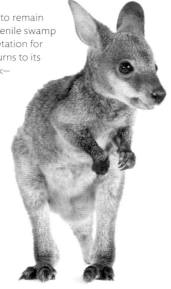

Out of pocket
At 8 months, too big to remain in the pouch, this juvenile swamp wallaby hides in vegetation for protection. It still returns to its mother to suckle milk—something that it will continue to do for another 6 months.

Pouched protection
This infant swamp wallaby (*Wallabia bicolor*) spends around 8 months in its mother's pouch. During this time, a new embryo may already be developing—ready to take possession of the pouch when it is its turn.

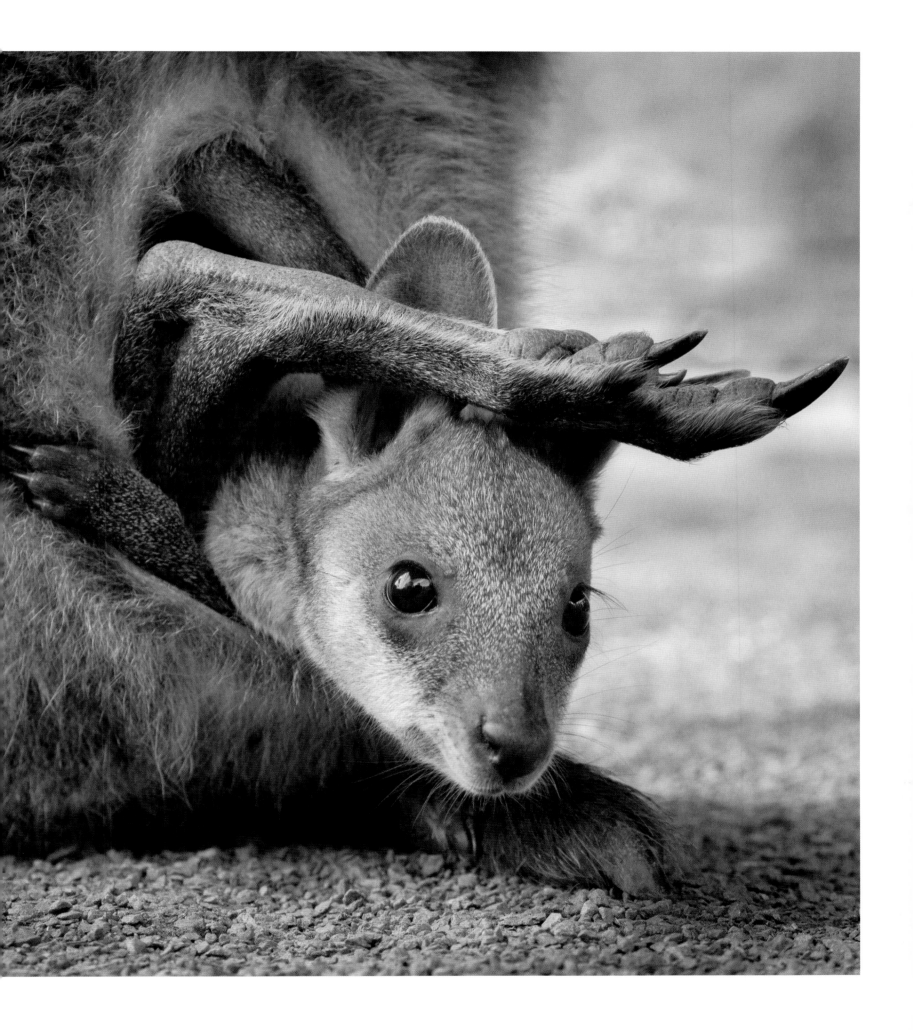

Colorful transformation

Caterpillars are vulnerable to predators as they develop into butterflies within the protective casing of the chrysalis. In tropical Asia, this tawny coster butterfly (*Acraea terpsicore*) is safeguarded by the poison it obtains from the caterpillar's food plant. All the stages advertise this fact with their striking warning colors.

Caterpillar attaches its rear end to underside of a leaf by silken threads just before transformation

After metamorphosis the butterfly secretes an enzyme to soften the outer wall so the chrysalis starts to split

Hardened casing of the chrysalis is revealed

Caterpillar has reached its maximum size and is ready to shed skin for final time

Butterfly struggles out of the chrysalis, aided by its new long, jointed legs

Butterfly antennae are revealed for the first time

METAMORPHOSIS

In growing larvae—whether caterpillars or the maggots of flies—hormones trigger growth spurts. When they reach maximum larval size, the juvenile-controlling hormone disappears, triggering a complete metamorphosis into adult form. During these final stages, adult body parts develop from clusters of cells in the larva, known as imaginal discs.

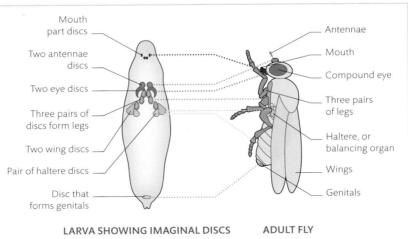

Mouth part discs

Two antennae discs

Two eye discs

Three pairs of discs form legs

Two wing discs

Pair of haltere discs

Disc that forms genitals

Antennae

Mouth

Compound eye

Three pairs of legs

Haltere, or balancing organ

Wings

Genitals

LARVA SHOWING IMAGINAL DISCS ADULT FLY

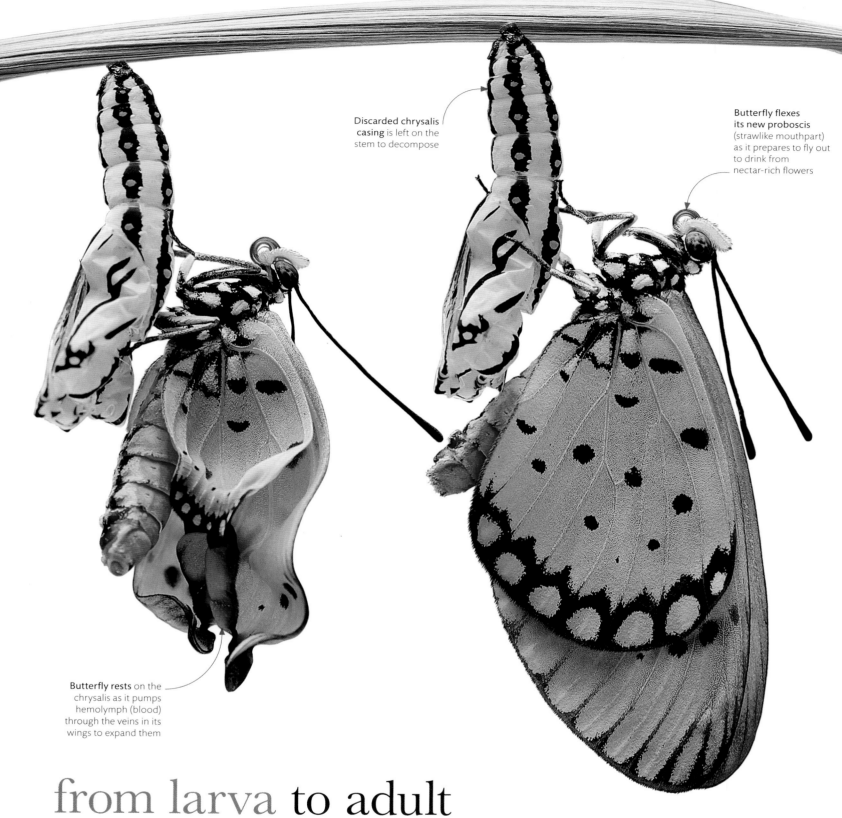

Discarded chrysalis casing is left on the stem to decompose

Butterfly flexes its new proboscis (strawlike mouthpart) as it prepares to fly out to drink from nectar-rich flowers

Butterfly rests on the chrysalis as it pumps hemolymph (blood) through the veins in its wings to expand them

from larva to adult

All animals change as they develop from juveniles into sexually mature adults, but in insects the transformation can be dramatic. For some, for example cockroaches and grasshoppers, the young are small, flightless versions of adults, but in others, such as the butterfly, metamorphosis from a caterpillar involves a complete overhaul of body structure.

amphibian
metamorphosis

When animals develop by metamorphosis, their juvenile and adult forms can use different habitats and resources in contrasting ways. In frogs this means that swimming, underwater larvae transform into adults that can walk on dry land. It is a process that involves replacing fins with legs and gills with lungs for breathing in air. Their entire behavior—from how they move around to what they can eat—changes as much as their shape-shifting bodies.

Fully aquatic tadpole
The larva, or tadpole, of a common European frog (*Rana temporaria*) is adapted for life in water. More than half its length is a muscular tail, while gills—protected inside a swollen chamber—extract oxygen from the water. Horn-rimmed jaws are used first for grazing on algae, and in older tadpoles, for attacking animal prey.

Blocks of muscle, like those of a fish, contract to move tail from side to side

Broad tail fin pushes through water to provide propulsion

Gradual shape-shifting
Metamorphosis depends on the hormone thyroxine—the same one that speeds metabolism and controls growth in humans. In the common frog, this hormone triggers the genes that launch remodeling—making its limbs grow and tail shrink. The speed at which this transformation takes place depends on temperature, food, and oxygen—but by summertime most of the tadpoles that hatched in spring have become froglets.

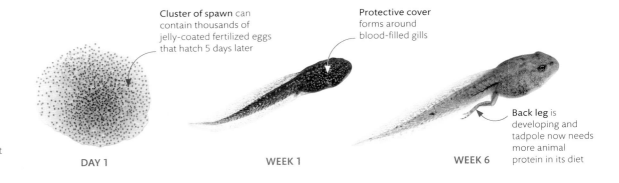

Cluster of spawn can contain thousands of jelly-coated fertilized eggs that hatch 5 days later

Protective cover forms around blood-filled gills

Back leg is developing and tadpole now needs more animal protein in its diet

DAY 1

WEEK 1

WEEK 6

PARENTAL CARE

Most amphibians leave the fate of eggs and larvae to chance, but the parents of some species take greater care of their brood. A few protect their young inside their vocal sacs, while others carry them on their backs. In Surinam toads (*Pipa* sp.), the newly fertilized eggs roll onto the mother's back during mating, where they then sink and become embedded in her skin, forming small pockets. Depending on species, they then hatch either as swimming tadpoles or, with some, as tiny toadlets. The mother then slowly sheds the thin layer of skin that was used to birth them.

SURINAM TOADLETS HATCHING FROM A FEMALE'S BACK

The male cross frog (*Oreophryne*) holds on to its eggs, guarding them until the froglets hatch

Metamorphosing within the egg
Many amphibian species complete their development inside eggs. This allows them to lay their eggs out of water in places that stay moist, such as the floor of tropical rain forests.

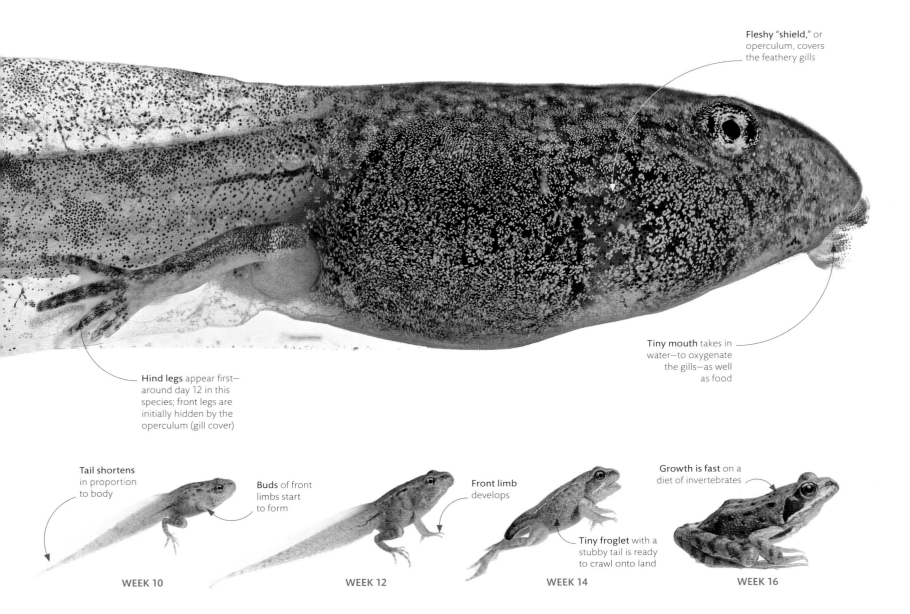

Fleshy "shield," or operculum, covers the feathery gills

Tiny mouth takes in water—to oxygenate the gills—as well as food

Hind legs appear first—around day 12 in this species; front legs are initially hidden by the operculum (gill cover)

Tail shortens in proportion to body

Buds of front limbs start to form

Front limb develops

Tiny froglet with a stubby tail is ready to crawl onto land

Growth is fast on a diet of invertebrates

WEEK 10

WEEK 12

WEEK 14

WEEK 16

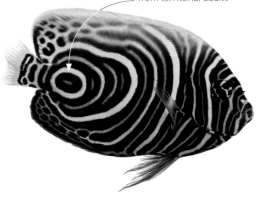

Dark blue coloring and
white circles help protect
young emperor angelfish
from territorial adults

JUVENILE EMPEROR ANGELFISH

reaching maturity

It takes time for animals to develop to a stage where they can reproduce
for themselves. Their sex organs must mature before they can show others,
by appearance or behavior, that they can produce eggs or sperm and are
ready for a mate. An individual's sex is genetic and preprogrammed in
some animals, such as mammals and birds, and in others is determined by
an environmental trigger, such as temperature. But a few animals, such as
the emperor angelfish (*Pomacanthus imperator*), even switch sex at maturity.

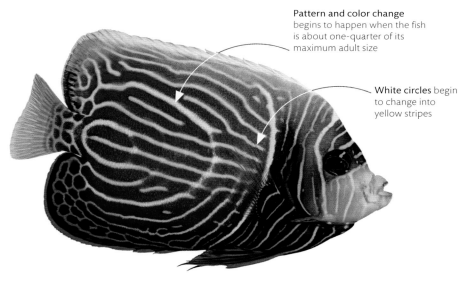

Pattern and color change
begins to happen when the fish
is about one-quarter of its
maximum adult size

White circles begin
to change into
yellow stripes

Patterns of growth
The difference between emperor
angelfish of different ages is striking;
the tiny, white-ringed juveniles could
be mistaken for a different species from
the large, yellow-striped adults.

SUBADULT EMPEROR ANGELFISH

Yellow stripes signify that
the emperor angelfish has
reached sexual maturity

Dark, masklike band
hides eyes, which
may help to confuse
predators

Circles to stripes
In many coral reef fish, reaching maturity
involves undergoing a shift of color and
pattern. This may be so juveniles are not seen
as competitors by adults, so are tolerated on
a busy coral reef. Adult emperor angelfish can
also change sex, from female to male. This
may occur when the dominant male dies and
another fish seizes the chance to replace him.

MATURE EMPEROR ANGELFISH

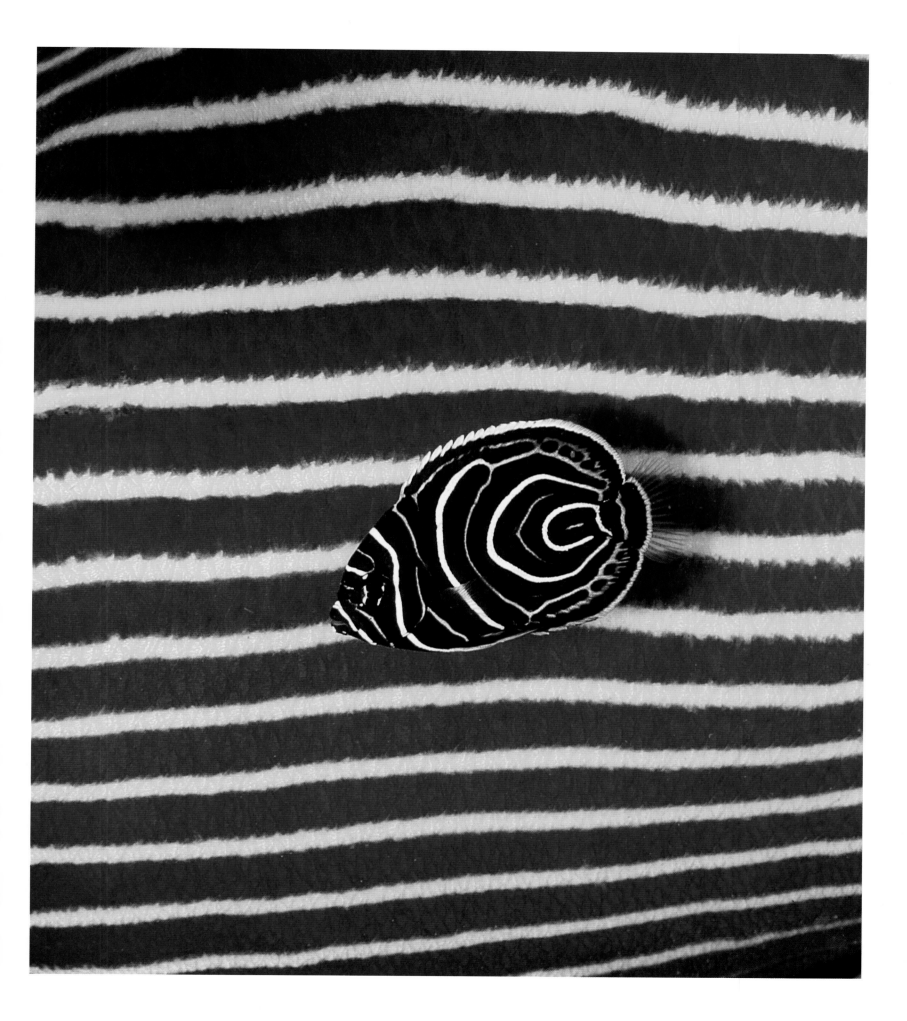

classification

classification. the arrangement
of animals into a series of ever more
narrowly defined groups based on shared
characteristics that they have inherited
from the same ancestor.

classifying animals

Modern classification of animals has its roots in 18th-Century science—and, in particular, with a landmark edition of *Systema Naturae*, published in 1758 by the Swedish naturalist Carl Linnaeus. He devized a hierarchical system for classifying all the kinds of animals known to science, as well as inventing a two-part Latinized name for each species. Linnaean classification and his binomial nomenclature are still used by zoologists today—in a modernized format, in which groups reflect evolutionary relationships.

CLASSIFYING A GECKO
The crested gecko, like any animal, is identified first as a species, in this case *Correlophus ciliatus*, then grouped with other close relatives into a genus. Genera are grouped into families, families into orders, and so on. A series of ever-larger groups forms a hierarchy of taxonomic levels.

phylum
Animals are divided into over 30 groups called phyla. One of these, the phylum Chordata, unites animals with a supporting rod—in most cases, a backbone.

class
Modern members of the class Reptilia include lizards, snakes, turtles, and crocodilians—as well as many extinct forms, such as dinosaurs.

order
The order Squamata is one of the most species-rich orders of modern vertebrates. It includes lizards and legless descendants, such as snakes.

family
Geckos are included in several families of lizards—mostly without eyelids. The crested gecko belongs to the Pacific family Diplodactylidae.

genus (pl. genera)
The genus is the first part of an animal's two-part scientific name. *Correlophus* belongs, in this case, to three closely related gecko species all living on the Pacific island of New Caledonia.

species
A species, such as *Correlophus ciliatus*, is traditionally a group of individuals that can interbreed to produce viable offspring.

A species named
Since the time of Linnaeus, every recognized animal species is named in its own published description. This specimen of a crested gecko belongs to a species described and named *Correlophus ciliatus* by the French zoologist Alphone Guichenot in 1866.

Row of spinelike scales along each side of back distinguishes this species from other *Correlophus*

CRESTED GECKO
Correlophus ciliatus

Vintage classification
In *The Genera Vermium of Linnaeus* of 1788, the English naturalist James Barbut illustrated animals united as "Testacea" (animals with shells) by Linnaeus. But modern evolutionary zoology places them in disparate groups, according to relatedness. Barnacles (top right) are arthropods: more closely related to crabs and shrimp than they are to scallops, clams, and other mollusks (bottom).

Animals inhabiting Multivalve, and Bivalve Shells.

Tab.13

Publish'd Aug.ᵗ 7.1788 by J. Barbut, Nº 46 Great Titchfield Street, Cavendish Square.

sponges

PHYLUM: Porifera **KINGDOM:** Animalia

Sponges are the simplest multicelled animals alive today. They live anchored to one spot in marine or freshwater environments. Although they contain various types of cells, they have no organs or specialized tissues like other animals. Many large and colorful species live on coral reefs. The simplest sponges are small and shaped like a hollow vase: they take in water through small pores in their sides and eject it through a larger aperture at the top called the osculum, while sieving out food particles. The current is created by thousands of cells with tiny beating hairs, or flagella (see pp. 12, 30). Most sponges have a more complicated arrangement of chambers and internal channels, but the principle is the same. Sponges' bodies are supported and stiffened in various ways. The calcareous sponges have tiny skeletal units called spicules made of calcium carbonate embedded within their body substance. In glass sponges, the spicules are made of silica, and demosponges are supported by a fibrous protein called spongin, as in the traditional bath sponge. Spicules come in many shapes and aid in identification.

Sponge body structure
These illustrations from 1892 show the anatomy of *Halichondria fallax* (figs. 1–5) and *Spheciospongia vesparium* (fig. 10), and schematic diagrams of *Euplectella*, *Semperella*, and *Hyalonema* (figs. 6–9).

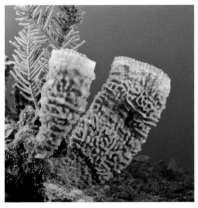

Azure vase sponge
Callyspongia plicifera

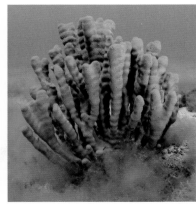

Lake Baikal sponge
Lubomirskia baicalensis

Bluish encrusting sponge
Phorbas tenacior

jellyfish, corals, and sea anemones

PHYLUM: Cnidaria **KINGDOM:** Animalia

These animals, together called cnidarians, are basically a bowl of tissue with a single opening typically surrounded by stinging tentacles. The bowl can be upright, as in sea anemones and corals, or upside down, as in jellyfish. The body has radial symmetry like the symmetry of a star. Between the outer and inner body surface is a jellylike substance. Unlike sponges, cnidarians have muscles and nerves, although there is no brain or head. Most are predators and sting prey using tiny harpoons called nematocysts, fired by specialized cells. Many cnidarians alternate their life cycles between an anchored form called a polyp and a swimming form, the medusa. In jellyfish, the medusa is the adult. Sea anemones and corals do not have a medusa. Coral polyps are similar to sea anemones, but, like many other cnidarians, they are colonial and grow into large structures of linked individuals. Corals create skeletons, either hard and made of calcium carbonate, or more flexible. They often get food from algae embedded in their bodies. Other colonial cnidarians include sea fans, sea pens, and the jellyfish-like siphonophores, such as the Portuguese man o' war.

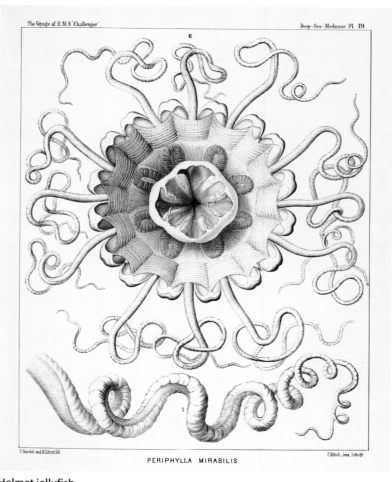

Helmet jellyfish
This bottom view of a deep-sea jellyfish, *Periphylla*, is from the *Report of the Scientific Results of the Exploring Voyage of H.M.S. Challenger during the years 1873–76*—the results of a pioneering oceanographc expedition.

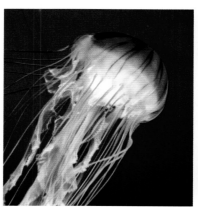

Jellyfish
Chrysaora melanaster

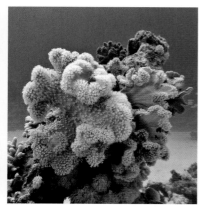

Soft coral
Sarcophyton sp.

Snakelocks anemone
Anemonia viridis

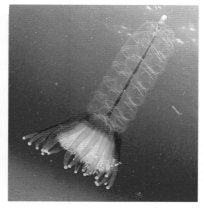

Siphonophore
Physophora hydrostatica

comb jellies

PHYLUM: Ctenophora **KINGDOM:** Animalia

Comb jellies are transparent marine animals that
mainly live in open water. Although they look rather
like jellyfish, they are not closely related. They are often
round or oval, but some species are long and straplike.
They have eight bands running down the outside of their
bodies, which bear comblike rows of beating hairs, or
cilia, that they use to swim—ctenophore literally means
"comb-bearer." Comb jellies are predators, generally of
small animals—mostly plankton—but some large-
mouthed species eat other comb jellies. Most species have
two large, branched, retractable tentacles. These do not
have stinging cells, but can stick onto prey to capture
it. Many species are bioluminescent, meaning that
they can produce their own light.

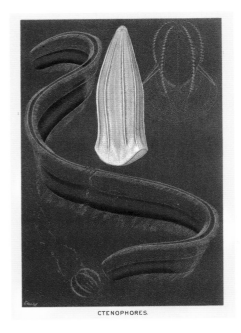

Cigar comb jelly
This illustration shows a cigar
comb jelly (*Beroe* sp., centre).
Some species can stretch their
stomachs to consume prey
almost half their own size.

flatworms

PHYLUM: Platyhelminthes **KINGDOM:** Animalia

Flatworms are found in the sea, freshwater, or damp
places on land, or some live as parasites. Unlike cnidarians
and ctenophores, they are bilaterally symmetrical—they
have a left and right side, a head and a tail—and have a
brain, eyes, and other organs. Flatworms crawl along
surfaces using muscle action or tiny beating hairs (cilia).
Their flat shape means they can get enough oxygen from
water without needing gills. Free-living flatworms have
a tubelike mouth on their underside and are mostly
carnivores. Species on coral reefs are often brightly
colored. Some species prey on sea squirts or coral. Flukes
and tapeworms are parasitic flatworms that can cause
serious diseases. Flukes live in body tissues, and adult
tapeworms in the gut of vertebrates.

Broad tapeworm
This engraving shows
Diphyllobothrium latum. It
can grow up to 9 m (30 ft)
in length and is one of the
largest tapeworms that
can infect humans.

segmented worms

PHYLUM: Annelida **KINGDOM:** Animalia

Segmented worms, or annelids, include earthworms, leeches, and marine worms, such as ragworms and fanworms. Their bodies are in segments, often visible as rings on the surface. They lack hard skeletons but keep their shape through a combination of muscle action and internal pressure. In evolutionary terms, the oldest are the marine polychaetes, meaning "many bristles." These come in many shapes, and the sides of many bear bristly leglike flaps called parapodia. Most live on the ocean floor, although some are swimmers. Some types are not worm-shaped—the sea mouse is rounded, for instance. Polychaetes include active predators such as ragworms, which have tough jaws; mud-eating lugworms; and many worms that create permanent tubes they never leave. Worms in this last group have tentacles or fans that they spread to obtain food particles from sea water or mud.

Oligochaetes, meaning "few bristles," is the group that contains earthworms and smaller water-living relatives. It also includes leeches, which have suckers at both ends, which aid movement. Most are bloodsuckers, although some are predators.

King ragworm
This illustration of the marine polychaete *Alitta virens* is from William MacIntosh's *A Monograph of the British Marine Annelids,* published in 1873.

Golden bristle worm
Chloeia flava

Tiger leech
Haemadipsa sp.

Common earthworm
Lumbricus terrestris

Feather duster worm
Sabellidae sp.

chitons

CLASS: Polyplacophora **PHYLUM:** Mollusca

Chitons are shelled marine animals with flattened bodies that live on rock surfaces and graze algae, crawling along using an adhesive, muscular "foot" that covers their underside. They are primitive members of the phylum Mollusca, which also includes snails, clams, octopuses, and squid. Chitons show many features of the hypothetical ancestral mollusk: a clinging foot; a rasping, tonguelike structure called a radula that scrapes food; a fleshy mantle covering the animal's upper surface, overlapping the body underneath; and a chalky shell that the mantle secretes. Early mollusks probably only had one shell, but chitons have eight, positioned in a line from front to back. The shells overlap and allow chitons to bend, and curl up into a ball if disturbed. They are surrounded by the mantle— called a girdle in chitons—the upper surface of which is often colored or hairy-looking. Chitons are most common in shallow waters. The largest species can reach 1ft (30 cm) long, but most are much smaller. They have pairs of gills underneath the mantle on both sides. Like most other mollusks, their eggs hatch into tiny swimming larvae called trochophores, which mature into the adult form.

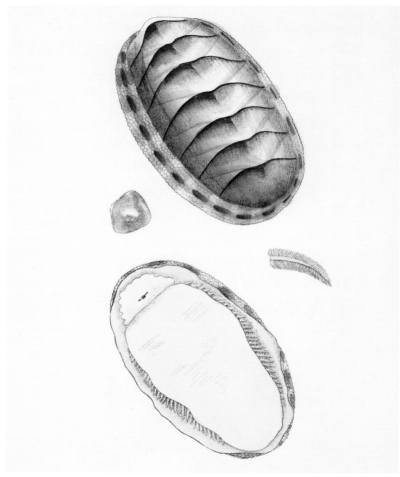

Scaly chiton
This copperplate engraving of *Chiton squamosus* is from George Shaw and Frederick Nodder's *The Naturalist's Miscellany,* published in 1796.

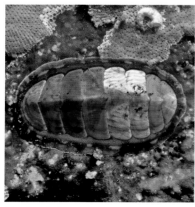

Blue lined chiton
Tonicella undocaerulea

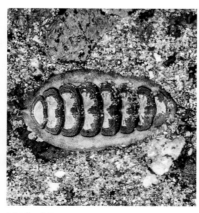

Hind's chiton
Mopalia hindsii

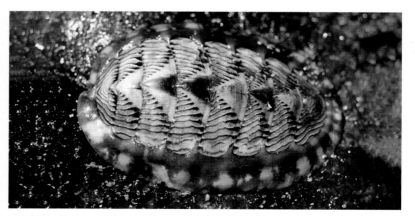

Lined chiton
Tonicella lineata

slugs and snails

CLASS: Gastropoda PHYLUM: Mollusca

Snails and slugs are the largest class of mollusks and include sea, freshwater, and land types. They have a definite head, usually equipped with eyes and tentacles, and most species crawl along, much like chitons do. Their upper body becomes twisted during development so that their internal anatomy is asymmetrical. Most have a spiral-shaped shell that they can pull their bodies back into for protection. Some, for example limpets and cowries, have other shell shapes. Many have a horny "door" called an operculum that seals the opening to their shells when they retreat inside. Advanced sea snails, such as whelks and cone shells, have their radula—a tonguelike structure—at the end of a proboscis, sometimes shaped as a venom-tipped harpoon. These snails are carnivores, and some can drill through other shells, such as mussel shells. Slugs are gastropods that have lost their shells: they are not all closely related. Land slugs breathe air, as do land snails. Sea slugs are predators, often brightly colored to advertise that they are poisonous or venomous. Other shell-less gastropods called sea butterflies can swim using finlike mantle projections.

True harp
This watercolor by J. Hayes is from *Mollusca and Radiata of India, c.1820*. It shows a harp snail, *Harpa harpa*, which occurs in the Red Sea, Indian Ocean, and Western Pacific.

Flamingo tongue snail
Cyphoma gibbosum

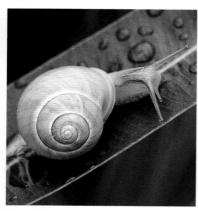

Brown-lipped snail
Cepaea nemoralis

Great pond snail
Lymnaea stagnalis

Red slug
Arion ater rufus

bivalves

CLASS: Bivalvia **PHYLUM:** Mollusca

Bivalves are water-living mollusks, such as clams, oysters, mussels, and scallops, with shells that are in the form of two halves hinged together. Anatomically, the shell halves or "valves" represent the left and right side of the body. The hinge is the dorsal (back) surface, and the foot is not used for crawling, but is often tongue-shaped and used to burrow. Strong muscles clamp the valves shut for protection against predators or drying out. Bivalves have no obvious head and a small brain. About one-third of species live in freshwater. Bivalves are mainly sedentary animals that live attached to hard surfaces or buried in sand or mud. They have large, flattened gills under their shells, which are used for filtering and sorting the food particles they live on. Burrowing species have a pair of retractable tubes called siphons, which they stick out into the water. One siphon sucks in water and food particles, while the other expels water and waste. Shipworms are long-bodied bivalves that burrow into submerged wood for protection, while similar species bore into stone. The largest bivalve, the giant clam, lives on coral reefs and feeds largely on algae living in its tissues.

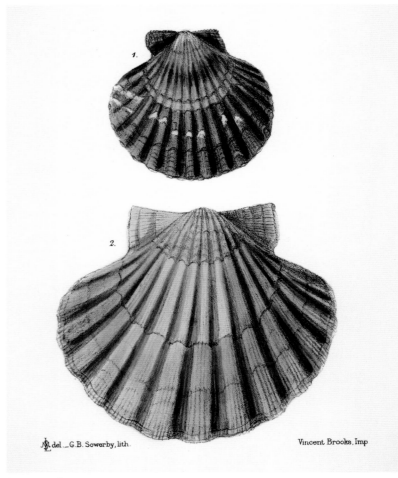

M del _G.B. Sowerby, lith. Vincent Brooks, Imp

Queen scallop
This illustration shows the shell of *Aequipecten opercularis*. Like all scallops, this species filter feeds on plankton. It occurs from the North Sea to the Mediterranean.

Sydney rock oysters
Saccostrea glomerata

Blue mussels
Mytilus edulis

Giant clam
Tridacna gigas

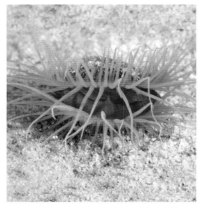

Common file clam
Lima vulgaris

squids and octopuses

CLASS: Cephalopoda **PHYLUM:** Mollusca

Squids and octopuses, or cephalopods, are intelligent, predatory marine mollusks in which the original molluscan foot has evolved into the front of the body, equipped with grasping arms. Cephalopod literally means "head–foot." The most primitive living type, the nautilus, has an external snail-like shell and many suckerless arms. Other cephalopods either have eight arms and two long tentacles, all with suckers (squid and cuttlefish) or eight arms and no tentacles (octopuses). Squid are fast-moving hunters in the open sea, equipped with fins and a form of jet propulsion, in which seawater is forced rapidly out of a tube called a siphon, propelling the animal in the opposite direction. Octopuses are slower, most species clambering around on the seafloor, but they also have a jet-propulsion ability. Cephalopods have hard beaks, which they use to tear food, and large eyes with good color vision. They can change skin color rapidly for camouflage or signaling purposes. Squid and cuttlefish have an internal rodlike shell, but octopuses lack this. Cephalopod eggs hatch into miniature adults, rather than larvae like other mollusks.

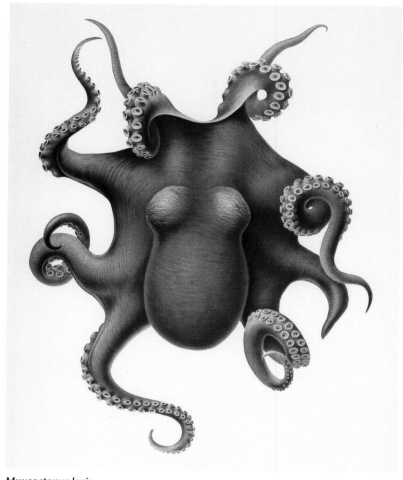

Muusoctopus levis
This illustration is from *Die Cephalopoden* by marine biologist Carl Chun. It was published in 1915 following his deep-sea expedition on the *Valdivia*, 1898–99.

Pharaoh cuttlefish
Sepia pharaonis

Caribbean reef squid
Sepioteuthis sepioidea

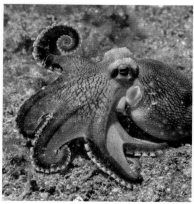

Coconut octopus
Amphioctopus marginatus

Nautilus
Nautilus pompilius

velvet worms

PHYLUM: Onychophora **KINGDOM:** Animalia

Velvet worms are caterpillar-like predators that live in damp forests. They are relatives of the arthropods (jointed legged animals, including insects, spiders, and crustaceans). Like arthropods, the body of velvet worms is divided into segments, they molt their skins, and they have an open blood system where the internal organs are bathed in a blood-filled cavity. They also have a pair of antennae on their heads. Unlike arthropods, however, their many legs are stubby and lack joints, and they have no tough exoskeleton outside their soft skin. Velvet worms are nocturnal and can only live in damp places because they dry out easily. They feed on other invertebrates, sometimes as large as themselves, using a sticky slime that they squirt at their prey to immobilize them.

Peripatopsis capensis
Native to South Africa, *Peripatopsis capensis* belongs to the Peripatopsidae family, which is circumaustral in distribution. Species also occur in Australia and Chile.

horseshoe crabs

CLASS: Merostomata **SUBPHYLUM:** Chelicerata **PHYLUM:** Arthropoda

Horseshoe crabs are not crabs but an ancient group of marine animals more closely related to spiders. The front of their body is protected by a strong horseshoe-shaped shield called a carapace, and they have a long, movable spine to the rear, which they use to turn themselves upright when necessary. They also have primitive compound eyes—eyes made up of many facets—a feature shared by most arthropods. They have five pairs of legs that they use for walking. Horseshoe crabs live on the seafloor and eat a wide range of food, both taking live prey and scavenging dead fish. In the breeding season they congregate by the shoreline in large groups to mate. Afterward, the females bury their eggs in the sand to hatch.

Atlantic horseshoe crab
The only extant species native to the Americas, *Limulus polyphemus* favours estuaries, lagoons, and mangroves, especially in breeding season.

arachnids

CLASS: Arachnida **SUBPHYLUM** : Chelicerata **PHYLUM**: Arthropoda

Arachnids are the group of air-breathing arthropods that includes spiders, scorpions, mites, and ticks, as well as lesser-known groups including whip-spiders and sunspiders. They usually have four pairs of legs and a body in two parts: a combined head and leg-bearing region—called the cephalothorax—and an abdomen. Unlike most arthropods, they lack antennae.

Spiders and scorpions are predators, the latter are mainly active at night. Scorpions use the sting in their tails to subdue prey, whereas spiders inject paralyzing venom through their fangs. Spiders' ability to make silk is put to many uses: not only for constructing webs, but for lining burrows, tying down prey, making cocoons to protect their eggs, and—especially in young spiders—creating a long gossamer thread that catches the wind and transports them long distances. Not all spiders spin webs: many are active hunters or ambush predators.

Mites and ticks form a very large group of small or microscopic animals. Many, including the ticks, live off larger animals, feeding from their skin or sucking blood. Others eat plants or dead material, or hunt other mites.

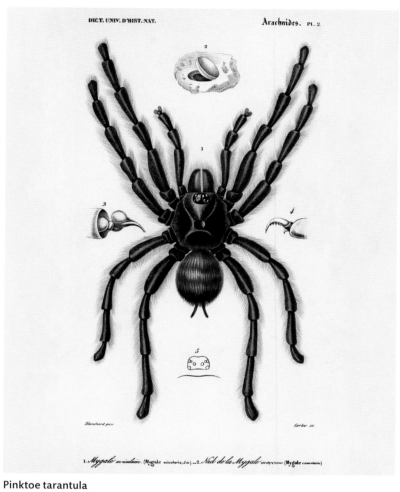

Pinktoe tarantula
Also called the Guyana pinktoe, *Avicularia avicularia* can grow up to 6 in (15 cm) long. Juveniles have paler bodies and dark feet but the coloration reverses as they mature.

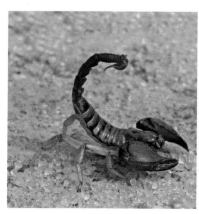

Robust burrowing scorpion
Opistophthalmus carinatus

Red velvet mite
Trombidium sp.

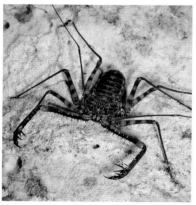

Whip-spider
Damon variegatus

Egyptian giant solifugid—a sunspider
Galeodes granti

sea spiders

CLASS: Pycnogonida **SUBPHYLUM:** Chelicerata **PHYLUM:** Arthropoda

Sea spiders are found in seafloor habitats throughout the oceans. Their main body is tiny compared with their legs, and body systems such as the digestive system compensate by extending into the legs. Their feeding appendages, or chelifores, may be related to the "chelicerae" mouthparts of spiders and other arachnids, so they are placed with the arachnids in the subphylum Chelicerata. Sea spiders are usually small, but leg spans of up to 30 in (75 cm) have been measured in the largest species. Most species have four pairs of walking legs, but some have five or six. They are carnivores that feed on nonmoving animals such as sponges and corals. Their mouthparts include the clawlike chelifores and a slightly mobile, tubular proboscis that sucks up food.

Ammothea carolinensis
The sea spider *Ammothea carolinensis* has a brown to dull-reddish body and has three triangular tubercles, or protuberances, on its back.

centipedes and millipedes

SUPERCLASS: Myriapoda **SUBPHYLUM:** Mandibulata **PHYLUM:** Arthropoda

Myriapods are many-legged land arthropods with segmented bodies and include centipedes, millipedes, and some smaller groups. Centipedes are predators, attacking their prey using venom-delivering claws behind their heads. They are mainly nocturnal and usually flattened in shape. In one family, the scutigerids, the legs are very long. The largest species can catch and eat small reptiles, mammals, and birds. Millipedes usually live among leaf litter or fallen logs. They eat mainly dead or living vegetable material, although some are predators. There are two pairs of legs per body segment, unlike the single pair in centipedes. Millipedes can be cylindrical or flattened; members of one short-bodied family resemble woodlice and can curl up in a ball for protection.

Amazonian giant centipede
This illustration of *Scolopendra gigantea* is from *The Naturalist's Miscellany* by George Shaw and Frederick Nodder, published in 1789.

crustaceans

SUPERCLASS: Crustacea **SUBPHYLUM:** Mandibulata **PHYLUM:** Arthropoda

Crustaceans are a diverse group of invertebrates that includes crabs, lobsters, shrimps, and many smaller animals. They are the dominant arthropods in the sea, and there are also many freshwater and some land-dwelling species. They eat a wide range of food, both animal and vegetable, living and dead. All crustaceans have an external skeleton, or exoskeleton. Once they take adult form, they can grow only by molting their exoskeleton and replacing it. Crustaceans typically have a number of pairs of appendages specialized for different uses, such as seizing prey, swimming, walking, holding eggs, or obtaining oxygen. Swimming crustaceans include small planktonic forms, such as copepods, krill, shrimps—a word used for several different groups—and the larvae of bottom-dwelling species. All of these are important elements in the marine food chain. Benthic, or bottom-dwelling, types include lobsters, true crabs, hermit crabs, and mantis shrimps. Among the most specialized species are the barnacles. Some live cemented to rocks protected by chalky shells, but others are parasitic and have given up shells and exoskeleton.

European lobster
Also called the common lobster, *Homarus gammarus* can grow up to 24 in (60 cm) long. Its large claws are unequal in size and are used for crushing and cutting prey.

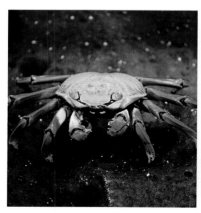

Sally Lightfoot crab
Grapsus grapsus

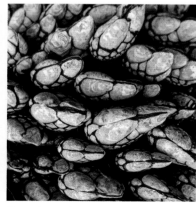

Goose barnacles
Order Penduculata

Calanoid copepod
Eudiaptomus gracilis

Dancing, or camel, shrimp
Rhynchocinetes durbanensis

springtails

CLASS: Collembola **SUPERCLASS:** Hexapoda **PHYLUM:** Arthropoda

Springtails are small, wingless, six-legged arthropods that live mainly in or around damp soil, where they can be very common. They were once considered insects, which also have six legs, but are now classified separately because of anatomical differences, including having enclosed mouthparts and an abdomen with fewer segments. Some springtails have elongated bodies, while others are almost globular. Their most distinctive feature, after which they are named, is a forked structure called a furcula that is held against their underside by a catch. When a predator threatens, the catch is released, the furcula is forced down on to the ground with great speed, and the animal springs tumbling into the air, landing at random some distance away.

Globular springtail
This illustration of a globular springtail, with visible furcula, is from Félix-Edouard Guérin-Méneville's *Dictionnaire Pittoresque d'Histoire Naturelle et des Phénomènes de la Nature* (1833–39).

silverfish

ORDER: Zygentoma **CLASS:** Insecta **SUPERCLASS:** Hexapoda **PHYLUM:** Arthropoda

Silverfish and their relatives are scavengers that live in damp habitats on the ground and in human habitations. Although wingless, they are true insects, with a body divided into a head, a thorax—bearing three pairs of legs—and an abdomen. Like other insects, they have compound eyes and breathe using holes down their sides called spiracles, which lead to air-filled tubes (tracheae) that branch throughout their bodies. They continue to molt their skins when adult, unlike other insects. The silverfish itself has a flattened, streamlined body covered with shiny scales and has three long tail filaments. It lives in buildings worldwide, feeding off sugars and starches, and sometimes damages wallpaper and also books—by eating the glue in the binding.

Lepisma saccharina
This species is up to 1 in (25 mm) long. As its common name suggests, it is silver-gray in color and fishlike in motion. The filaments at the rear of the abdomen are called cerci.

mayflies

ORDER: Ephemeroptera **CLASS:** Insecta **SUPERCLASS:** Hexapoda **PHYLUM:** Arthropoda

Mayflies are flying insects, the young stages (nymphs) of which live in freshwater and breathe using gills. They are considered a primitive group because they cannot fold their wings flat over their bodies: instead, they are held vertically behind the body at rest. Their hindwings are much smaller than their forewings, and are completely absent in some species. Mayflies are weak fliers and the adults do not feed, living only long enough to mate and lay eggs—which in some species is just a few hours. Adults and nymphs typically have three long "tails," known as cerci, at the end of their body. Mayfly nymphs feed by collecting or scraping off small food particles under water. Nymphs can molt their skins up to 40 or 50 times—far more than other insects.

Autumn dun mayfly
This copperplate engraving is by entomologist John Curtis and shows *Ecdyonurus dispar*. It is from his *British Entomology*, published in 1834.

dragonflies and damselflies

ORDER: Odonata **CLASS:** Insecta **SUPERCLASS:** Hexapoda **PHYLUM:** Arthropoda

Dragonflies are robust, long-bodied, predatory insects whose nymphs grow up underwater. Adults have large eyes and excellent flight skills, catching insect prey in the air or snatching it off the ground using their forward-pointing legs. Some species patrol actively, whereas others perch on vegetation until prey flies by. Males often defend territories from other males. Some species migrate long distances. The freshwater nymphs are also predatory, and have a hinged structure under their heads called a mask that they shoot out to catch prey, including small fish. Their relatives, the damselflies, have more delicate bodies and are weaker fliers, but have otherwise similar lifestyles. They fold their often colorful wings behind their backs at rest, like mayflies.

Azure hawker
One of the smaller hawker dragonflies, *Aeshna caerulea* is about 2.4 in (62 mm) long. Compared to this male, females are duller blue or brownish.

earwigs

ORDER: Dermaptera **CLASS:** Insecta **SUPERCLASS:** Hexapoda **PHYLUM:** Arthropoda

Earwigs are nocturnal insects with flattened bodies and brownish coloration. They have pincerlike forceps at their tail end—more curved in the male—which are used for defense and by the male during mating. Earwigs eat a wide range of food: dead material, plants (including flower petals), and smaller insects. By day, they hide in dark crevices. Like the other insect groups described on these two pages, the young look like the adults—there is no larval or pupal stage—and the growing wings are visible on the outside. The forewings are short, tough covers protecting the folded hindwings underneath, but many earwigs are wingless or rarely fly. They show maternal care, with the females protecting their eggs and feeding the newly hatched young.

Hop-garden earwig
This short-winged earwig, *Apterygida media*, has a brownish body and yellow legs. It is found in woodland scrub, and hedges in southeast England.

classification

grasshoppers, crickets, and katydids

ORDER: Orthoptera **CLASS:** Insecta **SUPERCLASS:** Hexapoda **PHYLUM:** Arthropoda

These insects are easily recognized by their large hind legs, which allow their owners to jump. They share a common ability to produce sound by "stridulation"—rubbing parts of their body against each other, the sound varying between species. True grasshoppers, including locusts, have short antennae, and many specialize in eating grass. Apart from locusts, most species do not fly far, generally using their wings to prolong their jumps. Hindwings may be brightly colored to startle predators. Katydids, also called bush crickets, have long antennae and may eat insects as well as plants. True crickets have long antennae and wider, flatter bodies than other orthopterans. Mole crickets have spadelike front legs, which they use to dig underground.

THE BOMBAY LOCUST.

Bombay locust
Native to India and southern Asia, *Patanga succincta* changes color as it matures. Young adults are pale brown, then turn a pale red, and lastly dark brown.

stick insects and leaf insects

ORDER: Phasmatodea **CLASS:** Insecta **SUPERCLASS:** Hexapoda **PHYLUM:** Arthropoda

Stick insects and leaf insects, also called phasmids, are a mainly tropical group of plant-eaters, and include the longest insect in the world—*Phryganistria chinensis*, which measures up to 24½ in (62.4 cm) long. Phasmids are mainly nocturnal and keep still among vegetation by day, aided by their amazing camouflage. Some leaf insects look exactly like fallen leaves, complete with apparently decaying and "nibbled" regions. Some species are wingless, but others can startle predators by exposing their brightly colored hindwings. Some also have defensive spines on their legs. There are many species where females can produce eggs that hatch without fertilization by males. Phasmids' eggs are usually dropped onto the ground and may take months to hatch.

Indian stick insect
Carausius morosus, or the Indian stick insect, is a species familiar worldwide as a pet. The females breed asexually (without fertilization) and no male has ever been discovered.

mantids

ORDER: Mantodea **CLASS:** Insecta **SUPERCLASS:** Hexapoda **PHYLUM:** Arthropoda

Mantids are long-bodied predatory insects, which catch their prey using highly modified, spiny front legs that they keep folded ready to pounce. It is from this very distinctive posture that one species gained the common name, the praying mantis. Nearly all are ambush predators that wait for prey to come close. Their eyes are far apart on their triangular head, and their neck is mobile, allowing them to locate and judge the distance of prey with great accuracy. They eat other insects of all kinds, and the larger species also eat small vertebrates. Males sometimes fly at night to seek females, when there is less danger from bird predators. Most species are green or brown for camouflage, but the flower mantises imitate flowers such as orchids, and may be bright pink.

Praying mantis
At up to 3 ½ in (9 cm) long, the female European mantis, *Mantis religiosa*, is larger than the male and may cannibalize her partner after, or even during, copulation.

cockroaches

ORDER: Blattodea **CLASS:** Insecta **SUPERCLASS:** Hexapoda **PHYLUM:** Arthropoda

Cockroaches are insects with long antennae, flattened bodies, and chewing mouthparts. Often large and usually nocturnal, they originate in warmer regions of the world and eat a wide variety of foods. The best known are the brown-colored pest species found worldwide. These fast-running animals flourish in the warmth of buildings, where they congregate in large numbers and taint food, even the air, with an unpleasant odor. There are also thousands of harmless wild species that live in concealed habitats such as leaf litter or decaying wood. Some are fully winged, even though they seldom fly, with tough forewings that protect the delicate hindwings underneath. In other species, only the males are winged, or both sexes are wingless.

German cockroach
A small, pest species, typically ½–⅔ in (1.1–1.6 cm) long, this cockroach, *Blattella germanica*, can barely fly, but may glide if disturbed.

termites

ORDER: Blattodea **CLASS:** Insecta **SUPERCLASS:** Hexapoda **PHYLUM:** Arthropoda

Like ants (see p.343), termites live in large colonies, but with important differences in organization. They are not related to ants; instead, they evolved from wood-eating cockroaches, and some species can seriously damage wooden buildings. Unlike ants, which are often their enemies, termites are not predators. They have specialized bacteria and protozoans in their gut that help them digest plant fibers. Their nests may be in trees, underground, or in huge rock-hard mounds built by the white, wingless worker termites and protected by large-jawed soldiers. Only reproducing individuals have wings, which they tear off after mating. The large queen termite lays eggs for the colony for many years; unlike in ant colonies, she lives with a "king" who fertilizes her eggs.

Harvester termites
Harvester termites (*Macrohodotermes* sp.) live in the deserts of southern Africa. As in most termites, their colonies consist of specialist castes of individuals with radically different sizes and shapes.

true bugs

ORDER: Hemiptera **CLASS:** Insecta **SUPERCLASS:** Hexapoda **PHYLUM:** Arthropoda

Although many insects are loosely called "bugs," to an insect specialist a bug is a member of the Hemiptera, a diverse order that includes shieldbugs, leafhoppers, bedbugs, cicadas, and aphids, as well as water-living species such as pond skaters and backswimmers. These insects have mouthparts in the form of a long sucking tube, the rostrum, equipped with piercing "stylets". Their food is most commonly plant sap, although assassin bugs suck the body fluids of animal prey. The rostrum is folded under the body when not in use.

Aphids and their relatives, including whiteflies and scale insects, are notorious pests of cultivated plants. The females often reproduce without the need for males (parthenogenesis), which allows them to multiply rapidly.

Double drummer
Now known as *Thopha saccata*, this is the largest cicada species in Australia, and one of the loudest insects worldwide. The male amplifies his call with saclike pockets ("drums") in his abdomen.

lacewings and relatives

ORDER: Neuroptera **CLASS:** Insecta **SUPERCLASS:** Hexapoda **PHYLUM:** Arthropoda

The order Neuroptera is one of the oldest groups of endopterygotes—insects whose wings develop out of sight within their growing larvae (see pp.314–15). (The "big four" insect orders on pages 342–43 are all also endopterygotes.) Their larvae usually look quite different from the adults and enter a pupal stage within which the adult body is formed. Lacewings themselves have delicate, netlike wings, which they hold over their slender bodies when at rest. Their predatory larvae have biting, grooved jaws through which they suck up the juices of their prey—commonly aphids. Larvae of the antlion family hide in pits with only their jaws showing, catching any insects that fall in. The adults of another family, the mantispids, look and feed like small mantises.

Lacewing
From entomologist Charles Waterhouse's 19th-century book, *Aid to the Identification of Insects*, this illustration depicts the species *Osmylus multiguttatus*.

beetles

ORDER: Coleoptera **CLASS:** Insecta **SUPERCLASS:** Hexapoda **PHYLUM:** Arthropoda

There are more known kinds of beetles than any other animal—an estimated 350,000–400,000 species have been described, from numerous minute species up to the world's heaviest insect, the goliath beetle. It is certain that there are many more yet to be discovered. Their success derives from their strong, compact body plan, featuring hardened forewings, or elytra, that fit snugly over the body and protect the usually functional hindwings underneath.

Beetles, and their larvae, consume a huge range of foodstuffs. Some, including many water beetles, are predatory, and have active long-legged larvae. In other beetle families, the often legless larvae feed on wood, fungi, carrion, dung, and plant leaves or roots.

Atlas beetle
Once named *Scarabaeus atlas*, as in this 1800 illustration, *Chalcosoma atlas* is a huge rhinoceros beetle of south Asia. It can reach 5 in (13 cm) in length.

flies

ORDER: Diptera **CLASS:** Insecta **SUPERCLASS:** Hexapoda **PHYLUM:** Arthropoda

"True flies" make up a diverse order, all of which have only a single pair of wings—the second pair have become club-shaped structures, called halteres, that sense movement and balance. Primitive flies, such as craneflies, have longer bodies and antennae than other flies.

Adult flies eat liquid food, but their mouthparts vary depending on whether they pierce flesh (as mosquitoes do) or sponge up liquids (as do houseflies). Some, such as hoverflies, mimic bees and wasps in appearance.

Fly larvae lack legs, but otherwise vary considerably, from the bristly water-living larvae of mosquitoes to almost featureless maggots. The larvae often feed on decaying plants and animals, but there are also many parasitic species.

Soldier fly
Now called *Odontomyia argentata*, this fly is a member of the soldier flies—one of the families of more "advanced" flies with squat bodies, and short legs and antennae.

butterflies and moths

ORDER: Lepidoptera **CLASS:** Insecta **SUPERCLASS:** Hexapoda **PHYLUM:** Arthropoda

All members of this large order have tiny pigmented scales on their wings that give them their colors (see pp.98, 281). In the lepidopteran family tree, moths occupy the trunk and most of the branches, with butterflies representing one large branch. Moths are mostly noctural. Butterflies are day-flying, usually have club-ended antennae, and couple their fore- and hindwings with a hooklike frenulum. They typically hold their wings vertically above the body at rest. Lepidopteran larvae, or caterpillars, have three pairs of jointed legs and usually five pairs of stubby prolegs. Caterpillars have chewing mouthparts and nearly all eat plants, often specializing in particular species. The adults feed on nectar and other fluids via a long tube called a proboscis.

Soldier butterfly
This 19-century illustration shows three life stages of a soldier butterfly (*Danaus eresimus*): caterpillar, pupa, and the upper and lower sides of an adult.

bees, wasps, ants, and sawflies

ORDER: Hymenoptera **CLASS:** Insecta **SUPERCLASS:** Hexapoda **PHYLUM:** Arthropoda

Insects of this order show very diverse lifestyles. They typically have two pairs of transparent wings, the first larger than the second. They have biting mouthparts, and many bees have long, nectar-drinking tongues. Advanced hymenopterans have a narrow "waist" that gives their body flexibility, and helps the parasitic species aim their hypodermic-like egg-laying organ (ovipositor) into their insect or spider prey. In bees, typical wasps, and some ants, the ovipositor is modified into a sting. Sawflies lack the "wasp waist," and the female's sawlike ovipositor cuts into the plant tissue that the larvae eat.

Ants, and many wasps and bees, live in social colonies headed by a queen, helped by sterile workers who feed and raise the grublike larvae of the next generation.

Plate 3.

Leafcutter ant
The leafcutter (*Atta cephalotes*), seen in this early 19th-century engraving, can cut, process, and carry leaves 20 times its body weight. These ants live in mounds that contain millions of indivuals.

1. Œcodoma cephalotes ♀ major. 3. Stenamma Westwoodii ♀.
2. " " " minor. 4. Solenopsis fugax "

sea lilies and feather stars

CLASS: Crinoidea **PHYLUM:** Echinodermata

Sea lilies and feather stars are marine animals that spread out large, branched arms to trap particles of food. They share many features with other echinoderms such as starfish and sea urchins: their body plan is based on a five-fold symmetry; their skeleton is made up of chalky units in their skin called ossicles; and they have a water-vascular system—a hydraulic system of water-filled tubes that works thousands of tiny, flexible projections (podia) on their arms. Their tiny swimming larvae have a left and right side, like most other animals, before settling down and changing into radially symmetrical adults.

Sea lilies have a stalk attaching them to the seafloor, and are the oldest living echinoderm group. It is thought that starfish and other echinoderms evolved from sea-lily-like ancestors: they broke from their stalks, turned upside down, and their podia (which sea lilies use for feeding) became walking, gripping tube feet.

Feather stars begin their adult life on a stalk but subsquently break free from it. They are common, colorful inhabitants of coral reefs, where they perch on coral and feed in the same way as sea lilies. Feather stars can also swim slowly by beating their arms.

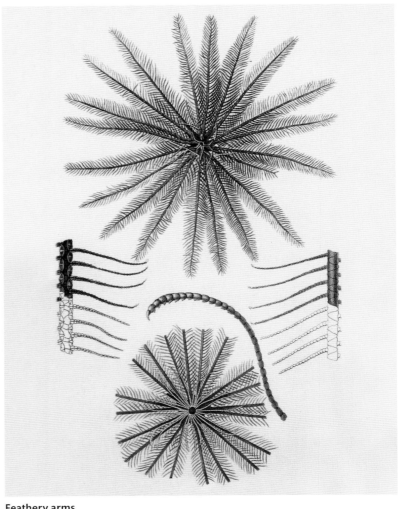

Feathery arms
In most feather stars, the arms are subdivided into branches. The branches themselves are lined with appendages called pinnules, which produce the characteristic feathery appearance.

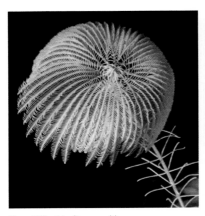

Great West Indian sea lily
Cenocrinus asterius

Longarm feather star
Dichrometra flagellata

Bennet's bushy feather star
Oxycomanthus bennetti

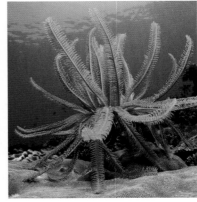

Variable bushy feather star
Comaster schlegelii

starfish

CLASS: Asteroidea **PHYLUM:** Echinodermata

Starfish, or sea stars, are seafloor predators, typically with five arms, although larger species can have up to 50 arms and reach up to 3¼ ft (1 m) in diameter; some, the cushion stars, may lack arms altogether. The mouth, on the underside, can stretch to swallow prey whole. Starfish mainly eat slow-moving or immobile prey, such as mussel shells and coral, and can push their stomachs out of their mouths to start digestion outside their bodies. Thousands of tube-feet on their undersides are used for gripping, walking, and pulling open prey. Some starfish live buried in sand or mud and feed on smaller particles. Like other echinoderms, they have a nervous system but no head or brain, and can move in any direction. If torn into pieces, they can often regenerate from fragments.

Cushion star
The arms of cushion stars are short and stubby, as here, or sometimes absent altogether; the mouth and stomach are on the underside, at the center of the animal.

brittle stars

CLASS: Ophiuroidea **PHYLUM:** Echinodermata

Brittle stars are five-armed sea animals that look rather like starfish, but with important differences. Their arms, which are sharply marked off from the central body, are thin and flexible, and made of ossicles that articulate together, similar to a vertebrate's backbone. Brittle stars live on the seafloor, sometimes in vast numbers. They raise their arms to catch small food particles, sometimes even shrimps or fish, which are passed to their mouth. Brittle stars' tube feet help with food capture but are not used for walking; instead, they move by sweeping their arms. Most brittle stars are small, but some, known as basket stars, can grow to nearly 3¼ ft (1 m) across. Their arms are finely subdivided: some resemble ferns, others look more like the tendrils of climbing plants.

Articulated arms
The individual, articulated ossicles that make up the flexible arms of a brittle star can be seen in this engraving. Brittle stars belong to the class Ophiuroidea: the name comes from the ancient Greek for "snake tails," referring to the arm's serpentlike movement. .

sea urchins

CLASS: Echinoidea **PHYLUM:** Echinodermata

Sea urchins are ball-shaped echinoderms with a rigid skeleton, or test, made of small fused units (ossicles). They graze algae from underwater surfaces, using a complex internal structure called Aristotle's lantern, which operates five teeth in the downward-facing mouth. Their skin is covered with movable spines and sucker-ended tube feet. Spines can be for defense but also for digging and burrowing, sieving food, or even walking in some long-spined species. Heart urchins and sand dollars are more unusual echinoids. Heart urchins have soft spines and burrow in mud, keeping a flow of water over themselves to provide food particles and oxygen. The flat, rigid sand dollars live buried or half-buried in sand and sieve food using their covering of tiny spines.

Long-spine slate pen sea urchin
The primary spines of the long-spine slate pen sea urchin (*Cidaris cidaris*) may extend up to 6 in (16 cm) from the round test, which has a dense covering of short secondary spines.

sea cucumbers

CLASS: Holothuroidea **PHYLUM:** Echinodermata

Sea cucumbers are soft-bodied animals that mainly live on the seafloor, although a few species are swimmers. Anatomically, a sea cucumber is like a sea urchin with a soft body that is stretched vertically and laid on its side. Its internal anatomy is typical of an echinoderm, with organs in sets of five, but unlike others, it has a "head" end and a "tail." Some species occur in large numbers on deep ocean floors, grazing the mud for food particles as they crawl along head-first. Others bury their bodies in mud and hold up tentacles to catch floating food morsels. They eject sticky threads from their back ends to defend themselves. Some species are roughly cucumber-shaped, but others are wormlike or round. Tube feet are often limited to the underside, or they may be entirely lacking.

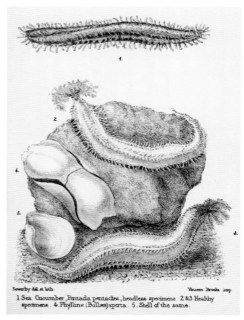

Treelike tentacles
Sea cucumbers have a crown of branched tentacles, shown here in yellow, around their mouth, which they use to collect food particles.

tunicates and lancelets

SUBPHLYA: Tunicata and Cephalochordata PHYLUM: Chordata

Tunicates and lancelets form separate groups within the chordates—the same phylum as vertebrates. Sea squirts are tunicates that mainly live anchored to the seabed and filter food from sea water that they pass through their bodies using "in" and "out" siphons. Their lifestyle resembles that of sponges, but sea squirt anatomy is more complex. They have a tough covering called a tunic, and some species form colonies of merged individuals. Other tunicates, including salps and pyrosomes, float freely in the open ocean and can form chains of linked individuals up to ten feet (several meters) long. Adult tunicates look nothing like vertebrates, but their swimming larvae have some similarities and possess a notochord, like lancelets.

Lancelets are small, fishlike invertebrates that live half-buried in sandy seafloors, where they sieve food from the water. Being chordates, they may help to show what an ancestral prevertebrate chordate looked like. Their body is strengthened by a stiffening rod called a notochord, which appears in vertebrate embryos. When disturbed, lancelets swim away in a fishlike manner by contracting blocks of muscles along their sides.

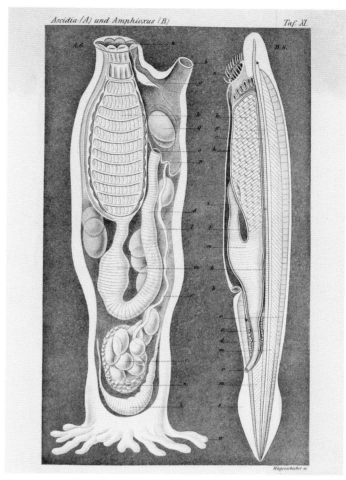

Sea squirt and lancelet anatomy
German biologist and artist Ernst Haeckel made these anatomical drawings of a sea squirt (left, *Ascidia*) and a lancelet (right, *Branchiostoma*, at the time known as *Amphioxus*).

Twin-sailed salp
Thetys vagina

Green barrel, or green reef, sea squirt
Didemnum molle

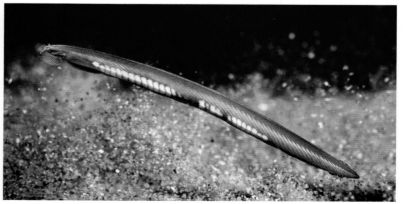

European lancelet
Branchiostoma lanceolatum

hagfish

CLASS: Myxini **SUBPHYLUM:** Vertebrata

Hagfish are jawless fish. Jawless fish of many kinds flourished in the world's oceans before vertebrates with jaws evolved, and hagfish form one of two remaining groups. Hagfish are eel-like in shape but lack fins, having only a small fold of tissue down their backs. They live on the seafloor and feed on various invertebrates, as well as scavenging dead bodies of larger animals such as whales. Hagfish produce large amounts of slime as a defense measure. Their mouth is slitlike with horny teeth inside and surrounded by fleshy, sensory barbels. The eyes are rudimentary. They have a cartilage skull, but they lack a true vertebral column—their body is stiffened instead by a flexible notochord. For that reason, it has been debated whether they are true vertebrates.

Broadgilled hagfish
This hagfish, *Eptatretus cirrhatus,* lives in New Zealand waters at depths of up to 3,000 ft (900 m). It is named after its broad gill slits and bears rows of slime-producing pores down its body.

lampreys

CLASS: Petromyzontida **SUBPHYLUM:** Vertebrata

Like hagfish, lampreys are eel-shaped jawless fish, but otherwise the two groups are not alike. Unlike hagfish, adult lampreys have a true vertebral column, as well as a skeleton of cartilage, large eyes, and dorsal fins. Lampreys live either in freshwater or commute between freshwater and the sea, in the latter case returning to rivers and lakes to breed, after which the adults die. Eggs hatch into larvae called ammocoetes that look nothing like the adults, but live half-buried in the bottoms of rivers, filtering the water for small food particles. Adults either do not feed at all or are parasites of other fish: their round, suckerlike mouths, equipped with horny teeth and a rasping tongue, allow them to burrow into the host's flesh to feed. Some species can grow to over 3¼ ft (1 m) long.

Sea lamprey
The sea lamprey lives in the ocean only as an adult. Its scientific name, *Petromyzon marinus,* means marine rock sucker, although it actually sucks the blood and flesh of fish.

sharks, rays, and chimaeras

CLASS: Chondrichthyes **SUBPHYLUM:** Vertebrata

Fish in this class are called cartilaginous fish, due to their skeleton of cartilage. Unlike most bony fish, they either give birth to live young or lay a small number of large, yolky eggs. Many sharks are large predators, their features including a constantly renewed supply of teeth and scales in the form of sharp "denticles" that give their skin a rough feel. The upper lobe of a shark's tail contains the backbone and is longer than the lower. Although open-ocean sharks have a streamlined shape, there are also flat, bottom-living species. Basking sharks and whale sharks feed on small prey filtered through their large mouths.

Rays have flat bodies featuring enormously enlarged front (pectoral) fins. Most are camouflaged for a seafloor life with the mouth on the underside equipped with platelike teeth that crush shelly prey. Stingrays have a venomous spine on their tail. Some rays including the manta ray filter feed in open water. A few, such as the guitarfish and sawfish, look more like flattened sharks.

The more distantly related chimaeras, also called rabbitfish due to their large heads and eyes and chisel-like teeth, live in deeper water and feed on invertebrates.

Thornback ray
Also known as the thornback skate, *Raja clavata*, this ray's name refers to the spines covering its back and tail. Unlike those of stingrays, none of the spines is venomous.

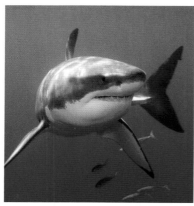

Great white shark
Carcharodon carcharias

Speckled carpetshark
Hemiscyllium freycineti

Leopard, or honeycomb, stingray
Himantura uarnak

Spotted ratfish, a chamaera
Hydrolagus colliei

lobe-finned fish

CLASS: Sarcopterygii **SUBPHYLUM**: Vertebrata

The fossil record tells us that the first four-legged
terrestrial vertebrates evolved from this class of fish
around 400 million years ago. Walking legs evolved from
the fleshy pectoral and pelvic fins, which are muscular
lobes with sturdy bones (fins of all other bony fish, which
belong to the Actinopterygii, are constructed with flimsy
rays of bone). Despite its importance to our evolutionary
history, this class of fish has been roundly out-competed
by its ray-finned cousins. The eight surviving species are
all highly unusual and specialized fish. They include the
lungfishes, which live in seasonal freshwater habitats that
are prone to shrinking and becoming low in dissolved
oxygen. In response, the lungfish gulp air at the surface
to supplement the action of the gills. If the water dries
out completely, some lungfish seal in their moisture with
a thick mucus cocoon and lie dormant in the soil. The
rest of the class comprises the coelacanths, which are
deep-sea fish living in submarine caves and canyons.
The closest living marine relatives to the first terrestrial
tetrapods, the coelacanths were known only in fossils
and thought extinct until 1938, when a specimen
was caught in the Indian Ocean.

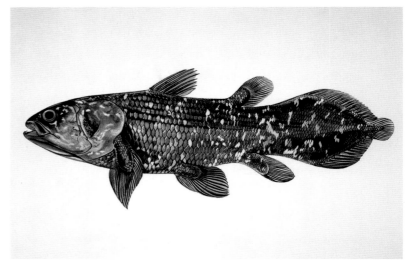

West Indian Ocean coelacanth
Coelacanths such as *Latimeria chalumnae* use
their strong pectoral (front) fins to maneuver
over the rocky seabed in search of prey.

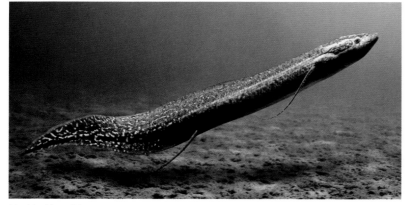

Marbled lungfish
Protopterus aethiopicus

Australian lungfish
Neoceratodus forsteri

sturgeons and paddlefish

SUBCLASS: Chondrostei **CLASS:** Actinopterygii **SUBPHYLUM:** Vertebrata

The four dozen or so species in this group, which also includes the gars, bichirs, and reedfish, have an unusual skeleton made partly of cartilage—like a shark's—and partly of bone. This shows that the subclass represents a primitive form of bony fish, one that has been largely superseded in most aquatic habitats. Nevertheless, member species are found across the world and are mostly freshwater and estuarine predators or filter feeders. Most sturgeons are anadromous, which means they breed in rivers and lakes but spend most of their lives at sea—although they rarely stray far from the coast. The paddlefish, named after its long oar-shaped snout, strains plankton from water using its gills and is one of the few freshwater fish to do this.

European sea sturgeon
Over 13 ft (4 m) long. sturgeons such as *Acipenser sturio* are among the largest river fish. The largest species are rare due to over fishing for their eggs, which are sold as caviar.

bony-tongued fish

SUPERORDER: Osteoglossomorpha **CLASS:** Actinopterygii **SUBPHYLUM:** Vertebrata

This order's 244 species all occur in freshwater habitats in tropical parts of South America, Africa, and south Asia. They range from the arapaima, a huge fish of the Amazon can grow up to 15 ft (4.5 m) long, to Africa's butterflyfishes and elephantnose fish. The former has winglike pectoral fins, hence the name, but also stands on spinelike pelvic fins on shallow river beds to save energy. The elephantnose fish has a fleshy probe on its chin that detects electrical activity from prey in murky waters. All these species have some things in common: their tongues are studded with bones or actual teeth. These grind against rough bones on the roof of the mouth and are used to chew invertebrates, which form the diet for the majority. Most species rely on breathing air into their swim bladder.

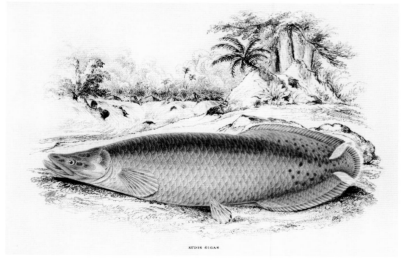

Arapaima, or pirarucu
One of the largest freshwater fish, *Arapaima gigas* inhabits the Amazon basin. It surfaces frequently to breathe air into the swim bladder, to supplement the work of the gills.

eels and relatives

SUPERORDER: Elopomorpha **CLASS:** Actinopterygii **SUBPHYLUM:** Vertebrata

The eels are fish that have long, snakelike bodies and swim with an undulating motion. Some have more than 100 vertebrae in their flexible skeletons. There are four distinct orders, and a minority of the 1,000-plus species in this group have a more typical fish body plan as adults, but share the elongated larval form with eels. These relatives include tarpons, ladyfish, and bonefish. True eels are found worldwide. Most are marine predators, living in benthic (seabed) habitats or in open water. The most voracious hunters are the moray eels, which live in coral reefs and shallow tropical seas. Gulper eels live in the midnight zone, where they lure prey into their elastic mouths using a luminescent tail. The so-called freshwater eels breed at sea but spend most of adulthood in rivers.

European eel
With thick skin that stops them from drying out and efficient use of oxygen, European eels (*Anguilla anguilla*) can survive out of water for many hours. They cross dry ground with a slithering, snakelike motion.

herrings and relatives

SUPERORDER: Clupeomorpha **CLASS:** Actinopterygii **SUBPHYLUM:** Vertebrata

This group of over 400 small- to medium-sized fish species includes anchovies, sardines, and pilchards. The fish are mostly marine and live in coastal waters, being most common where ocean currents and upwellings deliver a supply of plankton, their main food. The fish form vast schools for protection as they feed. They follow the plankton in the water column in a daily migration, in which the school dives to around 164 ft (50 m) by day and comes nearer to the surface at night. Herrings and other species have a streamlined, torpedo-shaped body that is built for fast, darting swims. The fish are covered in mirrorlike scales, which appear silvery out of water but reflect the ocean's blue surroundings when submerged and so help the fish fade into the background.

European pilchard
Once classified in the herring's own genus, *Clupea*, *Sardina pilchardus* is a typical small, schooling member of this group and lives in the northeast Atlantic, and Mediterranean, and Black Sea.

catfish and relatives

SUPERORDER: Ostariophysi **CLASS:** Actinopterygii **SUBPHYLUM:** Vertebrata

With more than 10,000 species, this is the second-largest superorder of fish, and its members make up around 75 percent of freshwater species worldwide. Most have acute hearing due to a bony sound-transmitting structure called the Weberian apparatus, and many species use sound in communication—useful in murky freshwater habitats. Members include the Eurasian wels, which at 300 lb (136 kg) is one of the largest freshwater fish; the tetras of the tropical Americas, now popular aquarium fish; the electric eel, which can deliver a 600-volt electric shock; and the piranhas. It is not just the catfish that have the distinctive touch-sensitive whiskerlike barbels on the chin. These are also a feature of the minnows and carp species, which outnumber catfish two to one.

Spiny catfish
Acanthodoras cataphractus, like all ostariophysians, has excellent hearing. Vibrations picked up by the swimbladder are transmitted to the inner ear by the skeleton.

dragonfish and relatives

SUPERORDER: Osmeromorpha **CLASS:** Actinopterygii **SUBPHYLUM:** Vertebrata

This superorder is a varied collection of several hundred species, which have been included in different groups in the past. Many are long, almost eel-like fish that mostly live in deep-sea habitats. They include such groups as the slickheads—named for their smooth, scaleless skin; the barreleyes—so-called due to their tubular eyes; and the spookfish—which have transparent skin. They were previously grouped with the salmon and pikes, but more recent genetic evidence places them with the dragonfish. Dragonfish themselves are also long eel-like deep-sea hunters. In the emptiness of the deep, dark ocean, where food is scarce, a dragonfish lures prey using the photophores that run down both sides of its body. Its huge teeth then close to create a cage, trapping its victim.

Sloane's viperfish
Chauliodus sloani arches a long ray on its dorsal fin over the head to lure prey toward its mouth. Its barbed fangs are transparent and so are almost invisible under water.

lanternfish and relatives

SUPERORDER: Scopelomorpha **CLASS:** Actinopterygii **SUBPHYLUM:** Vertebrata

Members of this grouping of around 520 exclusively marine species are well adapted to life in the dark, either when living in deep waters or when hunting nearer the surface at night. The lanternfish have a rounded head that appears large compared to the slender body behind it. The head is proportionally large because it has to accommodate huge, sideways-facing eyes, which can detect the faintest light in the dark water. By day, lanternfish are generally found in large schools in the midnight zone, hundreds of feet below the surface. Each species has a unique pattern of studlike light-emitting photophores on its body, which help ensure that the schools stay together in the dark. At dusk, the school will head up to the surface to feed on plankton.

Spotted lanternfish
The spotted lanternfish, *Myctophum punctatum*, lives in schools in the North Atlantic and Mediterranean, where it feeds on krill and other small crustaceans.

cod, anglerfish, and relatives

SUPERORDER: Paracanthopterygii **CLASS:** Actinopterygii **SUBPHYLUM:** Vertebrata

This large collection of fish, around 1,600 species, includes cod itself, haddock, hake, and pollock, as well as deep-water grenadiers, which are found at depths of up to 20,000 ft (6,000 m). Cod and other schooling fish in this group spend their lives in shallow coastal waters, and are important prey for seals and other marine predators when young. Once fully grown—some cod will reach 6 ft (2 m) long—the fish become predators of squid and shellfish, thus helping control those populations. True cod have a long, slender body and their fins lack spines. Bottom-feeding species have a sensory barbel in the lower jaw, which helps them locate invertebrate prey. Many large species of codfish are prolific egg layers—a mature Atlantic cod can spawn up to 10 million eggs in a season.

COD (GADUS MORRHUA LINNÆUSII)

Atlantic cod
Gadus morhua is a powerfully built fish with a large head and single chin barbel. Coloration varies from reddish, especially in young fish, to mottled brown.

salmon and relatives

SUPERORDER: Protacanthopterygii **CLASS:** Actinopterygii **SUBPHYLUM:** Vertebrata

The species in this group include salmon, trout, and freshwater pikes. Some salmon are anadromous (see eels, p. 352) and have fascinating life cycles, spending most of their lives in the ocean but moving to freshwater to spawn. These journeys can be several thousand miles long and involve negotiating fast currents, requiring them to leap clear of the water to progress upstream. Salmon and their close relatives share a slim, muscular body, either scaleless or with only small scales. The fins are small, apart from a large, powerful tail. Most species also have a small, fleshy adipose fin toward the base of the tail. Some species, such as the pikes, are ambush predators with large mouths allowing them to swallow prey up to half their own size. Other species hunt prey with short bursts of speed.

THE GOLDEN TROUT OF SODA CREEK, CALIFORNIA (ADULT MALE)
SALMO-GILBERTI-WHITE)

Golden trout
At the time of this illustration, the golden trout, *Oncorhynchus aguabonita*, a native to California, was thought to belong to the salmon genus, *Salmo*.

perch and relatives

SUPERORDER: Acanthopterygii **CLASS:** Actinopterygii **SUBPHYLUM:** Vertebrata

All members of this vast grouping have soft, flexible rays alongside stiffer spines in their dorsal and anal fins. They encompass a greater diversity of fish than any other superorder. Many, such as perch and darters, are freshwater fish, but most species are marine. Out in the ocean, they are represented by mackerel, tuna, flatfish—such as halibut—seahorses, and the suckerfish that cling to whales and sharks. Mudskippers, which can clamber into the air, are also included, as is the oceanic sunfish, the largest bony fish in the sea, and the sailfish, which is the fastest. In addition, there are tropical aquarium fish, such as the angelfish, the highly toxic pufferfishes, which inflate themselves for protection, and the icefish that survive in sub-zero Antarctic waters.

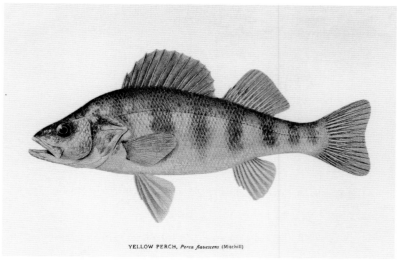

YELLOW PERCH, *Perca flavescens* (Mitchill)

Yellow perch
Like all members of the perch family, *Perca flavescens* has two dorsal fins. This species is native to North America and feeds on invertebrates, small fish, and crustaceans.

newts and salamanders

ORDER: Caudata **CLASS:** Amphibia **SUBPHYLUM:** Vertebrata

Salamanders are amphibians, whose typical life cycle involves an aquatic, gill-breathing stage as a juvenile, followed by an adulthood on land. Many look lizardlike, but unlike lizards, salamanders have moist, water-permeable skin and have to live in damp places on land. They are predators, eating mainly invertebrate prey. Some poisonous species have bright warning colors. Newts are small salamanders that live partly in freshwater as adults. Some salamanders never leave water, including the Chinese giant salamander, which can reach 6 ft (1.8 m) long. Other water-living species are almost legless, while some kinds retain gills and never breathe air. Even some land salamanders lack lungs and breathe air through their skin.

SALAMANDRA MACULOSA
(Orig.)

Fire salamander
The bright colors of the fire salamander (*Salamandra salamandra*) warn predators, such as snakes and birds, that glands in the animal's skin produce a powerful toxin.

caecilians

ORDER: Caecilia **CLASS:** Amphibia **SUBPHYLUM:** Vertebrata

Caecilians are limbless amphibians that live in tropical regions. They resemble snakes or worms; some even have earthwormlike rings around their bodies. Their eyesight is rudimentary, but they can detect prey using retractable tentacles that transmit smells to their nose. The largest species can grow to over 5 ft (1.5 m) long. Most caecilians hide in the soil, burrowing using their shovel-like heads, and come out at night to feed on worms, termites, and other small prey, using their needlelike teeth. Some species live in water and swim using a fin on their tail. In some caecilians, the young hatch as larvae, which begin their lives in water; other species give birth to miniature adults.

Ringed caecilian
Named for its distinctive white rings, the ringed caecilian (*Siphonops annulatus*) is native to the forests of South America.

frogs and toads

ORDER: Anura **CLASS**: Amphibia **SUBPHYLUM**: Vertebrata

Frogs and toads make up the largest group of living amphibians. Anurans with rougher skin, a heavy body, and shorter legs tend to be called toads, but the distinction is not exact. Adult frogs and toads are carnivores, and most species are shaped for jumping, with long back legs and a short, inflexible body. Large heads and mouths, combined with good binocular vision, allow them to catch and devour large prey. Many anurans produce toxins in their skin to deter predators, which they may advertise with bright colors—most notably in the poison frog family, native to the Neotropics (of Central and South America).

Male anurans commonly gather in groups in the breeding season and call to attract females, each species having a distinctive voice. Typically, a successful male attaches to a female in a grip called "amplexus," and she may carry him on her back for several days. Eggs are usually laid in water and hatch into tadpoles, but there is great variety in reproductive strategies: some frogs lay eggs on land that hatch directly into tiny froglets; others carry the eggs in their mouths until they hatch.

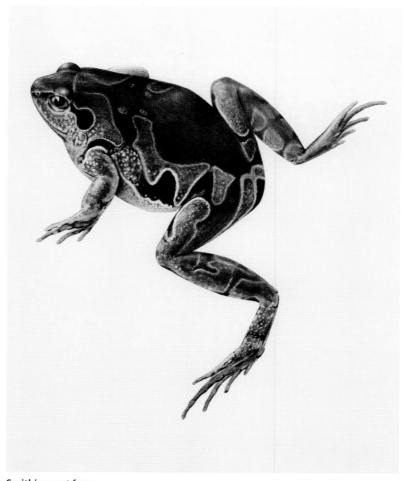

Smith's squat frog
Glyphoglossus smithi is a rarely seen burrowing frog of the forest floor of Malaysian Borneo. Its lack of enlarged toe pads suggests that it is not a good climber.

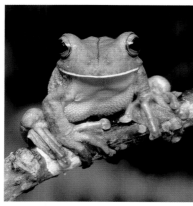

Map tree frog
Boana geographica

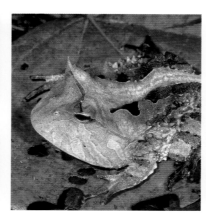

Surinam horned frog
Ceratophrys cornuta

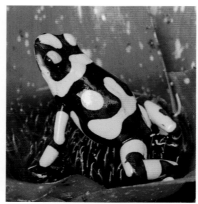

Harlequin poison dart frog
Oophaga histrionica

Common toad
Bufo bufo

lizards

SUBORDER: Lacertilia **SUBCLASS:** Squamata **CLASS:** Reptilia **SUBPHYLUM:** Vertebrata

Lizards are the most diverse group of reptiles alive today. In contrast to amphibians, lizards (like other reptiles) have waterproof skin typically covered with scales. Most lizards lay eggs with waterproof protective shells, which means they can live their entire lives on land—although some species give birth to live young. Like other living reptiles, lizards are cold-blooded, meaning they must regulate their temperature behaviorally, such as by basking in the sun. Being cold-blooded, lizards need little food, which allows them to thrive in habitats such as deserts. Most lizards are predators, although some iguanas have a vegetable-based diet.

Many lizards have spines, frills, or colored patches that they use in threat displays or for communication. There is much physical variability between families. The nocturnal geckos have clinging pads on their toes, allowing them to walk upside down. Chameleons have long tongues that shoot out to capture their insect prey. Slow worms and some skinks are legless and look rather snakelike. The largest lizards are in the monitor family, including the Komodo dragon of Indonesia.

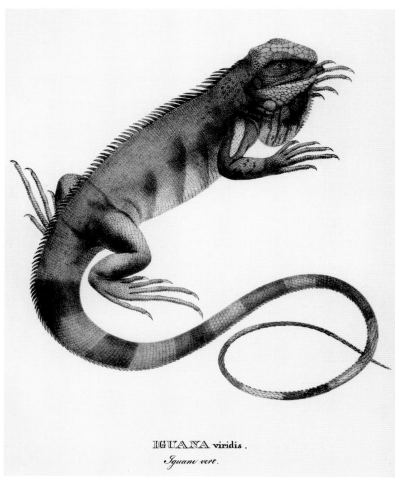

IGUANA viridis.
Iguane vert.

Green iguana
Native to the rain forests of South and Central America, the green iguana (*Iguana iguana*; formerly known as *viridis*) uses its dewlap to communicate with rivals and potential mates.

Leopard gecko
Eublepharis macularius

Panther Chameleon
Furcifer pardalis

Komodo dragon
Varanus komodoensis

Lined supple skink
Lygosoma lineata

snakes

SUBORDER: Serpentes **SUBCLASS:** Squamata **CLASS:** Reptilia **SUBPHYLUM:** Vertebrata

Although snakes almost certainly evolved from lizards, they are much more specialized and successful—and typically much larger—than other legless lizards. Snakes have the unique ability to dislocate their jaws temporarily, allowing them to swallow large prey whole. Most snakes have a row of wide scales on their undersides that help them grip surfaces, for example when climbing trees.

There are several families of small, burrowing snakes, but the larger, better-known kinds belong to a few families only. The large—but relatively primitive—boas and pythons still have tiny remnants of their back legs in their bodies. They have many teeth but are not venomous and kill their prey by constriction. The largest family is composed of the colubrids: some are venomous, but their fangs are typically at the back of their mouths and seldom pose a risk to humans. Front-fanged snakes include the cobra and viper families. The cobra family—of which all are venomous—probably evolved from colubrids, and include coral snakes and sea snakes. Members of the viper family have longer, foldable fangs and wide heads that accommodate their venom glands.

Duméril's false coral snake
A member of the colubrid family, Duméril's false coral snake (*Oxyrhopus clathratus*), found in Brazil, has distinctive light bands running down its body.

Royal python
Python regius

King cobra
Ophiophagus hannah

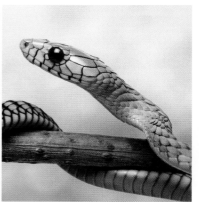

West African green mamba
Dendroaspis viridis

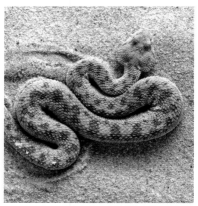

Sidewinder rattlesnake
Crotalus cerastes

tuataras

ORDER: Rhynchocephalia **CLASS:** Reptilia **SUBPHYLUM:** Vertebrata

The lizardlike tuatara is the only living member of the order Rhynchocephalia, otherwise known only from fossils. Tuataras show various primitive features, including a rudimentary third eye, the parietal eye, on top of their head. Present-day tuataras—formed of one species split into two subspecies—live on islands off the shore of New Zealand, having become extinct on the mainland. They are nocturnal and adapted to the cool conditions of their habitat. Tuataras are slow-growing, reaching about 24 in (60 cm) in length, and can live for over 100 years. Wild populations are associated with seabird colonies, with seabirds and chicks supplementing the mainly insectivorous diet of the tuatara. They live in burrows that they either dig themselves or take over from seabirds.

Tuatara
This illustration of a tuatara (*Sphenodon punctatus*) is by the German illustrator Heinrich Harder, from a book called *Tiere der Urwelt* (*Animals of the Primeval World*).

turtles

ORDER: Testudines **CLASS:** Reptilia **SUBPHYLUM:** Vertebrata

Turtles and tortoises, with their instantly recognizable body design, have flourished on Earth for at least 200 million years. Most species live in freshwater, but there are many land-living types, as well as seven species of sea turtle. Land tortoises, which have evolved to giant sizes on some oceanic islands, tend to have higher-arched shells than water-living species. Apart from in the so-called "softshell turtles," both the upper shell (carapace) and lower shell (plastron) of turtles and tortoises are made of interlocking flat bones, covered by horny plates called scutes. All turtles have to return to land to lay their eggs, which can mean long migrations for the marine species. Freshwater turtles typically have broad diets, eating both plants and other animals.

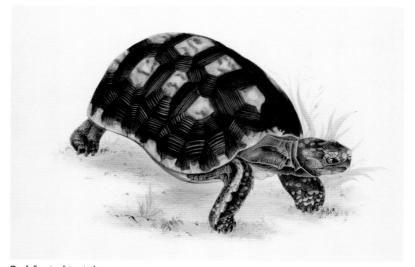

Red-footed tortoise
The red-footed tortoise (*Chelonoidis carbonarius*) can grow up to 20 in (50 cm) in length. It has an usually elongated shell, covered in red or orange markings.

alligators and crocodiles

ORDER: Crocodilia **CLASS:** Reptilia **SUBPHYLUM:** Vertebrata

Crocodilians are semiaquatic reptiles that are the nearest living relatives of dinosaurs and birds. They are predators and scavengers that spend most of their time in water, although some can also move quickly on land. Their usual habitats are rivers, lakes, and estuaries, although the saltwater crocodile—the world's largest reptile—can cross the open sea. Powerful tails, as well as eyes and nostrils mounted high on their heads, are adaptations to their aquatic environment. True crocodiles differ from the alligator family in various details: most obviously, crocodiles have narrower snouts and some of their lower teeth are visible when their mouths are closed. The endangered gharial of south Asia has a very long, narrow snout used for catching fish. Crocodiles deal with large land prey by dragging the animal into the water, drowning it, and then rotating their own bodies rapidly to twist off pieces of flesh.

Crocodilians are diligent parents. The females bury or make mounds for their eggs on land, guard them, and help the young at hatching time. Young crocodilians often stay with their parents until they are well grown.

Fig. 196. Das Brillen-Kaiman, oder Leisten-Krokodil (Champsa sclerops)

Spectacled caiman
Named for the characteristic ridge of bone between its eyes, the spectacled caiman (*Caiman crocodilus*), like all other caimans, is a member of the alligator family.

Spectacled caiman
Caiman crocodilus

American alligator
Alligator mississippiensis

Nile crocodile
Crocodylus niloticus

Gharial
Gavialis gangeticus

egg-laying mammals

ORDER: Monotremata **CLASS:** Mammalia **SUBPHYLUM:** Vertebrata

This small mammal order includes just three species, all found in Australia and New Guinea. These unusual animals are all that remains of a group of mammals that diverged, in evolutionary terms, from the rest of the class around 200 million years ago. The lines of the three surviving species have persisted, relatively unchanged, for tens of millions of years since, due to highly specialized lifestyles. The two echidna, or spiny anteater, species use a jaw elongated into a sensitive beaklike probe that seeks out food among soil and leaf litter, while the semiaquatic platypus finds food with a duckbill that detects electrical activity of its crayfish prey. All species (but only the male platypus) are equipped with a venomous spur on the back leg, used in fights over mates and in defense.

The name monotreme means "one hole" and these animals have a cloaca, which serves both as the anus and vagina. Monotremes lay small leathery eggs: the platypus incubates a pair of eggs in a burrow, while echidnas lay a single egg into a pouch on the belly. These mammals have no teats and upon hatching, the undeveloped newborns lap milk secreted from mammary glands onto the mother's fur.

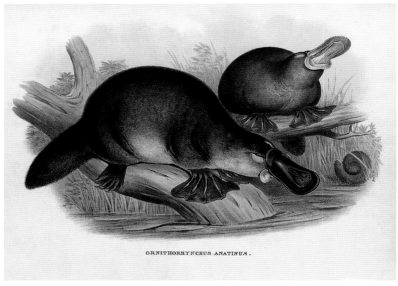

Platypus
This illustration of the platypus, *Ornithorhynchus anatinus*, is taken from *The Mammals of Australia* by John Gould, published in 1855.

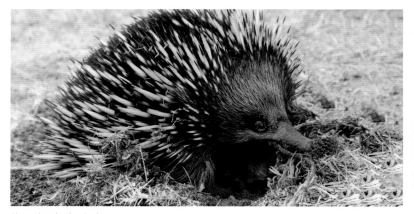

Short-beaked echidna
Tachyglossus aculeatus

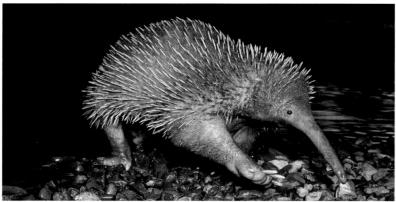

Eastern long-beaked echidna
Zaglossus bartoni

marsupials

INFRACLASS: Marsupialia **CLASS:** Mammalia **SUBPHYLUM:** Vertebrata

Mostly associated with Australia where 80 percent of the species live, including Macropodiformes (the hopping kangaroos and wallabies) and Phalangeriformes (gliders and possums). Marsupials diverged in their evolution from the placental mammals (which have a placenta to nourish their young during gestation) around 100 million years ago, probably in what is now North America. Around 55 million years ago, the group had spread through South America and Antarctica to Australia (when all three continents were joined as Gondwana). The key difference from placental mammals arose due to the location of the ureters, which connect the kidneys to the bladder. In marsupials, these vessels prevent the oviducts from merging into a uterus large enough for a fetus to develop for longer than a single estrus cycle (as happens in placental mammals). As a result marsupial babies—or joeys—must be born after just a few weeks, when highly undeveloped. Blind, hairless, and lacking hind limbs, the joey uses huge temporary claws on its forelegs to haul itself into its mother's pouch. Inside it latches onto a teat for a constant supply of milk until it is fully developed.

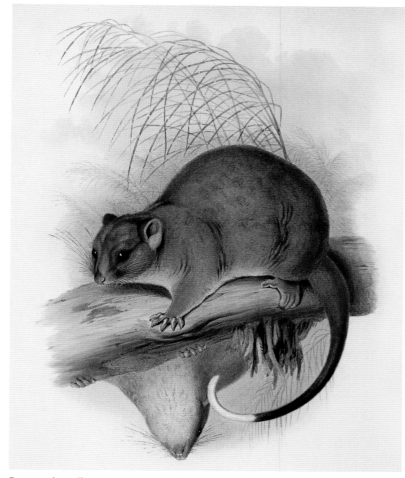

Eastern ringtail possum
This illustration of *Pseudocheirus peregrinus*, also called the common ringtail possum, is by John Gould and is taken from *The Mammals of Australia*, 1885.

Red kangaroo
Macropus rufus

Virginia opossum
Didelphis virginiana

Eastern quoll
Dasyurus viverrinus

Koala
Phascolarctos cinereus

sengis

ORDER: Macroscelidea **CLASS:** Mammalia **SUBPHYLUM:** Vertebrata

Initially named elephant shrews for their resemblance to shrews, though they are much larger, sengis are more closely related to elephants and hyraxes. With a tail that adds 50 per cent to their length, sengi bodies range from 10–25 cm (4–10 in). Exclusively African, the preferred habitat of the 19 sengi species is dry woodland with thick grass and leaf litter. The sengi diet is mostly insects and worms, but some species also eat fruits and seeds. Most foraging occurs at night; by day the sengi sleeps in nests built in a shallow hollow covered with leaves. Living in monogamous breeding pairs, which produce several small litters throughout the year, sengis maintain a territory by scent marking a network of trails through leaf litter with dung. If disturbed, they bound away to hide in undergrowth.

North African sengi
The only extant species of sengi that lives north of the Sahara, *Petrosaltator rozeti* has a long snout and sensory whiskers, typical of elephant shrews.

aardvarks

ORDER: Tubulidentata **CLASS:** Mammalia **SUBPHYLUM:** Vertebrata

Containing just one species, the aardvark, this order is the final extant member of a branch of Afrotherian that diverged from the sengis about 70 million years ago. The name aardvark means "earth pig" in Afrikaans. It lives in woodlands and savannas of sub-Saharan Africa. A solitary, nocturnal forager, it uses its long snout to sniff out termite mounds, and then dig out its insect prey using powerful legs with spoon-shaped claws. It slurps up the termites using its sticky tongue. Termites are swallowed whole and ground to a pulp in a toughened area of the stomach. The aardvark covers up to 3 miles (5 km) a night, scenting out termite trails. Aardvarks stick to their own territories until breeding season. A single baby is born in fall and will live with the mother for about two years.

Aardvark
This engraving of an aardvark, once known as the "Cape anteater" (*Oryctoropus afer*), by M. Griffith is from Edward Griffith's *The Animal Kingdom*, 1826, by the Baron Cuvier.

tenrecs and golden moles

ORDER: Afrosoricida **CLASS:** Mammalia **SUBPHYLUM:** Vertebrata

Once lumped in with other small insect-eating mammals, such as moles, hedgehogs, and shrews, this group has more recently been considered as a distinct order, one linked to the Afrotheria, an offshoot of mammals that includes elephants, sengis, and sea cows. Golden moles, from the family Chrysochloridae, are adapted to a fossorial or burrowing lifestyle, and so appear similar to true moles. They have a cylindrical body, sturdy claws on short but powerful limbs, and vestigial eyes that are covered with furred skin. The 20 or so species of golden moles live in soils across southern Africa. The tenrecs, belonging to the family Tenrecidae, are endemic to Madagascar, and the 31 species have adapted to a wide range of habitats there. Some live beside rivers, others forage on the ground, and yet more live in trees. The aquatic species—the Potamogalidae family, known as otter shrews—have long tails and sleek fur. Terrestrial tenrec species have short tails, and their back hair is thickened into protective spines. In some species, this gives them a sharp-spined appearance, similar to that of a hedgehog.

Streaked tenrec
Tenrecs use their long snouts to snuffle out their preferred prey of worms. They raise the long spiky hairs on their backs when they are alarmed.

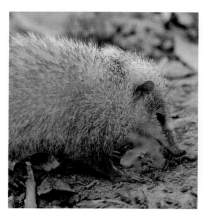

Common tenrec
Tenrec ecaudatus

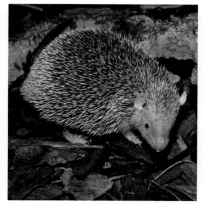

Lesser hedgehog tenrec
Echinops telfairi

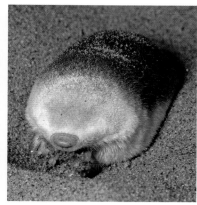

Grant's golden mole
Eremitalpa granti

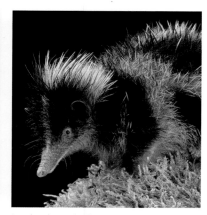

Lowland streaked tenrec
Hemicentetes semispinosus

dugongs and manatees

ORDER: Sirenia **CLASS:** Mammalia **SUBPHYLUM:** Vertebrata

With their flippers, tail flukes, and exclusively aquatic life, it is tempting to think of sea cows, or sirenians, as a kind of link between seals and dolphins. However, they are actually relatives of elephants and hyraxes. All four species graze on aquatic plants, manipulating it with flexible bristle lips. Such food offers meager nutrition, but sirenians move little and conserve energy. The order is divided into two families. One contains the dugong, a sea cow that lives near the coasts and islands of the Indian Ocean and southwestern Pacific, where it eats seagrasses. It is identifiable by its tail fin with two lobes. The other family contains three manatee species, based in the Atlantic basin, and which all have rounded tails. Manatees swim into river mouths to eat freshwater plants.

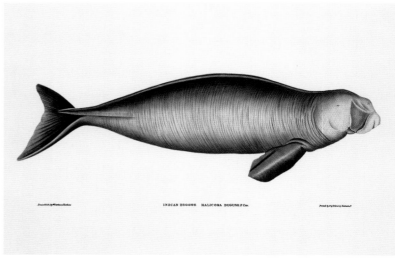

Dugong
The dugong, *Dugong dugon*, can reach lengths of up to 10 ft (3 m) and weigh as much as 1,100 lb (500 kg). They live for around 70 years.

hyraxes

ORDER: Hyracoidea **CLASS:** Mammalia **SUBPHYLUM:** Vertebrata

Hyraxes are the closest living relatives to the elephants, but these little rabbit-sized mammals could not appear more different. These sturdy mammals have small heads on round bodies, short tails, and feet adapted for climbing. Rock hyraxes gather in large groups on arid, stone hills. The bush hyrax lives in more verdant rock habitats, while the three species of tree hyrax live in woodlands. The only non-African hyrax is a subspecies of the rock hyrax that lives in a similar habitat in southern Arabia. Hyraxes eat grass, which is digested in convoluted guts filled with microbial helpers. One adult male rules over a group of half a dozen females and their young. Maturing at 18 months, females stay with their mothers and aunts, while young males seek out a harem of their own.

Western tree hyrax
This arboreal hyrax, *Dendrohyrax dorsalis*, is an excellent climber and uses its highly adapted feet to scale smooth tree trunks.

elephants

ORDER: Proboscidea **CLASS:** Mammalia **SUBPHYLUM:** Vertebrata

Few mammals are as iconic as the elephants. All three surviving species rank as the top three largest land mammals alive today, with the two African species, the forest elephant and savanna elephant, being taller and heavier than the Asian elephant. The animal's great size, often 10 ft (3 m) to the shoulder, is linked to their diet of leaves, bark, and twigs. The efficiencies of scale counter the poor quality of this food. The differences between African and Asian species is easily identifiable by this order's famous characteristics. Firstly the trunk. This is a muscular extension of the nostrils, which contains 100,000 individual muscle blocks to create a dextrous but powerful fifth limb. African elephants have two fingerlike extensions on the tip, while the Asian species has just one. African elephants also have larger ears than Indian ones. In both cases, the huge flappy ears help them swish insects and radiate away excess heat. Only male Asian elephants have tusks, which are enormously extended upper front teeth. Both sexes of African elephants are tuskers, but forest elephants generally have shorter and straighter ones than their grassland cousins.

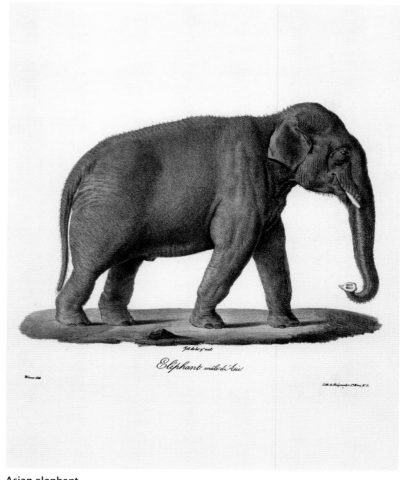

Asian elephant
This illustration of *Elephas maximus* is from *Histoire Naturelle des Mammiferes,* by Etienne Geoffroy Saint-Hilaire and Frédéric Cuvier, 1819–42.

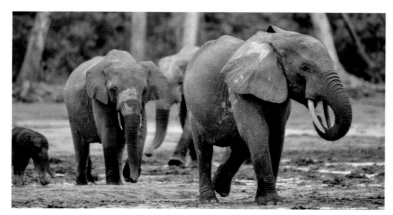

African forest elephant
Loxodonta cyclotis

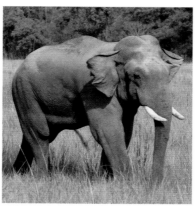

Indian elephant
Elephas maximus indicus

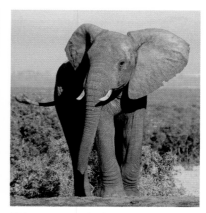

African savanna elephant
Loxodonta africana

armadillos

ORDER: Cingulata **CLASS:** Mammalia **SUBPHYLUM:** Vertebrata

The name armadillo comes from the Spanish for "little banded one" and refers to the protective bony plates coated in horny skin that cover the back. Legend has it that armadillos roll into an impervious ball when attacked. Only two of the 20 species can do this; the others run away, or bury themselves in soft ground. Found from the southern US to Patagonia in Argentina and ranging in length from 5 in to 3 ft (12 cm to 1 m), armadillos are largely insectivorous. Being nocturnal, they have poor vision and use smell to find prey buried in leaf litter or soil, digging it out with powerful clawed legs. Armadillos are almost toothless, and larger prey are crushed in the jaws before swallowing, while smaller food like ants are licked up using a tongue with a spit-coated feathery tip.

Nine-banded armadillo
Despite the name, *Dasypus novemcinctus* can have 7–11 bony plates covering the back. This species is the only armadillo found in the US.

anteaters and sloths

ORDER: Pilosa **CLASS:** Mammalia **SUBPHYLUM:** Vertebrata

While all species live in Central or South America, the members of this order divide into two distinct suborders. The Folivora ("leaf eaters") are made up of the six sloth species, while the Vermilingua (worm-tongues) include the four anteaters. All the sloths are arboreal. Their leaf diet does not supply many calories, but they hang still from claws hooked over branches and consume little energy. They move to the forest floor every few days to defecate. Anteaters (also called tamanduas) are also mostly arboreal, apart from the ground-living giant anteater. An anteater's long face is a tube-shaped jaw with nostrils and a tiny mouth at the tip through which a long sticky tongue—up to half their body length—can flick out 150 times a minute to collect their ant food.

Giant anteater
Once known as the ant bear, *Myrmecophaga tridactyla* is the largest member of the order Pilosa. It can reach over 7 ft (2 m) in length from its snout to the tip of its tail.

rabbits, hares, and pikas

ORDER: Lagomorpha **CLASS:** Mammalia **SUBPHYLUM:** Vertebrata

Roughly two-thirds of the 92 species in this order are rabbit, hare, or jackrabbit species. They live in all habitats bar the Amazon and Congo rain forests—and are found worldwide since being introduced to Australia and New Zealand. The other third are the less familiar pikas, which are mountain creatures, most often living in scree fields. They have rounded ears and shorter legs than their rabbit cousins. All lagomorphs are herbivores, and they extract maximum nutrients from their foods by digesting it twice. That involves coprophagy, which is eating the hard round droppings from the first digestive pass. Only the European rabbit digs an extensive burrow. Hares and jackrabbits run from danger, while rabbits, which have shorter legs, dash for cover in the undergrowth.

White-tailed jackrabbit
Native to North America, *Lepus townsendii* is most at home on open grasslands. Its coat changes color with the seasons and its habitat.

rodents

ORDER: Rodentia **CLASS:** Mammalia **SUBPHYLUM:** Vertebrata

This is the largest and most widespread order of mammals, with nearly 2,500 species. The term rodent means "gnawer." All species have long chisel-like incisors that grow throughout life, and the act of gnawing wears the teeth down and keeps them sharp. These teeth, along with short legs, a flexible spine, and long tails—used for balancing and as a tactile organ—have helped rodents adapt to all terrestrial habitats. The order is divided into three suborders: squirrel-like species (which include the beavers); mice and rats (which also include hamsters and gerbils); and finally the guinea pigs, chinchillas, and their allies (which are exclusive to the Americas). This group includes the capybara, which at 145 lb (66 kg) is the largest rodent—most rodents weigh less than 4 oz (100 g).

Brazilian yellow-toothed cavy
Galea flavidens has the short body and large head that are common to most cavies, including the guinea pig.

bats

ORDER: Chiroptera **CLASS:** Mammalia **SUBPHYLUM:** Vertebrata

There are more than 1,200 species of bats, making them the biggest mammal order after the rodents. Bats are the only mammals capable of true flight, as opposed to the controlled glides of flying squirrels. The order's name is derived from the Greek for "hand wing," and a bat's wing is formed from a membrane of skin that is largely supported by elongated finger bones. The order is split into two suborders. The smaller of the two, with about one-fifth of bat species, includes those commonly called flying foxes and features the biggest bats, with wingspans reaching 5½ ft (1.7 m). Flying foxes eat mainly fruits, and sometimes nectar or pollen, and use vision and smell to find food, sometimes by day. The second suborder is filled with much smaller bats that are universally nocturnal and orientate themselves in darkness by echolocation. They emit ultrasonic calls and listen to the echoes from the surroundings to identify obstacles and prey. Most echolocating bats hunt insects, either snatching them from midair or gleaning them from vegetation. In colder areas, bats will find dark, isolated roosts, such as caves, in which to hibernate.

Flying fox
Large bats, like this fruitbat, or flying fox, have big eyes and a longer muzzle than small bats. They have strong thumbs with curved nails, to help them climb in trees and grip fruit.

Franquet's flying fox
Epomops franqueti

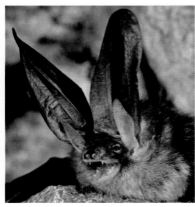

Grey long-eared bat
Plecotus austriacus

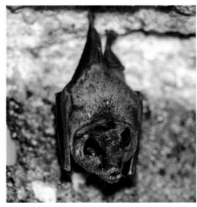

Seba's short-tailed bat
Carollia perspicillata

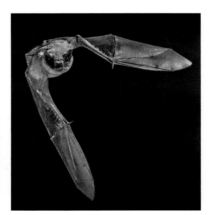

Common pipistrelle
Pipistrellus pipistrellus

primates

ORDER: Primates **CLASS:** Mammalia **SUBPHYLUM:** Vertebrata

This group of 479, largely forest-living mammals is the order to which our species belongs. We owe our quick wits and intelligence to our primate cousins. Life in trees requires a large forebrain capable of making decisions fast when moving through the branches, a good memory and mental map to locate food supplies, plus forward-facing color vision to judge distances and find the ripe leaves and fruits, which form the diet of most primates. Mostly confined to the tropical regions of the world, the primates split into two suborders: the Haplorhini includes the Old-World monkeys of Africa and Asia, such as baboons and langurs, plus the New-World monkeys of the Americas, such as the marmosets, capuchins, and spider monkeys. Many of these "New World" species have a prehensile tail that acts as a fifth limb. The same suborder includes the gibbons and great apes, which have no tail, and include gorillas (the largest primates), chimpanzees, and humans. The second suborder, Strepsirhini, are limited to Asia and Africa. They include bushbabies and lorises, which emerge in the forest at night, as well as the lemurs of Madagascar.

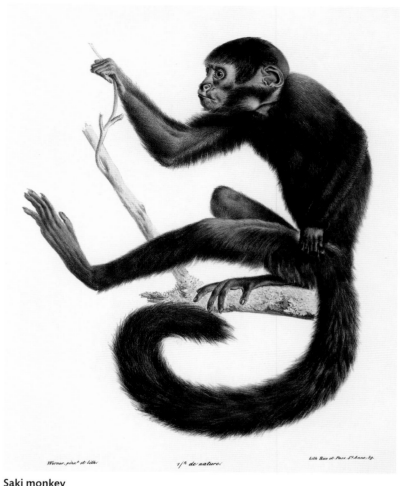

Saki monkey
This illustration of a New World saki monkey, *Pithecia* sp., is from *Histoire Naturelle des Mammiferes*, by Etienne Geoffroy Saint-Hilaire and Frédéric D. Cuvier.

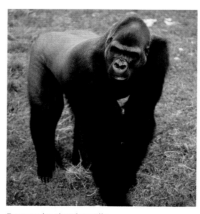

Eastern lowland gorilla
Gorilla beringei graueri

Senegal bushbaby
Galago senegalensis

Verreaux's sifaka
Propithecus verreauxi

Golden snub-nosed monkey
Rhinopithecus roxellana

hedgehogs, moles, and shrews

SUPERORDER: Eulipotyphla **CLASS:** Mammalia **SUBPHYLUM:** Vertebrata

These small, mostly insect-eating mammals, totaling around 530 species, mostly live in Eurasia and North America, although some species live in Africa and South America. The shrews make up 80 percent of the order, and at 1½ in (3.5 cm) long, the pygmy white-toothed shrew is one of the smallest mammals. Shrews have a pointed snout, which they poke inquisitively as they forage in fallen leaves, in grasses, or up trees. The next largest group is the Talpidae family of 54 species. This includes the moles, which dig through soil looking for worms, using spade-shaped feet, and the desmans, which are swimmers and so have more slender paddle-shaped feet that help them hunt in shallow rivers. The hedgehogs are nocturnal foragers that rely on hair thickened into bristles, which deters attackers, and curl into a spiky ball when alarmed. They belong to the Erinaceidae family, which includes the gymnures of Southeast Asia. Finally, the order includes two Caribbean solenodon species. Looking like giant shrews, they are 10 times as long and 500 times heavier. Like some shrews, they have toxic saliva, which they inject, as venom, down grooves in their teeth.

Hylomys suillus Müll.

Short-tailed gymnure
Like all gymnures, *Hylomys suillus* has a long, pointed snout and an excellent sense of smell, which helps it locate prey when hunting on the forest floor at night.

European hedgehog
Erinaceus europaeus

European mole
Talpa europaea

Common shrew
Sorex araneus

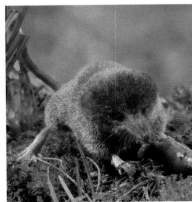

Pygmy shrew
Sorex minutus

pangolins

ORDER: Pholidota **CLASS:** Mammalia **SUBPHYLUM:** Vertebrata

Appearing to break the rules on what a mammal can be, the pangolins are tiled in scales of hornlike material, and any hairs they have sprout in between. The lifestyles of the eight pangolin species of Africa and south and east Asia closley mirror those of the South American anteaters (see p.368) . The pangolins specialize in eating ants and termites and use a long, flat tongue to lick them up. They have no teeth but instead use a gastric mill, a section of the stomach that is lined with the same horn that covers the exterior of the body, which grinds the food to mush. About half of the pangolin species live on the ground, while the rest—the smaller ones—live in trees and have exceptionally long and dextrous tails that aid with climbing.

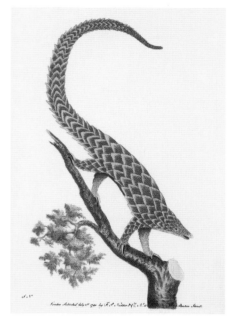

African tree pangolin
Also known as the scaly anteater, *Manis tricuspis* is found across central Africa. It is largely arboreal and lives in tropical forests.

treeshrews

ORDER: Scandentia **CLASS:** Mammalia **SUBPHYLUM:** Vertebrata

The common name for this order was poorly conceived in the 1780s. Apart from the longish snouts of a few types, these 23 species of mammal, mostly of the forests of Southeast Asia, look and behave much more like squirrels than shrews, and several "treeshrews" live on the ground. The treeshrews are in fact more closely related to primates, and occupy a similar niche to tree squirrels elsewhere in the world. They scamper up and down trees searching for food, which is largely insects, fruits, and seeds. Most of this diet is found while rooting around in leaf litter, although flying insects are snatched from the air in the forepaws. Also like tree squirrels, the treeshrews are mostly diurnal and retire to cozy nests lined with dry leaves in the hollow of a tree.

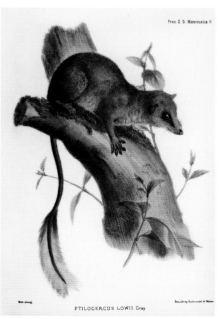

Pentailed treeshrew
Native to Southeast Asia, *Ptilocercus lowii* habitually drinks the naturally fermented nectar of the bertram palm, because the animal is naturally tolerant of the alcohol it contains.

Dogs

FAMILY: Canidae **ORDER:** Carnivora **CLASS:** Mammalia **SUBPHYLUM:** Vertebrata

Dogs are the most widespread large mammals, apart from humans, living on all continents bar Antarctica. Their success is due to the dog body plan: this combines a big head, powerful jaw, and large thorax that allows for a substantial heart and lung capacity all within a flexible, lightweight frame on long legs. The result is an animal that can pursue prey over long distances in almost any climate with very high stamina—and always be ready to kill. The 35 canine species fall into three groups: wolves, jackals, and domestic dog; foxes; and a third group of intermediate creatures, such as the African wild dog and South American bush dog. Wolfish species tend to live in packs and hunt together to bring down large prey. Smaller species live in tight family groups.

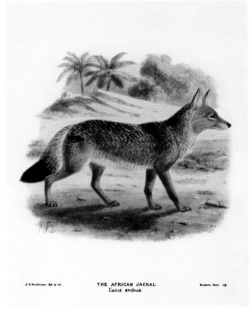

African golden wolf
Also known as the Egyptian or grey jackal, *Canis anthus* is native to north Africa and has only recently been recognized as a full species.

Bears

FAMILY: Ursidae **ORDER:** Carnivora **CLASS:** Mammalia **SUBPHYLUM:** Vertebrata

Bears rely more on weight than speed to subdue prey, often killing with a blow from a paw. All species are massively built with immense shoulders carrying the muscles required to hold up a wide, heavy head fitted with huge jaw muscles. The largest land carnivores—the polar and brown bears—are in this group but only the polar bear is an obligate meat eater, stalking prey across the Arctic sea ice. Despite their power, the brown bear—now confined by human persecution to remote cold forests—and its six smaller relatives, which generally live in warmer areas, are omnivorous. Their diets include flower buds, insects, fish, and roots. The giant panda eats almost solely tender bamboo shoots—and needs to eat constantly for 16 hours a day to meet its nutritional requirements.

Brown bear
Often called grizzly bear in North America, *Ursus arctos* varies in color across its extensive range from reddish or yellowish brown to cream and almost black.

Sea lions and fur seals

FAMILY: Otariidae **ORDER:** Carnivora **CLASS:** Mammalia **SUBPHYLUM:** Vertebrata

Despite spending much of their lives at sea, the seals and sea lions are very much part of the Carnivora, being closely allied to the bear and dog families. The Otariidae family includes 17 species that are most common in the Pacific and Arctic Oceans but are found worldwide. Sporting visible ears, unlike the 19 species of true seal in the Phocidae family, this group uses large front flippers to push through the water and waddle on all fours on land. (True seals swim with their tail-like hind flippers and are less agile on land.) Among the members of this family, fur seals have thicker, shaggier coats than the sleek sea lions. All are oceanic hunters, preying mostly on fish, but they must return to land to mate and pup, where competition for beach space and mates is intense.

Australian sea lion
Neophoca cinerea inhabits sandy coves on the islands off the coast of South and Western Australia. Males can be up to twice the size of females.

Walruses

FAMILY: Odobenidae **ORDER:** Carnivora **CLASS:** Mammalia **SUBPHYLUM:** Vertebrata

The walrus family contains only one species, which lives throughout the Arctic Ocean and northern Atlantic and Pacific Oceans. There are three distinct populations, one in the Canadian Arctic and Greenland, one around the Bering Sea between Siberia and Alaska, and a third in the Laptev Sea along the northern coast of Siberia. These are subspecies with small differences in adult size and tusk length. At more than 10 ft (3 m) long and weighing more than a ton, the Atlantic subspecies is the largest member of the Odobenidaes. Walruses rarely come to land and rely on thick blubber for buoyancy in the water. They dive to the seabed and use a moustache of sensitive whiskers to feel for shellfish. The hefty walrus rests on sea ice, hauling itself out of the water using its slightly hooked tusks.

Walrus
The impressive tusks of *Odobenus rosmarus* are used by males in visual displays and duels over space on the ice and over access to mates.

badgers, weasels, and otters

FAMILY: Mustelidae **ORDER:** Carnivora **CLASS:** Mammalia **SUBPHYLUM:** Vertebrata

Collectively described as the small carnivores, the 55 or so members of this family rely on an agile body to catch prey. It serves them well and there are members found in all parts of the world, except the Sahara, Australasia, and Antarctica. The body plan is most obvious among the weasels and polecats, which have a long, flexible body with short legs and a low center of gravity, ideal for pursuing prey into burrows, over rough ground, and through tree branches. The otters have repurposed the body for swimming, using webbed paws, thick waterproof fur that aids buoyancy, and a sleek and sturdy tail for steering. The badgers are the most robust group, with a wider head that boosts bite strength and large shoulders to accommodate large digging muscles.

Hairy-nosed otter
Native to Southeast Asia, *Lutra sumatrana* is similar in appearance to the European otter. It has short brown fur that is paler on its underside.

raccoons

FAMILY: Procyonidae **ORDER:** Carnivora **CLASS:** Mammalia **SUBPHYLUM:** Vertebrata

The name of this family means "before dogs" but it is the view of some taxonomists that the 12 species represent close relatives of extinct bears. A debate centered around the red panda, which some proposed as a member of the Ursidae, while others regarded it as the single Asian species of the raccoon group, which is otherwise American. It is now separated in its own family. All other species are medium-sized mammals, with long bodies, short legs, and a bushy tail. They are adapted to life in trees and on the ground, and adopt a omniverous diet, searching for a wide range of foods. Active hunting is rare, but animal foods include worms, shellfish, and insects. Members of this family are largely solitary but tolerate each other where food is plentiful.

Crab-eating raccoon
Despite its name, *Procyon cancrivorus* is omnivorous and eats fruit and eggs, as well as shellfish. It is native to South America, with a wide range to the east of the Andes.

civets, genets, and binturong

FAMILY: Viverridae **ORDER:** Carnivora **CLASS:** Mammalia **SUBPHYLUM:** Vertebrata

This family of mammals lives in the grasslands and forests of sub-Saharan Africa and south Asia, with one species, the European genet, also living in southern Europe. Viverrids have a long, flexible body plan like the mustelids, but also have many catlike features—the binturong of south and Southeast Asia is also known as the bearcat. Eleven of the 34 species in the family are palm civets, which are fruit eaters—although some eat insects, too. The rest of the group has a more mixed, omnivorous diet. Civets and genets are solitary animals, generally foraging at night. They will stick to their own small territory when looking for food and stay out of each other's way. A dominant male controls an area that encompasses the territories of several females.

Servaline genet
This genet, *Genetta servalina*, is native to central Africa. Its long tail, up to 19 in (49 cm) long, helps it balance as it moves through its forest habitat.

cats

FAMILY: Felidae **ORDER:** Carnivora **CLASS:** Mammalia **SUBPHYLUM:** Vertebrata

Unlike members of the other Carnivora families, the 37 cat species are universally meat eaters. Although ranging in size from the 10 ft- (3 m-) long tiger to the black-footed cat of Africa—only 14 in (35 cm) long—all cats share the features that make them expert hunters. Their body plan is built for a burst of speed and for powerful leaps, which help snatch up small prey or bring down larger prey in surprise attacks. They have flat faces with wide jaws, and long canine teeth used to kill prey by crushing the neck or head. Cats can see in color by day and have good monochrome night vision. Their claws can be retracted when not needed, to reduce chances of injury. The group is divided into seven species of "big cat," which are able to roar. The "small cats" can only hiss, growl, or purr.

Leopard
The leopard, *Panthera pardus*, is opportunistic, highly adaptable, and is found in a wide range of habitats from sub-Saharan Africa to east Asia.

odd-toed hoofed mammals

ORDER: Perissodactyla **CLASS:** Mammalia **SUBPHYLUM:** Vertebrata

The perissodactyls diverged from the other hoofed mammals around 60 million years ago, soon after the start of the Cenozoic Era, or "Age of Mammals." Far less numerous than their even-toed relatives, the surviving members of the order form three highly distinctive families. In a testament to their long heritage, these families are widespread across the world. The seven species of equids, which include the horse, zebras, and wild asses, are all herd-forming grazers in the open grasslands of Central Asia and Africa. Their slender-legged body plan makes them high-speed runners that flee from danger. Meanwhile the five rhinoceros species confront threats head on. Each species, mostly solitary woodland browsers of Africa and Asia, is characterized by one or two solid horns on the snout. At more than 2 tons, the African rhino species are the largest of all hoofed mammals. The tapirs are sturdy forest browsers. One species lives in Southeast Asia with another three in Central and South America. Tapirs have a wedge-shaped body with a small head and wide rump, which helps them push through dense undergrowth.

Indian rhinoceros
This illustration of the single-horned *Rhinoceros unicornis* is from *Histoire Naturelle Des Mammifères* by Etienne Geoffroy Saint-Hilaire and Frédéric D. Cuvier.

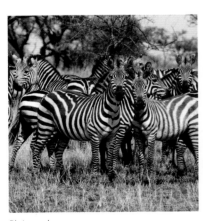

Plains zebras
Equus quagga

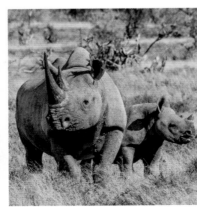

Black rhinoceros
Diceros bicornis

Brazilian tapir
Tapirus terrestris

Persian onager
Equus hemionus onager

even-toed hoofed mammals

ORDER: Cetartiodactyla **CLASS:** Mammalia **SUBPHYLUM:** Vertebrata

With nearly 200 members, this order contains many of the most familiar mammals, including the wild relatives of common livestock animals, such as cattle and sheep. Native to all continents bar Antarctica and Australia, the artiodactyls are all herbivorous, and mostly sure-footed and fast-running due to the anatomy of the lower legs. As in perissodactyls (opposite), leg length is maximized by the animals standing on the tips of their toes, and the hooves are equivalent to claws or toenails. This adaptation boosts running speeds, so deer and antelopes can outpace their predators. The hooves grip the ground like the tread on a tire, which is why mountain goats can move safely on precipitous cliffs. The order also contains several families that prove exceptions to these general rules. The hogs and boars, plus their sister group the peccaries, have a snout with which they root through soil for buried foods; giraffes beat other animals to the freshest leaves atop a tree with their long necks; camels carry humps of fat that sustain them during long periods without food or water; while the hippos keep cool in rivers by day and only emerge at night to feed.

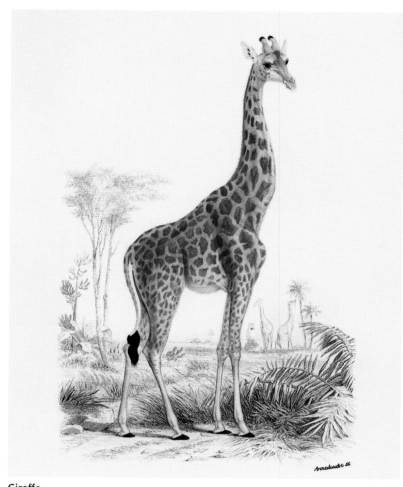

Giraffe
This illustration of a giraffe, *Giraffa camelopardalis*, is from *Illustrations of the Zoology of South Africa* by Andrew Smith, published in 1849.

Greater kudu
Tragelaphus strepsiceros

Nubian ibex
Capra nubiana

Common hippopotamus
Hippopotamus amphibius

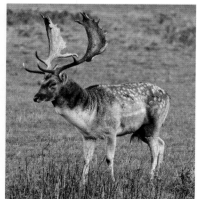

Fallow deer
Dama dama

whales and dolphins

INFRAORDER: Cetacea ORDER: Cetartiodactyla **CLASS:** Mammalia **SUBPHYLUM:** Vertebrata

This fascinating group includes the blue whale—the largest animal that has ever lived—and the dolphins, which have an intriguing nonprimate intelligence. They evolved from a common ancestor with the hoofed artiodactyls (see p.379) around 50 million years ago. The cetacean forelegs are flippers, while all that remains of the hind legs are small internal bones. The flattened tail fluke, which powers swimming, is made from cartilage. Cetaceans breathe at the surface through a blowhole on the top of the head—they have no nose. Around 35 million years ago, the group split into two suborders: the toothed whales and baleen whales. The latter includes the biggest cetacean species, which filter food from a mouthful of water by squeezing it through a sieve of baleen plates that line the gums in place of teeth. The toothed whales include the dolphins (including the orca, or killer whale), porpoises, sperm whales, beaked whales, and the narwhal and beluga. All cetaceans use sounds to communicate, and the dolphins use a waxy lobe in the head to focus sounds into beams that work as part of a sonar system and can even stun prey.

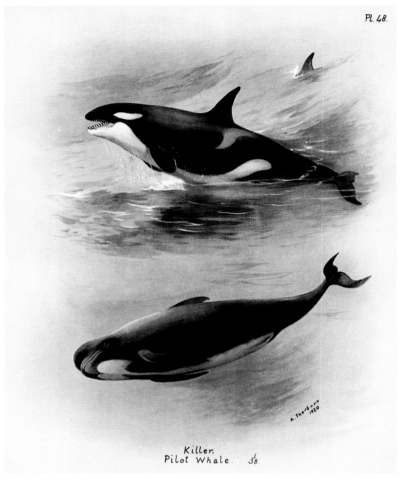

Orca and pilot whale
The orca, *Orcinus orca* (top), is the largest of the dolphin family, followed by the pilot whales *Globicephala* spp. (bottom). All both have worldwide ranges.

Amazon river dolphin
Inia geoffrensis

Harbor porpoise
Phocoena phocoena

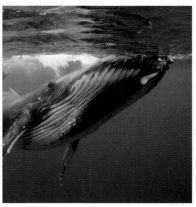

Humpback whale
Megaptera novaeangliae

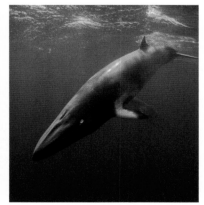

Common, or northern, minke whale
Balaenoptera acutorostrata

tinamous

ORDER: Tinamiformes **CLASS:** Aves **SUBPHYLUM:** Vertebrata

Round-bodied, short-legged, and small-headed, tinamous resemble gamebirds, especially Old World francolins, but with a longer, slender bill. They live in grasslands and rain forests, from sea level to 16,000 ft (5,000 m) in South America, north to Mexico, with the greatest diversity found in the Amazon basin. They can fly, but rarely do so, seeming to tire easily, having the smallest hearts and lungs of any bird relative to their bodyweight. They crouch and "freeze," or run when threatened. Each species has its own distinctive flutelike call. In most species, females visit the territories of several males. They each lay eggs in a single nest in each territory, leaving the male to incubate a clutch comprising eggs from a number of females.

Bartlett's tinamou
Crypturellus bartletti is native to the seasonally flooded forest and shrubby thickets of the western Amazon basin.

ostriches

ORDER: Struthioniformes **CLASS:** Aves **SUBPHYLUM:** Vertebrata

Three closely similar species of the African savannas, the world's largest birds, weigh up to 320 lb (145 kg), stand 9 ft (2.8 m) tall and can run at 44 mph (70 kph). They lay the largest eggs, have the largest eyes of any land vertebrate— 2 in (5 cm) in diameter—uniquely have only two toes, the larger inner one with a broad, hooflike claw, and live for 40 years or more. Ostriches lack the tiny hooks on the barbules that hold typical feathers together, so their plumage is loose but serves as excellent insulation, but it may become sodden in rain. Spreading the wings exposes bare skin, which helps dissipate heat. Wing spreading also aids balance in dashing, twisting runs. Males fight for territories and pair with up to three females, which lay eggs in a single nest.

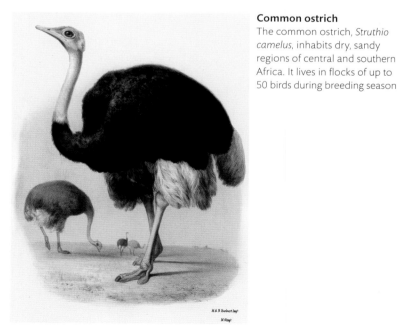

Common ostrich
The common ostrich, *Struthio camelus*, inhabits dry, sandy regions of central and southern Africa. It lives in flocks of up to 50 birds during breeding season.

rheas

ORDER: Rheiformes **CLASS:** Aves **SUBPHYLUM:** Vertebrata

Rheas, ostriches, cassowaries, emus, and kiwis are all thought to derive from a common flightless ancestor that lived before the continents separated. Rheas are flightless but fast-running birds of South American grasslands and savanna—habitats that are under threat. Rheas look similar to ostriches (some taxonomists now group them with ostriches), but are smaller. Greater rheas (*Rhea americana*) can reach 5½ft (1.7 m) in height, while lesser rheas (*Rhea pennata*) reach about 3 ft (1 m). Male rheas attract females with booming calls and mate with up to 12 partners, all of which lay eggs in his nest. The male usually incubates the eggs, but some leave the task to a subordinate male and find a new harem of females. Like ostriches, rheas form flocks outside the breeding season.

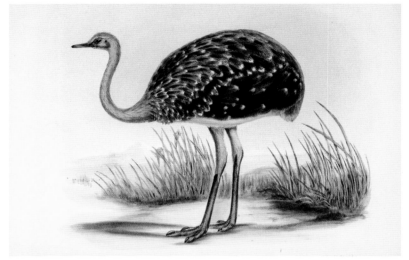

Darwin's rhea
The lesser rhea (*Rhea pennata*) is also sometimes called Darwin's rhea, after Darwin's description of the species in his book *The Voyage of the Beagle.*

cassowaries and emus

ORDER: Casuariiformes **CLASS:** Aves **SUBPHYLUM:** Vertebrata

These large flightless birds of Indonesia, Papua New Guinea, and Australia have shorter necks and legs than ostriches or rheas. Cassowaries weigh up to 187 lb (85 kg) and can reach 6 ft (1.8 m) tall. They have a high, bony casque on the head and a long, daggerlike claw on the inner toe. Males build nests and incubate the eggs.

Emus are slightly taller but lighter in weight. They lead nomadic lifestyles, wandering over long distances, and can reach nearly 31 mph (50 kph) in a sprint. They prefer open woodland and grassland and usually live in small, loose groups, with high densities on sheep and cattle ranches. Females fight for the fittest males and may produce several clutches in a season. Males incubate the eggs for eight weeks, during which time they seldom feed.

Southern cassowary
The most widespread of the three cassowary species, the southern cassowary (*Casuarius casuarius*) is found in New Guinea, Australia, and the Aru Islands. Females are larger and even more brightly colored than males.

kiwis

ORDER: Apterygiformes **CLASS:** Aves **SUBPHYLUM:** Vertebrata

New Zealand's flightless birds became isolated after the islands separated from Antarctica some 70 million years ago. The giant, flightless moas were hunted to extinction, but the smaller, more secretive kiwis survived. These ususual birds measure up to 2 ft (65 cm) long and have a long, slender bill, fluffy plumage, no tail, minute wings, and short, sturdy legs. Although nocturnal, kiwis have very poor vision but large earholes that can be directed toward sounds. They have an acute sense of smell, with nostrils located at the tip of a bill used to probe for food in leaf litter—an activity accompanied by snuffling sounds as debris is blown out of the nostrils.

Kiwis form lifelong pairs attached to a territory and sleep by day in burrows up to 6½ ft (2 m) long. At night they separate to forage, calling frequently—singly or in duets—with long, shrill whistles that can be heard from more than ½ mile (1 km) away. Females lay 2–3 eggs that are four times as big as expected for birds of their size and have exceptionally large yolks. The eggs are incubated for 2–3 months, the long period a consequence of the bird's unusually low body temperature.

Little spotted kiwi
The smallest of the five kiwi species, the little spotted kiwi (*Apteryx owenii*) is now extinct on mainland New Zealand due to predation by cats and other introduced mammals. It survives on a small number of offshore islands.

Southern brown kiwi
Apteryx australis

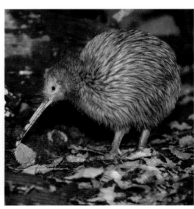

North Island brown kiwi
Apteryx mantelli

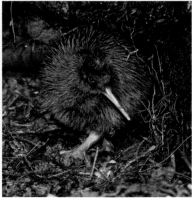

Okarito kiwi
Apteryx rowi

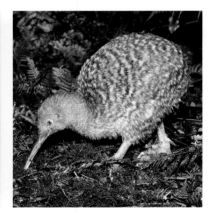

Great spotted kiwi
Apteryx haastii

waterfowl

ORDER: Anseriformes **CLASS:** Aves **SUBPHYLUM:** Vertebrata

Waterfowl exploit aquatic habitats all over the world, from streams and ponds to coasts. Most are powerful fliers, with some species undertaking annual migrations of thousands of miles between their wintering and breeding areas. Many also form flocks that make daily movements from feeding areas to roosting sites. All have webbed feet and can swim, but many also feed on dry ground. A small number of species is flightless.

Swans are large and mostly white. The largest species, including mute and whooper swans, can weigh over 33 lb (15 kg) and are among the heaviest flying birds. Geese are smaller and variable in color. Shelducks are intermediate between geese and smaller ducks. Ducks form several groups. Dabbling ducks feed from water or on dry land; diving ducks submerge themselves; sawbills have hooked bills with serrated edges used for grasping fish.

Swans form lasting pair bonds and cooperate when breeding. Male ducks are in courtship plumage long before the nesting season, when they become dull and flightless, leaving females to incubate eggs and care for the young alone.

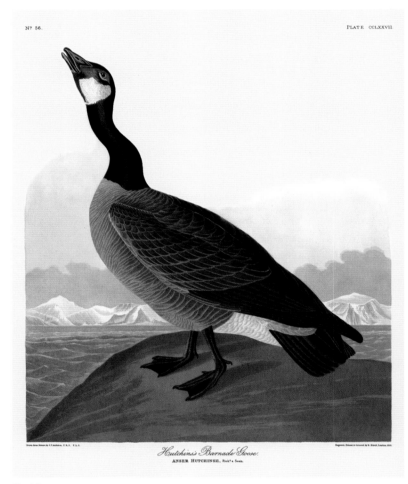

Cackling goose
The cackling goose (*Branta hutchinsii*) is a close relative of the larger Canada goose, which shares a similar white chinstrap. It breeds in the Canadian Arctic and overwinters in much of North America. This 1835 engraving first appeared in J.J. Audubon's *The Birds of America*.

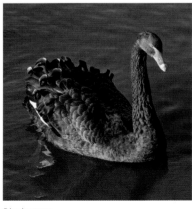

Black swan
Cygnus atratus

Egyptian goose
Alopochen aegyptiaca

Mallard
Anas platyrhynchos

Horned screamer
Anhima cornuta

gamebirds

ORDER: Galliformes **CLASS:** Aves **SUBPHYLUM:** Vertebrata

From tiny quails and small partridges to massive woodland grouse and wild turkeys, gamebirds all have small but strong, curved or hooked bills; short legs (bare or feathered, some with a strong spur); rather rotund bodies; and broad bowed wings. Several species have large, rounded tails, variously shaped ornamental tail feathers, or very long, tapered, stiff, or drooping tails up to almost 6½ ft (2 m) long.

 Gamebirds mostly live on the ground but several also feed or roost in trees. Habitats range from forest to open plains and mountains. Some species are monogamous; in others, females raise chicks alone. Some gamebirds display in "leks," where males engage in ritualized fighting at traditional sites, while females look on.

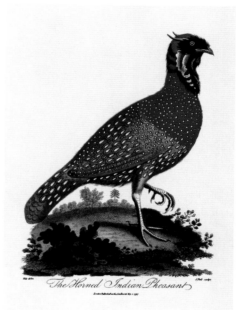

Satyr tragopan
A Himalayan resident, the satyr tragopan (*Tragopan satyra*) lives in montane forests. Males develop a brightly colored throat wattle in the breeding season.

loons

ORDER: Gaviiformes **CLASS:** Aves **SUBPHYLUM:** Vertebrata

Loons range widely around the Northern Hemisphere, breeding on lakes and sometimes feeding at sea, close to the shore. They prey on a variety of aquatic creatures, including fish. They have heavy but streamlined bodies up to 3 ft (90 cm) long; daggerlike bills with neither hook-tips nor serrations; short legs with webbed feet; and narrow wings that give little maneuverability. All have striking breeding plumage but are dark above and white below for most of the year. The feet are far back and used for underwater propulsion, with wings closed, but are almost useless on land. Loons may submerge for up to eight minutes and can swim as deep as 250 ft (75 m). They are monogamous and territorial, and both sexes incubate their two eggs and care for the chicks.

Common Loon
Also called the northern diver, the common loon (*Gavia immer*) lives among the lakes and waterways of North America and northern Europe.

penguins

ORDER: Sphenisciformes **CLASS:** Aves **SUBPHYLUM:** Vertebrata

Penguins are flightless, marine except when breeding, and adapted to fast underwater pursuits of fish, krill, and squid. Penguin beaks have evolved in shape and length to target their preferred prey items. Larger species dive to 870 ft (265 m) and remain underwater for around 7 minutes. The body is streamlined (reducing resistance in the water), wings modified to flippers; the short legs are so far back on the body that penguins stand and walk upright. All penguins are dark above, white beneath, with thousands of feathers that overlap like pointed scales, providing waterproofing and insulation in the absence of underlying down. Leaving cold water to stand in sunshine presents problems: feathers are raised to reduce heat, or compressed over a layer of air to maintain warmth. Not all penguins live in cold regions of the world, however; the Galapagos penguin actually lives near the equator. Most penguin species are colonial, some breeding together in many thousands of pairs far from open water. Both parents incubate the egg – one or two eggs, depending on the species – and feed the hatchlings in turn. In some species, only one chick will survive.

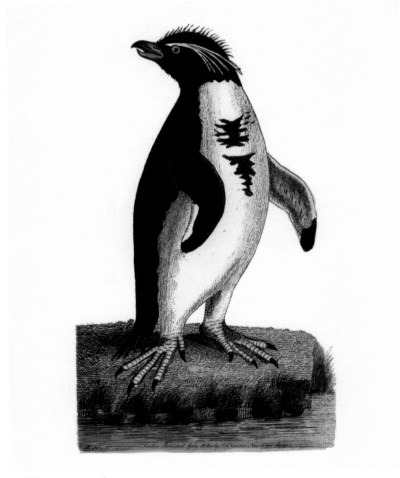

Rockhopper penguin
This early engraving of a rockhopper penguin (*Eudyptes chrysocome*) is from George Shaw and Frederick Nodder's *The Naturalist's Miscellany*, 1800.

Emperor penguin
Aptenodytes forsteri

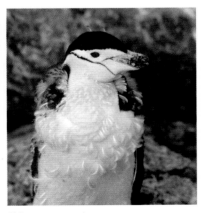

Chinstrap penguin
Pygoscelis antarcticus

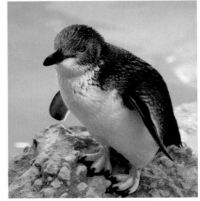

Little, or blue, penguin
Eudyptula minor

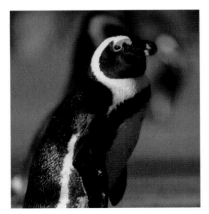

African, or Jackass, penguin
Spheniscus demersus

albatrosses, petrels, and shearwaters

ORDER: Procellariiformes **CLASS:** Aves **SUBPHYLUM:** Vertebrata

The "tubenoses" are marine birds with an acute sense of smell and also use their tubular nostrils to excrete excess salt. Albatrosses have heavy bodies but long, narrow wings, spanning up to 11½ ft (3.5 m); small petrels are as little as 6 in (15 cm) long with a wingspan under 16 in (40 cm). All have difficulty walking; smaller petrels flap, glide, and patter over the water surface, while larger ones exploit air currents over wavetops and strong winds, banking steeply to "catch the wind" then glide down, eventually covering huge distances. They feed on fish, crustaceans, squid, and plankton and are severely threatened by hook-and-line fisheries that kill large numbers. Albatrosses nest on cliffs and flat islands, while most smaller species nest in burrows or crevices, coming to land only after dark.

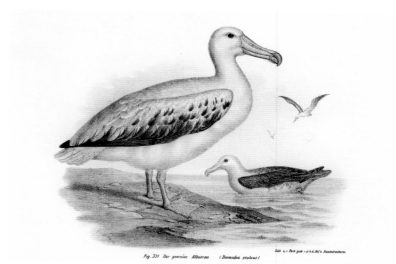

Wandering albatross
The wings of *Diomedea exulans* span more than any other bird. Catching updrafts from wave crests, it can circumnavigate the Southern Ocean three times in a single year,

grebes

ORDER: Podicipediformes **CLASS:** Aves **SUBPHYLUM:** Vertebrata

Like loons (see p.385), grebes are entirely aquatic and unable to walk on land, with legs set far back on the body, slender, pointed bills, heavy bodies, and tiny tails. Despite their small wings and apparently laborious flight, they migrate long distances. The toes are not webbed but have broad lobes on each side; the leg is flattened and the lobes fold back to reduce resistance in water, but spread on the backstroke for propulsion. Grebes' dense plumage gives good insulation and waterproofing. They swallow a few feathers to create balls in the stomach, preventing damage by fish bones. Breeding plumage includes head adornments used in territorial and courtship rituals. Nests are semifloating piles of waterweed, some of which may be heaped over the eggs when the birds are absent.

Great crested grebe
Although J. J. Audubon pictured this grebe, *Podiceps cristatus*, in his *Birds of America* (1838), he was mistaken—it has never lived in America. It lives only in Eurasia, Africa, and Australasia.

flamingos

ORDER: Phoenicopteriformes **CLASS:** Aves **SUBPHYLUM:** Vertebrata

Standing up to 5 ft (1.55 m) tall, flamingos are waders and uniquely equipped with a deep, angled bill, an extremely long neck, and elongated legs. A thick tongue pumps water through rows of bony plates (see p.187) extracting tiny algae, diatoms, and aquatic invertebrates. Their leg length gives flamingos access to deeper water than other waders—they can also swim and even upend to reach their food. They breed in colonies, by fresh- and saltwater lakes ranging from sea level to altitiudes of 14,764 ft (4,500 m) in the Andes. Some species exploit extreme conditions with highly alkaline water, hot springs, or sites exposed to very high temperatures. Some African colonies number more than a million pairs, but breeding is erratic, since birds settle only if conditions are suitable.

American flamingo
Also called the Caribbean flamingo, *Phoenicopterus ruber* is found in South America, Caribbean islands, and the Yucatán Peninsula of Mexico.

storks, herons, and relatives

ORDER: Ciconiiformes **CLASS:** Aves **SUBPHYLUM:** Vertebrata

Storks, herons, and ibises are upstanding, long-legged, dagger-billed, mostly waterside birds. Some experts now place herons and ibises in the Pelecaniformes, leaving storks alone in this order. Many herons are fish-eaters. They either stalk prey or stand still, waiting for fish to approach, then use their long neck, kinked to give a rapid strike, to grasp prey with their bill. Storks also use drier habitats, feeding on small prey or carrion. Despite their long legs and large, broad wings, herons nest in treetop colonies, while storks build huge nests in tall trees or on buildings, or specially provided structures. Herons fly with their head withdrawn, legs trailing, and wings bowed. Storks fly with their neck outstretched, and soar on flat wings like vultures, circling to gain height.

Wood stork
This plate from Audubon's *Birds of America*, features the wood stork, once called the wood ibis (although it is not an ibis), *Mycteria americana*. It is found in tropical habits of the Americas.

pelicans

ORDER: Pelecaniformes **CLASS:** Aves **SUBPHYLUM:** Vertebrata

This was originally a large, diverse group, encompassing cormorants and tropicbirds. However, the similarities between these types appear to be due to convergent evolution, rather than common ancestry, so this order is now reduced to pelicans (and often herons, ibises, spoonbills, and shoebills). Pelicans have long bills with large, extendible throat (gular) pouches that sweep up water as they swim—water then spills out, leaving fish and aquatic prey behind. Their long, angular wings have a more mobile humerus than most birds, giving them a particularly long span (up to 12 ft/3.6 m), which lifts their great weight (males can be up to 26 lb/12 kg). Their short legs have leathery feet with all four toes connected by webs. They breed in colonies on the ground or in trees.

Brown pelican
This North American bird, *Pelecanus occidentalis*, is unusual among pelicans in that it feeds by plunge-diving into the water rather diving from the surface.

gannets, cormorants, and relatives

ORDER: Suliformes **CLASS:** Aves **SUBPHYLUM:** Vertebrata

Birds in this ancient order have all four toes joined by a broad web and all eat fish. Gannets and boobies have daggerlike bills and heads padded with air sacs that provide protection when they plunge headlong 98 ft (30 m) or more into the sea. All are social, gannets breeding in cliff-ledge colonies comprising tens of thousands of birds. Frigatebirds have hooked bills, tiny feet, extremely long, angular wings, and deeply forked tails that provide the agility needed to steal food from other seabirds in the air and catch flying fish—because they cannot settle on water. Cormorants and shags both swim, diving from the surface to catch fish, in salt- and freshwater, and nest both on cliffs and in trees; humans sometimes exploit island colonies for deposits of nitrogen-rich droppings (guano).

Double-crested cormorant
Like all cormorants, the feathers of this bird, *Phalacrocorax auritus*, are not waterproof, and it must spend time drying them out after diving.

birds of prey

ORDER: Accipitriformes **CLASS:** Aves **SUBPHYLUM:** Vertebrata

Diurnal birds of prey are extremely varied: many take live prey, while others feed on dead animals. New World and Old World vultures are not related, but have evolved similar long, broad wings suited to long-range gliding, and have weak feet that are not suitable for killing or grasping prey. They feed on dead animals, often found by scent, while others follow; some open carcasses with large bills, and others then take advantage. Wingspans of up to 10 ft (3 m) exploit warm, rising air to gain height before gliding long distances with little effort. Eagles can be large, and are associated with water, forest, or mountainous country. Buteos are smaller, thickset, but soar well. Bird-eating hawks are shorter-winged, lending speed and maneuverability in tighter spaces. Specialized species include the secretary bird, which kills snakes with its feet, the harrier, with "double-jointed" legs that reach into birds' nest holes in trees, and honey-buzzards, which feed on wasp nests. All have excellent eyesight and use their feet to catch prey and their bills to dismember it. Vultures, eagles, and hawks build large nests on ledges or in trees, but some vultures lay eggs on bare ledges.

Golden eagle
One of the best-known birds of prey, the golden eagle (*Aquila chrysaetos*), is monogomous. It builds its nest in high cliffs and it often returns there for several years.

Bald eagle
Haliaeetus leucocephalus

Red kite
Milvus milvus

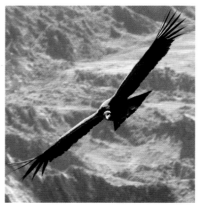

Andean condor
Vultur gryphus

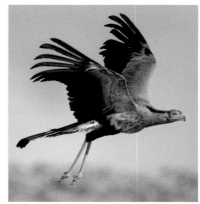

Secretary bird
Sagittarius serpentarius

bustards and relatives

ORDER: Otidiformes **CLASS:** Aves **SUBPHYLUM:** Vertebrata

Bustards, korhaans, and floricans are medium to very large terrestrial birds that live in dry steppe grasslands, farmland, or savanna, and eat small mammals, reptiles, insects, roots, shoots, and seeds. Most are threatened by habitat loss, some by hunting. Two bustard species are amongst the heaviest flying birds in the world, weighing up to 44 lb (20 kg), with a wingspan of more than 8 ft (2.5 m). Males are bigger than females and have more contrasting, barred plumage, and reveal white wing patches in flight. Males mate with up to five females and fight for dominance at "leks" (see p.125), fanning the wings to show white areas in a visually striking display. Females incubate the eggs alone—adult males mostly live separately from females and young birds.

Male great bustard
Native to Europe and Asia, the great bustard (*Otis tarda*) is one of the heaviest flying animals. Asian birds migrate 2,500 miles (4,000 km) south in winter.

cranes, rails, and relatives

ORDER: Gruiformes **CLASS:** Aves **SUBPHYLUM:** Vertebrata

This order is a grouping of cranelike birds, which ranges from the largest cranes—standing up to 6 ft (1.8 m) tall with a wingspan of 8 ft (2.5 m)—to the tiny, elusive rails and crakes only 5 in (12 cm) long. Cranes are long-necked, but relatively short-billed birds of marshland and open grassland and fly with flat wings and their necks outstretched. Crakes and rails are associated with water, some are ducklike and swim, others are long-toed and slender-bodied, and creep in dense swamp vegetation; a few are flightless. Near relatives include trumpeters, chickenlike forest birds of South America; small, rail-like flufftails of southern Africa and Madagascar; and three species of streamlined, long-billed waterbirds—the finfoots, of southern Asia, Africa, and South America.

Whooping crane
This crane (*Grus americana*) is the tallest North American bird and can be up to 5 ft (1.6 m) tall. It is named for the distinctive whooping sound it makes

waders, gulls, and auks

ORDER: Charadriiformes **CLASS:** Aves **SUBPHYLUM:** Vertebrata

Waders have unwebbed toes, long legs, and bills ranging from short to very long, straight, downcurved, or upswept. Long-billed species probe mud; shorter-billed ones pick invertebrates from mud, sand, or soil. Most are long-distance migrants. Gulls, terns, skuas, and auks have webbed toes. Gulls have robust bills, walk and swim, and exploit varied habitats, from open sea and shores to urban areas and farmland. Terns do not walk, and feed by diving or dipping to water from the air. Skuas, which steal food from other seabirds, and auks are marine. Auks' bills are short or rather long and pointed, some with colorful sheaths in the breeding season. They dive for food, using their wings for propulsion. Most species are social; some nest in colonies on shorelines, marshes, or coastal cliffs.

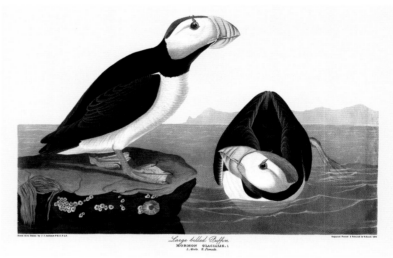

Horned puffin
Now known as the horned puffin (*Fratercula corniculata*), J.J. Audubon called this small, colorful auk the large-billed puffin in his *Birds of America* (1838).

pigeons and doves

ORDER: Columbiformes **CLASS:** Aves **SUBPHYLUM:** Vertebrata

Fruit- and seed-eating birds of forest, savanna, and open ground, pigeons and doves have short, soft bills, often with a fleshy patch at the base, round heads, and short legs. Most are rounded and round-tailed, but a few have crests or longer tail plumes. Many pigeons have an iridescent patch on the neck; doves more often have a thin collar or a patch of streaks. Rock doves have long been domesticated, and free-flying descendants (feral pigeons) are abundant worldwide. Pigeons have far-carrying cooing songs but few or no flight or alarm calls; some doves call in flight, and have distinctive, repetitive and often rhythmic cooing songs. They build flimsy nests in trees or rocky cavities and feed their chicks on "pigeon milk," a secretion from the crop (a pouch in the throat).

Nicobar pigeon
This 1834 illustration labeled Chinese tippeted pigeon (*Columba gouldiae*), is of a species now known as the Nicobar pigeon, *Caloenas nicobarica*—an Indian Ocean island species that is the closest living relative of the dodo.

cuckoos

ORDER: Cuculiformes **CLASS:** Aves **SUBPHYLUM:** Vertebrata

This group includes typical cuckoos, around 50 of which are brood-parasites, laying eggs in nests of other species. Their eggs are often small in relation to the parent and match those of their much smaller hosts. The majority of this group, however, make nests of their own, like most birds. New World roadrunners are terrestrial, longer-legged, and crested; Old World coucals are long-tailed and heavily built birds of low thickets and nearby open ground. Anis are New World birds, like blackish, thick-billed cuckoos. All have zygodactyl feet (with two backward-facing toes). Some feed on hairy caterpillars that other birds avoid: they may regurgitate their stomach linings at intervals to get rid of irritating caterpillar hair. They have distinctive, simple, and repetitive songs.

Great spotted cuckoo
John Gould made this illustration of *Clamator glandarius* for his book, *The Birds of Great Britain* (1862–1873). It breeds in the Mediterranean and Africa and is rarely seen in Britain.

turacos

ORDER: Musophagiformes **CLASS:** Aves **SUBPHYLUM:** Vertebrata

Once grouped in the cuckoo order Cuculiformes, turacos and go-away birds (named after their calls) make a distinct group with similarities in form and behavior. They are fruit eaters, although they occasionally take insects and grubs. Confined to Africa, they share several features with the cuckoos, including zygodactyl foot structure, which helps them run through forest canopies. Turacos, also known as loeries in southern Africa, are colorful birds of treetops, where they build large nests. The green color in their brightly colored plumage, which often includes crests, is derived from turacoverdin, a copper-based pigment unique among birds. Go-away birds and the similar plantain-eaters are generally smaller, duller, and grayer species of bushy savanna.

Guinea turaco
This illustration from the 1780s bears Linnaeus's original name for the Guinea turaco (now *Tauraco persa*), *Cuculus persa*. *Cuculus* is the genus of true cuckoos, and shows the close affinity people ascribed to cuckoos and turacos at the time.

Cuculus Persa, Linn:
Le Touraco.

owls

ORDER: Strigiformes **CLASS:** Aves **SUBPHYLUM:** Vertebrata

Some owls of open habitats feed by day, others are active by day but feed at dawn and dusk, and certain species are active only after dark. All have rounded heads and large, fixed, forward-facing eyes give binocular vision, but they must turn their heads to see around them. Owls are far-sighted and see little detail in poor light, but they are sensitive to movement. The bill is strongly hooked, typically hidden in deep feathering between flat "disks" around each eye that help direct sound into the ears. Hearing is very sensitive: ears are often asymmetrical, which allows greater accuracy in locating prey, even in pitch darkness. All have a mobile outer toe, often turned backwards; bigger species kill prey such as birds and small mammals with their long, curved claws. Even large species, however, also take insects and earthworms. Prey is swallowed whole; indigestible material, from beetle wing cases to bones and hair, is regurgitated in cohesive pellets, either randomly or under daytime roosts. Many owls are strictly territorial and sedentary, learning their home range in great detail; others are nomadic, settling wherever food is abundant (as in periodic "vole plagues").

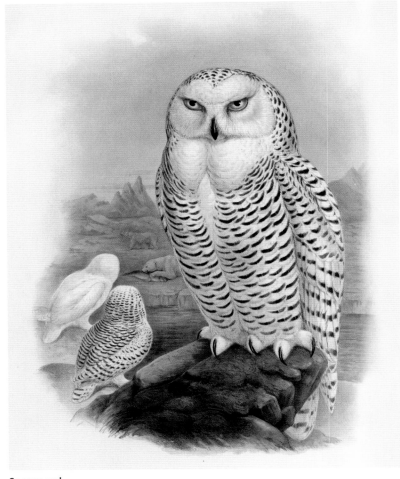

Snowy owl
The largest North American owl by weight, the snowy owl (*Bubo scandiacus*) spends summer hunting lemmings and other prey in the 24-hour daylight north of the Artcic Circle.

Eurasian eagle owl
Bubo bubo

Little owl
Athene noctua

Barn owl
Tyto alba

White-faced scops owl
Ptilopsis granti

nightjars and frogmouths

ORDER: Caprimulgiformes **CLASS:** Aves **SUBPHYLUM:** Vertebrata

Nightjars are slim-bodied, long-winged birds; their long, broad, twisted tails give extra agility in flight, helping them catch airborne insects in wide, bristle-fringed mouths. Their legs and bills are tiny; they perch along branches rather than across them, or crouch on the ground, to exploit their camouflage of dead-wood colors and patterns. The patches of white on the wings and tail are often more striking on males. The birds are active at twilight and can be located by their loud, distinctive songs, from short, liquid phrases to long, churring trills. Frogmouths are similar, but with larger heads and wider mouths they take small mammals and reptiles. They, too, are well camouflaged: perched more upright on branches, they are easily overlooked as broken stumps.

Nacunda nighthawk
The nacunda nighthawk (*Chordeiles nacunda*) is the largest of the nightjars and also unusual for its partly diurnal habits.

hummingbirds and swifts

ORDER: Apodiformes **CLASS:** Aves **SUBPHYLUM:** Vertebrata

Hummingbirds and swifts have a ball-and-socket joint that allows the humerus to rotate lengthwise, rather than swing up-and-down, to create a wingbeat. With this, and a bladelike wing, a hummingbird can hover to feed and fly backward from a flower after feeding. Most probe for nectar: long, curved bills match the size and shape of particular blossoms; shorter bills give access to a broader spectrum of flowers, some being pierced at the base. They also eat insects to obtain calcium for forming eggs. Swifts are exclusively aerial. Like hummingbirds, they have flexible necks, enabling them to react rapidly and snatch flying prey in the mouth. All toes point forward: swifts cannot perch, but instead cling to upright surfaces to roost or when nesting in cavities or palm fronds.

Mango hummingbird
This plate from Audubon's *Birds of America* shows mango hummingbirds (*Anthracothorax* sp.) using their long bills to probe flowers for sweet nectar.

trogons and quetzals

ORDER: Trogoniformes **CLASS:** Aves **SUBPHYLUM:** Vertebrata

Found in tropical forests worldwide, trogons are upright, medium-sized birds, often motionless and elusive in the forest canopy. They have wide mouths, broad bills, and short legs. Food is fruit and insects: like cuckoos, but unlike other birds, they can eat hairy caterpillars. Some species catch insects in flight in brief sallies from a perch. They have two backward-pointing toes, uniquely the third and fourth digits (not first and second, as in parrots and cuckoos). They are soft-plumaged and colorful (mostly greens, red, and white, with black-and-white barring on wings and tail). Nests are in burrows in rotten branches or termite hills (one species uses old wasp nests). Quetzals have extremely long, glittering tail plumes, used in high, fluttering display flights above the forest canopy.

Narina trogon
The Narina trogon (*Apaloderma narina*) is native to tropical Africa. The female lacks the vivid crimson breast of the male (shown here).

kingfishers, bee-eaters, rollers, and relatives

ORDER: Coraciiformes **CLASS:** Aves **SUBPHYLUM:** Vertebrata

Many members of this diverse order are Old World birds, although kingfishers are globally widespread and the few motmots and todies are New World species. Most have two toes fused together for much of their length. Kingfishers are upright, long-billed, and short-tailed, and most are dry-land birds, eating insects; a few dive into water for fish and aquatic invertebrates. Bee-eaters catch bees and wasps on the wing in their long, curved bills. The larger, stout-billed rollers feed by dropping from a perch onto large insect prey on the ground or in flight over forests; like the rest of this order, they are unable to run or walk on the ground. Neotropical motmots are like sleek, colorful rollers; some species of both groups have elongated, racquet-tipped central tail feathers.

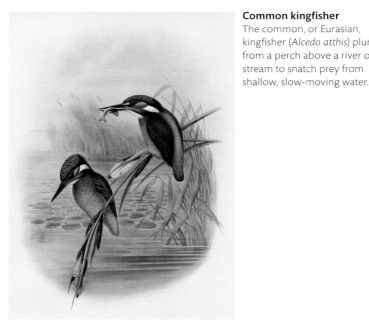

Common kingfisher
The common, or Eurasian, kingfisher (*Alcedo atthis*) plunges from a perch above a river or stream to snatch prey from shallow, slow-moving water.

hornbills and hoopoes

ORDER: Bucerotiformes **CLASS:** Aves **SUBPHYLUM:** Vertebrata

The hoopoe is a ground-living, boldly barred and crested species. Of its six or eight subspecies, two are sometimes considered full species. The related wood hoopoes and scimitarbills form a separate group of nine glossy, long-tailed species with metallic plumage but without crests. While the hoopoe's long bill probes the soil for insects, wood hoopoes use theirs to probe rotten wood and bark crevices in forest and savanna trees. Hornbills are mostly forest or savanna woodland birds, but the very large ground hornbills form a separate subgroup. They all have long, tapered bills, some adorned with decorative casques. The length and fine-but-strong tips aid feeding, but the color and shape are clearly for show and largely related to species recognition and display.

Black hornbill
Large fruits are the main food of the black hornbill (*Anthracoceros malayanus*), which inhabits lowland forests in parts of Southeast Asia.

woodpeckers, honeyguides, and relatives

ORDER: Piciformes **CLASS:** Aves **SUBPHYLUM:** Vertebrata

These birds of forest or woodland, some of which also feed on the ground, have a zygodactyl toe arrangement (two pointing forward, two backward), apart from some three-toed woodpeckers. Woodpeckers use their stiff tail feathers as a prop when clinging upright to a tree or seeking out ants on the ground. All Piciformes nest in cavities; woodpeckers chisel holes in trees. Barbets are widespread tropical birds, colorful and noisy, mostly shorter-billed than woodpeckers, some associated with termites. Neotropical jacamars, with long, straight, thin bills and long tails, are closely related to the kingfisher-like puffbirds. African honeyguides can digest beeswax, and some species call to "guide" mammals to bees' nests so that the nests are broken open and made accessible.

Toucan
A huge, colorful, yet lightweight bill is the distinguishing feature of the Neotropical toucans (Ramphastidae family). These Piciformes are most closely related to American barbets. The bill gives the birds an extended reach when plucking fruit from trees.

falcons and caracaras

ORDER: Falconiformes **CLASS:** Aves **SUBPHYLUM:** Vertebrata

Like other birds of prey, falcons have sharp, hooked bills that dismember prey, but they have a "tooth" on the upper mandible that helps kill small mammals (other birds of prey kill with their feet). Many smaller falcons eat mainly insects. They soar and glide, some twisting to catch aerial insects with the feet. Certain species "stoop" onto birds in fast dives. Others hover and scan below: their eyes, being sensitive to near-ultraviolet, can detect rodent urine trails. Falcons make no nest but lay eggs on ledges, in cavities, or in the old nests of other birds.

Caracaras behave like vultures but they are really closely related to falcons. They eat carrion, but also take birds, reptiles, amphibians, and insects. These aggressive birds will keep vultures at bay when feeding at carcasses.

Gyrfalcon
The gyrfalcon (*Falco rusticolus*), depicted in this engraving from Audubon's *Birds of America*, mainly hunts other birds. Like all falcons, the gyrfalcon has long, arched claws that it uses to grasp and pierce live prey.

parrots, parakeets, lovebirds, and relatives

ORDER: Psittaciformes **CLASS:** Aves **SUBPHYLUM:** Vertebrata

From slender budgerigars and dumpy African lovebirds to large cockatoos and macaws, all birds in this tropical and subtropical group have deeply hooked bills, topped by a fleshy patch. Tails are short and square or long and pointed. Strong feet share a two-toes-forward, two-back (zygodactyl) configuration with groups such as cuckoos; the feet are used to cling acrobatically to perches and grasp food. Australasian cockatoos—white, or black with red crests—are noisy and broad-winged, often flying high over forests. South America is home to large-billed, colorful macaws; large, green "Amazon" parrots; and parakeets, some multicolored. Fruit, roots, seeds, and insects are typical foods, but New Zealand's kea occasionally uses its long bill to feed on dead animals.

Scarlet macaw
Macaws, such as this scarlet macaw (*Ara macao*) are the biggest of the Psittaciformes order. The large bill is used to break open hard nuts.

ARARA MACAO ____ SCARLET MACAW

passerines

ORDER: Passeriformes **CLASS:** Aves **SUBPHYLUM:** Vertebrata

The hugely diverse passerines, described as songbirds or perching birds, make up the largest order of birds, with more than half the total number of species. They are characterized by a three-toes-forward, one-back arrangement of the feet. Groups such as thrushes, bulbuls, and tits are widespread; others, such as rockfowl and wattlebirds, are very restricted in range. Oscines, with complex muscles controlling the syrinx, count the finest songsters among their members (as well as crows that may merely croak). The suboscines include tropical forest groups such as pittas, broadbills, antbirds, and antthrushes. The largest passerines are ravens, as big as larger buteos; the smallest are tiny kinglets, smaller than many hummingbirds. Food varies from live animals or carrion to nectar. Small species tend to eat seeds but feed nestlings on insects. Bills may be slim in species that glean from leaves, wider and bristle-edged in catchers of flying insects, short and stout in birds with a more generalized diet, or stout and conical in species that crack or peel seeds. Crossbills' crossed mandibles pry open cones, so they can scoop out seeds with the tongue.

Black-billed magpie
This plate from Audubon's *Birds of America* shows the black-billed, or American, magpie (*Pica hudsonia*), a member of the crow family known for its raspy, chattering call.

Andean cock-of-the-rock
Rupicola peruviana

Scarlet-chested sunbird
Nectarinia senegalensis

European goldfinch
Carduelis carduelis

Yellow warbler
Setophaga petechia

glossary

ABDOMEN The hind part of the body, lying below the ribcage in mammals, and behind the thorax in arthropods.

ABORAL The region of the body that is farthest from the mouth, especially in animals that do not have an obvious upper and lower side, such as echinoderms.

ADIPOSE FIN A small fin lying between the dorsal and caudal (tail) fins of some fishes.

ALULA A small, bony projection that forms the first digit, or "thumb," on a bird's wing.

AMPLEXUS A breeding position adopted by frogs and toads, with the male using its front legs to hold the female. Fertilization usually occurs outside the female's body.

AMPULLARY ORGANS Special sensing organs made up of jelly-filled canals containing electroreceptors, which help some fishes—especially sharks, rays, and chimaeras—detect prey.

ANTENNA (pl. ANTENNAE) A sensory feeler on the head of an arthropod. Antennae always occur in pairs, and they can be sensitive to touch, sound, heat, and also taste. Their size and shape varies according to the way in which they are used.

ANTLER A bony growth on the head of deer. Unlike horns, antlers often branch, and in most cases they are grown and shed every year, in a cycle linked with the breeding season.

APOSEMATIC See *Warning coloration*.

ARBOREAL Living fully or partly in trees.

ARTHROPOD A major group of invertebrate animals, with jointed legs and a hard outer skeleton. It includes crustaceans, insects, and spiders.

ARTICULATION A joint—for example, between adjacent bones.

ASEXUAL REPRODUCTION A form of reproduction that involves just one organism. Asexual reproduction is most common in invertebrates, and is used as a way of boosting numbers quickly in favorable conditions. See also *Parthenogenetic, Sexual reproduction*.

BEAK A set of narrow, protruding jaws, usually without teeth. Beaks have evolved separately in many groups of vertebrates, not only birds but also tortoises and turtles, and some whales.

BILATERAL SYMMETRY A form of symmetry in which the body consists of two equal halves, on either side of a midline. Most animals show this kind of symmetry.

BILL An alternative name for a bird's beak. See also *Beak*.

BINOCULAR VISION Vision in which the two eyes face forward, giving overlapping fields of view. This allows an animal to judge depth perception.

BIPEDAL Moving on two legs.

BIVALVES Mollusks, such as clams, mussels, and oysters, that have a shell made up of two hinged halves. Most bivalves move slowly or not at all, and are filter feeders. See also *Filter feeder, Mollusk*.

BLOWHOLE The nostrils of whales and their relatives, positioned on top of the head. Blowholes can be single or paired.

BRACHIATION The arm-swinging movement used by primates, such as gibbons, to move through trees.

BREEDING COLONY A large gathering of nesting birds.

BROOD PARASITE An animal—often a bird—that tricks other species into raising its young. In many cases, a young brood parasite kills all its nest-mates, so that it has sole access to all the food that its foster parents provide.

BROWSING Feeding on the leaves of trees and shrubs, rather than on grasses. See also *Grazing*.

CALCAREOUS Containing calcium. Calcareous structures—such as shells, exoskeletons, and bones—are formed by many animals, either for support or for protection.

CAMOUFLAGE Colors or patterns that enable an animal to merge with its background. Camouflage is very widespread in the animal kingdom— particularly among invertebrates— and is used both for protection against predators and for concealment when approaching prey. See also *Mimicry, Cryptic coloration*.

CANINE TOOTH In mammals, a tooth with a single sharp point that is suited to piercing and gripping. Canine teeth are toward the front of the jaws, and are highly developed in carnivores.

CARAPACE A hard shield on the back of an animal's body.

CARNASSIAL TOOTH In mammalian carnivores, a bladelike cheek tooth that is suited to slice through flesh.

CARNIVORE Any animal that eats meat. The word carnivore can also be used in a more restricted sense, to mean mammals in the order Carnivora.

CARRION The remains of dead animals.

CARTILAGE A rubbery substance that forms part of vertebrate skeletons. In most vertebrates, cartilage lines the joints, but in cartilaginous fishes—for example, sharks—it forms the whole skeleton.

CASQUE A bony growth on the head of an animal, such as a chameleon or hornbill.

CAUDAL Relating to an animal's tail.

CELLULOSE A complex carbohydrate found in plants. Cellulose is used by plants as a building material, and it has a resilient chemical structure that animals find hard to break down. Plant-eating animals, such as ruminants, digest it with the help of microorganisms.

CEPHALOTHORAX In some arthropods, a part of the body that combines the head and the thorax. Animals that have a cephalothorax include crustaceans and arachnids.

CHEEK TOOTH See *Carnassial tooth, Molar tooth, Premolar tooth*.

CHELICERA (pl. CHELICERAE) In arachnids, each one of the first pair of appendages, at the front of the body. Chelicerae often end in pincers, and in spiders they are able to inject venom. In mites, they are sharply pointed and are used for piercing food.

CHELIPEDS Any limbs in crustaceans that bear pincers, or chela.

CHITIN A tough, fibrous substance that forms the exoskeleton of arthropods, including the shells of crabs; and the communal skeleton of some corals. See also *Exoskeleton*.

CHORDATE An animal belonging to the phylum Chordata, which includes all vertebrates. A key feature of chordates is their notochord, which runs the length of their bodies; it reinforces the body, yet allows it to move by bending.

CHRYSALIS A hard and often shiny case that protects an insect pupa. Chrysalises are often found attached to plants, or buried close to the surface of the soil.

CLASPERS A structure in some male invertebrates used to hold the female during mating; or a pair of modified pelvic fins in some male fishes, such as sharks, used to direct sperm into the female's reproductive tract. See also *Pelvic fins*.

CLASS A level used in classification. In the sequence of classification levels, a class forms part of a phylum and is subdivided into one or more orders.

CLOACA An opening toward the rear of the body that is shared by several body systems. In some vertebrates—such as bony fishes and amphibians—the gut, kidneys, and reproductive systems all use this single opening.

CLONE An asexually produced animal, genetically identical to its parent.

CLOVEN-HOOFED Having hooves that look as if they are split in two. Most cloven-hoofed mammals, such as deer and antelope, actually have two hooves, arranged on either side of a line that divides the foot in two.

COCOON A case made of open, woven silk. Many insects spin a cocoon before they begin pupation, and many spiders spin one to hold their eggs.

COLONY A group of animals, belonging to the same species, that spend their lives together, often dividing up the tasks involved in survival. In some colonial species, particularly aquatic invertebrates, the colony members are permanently fastened together. In others, such as ants, bees, and wasps, members forage independently, but live in the same nest together.

COMPOUND EYE An eye that is divided into separate compartments, each with its own set of lenses. Compound eyes are a common feature of arthropods. The number of compartments they contain varies from a few dozen to thousands.

COUNTERSHADING A type of camouflage pattern in which an animal is typically darker above and lighter beneath. It tends to counter the effect of shadows, making the animal more difficult to see.

COVERT A feather that covers the base of a bird's flight feather.

CRYPTIC COLORATION Coloration and markings that make an animal difficult to see against its background.

DACTYLUS In insects, one or more of the tarsal joints following the first, modified joint. In crustaceans, the movable finger of a pincer, which swivels up to open and down to close the claw. See also *Pincer*.

DEWLAP A fold of loose skin hanging from an animal's throat.

DIASTEMA A wide gap separating rows of teeth. In plant-eating mammals, the diastema separates the biting teeth, at the front of the jaw, from the chewing teeth at the rear. In many rodents, the cheeks can be folded into the diastema, to shut off the back of the mouth while the animal is gnawing.

DIGIT A finger or toe.

DIGITIGRADE A gait in which only the fingers or toes touch the ground. See also *Plantigrade*, *Unguligrade*.

DIPLOSEGMENT A pair of fused segments in the body of some arthropods, such as millipedes.

DORSAL On or near an animal's back.

ECHINODERMS A major group of marine invertebrates that includes starfishes, brittle stars, sea urchins, sea lilies, and sea cucumbers. Echinoderm bodies have radial symmetry. They have chalky protective plates under their skin and use hydraulic "tube feet" to move and to catch prey.

ECHOLOCATION A method of sensing nearby objects by using pulses of high-frequency sound. Echoes bounce back from obstacles and other animals, allowing the sender to build up a "picture" of its surroundings. Echolocation is used by several groups of animals, including mammals and a small number of cave-dwelling birds.

ELYTRON (pl. ELYTRA) A hardened forewing in beetles, earwigs, and some bugs. The two elytra usually fit together like a case, protecting the more delicate hindwings underneath.

EMBRYO A young animal or plant in a rudimentary stage of development.

ENDOPARASITE An animal that lives parasitically inside another (host) animal's body, either by feeding directly on its host's tissues or by stealing some of its food. Endoparasites frequently have complex life cycles, involving more than one host.

ENDOSKELETON An internal skeleton, typically made of bone. Unlike an exoskeleton, this kind of skeleton can grow in step with the rest of the body.

EPITHELIUM Covering or lining tissue that forms sheets and layers around and within many organs and other tissues in animals.

EVOLUTION Any change in the average genetic makeup of a population of living things between one generation and the next. The "theory of evolution" is based on the idea, supported by various lines of evidence, that such genetic change is not random but largely the result of natural selection, and that the operation of such processes over time can account for the huge variety of species found on Earth.

EXOSKELETON An external skeleton that supports and protects an animal's body. The most complex exoskeletons, formed by arthropods, consist of rigid plates that meet at flexible joints. This kind of skeleton cannot grow, and has to be shed and replaced (ecdysis) at periodic intervals. See also *Endoskeleton*.

FAMILY A level used in classification. In the sequence of classification levels, a family forms part of an order and is subdivided into one or more genera.

FEMUR (pl. FEMORA) The thigh bone in four-limbed vertebrates. In insects, the femur is the third segment of the leg, immediately above the tibia.

FERTILIZATION The union of an egg cell and sperm, which creates a cell capable of developing into a new animal. In external fertilization, the process occurs outside the body (usually in water), but in internal fertilization, it takes place in the female's reproductive system.

FIBULA (pl. FIBULAE) The outermost of the two lower leg or hind limb bones. See also *Tibia*.

FILTER FEEDER An animal that eats by sieving small food items from water. Many invertebrate filter feeders, such as bivalve mollusks and sea squirts, are stationary animals that collect food by pumping water through or across their bodies. Vertebrate filter feeders, such as baleen whales, collect their food by trapping it while they are on the move.

FLAGELLUM (pl. FLAGELLA) A long, hairlike projection from a cell. A flagellum can flick from side to side, moving the cell along. Sperm cells use flagella to swim.

FLIGHT FEATHERS A bird's wing and tail feathers, used in flight.

FLIPPER In aquatic mammals, a paddle-shaped limb. See also *Fluke*.

FLUKE A rubbery tail flipper in whales and their relatives. Unlike the tail fins of fish, flukes are horizontal, and they beat up and down instead of side to side.

FOOD CHAIN A food pathway that links two or more different species, in that each forms food for the next species higher up in the chain. In land-based food chains, the first link is usually a plant. In aquatic food chains, it is usually an alga or other form of single-celled life.

FORCIPULE In centipedes, the modified pincerlike first pair of legs, which are used to inject venom. See also *Pincer*.

FURCULA The forked, springlike organ attached to a springtail's abdomen.

GASTROPODS The group of mollusks that includes snails and slugs. See also *Mollusks*.

GENUS (pl. GENERA) A level used in classification. In the sequence of classification levels, a genus forms part of a family and is subdivided into one or more species.

GILL An organ used for extracting oxygen from water. Gills are usually positioned on or near the head, or—in aquatic insects—toward the end of the abdomen.

GRAZING Feeding on grass. See also *Browsing*.

GUARD HAIR A long hair in a mammal's coat, which projects beyond the underfur to protect it and help keep the animal dry.

HERBIVORE An animal that feeds on plants or plantlike plankton.

HIBERNATION A period of dormancy in winter. During hibernation, an animal's body processes drop to a low level.

HORN In mammals, a pointed growth on the head. True horns are hollow sheaths of keratin covering a bony horn core.

HOST An animal on or in which a parasite feeds.

INCISOR TOOTH In mammals, a tooth at the front of the jaw, used in biting, slicing, or gnawing.

INCUBATION In egg-laying animals, the period when a parent sits on the eggs and warms them, allowing them to develop. Incubation periods range from under 14 days to several months.

INTERNAL FERTILIZATION In reproduction, a form of fertilization that takes place inside the female's body. Internal fertilization is a characteristic of many land animals, including insects and vertebrates. See also *Sexual reproduction*.

IRIDOPHORE A type of specialized skin cell that contains light-reflecting guanine crystals. These are found in some species of crustaceans, cephalopods, fishes, amphibians, and reptiles, such as chameleons.

JACOBSON'S ORGAN An organ in the roof of the mouth that is sensitive to airborne scents. Snakes often employ this organ to detect their prey, while some male mammals use it to find females that are ready to mate.

KEEL In birds, an enlargement of the breastbone that anchors the muscles used in flight.

KERATIN A tough structural protein found in hair, claws, and horns.

KINGDOM In classification, one of the six fundamental divisions of the natural world.

LATERAL LINE SYSTEM The body mechanism by which fishes detect movement, vibration, and pressure underwater. Canals running under the skin channel water to move sensory cells back and forth, which then triggers them to send nerve impulses to the brain.

LARVA (pl. LARVAE) An immature but independent animal that looks completely different from an adult. A larva develops the adult shape by metamorphosis; in many insects, the change takes place in a resting stage that is called a pupa. See also *Cocoon, Metamorphosis, Nymph*.

LEK A communal display area used by male animals—particularly birds—during courtship. The same location is often revisited for many years.

MANDIBLE The paired jaws of an arthropod, or a bone that makes up all or part of the lower jaw in vertebrates.

MANTLE In mollusks, an outer fold of skin covering the mantle cavity.

MELON A bulbous swelling in the heads of many toothed whales and dolphins. The melon is filled with a fatty fluid, and is believed to focus the sounds used in echolocation.

METABOLISM The complete array of chemical processes that take place inside an animal's body. Some of these processes release energy by breaking down food, while others use energy by making muscles contract.

METACARPAL In four-limbed animals, one of a set of bones in the front leg or arm, forming a joint with a digit at the end. In most primates, the metacarpals form the palm of the hand.

METAMORPHOSIS A change in body shape shown by many animals—particularly invertebrates—as they grow from juvenile to adult. In insects, metamorphosis can be complete or incomplete. Complete metamorphosis involves a total reorganization of the organism during a resting stage, called a pupa. Incomplete metamorphosis embraces a series of less drastic changes; these occur each time the young animal molts. See also *Chrysalis, Cocoon, Larva, Nymph*.

MIMICRY A form of camouflage in which an animal resembles another animal or an inanimate object, such as a twig or a leaf. Mimicry is very common in insects, with many harmless species imitating those that have dangerous bites or stings.

MOLAR TOOTH In mammals, a tooth at the rear of the jaw. Molar teeth may have a flattened or ridged surface used for chewing vegetation. The sharper molar teeth of meat-eaters can cut through hide and bone.

MOLLUSKS A major group of invertebrate animals that includes gastropods (slugs and snails), bivalves (clams and relatives), and cephalopods (squids, octopuses, cuttlefishes, and nautiluses). Mollusks are soft-bodied and typically have hard shells, although some subgroups have lost the shell during their evolution.

MOLT Shedding fur, feathers, or skin so that it can be replaced. Mammals and birds molt to keep their fur and feathers in good condition, to adjust their insulation, or so that they can be ready to breed. Arthropods—such as insects—molt in order to grow.

MONOCULAR VISION A type of vision in which each eye is used independently, such as in chameleons. This gives a wide field of vision but limited depth perception. See also *Binocular vision, Stereoscopic vision*.

NEMATOCYST The coiled structure within the stinging cell of a jellyfish or other cnidarian that shoots out and injects toxin via a dartlike tip.

NEUROMAST Sensory cells that form part of the lateral line system in fishes. They are stimulated by the motion of water to help fishes detect movement. See also *Lateral line system*.

NOSE LEAF A facial structure in some bat species that focuses sound pulses emitted through the nostrils.

NICHE An animal's place and role in its habitat. Although two species may share the same habitat, they never share the same niche.

NOCTURNAL Active at night and sleeping during the day, as opposed to diurnal—active during the day.

NOTOCHORD A reinforcing rod that runs the length of the body. The notochord is a distinctive feature of chordates, although in some it is present only in early life. In vertebrates, the notochord becomes incorporated into the backbone during the development of the embryo.

NYMPH An immature insect that looks similar to its parents but that does not have functioning wings or reproductive organs. A nymph develops the adult shape by metamorphosis, changing slightly each time it molts.

OLFACTORY LOBE The area of the brain that receives and processes scent information from the olfactory nerves. In most vertebrates it is situated at the front of the brain.

OMMATIDIA The facets of light-receiving cells that make up the lenses of a compound eye, such as those common to many arthropods. See also *Compound eye, Photoreceptor*.

OMNIVORE An animal that eats both plant and animal food.

OPERCULUM A cover or lid. In some gastropod mollusks, an operculum is used to seal the shell when the animal has withdrawn inside. In bony fish, an operculum on each side of the body protects the chamber that contains the gills.

OPISTHOSOMA The abdomen, or back part of the body, behind the prosoma of arthropods including arachnids, such as spiders, and horseshoe crabs. See also *Prosoma*.

ORDER A level used in classification. In the sequence of classification levels, an order forms part of a class, and is subdivided into one or more families.

ORGAN A structure in the body, composed of several kinds of tissues, that carries out specific tasks.

OSSICLE A minute bone. The ear ossicles of mammals, which transmit sound from the eardrum to the inner ear, are the smallest bones in the body.

PALPS Pairs of long, sensory appendages that stem from near the mouths of arthropods. Similar to antennae, they have touch sensors and serve a variety of purposes, including touch and taste, and some are used for predation. See also *Pedipalps*.

PAPILLA (pl. PAPILLAE) A small, fleshy protruberance on an animal's body. Papillae often have a sensory function; for example, detecting chemicals that help pinpoint food.

PARAPODIUM (pl. PARAPODIA) A leg- or paddlelike flap found in some worms. Parapodia are used for moving, or for pumping water past the body.

PARASITE An animal that lives on or inside another animal (its host), and that feeds either on its host or on food that its host has swallowed. The majority of parasites are much smaller than their hosts, and many have complex life cycles involving the production of huge numbers of eggs. Parasites often weaken their hosts, but generally do not kill them. See also *Endoparasite*.

PARATOID GLAND In amphibians, a gland behind the eyes that secretes poison onto the surface of the skin.

PARTHENOGENETIC Relating to reproduction from an unfertilized egg cell. Females of some invertebrates, such as aphids, produce young parthenogenetically only during summer months, when food is abundant. A few species always reproduce in this way, and form all-female populations. Unfertilized parthenogenetic eggs typically already have two copies of each chromosome. See also *Asexual reproduction*.

PATAGIUM In bats, the flap of double-sided skin that forms the wing. This term is also used for the parachutelike skin flaps of colugos and other gliding mammals.

PECTORAL FINS The pair of fins positioned toward the front of a fish's body, often just behind its head. Pectoral fins are usually highly mobile and are normally used for steering but sometimes for propulsion too.

PECTORAL GIRDLE In four-limbed vertebrates, the arrangement of bones that anchors the front limbs to the backbone. In most mammals, the pectoral girdle consists of two clavicles, or collar bones, and two scapulae, or shoulder blades.

PEDICEL The region of the skull from which antlers grow and from which they are shed at the end of the mating season. See also *Antler*.

PEDIPALPS In arachnids, the second pair of appendages, near the front of the body. Depending on the species, they are used for walking, sperm transfer, or attacking prey. See also *Claspers, Palps*.

PELVIC FINS The pair of rear fins in fish, which are normally positioned close to the underside, sometimes near the head but more often toward the tail. Pelvic fins are generally used as stabilizers. In some species, such as sharks, they are also used to transfer sperm. See also *Claspers*.

PELVIC GIRDLE In four-limbed vertebrates, the arrangement of bones that anchors the back limbs to the backbone. The bones of the pelvic girdle are often fused, forming a weight-bearing ring called the pelvis.

PENTADACTYL The characteristic of having five digits—toes or fingers—common to many four-limbed vertebrates, or having evolved from such. See also *Digits, Tetrapods*.

PHEROMONE A chemical produced by one animal that has an effect on other members of its species. Pheromones are often volatile substances that spread through the air, triggering a response from animals some distance away.

PHOTORECEPTOR A type of specialized, light-sensitive cell that forms the retinal layer at the back of animals' eyes. In many animals photoreceptor cells contain different pigments, which allow for color vision. See also *Ommatidia, Retina*.

PHOTOSYNTHESIS A series of chemical processes that enable plants to capture the energy in sunlight and convert it into chemical form.

PHYLUM (pl. PHYLA) A level used in classification. In the sequence of classification levels, a phylum forms part of a kingdom and is subdivided into one or more classes.

PINCER In arthropods, pincers are pointed, hinged organs used for feeding or defense, such as the mandibles of an insect, or the chelae of crustaceans. See also *Dactylus*.

PINNA (pl. PINNAE) The external ear flaps found in mammals.

PHARYNX The throat.

PLACENTA An organ developed by an embryonic mammal that allows it to absorb nutrients and oxygen from its mother's bloodstream, before it is born. Young that grow in this way are known as placental mammals.

PLACENTAL MAMMAL See *Placenta*.

PLANKTON Floating organisms—many of them microscopic—that drift in open water, particularly near the surface of the sea. Planktonic organisms can often move, but most are too small to make any headway against strong currents. Planktonic animals are collectively known as zooplankton.

PLANTIGRADE A gait in which the sole of the foot is in contact with the ground. See also *Digitigrade, Unguligrade*.

PLASTRON The lower part of the shell in tortoises and turtles.

POLYP In cnidarians, a body form that has a hollow cylindrical trunk, ending in a central mouth surrounded by a circle of tentacles. Polyps are frequently attached to solid objects by their base.

PREDATOR An animal that catches and kills others, known as its prey. Some predators catch their prey by lying in wait, but most actively pursue and attack other animals. See also *Prey*.

PREHENSILE Able to curl around objects and grip them.

PREMOLAR TOOTH In mammals, a tooth positioned midway along the jaw, between the canines and the molars. See also *Canine Tooth, Molar Tooth*.

PREY Any animal that is eaten by a predator. See also *Predator*.

PROBOSCIS An animal's nose, or a set of mouthparts with a noselike shape. In insects that feed on fluids, the proboscis is often long and slender, and can usually be stowed away when not in use.

PROPODUS The fixed part of a pincer that cannot be moved. It consists of a wide, muscular palm. See also *Dactylus, Pincers*.

PROSOMA The front part of the body before the opisthoma in arthropods such as arachnids and horseshoe crabs. See also *Cephalothorax, Opisthosoma*.

PTEROSTIGMA A colored, weighted panel near the leading edge on some insects' wings, such as dragonflies.

PUPIL The hole in the center of the eye that allows light to enter.

RADIAL SYMMETRY A form of symmetry in which the body is arranged like a wheel, often with the mouth at the center.

RADULA A mouthpart that many mollusks use for rasping away at food. The radula is often shaped like a belt, and armed with many microscopic toothlike denticles.

RESPIRATION This refers to both the action of breathing itself and to cellular respiration, which is the biomechanical processes that take place within cells, which break down food molecules—usually by combining them with oxygen to provide energy for an organism.

RETINA A layer of light-sensitive cells lining the back of the eye that converts optical images into nerve impulses, which travel to the brain via the optic nerve. See also *Photoreceptor*.

RICTAL BRISTLES Modified feathers that project from the base of the bill in some birds such as nightjars and kiwis. The feathers have a stiff shaft that lacks barbs. They may work like whiskers and help the birds detect prey when hunting.

RODENT A large and adaptable group of mostly small, four-limbed mammals with a long tail, clawed feet, and long whiskers and teeth—especially the large incisors. Their jaws are adapted for gnawing. They are found worldwide expect for Antarctica, and represent over 40 percent of mammal species.

ROSTRUM In bugs and some other insects, a set of sucking mouthparts that looks similar to a beak.

RUMINANT A hoofed mammal that has a specialized digestive system, with several stomach chambers. One of these—the rumen—contains huge numbers of microorganisms that help to break down the cellulose in plant cell walls. To speed this process, a ruminant usually regurgitates its food and rechews it, a process called "chewing the cud."

RUTTING SEASON In deer, a period during the breeding season when males clash with each other for the opportunity to mate.

SALIVA A watery fluid secreted by the salivary glands in the mouth to aid chewing, tasting, and digestion.

SALIVARY GLAND Sets of paired glands in the mouth that produce saliva. See also *Saliva*.

SCALES The thin horny or bony plates that cover and protect the skin of fishes and reptiles. Scales are typically arranged so that they overlap.

SCAPE The first segment in an insect's antennae, nearest its head.

SCUTE A shieldlike plate or scale that forms a bony covering on some animals.

SEBACEOUS GLAND A skin gland in mammals that normally opens near the root of a hair. Sebaceous glands produce substances that keep skin and hair in good condition.

SEX CELLS The reproductive cells of all animals—the male sperm and female egg—also known as gametes. See also *Sexual reproduction*.

SEXUAL DIMORPHISM Showing physical differences between males and females. In animals that have separate sexes, males and females always differ, but in highly dimorphic species, such as elephant seals, the two sexes look different and are often unequal in size.

SEXUAL REPRODUCTION A form of reproduction that involves fertilization of a female cell or egg, by a male cell or sperm. This is the most common form of reproduction in animals. It usually involves two parents—one of either sex—but in some species individual animals are hermaphrodite. See also *Asexual reproduction*.

SHELL A hard, protective outer casing found in many mollusks and crustaceans, as well as some reptiles—the turtles and tortoises.

SILK A protein-based fibrous material produced by spiders and some insects. Silk is liquid when it is squeezed out of a spinneret but turns into elastic fibers when stretched and exposed to air. It has a wide variety of uses. Some animals use silk to protect themselves or their eggs, to catch prey, to glide on air currents, or to lower themselves through the air.

SIPHONOPHORE A group of cnidarians that live as floating colonies of connected individual polyps, which can form very long strings. Species include the Portuguese man o' war. See also *Polyp*.

SPAWN The release or deposit of eggs in aquatic animals such as crustaceans, mollusks, fishes, and amphibians.

SPERM Male reproductive cells. See also *Sex cells, Sexual reproduction*.

SPECIES A group of similar organisms that are capable of interbreeding in the wild, and of producing fertile offspring that resemble themselves. Species are the fundamental units used in biological classification. Some species have distinct populations that vary from each other. Where the differences between the populations are

significant, and they are biologically isolated, these forms are classified as separate subspecies.

SPICULE In sponges, a needlelike sliver of silica or calcium carbonate that forms part of the internal skeleton. Spicules have a wide variety of shapes.

SPIRACLE In rays and some other fish, an opening behind the eye that lets water flow into the gills. In insects, an opening on the thorax or abdomen that lets air into the tracheal system.

STEREOSCOPIC VISION The ability to use forward-facing eyes, as in humans or predators like tigers, to see in very similar but slightly differing ways with each eye. This allows accurate depth perception. See also *Binocular vision*.

STERNUM The breastbone in four-limbed vertebrates, or the thickened underside of a body segment in arthropods. In birds, the sternum has a narrow flap.

SUCKER A round, concave suction cup on the tentacles of squids and octopuses. Each sucker is highly flexible and has a ring of muscle that can squeeze tightly. It is also equipped with taste receptors. See also *Tentacle*.

SWIM BLADDER A gas-filled bladder that most bony fishes use to regulate their buoyancy. By adjusting the gas pressure inside the bladder, a fish can become neutrally buoyant, meaning that it neither rises nor sinks in the water column.

TAGMA (pl. **TAGMATA**) A distinct region in the bodies of arthropods and other segmented animals that consists of several connected parts, such as the head, thorax, and abdomen of insects. See also *Cephalothorax*.

TARSUS (pl. **TARSI**) A part of the leg. In insects, the tarsus is the equivalent of the foot, while in vertebrates, it forms the lower part of the leg or the ankle.

TELSON In arthropods, the last part of the abdomen, or the last appendage to it, as in horseshoe crabs.

TENDON A strong band of tough collagen fibers that usually joins muscle to bone and transmits the pull caused by muscle contraction, allowing movement of the skeleton.

TENTACLE One of two longest flexible appendages of squid and cuttlefishes or the stinging appendages of jellyfishes

TERRESTRIAL Living entirely or mainly on the ground.

TERRITORY An area defended by an animal, or group of animals, against other members of the same species. Territories often include some useful resources that help the male attract a mate.

TEST In echinoderms, a skeleton made of small calcareous plates.

TETRAPOD A member of the group of animals consisting of four-limbed vertebrates, or those that have evolved from them, such as snakes.

THORAX The middle region of an arthropod's body. The thorax contains powerful muscles, and bears the legs and wings, if the animal has any. In four-limbed vertebrates, the thorax is the chest. See also *Cephalothorax*, *Prosoma*.

TIBIA (pl. **TIBIAE**) The shin bone in four-limbed vertebrates. In insects, the tibia forms the part of the leg immediately above the tarsus, or foot. See also *Fibula*.

TINE A point that branches off from the main beam of an antler. See also *Antler*.

TISSUE A layer of cells in an animal's body. In a tissue, the cells are of the same type, and carry out the same work. See also *Organ*.

TORPOR A sleeplike state in which the body processes slow to a fraction of their normal rate. Animals usually become torpid to survive difficult conditions, such as cold or lack of food.

TRACHEA (pl. **TRACHEAE**) Part of the respiratory system, a breathing tube, known in vertebrates as the windpipe.

TUSK In mammals, a modified tooth that often projects outside the mouth. Tusks have a variety of uses, including defence and digging up food. In some species, only the males have them—in this case, their use is often for sexual display or competition.

TYMPANUM The external ear membrane of frogs and insects.

UNDERFUR The dense fur that makes up the innermost part of a mammal's coat. Underfur is usually soft, and is a good insulator. See also *Guard hair*.

UNGULIGRADE A gait in which only the hooves touch the ground. See also *Digitigrade*, *Plantigrade*.

UROPYGIAL GLAND Also known as the preening or oil gland, the uropygial gland is located at the base of the tail in most birds. It produces sebaceous oils that birds rub over their feathers with their beak to keep them waterproof. See also *Sebaceous gland*.

UTERUS In female mammals, the part of the body that houses developing young. In placental mammals, the young are connected to the wall of the uterus via a placenta.

VENTRAL On or near the underside.

VERTEBRA One of the bones that form the vertebral column (backbone or spine) in vertebrate animals.

VERTEBRATE An animal with a backbone. Vertebrates include fishes, amphibians, reptiles, birds, and mammals.

VIBRISSA See *Whiskers*.

WARNING COLORATION A combination of contrasting colors that warns that an animal is dangerous. Bands of black and yellow are a typical form of warning coloration, found in stinging insects. Also known as aposematic coloration.

WHISKER One of the long, stiffened hairs growing on the face, and particularly around the snout, of many mammals. Whiskers allow animals to sense vibrations in the water or air and are used as organs of touch. Also known as a vibrissa. See also *Rictal bristles*.

YOLK The part of an egg that provides nutrients to the developing embryo.

ZOOID An individual animal in a colony of invertebrates. Zooids are often directly linked to each other, and may function like a single animal.

ZOOPLANKTON See *Plankton*.

index

acknowledgments

DK would like to thank the following people at Smithsonian Enterprises:

Product Development Manager
Kealy Gordon,

Senior Manager, Licensed Publishing
Ellen Nanney

Director, Licensed Publishing
Jill Corcoran

Vice President, Consumer and Education Products
Brigid Ferraro

President
Carol LeBlanc

DK would also like to thank the directors and staff at the Natural History Museum, London, including Trudy Brannan and Colin Ziegler, for reading and correcting earlier versions of this book and providing help and support with photoshoots, particularly Senior Curator in Charge of Mammals, Roberto Portelo Miguez.

Thanks also to others who provided help with photoshoots: Barry Allday, Ping Low, and the staff of The Goldfish Bowl, Oxford; and Mark Amey and the staff of Ameyzoo, Bovington, Hertfordshire.

Finally, DK would like to thank

Senior Editor
Hugo Wilkinson

Senior Art Editor
Duncan Turner

Senior DTP Designer
Harish Aggarwal

DTP Designers: Mohammad Rizwan, Anita Yadav

Senior Jacket Designer
Suhita Dharamjit

Managing Jackets Editor
Saloni Singh

Jackets Editorial Coordinator
Priyanka Sharma

Image retoucher
Steve Crozier

Illustrator
Phil Gamble

Additional illustrations
Shahid Mahmood

Indexer
Elizabeth Wise

The publisher would like to thank the following for their kind permission to reproduce their photographs:

(Key: a-above; b-below/bottom; c-centre; f-far; l-left; r-right; t-top)

The publisher would like to thank the following for their kind permission to reproduce their photographs:

(Key: a-above; b-below/bottom; c-centre; f-far; l-left; r-right; t-top)

1 Getty Images: Tim Flach / Stone / Getty Images Plus. **2-3 Getty Images:** Tim Flach / Stone / Getty Images Plus. **4-5 Getty Images:** Barcroft Media. **6-7 Brad Wilson Photography. 8-9 Alamy Stock Photo:** Biosphoto / Alejandro Prieto. **10-11 Dreamstime.com:** Andrii Oliinyk. **12-13 Alexander Semenov. 12 Alamy Stock Photo:** Blickwinkel. **14-15 Getty Images:** Eric Van Den Brulle / Oxford Scientific / Getty Images Plus. **16 Getty Images:** David Liittschwager / National Geographic Image Collection Magazines. **17 Alamy Stock Photo:** Roberto Nistri (tr). **Getty Images:** David Liittschwager / National Geographic Image Collection (cl); Nature / Universal Images Group / Getty Images Plus (tl). **naturepl.com:** Piotr Naskrecki (cr). **18 Dorling Kindersley:** Maxim Koval (Turbosquid) (bc); Jerry Young (tr). **naturepl.com:** MYN / Javier Aznar (tl); Kim Taylor (c). **19 Philippe Bourdon / www.coleoptera-atlas.com:** (r). **Dorling Kindersley:** Natural History Museum, London (tl); Jerry Young (bl). **20 Alamy Stock Photo:** RGB Ventures / SuperStock. **21 naturepl.com:** MYN / Piotr Naskrecki. **22 Brad Wilson Photography. 23 Brad Wilson Photography. 24 Brad Wilson Photography. 25 Dreamstime.com:** Abeselom Zerit. **26 Alamy Stock Photo:** Heritage Image Partnership Ltd. **26-27 Bridgeman Images:** Rock painting of a bull and horses, c.17000 BC (cave painting), Prehistoric / Caves of Lascaux, Dordogne, France. **28-29 Alamy Stock Photo:** 19th era 2. **31 Alamy Stock Photo:** SeaTops (br). **Getty Images:** Auscape / Universal Images Group (bl). **NOAA:** NOAA Office of Ocean Exploration and Research, 2017 American Samoa. (bc). **33 Alamy Stock Photo:** Science History Images (br). **34 Alamy Stock Photo:** Science History Images (cra). **36 iStockphoto.com:** GlobalP / Getty Images Plus (bl, c, crb). **Kunstformen der Natur by Ernst Haeckel:** (cr). **36-37 iStockphoto.com:**

GlobalP / Getty Images Plus. **37 iStockphoto.com:** GlobalP / Getty Images Plus (tc, tr, cra, bc). **38 Kunstformen der Natur by Ernst Haeckel. 39 Alamy Stock Photo:** Chronicle (tr); The Natural History Museum (clb). **40-41 Alexander Semenov. 41 Alexander Semenov. 42-43 Alexander Semenov. 42 naturepl.com:** Jurgen Freund (br). **44-45 Getty Images:** Gert Lavsen / 500Px Plus. **45 Carlsberg Foundation:** (crb). **Getty Images:** GP232 / E+ (cra). **46 Getty Images:** Heritage Images / Hulton Archive. **47 Alamy Stock Photo:** Heritage Image Partnership Ltd (tr). **Photo Scala, Florence:** (cl). **50-51 Dreamstime.com:** Dream69. **51 Science Photo Library:** Science Stock Photography. **52 Dorling Kindersley:** Jerry Young (cl). **Dreamstime.com:** Verastuchelova (tr). **iStockphoto.com:** Farinosa / Getty Images Plus (bl). **naturepl.com:** MYN / JP Lawrence (tl). **53 Getty Images:** Design Pics / Corey Hochachka (c). **naturepl.com:** MYN / Alfonso Lario (bl); Piotr Naskrecki (cl). **54 Alamy Stock Photo:** Biosphoto (cra, crb, clb, cla). **55 Alamy Stock Photo:** Biosphoto. **56 naturepl.com:** Daniel Heuclin (cla). **Science Photo Library:** Ted Kinsman (crb). **56-57 Brad Wilson Photography. 58-59 Alamy Stock Photo:** Granger Historical Picture Archive. **59 Bridgeman Images:** British Library, London, UK / © British Library Board (tr). **60-61 Alamy Stock Photo:** Denis-Huot / Nature Picture Library. **61 Getty Images:** Mik Peach / 500Px Plus (crb). **62-63 Getty Images:** Nastasic / DigitalVision Vectors. **65 Dreamstime.com:** Erin Donalson (br). **66-67 Alexander Semenov. 67 Alexander Semenov. 69 Alamy Stock Photo:** The Natural History Museum (bc). **70-71 Igor Siwanowicz. 72 Image courtesy of Derek Dunlop:** (bl). **74-75 Igor Siwanowicz. 76 Getty Images:** Education Images / Universal Images Group (l). **77 Alamy Stock Photo:** Age Fotostock (t). **Getty Images:** Werner Forman / Universal Images Group (bl). **78-79 All images © Iori Tomita / http://www.shinsekai-th.com/. 81 Alamy Stock Photo:** Blickwinkel (br); Florilegius (bc). **82-83 Science Photo Library:** Arie Van 'T Riet. **84-85 Thomas Vijayan. 86 Image from the Biodiversity Heritage Library:** The great and small game of India, Burma, & Tibet (tl). **88-89 Getty Images:** Jim Cumming / Moment Open. **90-91 Dreamstime.com:** Channarong Pherngjanda. **92-93 Getty Images:** Matthieu Berroneau / 500Px Plus. **92 National Geographic Creative:** Joel

Sartore, National Geographic Photo Ark (tl). **94-95 National Geographic Creative:** David Liittschwager. **94 Getty Images:** David Doubilet / National Geographic Image Collection (br). **naturepl.com:** MYN / Sheri Mandel (crb). **96 FLPA:** Piotr Naskrecki / Minden Pictures (tr). **Image from the Biodiversity Heritage Library:** Proceedings of the Zoological Society of London. (cla). **98-99 Greg Lecoeur Underwater and Wildlife Photography. 98 Dreamstime.com:** Isselee (clb, cla). **Getty Images:** Life On White / Photodisc (cb). **99 Alamy Stock Photo:** WaterFrame (tr). **100-101 Getty Images:** David Liittschwager / National Geographic Image Collection. **100 Getty Images:** David Liittschwager / National Geographic Image Collection Magazines (bc, br). **102 Dorling Kindersley:** The Natural History Museum, London (fbr). **103 Science Photo Library:** Gilles Mermet (c). **104-105 Brad Wilson Photography. 105 Alamy Stock Photo:** Martin Harvey (crb); www.pqpictures.co.uk (tc); Ron Steiner (tr). **Dreamstime.com:** Narint Asawaphisith (c). **Getty Images:** Norbert Probst (cr). **106 naturepl.com:** Chris Mattison (clb). **106-107 Brad Wilson Photography. 107 Brad Wilson Photography:** (cra). **108 Alamy Stock Photo:** Imagebroker (cla, ca). **110 Alamy Stock Photo:** The History Collection (tl); The Picture Art Collection (crb). **111 Alamy Stock Photo:** Granger Historical Picture Archive. **113 akg-images:** Florilegius (cla). **114-115 Igor Siwanowicz. 115 FLPA:** Piotr Naskrecki / Minden Pictures (cra). **118-119 David Weiller / www.davidweiller.com. 119 FLPA:** Thomas Marent (cb). **National Geographic Creative:** Frans Lanting (crb). **120-121 Paul Hollingworth Photography. 122-123 iStockphoto. com. 122 iStockphoto.com:** GlobalP / Getty Images Plus (crb). **124-125 Dreamstime.com:** Isselee. **124 Bridgeman Images:** Natural History Museum, London, UK (tl). **125 Alamy Stock Photo:** Minden Pictures (br). **126 Getty Images:** Arterra / Universal Images Group (ca). **126-127 FLPA:** Sergey Gorshkov / Minden Pictures. **128 123RF. com:** Graphiquez (tc). **Alamy Stock Photo:** Nature Picture Library / Radomir Jakubowski (cr). **Dreamstime.com:** Lukas Blazek (bc); Volodymyr Byrdyak (c). **129 123RF.com:** Theeraphan Satrakom (tc); Dennis van de Water (tr). **Dreamstime.com:** Isselee (c); Scheriton (tl); Klaphat (cl). **National Geographic Creative:** Joel Sartore, National Geographic Photo Ark (br). **naturepl. com:** Suzi Eszterhas (cr). **130-131 Alamy Stock Photo:** Heritage Image Partnership

Ltd. **131 Alamy Stock Photo:** Niday Picture Library (tr). **132-133 Alamy Stock Photo:** Mauritius images GmbH. **132 Mogens Trolle:** (bc). **134-135 Brad Wilson Photography. 135 Getty Images:** Parameswaran Pillai Karunakaran / Corbis NX / Getty Images Plus (tr). **136-137 National Geographic Creative. 137 Image from the Biodiversity Heritage Library:** Compléments de Buffon, 1838 / Lesson, R. P. (René Primevère), 1794-1849 (tc). **138-139 123RF.com:** Patrick Guenette (c). **Dreamstime.com:** Jeneses Imre. **140-141 Leonardo Capradossi / 500px.com/leonardohortu96. 141 Dreamstime.com:** Photolandbest (br). **142-143 Sebastián Jimenez Lopez. 142 naturepl.com:** MYN / Gil Wizen (tl). **144 Alamy Stock Photo:** ART Collection (crb); Pictorial Press Ltd (tr). **145 Image from the Biodiversity Heritage Library:** Uniform: Metamorphosis insectorum Surinamensium.. **146 naturepl.com:** Tui De Roy (bc). **146-147 Dreamstime.com:** Anolis01. **148 Duncan Leitch, David Julius Lab, University of California - San Francisco. 149 Getty Images:** SeaTops (tr). **152-153 © Ty Foster Photography. 153 Dreamstime.com:** Isselee (b). **154-155 National Geographic Creative:** Joel Sartore, National Geographic Photo Ark. **155 Bridgeman Images:** © Purix Verlag Volker Christen (crb). **156 Getty Images:** David Liittschwager / National Geographic Image Collection (tl). **156-157 Javier Rupérez Bermejo. 158 Dreamstime.com:** Martin Eager / Runique (c); Gaschwald (tc); Joanna Zaleska (bc). **Getty Images:** David Liittschwager / National Geographic Image Collection (cr, br); Diana Robinson / 500px Prime (tl). **naturepl.com:** Roland Seitre (tr). **159 Dorling Kindersley:** Thomas Marent (cl). **Getty Images:** Fabrice Cahez / Nature Picture Library (bl); Daniel Parent / 500Px Plus (c); Anton Eine / EyeEm (cr); Joel Sartore / National Geographic Image Collection (bc); Jeff Rotman / Oxford Scientific / Getty Images Plus (br). **160-161 John Joslin. 161 John Hallmen. 164 iStockphoto. com:** Arnowssr / Getty Images Plus (ca). **165 Getty Images:** Joel Sartore, National Geographic Photo Ark / National Geographic Image Collection. **166-167 FLPA:** Paul Sawer. **168 naturepl.com:** John Abbott (tl). **168-169 naturepl.com:** John Abbott. **170 National Geographic Creative:** Joel Sartore, National Geographic Photo Ark. **171 Getty Images:** DEA / A. De Gregorio / De Agostini (cra). **National Geographic Creative:** Joel Sartore, National Geographic Photo Ark (cla). **172 Alamy**

Stock Photo: The Picture Art Collection. **173 Alamy Stock Photo:** Artokoloro Quint Lox Limited (r). **174-175 Alamy Stock Photo:** Biosphoto. **174 Getty Images:** Visuals Unlimited, Inc. / Ken Catania. **178 Dorling Kindersley:** Jerry Young (ca). **178-179 Brad Wilson Photography. 180 FLPA:** Piotr Naskrecki / Minden Pictures (bl). **Science Photo Library:** Merlin D. Tuttle (bc); Merlin Tuttle (br). **181 Kunstformen der Natur by Ernst Haeckel. 182-183 Getty Images:** Alexander Safonov / Moment Select / Getty Images Plus. **182 Image from the Biodiversity Heritage Library:** Transactions of the Zoological Society of London.. **184-185 123RF.com:** Andreyoleynik. **186-187 naturepl.com:** ZSSD. **187 Alamy Stock Photo:** WaterFrame (crb). **188-189 Dreamstime. com:** WetLizardPhotography. **190 Science Photo Library:** Scubazoo. **191 Casper Douma:** (ca). **192-193 Arno van Zon. 193 Getty Images:** Tim Flach / Stone / Getty Images Plus (bl). **194 Alamy Stock Photo:** Nature Photographers Ltd (tl). **196-197 Robert Rendaric. 197 Getty Images:** Erik Bevaart / EyeEm. **198 123RF.com:** Eric Isselee / isselee (bc). **Dreamstime.com:** Assoonas (cb); Nikolai Sorokin (cr); Ozflash (clb); Gualberto Becerra (crb); Birdiegal717 (bl). **199 123RF. com:** Gidtiya Buasai (cr); Miroslav Liska / mircol (c); Jacoba Susanna Maria Swanepoel (br). **Dreamstime.com:** Sergio Boccardo (bl); Isselee (clb, cb, bc); Jixin Yu (crb). **200 National Audubon Society:** John J. Audubon's Birds of America. **201 Image from the Biodiversity Heritage Library:** The Birds of Australia, John Gould. (cr); The Zoology of the Voyage of H.M.S. Beagle (tl). **202-203 Brad Wilson Photography. 204-205 National Geographic Creative:** Ami Vitale. **205 Image from the Biodiversity Heritage Library:** Recherches Sur Les Mammifères / Henri Milne-Edwards, 1800-1885. **207 Alamy Stock Photo:** Danielle Davies (br). **208-209 Brad Wilson Photography. 210-211 123RF.com:** Channarong Pherngjanda. **213 Alamy Stock Photo:** WaterFrame (cb); D. Roberts (tc). **217 FLPA:** Photo Researchers. **218 National Geographic Creative:** Joel Sartore, National Geographic Photo Ark (ca). **218-219 National Geographic Creative:** Joel Sartore, National Geographic Photo Ark. **219 National Geographic Creative:** Christian Ziegler (tr). **220-221 Solent Picture Desk / Solent News & Photo Agency, Southampton:** Shivang Mehta. **223 Science Photo Library:** Power And Syred (tr). **225 ©**

caronsteelephotography.com: (tr). **Mary Evans Picture Library:** Natural History Museum (br). **227 FLPA:** Steve Gettle / Minden Pictures (l). **Tony Beck & Nina Stavlund / Always An Adventure Inc.:** (r). **228 Getty Images:** Joel Sartore, National Geographic Photo Ark / National Geographic Image Collection (ca). **228-229 Thomas Vijayan. 230-231 Alamy Stock Photo:** Andrea Battisti. **232 Dorling Kindersley:** Jerry Young (tl). **232-233 Getty Images:** Joel Sartore, National Geographic Photo Ark / National Geographic Image Collection. **234-235 Alamy Stock Photo:** Artokoloro Quint Lox Limited. **235 Rijksmuseum, Amsterdam:** Katsushika Hokusai (tc). **236-237 National Geographic Creative:** Joel Sartore, National Geographic Photo Ark. **237 National Geographic Creative:** Joel Sartore, National Geographic Photo Ark (cr). **238 Dreamstime.com:** Isselee. **238-239 Science Photo Library:** Tony Camacho. **240-241 National Geographic Creative:** Tim Laman. **240 Image from the Biodiversity Heritage Library:** The Cambridge Natural History / S. F. Harmer (tl). **242-243 National Geographic Creative:** © David Liittschwager 2015. **242 Hideki Abe Photo Office / Hideki Abe:** (tl). **244-245 Aaron Ansarov. 245 Aaron Ansarov. 246 Alamy Stock Photo:** Arco Images GmbH (tr). **248-249 David Yeo. 248 Alamy Stock Photo:** Saverio Gatto. **250-251 Dreamstime.com:** Channarong Pherngjanda. **252 Getty Images:** George Grall / National Geographic Image Collection Magazines (tc). **Kunstformen der Natur by Ernst Haeckel:** (bc). **252-253 Alexander Semenov. 254 National Geographic Creative:** David Liittschwager. **254-255 naturepl.com:** Tony Wu. **257 UvA, Bijzondere Collecties, Artis Bibliotheek. 258-259 Erik Almqvist Photography. 259 Alamy Stock Photo:** Sergey Uryadnikov (tr). **260 Dreamstime.com:** Isselee (c); Johannesk (bc). **261 Dorling Kindersley:** Professor Michael M. Mincarone (cr); Jerry Young (bl). **Dreamstime.com:** Deepcameo (clb); Isselee (cl, bc); Zweizug (clb); Martinlisner (crb); Sneekerp (br). **264 Getty Images:** Leemage / Corbis Historical (bc). **264-265 SeaPics.com:** Blue Planet Archive. **266 Dreamstime.com:** Isselee (tc). **267 Alamy Stock Photo:** Hemis (tr). **268 Alamy Stock Photo:** Science History Images. **269 Digital image courtesy of the Getty's Open Content Program.:** Creative Commons Attribution 4.0 International License (cl). **Photo Scala, Florence:** (tr). **272 naturepl.com:** Pascal Kobeh (cb). **272-273 Greg Lecoeur**

Underwater and Wildlife Photography. 274-275 Jorge Hauser. 274 Alamy Stock Photo: The History Collection (bc). **276 Dreamstime.com:** Evgeny Turaev (bl, t). **276-277 Dreamstime.com:** Evgeny Turaev. **278-279 naturepl.com:** MYN / Dimitris Poursanidis. **279 Dreamstime.com:** Isselee. **280-281 Alamy Stock Photo:** Razvan Cornel Constantin. **281 Bridgeman Images:** © Florilegius (br). **Getty Images:** Ricardo Jimenez / 500px Prime (tr). **282 Solent Picture Desk / Solent News & Photo Agency, Southampton:** © Hendy MP. **283 Getty Images:** Florilegius / SSPL (bc). **Solent Picture Desk / Solent News & Photo Agency, Southampton:** © Hendy MP (t). **284-285 Alamy Stock Photo:** Avalon / Photoshot License. **286-287 naturepl. com:** Markus Varesvuo. **287 Dreamstime.com:** Mikelane45 (br). **288 Shutterstock:** Sanit Fuangnakhon (cl); Independent birds (cr). **Slater Museum of Natural History / University of Puget Sound:** (tl, tr, clb, crb, bl, br). **289 123RF. com:** Pakhnyushchyy (cr). **Slater Museum of Natural History / University of Puget Sound:** (tl, tr, cl, clb, crb). **290-291 Getty Images:** Paul Nicklen / National Geographic Image Collection. **292-293 National Geographic Creative:** Anand Varma. **293 National Geographic Creative:** Anand Varma. **294 Bridgeman Images:** British Museum, London, UK. **295 akg-images:** François Guénet (cr). **Getty Images:** Heritage Images / Hulton Archive (t). **297 naturepl.com:** Piotr Naskrecki (tc). **298-299 123RF.com:** Patrick Guenette. **300-301 Alamy Stock Photo:** Blickwinkel. **302-303 Alamy Stock Photo:** Life on white. **303 Alamy Stock Photo:** Life on white. **304-305 John Hallmen. 305 Alamy Stock Photo:** Age Fotostock (br). **306-307 Sergey Dolya. Travelling photographer. 307 Getty Images:** Jenny E. Ross / Corbis Documentary / Getty Images Plus. **308-309 naturepl.com:** Paul Marcellini. **310 Dorling Kindersley:** Natural History Museum (tl); Natural History Museum, London (tc, tr, cl, c, cr, br); Time Parmenter (bc). **311 Alamy Stock Photo:** Nature Photographers Ltd / Paul R. Sterry (tr). **Dorling Kindersley:** Natural History Museum, London (ftl, tl, tc, fcl, fbl, cl, c, cr, bl, bc, br). **312-313 Michael Schwab. 312 Alamy Stock Photo:** Gerry Pearce (bc). **314-315 Getty Images:** Rhonny Dayusasono / 500Px Plus. **316 naturepl. com:** MYN / Tim Hunt (bc, br). **317 Alamy Stock Photo:** The Natural History Museum (tc). **National Geographic Creative:** George Grall (tr). **naturepl. com:** MYN / Tim Hunt (fbl, bc, br, fbr). **319 Alamy Stock Photo:** Images &

Stories. **320–321 123RF.com:** Dmpank. **323 Mary Evans Picture Library:** Iberfoto. **324 Alamy Stock Photo:** Jaime Franch Wildlife Photo (br); Andrey Nekrasov (bc). **Dreamstime.com:** John Anderson (bl). **Image from the Biodiversity Heritage Library:** Spongiologische Beiträge (cr). **325 Dreamstime.com:** Roberto Caucino (bl); Jolanta Wojcicka (bc); Keman (br); Pvb969924 (fbr). **Image from the Biodiversity Heritage Library:** Challenger reports 1873-76 (cr). **326 Alamy Stock Photo:** 19th era (cr). **Mary Evans Picture Library:** Florilegius (bc). **327 Dreamstime.com:** John Anderson (bl); Salparadis (bc); Photographyfirm (br); Hotshotsworldwide (fbr). **Image from the Biodiversity Heritage Library:** A Monograph Of The British Marine Annelids. (cr). **328 Alamy Stock Photo:** Lee Rentz (bc). **Dreamstime.com:** Pnwnature (br). **Getty Images:** Jeff Rotman / Photolibrary / Getty Images Plus (bl). **Image from the Biodiversity Heritage Library:** The Naturalist's Miscellany, Or Coloured Figures Of Natural Objects (cr). **329 Alamy Stock Photo:** Hal Beral / VWPics (bl); The Natural History Museum (cr); Papilio (fbr). **Dreamstime.com:** Reinhold Leitner (bc). **Getty Images:** Jasius / Moment (cr). **330 Dreamstime.com:** Peter Leahy (br); Gordon Tipene (bl); Mosaymay (bc). **Image from the Biodiversity Heritage Library:** Edible British Mollusks (cr). **331 Alamy Stock Photo:** Michael Stubblefield (bc). **Dreamstime.com:** Flowersofsunny (br); Izanbar (bl); Eugene Sim Junying (bc). **Image from the Biodiversity Heritage Library:** The Cephalopoda (cr). **332 Alamy Stock Photo:** The Picture Art Collection (cr). **Image from the Biodiversity Heritage Library:** Dictionnaire Classique Des Sciences Naturelles (bc). **333 Alamy Stock Photo:** Blickwinkel (fbr); Ivan Kuzmin (br). **Dreamstime.com:** Ecophoto (bl); Ezumeimages (bc). **Image from the Biodiversity Heritage Library:** Dictionnaire Universel D'histoire Naturelle (cr). **334 Alamy Stock Photo:** The Book Worm (br). **Image from the Biodiversity Heritage Library:** The Naturalist's Miscellany, Or Coloured Figures Of Natural Objects (br). **335 Alamy Stock Photo:** Blickwinkel (br). **Dreamstime.com:** Andreas Altenburger / Arrxxx (bc); Jsphotography (bl); Jaap Bleijenberg (fbr). **Image from the Biodiversity Heritage Library:** Dictionnaire D'histoire Naturelle (cr). **336 Bridgeman Images:** © Purix Verlag Volker Christen (cr). **Getty Images:** De Agostini Picture Library / De Agostini (br). **337 Alamy Stock Photo:** The Natural History Museum (bc). **Image from the Biodiversity Heritage Library:** British Entomology (cr). **338 Alamy Stock Photo:** The History Collection (cr). **Image from the Biodiversity Heritage Library:** Indian Insect Life : A Manual Of The Insects Of The Plains (Tropical India) (bc). **339 Alamy Stock Photo:** Florilegius (cr). **artscult.com:** (bc). **340 Getty Images:** Encyclopaedia Britannica /

Universal Images Group (cr). **Mary Evans Picture Library:** Florilegius (br). **341 artscult.com:** (cr). **Image from the Biodiversity Heritage Library:** Aid To The Identification Of Insects (br). **342 Image from the Biodiversity Heritage Library:** Fauna Germanica, Diptera (br); Natural history of the insects of India (cr). **343 Image from the Biodiversity Heritage Library:** Ants, Bees, And Wasps ; A Record Of Observations On The Habits Of The Social Hymenoptera (bc); Papillons De Surinam Dessinés D'après Nature (cr). **344 Alamy Stock Photo:** Reinhard Dirscherl (fbr); The Protected Art Archive (cr). **Dreamstime.com:** Andamanse (br); Aquanaut4 (bc). **naturepl.com:** Doug Perrine (bl). **345 artscult.com:** (cr). **Image from the Biodiversity Heritage Library:** Manuel D'actinologie Ou De Zoophytologie (bc). **346 Image from the Biodiversity Heritage Library:** The British miscellany (cr); Popular History Of The Aquarium Of Marine And Fresh-Water Animals And Plants (bc). **347 Alamy Stock Photo:** Paulo Oliveira (br). **Dreamstime.com:** Alexander Ogurtsov (bc); Stephankerkhofs (bl). **Science Photo Library:** Mehau Kulyk (cr). **348 artscult.com:** (cra, br). **349 Alamy Stock Photo:** FLPA (bc). **Dreamstime.com:** Greg Amptman (fbr); Jagronick (bl); Zuzana Randlova / Nazzu (br). **Image from the Biodiversity Heritage Library:** A history of the fishes of the British Islands. (cr). **350 Alamy Stock Photo:** The Natural History Museum (cra); Paulo Oliveira (bl); Kumar Sriskandan (cr). **351 artscult.com:** (br). **Image from the Biodiversity Heritage Library:** British fresh water fishes (cra). **352 Image from the Biodiversity Heritage Library:** Allgemeine Naturgeschichte Der Fische (br); British Fresh Water Fishes (br). **353 artscult.com:** (br). **Image from the Biodiversity Heritage Library:** M.E. Blochii Systema Ichthyologiae Iconibus Cx Illustratum (cr). **354 Alamy Stock Photo:** PF-(usna1) (cr). **artscult.com:** (br). **355 Image from the Biodiversity Heritage Library:** The Fishes Of Illinois (br); Trout Fly-Fishing In America (br). **356 artscult.com:** (bc). **Image from the Biodiversity Heritage Library:** Animaux venimeux et venins (cra). **357 artscult.com:** (cr). **Dorling Kindersley:** Thomas Marent (bl, bc, br). **Dreamstime.com:** Valentino2 (fbr). **358 123RF.com:** Andrey Gudkov (br). **artscult.com:** (cr). **Dreamstime.com:** Oxana Brigadirova / Larusov (bc); Cathy Keifer / Cathykeifer (bl); EPhotocorp (fbr). **359 Dorling Kindersley:** Jerry Young (br). **Dreamstime.com:** Omar Ariff Kamarul Ariffin / Oariff (bc). **Image from the Biodiversity Heritage Library:** Expédition dans les parties centrales de l'Amérique du Sud (cr). **360 Getty Images:** Florilegius / SSPL (cr). **Image from the Biodiversity Heritage Library:** Tortoises, Terrapins, And Turtles: Drawn From Life (br). **361 Dreamstime.com:** Vladislav Jirousek (br). **Image from the Biodiversity

Heritage Library:** Bilder-Atlas Zur Wissenschaftlich-Populären Naturgeschichte Der Wirbelthiere (cr). **iStockphoto.com:** KenCanning / Getty Images Plus (bl); Carl Jani / Getty Images Plus (bc). **362 Alamy Stock Photo:** Auscape International Pty Ltd (br). **Image from the Biodiversity Heritage Library:** The Mammals Of Australia. (cr). **363 Alamy Stock Photo:** Robertharding (fbr). **Dreamstime.com:** Tamara Bauer / Tamarabauer (br). **Image from the Biodiversity Heritage Library:** The Mammals Of Australia (cr). **iStockphoto.com:** ArendTrent / Getty Images Plus (bl). **364 artscult.com:** (cr). **Getty Images:** Florilegius / SSPL (cr). **365 Alamy Stock Photo:** Monkey Business (bc). **artscult.com:** (cr). **Dreamstime.com:** Lukas Blazek (bl); Matthijs Kuijpers (fbr). **SuperStock:** Michael & Patricia Fogden / Minden Pictures (br). **366 artscult.com:** (br). **The New York Public Library:** Illustrations of Indian zoology (cr). **367 123RF.com:** Dinodia (bc). **Alamy Stock Photo:** The Natural History Museum (cr). **Dreamstime.com:** Ecophoto (br); Sergey Uryadnikov (bl). **368 artscult.com:** (br). **The New York Public Library:** The Viviparous Quadrupeds Of North America (cr). **369 artscult.com:** (br). **The New York Public Library:** The Viviparous Quadrupeds Of North America (cr). **370 Alamy Stock Photo:** Blickwinkel (bc); VWPics (br); Rudmer Zwerver (fbr). **artscult.com:** (cr). **iStockphoto.com:** Ivan Kuzmin / Getty Images Plus (bl). **371 Alamy Stock Photo:** Hemis (br). **Dorling Kindersley:** Thomas Marent (bc). **Image from the Biodiversity Heritage Library:** Histoire Naturelle Des Mammifères (cr). **372 123RF.com:** Piotr Krześlak (bl). **artscult.com:** (cr). **Dreamstime.com:** Dohnal (bc); Mikelane45 (br). **373 artscult.com:** (br). **Image from the Biodiversity Heritage Library:** The Naturalist's Miscellany, Or Coloured Figures Of Natural Objects (cr). **374 artscult.com:** (br). **Image from the Biodiversity Heritage Library:** Dogs, jackals, wolves, and foxes: a monograph of the Canidae. (cr). **375 artscult.com:** (br). **Image from the Biodiversity Heritage Library:** The Mammals Of Australia. (cr). **376 artscult.com:** (cr). **Image from the Biodiversity Heritage Library:** The Quadrupeds Of North America (br). **377 Image from the Biodiversity Heritage Library:** Archives du Muséum d'Histoire Naturelle, Paris. (cr); Recherches Pour Servir À L'histoire Naturelle Des Mammifères (cr). **378 123RF.com:** Thomas Samantzis (bl); Kongsak Sumano / Ksumano (fbr). **Dreamstime.com:** Lukas Blazek / Lukyslukys (br); Cathywithers (bc). **Image from the Biodiversity Heritage Library:** Histoire Naturelle Des Mammifères (cr). **379 123RF.com:** Nico Smit (br). **Dreamstime.com:** Surz01 (bc); Timelynx (fbr). **Image from the Biodiversity Heritage Library:** Dictionnaire Universel D'histoire Naturelle (cr). **380 Alamy Stock Photo:** Brandon Cole Marine Photography (fbr); Doug Perrine (br). **Dreamstime.com:**

Anirootboom1326 (bl); Colette6 (bc). **Image from the Biodiversity Heritage Library:** British mammals (cr). **381 Alamy Stock Photo:** The Picture Art Collection (cr). **Mary Evans Picture Library:** (bc). **382 artscult.com:** (cr). **iStockphoto.com:** Ruskpp / Getty Images Plus (bc). **383 Alamy Stock Photo:** The Natural History Museum (cr). **Dreamstime.com:** Lukas Blazek (bl). **Getty Images:** Robin Bush / Oxford Scientific / Getty Images Plus (fbr). **naturepl.com:** Tui De Roy (bc, br). **384 Dorling Kindersley:** Blackpool Zoo, Lancashire, UK (bl). **Dreamstime.com:** Jiri Hrebicek (br); Roger Utting (bc). **National Audubon Society:** (cr). **385 Wellcome Collection http://creativecommons.org/licenses/by/4.0/:** (br, cr). **386 Alamy Stock Photo:** Florilegius (cr). **Dreamstime.com:** Lizgiv (bc); Vladimir Zaytsev (bl). **387 iStockphoto.com:** Ruskpp / Getty Images Plus (cra). **National Audubon Society:** (br). **388 National Audubon Society:** (cr, bc). **389 National Audubon Society:** (cr, bc). **390 Dorling Kindersley:** Sean Hunter Photography (bc). **Dreamstime.com:** Ecophoto (br); Brian Kushner (bl). **National Audubon Society:** (cr). **391 National Audubon Society:** (bc). **Wellcome Collection http://creativecommons.org/licenses/by/4.0/:** (cr). **392 National Audubon Society:** (cr). **The New York Public Library:** Illustrations of Indian zoology (bc). **393 Image from the Biodiversity Heritage Library:** Gemeinnüzzige Naturgeschichte des Thierreichs (cr). **The New York Public Library:** The birds of Great Britain (cr). **394 Dorling Kindersley:** Sean Hunter Photography (br); British Wildlife Centre, Surrey, UK (bl, bc). **Dreamstime.com:** Alantunnicliffe (fbr). **The New York Public Library:** The birds of Great Britain (cr). **395 iStockphoto.com:** Ruskpp / Getty Images Plus. **National Audubon Society:** (bc). **396 iStockphoto.com:** Ruskpp / Getty Images Plus (cr). **The New York Public Library:** The birds of Great Britain (bc). **397 iStockphoto.com:** Ruskpp / Getty Images Plus (cr). **The New York Public Library:** Histoire Naturelle Des Oiseaux De Paradis Et Des Rolliers, Suivie De Celle Des Toucans Et Des Barbus (bc). **398 National Audubon Society:** (cr). **Wellcome Collection http://creativecommons.org/licenses/by/4.0/:** (bc). **399 Dorling Kindersley:** Thomas Marent (bl). **Dreamstime.com:** Paul Reeves (br). **National Audubon Society:** (cr)

Endpaper images: *Front and Back:* **Aaron Ansarov**

All other images © Dorling Kindersley
For further information see:
www.dkimages.com

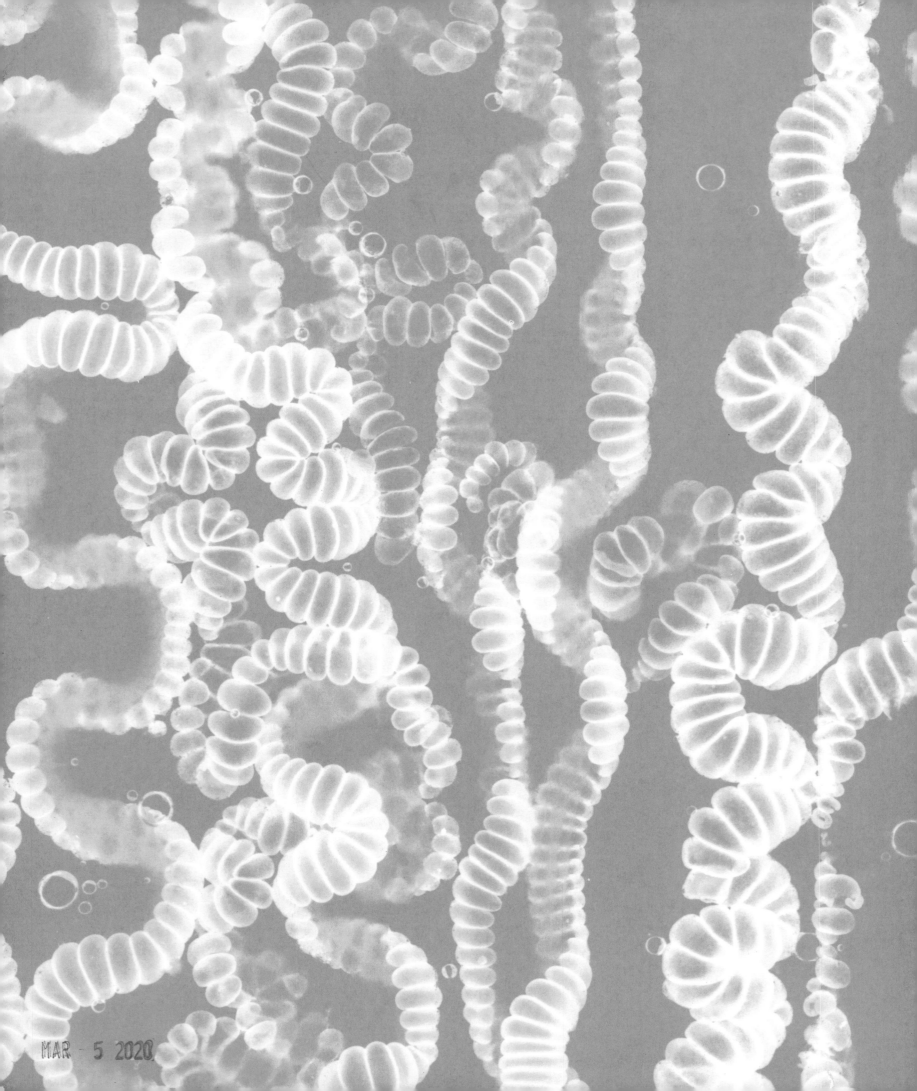